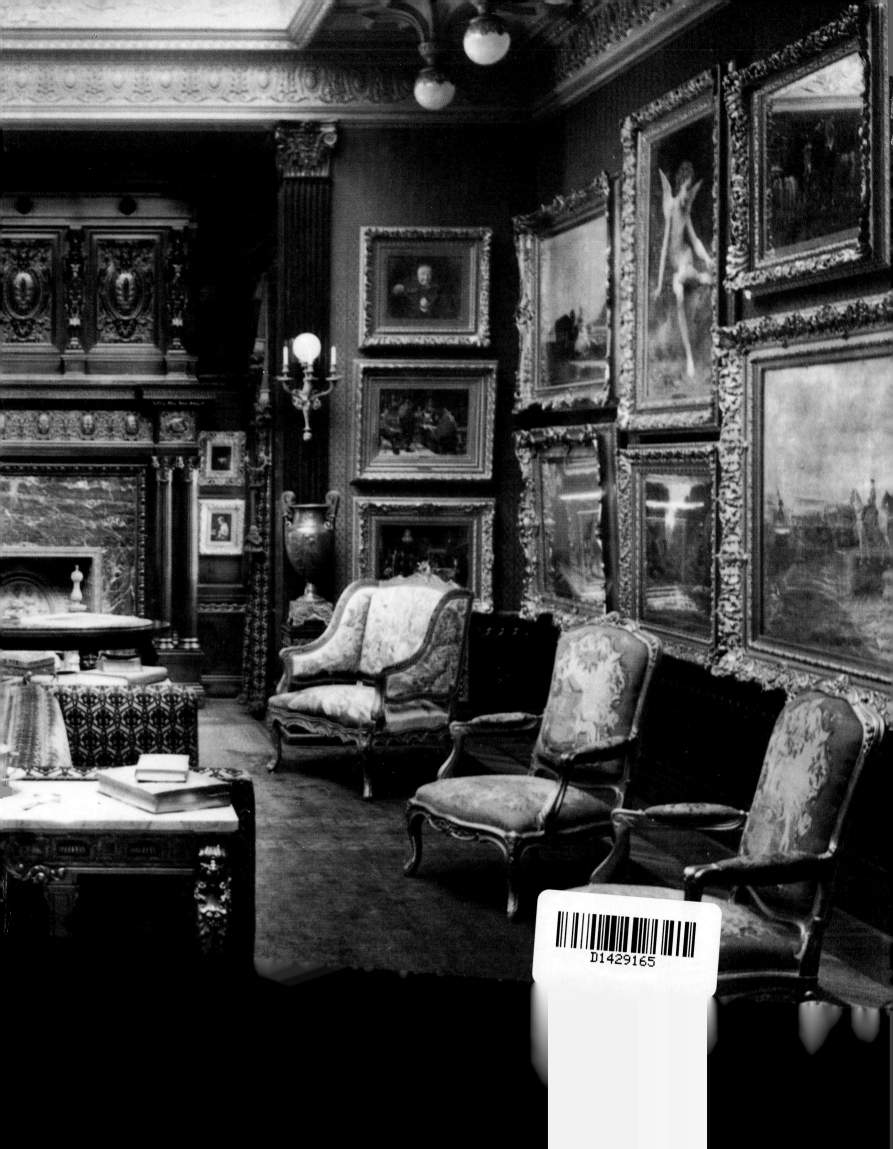

Collecting in the Gilded Age

Gabriel P. Weisberg

DeCourcy E. McIntosh

Alison McQueen

Collecting in

the Gilded Age

Art Patronage in Pittsburgh, 1890–1910

with essays by
John N. Ingham
Constance Cain Hungerford
Ruth Krueger Meyer and
Madeleine Fidell Beaufort

Organized by
DeCourcy E. McIntosh

Exhibition curated by
Gabriel P. Weisberg

with the assistance of
Yvonne M. L. Weisberg

Frick Art & Historical Center
Pittsburgh, Pennsylvania, 1997

Distributed by
University Press of New England
Hanover and London

Published on the occasion of the exhibition
Collecting in the Gilded Age:
Art Patronage in Pittsburgh, 1890–1910
6 April–24 June 1997

Organized by Frick Art & Historical Center,
Pittsburgh

Major support for the exhibition has been
generously provided by the Allegheny Foun-
dation. The exhibition catalogue has been
made possible by substantial underwriting
from the McCune Foundation. Additional
underwriting for the exhibition and educa-
tional programming has been contributed by
PNC Bank, N.A.

Technical Assistance for the exhibition
provided by The American Federation of Arts

Printed in Great Britain by
Balding + Mansell, Kettering

Distributed by University Press of New
England, Hanover and London

ISBN 1-881403-03-3

Library of Congress
Cataloging-in-Publication Data

Weisberg, Gabriel P.
Collecting in the Gilded Age : art patronage
in Pittsburgh, 1890-1910 / Gabriel P.
Weisberg, DeCourcy E. McIntosh, Alison
McQueen ; with essays by John N. Ingham . . .
[et al.].
p. cm.
Catalog of an exhibition: Frick Art & Histor-
ical Center, Apr. 6-June 24, 1997.
Includes bibliographical references and index.
ISBN 1-881403-03-3 (hardcover)
1. Painting—Private collections—Pennsylva-
nia—Pittsburgh—Exhibitions. 2. Art
patronage—Pennsylvania—Pittsburgh—
History—19th century—Exhibitions. 3. Art
patronage—Pennsylvania—Pittsburgh—
History—20th century—Exhibitions.
I. McIntosh, DeCourcy E. II. McQueen,
Alison, 1969- . III. Frick Art & Historical
Center. IV. Title.
N5216.P4W45 1997
750'.74748'86—dc21 96-47939
 CIP

Text Editor: Nancy Eickel
Photograph Editor: Linda Benedict-Jones,
with the assistance of
Medha Patel and Sarah Hall
Designer: Wynne Patterson
Typesetter: Jo Ann Langone

Frontispiece: John White Alexander,
Girl in Green with Peonies, 1896, oil on canvas.
University Club, Pittsburgh (cat. 1).

Notes to the catalogue:

Works now in the possession of the Frick Art
& Historical Center were formerly in the pri-
vate collection of Henry Clay Frick.

From 1890 to 1911 the *Pittsburgh Post*
dropped the *h* on the masthead of its newspa-
per, so the city's name appeared as Pittsburg.
For consistency throughout this publication,
the *h* in Pittsburgh has been retained when
referring to that newspaper.

The first Carnegie Annual exhibition was
held in 1896. The name and organization of
these exhibitions remained virtually the same
until the early 1920s, and in 1950 the title was
altered to the Pittsburgh International Exhi-
bition of Paintings. After several more name
changes, the now widely recognized title of
Carnegie International was adopted for these
exhibitions in 1982. Throughout this publica-
tion, the Carnegie Annual and Carnegie
International refer to the same early series of
exhibitions held at the turn of the nineteenth
century.

List of Lenders

Allegheny Cemetery, Pittsburgh

The Art Museum, Princeton University,
 Princeton, New Jersey

The Baltimore Museum of Art

Morton C. Bradley, Jr.

Laurada and Russell Byers

The Carnegie Museum of Art, Pittsburgh

Mrs. Henry Chalfant

The Chrysler Museum of Art, Norfolk, Virginia

The Columbus Museum of Art, Ohio

The Corcoran Gallery of Art, Washington, D.C.

The Dahesh Museum, New York

The Denver Art Museum

DePaul Institute, Pittsburgh

Mr. and Mrs. Roy G. Dorrance

Duquesne Club, Pittsburgh

Mr. and Mrs. James M. Edwards

Mr. and Mrs. Richard D. Edwards

Katherine L. Griswold

Mr. and Mrs. Henry L. Hillman

The Henry E. Huntington Library and Art Gallery,
 San Marino, California

Michael D. and Violanda R. LaBate

Dr. and Mrs. Robert Lipinski

Mr. George D. Lockhart

Mr. and Mrs. Edward McCague, Jr.

The McCune Foundation, Pittsburgh

Harold and Catherine Mueller

Musée Municipal Georges Garret, Vesoul, France

Museum of Art, Fort Lauderdale, Florida

National Museum of American Art, Washington, D.C.

The Nelson-Atkins Museum of Art,
 Kansas City, Missouri

New Britain Museum of American Art, Connecticut

The New-York Historical Society

Mr. and Mrs. Charles G. Pauli, Jr.

Grant A. Peacock, Inc., New York

Mr. and Mrs. A. Charles Perego

Philadelphia Museum of Art

Phipps Conservatory, Pittsburgh

Pittsburgh Athletic Association

Sagamore Hill National Historic Site,
 National Park Service, Oyster Bay, New York

Mr. Richard M. Scaife

Mr. and Mrs. Thomas M. Schmidt

Alexandra and Sidney Sheldon

Mr. and Mrs. William Penn Snyder III

Mr. Adam Stolpen

Joel R. Strote and Elisa Ballestas

University Club, Pittsburgh

Yale University Art Gallery, New Haven, Connecticut

Anonymous Private Collections

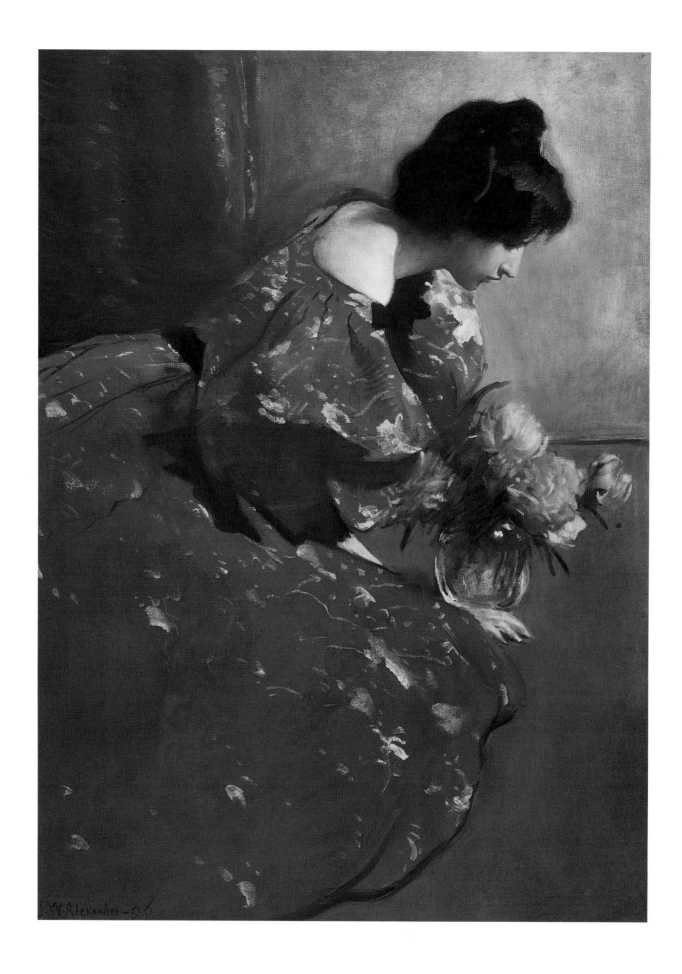

Contents

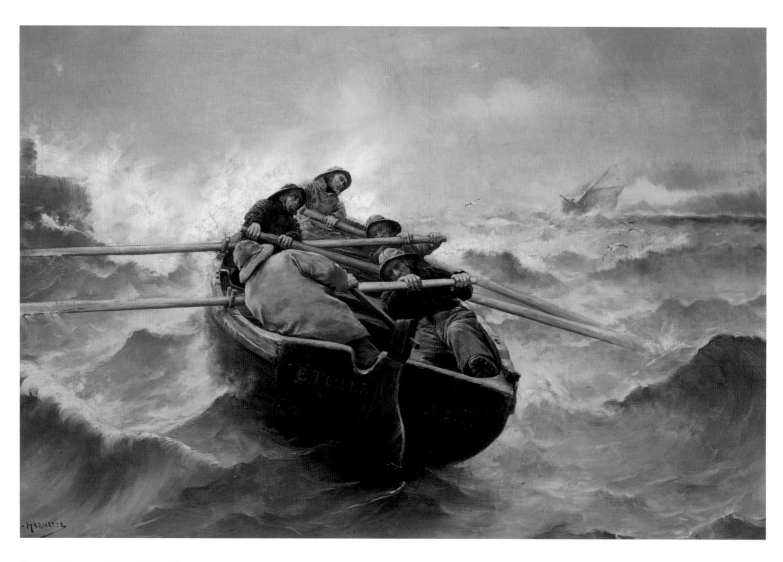

Cat. 2. Georges-Jean-Marie Haquette
(1854-1906). *Une Sortie*, n.d., oil on can-
vas. The McCune Foundation, Pittsburgh
[Ex. coll., Charles Lockhart].

Preface

THE TWENTY-YEAR period from 1890 to 1910—the Gilded Age—is often remembered for the rapid acquisition of new wealth and for astonishing episodes of conspicuous spending. In Pittsburgh, it was also a heroic time, one that merits serious attention because it was then that the city assumed its present form. Fueled by explosive growth in the industries of oil, glass, food processing, and above all, iron and steel, the booming economy of Pittsburgh in the Gilded Age furnished the basis for some of America's largest fortunes. Along with phenomenal industrial and financial expansion came cultural ambitions, which, unfortunately, have always been overshadowed by the city's image as a gritty, smoke-filled mill town. Yet for all its environmental drawbacks, the high profitability of heavy industry gave mill owners and business leaders the wherewithal to collect art.

And collect they did. By the early 1900s more than a thousand paintings could be found in Pittsburgh. Their presence on the walls of massive houses indicated how widespread art collecting had become among the city's leading industrialists, merchants, bankers, and lawyers. Until recently, few recognized or appreciated the full depth and breadth of this activity. Originally, because we knew no better, we had planned the exhibition as a relatively modest examination of the paintings that Henry Clay Frick had purchased and, in many cases, had returned for credit before he moved to New York City in 1905. We began our search with certain assumptions, chief among them being the old chestnut that, with the exception of Frick and Andrew Mellon, Pittsburgh's industrial barons were either too preoccupied with business, too tight with their money, or too restrained to care about art. As a result, we assumed that Frick, by filling Clayton, his Pittsburgh house, with a diverse assortment of paintings, was expressing yet another dimension of a notoriously inscrutable personality.

Just how wrong we had been dawned on me at a Christmas party held in 1994. In the home of an eighty-four-year-old friend, I found myself staring at a painting so similar to one Frick had acquired one hundred years earlier that I

could not help remarking upon the coincidence to the man standing next to me.[1] To my surprise, he said that he had inherited a painting from the same family collection. Would I like to see it? A few weeks later, as we studied the painting in his bright, comfortable apartment, he explained that over the course of a century, the painting, which was none other than Ernest Meissonier's last great battle scene, *1806, Jena,* had been passed down through the family of his late wife.

It seemed that Charles Lockhart, the founder of the family, had arrived in Pittsburgh from Scotland in 1836. By the time of his death in 1905, Lockhart had created not only one fortune in oil and another in iron and steel, but he had also assembled an art collection so large that he had been compelled to construct a sky-lit gallery as part of his mansion on Highland Avenue. This single fact challenged our assumptions both about Frick and about the context in which he collected art. Frick, we knew, did not build a private art gallery until after he had moved to New York City (although at one point he did commission plans for such a structure at Clayton). Was it reasonable to assume that Frick had known of the Lockhart collection while he lived in Pittsburgh? Might Frick have been inspired by Lockhart?

Questions led to more questions. Might there be other forgotten collectors? Who were they? What had they purchased and from whom? Where were their collections now? Were there art collections in Pittsburgh before the Gilded Age? Lead followed lead, tip followed tip. Within a few exhilarating months, we discovered that family after family associated with industry in Pittsburgh had collected art. We found substantial evidence of collections formed by A. M. Byers, H. J. Heinz, B. F. Jones, Senior and (especially) Junior, W. F. McCook, Alexander W. Peacock, Henry Kirke Porter and Annie Decamp Hegeman Porter, Mary Copley Thaw, D. T. Watson, Henry W. Oliver, Jr., and George T. Oliver, various members of the Laughlin family, and many others to a lesser degree, until the list reached nearly one hundred names.[2] In the popular story, the visit that Frick and Mellon had made to the Wallace Collection in London in 1880 had inspired them to collect art. We now had information that several prominent members of Pittsburgh society were purchasing paintings by the 1860s and that by the mid-1890s a plethora of prosperous industrialists were involved in collecting.

We turned to three institutions in Pittsburgh on whose walls hang artworks acquired in the Gilded Age: the Duquesne Club, the University Club, and the Pittsburgh Athletic Association (PAA). In the files of the PAA, we happened

upon a mother lode of information in the form of a crude catalogue of paintings that were in Pittsburgh private collections around 1906 to 1909. Although this undated, untitled, and long-forgotten document raised almost as many questions as it answered, it offered priceless clues as to who had owned what in Pittsburgh.

We cross-referenced the PAA catalogue with exhibition catalogues, columns on art and society in newspapers, and sales records of art dealers. In New York we studied the original books that documented the sales, stock, and correspondence of M. Knoedler & Co., the firm most actively patronized by collectors from Pittsburgh.[3] Studying the records line by line, year by year, we discovered that the trickle of Pittsburgh patronage, which had begun in 1864, had by the late 1890s swelled to a flood. So important were Pittsburgh patrons to Knoedler's business that in 1897 the firm opened a gallery in this city. Knowing that Pittsburghers who had traveled to New York, London, and Paris had made purchases from Arthur Tooth & Sons, a firm with galleries in the first two cities and an agent in the last one, we widened our search for information to Santa Monica, California, where Tooth's sales books have been preserved by the Getty Research Institute for the History of Art and the Humanities. Ironically, within sight of the Pacific Ocean we learned of the existence of additional Pittsburgh collectors and fascinating details of purchases made by Frick and others.

As word of our research spread, descendants of Pittsburgh collectors came forward to share the photograph albums in which their grandparents and great-grandparents had memorialized their houses and collections. Never exhibited publicly, these albums preserve scores of gelatin silver prints that document the most impressive interiors in Pittsburgh during the Gilded Age—luxurious rooms in which occasional flights of fancy punctuate decorous ensembles of paintings, furnishings, and architectural detail. Despite all the attention given recently to the Herter brothers, Louis Comfort Tiffany, and other influential designers of interiors in the late nineteenth century, this particular chapter in the development of American taste begs further investigation.

The identities of art collectors in Pittsburgh, the character and origins of their holdings, and the broader implications of acquiring works of art at the turn of the century unfold in the essays written for this catalogue. The exhibition itself aspires to represent as accurately as possible a composite of collections that would have been found in Pittsburgh during the Gilded Age, closely

hung in gilt frames in the age-old European tradition. We have borrowed paintings from homes and city clubs in Pittsburgh, from private collectors across the continent and abroad, and from some of the most distinguished museums in the United States. We have endeavored to represent artists and types of paintings in proportions that well reflect their presence in Pittsburgh in the late nineteenth century and to allow today's viewers to encounter works of art as they would have been seen in this city in the Gilded Age.

The directors of the Frick Art & Historical Center embraced this project at its inception and supported its development in every possible way, leaving no doubt as to their interest in encouraging the Center to expand its mission to promote Pittsburgh history and culture in broad terms. Major grants from the Allegheny Foundation and the McCune Foundation made it possible to assemble the exhibition and present the catalogue's subject matter in a manner befitting the Gilded Age. Richard M. Scaife, chairman of the Allegheny Foundation, took a lively interest in the project as it progressed and loaned three beautiful albums of photographs of his grandparents' house at 6500 Fifth Avenue, which was the last of the great mansions built in Pittsburgh to the designs of Alden and Harlow. The executive director of the McCune Foundation, along with individual members of the Distribution Committee, some of whom are descendants of Charles Lockhart, offered encouragement and valuable historical information concerning Mr. Lockhart. The catalogue and educational materials associated with the exhibition have benefited greatly from the generosity of PNC Bank, N.A. and the enthusiastic support of James M. Ferguson III, executive vice president of PNC Private Bank, and Edward V. Randall, Jr., president and chief executive officer of PNC Bank, N.A., Pittsburgh.

Gabriel P. Weisberg has been the most creative, dynamic guest curator for which an exhibition organizer could hope. Quick to point out the broader implications of our original idea to explore local collections, he soon introduced us to the art world of nineteenth-century America and Europe and formulated a provisional checklist. In addition to researching and writing the essay that forms the core of this catalogue, he brought his considerable experience to bear upon a host of practical problems. Yvonne Weisberg dispatched many thankless administrative tasks, in her role as "documentalist" and was particularly helpful as a liaison with the French lenders to the exhibition.

At Dr. Weisberg's direction, Alison McQueen explored a broad range of

local documentary sources and uncovered scores of turn-of-the-century collectors who hitherto had been forgotten. Her discoveries dovetailed conveniently with and benefited from the earlier research of John N. Ingham into the sociological background of the Pittsburgh industrial elite. We were fortunate to be able to recruit both scholars as catalogue essayists.

We are also grateful to Ruth Krueger Meyer and Madeleine Fidell Beaufort for drawing upon their lifetimes of scholarship to make comparisons between the Pittsburgh experience and art collecting in Midwestern cities. It would have been understandable if Constance Cain Hungerford's reaction to the discovery of Meissonier's *1806, Jena* had been less than ebullient—in 1993 she catalogued the painting as being lost. Her response to this news, however, was characteristically positive, and her essay on the painting is a welcome addition to literature on the fine arts in Pittsburgh.

The exhibition has benefited from the cooperation of many descendants of the protagonists in our story. In the Frick family, Peter P. Blanchard III, I. Townsend Burden III, Helen Clay Chace, Arabella S. Dane, Dr. Henry Clay Frick II, and Martha Frick Symington Sanger have been generous with information about works that bear a Frick provenance. When consulted about the project at its inception, Mrs. Sanger, a biographer of Henry Clay Frick, offered interesting perspectives on her great-grandfather's appreciation of several artists, especially the portraitist Théobald Chartran.

In the extended Lockhart family, George D. Lockhart, Richard D. Edwards, James M. Edwards, Janet Edwards Anti, and Katherine Lockhart Griswold made exceptional efforts to broaden our understanding of the life and achievements of Charles Lockhart. Their warm reception to my initial inquiries emboldened me to press on with other families.

Russell Byers and his sisters, Carol Mitsch and Mia Norton, patiently tolerated persistent inquiries about the Byers family. Regrettably, our limited budget could not accommodate transportation of all the works from the original A. M. Byers collection that they generously offered to lend to the exhibition.

Although the Peacock collection is represented by only one painting, Alexander R. Peacock's grandson, Grant A. Peacock, Jr., lent the extraordinary "Rowanlea" album and other important family documents and photographs. Many members of the interconnected Jones and Laughlin families came forward with information and documentation, in particular, Gordon and Donna Gordon, Nonie Wyckoff, Penny Jones, Colvin McCrady, Laughlin

Phillips, and James Laughlin. Margaret Pollard Rea provided invaluable information and hilarious anecdotes that helped us to locate *Hero* (cat. 16), a rare surviving work from the collection of Henry W. Oliver, Jr. Emily F. Oliver contributed valuable leads concerning her predecessors in the Frew and Park families. Joanne Lyman, widow of the last descendant of the Kelly branch of the Park family, enlarged our understanding of the collection that was sold from the residence of the late Eleanor Park Kelly in May 1995. Templeton Smith and his daughter Eliza Brown illuminated the frequent references to Julian Kennedy that we had encountered. McCook Miller, Jr., and Edward J. McCague, Jr., led us to paintings still existing in Pittsburgh from the collection of Willis F. McCook, Frick's lawyer.

The distinguished historian David Cannadine and his resourceful research assistant, Walter Friedman, are together researching a biography of one of the most important figures in our story, Andrew Mellon. They most generously shared insights into Mellon's life and personality, and provided welcome advice, encouragement, and merriment to this chronically worried exhibition organizer.

William H. Gerdts provided crucial information on the early art collector and dealer Christian H. Wolff, a crucial character in Pittsburgh before the Gilded Age. Vicky A. Clark, in her capacity as historian of the Carnegie International exhibitions, kindly read my essay and engaged me in numerous clarifying discussions about the formative years of the Carnegie Art Galleries.

I have often discussed the exhibition with other good friends, and they never failed to respond in ways that expanded my understanding of the subject, led to significant discoveries, or averted mistakes. I wish to express special thanks to Charles Altmann, Leon A. Arkus, Jane C. Arkus, Eric G. Carlson, Gregory Hedberg, Thomas J. Hilliard, Jr., John W. Ittmann, Robert Kashey, Edgar Munhall, Alexandra R. Murphy, Charles Pauli, Henry Hope Reed, Alden H. J. Sector, Graham P. Shearing, G. Whitney Snyder, Frank A. Trapp, and Harley N. Trice II. C. Holmes Wolfe, Jr., patiently read the catalogue manuscripts and offered factual information that improved their accuracy.

In September 1990, at the ceremony opening Clayton to the public, Thierry W. Despont, the architect for that project, remarked to me that the Frick Art & Historical Center would be a wonderful venue for exhibitions of late nineteenth-century art. Although for some time I was too preoccupied to think much about this suggestion, I never forgot it, and I now express special thanks to Mr. Despont for his prescient idea.

No survey of late nineteenth-century American collectors should proceed without consulting the records of M. Knoedler & Co., the firm that, above all others, provided the crucial link between European, in particular French, sources of artworks and the burgeoning American market for European painting. Ann Freedman, president of Knoedler, deserves many thanks for the liberal access given to the firm's historic records. Librarian Melissa De Medeiros cheerfully shared her encyclopedic knowledge of the firm's long history and her broad frame of reference with respect to personalities in the American art world in the second half of the nineteenth century. Both this exhibition and its catalogue would be the poorer without the many nuggets of information and insightful suggestions that Ms. De Medeiros contributed over many months.

Three other institutions merit specific mention for providing access to their resource collections: the Frick Art Reference Library in New York City, the Getty Research Institute for the History of Art and the Humanities in Santa Monica, and the Carnegie Library in Pittsburgh. Warm thanks go to Patricia Barnett, director, and to those who serve readers at the Frick Art Reference Library. At the Getty Research Institute for the History of Art and the Humanities, Donald Anderle, assistant director for the Resource Collections, Kirsten A. Hammer, senior Special Collections assistant, and Andrew Cooper, Special Collections assistant, made invaluable primary source material available to me. Burton Fredericksen, director, and Carol Tognieri and Maria L. Gilbert of The Provenance Index of the Getty Art History Information Program, opened for me countless useful files on the provenance of paintings in America. At the Carnegie Library of Pittsburgh, Kathryn P. Logan, head of the Music and Art Department, fortuitously called my attention to important documentation of the art collection of Christian H. Wolff and to newspaper records concerning the Pittsburgh Library Loan exhibition of 1879.

Equally generous with their time and resources has been the staff of the Carnegie Museum of Art. Louise Lippincott, curator of fine arts, and Monika Tomko, registrar, supplied files that answered many of our questions. Phillip M. Johnston, former director, and Richard Armstrong, his successor as Henry J. Heinz II director, deserve our lasting gratitude for their interest in this project and for approving and administering the museum's crucial loans to the exhibition.

Arthur P. Ziegler, Jr., president of the Pittsburgh History and Landmarks

Foundation, willingly opened the doors of his institution, and soon we were trailing behind Albert M. Tannler, archivist, as he combed its library for relevant information. Our grasp (such as it may be) of Pittsburgh architecture in the Gilded Age owes much to the Foundation's publication *Architecture After Richardson, Regionalism Before Modernism: Longfellow, Alden and Harlow in Boston and Pittsburgh* by Margaret Henderson Floyd.

The hunt for current owners of paintings that had once been in Pittsburgh proved to be intensely exciting. We would have missed our quarry, however, without the assistance of the department of nineteenth-century paintings at Sotheby's in New York City. Valerie Westcott, who adopted our cause, personifies Sotheby's dedication to service. Art galleries also provided invaluable assistance, none more than the Spanierman Gallery, where Ira Spanierman promptly furnished a critical lead. Similarly, M. R. Schweitzer extracted from his records valuable leads on paintings with a Pittsburgh provenance.

The nineteenth-century artists whose reputations have recovered most fully in recent years are those for whom accurate representation in the exhibition has been hardest to achieve. Paintings we desired entered and re-entered the market with frustrating frequency. With respect to the most elusive of all, Sir Lawrence Alma-Tadema, Vern G. Swanson, author of the catalogue raisonné of the artist's work, and Jennifer Gordon Lovett, curator of an Alma-Tadema exhibition organized in 1991, were genuine saviors.

Without a dedicated and tactful editor, this exhibition catalogue would have faltered at a critical moment. The publication, in effect, had two editors: Nancy Eickel for text and Linda Benedict-Jones for images. Ms. Eickel displayed uncommon diplomatic skill in working with authors and helping them to clarify their thoughts and words, while Ms. Benedict-Jones, with the assistance of Medha Patel and Sarah Hall, tracked down images and related them to texts with the determination and precision of a watchmaker. Their collaboration most assuredly promoted both the textual and the visual unity of the catalogue. Ms. Eickel's responsibilities extended to the preparation of a selected bibliography and a detailed index, which enhance the usefulness of the volume to readers, just as her concern for consistency and factual accuracy added solidity to the work. In the eight months preceding the exhibition's opening, Ms. Benedict-Jones capably coordinated each successive stage in the preparation of the catalogue and solved countless problems related to loans of artworks.

The Frick Art & Historical Center relied heavily upon the professional

expertise of Dennis Ciccone of White Oak Publishing to manage the production of this catalogue. We particularly thank him for negotiating agreements with the distributor, University Press of New England, and for nominating Wynne Patterson as catalogue designer. Thomas M. Johnson, associate director at the University Press of New England, was an understanding and helpful representative of his firm, and Ms. Patterson never permitted a mass of text and illustrations to subvert the execution of her clear and beautiful design.

It goes without saying that this exhibition greatly depended upon the generosity of lenders. In addition to the Carnegie Museum of Art, Monsieur and Madame Jean Adam Frumholz, the Musée Georges Garret in Vesoul, France (of which Sabine Gangi serves as curator), the Dahesh Museum in New York City (where J. David Farmer is director), and the New Britain Museum of American Art (with Laurene Buckley as director) made outstanding contributions. Sidney and Alexandra Sheldon, Joel R. Strote, and in Pittsburgh, Mrs. Henry Chalfant, Mr. and Mrs. Richard D. Edwards, Mr. and Mrs. James M. Edwards, Mrs. Katherine Lockhart Griswold, Mr. and Mrs. Edward J. McCague, Jr., Mr. and Mrs. Charles G. Pauli, Jr., Mr. Thomas M. Schmidt, and several anonymous private collectors deserve warm thanks for tolerating the disruptions of daily life that plague lenders when they offer works to museum exhibitions. Sandy Miller of the University Club and Philip Andrews and Stephen George of the Pittsburgh Athletic Association were particularly helpful in arranging for critically important works to be borrowed from those institutions.

Recognition of the long hours of work invested by the staff members of the Frick Art & Historical Center is of paramount importance. Their willingness to undertake this monumental endeavor and their determination to make it a success are particularly commendable. Stephen J. Hussman, archivist of the Frick family archives, dazzled everyone with his findings and was always ready to help researchers. Linda Benedict-Jones and I were ably assisted by Medha Patel, who meticulously coordinated loan documents and photography at the same time she delved into several research tasks. Robin Pflasterer, registrar of Clayton, worked carefully with outside photographer Richard Stoner, who repeatedly responded to our requests for additional transparencies and reproduction prints, often on short notice.

Nadine Grabania, assistant curator of The Frick Art Museum, served the exhibition as registrar, installation designer, and installation supervisor, as well

as liaison with The American Federation of Arts, which provided technical services in packing and transporting works of art. My assistant, Ruth Ferguson, coped with my mounting anxiety in addition to an ever-expanding universe of files. John R. Thomas and his staff in the finance department of the Frick Art & Historical Center capably managed the financial intricacies of the exhibition, and I am especially grateful to Mr. Thomas for shouldering more than his share of the burden of managing the Center during the many months I was preoccupied with the Gilded Age.

Sheena Wagstaff, curator both of The Frick Art Museum and of education for the Frick Art & Historical Center, devised educational programs around the exhibition themes, supervised the design and installation of the exhibition, and helped with its presentation in countless other ways. Lauren Kintner capably managed relations with supporters of the exhibition and its catalogue as well as with the general public.

Susan B. McIntosh read and re-read (only she knows how many times) every word of my modest contribution to this catalogue, and Charles W. Skrief kindly helped me present my thoughts in a manner that I sincerely hope is respectful of a reader's needs. All who peruse these pages have reason to be grateful to both.

DeCourcy E. McIntosh
Executive Director
Frick Art & Historical Center

NOTES TO THE PREFACE

1. The painting was *Meditation* by Daniel Ridgway Knight (collection of George D. Lockhart). In 1894 Frick made his first purchase from M. Knoedler & Co., Knight's *Coming from the Garden* (location unknown).

2. A list has been compiled by Alison McQueen in an unpublished manuscript entitled "Pittsburgh Private Art Collections c. 1890–1905."

3. In addition to Knoedler's, Pittsburghers patronized J. J. Gillespie & Co. and Wunderly Brothers, whose archives have been largely lost or destroyed.

Collecting in

the Gilded Age

Art Patronage in Pittsburgh, 1890–1910

HENRY CLAY FRICK
America's greatest organizer and manager of
industrial progress.

HENRY PHIPPS
Capitalist. Public benefactor
Interested in numerous enterprises of magnitude

WILLIAM H. SINGER
Director in the Carnegie Steel Co.
Connected with numerous commercial enterprises

HON. PHILANDER CHASE KNOX
United States Senator from Pennsylvania
Noted Attorney on International Law

FRANCIS THOMAS FLETCHER LOVEJOY
Capitalist, late Carnegie Steel Co.
Bank director, etc.
Interested in several large enterprises

CHARLES M. SCHWAB
World famous steel master and capitalist
Ex-President of the
United States Steel Corporation

GEORGE EMMETT McCAGUE
Capitalist
Director Philadelphia Co., Pittsburgh Railways
Co. and various financial institutions

LAWRENCE C. PHIPPS
Capitalist
Ex-First Vice President Carnegie Steel Co.
Ex-Treas. Carnegie Steel Co.

ALEXANDER R. PEACOCK
Capitalist
Ex-First Vice President Carnegie Steel Co.
Director various enterprises

COL. LEWIS T. BROWN
Capitalist. Ex-official Carnegie Steel Co.
Director Pennsylvania National Bank
Member Carnegie Veteran Association

THOMAS MORRISON
Capitalist. Director and former Gen'l Supt.
Edgar Thomson Works Carnegie Steel Co.
Large glass and coal interests

JOHN McLEOD
Capitalist
Retired official of the Carnegie Steel Company
Interested in various institutions

JOSEPH E. SCHWAB
Late assistant to the President United States
Steel Corporation. Capitalist. Financier

FRANCIS J. HEARNE
Ex-President of the National Tube Co
Capitalist

JAMES G. HUNTER
Capitalist. Retired manufacturer

WILLIAM MILLER, Sr.
Capitalist. Retired contractor
William Miller & Sons Co.

Reaching for Respectability

The Pittsburgh Industrial Elite at the Turn of the Century

John N. Ingham

PITTSBURGH IN THE LATE NINETEENTH CENTURY was a study in contrasts. Vast extremes of wealth and poverty, beauty and ugliness, opulence and squalor characterized a city that, riding on the shoulders of iron and steel, witnessed the creation of enormous fortunes that depended upon the labor of hordes of unskilled European immigrants who huddled in shacks near the roaring, bustling mills. The entrepreneurs themselves built great mansions in Allegheny City, Shadyside, and Sewickley Heights. As Herbert Casson noted in 1907,

> Its mansions are veritable museums of all that is costly and unique. The art stores of New York, Paris, London, Vienna, and Berlin have been ransacked to furnish them. Many of the masterpieces of European artists hang on their walls. Liveried servitors, silent and automatic, wait for orders. All that money can buy is in the palaces of these men. . . .[1]

These great men of wealth, at least according to legend at the time, possessed little in the way of social grace or status. To easterners, Pittsburgh was too raw, too young, too close to its frontier origins. Its fortunes were too newly minted to carry weight in the more hallowed sanctums of seaboard society. These new millionaires seemed to be, as Casson observed, "men, who, with scarcely an exception, were born and reared in the three-roomed cottages of the poor."[2] This image was not particularly accurate, but it stuck nonetheless. Pittsburghers, aristocrats from older eastern cities sniffed, were too crude, too *nouveau riche* to really count. A challenge was thus presented to Pittsburgh's industrial elite (fig. 1). Amazingly rich, they were not respected by the scions of the *Social Register* or by the arbiters of good taste in Boston, New York, and Philadelphia. How could the industrial elite of Pittsburgh gain their respect? As Casson suggests, they tried in a number of ways: by building huge man-

Fig. 1. Some of Pittsburgh's industrial elite. Reproduced from *Palmer's Pictorial Pittsburgh and Prominent Pittsburghers Past and Present 1758–1905* (Pittsburgh, 1905).

sions, by furnishing them with European antiquities, and by collecting art, especially the work of European painters.

Pittsburgh was a relatively young city. Founded as a fort in 1754, it grew slowly and inconsequentially over the next half century. By 1800 its population was just over fifteen hundred, and its commercial life revolved around sixty-three shops, with twenty-three general stores, four bakeries, six shoe shops, and four hat shops. The most important element of the city's population, however, was a rather large number of mechanics who formed the basis of an emerging handicraft industry. With its status as a commercial entrepôt and center for handicraft production, Pittsburgh's population surged to over five thousand by the end of the War of 1812. The wealthiest and most powerful men in the young city were merchants, such as Joseph McClurg and James O'Hara, who ran successful wholesale and retail operations. These men also provided the capital for Pittsburgh's first real industrial ventures, opening a glass factory, a brewery, a shipyard, and most significantly, an iron foundry. Another characteristic of the young city proved to be crucial: this emerging mercantile and manufacturing group was overwhelmingly from northern Ireland and belonged to the Presbyterian church, factors that placed a distinctive cultural stamp on Pittsburgh.

By the 1830s Pittsburgh's economy no longer depended on commerce. It was by then a thriving city with iron at the heart and soul of its industrial machine. Pittsburgh was operating mills in every branch of iron manufacturing, and soon it was being compared to the great industrial city of England. Charles Dickens, who visited Pittsburgh in 1842, commented, "Pittsburgh is like Birmingham in England, at least its townspeople say so. . . . It certainly has a great quantity of smoke hanging over it, and is famous for its iron works."[3] The Mexican War increased the demand for these products and turned Pittsburgh into a vital manufacturing center for guns, weapons, and ammunition. By 1860 the city was already a powerful industrial entity, and the production of iron and steel was deeply ingrained into its very fiber. The explosive demands of the Civil War pushed that industry to staggering heights.

The great industrial expansion during and after the Civil War was made possible by two factors. First, some Pittsburghers had made impressively large fortunes in mercantile and transportation enterprises, and second, these men felt a strong sense of affinity with their Scotch-Irish cohorts who were founding new iron and steel mills. The rise of heavy industry in Pittsburgh, however, did not create a significantly new elite class, as forecasted by Karl Marx and stip-

ulated by Herbert Gutman and others in historical studies.[4] Ethnic ties tended to transcend any animosities that might have existed due to differing economic systems. Scotch-Irish merchants invested in iron and steel joint stock companies and provided short- and long-term loans to these new ventures through their private banking houses.[5]

The new elite that emerged in Pittsburgh in the late nineteenth century included a number of members who came from humble origins but were closely tied to the older mercantile elite in the city. The negative reaction to Pittsburgh's industrial elite perhaps had more to do with ethnic origins than with their recently acquired wealth. Their position as cultural outsiders in America tended to unite old and new money in Pittsburgh. They were all striving for respectability and hoping to be accepted by the older upper-class society of English origins that dominated East Coast cities.[6]

Pittsburgh after 1880 became known as "Steel City," but before that it had been called "Iron City," and the complex of merchant iron mills that dotted its river banks formed the basis for the massive steel industry of the late nineteenth century. Before the steel barons Andrew Carnegie and Henry Clay Frick were the iron barons. The city's first iron foundry had been set up in Shadyside by George Anshutz in 1793, but it closed down in two years. Not until 1805 did Joseph McClurg establish a successful, continuing iron forge that marked the beginnings of the city's iron industry.

The real foundation of Pittsburgh's iron industry, however, was not secured until the 1820s, with the emergence of three highly successful iron rolling mills. The Juniata Mill, built in 1824 by Dr. Peter Shoenberger and his family, dominated the city's iron trade throughout much of the ante-bellum period. A year later the Sligo Mill was established by John Lyon and Robert T. Stewart. Pine Creek Rolling Mill, also built in 1824, went through a succession of owners before it was taken over by Henry S. Spang and his son in 1829. Under the new name of Etna Rolling Mill, the Spang and Chalfant families ran it successfully for the next one hundred years. These families—the Shoenbergers, Lyons, Stewarts, Spangs, and Chalfants—along with the manufacturers Scaifes, O'Haras, Scotts, and Bakewells, and the mercantile families of the Dennys, McClurgs, Craigs, and Childs, formed the backbone of the city's industrial aristocracy.

Pittsburgh's iron industry continued to grow and evolve during the pre–Civil War years. An important event was the building of the first blast fur-

nace in Allegheny County in 1859 by Graff, Bennett and Company, another large-scale operator on the Pittsburgh scene. Designed to use coke from the Connellsville region, the furnace was a huge success. By the 1880s Pittsburgh became the largest aggregate producer of pig iron in the country, and the Pennsylvania coal fields furnished several Pittsburgh fortunes, most notably that of Henry Clay Frick. Other families with ethnic origins soon joined the iron trade. From Germany were the Zugs, who ran the highly successful Sable Mill, and the Painters, operators of the Pittsburgh Iron Works. (Henry Graff of Graff, Bennett and Company was also of Germanic origin.) George Black and Henry Lloyd, both immigrants from England, ran the Kensington Rolling Mill, and John W. Chalfant joined the Spang family at the Etna Rolling Mill. Robert Dalzell, along with James and George Lewis, Jr., controlled the important Vesuvius Mill.

Undoubtedly the largest and best-known iron mill in Pittsburgh in the 1850s was American Iron Works, run by Benjamin F. Jones and James Laughlin. A successful merchant who had immigrated from northern Ireland, Laughlin provided the capital for the venture, while Jones was recognized for his managerial genius. Until the rise of Andrew Carnegie's massive steel concerns, Jones and Laughlin (J & L) reigned as the largest iron enterprise in Pittsburgh, and it remained a giant undertaking well into the late twentieth century.[7] James Parton, who visited the city in 1868, reported on American Iron for the *Atlantic Monthly*.

> The crowning glory of Pittsburg [*sic*] is the "American Iron Works" of Messrs. Jones and Laughlin. This establishment, which employs twenty-five hundred men, which has a coal mine at its back door and an iron mine on Lake Superior, which makes almost every large and difficult iron thing the country requires and which usually has seven hundred thousands of dollars of finished work, is such a world wonder, that this whole magazine would not contain an adequate account of it.[8]

During this time Pittsburgh, the "Iron City," also produced a high-quality crucible tool steel, not the famed Bessemer steel of later years. Numerous medium-size crucible firms were established in the city, and their owners became important cogs in Pittsburgh's industrial machine and its associated aristocracy. The most important firm was Hussey, Wells and Company, which was owned by Curtis Hussey, Thomas Howe, and Calvin Wells, all of whom

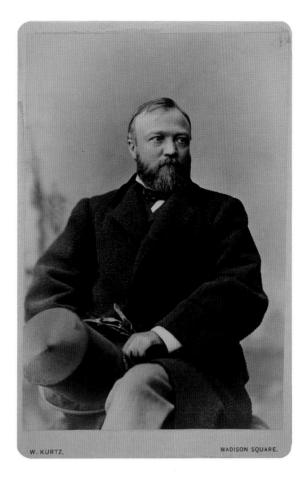

became members of the city's elite. Black Diamond Steel, owned by the Park family, joined the ranks of crucible firms in 1859 and rapidly grew to become the largest and most successful of the new enterprises. The Park family was instrumental in creating the Crucible Steel Company at the turn of the century. Among the other great crucible works was Sheffield Steel, owned by the Singer and Nimick families, and Crescent Steel, run by Reuben Miller III, Charles Parkin, and William Metcalf.[9]

During the Civil War seeds were sown for the transformation of Pittsburgh's iron and steel industry, its general economy, and its upper class when a new individual—Andrew Carnegie—quietly opened a small axle firm (fig. 2). Arriving from Scotland when he was a young boy, Carnegie had already forged his fabled career with the Pennsylvania Railroad and made a number of successful side investments in manufacturing railroad cars, oil, and now iron. His boyhood friend Henry Phipps, Jr., had become involved in making iron forgings and axles in a fledgling iron firm that developed into Kloman and Phipps. Meanwhile, Carnegie became a partner in Keystone Bridge, a firm that manufactured railroad bridges. Naturally, he built this into the largest and most

prosperous bridge company in the United States. In 1864 Carnegie became a silent partner in Kloman and Phipps. Three years later he made his rather inauspicious debut in the iron and steel industry by forcing Kloman out of the firm and reorganizing the company as Union Iron Mills, which he used to provide a steady and reliable source of beams and plates for Keystone Bridge.[10]

Although he was a newcomer to the field, Carnegie rapidly transformed the fundamental nature of the industry in Pittsburgh. Early on he set about making Union Iron a major force in the city by building blast furnaces that set production records in the early 1870s. His most significant step came at mid-decade when he decided to produce Bessemer steel. With the construction and operation of the Edgar Thomson Works in Braddock, Carnegie revolutionized steel production in America, transformed Pittsburgh into the largest producer of steel in the world, and laid the basis for some of the greatest fortunes in the United States.

The Bessemer process had been invented in England by Sir Henry Bessemer in the late 1850s, but not until the following decade was the process installed in the United States with limited success. Essentially, Bessemer found that by blowing cold air on molten pig iron in an acid-lined chamber, carbon, in addition to silicon and sulfur, could be released. Steel was the result. Even though steel was stronger and more durable than iron, it was far more expensive to produce under older processes, and only small quantities could be manufactured. The Bessemer process allowed the production of enormous quantities of relatively low-grade steel at a very competitive price. Steel thus became attractive for numerous uses, in particular the rails for America's vast and rapidly expanding network of railways. Obviously, Carnegie did not invent the new process, nor was he the first to build a Bessemer installation in this country. His accomplishment was producing steel on a scale that dwarfed other efforts in England and elsewhere in America.

It is virtually impossible to overstate the revolutionary implications of Carnegie's Bessemer steel enterprise. Through his intimate knowledge of railroads, Carnegie realized that the demand for Bessemer steel rails would soon replace the need for iron rails, and the quantities required would far exceed anything earlier imagined. In addition to installing the Bessemer process at his new rail plant, he built a structure that was larger, more sophisticated, and more vertically integrated than any previous enterprise. The Edgar Thomson plant stood out as a technological and organizational wonder. The crowning glory

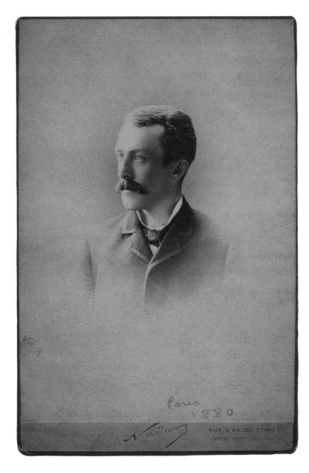

Fig. 3. Nadar Studio, Paris. Portrait of Henry Clay Frick, 1880, cabinet card. Frick family archives, Pittsburgh.

of this sprawling series of buildings, switchyards, sheds, and smokestacks was one of the most awesome spectacles in the industrial world—a series of screaming, belching Bessemer converters capable of manufacturing vast quantities of steel. When it reached its production peak a few years later, the ET plant could make 3,000 tons of steel daily, as much as a typical Pittsburgh iron puddling mill could supply in an entire year in the 1830s.

With the astounding success of the ET plant, Carnegie rapidly expanded his operations. In 1883 he made two of his most important acquisitions. The first was purchasing the massive Homestead mills, which had been erected by a group of older iron masters in Pittsburgh to compete with Carnegie but had run into labor difficulties. The second was the acquisition of H. C. Frick Coke Company, which brought massive supplies of coking coal in western Pennsylvania under Carnegie's control and also brought Henry Clay Frick into partnership as an owner and operator (fig. 3). In 1887 Frick became the managing partner of the entire Carnegie operation, and credit for much of the firm's enormous success in the late 1880s and 1890s must be attributed to him.

In 1890 Frick was responsible for absorbing Duquesne Mills, another impor-

tant competitor with the most technologically sophisticated plant in America at the time. Its "direct process" substantially reduced the time and cost required to produce a ton of steel. Around this time Frick and Carnegie began converting their plants from Bessemer to open hearth steel production, in response to the expanding demand for steel in a variety of structural uses, most significantly being the erection of skyscrapers and bridges in urban America.

As a result, the Carnegie mills emerged as models of production and profitability in the 1890s, despite several years of economic depression. By 1894 steel production stood at more than two million tons annually, and profits ranged from $3 million to $6 million each year in the early 1890s. Later in the decade Frick, in conjunction with Pittsburgh entrepreneur Henry W. Oliver, Jr., was responsible for acquiring expanses of iron ore lands in northern Minnesota, which completed the vertical integration of the Carnegie operations. At the turn of the century Carnegie's plants were producing four million tons of steel each year, just one million tons less than the entire production of all the steel mills in England. Profits for Carnegie Steel in 1899 were a staggering $25 million, and the next year they skyrocketed to $40 million. Together, the Carnegie mills generated more than $133 million in profit during these years. In an age of "big business," hardly any firm in the world, except perhaps for John D. Rockefeller's Standard Oil Company, was as large, powerful, or awesomely profitable as Carnegie Steel.

As Carnegie Steel grew, so too did Pittsburgh, along with the rest of its iron and steel and allied industries. In the brief span from 1880 to 1900 Pittsburgh became the world's leading center of iron and steel production. Much of this, of course, was centered in the Carnegie plants, but massive amounts of steel were produced in the independent mills of Pittsburgh. In 1894, fifty-eight iron and steel plants operated in the Pittsburgh district (fig. 4). Of their combined capacity to produce just over five million tons of iron and steel, 40 percent, or two million tons, was held by the Carnegie mills. Thus, over three million tons of iron and steel were produced in Pittsburgh outside the Carnegie behemoth. While many of these firms were small, some were quite large and were the progenitors of large fortunes. Jones and Laughlin was the second largest firm in the city, with capacity for over a million tons. Henry Oliver's five mills could produce 320,000 tons, National Tube manufactured 320,000 tons, Juniata Iron and Steel, owned by the Shoenbergers, had a capacity for 100,000 tons, and several others could make 50,000 to 70,000 tons annually.

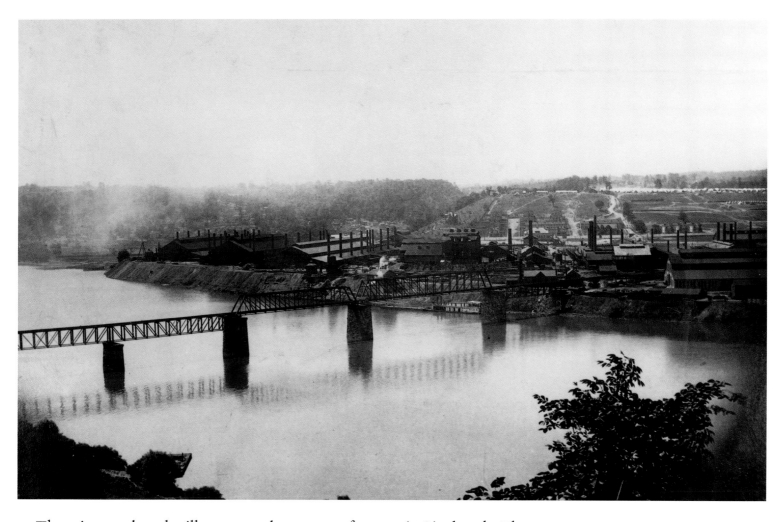

These iron and steel mills generated enormous fortunes in Pittsburgh. The greatest of all was that of Andrew Carnegie. When he sold his mills to J. P. Morgan's United States Steel Company in 1901 for $492 million in bonds and preferred and common stock, Carnegie personally received 57 percent of the total. Morgan sealed the deal with a handshake, saying to Carnegie, "I want to congratulate you on being the richest man in the world!" With a fortune in excess of $300 million, Carnegie held probably the greatest quantity of liquid capital in America, if not in the world. John D. Rockefeller was probably slightly richer, but his wealth was on paper. In any event, Carnegie's fortune was a staggering amount of money at a time when the dollar was worth at least twenty times what it is today, and in an era free of income taxes. Even Carnegie was a bit flustered, proclaiming, "I am the happiest man in the world. I have unloaded this burden on your back and I am off to Europe to play."

Many of Carnegie's partners benefited from the sale to U.S. Steel. Henry Clay Frick and Henry Phipps, Jr., each received some $60 million, and Charles

Fig. 4. B. L. H. Dabbs. Homestead Steel Works, 1892, Imperial card. Frick family archives, Pittsburgh.

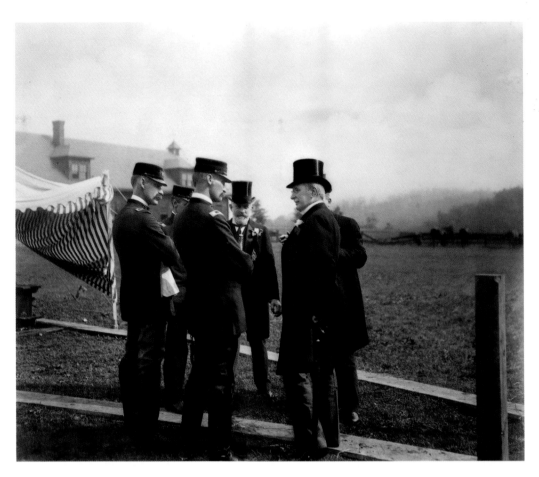

M. Schwab, William E. Corey, and William H. Singer also made large fortunes
with the sale. Massive wealth was also being accumulated outside the Carnegie
mills. Henry W. Oliver, Jr. (fig. 5), for one, sold his iron ore holdings and his
iron and steel mills to U.S. Steel, invested the proceeds in other areas, and left
a fortune of some $20 million.

One source of information about the smaller fortunes that were made in
Pittsburgh is the *New York Tribune* of 1 May 1892. Although not a completely
scientific survey, it offers at least a fair approximation of the extent of wealth
in Pittsburgh. The *Tribune* counted forty-two millionaires in Allegheny City,
where many of Pittsburgh's wealthiest families had homes, and another forty-
three in the city of Pittsburgh itself. By this time, however, Andrew Carnegie
resided in New York City and was counted among that city's millionaires, and
George H. Shoenberger lived in Cincinnati.[11] The newspaper calculated 379
millionaires were in all of Pennsylvania, giving Pittsburgh 23 percent of the
total. A clearer comparison can be seen between Philadelphia, with 206 mil-
lionaires, and Pittsburgh, with 86. In 1890 Pittsburgh and Allegheny City had
a combined population of just 344,000, while Philadelphia claimed just over

one million. Therefore, Pittsburgh and Allegheny City had a ratio of 24.5 millionaires per 100,000 residents, compared to just 20.6 per 100,000 in Philadelphia.[12] And this was a decade before the formation of U.S. Steel, which created a number of huge fortunes in Pittsburgh.

A total of twenty Pittsburgh firms, excluding Carnegie Steel, were sold to U.S. Steel. Many people at the time recognized that most of these mills were acquired for about twice their actual worth, simply to remove them as competitors. Therefore, old Pittsburgh iron families, such as the Painters, Leeches, Kirkpatricks, Clarks, Lindsays, and Shoenbergers, emerged with significant fortunes that ran to millions of dollars. At the same time, the Miller, Metcalf, Parkin, Howe, Brown, Smith, Park, Singer, Nimick, Vilsack, and Dupuy families sold their crucible steel firms at a healthy profit to the newly organized Crucible Steel Corporation.

In 1901 twenty-three independent iron and steel firms remained in Pittsburgh, producing over two million tons of iron and steel per year, and many continued to grow and make large profits into the twentieth century. The largest, of course, was the massive Jones and Laughlin Steel Corporation, but A. M. Byers, Carbon Steel, Oliver Iron and Steel (a new entity created by Henry Oliver after he sold his old mills to U.S. Steel), and Vesuvius Iron and Steel were all fairly large and profitable firms that accumulated impressive fortunes for their owners. The Jones and Laughlin families were among the wealthiest in Pittsburgh, after Carnegie, Frick, Phipps, and perhaps Oliver. B. F. Jones himself was said to be worth $18 million when he died in 1903, and the J & L firm was worth at least $30 million in the early twentieth century, with all the stock being held by members of the Jones and Laughlin families. The Park family "lost" one mill, Duquesne Steel, to Carnegie, but it later founded Crucible Steel, and each of the four sons of James Park, Jr., had fortunes worth at least $4 million in the opening years of the century.

One of the earliest large fortunes in Pittsburgh was that of Charles Lockhart (cats. 10, 11), who became a partner with Rockefeller in Standard Oil and was worth tens of millions of dollars by the late 1890s. He and his sons, judiciously investing that money in steel and other ventures, amassed another large fortune. Other fortunes, running into several millions of dollars each, were accumulated by the Dilworth family in their iron spike works and by the Scaife family in their metal works. The Frews, Dalzells, Donnellys, Blacks, Moorheads, Robinsons, and Reas grew wealthy through their iron, steel, and machin-

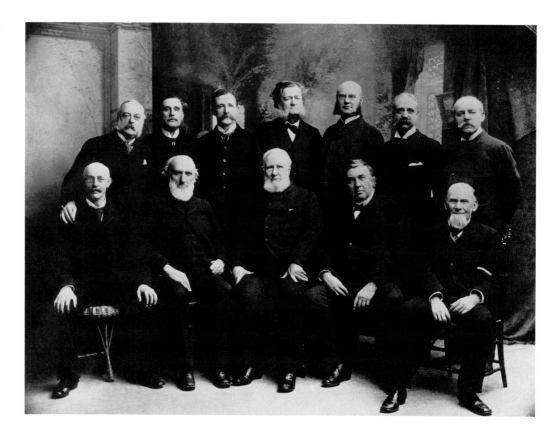

Fig. 6. Photographer unknown. Number Six Group of the Duquesne Club, 1892. Carnegie Library of Pittsburgh.

For years these men met daily for lunch in private dining room number 6 at the Duquesne Club. Standing, from left: J. H. Ricketson, A. E. W. Painter, C. L. Fitzhugh, G. Shiras, Jr., A. H. Childs, F. H. Phipps, and C. H. Spang. Seated, from left: S. Schoyer, Jr., C. B. Herron, B. F. Jones, J. W. Chalfant, and M. K. Moorhead. Henry W. Oliver, Jr., is the only member missing from this photograph.

ery firms, while Henry J. Heinz made his fame in food production and George Westinghouse prospered in air brakes for railroad cars and other industries.

These were hardly the only great fortunes being made in Pittsburgh at this time. With control of Mellon National Bank and huge holdings in coal, oil, steel, aluminum, and other industries, the total fortune of the Mellon family in 1924 was estimated to surpass $450 million. That made them not only the wealthiest family in Pittsburgh but also the fifth wealthiest family in America.[13] Other large family fortunes in Pittsburgh in that year were those of the Pitcairn family, founders of Pittsburgh Plate Glass, with an estimated $100 million, and the Phipps family (who by 1924 lived in New York City,) with $89 million. The study's author estimated that several other Pittsburgh families—Heinz, McClintic, Carnegie, Schwab, and Frick—held fortunes in excess of $25 million but had managed to escape income tax in 1924.[14]

The popular image of Pittsburgh's great wealth was reflected in a number of stories, whether accurate or not, that circulated at the time. One story told of a steward at the august Duquesne Club (fig. 6) who encountered one of the city's new millionaires covering page after page of the club's stationery with figures. When asked what he was doing, the harried man replied, as he bolted down his sixth drink, "I am trying to find out whether I am worth six million

or if it is eight million."[15] Two things are at work here: the man had such prodigious wealth that he could not count it, and he was too crude and inexperienced with money to calculate his own financial worth properly. How did he earn that much money in the first place? Perhaps he was just at the right place—Pittsburgh—at the right time, and industrialization took no special talent. In this way East Coast aristocrats could belittle the staggering accomplishments of new money makers in Pittsburgh.

Some idea of the extent of Pittsburgh wealth can also be gleaned from the massive mansions that were constructed during these years. Pittsburgh's first exclusive area of magnificent dwellings was actually located across the river in Allegheny City. There, in the mid-nineteenth century, Ridge Avenue and Western Avenues were lined with a glittering array of mansions. On Ridge in 1900 were the residences of twenty-seven of the city's iron and steel families, including Henry W. Oliver, Jr., the Fitzhughs, Dennys, Smiths, Painters, Byers, Lyons, Moorheads, Dalzells, and Bakewells. Western Avenue was home to another ten steel families, including the Singers, more Painters, Dupuys, Scaifes, and Walkers. On nearby Lincoln Avenue were twenty-two other steel families, including more Singers, Wells, Thaw, McCandless, Miller, Donnelly,

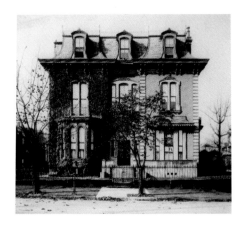

Fig. 7. Photographer unknown. Residence of B. F. Jones at 52 Irwin Avenue, Northside, n.d. Carnegie Library of Pittsburgh.

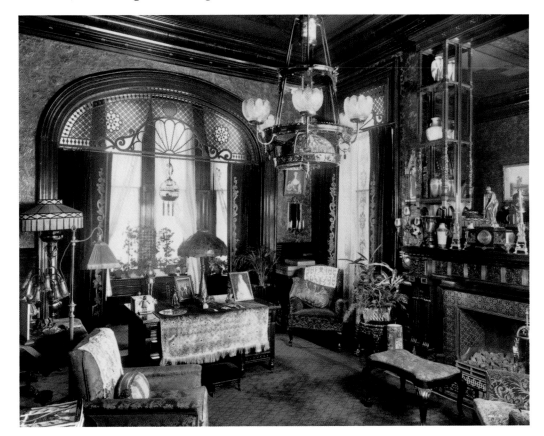

Fig. 8. R. W. Johnston. Sitting room of Mrs. B. F. Jones's residence at 52 Irwin Avenue, Northside, c. 1929. Collection of Mr. and Mrs. Gordon Gordon, Pittsburgh.

Although the photograph was taken around 1929, the room is shown substantially as it was furnished in the 1880s.

Fig. 9. R. W. Johnston. Parlor of Mrs. B. F. Jones's residence at 52 Irwin Avenue, Northside, c. 1929. Collection of Mr. and Mrs. Gordon Gordon, Pittsburgh.

Although the photograph was taken around 1929, the room is shown substantially as it was furnished in the 1880s.

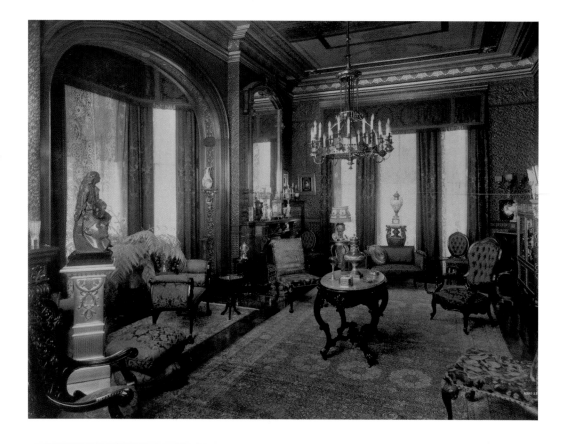

Fig. 10. R. W. Johnston. Dining room of Mrs. B. F. Jones's residence at 52 Irwin Avenue, Northside, c. 1929. Collection of Mr. and Mrs. Gordon Gordon, Pittsburgh.

In the background is Théobald Chartran's portrait of B. F. Jones.

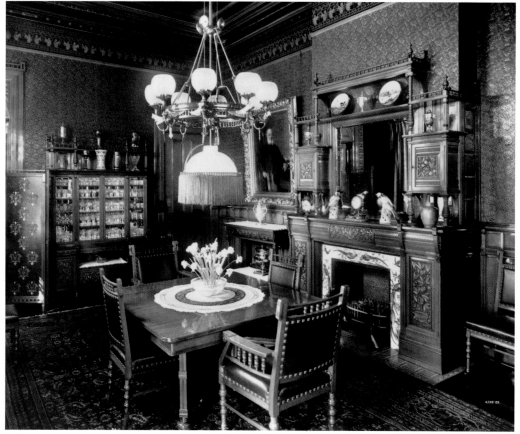

Laughlin, and more Dalzells. B. F. Jones lived on Irwin Avenue (figs. 7–10), as did some Laughlins and several other wealthy families.

Many of these enormous structures housed extended families, such as the Byers-Lyon home on Ridge. Built for $200,000 in 1897 to resemble an English-Flemish Renaissance home, it contained fifty to sixty rooms. Also on Ridge was the home of Henry W. Oliver, Jr. (figs. 11, 12), which was originally built for A. H. English in 1871. Oliver bought it twenty years later and commissioned a lavish renovation that transformed it into a prime example of the Pittsburgh adaptation of Romanesque and Italian styles of architecture during the Victorian era. These styles had been dramatically introduced into Pittsburgh in the 1880s by the eminent architect H. H. Richardson. He had designed the Allegheny County buildings in the Romanesque revival style, and he considered those buildings, along with the court house and jail in Pittsburgh and the Marshall Field department store in Chicago to be his greatest achievements.[16] Copying this style, the exterior of Oliver's home was re-cased with limestone, and inside, the best paneling, carving, wood inlay, and marble were installed. One high point was an ornate vestibule, with a domed ceiling, walls, and floor covered with tiny tiles. The home also boasted a small but magnificent paneled and beamed library, a main parlor heavily paneled in walnut, and a dining room that was reputed to be one of the finest of its kind.

Another great mansion in the area was the Harmar Denny residence, built

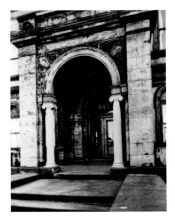

Fig. 11. Photographer unknown. Entrance to the home of Henry W. Oliver, Jr., 845 Ridge Avenue, n.d. Carnegie Library of Pittsburgh.

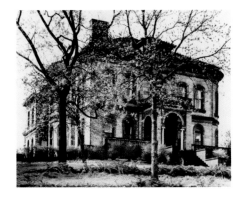

Fig. 12. Photographer unknown. Home of Henry W. Oliver, Jr., at 845 Ridge Avenue, n.d. Carnegie Library of Pittsburgh.

Fig. 13. Photographer unknown. Last days on Ridge Avenue, 19 April 1921. Collection of Mr. and Mrs. Gordon Gordon, Pittsburgh.

The streetscape remains intact, with the Snyder house on the left and the Oliver house on the right, yet none of these children attending a birthday party in 1921 was raised on Ridge Avenue. Like many of their parents, this generation of Pittsburghers grew up in the East End or in the suburb of Sewickley.

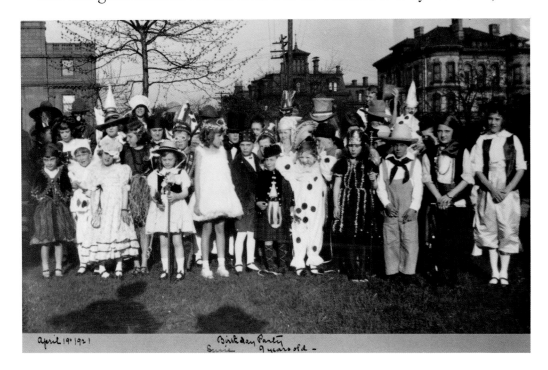

Fig. 14. Photographer unknown. Clayton, residence of Henry Clay Frick, n.d. Carnegie Library of Pittsburgh.

Also see figs. 64–66, 68, 112.

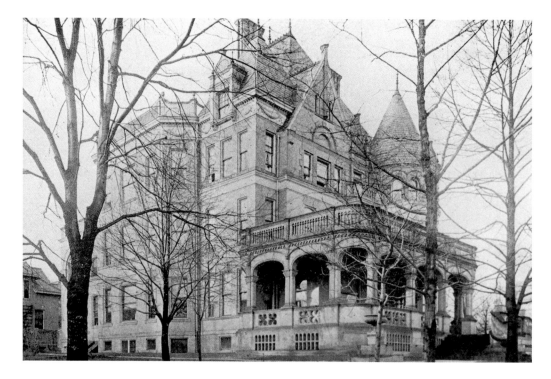

Fig. 15. Photographer unknown. Eastern façade of R. B. Mellon's residence at 6500 Fifth Avenue, 20 June 1914. Photograph album of 6500 Fifth Avenue, vol. 1, pl. 5. Collection of Richard M. Scaife, Pittsburgh.

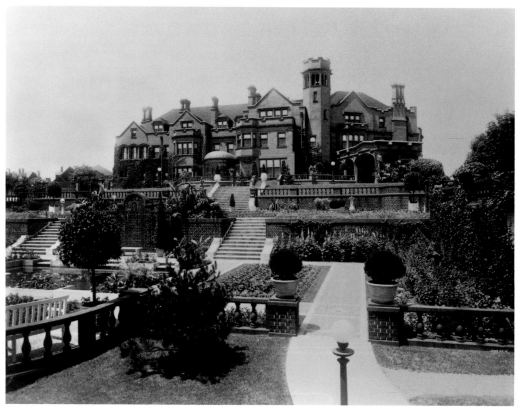

in the 1890s and decorated by Tiffany studios. The "Richardson" Romanesque exterior was austere and forbidding, but the interior, with its curved rooms, leaded glass doors, and stained glass windows, was lighter in feeling due to

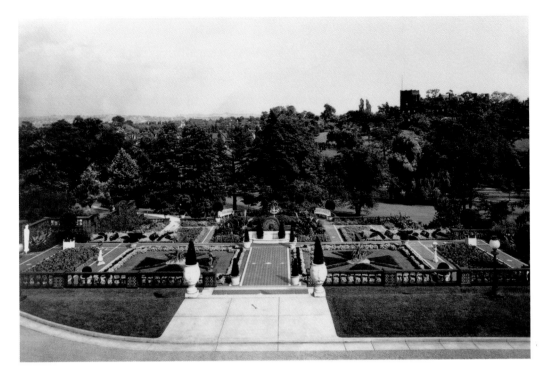

Fig. 16. Photographer unknown. View across the terraced garden of R. B. Mellon's residence at 6500 Fifth Avenue, looking toward Lyndhurst, home of Mrs. William Thaw, c. 1914. Photograph album of 6500 Fifth Avenue, vol. 1, pl. 2. Collection of Richard M. Scaife, Pittsburgh.

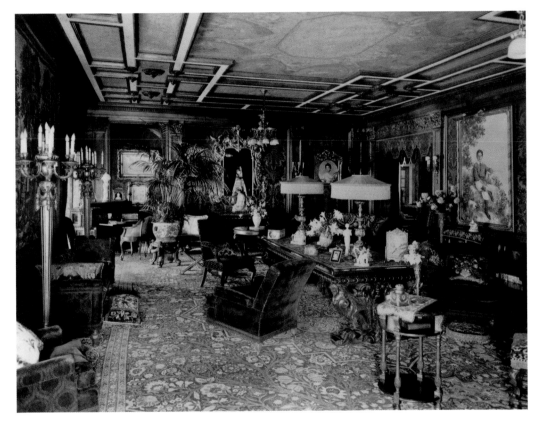

Fig. 17. Photographer unknown. Drawing room of R. B. Mellon's residence at 6500 Fifth Avenue, c. 1914. Collection of Richard M. Scaife, Pittsburgh.

In the background is Théobald Chartran's portrait of Jennie King Mellon, painted shortly before her marriage to R. B. Mellon.

Tiffany's influence. Most of the surrounding homes were nearly as elegant, causing Mrs. Denny to refer to Ridge Avenue as "Pittsburgh's Park Avenue" (fig. 13).[17]

These elegant Allegheny homes were built before the dazzling wealth was realized with Carnegie Steel and U.S. Steel. New millionaires tended to locate their even more stunning mansions in the largely suburban environments of the East End or to the west of Pittsburgh, in Sewickley Heights. This allowed for the construction of even larger homes on more expansive acreage. The East End was actually a succession of suburban neighborhoods that were held together in the early years by the railroad. Far out on Penn Avenue, at its intersections with Lexington and Homewood, emerged the "Carnegie Colony." Once part of a large estate held by Judge Wilkins, Andrew Carnegie and his brother Thomas bought homes there, and several other Carnegie partners followed suit. One of the most gracious homes in the area was Henry Clay Frick's thirty-room mansion called Clayton (fig. 14). On Fifth Avenue were even more massive edifices. A. M. Byers's huge new home had ninety rooms and fourteen baths. R. B. Mellon's home contained sixty-five rooms and eleven baths (figs. 15–17), and Michael Benedum, who made his money as an oil "wildcatter," built a residence on Woodland Road that was noted for its opulent marble pillars and statuary. Also in the area, the McCook mansion had its own chapel and A. A. Frauenheim's home its own ballroom. In keeping with the latest trends, several places also installed their own bowling alleys.[18]

Herbert Casson called Sewickley Heights "the highest of all Pittsburgh heavens," noting that "all homes are built after the fashion of baronial castles with imposing entrances and winding roadways from gate to house. Fortunes have been spent in landscape gardening. Most of the owners of this smokeless, slumless Eden are steel millionaires."[19] B. F. Jones was the first to leave his stately home in Allegheny to begin the exodus from Pittsburgh to Sewickley (fig. 18). There, he not only built a magnificent mansion for himself but also one for each of his three daughters. Although he was soon followed by Mrs. Henry W. Oliver, W. H. Singer, the Scaife family, and William Penn Snyder, Jones's mansion stood out as the largest and most opulent of them all, with fully one hundred rooms. Unquestionably, iron and steel provided enormous wealth for these Pittsburghers, making them rich beyond the imagination of most people, and they had the money to live lavish lifestyles equal to those of millionaires in New York City, Newport, Rhode Island, or Palm Beach, Florida.

To understand better their outlook and position at the turn of the century, let us look at these wealthy industrialists and their families in a more detailed, analytic manner. In examining a broad sample of 360 of Pittsburgh's iron and

steel manufacturers, several salient traits emerge. First of all, in terms of ethnicity, the greatest number of them (42 percent), were from Scotland and northern Ireland. Another 37 percent were English or Welsh, while 17 percent were German. One persistent claim concerning Pittsburgh's iron and steel elite, which reflected the prominence of the Scottish immigrant Andrew Carnegie, was that most of them were immigrants. This was not true. Although Pittsburgh was a young city and attracted a large number of immigrants during the nineteenth century to work in its iron and steel mills, this was not reflected in the upper classes.[20] Only 31 percent were in those categories. Slightly over half the families (53 percent), in fact, had come to America prior to 1800, while another 37 percent arrived between 1800 and 1850. Just 10 percent came in the second half of the century.

An even more compelling image about Pittsburgh's elite, again because of Carnegie's prominence, was the idea that they all had risen from humble, working class origins. This popular stereotype from the turn of the century was repeated by Herbert Casson in his book on iron and steel. "Pittsburgh has about

Fig. 18. Photographer unknown. Franklin Farm, residence of Mrs. B. F. Jones, Sr., Sewickley Heights, c. 1900. Carnegie Library of Pittsburgh.

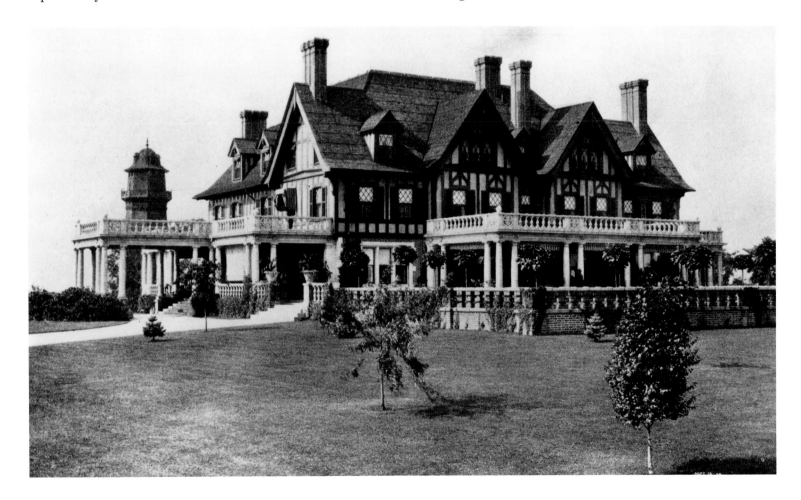

one hundred shirt-sleeve millionaires and very few silk hat ones. Without a single exception, the steel kings and coal barons of to-day were the barefooted boys of yesterday. . . . Its motto might be 'From rags to riches'; and its name should be spelled Pittsburgh. It is a region where even yet 'all men are born free and equal.'"[21] This sort of image seemed to be universally accepted and was reinforced time and again in later years by historians. Stewart Holbrook, in his *Age of the Moguls,* said of Pittsburgh's steel millionaires, "Some of them still smelled a bit of burning coke, and a Penn Avenue barber in Pittsburgh reported that the first shampoo one of these newly rich men ever had brought out two ounces of fine Mesabi ore and a scattering of slag and cinders."[22]

In many respects, Pittsburgh's iron and steel elite actually did not differ much from upper-class denizens of other cities in the United States. Studies of American businessmen during this period show that about 90 percent of them were born in this country, as was 87 percent of the general American population during this time.[23] And despite the Horatio Alger myths about the city, few of Pittsburgh's iron and steel manufacturers were from working class backgrounds. In reality, little difference existed between such manufacturers in Pittsburgh and those in other cities, or with American business leaders in general. Seventy percent of Pittsburgh's iron and steel manufacturers were the sons of businessmen, while another 14 percent had fathers in other professions, such as medicine, law, and the ministry. These percentages almost exactly mirror those for iron and steel manufacturers in other cities, and they are well above figures for other business leaders. Frances Gregory and Irene Neu, for example, found 48 percent of their business leaders were the sons of businessmen and 16 percent were of professionals, while William Miller placed 56 percent of his business leaders in the first category and 29 percent in the second. By point of comparison, in the general American population in the mid-nineteenth century, just 8.1 percent were in business and 2.3 percent were in the professions.[24] Pittsburgh's iron and steel manufacturers, like business leaders in other cities, thus came from economically privileged backgrounds. Why, then, did this image persist of Pittsburgh millionaires rising from immigrant, poor, and deprived backgrounds?

There was, of course, the influence of Andrew Carnegie. He fit the stereotype perfectly, and he was adept at public relations and self-promotion. Many journalists and others tended to conflate Carnegie and the rest of the iron and steel manufacturers. The fact that a few other prominent ones, such as Charles

M. Schwab and William E. Corey, loosely fit that model simply served to reinforce it. Yet, despite abundant evidence that many other well-known steel manufacturers, including Henry Clay Frick, did not adhere to the archetype, why did it continue? It would seem that the cultural image of Pittsburgh and its elite played an important role in creating that stereotype.

Two elements appear to be significant: first, the image of Pittsburgh itself, as a rough, dirty, crude center of ruthless competition and stunning growth, and second, the cultural stamp of Pittsburgh's elite, with a large proportion of them being Scotch-Irish Presbyterian. Outside observers of Pittsburgh in the nineteenth century were repeatedly impressed by its awesome industrial capacity, and both the wealth and filthy squalor it produced. For decades Pittsburgh was covered with a dense layer of smoke from the mills, and this cast a somber pall over the city that seemed to affect its very being. J. Ernest Wright called Pittsburgh "the blackest, dirtiest, grimiest city in the United States," and Anthony Trollope, stopping there while on a nationwide tour in 1862, called it the "blackest place . . . I ever saw."[25] These images were echoed as well by the historian James Parton in 1868, who wrote that "every street appears to end in a huge, black cloud."[26]

Three years later, in 1871, *Harper's Weekly* published a feature story on Pittsburgh, and again, the image was similar—it was a grimy, smoky city. "The dense volumes of black smoke pouring from the hundreds of furnaces, the copious showers of soot, the constant rumbling of ponderous machines, the clatter of wagons laden with iron," all bespoke the industrial might and the visual and cultural deprivation of Pittsburgh.[27]

Harper's returned in 1880, and although many of its observations still focused on the smoke and grime of the city, Pittsburgh by then was viewed in a somewhat more positive light. A typical Pittsburgh resident, we are told, regarded smoke as "incense in his nostrils, and his face is brightest when, in approaching the grimy burg of his nativity, sights her nimbus of carbon from afar, or after nightfall, her crown of fire, and the stranger soon learns to understand this feeling."[28]

What made the smoke more palatable by this time was not just that "smoke means jobs," the legendary Pittsburgh mantra, but with the building of Carnegie's ET mill, smoke meant money, lots and lots of money. Yet, to aristocrats in the east, whose opulent homes and high society lives were relatively far removed from the more mundane sources of their wealth, the soot and

Fig. 19. Abram M. Brown. View of the Strip District, looking northwest from the roof of Union Railroad Station, 20 June 1906, 11 a.m. Carnegie Library of Pittsburgh.

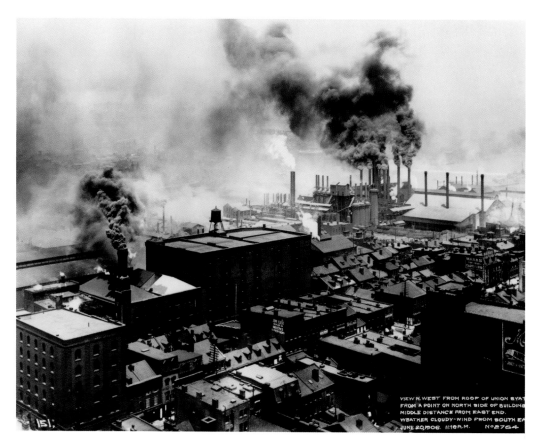

grime of Pittsburgh also reeked of coarseness—of wealthy men with dirt under their fingernails and soot on their collars.

In 1883, Willard Glazier proclaimed:

> It is as though one had reached the outer edge of the infernal regions, and saw before him the great furnace of Pandemonium with all the lids lifted. The scene is so strange and weird that it will live in the memory forever. One pictures, as he beholds it, the tortured spirits writhing in agony, their sinewy limbs convulsed, and the very air oppressive with pain and rage.[29]

Pittsburgh was, quite simply, "Hell with the lid off." That image stuck with the city for three-quarters of a century—and it was scarcely a compliment (fig. 19).

More positive images in the 1890s focused on the spectacular industrial might of the city. "Bessemer converters dazzle the eye with their leaping flames. Steel ingots at white heat, weighing thousands of pounds, are carried from place to place and tossed about like toys. Electric cranes pick up steel rails or fifty foot girders as jauntily as if their tons were ounces."[30] One message remained—Pittsburgh had brute power, but it lacked refinement.

This negative depiction of Pittsburgh was expressed most graphically and caustically by H. L. Mencken after World War I.

> Here is the very heart of industrial America, the center of the most lucrative and characteristic activity, the boast and pride of the richest and grandest nation ever seen on earth—and here was a scene so dreadfully hideous, so intolerably bleak and forlorn that it reduced the whole aspiration of man to a macabre and depressing joke. Here was wealth beyond computation, almost beyond imagination—and here were human habitations as abominable that they would have disgraced a race of alley cats.[31]

Part of the filth, grime, and disreputable nature of Pittsburgh, of course, was simply due to the nature of the iron and steel industry. Much of the criticism seemed to go deeper than that, with the fault for the cultural bleakness of the city being laid at the feet of its dour, Scotch-Irish industrial leaders.

Even a relatively friendly commentator such as James Parton was struck by the narrow provinciality of Pittsburgh's iron barons. They were, he noted, "mostly of the Scotch-Irish race, Presbyterians, keen and steady . . . singularly devoid of the usual vanities and ostentation, proud to possess a solid and spacious factory, and to live in an insignificant house. There are no men of leisure in this town."[32] Their industry and single-minded determination did much to create an industrial juggernaut in Pittsburgh, but as a group they were singularly lacking a sense of fashion or sophistication. Parton indicated that "if you wanted to be in the height of fashion [in Pittsburgh] you must be worth half a million, and wear a shabby suit of fustian. You must be the proprietor in some extensive 'works,' and go about not quite as well dressed as the workmen."[33]

This denigration of the Scotch-Irish was characteristic of seaboard elites throughout much of the nineteenth century, and it was poignantly felt in Pittsburgh. In 1889, when the Scotch-Irish Society of America was founded precisely to enhance the public image of the group and to assert a dollop of ethnic pride, Alexander K. McClure of Pittsburgh gave an impassioned speech to his cohorts, in which he lamented the way in which "Puritan" historians had ignored the contributions to society made by his ethnic group.[34]

The most damning critique of this Scotch-Irish group came in 1930. R. L. Duffus, writing in *Harper's*, was vicious in his castigation of them. "Newly fledged as the Pittsburgh aristocracy is—or perhaps because it is newly fledged—it has a narrowness and arrogance which rather startle visitors from

more democratic communities. . . . The inevitable result is that society in Pittsburgh is dull."[35] As a result of such sentiments, some time around the turn of the century Pittsburgh's elite, or at least a portion of it, attempted to shake this dour, dull, provincial image. Using their vast new wealth as a springboard, they tried to recreate themselves as a sophisticated, cosmopolitan element of the national upper class. Not all upper-class families approached it in the same manner. To understand better the stance that was taken, and how that fit both into the social status of these families and into the proclivities to collect art, it is necessary to develop a more intricate, in-depth analysis of the group.

Significant social gradations can be detected among the 207 families engaged in the iron and steel business in Pittsburgh during the late nineteenth century. Nearly one-third of them, although relatively wealthy and successful, did not form part of the city's social upper class, largely because they were newcomers to the United States and/or did not share in its common Scotch-Irish heritage. Few of them sunk very deep roots—after making their fortunes in a decade or two, they left Pittsburgh without a trace, playing no major role in the city's social and cultural transformation at the turn of the century.

A second group of thirty-two families was also somewhat tangential to the Pittsburgh scene. Although many were integrated into the city's upper class, they always remained somewhat marginal to it. Within these families were two subgroups with important distinctions. About two-thirds of these marginal upper-class families were indigenous to Pittsburgh. The Husseys and the Darlingtons, for example, were old families of the "proper" cultural and religious pedigree and were "old money," at least in the Pittsburgh context. They also seemed content to remain dull and provincial, characteristic of Pittsburgh's upper class. They were not "fancy," did not build impressive homes in new suburban neighborhoods, and generally did not participate in the elite transformation.

The second group of marginal families was different. These greatly admired upper-class migrants from Boston, New York, and Philadelphia enjoyed tremendous social prestige before they came to Pittsburgh to start their iron or steel mills. When Taylor Allderdice, one member of this group, decided to remain in Pittsburgh, he was immediately accorded high social status and given a major role to play in the city's cultural and social affairs. Even though most of these families, such as the Abbotts, Converses, Baches, and Crosbys, did not stay long in the city, they did create a model that was emulated by the older

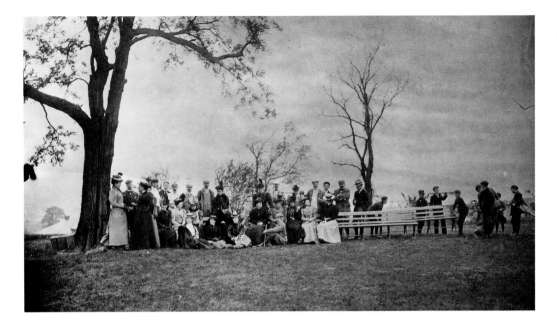

Fig. 20. Photographer unknown. An informal gathering of members of the Pittsburgh Golf Club, c. 1896. Carnegie Library of Pittsburgh.

Fig. 21. Photographer unknown. The Duquesne Club on Sixth Avenue, n.d. Carnegie Library of Pittsburgh.

Pittsburgh families. They demonstrated the role that gracious homes, elegant furnishings, country clubs, and of course, art could play in their lives. Pittsburgh's upper class observed them closely and soon began to ape their mannerisms.

This leaves just over one hundred families, about half of Pittsburgh's iron and steel mill owners, who made up the most important elements of the city's upper class. Their great local prestige afforded them positions in the most important men's social clubs and country clubs. They were listed in the *Social Register*, and most importantly, they intermarried extensively, creating a dense network of families that defined the city's upper class. Of these one hundred families, however, two groups emerged, and their differences say much about their relationship to the city. One group, the Non-Core Upper Class, consisted of very wealthy old families with high social status, but after the turn of the century they decided to move away from Pittsburgh. Most, such as Frick and Phipps, built several palatial homes in New York, Europe, and elsewhere, and became part of a cosmopolitan elite. Their opulent lifestyles, complete with massive art collections, strongly influenced the cultural stance of Pittsburgh's upper class. Meanwhile, the Core Upper Class, who continued to live in Pittsburgh and marry into other upper-class families in the city, tried to transcend the provinciality of Pittsburgh in the nineteenth century.[36]

A significant aspect of these upper-class families, both Core and Non-Core, is the degree to which they interacted through neighborhoods, social clubs, civic organizations, business, politics, and other social engagements, such as

parties, balls, and simple visits. This networking of associations, of course, is difficult to reconstruct in any comprehensible fashion. Looking at residences from 1892 to 1915, clear patterns of propinquity emerge among these families. In 1892, of 339 iron and steel families in Pittsburgh, 47 percent resided in the East End, and 28 percent were located in Allegheny. These proportions had not changed much by 1900, with 49 percent and 22 percent, respectively. By 1915 there were 64 percent in the East End and 12 percent in Allegheny, with another 10 percent in Sewickley.[37]

A clearer picture of this network becomes visible when looking at social clubs. Of the forty-three Core families, 91 percent were members of the Pittsburgh Club, 81 percent of Pittsburgh Golf (fig. 20), 88 percent of Allegheny Country Club, 97 percent of Duquesne Club (fig. 21), 77 percent of Union Club, 63 percent of Pittsburgh Country Club, and progressively lower percentages in Oakmont Country Club, Edgeworth Country Club, Edgewood Club, and Pittsburgh Athletic Association. Although the Non-Core families joined clubs in similar percentages, they had lower membership totals, primarily because a large portion of the Non-Core families resided outside Pittsburgh. Of the sixty Non-Core families, 57 percent belonged to the Pittsburgh Club, 45 percent to Pittsburgh Golf, 35 percent to the Allegheny Country Club, 83 percent to the Duquesne Club, 52 percent to Union, 24 percent to Oakmont, and correspondingly lower percentages to other clubs.

These families also intermarried frequently. The Core families had particularly high percentages of endogamous marriages, accounting for about one-third of their total marriages. The endogamous marriage pattern for the Non-Core families was nearly as high, standing at 27 percent.[38] In addition, both the Core and Non-Core families sent their sons to eastern prep schools, with St. Paul's in Concord, New Hampshire, becoming the special preserve of wealthy students from Pittsburgh. They also sent their sons to Ivy League schools in the east, with 70 percent of the Core families choosing Yale, 49 percent Princeton, 33 percent Harvard, and 16 percent the University of Pennsylvania. The Non-Core families used these East Coast school ties, in addition to relocating to New York and elsewhere, to begin marrying into upper-class families from other cities. The Core families, however, continued to choose their marriage partners from Pittsburgh.

These relations can perhaps be made more concrete by looking at Henry Clay Frick and the nature of his business and social relationships. By referring

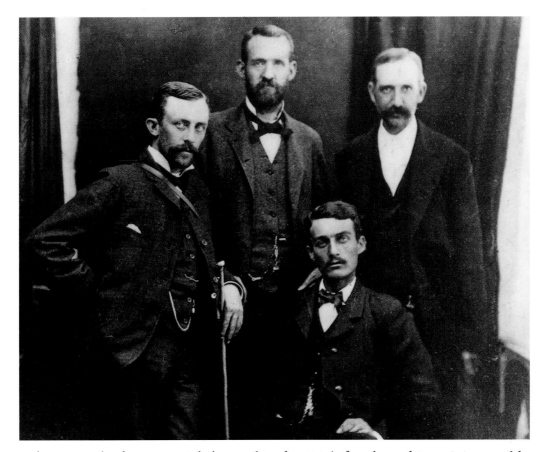

Fig. 22. Photographer unknown. Henry Clay Frick (left) with (clockwise) A. A. Hutchinson, Frank Cowan, and Andrew W. Mellon en route to Europe, 1880. Frick family archives, Pittsburgh.

to letters and other materials located in the Frick family archives, it is possible to develop a crude network of Frick's relations with other members of the Pittsburgh upper crust. Like nearly all the wealthy people in the city, Frick belonged to a staggering number of clubs and organizations, which allowed him to interact with numerous individuals and families. He belonged to the following Pittsburgh social clubs: Allegheny Country Club, Pittsburgh Country Club, Duquesne Club, Edgewood Golf, Oakmont Country Club, Pittsburgh Golf Club, Pittsburgh Club, Pittsburgh Athletic Association, Princeton Club of Western Pennsylvania, Union Club, and the University Club. Frick, especially after he moved to New York, belonged to several clubs there, which gave him connections to the elite in that city and elsewhere: the Country Club of Westchester County, the Metropolitan Club, the New York Yacht Club, the Princeton Club of New York, the Racquet and Tennis Club, The Recess, and Union League Club. In addition, he belonged to clubs in Massachusetts, Philadelphia, Chicago, and elsewhere, which created an extensive and intensive network of upper-class families throughout the country. Besides these social clubs, Frick also joined civic and charitable associations, such as the Americus Republican Club, the Art Society of Pittsburgh, the Chamber of Commerce

of Pittsburgh, the Church Club of Pittsburgh, the Chamber of Commerce of New York City, Homestead Hospital, Homeopathetic Medical and Surgical Hospital and Dispensary, Kingsley House Association, the Pittsburgh Orchestra, the Pittsburgh Free Dispensary, the Pennsylvania Society of New York, the Symphony Society of New York, and Western Pennsylvania Hospital, Dixmont.[39]

Listing these club memberships reveals little about the quality of relationships that resulted from these social contacts. A somewhat clearer understanding of Frick's relationships may be gained by reading his correspondence, now in the Frick family archives. He appeared to have continual, extensive, and ongoing correspondence and interaction with eight individuals and families. Many letters were exchanged with various members of the Childs family, all of which in one way or another must be considered personal and familial. The numerous letters written to Andrew W. Mellon, Frick's closest friend (fig. 22), encompass all aspects of their relationship and deal extensively with their common business interests, social arrangements, personal friendship, and paintings and art. Frick also wrote to R. B. Mellon and other members of the Mellon family. He had a good deal of correspondence with Donald P. Black, but it concerned the Civic Commission and Civic Club as well as business affairs through the Real Estate Trust. Similarly, Frick exchanged much correspondence with Willis F. and J. J. McCook, most of which dealt with business and legal affairs but included personal matters. Frick had a similar relationship in letters with D. T. Watson, who was assisting Frick in collecting art. Judging by their letters, F. F. Nicola handled many of Frick's real estate matters and other business affairs. Extensive correspondence was addressed to Henry W. and George T. Oliver, nearly all of which discussed business interests over ore lands. Finally, Frick wrote many letters to Henry Phipps, Jr., some of which involved social matters and art, but most of which dealt with Andrew Carnegie as well as Carnegie Steel and its sale to other parties.

Beyond this, however, a great deal of the correspondence in the archives brings in a very large number of individuals in Pittsburgh. On purely business matters, much of it rather minor in nature, Frick exchanged correspondence with F. T. F. Lovejoy, John W. Chalfant, John and R. B. Caldwell, John and Thomas K. Dalzell, W. H. Donner, A. M. Byers, Charles Donnelly, W. J. McCutcheon, Reuben Miller, David E. and James Park, Charles E. Clapp, P. R. Dillon, Henry P. Snyder, Julian Kennedy, Charles A. Painter, James W.

Brown, and Frank N. Hoffstot. With others, he had somewhat more social relations: William Thaw, James Laughlin, Jr., and other members of the Laughlin family, William H. and James C. Rea, Henry Kirke Porter, Henry Graham Brown, and Anthony F. Keating.

With still others, Frick had more complex written relationships, covering aspects of business, politics, charities, and social affairs. Correspondence with Charles M. Schwab involved business, affairs at the Carnegie Institute, and art. With William Nimick Frew, Frick dealt with matters at the Carnegie Library (of which Frick was treasurer), the Pittsburgh College for Women, and other business and social matters. With Charles and James Lockhart, Frick had a great deal of correspondence beseeching them to invest in various enterprises, especially Carnegie Steel interests. With William M. Kennedy, Frick discussed the Civic Club and the Union Club. With Christopher L. Magee, he addressed a mixture of political and social issues. With James H. Reed, there were legal and social matters, and with Carter C. Biggs, politics and business. He discussed personal, social, and business matters with B. F. Jones, and just business matters with Jones's son. He dealt with both business matters and Kingsley House, a settlement house, with Joseph F. Guffey, politics with James O. Brown, and politics and charity work with John F. Dravo. Charities were a topic of interest shared with Herbert Dupuy, and Kingsley House with H. D. W. English.

In being better able to grasp the vast extent of Frick's correspondence, we can see, first, he wrote to a staggering number of individuals within Pittsburgh's upper-class community, and second, these relationships ranged from simple business matters to more complex interactions. Finally, all the letters, even those to family and close friends such as Andrew Mellon, contained a high degree of formality, making it difficult, at least superficially, to distinguish close friends from mere acquaintances. Significantly, Andrew Carnegie was virtually the only person to use a familiar tone with Frick, addressing him in letters as "Old Pard." This most likely rankled Frick greatly, and he certainly did not return that level of familiarity to Carnegie (fig. 23).

The letters also reveal other connections. Frick held a position on the board of managers of the Pittsburgh Free Dispensary with Reuben Miller, James I. Buchanan, D. Herbert Hostetter, Benjamin Thaw, and C. P. Orr. He gave donations to the Kindergarten Association through Martha Frew. He served on the Orchestra Fund Committee with William Frew, Andrew and Richard Mel-

Fig. 23. Photographer unknown. On vacation in Scotland, with Andrew Carnegie seated at center of group, c. 1895. Frick family archives, Pittsburgh.

Seated to Carnegie's left are (clockwise) Childs Frick, Helen Clay Frick, tutor Clyde Duniway, Henry Clay Frick (standing), and to Carnegie's right, Martha Howard Childs. Other members of the group are unidentified.

lon, James H. Reed, and Henry M. Curry, and on the Carnegie Music Hall committee with John Eaton, Henry J. Heinz, E. M. Ferguson, E. H. Jennings, James H. Reed, George W. Guthrie, Alexander Dempster, F. F. Nicola, Murray A. Verner, Edward A. Woods, and E. B. Alsop. Frick supported the Industrial Home for Crippled Children through Mary Irwin Laughlin, the Ladies Aid Society of Mercy Hospital through Mary F. McCook, the Western Pennsylvania Hospital through James R. Mellon, and Shadyside Presbyterian Church through W. J. Marshall, in addition to a number of other causes.

Perhaps most revealing in these networks and relationships, and the complex web of business, social contacts, politics, and personal friendships that they represent, is a grand ball that Frick held in November 1898. He invited the following business associates: F. T. F. Lovejoy, Charles M. and Joseph E. Schwab, Alexander R. Peacock, Thomas Morrison, Lawrence C. Phipps, William E. Corey, John Walker, D. G. Kerr, A. M. Moreland, James Gayley, H. M. Curry, James McCreery, and John G. A. Leishman, all of Carnegie Steel. Other Pittsburgh business associates included S. L. Schoonmaker, Thomas Lynch, G. B. and M. M. Bosworth, L. T. Brown, James Hunter, Emil Swenson, Charles T. Shoen, M. R. Ward, James Scott, E. F. Wood, R. A. Franks, George Megrew, W. A. Carr, James S. McKean, George A. McCague, George H. Wightman, and G. D. Packer. Among the out-of-town business associates were A. R.

Whitney and Walter Scranton of New Jersey, J. O. Hoffman of Philadelphia, C. W. Baker and Charles Stuart Smith of New York, John C. Fleming and John W. Gates of Chicago, Marcus A. and Leonard C. Hanna, Samuel Mather, and H. H. Brown, all of Cleveland, J. C. Morse of Wheaton, Illinois, and Robert P. Linderman of Bethlehem, Pennsylvania. From the art world were dealers Roland F. and Charles Knoedler, along with C. S. Carstairs, all of M. Knoedler & Co. in New York, and the artist Théobald Chartran (fig. 24). Social and family contacts were represented by Walton Ferguson of Stamford, Connecticut, and the Misses Canfield of Allegheny.[40]

To some measure Frick's complex set of relationships was duplicated by virtually all the other upper-class individuals and families in Pittsburgh during this time. They were intermarrying, joining exclusive clubs, building fabulous mansions that they filled with expensive furnishings and artwork, and interacting with members of other upper-class families at prep schools, universities, and out-of-town social clubs. When some of these Pittsburghers began to entertain ideas of cementing relations by marrying into families in other cities, they often found that they were regarded rather disdainfully by these seaboard aristocrats. Therefore, a great drive for respectability by the Pittsburgh upper class began around the turn of the century.

One way to achieve this desired respectability, at least in the minds of some of these wealthy Pittsburgh families, was through conspicuous consumption. This phenomenon of purchasing or constructing enormous mansions and filling them with expensive European antiques and furniture was hardly limited to Pittsburgh—it emerged as an integral part of the new plutocracy in urban America. Urban upper-class families, especially those in New York City, set the tone for the new century by building massive homes on Fifth Avenue and summer "cottages" in various locations.

For several decades the Vanderbilt family of New York set the standard for lavish homes. In the early 1880s William H. Vanderbilt and two of his sons built opulent homes on Fifth Avenue. Soon, the family owned on that street seven houses within seven blocks of one another, worth a total of $12 million. This paled in comparison with their summer homes in Newport, Rhode Island, and elsewhere. They constructed one summer house of seventy rooms at a cost of $5 million, and another for $2 million that was appointed with $9 million worth of furnishings. As a crowning achievement, George W. Vanderbilt commissioned Biltmore, in Asheville, North Carolina. Set on a 146,000-acre estate, it

Fig. 24. Photographer unknown. Portrait of Théobald Chartran, inscribed: "To my charming friend, Frick, after the Poker, 11 July morning, 1898, 2 o'clock, Chartran," 1898. Frick family archives, Pittsburgh.

had 250 rooms, with forty bedrooms, and cost $6 million. The Rockefellers also built a massive estate in the Adirondacks, and they, like so many other wealthy families, owned palatial homes in New York and elsewhere.

Pittsburgh's iron and steel elite eagerly joined in this orgy of conspicuous consumption, moving to New York and building or purchasing homes among the wealthy there. Andrew Carnegie had long owned a home in New York City, but given his enormous wealth, it was relatively simple and unostentatious. In 1898 he announced his intention to build "the most modest, plainest, and roomiest house in New York." With sixty-four rooms it was certainly roomy, but it was far from modest or plain. The Carnegie mansion, located on Fifth Avenue between 90th and 91st Streets, cost $1,500,000 to build and had six stories, complete with an organ, library, public and private living rooms, servants' quarters, a large utility area with massive boilers in the basement, and an extensive garden. This continued to be his principal home for the rest of his life. His one genuflection toward simplicity was that he continued to sleep in the same simple brass bed he had used as a child in Pittsburgh.[41] In 1976 his New York home became part of the Smithsonian Institution as the Cooper-Hewitt Museum.

Fig. 25. Whyte, photographer. Skibo Castle, Inverness, Scotland, c. 1890s. Frick family archives, Pittsburgh.

Carnegie also owned an enormous castle in Scotland (fig. 25). He had purchased Skibo Castle, once the estate and manor of Roman Catholic bishops, in 1897 and had it rebuilt and refurbished at the cost of $1,700,000. That sum came to him when his first attempt to sell Carnegie Steel—to the Moore brothers in a deal brokered by Henry Clay Frick and Henry Phipps, Jr.—fell through, and Carnegie kept the deposit. Carnegie spent his summers there until 1914, and Skibo Castle remained in the family after his death.

Back in Pittsburgh, Frick had his impressive thirty-room Clayton, a residence he never completely forsook. After 1905, however, he lived in New York City, and in 1906 he erected a magnificent country estate at Pride's Crossing, Massachusetts. Frick rented his first New York home from George W. Vanderbilt, an elegant house located at 640 Fifth Avenue that he had coveted for a quarter century. In 1914 he and his family moved into the $5.4 million house he built on the previous site of the Lenox Library. Located on Fifth Avenue and 70th Street, this residence today houses the Frick Collection.[42] Similarly, Henry Phipps, Jr., who had long lived outside Pittsburgh, bought a fine mansion in New York and built several grand country houses for his family.

A national outcry arose against this garish display of wealth in New York.

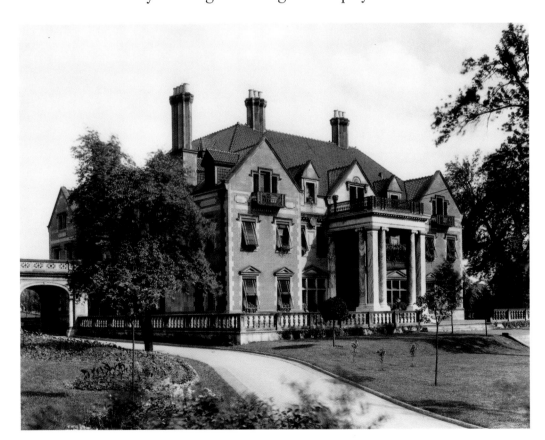

Fig. 26. R. W. Johnston. Rowanlea, residence of Alexander R. Peacock, n.d. Collection of Mr. and Mrs. Grant A. Peacock, Jr., Ridgefield, Connecticut.

Also see figs. 27, 47.

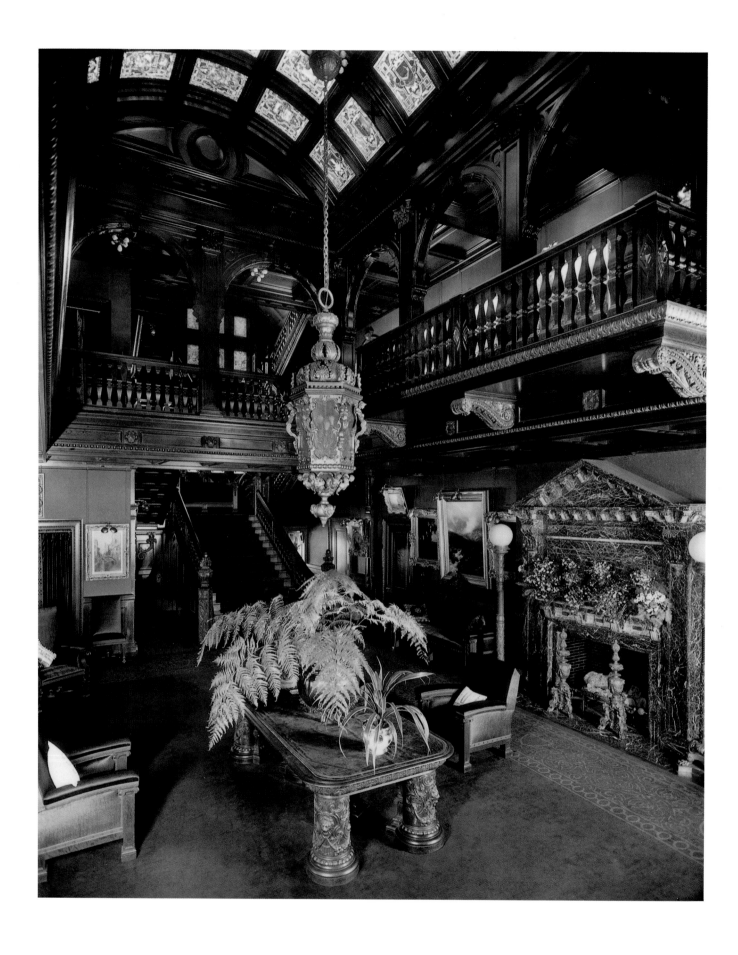

Members of the city's older "Knickerbocker" society bemoaned the passing of the old order and regretted the vulgar new displays of wealth that they had neither the money nor the inclination to emulate. "The mighty city of today," rued the aristocratic F. J. DePeyster, "knows nothing of our traditions. Strangers in our own city. . . . Life here has become so exhausting and so expensive that but few of those whose birth or education fit them to adorn any gathering have either the strength or wealth enough to go at the headlong pace of that gilded band of immigrants and natives, 'The Four Hundred.'"[43] Wealth and success alone, or the ability to spend vast amounts of money on palatial estates, were not enough to buy universal respect from the older upper class, as was discovered by Charles M. Schwab, James Gayley, W. E. Corey, J. G. A. Leishman, and other Carnegie partners who transferred their residences to New York.

This was even more true for those families who remained in Pittsburgh. Many beautiful and graceful mansions were built by the leaders of the iron and steel industry, and admittedly some of them tended toward garish overstatement. Reaction in the east to the pretensions of the new Pittsburgh plutocracy was uniformly critical. Herbert Casson castigated Alexander Peacock, another of Carnegie's partners, for his lack of taste and for his spending habits.

> Alexander R. Peacock was one of those who were swept off their feet by the sudden flood of gold. . . . Mr. Peacock built a dazzling, showy mansion on Highland Avenue, Pittsburgh. Encircling the spacious grounds of Rowanlea is a nine-foot iron fence, entered through massive gates that roll inward on wheels. . . . Within, the rooms resemble a series of magnificent halls, decorated with oriental lavishness. It is the dream of a poor linen clerk come true [figs. 26, 27].[44]

A half-century later, historians repeated this criticism of the Pittsburgh upper class. Gerald W. Johnson called Peacock's home an "elephantine mansion" and accused the iron and steel manufacturers of building "atrocious-looking homes with rooms and rooms to be filled to the brim with gaudy furniture, giant vases, and all sorts of bric-a-brac."[45]

The tendency to spend vast sums on opulent homes—and to scandalize the older establishment—intensified when the new industrial elite threw lavish parties or followed the latest fads and foibles. The historian Charles Beard, no friend of the rich, wrote of these New York extravaganzas:

Fig. 27. R. W. Johnston. Living hall of Rowanlea, residence of Alexander R. Peacock, n.d. Collection of Mr. and Mrs. Grant A. Peacock, Jr., Ridgefield, Connecticut.

Also see figs. 26, 47.

At a dinner eaten on horseback, the favorite steed was fed flowers and champagne; to a small black and tan dog wearing a diamond collar worth $15,000 a lavish banquet was tendered; at one function, the cigarettes were wrapped in hundred-dollar bills; at another, fine black pearls were given to the diners in their oysters; at a third, an elaborate feast was served to boon companions in a mine from which came the fortune of the host. Then weary of such limited diversions, the plutocracy contrived more freakish occasions—with monkeys seated between guests, human goldfish swimming about in pools, and chorus girls hopping out of pies.[46]

A similar phenomenon occurred in Pittsburgh. Casson recounted the story of one Pittsburgh millionaire who ordered a special brand of cigars made in Cuba, with his name and coat of arms on the wrapper, and another who spent a fortune making "the finest mushroom cellar in America." He also told of those who bought automobiles for their friends or built vast libraries in their own homes but, since they were unlettered, were easy prey for book agents who could sell them anything.[47] Gerald Johnson went further, stating, "The image of a Pittsburgh millionaire was that of a nouveau riche with low tastes and ostentatious habits, vulgar and uneducated, coarse and without refinements, freewheeling and free spending."[48] He expanded his critique:

> The new millionaires spent their money with careless abandon. They cruised about the country in their glittering private trains; they took suites on ocean liners to Europe and made the Grand Tour with their families; they commissioned artists to paint portraits of themselves, their wives and their children; they bought paintings by the yard and sculptures by the ton, jewelry and antiques, homes and boats in Newport and Florida.[49]

For many, a prime example of the crude and tawdry nature of these Pittsburgh upstarts was the sensational affair involving Harry Kendall Thaw, Stanford White, and Evelyn Nesbit. Thaw was the son of William Thaw, who had accumulated a vast fortune in the Union Transportation Line, the Pennsylvania Railroad, and large holdings of coal lands. In 1892 the *New York Tribune* gauged Thaw's estate was worth between $8 million and $10 million but said it was "estimated by some to be even higher than that."[50] Later accounts placed the fortune at some $40 million. Harry Thaw, however, was always a bit of a

ne'er-do-well, and his father had not given him his share of the family fortune. Thaw's doting mother, though, provided her son with a yearly allowance of $80,000. In 1905, at age fifty-three, Thaw married the aspiring actress Evelyn Nesbit, whom Irvin S. Cobb described as "the most exquisitely lovely human being I ever looked at."[51] Before her marriage, young Evelyn had often kept company with the celebrated architect Stanford White.

On 25 June 1906 Thaw and his wife went to a theater performance at Madison Square Garden, a building designed by White. The architect was also attending the play, and when Thaw saw White, he casually walked over and shot him. As a policeman approached, Thaw calmly said, "He deserved it. . . . He ruined my wife and then deserted the girl."[52] The trial that followed was one of the most sensational in American history, since it brought to light the sexual relations of the upper classes. To many in New York, it also exposed the vulgarity of Pittsburgh's rich. Even though his father had been a highly respectable scion of Pittsburgh's establishment, to New Yorkers and others on the eastern seaboard, Harry Thaw was the typical brash, coarse example of new money.

Thaw's mother spent $100,000 to hire the best defense lawyer available, and ultimately Harry Thaw was declared not guilty by reason of insanity. Thaw later escaped from his sanitarium, fled to Canada, and was brought back for another trial. This time the jury acquitted him of all charges. A free man, Thaw returned to his hometown to a hero's welcome, as thousands escorted him in a noisy parade to his mother's home. For many East Coast journalists and aristocrats, this whole incident simply demonstrated how uncouth everyone in Pittsburgh was, and it amply illustrated that those of wealth, position, and prestige in the city did little to raise the level of the citizens' morals or culture.

Thus, a lavish lifestyle and a grand, palatial home were simply not enough to guarantee acceptance by the establishment. This was all rather ironic. When they lived in relatively humble abodes and watched their spending closely, these Scotch-Irish millionaires were castigated as being dour, stingy, and dull, yet when they spent their money freely, they were criticized as being vulgar and uncouth, with atrocious taste and no sensitivity to culture or tradition. To gain their longed-for respect, the Pittsburgh elite turned to philanthropy, especially cultural philanthropy, and to collecting art.

As in most cities at the turn of the century, the upper class in Pittsburgh established a solid record for philanthropy, although many argued that they

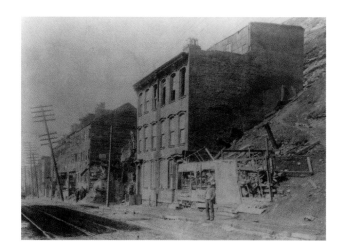

could have done much more. Admittedly, Pittsburgh was a sinkhole of squalor and disease (fig. 28), and philanthropic efforts could do little to alleviate that. One basic problem was the nature of Pittsburgh's industry. As S. J. Kleinberg has stated, "Iron and steel mills made bad neighbors."[53] In 1914 F. Elisabeth Crowell came to a similar conclusion when she wrote that "dirt and noise were inseparable adjuncts to life in a mill district."[54] The fact that she was talking about company housing, once owned by one of Pittsburgh's oldest and most aristocratic iron-making families and now held by U.S. Steel, just made the inequity that much more apparent. The horrible conditions of life for Pittsburgh's workers were recognized by large numbers of critics, both inside and outside Pittsburgh, but for decades little was done by the city's elite.

Formal response to the city's poverty and squalor was not organized until the 1870s, when Pittsburgh was wracked by economic depression. Individual and municipal efforts had proven ineffective in the face of the massive unemployment and distress that existed. The situation finally came to a head in the bitter winter of 1875, when suffering and impoverished workers begged for assistance from the industrial elite who were still living nearby in downtown wards. In response, Louise Herron and other wealthy women founded the Pittsburgh Association for Improvement of the Poor. "A series of meetings in fashionable Fourth Ward parlors produced the association, many of whose members also belonged to other charitable and welfare associations in Pittsburgh and Allegheny City."[55] The new association set up a cumbersome system designed to prevent the "unworthy" from receiving assistance and to eliminate the possibility of giving multiple donations to the needy. It was a highly paternalistic, and not terribly effective, means for distributing aid. Most of its clientele were widows and orphans, a condition created largely by the high accident rate in the city's industries.

Such efforts did little to alleviate the desperate situation, nor did they greatly improve the image of Pittsburgh's upper class in other cities. Therefore, in the 1890s a series of stronger movements emerged, although many of these gestures were ameliorative and did not address the core problems of poverty and miserable living conditions. On an individual level, Henry Phipps, Jr., began making donations to a number of causes but "only to [those] causes he believed just," which created quite a furor. He donated $25,000 to the Pittsburgh public library and made larger donations to the city for public parks, playgrounds, reading rooms, baths, and finally in 1893, a conservatory. Christopher L. Magee and his partners built a zoo in Highland Park, stocked it with animals, and presented it to the city in 1894 (fig. 29). Although such efforts did not attack the root causes of disease and inadequate housing, these benefactions were significant, since before 1880 Pittsburgh did not even have parks.

The most important step in civic improvement came in 1895 with the founding of the Civic Club by Kate McKnight, a member of an upper-class family. This organization fought for children's playgrounds (fig. 30), a child labor association, juvenile courts, a hospital for contagious diseases, and other worthy causes. Another vital reform organization was Kingsley House, which was founded in 1894 and became the first settlement house in the city. It received a good deal of its funding from Henry Clay Frick and was also supported by the Carnegies and the Mellons.[56]

Fig. 29. Photographer unknown. Highland Park Zoo, c. 1895. Carnegie Library of Pittsburgh.

Much of the impetus for reform during this time came from the Calvary Episcopal Church, under the guidance of the Reverend George Hodges, who "provided Pittsburgh a great vision."[57] His church was the spiritual home of many of Pittsburgh's most eminent families, who by that time had forsaken their stodgy Presbyterian ways for the higher status of the Episcopalians. Located in the burgeoning East End, the church provided a voice for many young members of upper-class families who wished to transcend the narrow provincialism of their fathers and mothers. Calvary Church, along with the Civic Club, the Pittsburgh Chamber of Commerce, and the Pittsburgh Board of Trade, formed the organizational focus for the city's broad-based Progressive movement.

An important end result of this social consciousness came in 1907–1908, when H. D. W. English, who had close ties to Pittsburgh's upper class, George W. Guthrie, another prestigious figure who had just been elected mayor on a reform ticket, and Judge Joseph Buffington contacted the Russell Sage Foundation in New York City to conduct a survey of social and economic conditions in Pittsburgh.[58] The result, published in six volumes as the *Pittsburgh Survey*, was perhaps the most important social reform document to come out of the Progressive era. The *Pittsburgh Survey* attacked a number of evils in the city (figs. 31, 32) and especially pushed for the structural reform of the existing political system.[59] Wealthy Pittsburgh families, including Henry Clay Frick, H. J. Heinz, Wallace Rowe (a steel manufacturer), and members of

Fig. 31. Lewis W. Hine. *"Out of Work,"*
Homestead Court, 1908. Courtesy George
Eastman House, Rochester, New York.

Fig. 32. Lewis W. Hine. *Dragging Billets*
by Hand in Steel Mill, c. 1908. Courtesy
George Eastman House, Rochester, New
York.

Fig. 33. Photographer unknown. The Carnegie Free Library, n.d. Carnegie Library of Pittsburgh.

the Thaw family, underwrote much of the expense of this massive social investigation.

It was Andrew Carnegie, however, who raised the practice of philanthropy to a radially new level. He presented his first gift—$25,000 for a public swimming pool in Dunfermline, Scotland—in 1873, and in 1881 he provided funds for his first library building, a free public library in Dunfermline. That same year he also offered one to Pittsburgh, but the city refused because it could not meet his conditions that it should stock the library and pay for its maintenance. In turn, the city of Allegheny did meet Carnegie's terms, and in 1890 the Carnegie Free Library opened (fig. 33). It was the first of thousands of municipally supported libraries he was to construct (fig. 34). Leaders in Pittsburgh later persuaded Carnegie to renew his offer, and a magnificent library was built there as well. In due course Carnegie gave in excess of $56 million for more than 2,500 library buildings around the world. All but three were given on the same condition—that the community had to support the library.

In 1889 Carnegie wrote "Wealth," an essay for the *North America Review* that soon became better known at "The Gospel of Wealth." In it, Carnegie delineated his principles of "scientific philanthropy." "The problem of our age," he wrote, "is the proper distribution of wealth." He asserted that it was his personal responsibility "to spend the surplus [of my wealth] . . . for benevolent purposes." To that point his philosophy did not go much beyond existing philanthropic practice, but he went farther. In continuing he remarked that a man who died rich died disgraced. It was the rich man's duty to dispose of his wealth by supporting a range of useful institutions: universities, libraries, hospitals, parks, meeting and concert halls, swimming pools, and church buildings. It became Carnegie's stated intention to give away his massive fortune, or at least a good part of it. This decision naturally shocked many in America's upper classes. These rich families had no intention of dispensing with their wealth; they just wanted to share a small portion of it with the less fortunate. In certain respects, Carnegie changed the nature of charitable giving forever.

After the publication of his "Gospel," Carnegie began in all earnestness to follow his own dictates. Libraries were his specialty in the early phase of his philanthropic career (fig. 35), and by 1901 he had already given away $16,363,252. He knew that he wanted to spend his money on education in one form or another, with community welfare and peace being tangential. It is difficult even to list the charitable trusts Carnegie set up during the first decade

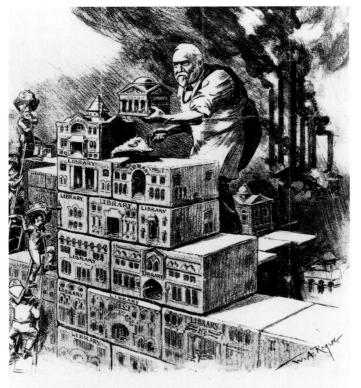

BUILDING A VERY SOLID TEMPLE OF FAME

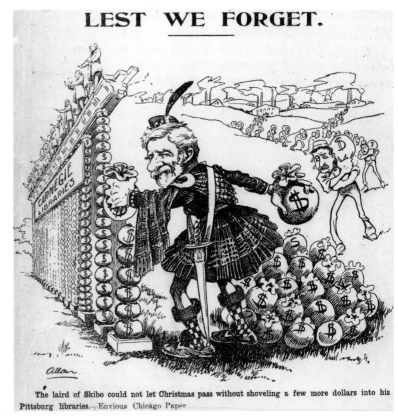

LEST WE FORGET.

The laird of Skibo could not let Christmas pass without shoveling a few more dollars into his Pittsburg libraries.—Envious Chicago Paper.

after the sale of Carnegie Steel to U.S. Steel in 1901. He established the Carnegie United Kingdom Trust to supply funds for library buildings and church organs; the Carnegie Trust for the Universities of Scotland, which he endowed with $10 million; and the Carnegie Relief Fund, which gave $4 million to provide pensions and relief to Carnegie Steel workers. A year later he founded the Carnegie Institute of Washington with an initial endowment of $10 million, and he subsequently gave it another $15 million. He set up funds to provide for workers in Dunfermline and Pittsburgh, and in 1904 established the Carnegie Hero Fund in Pittsburgh with $5 million to reward those who risked their lives to save others. He later endowed hero funds in other countries.

The next year Carnegie turned his interest to higher education, setting up the Carnegie Endowment for the Advancement of Teaching with an initial $10 million and a subsequent $6.35 million. At a time when the wealthy in Pittsburgh and elsewhere were showering money on Ivy League universities, Carnegie gave more that $15 million to individual colleges, universities, and schools, but most of these funds went to smaller, rural schools. Carnegie was, in fact, one of the few philanthropists to provide money to Hampton and Tuskegee Institutes, both of which offered higher educations to African American youth in the rural South.

Fig. 34. W. A. Rogers. "Building a Very Solid Temple of Fame," n.d. Original cartoon in the collection of the Carnegie Birthplace Memorial, Dunfermline, Scotland. Carnegie Library of Pittsburgh.

Fig. 35. Allan, illustrator. "The laird of Skibo could not let Christmas pass without shoveling a few more dollars into his Pittsburg libraries.—Envious Chicago Paper," 2 January 1905. Carnegie Library of Pittsburgh.

By 1910 Carnegie had given away a staggering $180 million of his fortune, but he still had almost the same amount left due to accruing interest on his capital. Perhaps it was typical of Carnegie that his fortune grew almost as fast as he could give it away. Still fearing that he would die in disgrace as a wealthy man, he set up the Carnegie Corporation in New York in 1911 to support and develop his various charitable projects. He gave the trust an initial endowment of $25 million, to which he added $100 million in 1912 and another $10 million in his will. In addition, he contributed $22 million to the Carnegie Institute of Technology, another $22 million to the Carnegie Institute of Washington, and $10 million to the Carnegie Endowment for International Peace, as well as to several other benefactions. Only John D. Rockefeller, with his massive charitable foundations, engaged in philanthropy on such a grand scale.

No other Pittsburgh benefactor could approach Carnegie's level of giving, partially because no one else was as wealthy, but mostly because members of the upper class refused to adopt the principles enunciated in "The Gospel of Wealth." Several of the city's wealthy citizens nonetheless engaged in important philanthropic activity. Henry Clay Frick pursued a variety of philanthropic interests during his lifetime, with perhaps his most visible and dramatic benefaction being the gift to the city of Pittsburgh of 132 acres of land and $2 million for the upkeep of Frick Park. He also made liberal donations to Princeton University, which his son Childs had attended, and over $300,000 for the improvement of Pittsburgh's elementary schools. Frick's other most visible benefaction was his art collection and home on Fifth Avenue in New York City. When he died in 1919 newspapers lauded Frick's philanthropies, asserting that

Fig. 36. Photographer unknown. Panoramic view of Carnegie Library as built with Phipps Conservatory in the background, c. 1900. Carnegie Library of Pittsburgh.

Fig. 37. Photographer unknown. Carnegie Library, as expanded and remodeled, seen from the roof of Hotel Schenley, c. 1907. Carnegie Library of Pittsburgh.

he, like Carnegie, was "getting rid of it all." That was hardly the case. Of his $77.5 million estate (what remained after his earlier benefactions and gifts to individuals), $20 million went to his daughter and $5 million to his widow. The rest was left to various institutions, such as Harvard, Princeton, Massachusetts Institute of Technology, Kingsley House, and several Pittsburgh hospitals.[60]

Henry Phipps's later philanthropies were largely directed outside Pittsburgh. In 1903 the Henry Phipps Institute for the Study, Treatment, and Prevention of Tuberculosis was opened at the University of Pennsylvania. By 1919 his gifts to it totaled $3 million, and the institute became a permanent part of the university. He founded the Phipps Tuberculosis Dispensary at Johns Hopkins Hospital in Baltimore in 1905, and four years later he underwrote the cost of beds for tuberculosis patients in Pennsylvania state hospitals. His most dramatic efforts were aimed at housing, with the establishment of the Phipps Homes in New York. This complex of buildings, designed to provide housing for 142 families, became a model for public housing authorities. After retirement, Phipps gave more than $7 million to various institutions for scientific study. Like Frick, however, most of Phipps's fortune went to his family.[61]

Despite their vast fortune, the Mellons did not give extravagantly in the early years of the twentieth century. Of R. B. Mellon's fortune of more than $200 million at his death in 1933, just over $3 million went to a Pittsburgh church and several hundred thousand dollars to unemployed workers in Pittsburgh. Essentially, he left some $198 million to his family. The brothers Andrew and Richard founded the Mellon Institute in 1908 in memory of their father, and two years later Andrew helped finance the physical rehabilitation of the rundown University of Pittsburgh. The Mellons' most dramatic benefaction occurred in the cultural arena, with Andrew Mellon's donation of his art collection to the nation and the founding of the National Gallery of Art in Washington, D.C.[62]

This monumental gift of art was actually an extension of Carnegie's radically new and different approach to cultural philanthropy. His plan—to bring culture to the working classes and those who labored in his mills—came to full fruition in the Carnegie Institute in the Oakland section of Pittsburgh in the early twentieth century. His vision was far more populist and plebeian than any pursued by elites in other cities, and it would revolutionize libraries, museums, and other cultural institutions in America. As Francis Couvares had noted, the Carnegie Complex was "a public institution with an explicit public agenda . . . [to] define, create and disseminate the 'highest culture' and thereby to civilize the inhabitants of the industrial city."[63] That goal, of course, was superficially similar to that of museums founded by aristocrats on the East Coast—but with Carnegie there was a very real difference.

According to Carnegie's plan, the Carnegie Institute in Oakland included a public library, a music hall, and an art institute (figs. 36, 37). Constructed on the edge of Schenley Park, which had been recently donated to the city by Mary Schenley, the institute was near the University of Pittsburgh and the Carnegie Technical Schools, the Bellefield and Pittsburgh Athletic clubs, and the exclusive new Schenley Hotel. By 1896 the Pittsburgh Orchestra, under the direction of Frederick Archer, had begun regular concerts in the library building's music hall, and that November the first Carnegie Annual art exhibition was held, an event that has continued to the present day. In 1907 the complex was completed with the opening of the art gallery and museum. Five years later the Carnegie Technical Schools were reorganized into the Carnegie Institute of Technology.

In spite of his generous contributions to cultural philanthropy, many in Pittsburgh and elsewhere felt Carnegie's vast amounts of money were

"tainted." Iron and steel workers resented his involvement in the Homestead Strike of 1892 and denounced the erection of Carnegie Libraries in Allegheny and Pittsburgh.[64] Members of older, upper-class families felt he had no pedigree, no standing, and worst of all, no culture.

Although Pittsburgh's wealthy held their tongues about Carnegie's money, aristocrats in other cities were not so circumspect. Richard T. Crane, a scion of a plumbing manufacturing empire in Chicago, was scathing in his attack on Carnegie and his method of philanthropy, referring to him as "the Dr. Jekyll of library building, and the Mr. Hyde of Homestead rioting and destruction."[65] Poultney Bigelow, whose father worked with Carnegie to establish the New York Public Library system, was brutally harsh in his judgment of Carnegie's philanthropy.

> Never before in the history of plutocratic America had any one man purchased by mere money so much social advertising and flattery. No wonder that he felt himself infallible, when Lords temporal and spiritual courted him and hung upon his words. They wanted his money, and flattery alone could wring it from him. . . . He had no ears for any charity unless labeled with his name. . . . He would give millions to Greece had she labeled the Parthenon Carnegopolis.[66]

Fig. 38. Martin, photographer. The Frick mansion from Central Park, New York City, c. 1935. Frick family archives, Pittsburgh.

Against these divided opinions over Carnegie, the cultural philanthropies of Henry Clay Frick and Andrew W. Mellon, along with lesser gifts from several other Pittsburgh families, went some distance in dispelling the notion of Pittsburgh as a cultural backwater. Frick began collecting art earnestly in the 1890s, and by the early twentieth century he had accumulated one of the most impressive collections of old master paintings in the United States. Many have noted that Frick approached art collecting with the same clear-headed caution he used in business.[67] He loved art and had his own personal likes, but he also was careful to purchase art that had lasting value. As John Walker, former director of the National Gallery of Art, stated:

> The two Frick houses, in Pittsburgh and New York, are a remarkable measure of the increase in American sophistication between 1880 and 1914. The earlier house appears to be more original because so much of our Victorian architecture has vanished, but the house on Fifth Avenue has always seemed to me the most beautiful example of domestic architecture and interior decoration produced in the twentieth century [fig. 38].[68]

Frick's art collection was similarly considered to be one of the most important in private hands by the time of his death in 1919, and it was estimated to be worth $30 million to $40 million. What truly raised its significance, however, was the transformation of his home on Fifth Avenue into a public art museum. A tribute to Frick and the collection said, "In giving his house along with his pictures and other beautiful possessions he has done all that a collector could do to send a Velasquez or a Rembrandt or a Gainsborough down to posterity, not as a 'museum specimen' but as a human being, a work made truly for the delight of mankind."[69]

Frick had done much to erase the image of Pittsburgh's elite as provincial, uncouth, and stingy. This was a major step in attaining the respect of aristocrats throughout the nation. For the residents of Pittsburgh, the generosity of Frick, Carnegie, Phipps, and so many others made a tremendous difference. The novelist Annie Dillard, who grew up in a middle-class home in Pittsburgh, remembers her youth.

> It was a great town to grow up in, Pittsburgh. With one thousand other Pittsburgh schoolchildren, I attended free art classes in Carnegie Music

"tainted." Iron and steel workers resented his involvement in the Homestead Strike of 1892 and denounced the erection of Carnegie Libraries in Allegheny and Pittsburgh.[64] Members of older, upper-class families felt he had no pedigree, no standing, and worst of all, no culture.

Although Pittsburgh's wealthy held their tongues about Carnegie's money, aristocrats in other cities were not so circumspect. Richard T. Crane, a scion of a plumbing manufacturing empire in Chicago, was scathing in his attack on Carnegie and his method of philanthropy, referring to him as "the Dr. Jekyll of library building, and the Mr. Hyde of Homestead rioting and destruction."[65] Poultney Bigelow, whose father worked with Carnegie to establish the New York Public Library system, was brutally harsh in his judgment of Carnegie's philanthropy.

> Never before in the history of plutocratic America had any one man purchased by mere money so much social advertising and flattery. No wonder that he felt himself infallible, when Lords temporal and spiritual courted him and hung upon his words. They wanted his money, and flattery alone could wring it from him. . . . He had no ears for any charity unless labeled with his name. . . . He would give millions to Greece had she labeled the Parthenon Carnegopolis.[66]

Fig. 38. Martin, photographer. The Frick mansion from Central Park, New York City, c. 1935. Frick family archives, Pittsburgh.

Against these divided opinions over Carnegie, the cultural philanthropies of Henry Clay Frick and Andrew W. Mellon, along with lesser gifts from several other Pittsburgh families, went some distance in dispelling the notion of Pittsburgh as a cultural backwater. Frick began collecting art earnestly in the 1890s, and by the early twentieth century he had accumulated one of the most impressive collections of old master paintings in the United States. Many have noted that Frick approached art collecting with the same clear-headed caution he used in business.[67] He loved art and had his own personal likes, but he also was careful to purchase art that had lasting value. As John Walker, former director of the National Gallery of Art, stated:

> The two Frick houses, in Pittsburgh and New York, are a remarkable measure of the increase in American sophistication between 1880 and 1914. The earlier house appears to be more original because so much of our Victorian architecture has vanished, but the house on Fifth Avenue has always seemed to me the most beautiful example of domestic architecture and interior decoration produced in the twentieth century [fig. 38].[68]

Frick's art collection was similarly considered to be one of the most important in private hands by the time of his death in 1919, and it was estimated to be worth $30 million to $40 million. What truly raised its significance, however, was the transformation of his home on Fifth Avenue into a public art museum. A tribute to Frick and the collection said, "In giving his house along with his pictures and other beautiful possessions he has done all that a collector could do to send a Velasquez or a Rembrandt or a Gainsborough down to posterity, not as a 'museum specimen' but as a human being, a work made truly for the delight of mankind."[69]

Frick had done much to erase the image of Pittsburgh's elite as provincial, uncouth, and stingy. This was a major step in attaining the respect of aristocrats throughout the nation. For the residents of Pittsburgh, the generosity of Frick, Carnegie, Phipps, and so many others made a tremendous difference. The novelist Annie Dillard, who grew up in a middle-class home in Pittsburgh, remembers her youth.

> It was a great town to grow up in, Pittsburgh. With one thousand other Pittsburgh schoolchildren, I attended free art classes in Carnegie Music

Hall every Saturday morning for four years. . . . Under one roof were the music hall, library, art museum, and natural history museum. . . . I felt I was most myself here, here in the churchlike dark lighted by painted dioramas in which tiny shaggy buffalo grazed as far as the eye could see on an enormous prairie I could span with my arms. . . . Week after week, year after year, after art class I walked the vast museum, and lost myself in the arts, or the sciences.[70]

The Pittsburgh upper class might not have completely won over the eastern establishment, but for bright youngsters growing up in the city, they created truly magical childhoods.

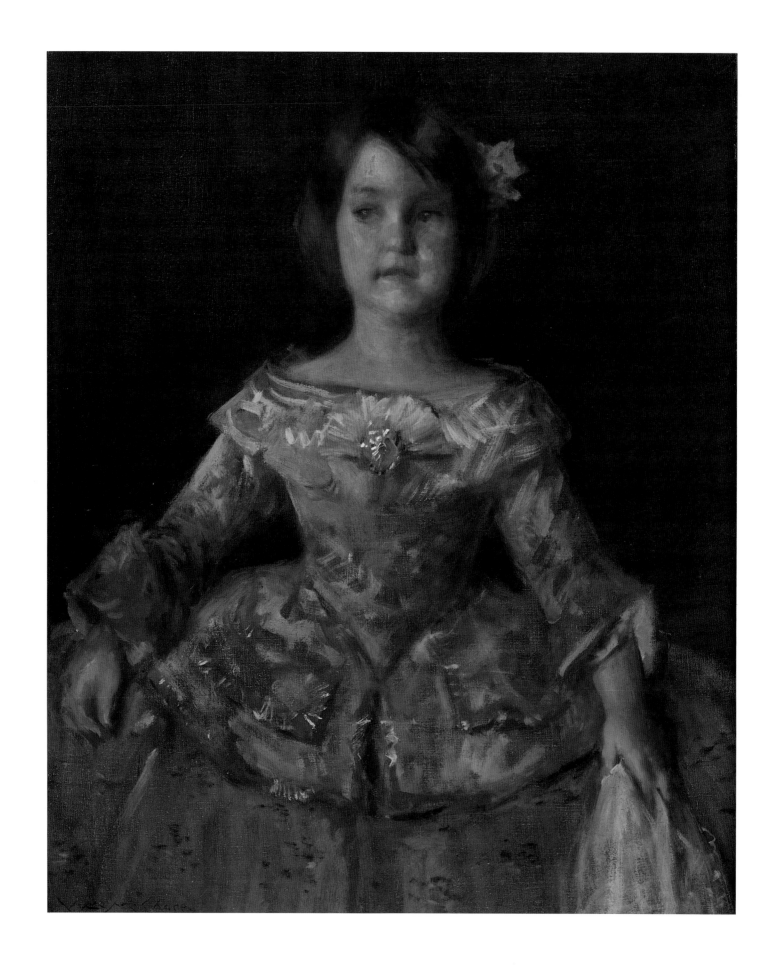

Private Art Collections in Pittsburgh

Displays of Culture, Wealth, and Connoisseurship

Alison McQueen

THE FOUNDATION OF PITTSBURGH'S REPUTATION as an active art center is traditionally ascribed to the magnanimity of two philanthropists, Andrew Carnegie and Henry Clay Frick, whose legacies survive through the institutions and resources they left to the city. Dwarfed by these benefactors and obscured over time was the significant role played by a large group of private art collectors at the turn of the century. Today, more than 1,800 works can be documented in private collections between 1890 and 1905. The rise of Pittsburgh's art community in the nineteenth century was both welcomed and encouraged.

> The plan of Pittsburgh artists to establish a permanent exhibition of pictures in this city will meet with general favor. . . . The time has passed when Pittsburgh was a community of manufacturers pure and simple. . . . The interest taken in exhibitions of pictures at the Art Society's rooms lately shows that there is a strong feeling in favor of art in this city, and it will be strange if the new art gallery is not one of the most popular resorts in Pittsburgh, to say nothing of the encouragement it will offer to the artists of Western Pennsylvania and elsewhere.[1]

By 1900 Pittsburgh was an internationally renowned center for the arts. The city attracted artists to its exhibitions and foreign dealers to its galleries, thus creating an environment that fostered the development—in terms of both quantity and quality—of local art collections. Many collectors were active in Pittsburgh well before the first Carnegie International exhibition was held in 1896, and their participation in local exhibitions had a significant impact on the community. An unfortunate phenomenon occurred in the early twentieth century with the dismantling of several collections and the transportation of numerous works from Pittsburgh. Still, many prominent collectors maintained

Cat. 3. William Merritt Chase (1849-1916). *An Infanta, A Souvenir of Velasquez (Helen Velasquez Chase)*, 1899, oil on canvas. Collection of Joel R. Strote and Elisa Ballestas, Westlake Village, California [Ex. coll., Henry Kirke Porter].

their ties to the city and thus encouraged following generations to do the same. Art was certainly collected and exhibited in Pittsburgh both before 1890 and after 1910, but this period has proven to be a pivotal time in the history of Pittsburgh's art community.

The Pittsburgh Art Scene Before 1890

Pittsburgh collectors as well as venues for the exhibition of art were well in place by the 1850s. John and Mary Shoenberger's collection was probably the most renowned in Pittsburgh in the mid-nineteenth century. Their house, built at 425 Penn Avenue, was home to one of the first art galleries in the city and contained a gallery designed for their collection of works gathered mostly during their trips abroad.[2] The Shoenberger's collection sets a precedent for many Pittsburgh collections since it was funded by the successes of local industry, in this case the Juniata Iron Works.

Long before the Carnegie Institute provided exhibition space for local private collections and brought contemporary art to the city, the first Pittsburgh museum was founded by James Reid Lambdin in 1828 and closed four years later. Three decades later the exhibitions of the Pittsburgh Art Association gave many their first exposure to art.[3] The Art Association's exhibitions, which began in 1859, were among the earliest venues where collectors and artists could meet and discuss local art. In the mid-nineteenth century collectors almost exclusively purchased works produced by local artists, such as David Blythe, J. H. Lawman, and J. W. Woodwell.[4] The promotion of regional art continued with the foundation of the Pittsburgh School of Design in February 1865, which opened in the Phelan building on Fifth Avenue with the support of many Pittsburghers, including Andrew Carnegie, James Laughlin, John Shoenberger, and William Thaw.[5] In 1884 the School of Design transferred its studios to the new YMCA building in a move orchestrated by Thaw.[6] In addition to the School of Design and the Academy of Art and Science, other groups held regular exhibitions of its students' works, including the Art Students' league, which was founded in 1886 and received substantial financial support from Louise Carnegie and Annie Porter.[7] In 1897 an Artists' Association was instituted under the auspices of the Art Society.[8] Holding its annual meeting in the studios of different painters, the Artists' Association was undoubtedly a significant outlet for Pittsburgh and Allegheny talent since it offered regular exhibitions and created a sense of loyalty to the artists in the community.[9] The Art

Cat. 4. A. Bryan Wall (1825-1896).
Landscape, n.d., oil on canvas. Frick Art
& Historical Center, Pittsburgh.

Society also played a central role in establishing the city's first permanent art gallery in 1892, providing a venue for the exhibition of local art and of collections from outside Pittsburgh.[10] An Arts and Crafts league was also organized through the Art Society in December 1900 under the direction of Professor Oscar Lovell Priggs of the University of Chicago. Designed after the Illinois Art league, the Pittsburgh Arts and Crafts league was also intended to provide exhibitions and venues for the sale of art produced in the Pittsburgh area.[11]

By the turn of the nineteenth century, however, most Pittsburgh collectors favored artists with established national and international reputations, and the names of fewer "local" artists appear in their collections.[12] While they bought fewer works by Pittsburgh-based artists, many collectors still actively supported the finances and curriculum of these local art groups. Many of the city's collectors served as officers of the School of Design between 1899 and at least 1902, including T. M. Armstrong, A. M. Byers, John Caldwell, Henry Clay Frick, Andrew Mellon, R. B. Mellon, Henry Phipps, Jr., and H. H. Westinghouse.[13] Frick also created a fund for the Art Society to award prize money to local art students, and Annie Porter supported the Art Students' league.[14]

Many Pittsburgh artists were also promoted by the local press.[15] Among these "local" artists who retained either a natal or a familial link to Pittsburgh and were frequently discussed in local publications were John White Alexander, Henry O. Tanner, Mary Cassatt, George Hetzel, Clarence Johns, Johanna Woodward Hailman, Howard Hildebrandt, Frank Kaufmann, A. F. King, M. B. Leisser, Miss McCreery, Edith McIlvaine, Eugene A. Poole, W. H. Singer, Ida Smith, Horatio S. Stevenson, A. Bryan Wall, and Charles Walz.[16] Alexander, with his strong national and international reputation, was popular among local collectors, but works by Hetzel and Wall (cat. 4) actually appeared in more collections.[17] They were the only local artists who maintained their strong popularity in spite of the growing international tastes of Pittsburgh collectors. Of this group, however, Cassatt, Singer, and Stevenson were represented in one Pittsburgh collection each, and works by the remaining artists did not figure in local collections.[18]

The Sources of Pittsburgh Collections:
An Array of Galleries and Dealers
While the sources of Pittsburgh art collections vary, many works were definitely purchased from local dealers, including S. Boyd and Company, J. J.

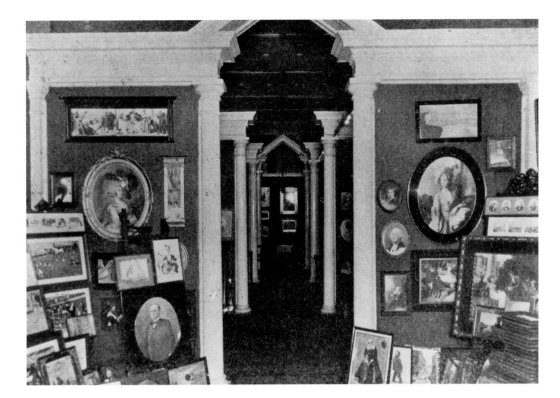

Fig. 39. Photographer unknown. View of Wunderly Brothers' general gallery. Reproduced in the *Index*, 31 May 1902.

Gillespie and Company, and Wunderly Brothers, all of which held frequent exhibitions of works by local artists and special exhibitions of national and international art (fig. 39).[19] Gillespie's, the first art gallery in Pittsburgh, was founded by John Jones Gillespie when he bought Albree's Novelty Shop at 6 Wood Street in March 1832. After this first location burned down in the great Pittsburgh fire of 1845, Gillespie's relocated to 86 Wood Street. Beginning in the early 1850s Gillespie made trips abroad to buy prints and lithographs of works by well-recognized European artists.[20] Although not all of the Gillespie gallery records from this period survive, those that do exist substantiate numerous independent sales and instances when Gillespie's represented other galleries.[21] The success of Wunderly Brothers led it to expand its galleries in 1899, when it added a two-story building, and again in 1901, when an apartment was constructed where artists could hold individual exhibitions.[22] Special exhibitions at these galleries were certainly intended to spark local interest, and galleries typically displayed works of art in their front windows. Imagine how the announcement of works arriving in Pittsburgh would generate a crowd of curious onlookers around a gallery's windows![23]

While not all collectors sought dealers outside Pittsburgh, many national and international dealers used local galleries, most notably Gillespie's, as a vehicle to enter the city's art world. The dealers Arthur Tooth & Sons,

Durand-Ruel, and S. Collins all regularly mounted exhibitions in Gillespie's galleries.[24] Other dealers and collectors, including S. P. Avery, Bleiman, Gross and Lane/Gross and van Gigch, Haseltine, Thomas McLeon, and Henry Reinhardt, exhibited works at Gillespie's on at least one occasion, and the Art Society helped organize a few of these presentations.[25] Gillespie's was not, however, solely a passive receptacle for other dealers' exhibitions. The gallery regularly displayed works by Pittsburgh artists and exhibited collections from other cities. Its representatives, including John Frazier, often traveled to New York and Philadelphia to tap into new art scenes and meet with artists.[26] Albert

McCallam, also employed by Gillespie's, made specific trips to Europe on what were "solely a hunt for fine pictures to bring back to Pittsburgh." In 1901 he spent two months in Egypt, Italy, Germany, Holland, Spain, and England. He visited artists' studios, including those of Gruppe, Mesdag, and Israels in Holland (cat. 5).[27] When completed works were not immediately available, he commissioned paintings that would be sent to Pittsburgh in a year or two.

In addition to using the Gillespie gallery, dealers from outside Pittsburgh rented exhibition space in local hotels, private offices, and the Carnegie building.[28] In some instances these exhibitions served as a preview to a public auction. The sale of the Max Bleiman collection in 1893, for example, was touted as "the greatest art sale ever held in Pittsburgh."[29] Presumably in most cases works were sold privately from dealers' galleries directly to collectors. These out-of-town dealers often met with notably successful sales. In fact, in October 1897 works exhibited by the Durand-Ruel gallery had to be rehung because the large number of sales created too many holes in the installation.[30] M. Knoedler & Co., of New York, London, and Paris, went one step farther by opening an independent gallery at 432 Wood Street in early November 1897, giving its representative, C. S. Carstairs, permanent exhibition space for the first time. One indication of Knoedler's success was its move to larger, new galleries on the second floor of the building by 1901.[31] Dealers from beyond Pittsburgh also used the local newspapers as a way to advertise their exhibitions outside the city, particularly those held in New York. Pittsburgh journalists assisted them by continually mentioning and praising their art exhibitions.[32] Many dealers, including S. P. Avery, Boussod, Valadon et Cie, Cottier and Company, L. Christ Delmonico, Durand-Ruel, M. Knoedler & Co., William Macbeth, and Arthur Tooth & Sons made their presence known by visiting or loaning works to local exhibitions, specifically those held at the Carnegie Institute.[33] In the case of the Frick and Peacock collections, which have the most clearly documented provenances of all these local collections, Arthur Tooth & Sons, M. Knoedler & Co., and Scott and Fowles were their principal sources for paintings and other works of art. Durand-Ruel and Delmonico were also significant sources. One-third of the works in the Peacock collection filtered through the Gillespie galleries, and purchases from or through Gillespie's can be documented in at least twenty other collections.[34]

Many of the dealers from outside Pittsburgh emphasized particular countries or schools of art in their exhibitions, and their promotion of specific artists

and works exerted a strong influence on collectors. The largest number of works in Pittsburgh collections were by Barbizon artists, and the Durand-Ruel gallery was probably the most significant source. Durand-Ruel was renowned for his personal contact with these French landscape painters, and he was praised for buying their works while they were still largely unknown.[35] An unnamed dealer who may have represented the Durand-Ruel gallery was quoted in the *Pittsburgh Post* in 1898 when he remarked that the "pictures that have increased most in value, are those of the Barbizon school of art. They are the works of such men as Jules Dupré, Corot, Rousseau, Daubigny, Millet, Diaz, Delacroix, Fromentin, Jacque and Decamps. Paintings belonging to the Dutch school have had a similar experience. The increase in value of the works of James and William Maris has been marvelous. Anton Mauve's pictures bring a price 10 times as great as that paid for them when they were new."[36] The promotion of Barbizon artists, compounded by such views of their increasing value of their paintings, made a great impression on Pittsburgh collectors. The Barbizon school was represented in every Pittsburgh collection at the turn of the century, and these paintings constituted the majority of works acquired. Providing at least a minimal diversion from the dominance of French art were works by the English painters Raeburn, Romney, Reynolds, Gainsborough, and Hoppner, which Knoedler and Durand-Ruel promoted as early as 1897.[37]

Not all Pittsburghers waited for dealers to come to them. Many traveled to national and international centers, although their journeys are now difficult to document. Sometimes only allusions are made to travel undertaken to see an exhibition, such as a reference to "a Pittsburgh picture collector who made a trip to New York the first of the week to see the exhibition of the American Water Color society."[38] Nonetheless, the impact of both national and international travel on the formation of local collections was significant. For those who did not or could not travel, collectors could meet with international artists when they came to Pittsburgh.

A Range of Artists

The most important vehicle for attracting artists to Pittsburgh was the famous Carnegie International exhibitions. Beginning in 1896, the Internationals attracted many of the most acclaimed American artists, including Cecilia Beaux, Frank W. Benson, William Merritt Chase, Thomas Eakins, Childe Hassam, and Winslow Homer. All these artists either served as jurors, selecting the

works exhibited and determining prize winners, and/or were themselves prize winners between 1896 and 1910.[39] It was undoubtedly through their presence in Pittsburgh and their reputations from the Internationals that works by many of these artists appeared in local collections. Paintings by Chase and Hassam were widely collected, but works by Homer are noted in only one collection. Neither Beaux's nor Eakins' numerous successes at the Internationals are reflected by the inclusion of their works in local collections. These facts demonstrate that the local taste for art collecting was not solely defined by the International exhibitions.[40]

The Internationals also attracted European artists, such as Edmond Aman-Jean, Alfred East, Albert Neuhuijs, Jean-François Raffaëlli, and Frits Thaulow. Works by East, Neuhuijs, and Raffaëlli were in local collections, and Raffaëlli's praise of Pittsburgh as a world-class art center during his visit to the city in 1899 undoubtedly won him many supporters.[41] Raffaëlli said his decision to be a juror for that year's International was, in fact, due to his commitment to the many Pittsburghers—unfortunately unnamed—he had befriended in Paris.[42] The artist also generated great excitement in his pursuit of the "perfect" female model for his painting of a "typical American girl." It is unclear whether this unnamed woman, who lived on the city's north side, was ever the subject of one of his works, but his painted views of Pittsburgh did attract crowds.[43] One work was noted as being his first painting completed in the United States. Aman-Jean's presence seems to have made less of an impact, although he was promoted in local newspapers. Contemporary documents suggest that only John W. Beatty, the secretary of the Art Society and later director of the department of fine arts of the Carnegie museum, collected Aman-Jean's work.[44] The most popular artist introduced to the Pittsburgh public through the Internationals was the Norwegian artist Frits Thaulow, who was best known for his placid scenes of running streams and snowy landscapes.[45]

It is curious that the work of Mary Cassatt, who was born in Pittsburgh, trained in Philadelphia and Paris, and had a solid international reputation by this period, was not acquired by more local collectors. Her absence from all collections, except that of the Fricks, has even greater resonance in the context of the small portion of works by female artists in all Pittsburgh collections. A total of twenty-five paintings by female artists, out of more than 1,800 works, are noted in contemporary sources. (This figure represents less than 1.5 percent of all works collected.) The other women whose works were collected include the

Cat. 6. Frederick Goodall (1822-1904).
Rosa Bonheur at Work near Wexham, 1856,
oil on panel. Collection of Morton C.
Bradley, Jr., Arlington, Massachusetts
[Ex. coll., H. J. Heinz].

Pittsburgh artist Olive Turney, the Polish painter Olga de Boznanska, the American Anna Klumpke, and the French artists Rosa Bonheur, Elizabeth Gardner, Madeleine-Jeanne Lemaire, and Elisabeth Vigée-Lebrun.[46] Bonheur, the famous French Salon artist who was most noted for her paintings of animals (cat. 6), had the strongest reputation in Pittsburgh of any female artist— a total of ten works in nine collections.[47] The general popularity of landscape painting in Pittsburgh, and Bonheur's recognition by the leading art institution and rulers of France—she received the Legion of Honor from Empress Eugénie in 1865—made her works more appealing to Pittsburgh collectors than those by other female artists. The greatest concentration of works by female artists was in the Thaw collection.

Few European artists who were not associated with the Internationals visited Pittsburgh. Certainly the presence of Théobald Chartran in Pittsburgh enhanced his reputation, and he received numerous portrait commissions from

the most prominent collectors in the city, including the Byers, Frick, Jones, Lockhart, Mellon, Oliver, Rea, and Woodwell families.[48] The Spanish artist Raymundo de Madrazo, who was best known at the turn of the century for his bravura society portraits, was often accessible in New York, and he received commissions from Byers, Peacock, Porter, and Schoonmaker. In fact, Madrazo made such an impact on the local community that the *Index* ran a five-page illustrated article on the various stages of his production of the Peacock portraits (figs. 48, 49).[49] The world's fairs in Chicago and Buffalo in 1893 and 1901 certainly drew international artists to the United States, and a few may have passed through Pittsburgh. Oscar Matthieson, a Danish artist, definitely traveled to Pittsburgh before going to Buffalo, and he prepared several drawings from which he planned to complete paintings.[50] Finally, the German sculptor William Spiesterbach, who spent much of his youth in Pittsburgh, visited friends in the city for several months in 1900 and 1901, but his influence on the art community, like that of Matthieson, remains undocumented.[51] Spiesterbach's absence in period documents is most likely caused by the focus on oil paintings in turn-of-the-century inventories and the omission of sculpture, miniatures, and works on papers. Indeed, biases towards oil painting, particularly at the Carnegie International exhibitions, was subject to criticism. "If there is a weak point in the Carnegie management, it seems to us that it lies in limiting their exhibitions to easel pictures. It seems to us that the graphic arts should be included, and that wood-engraving and etching should be shown. . . . The sooner America learns that art is not limited to the easel picture, the better."[52]

Choice of Media

While the general lack of evidence concerning media makes it impossible to evaluate fully the popularity of certain kinds of works with collectors, the numerous exhibitions of prints, watercolors, miniatures, and sculpture that were held should be regarded as indicators of a substantial level of interest. It appears today that only a handful of collectors owned prints, but frequent exhibitions of etchings, engravings, and reproductions of paintings were held. John Caldwell owned a sizable collection of prints, as did the Lockharts, who installed specially designed cases for their print collection in their art gallery. At least six other collections included prints.[53] A steady stream of print exhibitions that were held at Gillespie's and Wunderly Brothers featured works by American, French, and Dutch printmakers.[54] Color photogravures and prints

after famous paintings in public and private collections were also increasingly popular, which suggests that collectors were interested in acquiring high-quality reproductions of paintings.[55] Wunderly's sale of signed color facsimiles of Thaulow's paintings and artist proof etchings of Bonheur's and Harpignies' works were undoubtedly of specific interest to local collectors.[56]

Although fifty-four watercolors can now be traced to fourteen collections, certainly more were in Pittsburgh at the turn of the century.[57] Watercolors were shown at Gillespie's, with one presentation being hailed as among the "finest" exhibitions ever held in the city.[58] The Carnegie Institute displayed Winslow Homer's scenes of Canada in a watercolor exhibition that later traveled to New York.[59] And Wunderly's held an annual watercolor exhibition of works by American artists.[60] In March 1898, when the German artist Baroness Helga von Cramm arranged and exhibited a selection of her watercolors at Gillespie's at the same time as watercolors by American artists were shown at Boyd's and Wunderly's, one journalist remarked on the developing interest in the medium in Pittsburgh, saying the "fondness for watercolors seems to have come with the spring."[61] The Japanese artist Telijiro Hasekama, who had been invited to the United States by the Boston Art School, visited Pittsburgh in 1901 and exhibited his watercolors at Gillespie's. While his name does not appear in any collections, one writer predicted, "There is little doubt that several of Mr. Hasekama's pictures will find a permanent hanging place here, a number of the collectors having a strong fancy for Japanese art." A later report noted that "several of the pictures are to remain in the city permanently." The works Hasekama definitely sold to Pittsburghers included *Sleeping Heron, Flight of Birds, Misty Morning,* and *Cherry Blossoms.* Today, these works stand out as rare evidence of the taste of Pittsburgh collectors for works produced outside the art traditions of North America and western Europe.[62] The most significant early collection of Asian art in Pittsburgh was certainly that of Henry J. Heinz, who began collecting Asian art in 1902, when he made his first trip to Japan. Many of these works were later donated to the Carnegie Institute through descendants. By 1898 Heinz and his wife Sara exhibited their collection of "curios" in a museumlike space in their attic.[63] While evidence indicates that watercolors and Asian art were exhibited and collected in the city, less information remains about pastels and drawings, although they were included in at least four Pittsburgh collections.[64]

A select number of miniatures were also owned by Pittsburghers. Judging

by the popularity of miniatures, particularly those produced by artists involved with the Duquesne Ceramic Club, this fragile and jewel-like medium undoubtedly attracted collectors.[65] Miniatures were exhibited at the Art Society's galleries, Boyd's, and Gillespie's.[66] A large exhibition of about seventy-five miniatures by the English artist Charles J. Turrell was presented at Gillespie's in 1901. The organization of such a sizable show by a gallery that was so closely attuned to the interests of Pittsburgh collectors certainly confirms the high level of local interest.[67] In fact, Turrell received at least one additional commission during this, his first visit to Pittsburgh, for a miniature portrait of Mrs. Schwab.[68] The collection of miniatures formed by Amy and Herbert Dupuy may have begun in these years. In the following decades it was ranked as the second largest in the United States.[69]

Little solid evidence indicates that Pittsburghers collected sculpture. While such works were regularly for sale in Pittsburgh and were often prominently displayed in the windows of local galleries, only sixteen works in sculpture can be documented in six local collections.[70] One sculpture displayed in Gillespie's window in 1898 was a terra cotta study of M. B. Leisser's *Cuba Libre*.[71] Perhaps more important for reconstructing Pittsburgh collections at the turn of the century was the exhibition of a bronze of Frederic Remington's *Broncho Buster* in the window of Boyd's galleries in March 1898. This may be the *Broncho Buster* now in the collection of the Duquesne Club, whose provenance is unknown but probably belonged to a local collector.[72] While much attention in Pittsburgh newspapers was given to the work of the famous French sculptor Auguste Rodin, and particularly his exhibition in 1900, it is uncertain why local collectors did not acquire his work.[73] The scant amount of sculpture in Pittsburgh was, in fact, the subject of a lengthy article in 1903.[74] One exception was the Porter collection, which included three antique vases. Annie Porter bought one Etruscan amphora, a Greek black-figure amphora, and a Greek red-figure stamnos during a trip to Rome around 1900. She was advised on these purchases by Professor Lanciani, who was then head of the United States government excavations in Rome.[75] These vases were a significant addition to the Porter collection, which contained a more diverse array of media than any other in the city. An intriguing number of mosaics could also be found in local collections, particularly those of the Eaton, Schwab, and Singer families. Charles Schwab purchased one of these mosaics directly from the Italian artist Tarentoni in Rome.[76]

This last point raises the question of exactly how many works Pittsburgh collectors bought directly from artists. Although any figure remains speculative, including portrait commissions and documented purchases, at least twenty-eight Pittsburgh collectors acquired a minimum of sixty-nine works directly from artists.[77] These numbers clearly represent a small fraction of all the works collected, but it is still important to consider all the possible levels at which the display and acquisition of art operated. Based upon available evidence, the majority of works in Pittsburgh at the turn of the century were oil paintings that had been purchased through well-established dealers and which, therefore, came with a stamp of approval that no doubt validated the substantial financial investments that had been made.

Growth of Connoisseurship

Collectors' interest in international art was certainly fed by Raymond Gros, a Frenchman who as early as 1901 became a regular art critic for the *Index*, a weekly society publication.[78] His articles on European art may have helped educate upper-class Pittsburghers in both contemporary art and art history; he also promoted exhibitions of visiting collections and works for sale at local galleries.[79] The *Index* contracted foreign artists, including Aman-Jean and Robert Vonnogh, to write articles on the "trends" of modern art, describing the variety of subject matter and international exhibitions.[80] Local artists joined in the praise of internationalism, and Joseph Woodwell wrote about the French painters Corot and Meissonier in his article "Masters of Modern French Art" in 1899.[81]

In addition to articles in local and national newspapers, local social clubs were another place where Pittsburgh society could learn about art and art history. The most active group in this sphere was the Twentieth Century Club, whose object was "to secure higher literary and social culture, combined with a concentration of philanthropic work."[82] This women's club offered regular evening lectures on contemporary art, art history, local and national exhibitions, and the study and appreciation of art.[83] Lecturers included local artists Martin Leisser and Joseph Woodwell, and Ida Smith gave her critical reactions to the Carnegie International exhibitions.[84] The club also sponsored John W. Beatty to conduct explanatory sessions on the Internationals and to introduce other national exhibitions.[85] In this way many Pittsburghers were encouraged to appreciate and critically evaluate the flood of art into their city and other

by the popularity of miniatures, particularly those produced by artists involved with the Duquesne Ceramic Club, this fragile and jewel-like medium undoubtedly attracted collectors.[65] Miniatures were exhibited at the Art Society's galleries, Boyd's, and Gillespie's.[66] A large exhibition of about seventy-five miniatures by the English artist Charles J. Turrell was presented at Gillespie's in 1901. The organization of such a sizable show by a gallery that was so closely attuned to the interests of Pittsburgh collectors certainly confirms the high level of local interest.[67] In fact, Turrell received at least one additional commission during this, his first visit to Pittsburgh, for a miniature portrait of Mrs. Schwab.[68] The collection of miniatures formed by Amy and Herbert Dupuy may have begun in these years. In the following decades it was ranked as the second largest in the United States.[69]

Little solid evidence indicates that Pittsburghers collected sculpture. While such works were regularly for sale in Pittsburgh and were often prominently displayed in the windows of local galleries, only sixteen works in sculpture can be documented in six local collections.[70] One sculpture displayed in Gillespie's window in 1898 was a terra cotta study of M. B. Leisser's *Cuba Libre*.[71] Perhaps more important for reconstructing Pittsburgh collections at the turn of the century was the exhibition of a bronze of Frederic Remington's *Broncho Buster* in the window of Boyd's galleries in March 1898. This may be the *Broncho Buster* now in the collection of the Duquesne Club, whose provenance is unknown but probably belonged to a local collector.[72] While much attention in Pittsburgh newspapers was given to the work of the famous French sculptor Auguste Rodin, and particularly his exhibition in 1900, it is uncertain why local collectors did not acquire his work.[73] The scant amount of sculpture in Pittsburgh was, in fact, the subject of a lengthy article in 1903.[74] One exception was the Porter collection, which included three antique vases. Annie Porter bought one Etruscan amphora, a Greek black-figure amphora, and a Greek red-figure stamnos during a trip to Rome around 1900. She was advised on these purchases by Professor Lanciani, who was then head of the United States government excavations in Rome.[75] These vases were a significant addition to the Porter collection, which contained a more diverse array of media than any other in the city. An intriguing number of mosaics could also be found in local collections, particularly those of the Eaton, Schwab, and Singer families. Charles Schwab purchased one of these mosaics directly from the Italian artist Tarentoni in Rome.[76]

This last point raises the question of exactly how many works Pittsburgh collectors bought directly from artists. Although any figure remains speculative, including portrait commissions and documented purchases, at least twenty-eight Pittsburgh collectors acquired a minimum of sixty-nine works directly from artists.[77] These numbers clearly represent a small fraction of all the works collected, but it is still important to consider all the possible levels at which the display and acquisition of art operated. Based upon available evidence, the majority of works in Pittsburgh at the turn of the century were oil paintings that had been purchased through well-established dealers and which, therefore, came with a stamp of approval that no doubt validated the substantial financial investments that had been made.

Growth of Connoisseurship

Collectors' interest in international art was certainly fed by Raymond Gros, a Frenchman who as early as 1901 became a regular art critic for the *Index*, a weekly society publication.[78] His articles on European art may have helped educate upper-class Pittsburghers in both contemporary art and art history; he also promoted exhibitions of visiting collections and works for sale at local galleries.[79] The *Index* contracted foreign artists, including Aman-Jean and Robert Vonnogh, to write articles on the "trends" of modern art, describing the variety of subject matter and international exhibitions.[80] Local artists joined in the praise of internationalism, and Joseph Woodwell wrote about the French painters Corot and Meissonier in his article "Masters of Modern French Art" in 1899.[81]

In addition to articles in local and national newspapers, local social clubs were another place where Pittsburgh society could learn about art and art history. The most active group in this sphere was the Twentieth Century Club, whose object was "to secure higher literary and social culture, combined with a concentration of philanthropic work."[82] This women's club offered regular evening lectures on contemporary art, art history, local and national exhibitions, and the study and appreciation of art.[83] Lecturers included local artists Martin Leisser and Joseph Woodwell, and Ida Smith gave her critical reactions to the Carnegie International exhibitions.[84] The club also sponsored John W. Beatty to conduct explanatory sessions on the Internationals and to introduce other national exhibitions.[85] In this way many Pittsburghers were encouraged to appreciate and critically evaluate the flood of art into their city and other

national art centers. Presentations on American, Greek, Byzantine, and Italian Renaissance art—the latter given by the famous art historian John C. Van Dyke—indicate the level of demand and/or promotion of art-related knowledge in Pittsburgh.[86] Issues of modern art, criticism, art appreciation, and techniques were also topics of discussion, and many of the lectures were illustrated with a stereopticon.[87]

The Twentieth Century Club, founded in 1894, claimed many local art collectors among its charter and early members as well as its board members, who were responsible for the club's events, including organizing lectures.[88] Two collectors, Jane Lockhart and Mary Thaw, were specifically noted in 1899 as patronesses of a series of lectures on American art, thus demonstrating how some collectors actively promoted the dissemination of information and ideas about art to the Pittsburgh community.[89]

Talks were also offered through the Carnegie Institute, which presented a series of four lectures on Barbizon artists by Professor Charles Sprague of New York in 1896.[90] The artist Jean-François Raffaëlli lectured on "Our Art of To-Day in France—Impressionism" in 1899, and one newspaper article noted the importance of such talks for informing Pittsburghers so they could benefit more from the next annual exhibition.[91] The well-known local artist Joseph Woodwell delivered a lecture on French and Italian artists at the Carnegie Institute in May 1898.[92] Other lecturers brought to Pittsburgh included Professor James H. Breasted of the University of Chicago, who gave a series of six lectures on Egyptian art in November 1898, and Professor Oscar Lovell Priggs, also of the University of Chicago, who presented six lectures on a variety of art-related subjects in January 1899.[93] This sampling offers a sense of the collectors' growing knowledge of art and their interest in such information.

During this period many writers frequently praised the caliber of the art community in Pittsburgh. In 1902 one local journalist commented, "It is said that Pittsburgh has progressed more in the last seven years in art than any other city in fifty."[94] Much of this advancement was accredited to the yearly Carnegie exhibitions. Another journalist wrote more extensively in the national publication the *Collector.*

One of the esthetical phenomena of our time is the avidity with which Pittsburgh has taken to collecting works of art since she has had light enough to see them by. Once upon a time, when the great Pennsylvania

iron metropolis was still the dirtiest and most picturesque town in the country, I remember meeting out there a couple of painters who contrived, like ill-nourished children, to languish out an anemic existence at her sooty breast. . . . Now she has her art schools, her public galleries, her picture dealers, and studios full of men and women of talent . . . and Pittsburg[h] is now the American city to which all the peripatetic picture-venders look as an oasis of profit on the way to the great Mecca of Chicago.[95]

To some, Pittsburgh's position clearly remained subordinate to other art centers, particularly when compared to the Columbian Exposition held in Chicago in 1893, but the quality of the city's art scene was nevertheless notable. The mounting reputation of the Pittsburgh art community is underscored by an article published in the *Art Amateur* in 1892, which specifically praised the Art Society, the Art School, and the School of Design for Women.[96] Thus Pittsburgh was regarded as an active and rich art center by the early 1890s, even before the opening of the Carnegie Institute or the first International exhibition.

Private Art Collections in Pittsburgh, 1890–1905

It is difficult to determine the quality of works in most Pittsburgh collections because so few documents survive and few works can be located in modern collections. The only remaining means of comparison are, therefore, the size of collections and media acquired. The quantity of works in individual collections can be divided into six groups: large collections (eighty to one hundred or more works), medium to large collections (forty to eighty works), medium-sized collections (twenty to forty works), medium to small collections (ten to twenty works), small collections (less than ten works), and collections whose existence is documented but whose contents now cannot be documented or evaluated.

The first group, the largest collections of eighty to one hundred or more works, includes those of the Byers, Frick, Lockhart, Porter, and Watson families.[97] The Frick collection is included in this group even though numerically it now appears to have held more than twice as many objects as the other collections. More than 240 works of art can be documented in the Frick collection at different times between 1880 and 1905. The size of this collection may, however, appear significantly larger than the others due to comprehensive archival documentation on the Frick family, whereas comparatively little is known about the other collectors. This first group represents the leading private col-

lectors of the period. Contemporary newspaper reports substantiate this evaluation, as does the interest these collections drew from André Michel, a noted art critic and buyer for the Louvre museum, who came to Pittsburgh in December 1903 and visited the Byers, Frick, Lockhart, and Watson collections.[98]

The second group of medium to large collections (forty to eighty works) includes the Caldwell, Donnelly, Laughlin, Peacock, Stimmel, and Thaw collections.[99] The greatest number of Pittsburgh collections falls into the third category, medium-sized collections. At least sixteen collections contained from twenty to forty works: William Black, Bosworth, Andrew Carnegie, Darlington, Dupuy, Finley, Frew, Holmes, both Andrew and J. R. Mellon, Moorhead, both Olivers, Lawrence Phipps, Schoonmaker, Schwab, Singer, and B. Wolff, Jr.[100] Several of the private collectors in this group were also actively involved in developing the Carnegie Institute and in sponsoring local exhibitions.[101] The fourth group, medium to small collections, includes those of George Black, Jones, Julian Kennedy, George Laughlin, Nicola, O'Neill, and Vandergrift.[102] It is with the fifth group, the small collections, that the scarcity of documentation hinders an understanding of collecting patterns. Still, at least a dozen other Pittsburgh collections had from one to ten works.[103] Finally, the sixth group

Cat. 7. Jacobus Simon Hendrik Kever (1854–1922). *Children Peeling Apples (Interior View, Family)*, n.d., watercolor. University Club, Pittsburgh [Ex. coll., James B. Laughlin].

Cat. 8. J. J. Henner (1829-1905). *Meditation*, n.d., oil on canvas. Allegheny Cemetery, Pittsburgh; Given in memory of William C. Moreland.

includes at least two dozen collections whose contents remain too unclear for them to be treated adequately.[104]

From the existing evidence it is obvious that landscapes, portraits, and genre paintings were the most popular subjects among Pittsburgh collectors (cat. 7). Appropriate subject matter, specifically the use of the female nude, was frequently discussed.[105] This debate intensified particularly after the exhibition of several paintings of female nudes at the Chicago world's fair in 1893, but few such works can be documented in Pittsburgh collections. Some scenes of nymphs, bathers, and a study of the nude figure can be traced to the Byers, Caldwell, and Frick collections. Certainly Stimmel's purchase in 1907 of Latouche's *The Bath* (cat. 112), with its full-length view of a female nude seen from the back, marks a shift in taste, but such works did not appeal to the majority of Pittsburgh collectors. The scarcity of nudes, male or female, was likely caused by a general perception of this subject as being immoral and thus unappealing to have connected with one's private art collection. The popularity of J. J. Henner's sensual heads does suggest some interest in images of alluring women, but the demure glances of these women are cut off at neck level and do not display the female body in a way that would actively challenge or disrupt the general emphasis on propriety and morality (cat. 8). Still lifes and religious scenes were more popular than nudes, but neither can be compared with the great appeal of landscapes, portraits, and genre subjects.

Individual Collections

The Frick Collection

Of international renown today, the Frick collection was commonly known in Pittsburgh as one of the most significant holdings in the city.[106] The earliest recorded works in the Frick collection, acquired in 1881, were paintings by Adam, Cicere, Glassies, Jiménez, Leloir, Lemaire, and Mesgrigny. Although these works do not reflect the most valuable acquisitions made by the Fricks, these early purchases obviously held considerable personal significance since records indicate that they never parted with any of them. Between 1890 and 1905, however, the Fricks sold or exchanged no less than fifty-four works as they sought the best-quality paintings by certain artists.[107] While they did look to dealers for advice on several occasions, the Fricks also brought many paintings on consignment to Clayton, their home at Penn and Homewood Avenues,

so they could experience them among the other works in their collection before they decided to purchase or return them.

The constant sale and exchange of works with the Knoedler galleries that typifies the development of the Frick collection was perhaps common practice among several Pittsburgh collectors. Paintings from the Byers, Lockhart, Phipps, Thaw, and Wolff collections followed the same pattern.[108] Exchanging works—even if at a slight loss, but usually for significant gain—was not an indication of poor judgment but rather the result of changes in taste and the growth of the collectors' knowledge of art with each passing year. The most financially rewarding returns made by Frick were for Breton's *The Last Gleanings,* which he purchased in 1895 for $14,000 and returned in 1907 for $25,000 credit, Corot's *The Seine at Nantes,* purchased in 1901 for $15,000 and returned two years later for $23,000 credit, and Maris's *Mussel Gatherers,* bought in 1901 for $14,639.45 and returned in 1906 for $25,000 credit.[109] Exchanging art for credit also gave many Pittsburghers the funds for more expensive purchases. Alternative forms of payment achieved the same goal. In 1899, for example, Frick purchased a work from the Knoedler galleries with one hundred shares of Pittsburgh Plate Glass.[110]

The Fricks enjoyed an excellent rapport with both Charles and Roland Knoedler, entertaining them in Pittsburgh, traveling with them in Europe, and even receiving a painting, Domingo's *Cabaret* (cat. 57), as a gift from them in 1895. M. Knoedler & Co. was not the only source of Frick's collection—he bought a few works from Gillespie's—but it was the most significant, and it often acted as an intermediary for purchases from other European dealers.[111] Frick also purchased works directly from artists on at least six occasions. Since Frick favored reputable national and international dealers, Gillespie's in and of itself did not have the notoriety to sustain his patronage. He did, however, buy works exhibited by other dealers in Gillespie's galleries and certainly relied on Gillespie's as well as Knoedler's and Cottier and Company to make shipping arrangements and to conduct the necessary restoration, framing, and installation of works in Clayton.[112]

After the 1880s the Frick collection grew exponentially. Looking at the collection at three different dates—1896, 1900, and 1905—provides a better sense of the depth of the Frick collection. By 1896 Frick owned 81 works. Between 1896 and 1900 the collection grew to 139 objects, and between 1900 and 1905 it expanded to 191 works of art. At this number it was more than double the size

of any other collection in the city. Frick clearly had some concern over how to accommodate this growing collection, and in 1898 he considered adding an art gallery to Clayton. He even asked Roland Knoedler to look over an architect's plans, but ultimately Frick was not satisfied with the proposal and dropped the idea entirely.[113] While oil paintings comprised the majority of the collection, Frick also owned a significant number of watercolors, prints, and drawings, which he acquired as early as 1881 but primarily beginning in the 1890s.

At the heart of the network of Pittsburgh art collectors, Henry Clay Frick had business connections with a large number of the city's collectors, and he and his wife Adelaide attended numerous social engagements with other art-collecting couples.[114] Indeed, viewing recent art acquisitions often formed the main reason for a social gathering at Clayton.[115] Frick nominated his colleagues to art associations, arranged for them to have their portraits painted by Chartran, introduced them to the Knoedlers, and traveled with them in Europe.[116] Actively involved in several art associations himself, Frick served as a trustee of the Carnegie Institute as well as a member of the honorary committee of art patrons for the South Carolina, Inter-State and West Indian Exposition in 1901. Most significantly, he was honored by the request to be one of the vice presidents of the National Arts Club and to represent "the art interests and the art collectors of Pittsburgh."[117] At the international level, Frick and his fellow art collector Charles Schwab were among the charter patrons of the League of American Artists in Paris and attended its exhibition together in 1905.[118]

The Fricks certainly loaned their works to local exhibitions, although less frequently after the early Carnegie exhibitions attracted other sources. Like the Porters and the Thaws, they also helped make Pittsburgh a well-known art center by loaning works to national and international exhibitions. Beyond the internationally famous acquisition and exhibition of Dagnan-Bouveret's *Christ and the Disciples at Emmaus* (cat. 101), in 1901 they loaned Coffin's *A Rainy Day in Autumn* to the American Exposition in Buffalo, Dagnan-Bouveret's *Consolatrix Afflictorum* (cat. 108) to the Chicago Art Institute, and his *Portrait of Childs Frick* (cat. 9) to the Pennsylvania Academy of the Fine Arts. Also in 1901 and extending into 1902 they loaned Chartran's *Signing of the Protocol* (The White House, Washington D.C.) to the South Carolina, Inter-State and West Indian Exposition in New York before the work was donated to the United States government. In 1904 two works were loaned to the Louisiana Purchase Exposition: Ruysdael's *A Waterfall* (cat. 24) and Vermeer's *Music Lesson* (Frick Collection, New York).[119]

As art patrons recognized outside Pittsburgh, the Fricks received many visitors to their home, including the artists Chartran, John La Farge, Aman-Jean, and Thaulow; the critic Raymond Gros; collectors from beyond Pittsburgh such as George Reuling, a doctor from Baltimore; and such dealers as the Knoedlers and the Gillespies, Charles Dowdeswell of the New York Dowdeswell gallery, and H. Goujon, a dealer from Paris.[120] On their national and inter-

national travels, often made specifically to acquire art, the Fricks came into direct contact with Bonheur, van Boskerck, Breton, Cazin, Chartran, Chelminski, Dagnan-Bouveret, and Thaulow.[121] Such travel and contact with artists and art experts both at home and abroad were perhaps the most extensive of any private collector in Pittsburgh.

The Byers Collection

Ranking second largest in size, the collection of Alexander McBurney Byers illustrates both the taste for European genre painting and the increasing interest in old master paintings that characterized Pittsburgh at the turn of the century. By the time of his death in 1900, Byers and his wife Martha had acquired a collection of Dutch, English, Flemish, and French paintings that was more diverse than most in the city. While Barbizon paintings still dominated their collection of ninety-seven works, the Byers demonstrated an interest in English portraiture and seventeenth-century Netherlandish art at a time when few other collectors in Pittsburgh followed such a pattern.[122] Indeed, Byers, of the A. M. Byers and Company iron manufacturers, and Martha, both Pennsylvanians by birth, were obviously among the most discerning and original collectors in the city, and they certainly devoted a large amount of their household

Fig. 40. Photographer unknown. Dining room of the Byers residence on Ridge Avenue, n.d. Courtesy of Community College of Allegheny County, Pittsburgh.

Also see figs. 41, 57–59.

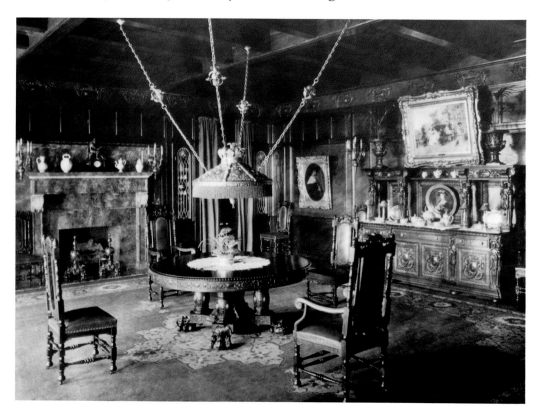

wealth towards acquiring art.[123] The Byers collection was so highly regarded that William Merritt Chase selected it as the subject of a tour he led for members of the Pittsburgh Art Students' league in 1899.[124] Three works from the Byers collection were exhibited at the new Knoedler galleries at 355 Fifth Avenue in New York for several weeks in November 1899: Daubigny's *Solitude*, Gainsborough's *Mrs. Isabella Kinlock*, and Turner's *The Wreckers*.[125] These three paintings were among only four hung at the new galleries—the fourth was a Corot owned by Knoedler—and each work was displayed on a separate wall in one room. Both Pittsburgh and New York newspapers noted the high quality of the works and the compliment that had been made to the Byers to have their paintings exhibited in such an unusual manner. Pittsburgh sources also observed that the presentation of these works demonstrated to New Yorkers the quality of collections in Pittsburgh and their growing recognition on a national level. It was also suggested that the Byers would soon hold an auction to get rid of some lesser-quality works as they moved to a higher level of col-

Fig. 41. Photographer unknown. Library of the Byers residence on Ridge Avenue, n.d. Courtesy of Community College of Allegheny County, Pittsburgh.

Also see figs. 40, 57–59.

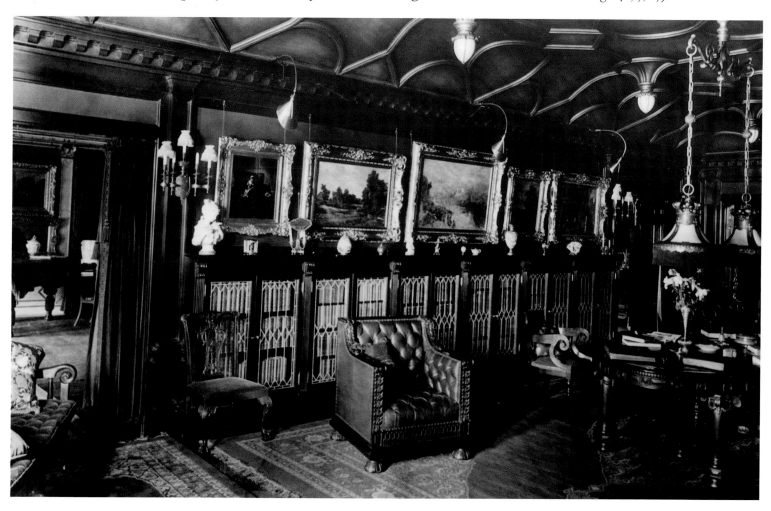

lecting after this exhibition.[126] This comment is further evidence of the turnover in Pittsburgh collections, a factor that helps to explain the elimination of works by local artists with the growing international taste in the city.

The Byers definitely purchased works in Pittsburgh from special exhibitions at Gillespie's, and they undoubtedly acquired paintings on their trips abroad.[127] In fact, by the time they traveled to Europe in 1898, they had clearly established a strong relationship with the Knoedler galleries. In a letter to Charles Carstairs, who was then at the Knoedler offices in Paris, Henry Clay Frick announced the Byers' arrival in France. Carstairs replied he was pleased to tour them around several collections that he had often wanted to show them.[128] The quality and size of the Byers collection was also well known to Pittsburghers since works were loaned periodically to exhibitions at the Carnegie museum, as was noted in local newspapers.[129] Their collection was valued at $50,000 in 1890, and they clearly made significant additions in the ensuing years, acquiring Millet's *Portrait of a Child* for $30,000 in April 1897 and Turner's *The Wreckers* for $50,000 two years later.[130]

In 1902 and 1903, after her husband's death, Martha Byers loaned thirty-three works to a special exhibition at the Carnegie museum, thus demonstrating both her pride in their collection and her continued philanthropic activity in the community. She also permitted three views of their home on Ridge Avenue to be published in the *Index* to show how paintings were installed in the drawing room, dining room, and library (figs. 40, 41).[131] Only a few collections received such extensive journalistic treatment, and these views further document the significance of the Byers collection. Their residence on Ridge Avenue, designed in 1898 as a double home for the couple and their daughter's family, was constructed specifically to house their art collection in an appropriate setting with correct lighting fixtures.[132] This grand structure is one of the few houses from the period that can still be appreciated in Pittsburgh today.[133]

The Lockhart Collection

The extensive collection of Jane and Charles Lockhart (cats. 10, 11) was also installed in a specially designed art gallery on the second floor of their home at 608 North Highland Avenue (fig. 42). Charles Lockhart, co-founder of the Lockhart Iron and Steel Company, was president of the Pittsburgh Bank of Commerce for many years and, along with John D. Rockefeller, was one of the founders of Standard Oil.[134] Unlike most of the other keepers of collections in

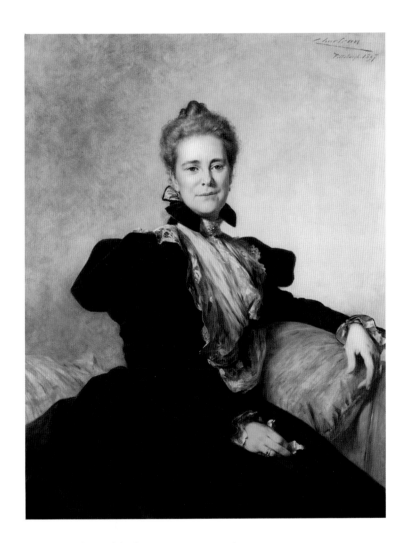

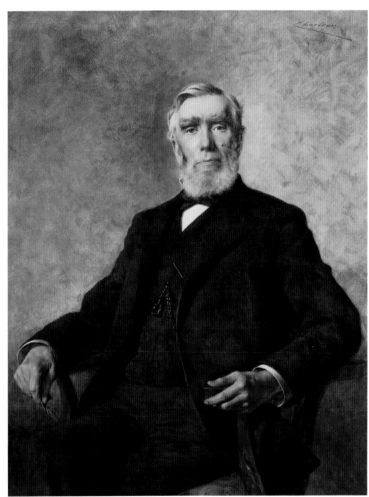

Cat. 10. Théobald Chartran (1849-1907).
Portrait of Mrs. Charles Lockhart, 1897, oil
on canvas. Collection of Mr. and Mrs.
James M. Edwards, Pittsburgh [Ex. coll.,
Charles Lockhart].

Cat. 11. Théobald Chartran (1849-1907).
Portrait of Charles Lockhart, 1897, oil on
canvas. Collection of Mr. and Mrs. James
M. Edwards, Pittsburgh [Ex. coll.,
Charles Lockhart].

Fig. 42. Photographer unknown. Painting gallery of the Lockhart residence, c. 1899, Lockhart photo album. Collection of Mr. James M. Edwards, Pittsburgh.

Also see figs. 43, 44, 76.

Pittsburgh, descendants of the Lockhart family maintained much of the nineteenth-century collection and records intact.[135] Among these surviving documents is a series of professional photographs taken of the Lockharts' home, including their private art gallery at the turn of the century. These photographs record the gallery's installation and lighting, both with hanging lamps and a stained glass window skylight, as well as built-in cupboards used to store books and etchings.[136] The photograph album documents how the Lockharts hung their collection of ninety-six works throughout their home and lined the main hallway with large paintings. Other works were clearly placed as the focal point of the reception room and dining room (figs. 43, 44). This album also includes many photographs of individual paintings out of their frames, a point that indicates the Lockhart collection was a source of pride and pleasure.

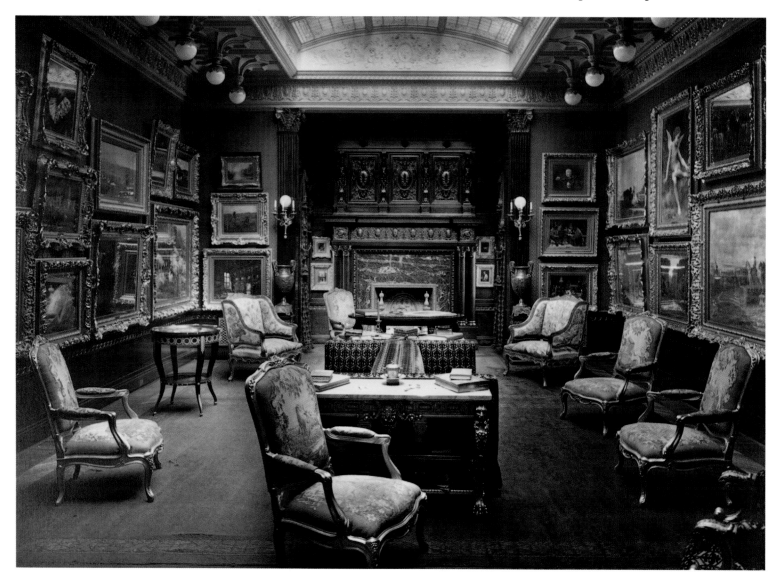

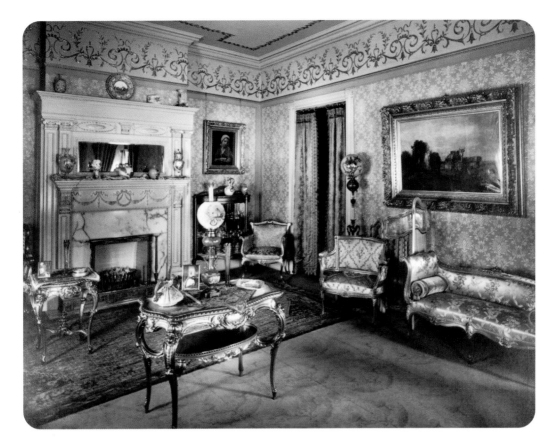

Fig. 43. Photographer unknown. Reception room of the Lockhart residence, c. 1899, Lockhart photo album. Collection of Mr. James M. Edwards, Pittsburgh.

Also see figs. 42, 44, 76.

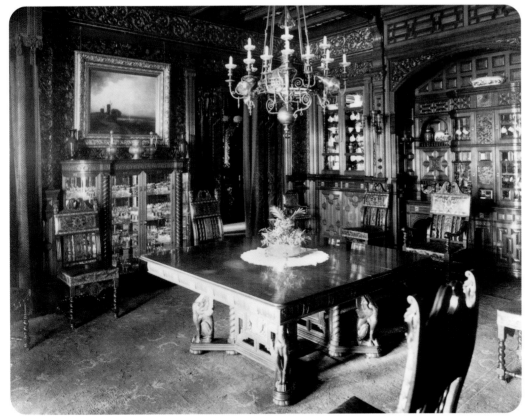

Fig. 44. Photographer unknown. Dining room of the Lockhart residence, c. 1899, Lockhart photo album. Collection of Mr. James M. Edwards, Pittsburgh.

Also see figs. 42, 43, 76.

Even though it was not the largest in the city, the Lockhart collection was repeatedly cited as one of the finest and most valuable collections in Pittsburgh.[137] Despite such reports, the Lockharts maintained a surprisingly low profile, perhaps because of their strong religious beliefs and connections with the United Presbyterian Church, which advocated restrained personal conduct. The Lockharts loaned paintings to a few exhibitions in the city, but when they acquired works from local galleries the family name was not typically noted in newspapers.[138] When a purchase was noted, specific details were not given, as was common with other collectors.[139] They acquired Daubigny's *My Houseboat on the Oise* (cat. 12) and Flameng's *Promenade in the Tuileries* from a special exhibition of paintings from the New York dealer S. Collins held at Gillespie's gallery in January 1895, but the works were described only as sold "to a wealthy Pittsburg[h]er, whose private collection includes some gems of art."[140]

The Lockhart collection included paintings by many of the day's most popular artists, such as Bouguereau, Cazin, Chartran, Corot, Diaz, and others

Cat. 12. Charles-François Daubigny (1817-1878). *My Houseboat on the Oise*, n.d., oil on canvas. Carnegie Museum of Art, Pittsburgh; Gift of Mary McCune Edwards [Ex. coll., Charles Lockhart].

Cat. 13. Alphonse Marie De Neuville (1835-1885). *French Grenadier*, 1876, oil on panel. Collection of Katherine L. Griswold, Pittsburgh [Ex. coll., Charles Lockhart].

from the Barbizon school. It also contained several works that appealed to the Lockharts as individuals. Unfortunately, it is not possible now to reconstruct where or how they acquired this extensive knowledge of art and independence in collecting. They did travel in North America and Europe and undoubtedly purchased many works on these occasions.

The Lockharts had two specific interests outside the contemporary preference for French genre: French military painting and Belgian genre scenes.

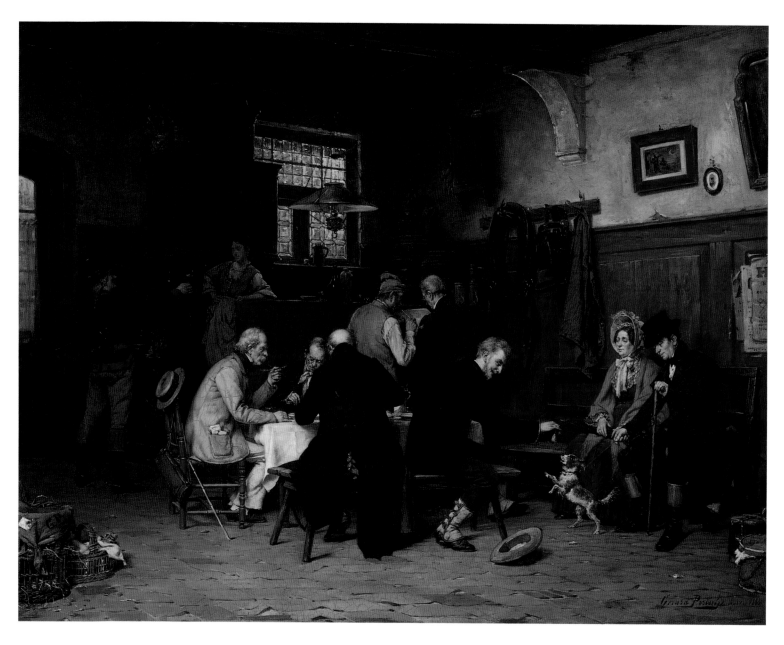

Cat. 14. Gerard Portielje (1856-1929). *The Relay*, 1885, oil on canvas. Collection of Mr. and Mrs. James M. Edwards, Pittsburgh [Ex. coll., Charles Lockhart].

They owned several battle scenes by Alphonse De Neuville (cat. 13) as well as Meissonier's impressive *1806, Jena* (cat. 119).[141] Their works by Brunin, Madou, Meyer, and Portielje (cat. 14) indicate their special interest in Belgian nineteenth-century painting, and works by these artists appear in few if any other Pittsburgh collections.[142] The Lockharts devoted considerable energy and financial resources to acquiring and displaying their works of art, and their collecting patterns suggest they were well informed about art and were prepared to take risks that set them apart from their contemporaries.

Cat. 13. Alphonse Marie De Neuville (1835-1885). *French Grenadier*, 1876, oil on panel. Collection of Katherine L. Griswold, Pittsburgh [Ex. coll., Charles Lockhart].

from the Barbizon school. It also contained several works that appealed to the Lockharts as individuals. Unfortunately, it is not possible now to reconstruct where or how they acquired this extensive knowledge of art and independence in collecting. They did travel in North America and Europe and undoubtedly purchased many works on these occasions.

The Lockharts had two specific interests outside the contemporary preference for French genre: French military painting and Belgian genre scenes.

Cat. 14. Gerard Portielje (1856-1929).
The Relay, 1885, oil on canvas. Collection
of Mr. and Mrs. James M. Edwards, Pittsburgh [Ex. coll., Charles Lockhart].

They owned several battle scenes by Alphonse De Neuville (cat. 13) as well as Meissonier's impressive *1806, Jena* (cat. 119).[141] Their works by Brunin, Madou, Meyer, and Portielje (cat. 14) indicate their special interest in Belgian nineteenth-century painting, and works by these artists appear in few if any other Pittsburgh collections.[142] The Lockharts devoted considerable energy and financial resources to acquiring and displaying their works of art, and their collecting patterns suggest they were well informed about art and were prepared to take risks that set them apart from their contemporaries.

The Watson Collection

The collection of David Watson, the internationally recognized lawyer, and his wife Margaret ranked as one of the five largest in the city.[143] Their collection was unusual in this circle, however, because theirs was the only one not formed by a leader of local industry and manufacturing, although much of their wealth undoubtedly stemmed from their professional and personal connections with the heads of local businesses. The Watsons purchased some works from exhibitions held at galleries of local dealers, but they also traveled to New York and extensively in Europe every summer for twenty-six consecutive years (between 1890 and 1916), with acquiring art as the main focus of their visits.[144] While Watson undoubtedly purchased numerous works on these trips, the only acquisition that can be documented is *The Beggar Boy* by the seventeenth-century Spanish artist Bartholomé Estaban Murillo from Sully and Company in London in 1905.[145] Like his contemporaries, Watson regularly loaned works to local exhibitions, thus making the collection familiar to Pittsburghers.[146] David Watson was also on the Fine Arts Committee of the Carnegie Institute and judged works submitted to the 1896 exhibition.[147]

Watson owned at least ninety works, including Barbizon paintings and "old masters," but his collection of early English art was regarded as the best in the city.[148] Like most Pittsburgh collectors, he owned and commissioned many family portraits, and the Watson collection of watercolors is one of the few documented holdings of this medium in the period. Thus the Watson collection was perhaps more adventuresome than most since it contained a variety of media. Certainly the Watsons' yearly trips to Europe demonstrated their serious commitment to the collection. After both Martha and David Watson died in 1916, Henry Clay Frick was given the opportunity to purchase the collection in its entirety.[149] Although he declined the proposal, the offer underscores the professional and personal relationship between the collectors. In 1905, for example, Frick wrote to Watson that he wanted to take him to see a collection of paintings in New York. While this is the only surviving evidence that they discussed art matters, the invitation was appended to a professional letter in a casual manner, which suggests they had a pre-established rapport concerning art and collecting.[150] It is unclear whether the Watson collection was offered to any other private collectors in Pittsburgh, but it was exhibited at the Carnegie Institute in 1917 before being sold to various collectors.

Fig. 45. Photographer unknown. "Oak Manor," estate of Mr. and Mrs. Henry Kirke Porter, c. 1897. Built before 1850 in the Third Church Colony (now part of Oakland), Oak Manor was originally named Grove Hill. The house was renamed and greatly enlarged by the Porters to include a picture gallery and, reputedly, twenty bedrooms with modern baths. To the left is the estate of iron manufacturer John Moorhead. Buildings associated with the University of Pittsburgh Medical Center as well as Children's Hospital of Pittsburgh and Scaife Hall now occupy this hillside. Carnegie Library of Pittsburgh.

The Porter Collection

The Porters' diverse and rich art collection contained at least eighty-five works.[151] Henry Kirke Porter settled in Pittsburgh in 1866, and he and Annie Decamp were married in 1875 and moved into their home, Oak Manor, on Fifth Avenue in 1897 (fig. 45).[152] Porter manufactured light locomotives, and his business was incorporated in 1899 as the H. K. Porter Company. Beginning in 1903, the Porters also had a residence in Washington, D.C., when Henry was elected to Congress. They maintained their ties to Pittsburgh and Oak Manor until they closed the house in 1907.[153]

While a small part of the art collection may have been formed by Annie Porter in New York before she married Henry, their collection was built principally in Pittsburgh. It is clear, however, that Mrs. Porter was the more active patron of the couple. Indeed, soon after they bought Oak Manor, she had an addition built to the house, which was to be used as an art gallery for their collection. Local newspapers noted that "Mrs. Porter was an artist of considerable note and an art collector and to accommodate their fine collection of paintings an art gallery was added as a wing to the mansion," and that "the art gallery she had built on as a wing to the old house [was] for the private collection she had assembled."[154] As one of the few private art galleries in Pittsburgh at the turn

of the century, it appears to have been the largest and most impressive interior gallery space, with two levels, a full skylight, and an inner courtyard. The gallery made such a strong impression that an article on their collection and its installation, complemented by two views of the gallery space, was published in the *Pittsburgh Post* in 1899 (fig. 46).[155]

The Porters purchased many works by artists represented in the Carnegie Internationals, such as Alexander,[156] Chase,[157] Cottet,[158] Gay,[159] and Weir.[160] Some works were acquired directly from the exhibitions (cats. 113, 114). Interestingly, most of these artists are not represented in other local collections, and the Porters also purchased more works from the Internationals than most other collectors in the city.[161] Few paintings by local artists appear in the records of the Porter collection, but Annie Porter did sponsor Rhoda Holmes Nicholls to direct and criticize the Art Students' league at Oak Manor in the 1890s, an invitation that demonstrated "the kindly interest the owners take in the efforts of the art students in Pittsburgh."[162] She also funded Chase's lecture for the league and Pittsburgh public at the Carnegie Library in 1899, thus providing direct support to local artists.[163] The Porters frequently loaned works to local and national exhibitions. Two of their paintings, J. Humphreys Johnson's *Setting of Midnight Sun/Light Nights in Norway* and Julian Story's *Emma Eames, "Music,"* were displayed at the 1901 Pan-American Exposition in Buffalo.[164] The Porters' significance to the local art community is confirmed by their special invitation to preview the works submitted to the International exhibition in 1899 and to meet the members of the jury. Few Pittsburghers received such treatment.[165] They also received Charles Dowdeswell, of the Dowdeswell gallery in New York, as a visitor to their collection in 1900.[166]

Unlike most local collectors, the Porters' interests went beyond collecting works promoted by established dealers and at exhibitions. Instead, they developed relationships with artists—most notably William Merritt Chase—and commissioned works outside the usual traditions of portraiture and Barbizon landscapes. Firstly, Annie Porter was one of the major benefactors of Chase's school in Shinnecock Hills on Long Island, where the Porters owned a home and typically spent their summer vacations.[167] At Shinnecock, when Chase posed some of his famous tableaux in the Porters' house, Mrs. Porter asked him to paint a portrait of his daughter. This work, *An Infanta, A Souvenir of Velasquez* (cat. 3), formed a central part of the collection of Chase works displayed at Oak Manor.[168] Even more significant documentation of their rela-

Fig. 46. View of H.K. Porter's Art Gallery. Reproduced in the *Pittsburgh Post*, 28 May 1899, p. 25.

tionship is *Interior, Oak Manor* (cat. 116), a view of the front hallway of their home that the artist inscribed, "To my friend Mrs. H. K. Porter."[169] Chase visited Pittsburgh twice, once as a member of the Carnegie International jury, and again during the first week of April 1899 as a guest of the Art Students' league. During this latter visit Chase spoke positively about Pittsburgh, remarking that "people here don't half realize the beauty of their homes. I know of no city where more artistic dwellings are to be found."[170] On this trip he began *Interior, Oak Manor* by making a sketch of the entrance and one of the hall of the Porters' home, which he used as studies. He presumably finished the painting in New York and then sent it to the Porters.[171] Annie Porter's connection to Shinnecock and Chase's presence in Pittsburgh undoubtedly influenced many local artists to spend their summer months training at the Long Island school.[172] Finally, the Porters also bought works by John White Alexander, both from the Carnegie International exhibitions and directly from the artist in Paris.[173] Their patronage of Alexander was probably one of many relationships that the Porters developed during their extensive travel in Europe and the United States.[174]

The Porters' art gallery was not, however, entirely devoted to oil paintings, and their collection was one of the few in which other media were prominently displayed. They owned watercolors, pastels, etchings, sculptures, and a significant number of tapestries, which they exhibited in the upper and lower levels of their gallery. A Flemish tapestry after Raphael's famous *Joseph Interpreting His Dreams to the Pharaoh* in the Vatican and a Spanish banner hung in the lower level gallery. Another Flemish tapestry, *Moses Declaring the Law,* and a Venetian tapestry of a boar hunt, flanked by Gobelins tapestries designed by Boucher, were displayed in the upper gallery.[175] The Porters also hung oil paintings in their library, "French room," and their entrance hall to take advantage of its good lighting.[176] Lighting was a concern for the Porters in the installation of their works, and in 1898 H. K. Porter wrote to Henry Clay Frick asking for advice on lighting their collection.[177] This letter is one of the few examples of Pittsburgh collectors asking advice from one another, but it certainly suggests that a fertile interchange of information and experiences marked their social occasions.

Annie Porter was one of four Pittsburghers that William Coffin appointed to the honorary committee of the Fine Arts division of the Pan-American Exposition. The others were John W. Beatty, William Nimick Frew, and Henry

Clay Frick. Mrs. Porter and Frick were, therefore, the only representatives selected who were not directly employed by the Carnegie Institute.[178] While records indicate the Porter collection was approximately half the size of the Frick collection, its quality and specifically Mrs. Porter's skills as an art connoisseur and her contribution to the local art community were considerable.

Although the Porter collection was at the forefront of Pittsburgh's private holdings of art, unfortunately, like most in the city, only a small portion of the collection can be traced today. Many of the art objects and paintings were donated to the Carnegie museum in 1927, 1937, 1939, and 1942 through Annie May Hegeman, Mrs. Porter's daughter from her previous marriage. The remaining works were sold at auction in 1942.[179]

Medium to Large Collections

The Thaw Collection

Mary and William Thaw owned a sizable collection of about fifty works.[180] Both Thaws were involved in the Pittsburgh art community: William was a principal benefactor of the Pittsburgh School of Design for Women and a supporter of local artists. When he died in 1889 numerous articles praised his generosity as a benefactor of art. "The ambitions of several now famous artists and musicians were made to bud and blossom by the substantial encouragement of Mr. Thaw. He took more satisfaction, his close friends say, in thus developing talent than from any of his numerous methods of distribution. His old-fashioned residence . . . is adorned by numerous paintings, the work by artists whom he had helped on to fame."[181]

After William's death Mary Thaw moved into Lyndhurst, the mansion they had begun building on Beechwood Boulevard in 1888.[182] She acquired a significant amount of art after 1889, although some of the Thaw collection, particularly works by local artists, had been assembled before then. They began loaning works to exhibitions at the Carnegie Institute as early as 1879. Judging by the inventory of the collection before her death in 1927, Mrs. Thaw must have sold or given away many of the works by local artists that supposedly comprised the majority of the earlier collection.[183] She focused on artists with national and international reputations in the 1890s and early 1900s and, like Annie Porter, developed strong ties with one artist—in this case Anna Klumpke, an American who worked principally in France. Despite contempo-

Cat. 15. Anna Klumpke (1856-1942). *Portrait of Mary Copley Thaw*, 1897, oil on canvas. Collection of Harold and Catherine Mueller, Sedona, Arizona [Ex. coll., Mrs. William Thaw].

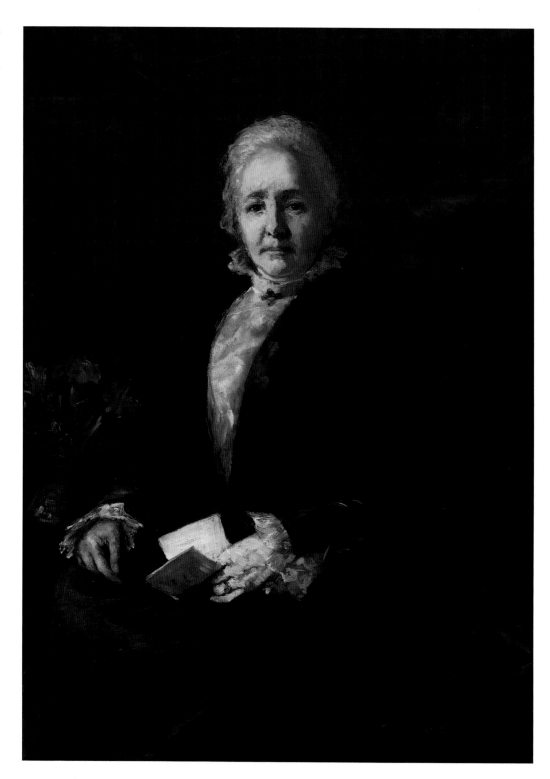

rary references to Klumpke's "many Pittsburg[h] friends," Mary Thaw is the only collector known to have purchased Klumpke's works.[184] Klumpke visited Pittsburgh in 1897, exhibited forty works at Gillespie's, and stayed with Mrs. Thaw at Lyndhurst.[185] Their artist/collector relationship, which was obviously established before this date, may have developed through Klumpke's partner

Rosa Bonheur, whose *Highland Cattle* was in the Thaw collection by 1895.[186] Mary Thaw owned at least four works by Klumpke: *Old Recollections, Reading, Study,* and *Portrait of Mrs. Thaw,* which was painted in 1897 when the artist was in Pittsburgh (cat. 15). A photograph of Klumpke at work in her Paris studio, which was published in the *Bulletin* in 1897, includes a view of *Old Recollection: The Woman at the Well,* a work noted for its references to Millet's famous painting *The Angelus.*[187] Mrs. Thaw loaned these works not just to Klumpke's Pittsburgh exhibition, but she also allowed them to travel to Cincinnati, with her portrait going on to San Francisco.[188] In this way she joined Byers, Frick, and Porter as collectors who expanded the reputation of Pittsburgh collections through their loans to exhibitions in other cities. Since only *At the Well* was cited in Mrs. Thaw's inventory of 1917, the other works may have been moved to her ranch in California.[189]

Mary Thaw also purchased works that had been exhibited at the Carnegie Internationals, including Alexander's *Before the Mirror* and *The Rose.*[190] She undoubtedly purchased many works on her travels in Europe, and she definitely bought Elizabeth Gardner's Salon painting *David the Shepherd* during a trip abroad. One Pittsburgh newspaper praised the work and Mrs. Thaw's philanthropy. "Her (Gardner's) Salon picture, *David the Shepherd,* considered her most famous work, was purchased by Mrs. William Thaw during a recent visit abroad and is now in Lyndhurst. The picture is said to have won for the artist higher criticism than anything else she has ever painted. After having the picture brought to Pittsburgh Mrs. Thaw, with characteristic generosity, loaned it for public exhibition in the Carnegie gallery for several weeks, in order that all art lovers might see and enjoy it with her."[191] The Thaw collection was also noted for its paintings by the American landscape artist George Inness.[192]

The Peacock Collection

Alexander Rolland Peacock and his wife Irene May Affleck Peacock displayed their collection of predominantly European art at Rowanlea, their home on North Highland Avenue (fig. 26).[193] Their preference for Barbizon landscapes was thus in line with most Pittsburgh collectors, but they also acquired works by English, Dutch, and a few American artists.[194] Their interest in British art and scenes of the Scottish Highlands and cattle, while not unique in Pittsburgh, undoubtedly stemmed from Alexander Peacock's roots in Scotland.[195] While

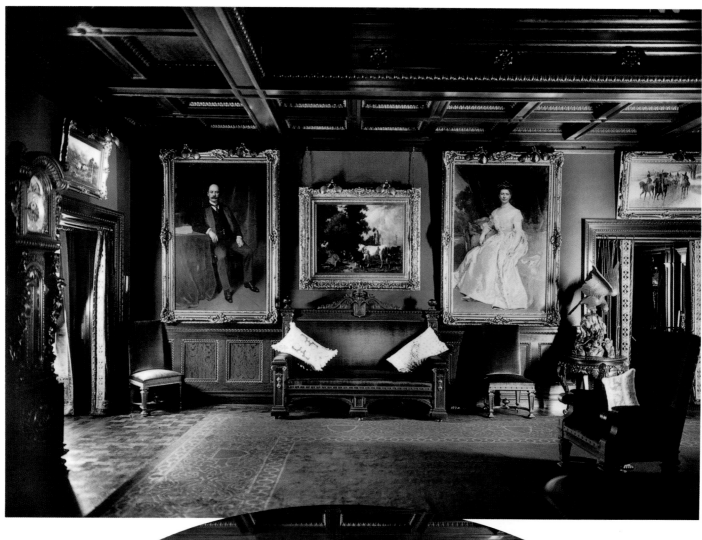

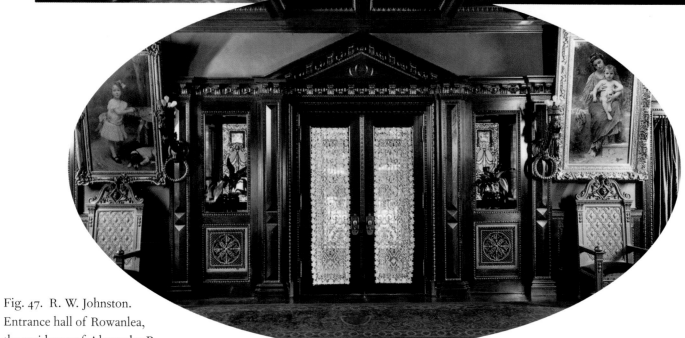

Fig. 47. R. W. Johnston.
Entrance hall of Rowanlea,
the residence of Alexander R.
Peacock, showing portraits by Ray-
mundo de Madrazo (above) and *Mother
and Child* by William-Adolphe
Bouguereau (below), n.d. Collection of
Mr. and Mrs. Grant A. Peacock, Jr.,
Ridgefield, Connecticut.

Also see figs. 26, 27.

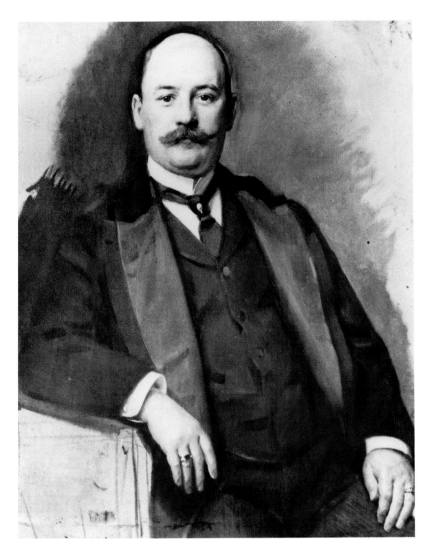
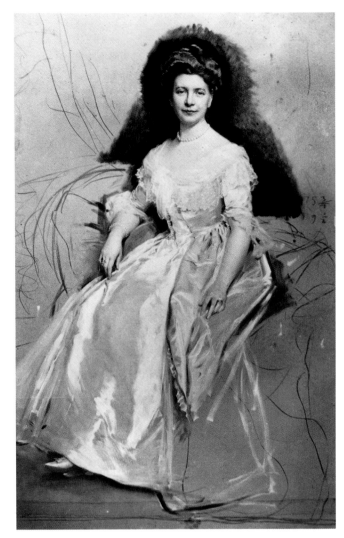

the Peacocks maintained a low profile with their collection and loaned few works to local exhibitions, they were known for their extensive number of family portraits—seven—by Raymundo de Madrazo (fig. 47). The most noted were the portraits of Mr. and Mrs. Peacock undertaken in Madrazo's temporary New York studio in 1902.[196] These full-length society portraits present the millionaire vice president of Carnegie Steel Company and his wife as cultured and successful figures.[197] Typical of the period, his portrait emphasizes his career and character, while hers focuses on her physical beauty and refinement. Interestingly, the Peacock commissions went to Madrazo rather than to Théobald Chartran, who dominated Pittsburgh portraiture throughout the 1890s. Perhaps the Peacocks wanted to commission something different from other Pittsburghers and preferred Madrazo's fluid brushstroke over Chartran's more academic and severe style.

The Peacocks forged their own path in these commissions, perhaps in part

Figs. 48, 49. Photographer unknown. Photographs of Alexander R. and Irene M. Peacock as they appeared in their unfinished portraits by Raymundo de Madrazo, c. 1902. Collection of Mr. and Mrs. Grant A. Peacock, Jr., Ridgefield, Connecticut.

due to their connections to New York, and they did not feel obligated to choose an artist who would come to them in Pittsburgh.[198] The Madrazo portraits were illustrated in the *Index* in June 1902, with many instructive views and explanations of the paintings' production and technique (figs. 48, 49). They were then briefly exhibited at Gillespie's before they were finally installed in Rowanlea.[199]

Judging by their collection, the Peacocks did not focus solely on the steady stream of Cazins, Harpignies, Ricos, and Ziems that were promoted by local dealers, although they purchased at least one work from the Gillespie gallery.[200] Indeed, their two works by the French Salon painter Henri Fantin-Latour were noted in the *Index,* which hinted these might well be the only two works by the artist in the United States. While the critic was undoubtedly incorrect, the comment suggests at least the awareness of the Peacocks' astute abilities as collectors.[201] Sadly, this rich collection was sold in its entirety in 1921, when the Peacock fortune dwindled and the couple sold Rowanlea and moved to New York.[202]

The Donnelly Collection
The collection of Alice and Charles Donnelly does not figure among the largest of Pittsburgh collections. They did, however, install a private art gallery in their home at 5720 Fifth Avenue for their collection of approximately fifty works. The high quality of their holdings of English, American, and nineteenth-century French art was well known to Pittsburghers.[203] They regularly loaned significant portions of their collection to the Carnegie museum between 1891 and 1910, which made their paintings among the most familiar to the local community.[204] Their art acquisitions were financed by Donnelly's success in the railroad business, and he and his wife Alice traveled regularly to Europe. In 1896 Donnelly undertook a four-month trip to Europe but said he would resist any temptation to add to their collection while abroad since he had already purchased several works earlier in the year.[205] The Donnellys definitely acquired part of their collection in Europe, where they met artist Giovanni Boldini in France.[206] In Pittsburgh they stood out among the most generous private collectors in the city.

Another important patron to the Carnegie Institute was John Caldwell, whose positions as chair of the Fine Arts Committee of the Institute and director of fine arts for the United States at the Paris Exposition Universelle in 1900 demonstrate his local and international significance.[207] Caldwell's experience in

gathering works for the Carnegie Internationals and smaller loan exhibitions influenced his private collection, which included a large number of etchings and displayed a level of connoisseurship that extended beyond the contemporary taste for oil paintings.[208]

Surprisingly, those collectors who regularly loaned their artworks to local exhibitions were not those with the largest collections. Between 1895 and 1910 Caldwell and the Donnellys, Laughlins, and Thaws regularly loaned works to the Carnegie museum.[209] While Byers, Frick, Lockhart, Porter, and Watson loaned one or more paintings to several exhibitions, their efforts cannot compare with the steady stream of works that came from the medium to smaller collections. Some of these leading figures loaned their works during the nascent years of the Carnegie Institute, while others sustained the loan exhibitions.

In fact, those works that were best known to Pittsburghers were owned by the second group of collectors, in addition to Carnegie, Moorhead, O'Neill, Schoonmaker, and Vandergrift, who had even smaller private collections.[210] Since few paintings from private collections were exhibited publicly on more than one occasion between 1890 and 1905, the reappearance of works is significant. Perhaps certain paintings were exhibited time and again due to popular demand. Five works from private collections were shown four times between 1890 and 1905: von Bremen's *The Faggot Gatherer,* Cazin's *The Village Street,* Chase's *Port of Antwerp,* Jacque's *Sheep in Pasture,* and Simmon's *Heavy Sea.*[211] While it is not always clear when works in local collections were purchased, evidence suggests that several private collectors, eager to share and exhibit their works publicly, loaned paintings to the Carnegie Institute soon (sometimes within months) after they were purchased.[212]

The final collection in this second group, that of Laura and William Stanton Stimmel, in many ways brackets the end of this period. The Stimmels acquired many of their most prized works after 1905, but their collection was established in the early years of the twentieth century.[213] The Stimmels' later familial ties to the University Club of Pittsburgh resulted in the purchase or donation of eleven paintings, including Gaston Latouche's *The Bath* (cat. 112) and Olga de Boznanska's *Portrait of a Young Woman,* both prize-winning works at the Internationals.[214] Much of the Stimmel collection can still be seen in Pittsburgh today.

Medium-sized Collections

The third group of collectors, those with medium-sized collections of twenty to forty works, includes Andrew Carnegie, whose personal art collection is overshadowed today by his magnanimity as the benefactor of the Carnegie Institute. Most of Carnegie's art purchases went directly to the museum, but his private collection contained paintings by locally, nationally, and internationally recognized artists. While Carnegie purchased some works from the International exhibitions, most of the collection undoubtedly resulted from the extensive travels that he undertook with his wife Louise.[215]

Carnegie's knowledge of his private collection was, however, a topic of some jest and amusement. One local newspaper recounted his visit to the Institute in the company of John Caldwell and John Beatty, and his disbelief that Gérôme's *Diana* and La Thangue's *Love in the Harvest Field* were from his own collection.

> Coming up before the *Diana*, Mr. Carnegie looked at it a few minutes and then turning to Mr. Caldwell, said: "Whose it is, John?"
>
> "It's a Gérôme," was the reply.
>
> "No, no; I mean, where did you get it; when did you buy it?"
>
> "We didn't buy it; it's yours; it's here as a loan," said Mr. Caldwell.
>
> "Is that my picture?" Mr. Carnegie asked incredulously; "I didn't know that," and then after a pause, he said "well, it's a fine one, and I am proud of it."
>
> The group then passed on and stopped before *Love in the Harvest Field* by Thangue. Mr. Carnegie looked at it admiringly, and asked Mr. Beatty when the picture had been acquired, as he did not remember having seen it before.
>
> "It's yours," laconically replied Mr. Beatty.
>
> When assured that it was he said, "It's Mine! well, I am proud of that one too, but I had forgotten that I had given orders for its purchase."[216]

The publication of this dialogue surely misrepresents Carnegie's interest in the works in his private art collection, yet the same article also noted that Carnegie permitted his friends to buy works for him that they thought he would like.

The Mellon Collection

Another figure in this group who is famous in the history of art institutions in

the United States is Andrew Mellon. While the Mellon family is best known for its extensive patronage of the National Gallery of Art in Washington, D.C., the early collection of Andrew Mellon reveals the roots of this artistic taste and skill as a connoisseur.[217]

Like its counterparts, the early Mellon collection included paintings by Barbizon artists and a few works by leading English and American painters. Mellon purchased one American work, Frank D. Millet's *Anthony Van Corlear, the Trumpeter of New Amsterdam* (cat. 39) from the Knoedler gallery in 1896 after it had been exhibited at the Columbian Exposition in 1893 and the Carnegie Institute's exhibition in 1895. He bought other works from Knoedler's, and in one instance purchased a painting that had been returned from the Frick collection. Art was definitely a topic of discussion between Henry Clay Frick and Andrew Mellon during their travels in Europe together in 1896, 1897, and 1898.[218] Furthermore, Knoedler wrote to Frick that both he and Mellon would enjoy a work by Daubigny that would arrive at Clayton in October 1898. Frick responded that if he did not purchase the painting, Mellon might.[219] The following year Knoedler consulted Frick again, since Mellon did not seem interested in two works by Corot and Daubigny that the dealer wanted to sell.[220] While documentation for the early years of the Mellon collection is sparse, existing information suggests that Mellon was an informed but independent collector who did not rely upon contact with other local collectors and dealers.

The Schwab Collection

Like Andrew Mellon, Charles Schwab, who was president first of the Carnegie Steel Company and then of the United States Steel Corporation, traveled with the Fricks and developed a rapport with the Knoedlers. In fact, in 1900, when Schwab added a gallery to his new home (the old Vanderbilt mansion on Fifth Avenue at Shady Avenue), the installation of the new gallery was arranged by one of the Knoedlers.[221] On display were mosaics and paintings, including works that Schwab had purchased in Rome and Paris or had commissioned from local artists. In that same year Schwab added eight paintings to his collection—all purchased from M. Knoedler & Co. It seems likely that, given the strength of the Knoedler brothers' ties with their Pittsburgh patrons, they helped other collectors design and install their own private galleries. Schwab traveled to Europe with the Fricks in 1898, and they met with the artist Vibert in Europe during the summer of 1899.[222] Without a question Schwab's most

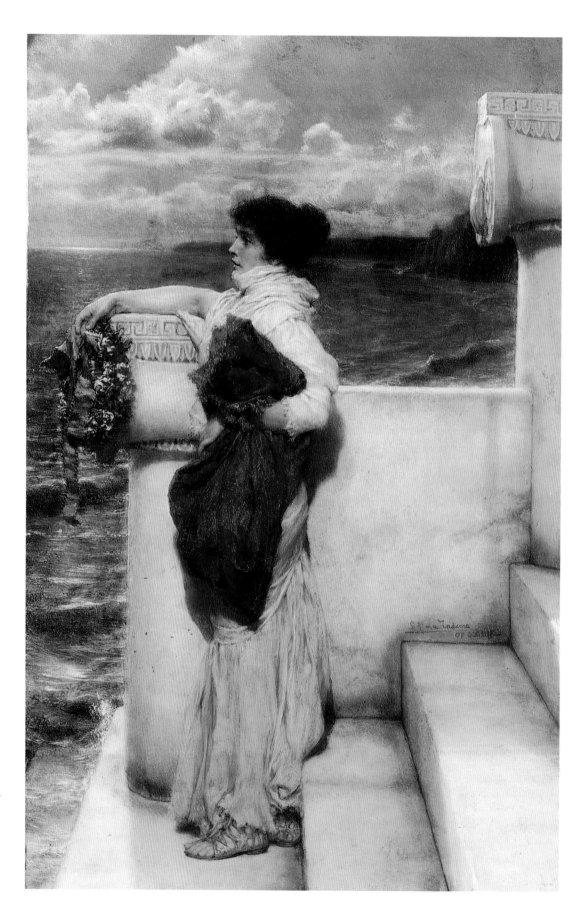

Cat. 16. Sir Lawrence Alma-Tadema (1836-1912). *Hero*, 1898, Opus CCCLII, oil on panel. Private Collection, Courtesy Guggenheim-Asher Associates, New York [Ex. coll., Henry W. Oliver, Jr.].

famous acquisition remains Ziem's *Bridge on a Canal in Venice,* which he purchased through a commissioner in Paris in 1902 and then shipped to the United States. Unfortunately, when the painting arrived in New York, only the frame was left in the crate. Schwab engaged in a seemingly unsuccessful pursuit of his work, which was valued at 60,000 francs.[223]

The Oliver Collections

Henry W. Oliver, Jr., of the Oliver Iron and Steel Corporation, displayed his art collection in his home at 845 Ridge Avenue. His house was regarded as one of the grandest of all those along the "millionaire row" of the North Side.[224] While little is known about the origins of this collection, evidence suggests that Oliver and his wife Edith traveled, and they too commissioned Chartran as a portraitist. The most important record of their collection's local significance was Henry Oliver's highly praised acquisition of Alma-Tadema's *Hero* (cat. 16) in 1901.[225] Henry's brother George Oliver gave him the painting as a gift, and the following year bought another work, *Caracalla* by Alma-Tadema, for his and his wife Mary's own collection. The collections of both Oliver families were of comparable size and quality.

The Frew and Moorhead Collections

While neither of the Oliver families made a practice of loaning their works to local exhibitions, many of the collectors in this third group did share their paintings with the community. William Nimick Frew and his wife Emily graciously made loans to the Carnegie museum due in part to their personal relationship with Carnegie and to William's position on the museum's board of trustees and his later role as president of Carnegie Institute.[226] They acquired at least one painting from Gillespie's and probably many more on their European travels.[227] The Frews' collection at Beechwood Hall, their home at 6516 Fifth Avenue, was aligned with contemporary taste (cat. 17) and included three works by J. J. Henner, making it the largest concentration of Henner's works in Pittsburgh.[228]

The artist's alluring female heads attracted other collectors, including Anne and John Moorhead, Jr., of 928 Ridge Avenue. Their painting by Henner was illustrated twice in the *Index* within a five-month period, including once on the cover, which attests to the popularity of their recent purchase.[229] The Moorheads shared similar tastes in art to those of Rebecca and Colonel James

Cat. 17. Toby Edward Rosenthal
(active 1848-1917). *Woodcarver of
Oberammergau*, n.d., oil on canvas.
Private Collection, Pittsburgh [Ex.
coll., William N. Frew].

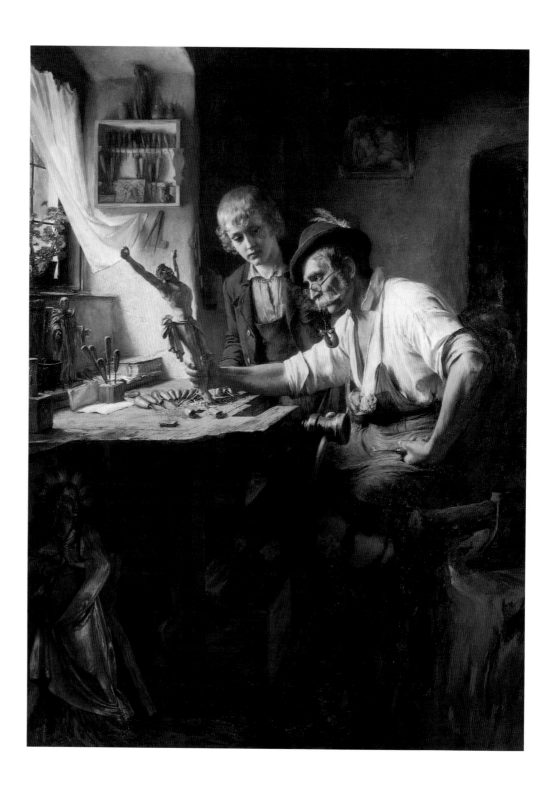

famous acquisition remains Ziem's *Bridge on a Canal in Venice,* which he purchased through a commissioner in Paris in 1902 and then shipped to the United States. Unfortunately, when the painting arrived in New York, only the frame was left in the crate. Schwab engaged in a seemingly unsuccessful pursuit of his work, which was valued at 60,000 francs.[223]

The Oliver Collections

Henry W. Oliver, Jr., of the Oliver Iron and Steel Corporation, displayed his art collection in his home at 845 Ridge Avenue. His house was regarded as one of the grandest of all those along the "millionaire row" of the North Side.[224] While little is known about the origins of this collection, evidence suggests that Oliver and his wife Edith traveled, and they too commissioned Chartran as a portraitist. The most important record of their collection's local significance was Henry Oliver's highly praised acquisition of Alma-Tadema's *Hero* (cat. 16) in 1901.[225] Henry's brother George Oliver gave him the painting as a gift, and the following year bought another work, *Caracalla* by Alma-Tadema, for his and his wife Mary's own collection. The collections of both Oliver families were of comparable size and quality.

The Frew and Moorhead Collections

While neither of the Oliver families made a practice of loaning their works to local exhibitions, many of the collectors in this third group did share their paintings with the community. William Nimick Frew and his wife Emily graciously made loans to the Carnegie museum due in part to their personal relationship with Carnegie and to William's position on the museum's board of trustees and his later role as president of Carnegie Institute.[226] They acquired at least one painting from Gillespie's and probably many more on their European travels.[227] The Frews' collection at Beechwood Hall, their home at 6516 Fifth Avenue, was aligned with contemporary taste (cat. 17) and included three works by J. J. Henner, making it the largest concentration of Henner's works in Pittsburgh.[228]

The artist's alluring female heads attracted other collectors, including Anne and John Moorhead, Jr., of 928 Ridge Avenue. Their painting by Henner was illustrated twice in the *Index* within a five-month period, including once on the cover, which attests to the popularity of their recent purchase.[229] The Moorheads shared similar tastes in art to those of Rebecca and Colonel James

Cat. 17. Toby Edward Rosenthal
(active 1848-1917). *Woodcarver of
Oberammergau*, n.d., oil on canvas.
Private Collection, Pittsburgh [Ex.
coll., William N. Frew].

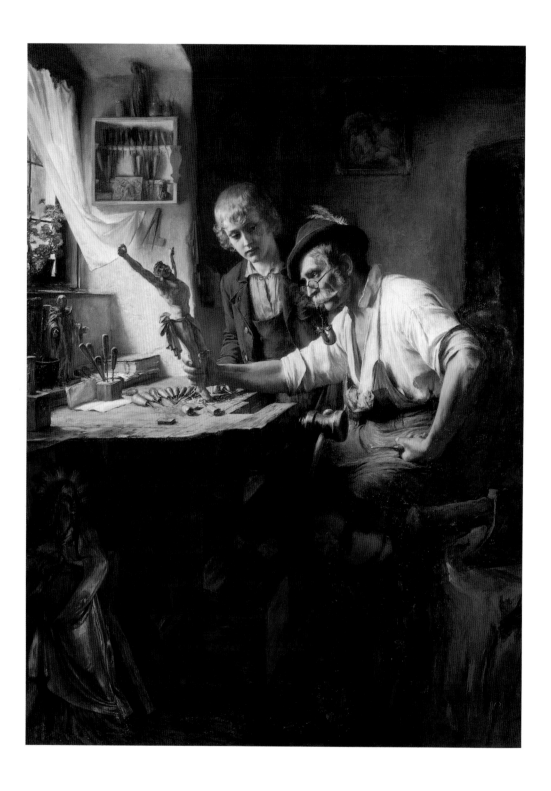

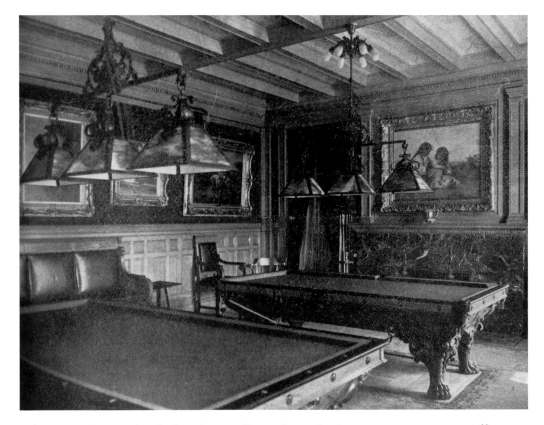

Fig. 50. Photographer unknown. Billiard room in the residence of Lawrence C. Phipps, showing (right) William-Adolphe Bouguereau's 1900 *Idylle Enfantine*. Reproduced in the *Index*, 4 October 1902.

Schoonmaker, as both families collected works by Henner, Berne-Bellecour, Grolleron, Hermann, and Vibert, among others.[230]

Of the seven remaining collections in this third group, most were financed through successes in the Pittsburgh steel industry. Unfortunately, scant information on the origins of the Bosworth, Darlington, Dupuy, Finley, and Singer collections is available.[231] It is known that Adaline and William Black acquired a large portion of their collection from Gillespie's and other dealers who exhibited paintings in the city.[232] Lawrence Phipps and his wife Genevieve purchased at least one work, Bouguereau's *Idylle Enfantine* (cat. 76), from Arthur Tooth & Sons in London.[233] While the Phipps did not have a true art gallery in Grandview, their home on Fifth Avenue, a contemporary description of the collection noted that "the deep tapestried walls are hung with many paintings by the old and modern masters . . . the billiard room is happily used for a picture gallery. . . . All the pictures are individually lighted and judiciously hung" (fig. 50).[234] Their practice of hanging works in the front hall, the library, and other rooms used principally for entertaining was no doubt common practice for the majority of Pittsburghers, who perhaps had neither the means nor the interest in installing a separate gallery space.

Medium to Small Collections

Beyond some records of travel, not enough information is available to analyze every collection in the fourth and fifth categories individually.[235] J. J. Vandergrift and Eugene O'Neill, two collectors in the fourth group of ten to twenty works, did loan works to local exhibitions more regularly than did most of the leading collectors of the day. The quality of the Vandergrift collection was also the only one of this group that was noted in contemporary journals. Vandergrift and his wife Frances no doubt received more attention because of Highmont, their impressive home built in 1888–89.[236] It is important to remember that, while art collecting was one way of visibly demonstrating success, taste, and wealth, the construction of a palatial home made a tremendous public statement. Vandergrift and other collectors made conscious choices when they allocated their resources.

Those collections with up to twenty works were definitely formed in accordance with contemporary taste. They included mainly landscape paintings, particularly by members of the Barbizon school, and a few works by American artists. It was not the practice of collectors in this group to form relationships with particular artists or to commission works other than portraits. Their purchases were not topics of great interest in the city. Many of these collectors bought works through Gillespie's, and a few experimented by acquiring watercolors and prints. In one instance, the small collection of B. F. Jones, Jr., became a fertile foundation for a much more extensive collection in the 1920s and 1930s.[237]

One exception to the practices of most collectors in these groups is John W. Beatty's small but rich collection. As director of the department of fine arts of the Carnegie Institute, Beatty had unusual opportunities to travel to exhibitions and to meet painters and art experts. His collection was largely formed from works by artists connected to the Internationals. Of particular note is an etching he received from Raffaëlli, *Norman Market Scene,* that was inscribed, "To my good friend John W. Beatty." This work, along with his paintings by Alexander, Aman-Jean, Chase, East, and Hetzel, confirms that Beatty's professional position set him apart from other small-scale private collectors.

Distribution of Household Wealth

For some of these collectors, artworks were their principal means of exhibiting wealth in their homes. Complete inventories for every collector do not sur-

vive, but the construction of an art gallery or the use of a specific part of a home solely for the display of art provides a vital clue to the value placed on these works compared to other objects, all of which were referred to as "household goods" in inventories. Collecting paintings, sculpture, and graphic art was one way to demonstrate wealth and refinement. Listings of jewelry, silver, furniture, and rugs—particularly Persian and Indian—sometimes represent a comparable and in a few cases larger percentage of household wealth than did works of art.[238] In other instances, art represented more than 90 percent of the value of all household goods.[239] Artworks often composed just one part of a kaleidoscope of valuable objects in the domestic setting.

Newspaper reports, records of the Gillespie and Knoedler galleries, and the Frick family archives are important sources in determining the actual costs of works in various media. Paintings were sold for as little as $175 or as much as $115,000. Watercolors ranged from $18 to $2,200, with an average of approximately $500, and prints fluctuated from $20 to $6,000. It is not possible today to draw a correlation between these numbers and the quality of works, but it is clear that paintings in the largest collections, such as the Frick collection, commanded an average price of just over $9,000, whereas a work from a medium to small collection, such as that of William Black, Harry Darlington, or the Olivers, cost on the average $2,000 to $3,000.

The interest expressed by Pittsburgh journalists in the acquisition of art further indicates the vibrancy of the art-collecting community. Local newspapers noted the purchase of some of the most valuable works in the city, including Millet's *Portrait of a Child* ($30,000 in 1898) and Turner's *The Wreckers* ($40,000 in 1899, although Byers actually paid $50,000).[240] Although Frick paid more for a few of his paintings, the prices of his greatest purchases were not announced publicly.[241] The most expensive painting in Pittsburgh at the turn of the century appears to have been Gainsborough's *Mrs. Hatchet,* which Frick acquired for $115,000 in 1903.

Interaction Among Pittsburgh Art Collectors

Extensive travel created an inevitable pattern of interlacing voyages, yet the single most important international event that these art collectors attended was the Paris Exposition Universelle of 1900. No less than twenty-six collectors traveled from Pittsburgh to Paris, sometimes via London, for this momentous event.[242] H. K. Porter and Henry Phipps, Jr., were among the few Pittsburghers

who were invited to the American Chamber of Commerce's reception at the United States National Pavilion of the Exposition.[243]

While such travel provided much exposure to the international art world, many Pittsburghers took full advantage of their memberships in local and national art-related associations and their involvement with art institutions. A large number were members of the Pittsburgh Art Society, which fostered interaction among those collectors who did not have business relationships.[244] Some were also trustees of the Carnegie Institute and/or members of the Fine Arts Committee during its formative years and beyond.[245] Finally, over a dozen collectors belonged to the National Arts Club. Based in New York and incorporated in 1898, the club's purpose was to encourage art collectors throughout the United States to meet one another.[246] Frick was asked to be a vice president and was designated the representative of the city's collectors. Membership in the National Arts Club was a prestigious distinction, and it undoubtedly allowed many Pittsburghers to meet and develop connections with prominent collectors, dealers, and artists from other cities, such as Samuel P. Avery, Charles Freer, William Havemeyer, Sarah Cooper Hewitt, Walter Hubbard, Roland Knoedler, Julius Oehme, and Cornelius Vanderbilt. While some of the American artists in the club were already associated with Pittsburgh through its art schools and exhibitions, the National Arts Club was another way collectors could meet Alexander, Chase, Coleman, La Farge, St. Gaudens, Tiffany, Vedder, and Weir.

It is also possible to document social and professional connections among Pittsburgh art collectors.[247] Perhaps the most interesting affiliations relate to the practice of presenting paintings as gifts and transferring works of art between collections. In addition to the works he donated to the Carnegie Institute and the portraits he commissioned, Frick also gave paintings as gifts to his friends who collected art. He presented Hammer's *Glouster Harbour* to Joseph Woodwell around 1895, Robert van Boskerck's *Looking toward Wakefield* to H. W. Oliver in 1898, Frits Thaulow's pastel scene *Pittsburgh* to Charles Schwab in 1899, Thaulow's *Smoky City* (cat. 82) to Schwab in 1903, and Narcisse Diaz's *The Bracelet* to D. T. Watson in 1901.[248] Frick's generosity undoubtedly suggests a larger trend among the network of collectors in the city. One unidentified collector kept a reserve of works by David Walkley to give as wedding gifts. "There is one wealthy patron of Mr. Walkley here whose favorite wedding gift to any of his friends is one of this artist's pictures, either in oil or

water colors. On some occasions he has been known to buy as many as half a dozen of these pictures at one time and hang them in his home ready for a matrimonial emergency."[249]

Collectors also bought works from each other, either directly or indirectly. In three documented instances works from the Frick collection that had been returned to the Knoedler galleries were then purchased by other local collectors. James Reed bought Knight's *Coming from the Garden* less than a month after Frick returned it to Knoedler. Andrew Mellon acquired Thaulow's *Spring Afternoon* in December 1900, a work that Frick had returned less than two months earlier. Lawrence Phipps purchased Harpignies' *Souvenir de Bony-sur-Loire*, which Frick had also returned less than two months previously.[250] Charles Schwab apparently acquired at least one work, Proctor's *Playing for a Fortune*, from the Vandergrift collection.[251]

Investigating art collectors at the turn of the century, of course, does mean examining the upper-class strata of Pittsburgh society. In 1900 the population of Pittsburgh was 321,616, with art collectors representing less than one percent of that figure.[252] The general population undoubtedly knew of the activities of this upper class through newspaper reports, loans to exhibitions, and the intangible word-of-mouth gossip.

In Pittsburgh, the preference for art around 1900 was principally informed by North American and western European traditions. Art buyers focused on small to medium-sized oil paintings by acclaimed artists. Those with large or small collections displayed an overwhelming conformity in their preference for painting, although there were significant differences in the amount of money spent on individual art objects. Within this network of Pittsburghers, several collectors set themselves apart through their astute acquisitions, relationships with dealers and artists, and generosity towards the Pittsburgh community. The general decrease of interest in local art and the increasingly frequent acquisition of works by artists with strong national and international reputations came to characterize this group's desire to prove their expanding knowledge and refined cultural taste in a city that was experiencing astonishing industrial growth. Indeed, it was this growth in manufacturing, particularly the steel industry, that funded the acquisition of most art in Pittsburgh. Five collections—those of Donnelly, Heinz, Lockhart, Porter, and Schwab—were displayed in designated gallery spaces within private residences, yet many more

Fig. 51. R. W. Johnston. Billiard room in the residence of H. J. Heinz, n.d. Heinz family archives.

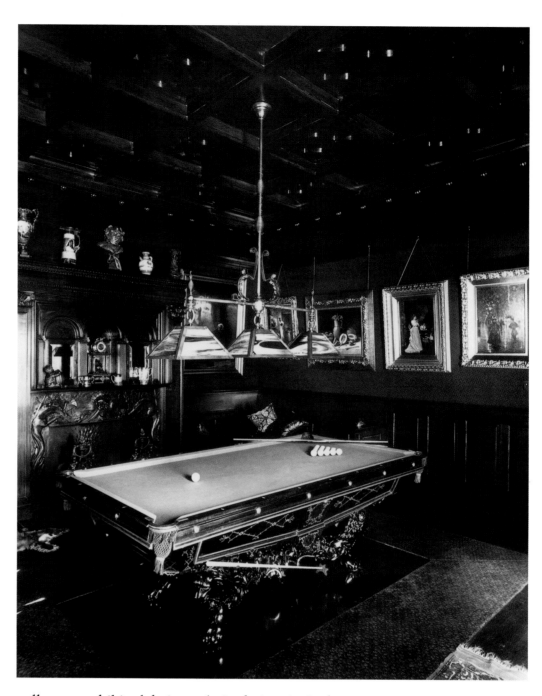

collectors exhibited their works in their principal entertainment rooms, as most collectors do today (fig. 51).

The high level of interest in buying art and attending exhibitions and lectures was a mixture of the desire for education, culture, entertainment, financial investment, and a certain level of competition among the leading figures of Pittsburgh business and society. The ready exchange of artworks as gifts, and the fact that many collectors traveled together, shared their contacts with dealers, and exchanged tips on buying and hanging art, indicates that for most of

them art was a topic of mutual interest and pleasure. The willingness of so many collectors to loan their prized artworks to local exhibitions was certainly a mixture of generosity and a display of pride. Still, the largest portion of loans was derived from medium and small collections, suggesting that art was a significant form of philanthropy and that magnanimity characterized these collectors. Pittsburgh thrived as a dynamic art center at the turn of the century, and its private art collectors were a driving force behind the city's vibrancy.

Notes to this essay appear on pages 349–65.

Demand and Supply

The Pittsburgh Art Trade and M. Knoedler & Co.

DeCourcy E. McIntosh

TO UNDERSTAND ART COLLECTING in Pittsburgh in the Gilded Age, we must examine prevailing attitudes towards art in the city in the previous decades. If we take as our guide _The Art Treasures of America_, a widely circulated series of articles compiled by Philadelphia art journalist Edward Strahan to glorify art collections formed in the 1860s and 1870s in America's leading cities, we might well conclude that Pittsburgh at this period had little to offer.[1] Strahan could spare only one sentence for Pittsburgh: an afterthought to a tribute to the collection of C. H. Wolff, an art collector who, Strahan claimed, maintained a "very fine gallery personally collected in Europe," not in Pittsburgh. Wolff lived part of the time in Pittsburgh and kept other residences in Philadelphia and Chambersburg, Pennsylvania.[2] The only actual Pittsburgh resident to capture Strahan's attention was W. E. Schmertz, "an enlightened collector of art" who was credited with owning _The Celibate_ by Toby Rosenthal, a painting that depicted "a young monastic devotee watching with irrepressible regrets the bridal excursion of a pair of butterflies" (fig. 52).[3]

For all the nationalistic intent of his publication, Strahan failed his subscribers when reporting the truth about Pittsburgh. Just how grossly ignorant he was of the sophisticated level of art collecting in Pittsburgh can be learned from a ledger kept by Christian H. Wolff, the same man Strahan so confidently disassociated from the city. Wolff's ledger, as well as other records preserved in the Carnegie Library of Pittsburgh, document his art collection and offer a vivid, albeit fragmented picture of the art world of Pittsburgh in the 1860s and early 1870s, just the period that had concerned Strahan.[4]

As a young man, Wolff moved northwest from Chambersburg to Pittsburgh.[5] By 1837 he had established himself in a partnership to merchandise hardware.[6] Although at first he lodged in the Exchange Hotel, near his hardware store, by 1861 he owned a house at 196 Penn Avenue, a fashionable address in those days. If this house was like the Shoenberger and Fahnestock

Fig. 52. Artist unknown. "_The Celibate_, facsimile of a sketch from the original painting by Toby Rosenthal (collection of Mr. M. E. Schmertz [_sic_], Pittsburgh)" Reproduced in _Art Treasures of America_ (Philadelphia, 1879–81).

Cat. 18. Jean-Baptiste-Camille Corot (1796-1875). _Crown of Flowers_, c. 1865–70, oil on canvas. The Baltimore Museum of Art: The Helen and Abram Eisenberg Collection [Ex. coll., Henry Clay Frick].

houses in the same section of Penn Avenue, it was a two-and-one-half or three-story brick townhouse abutting its neighbors and the sidewalk.[7] Wolff could afford such a residence because the hardware business, Whitmore and Wolff, became successful in the 1840s and was expanded to larger premises in the heart of Pittsburgh's business district at 50 Wood Street by 1847. There it prospered for many years under the "sign of the anvil." In 1865 Whitmore and Wolff acquired two partners, George J. Duff and Thomas J. Lane. By 1871 Wolff was residing once more in a hotel. He evidently left Pittsburgh a year later because the city directories for 1872 and 1873 identify him as a "resident of Philadelphia," although he was still associated with the hardware business in Pittsburgh.[8]

Wolff seems to have been well connected socially in Pittsburgh. In his ledger he mentions "my cousin Mary E. Horne" and "my aunt Mrs. A. M. Fahnestock," two important family names in nineteenth-century Pittsburgh.[9] His brother B. Wolff, Jr., ran a successful hardware business, and another Wolff was employed by W. E. Schmertz in his wholesale shoe manufactory.[10]

Wolff's association with Pittsburgh is important because by 1858 his hardware business had flourished sufficiently to enable him to collect art. Over the next fifteen years his art collection became the best in the city, according to authoritative sources.[11] His inventory reveals that by 1873 his collection was very large and, by the standards of the day, quite valuable. Wolff acquired 140 oil paintings that cost a total of $36,811, a sum equivalent to at least $750,000 today.

The Wolff collection was both large and varied. Prominently represented were works by local artists such as David G. Blythe, George Hetzel, George C. Lambdin, Joseph R. Woodwell, and especially Charles D. Linford. Often Wolff commissioned works from these men or acquired their paintings fresh off the easel. Despite this practice, he owned more European than American works, a fact of particular relevance to later developments in the Pittsburgh art world. Many of these works—by and large sentimental genre subjects or landscapes by painters of the Dusseldorf or Barbizon schools—were, as Strahan reported, "personally collected" in Paris or Berlin. Many others, however, were acquired in Philadelphia or New York. Invariably the source of paintings from Philadelphia was Charles F. Haseltine, an established dealer with galleries both there and, until 1889, in New York. (Charles Haseltine was the brother of the landscape painter William Stanley Haseltine.)

Wolff's most frequent sources in New York were William Schaus or M. Knoedler & Co. For example, he purchased no fewer than eight paintings from Knoedler between 1868 and 1873, giving his address each time as Pittsburgh.[12] All eight of these known works—landscapes by Charles-François Daubigny and Oswald Achenbach, and genre paintings by Compte-Calix, Pasini, Delort and others—remained in Wolff's collection to the end of his life and following his death were sold at the American Art Association in New York in 1888. This sale, which merited a catalogue of its own, contained 160 paintings,[13] the residue of a collection that, according to Wolff's ledger, had reached 193 paintings by 1885 and had cost approximately $160,000, or more than $3 million in today's currency.

Had Wolff done nothing more than assemble a large collection of paintings in Pittsburgh in the 1860s and 1870s, his place in the city's cultural history would be assured, but his role was larger and more crucial than that. Not only did he buy for his private collection, but, as is evident from his ledger, he bought for resale as well. During his Pittsburgh years, he acquired and resold 105 paintings over and above those that remained in his private collection. His customers included Charles Haseltine, the Philadelphia dealer to whom he sold forty-three paintings; New York collectors or dealers such as Michel Knoedler, to whom he sold an Oswald Achenbach landscape in 1873, and citizens of Pittsburgh, including his brother.

Wolff's Pittsburgh sales suggest that he not only exhibited art (in his home, at least) but also supplied paintings to the city's upper crust. In this dual capacity, he was, literally, a tastemaker. At his Penn Avenue residence, businessmen like himself would have had the combined pleasure of admiring contemporary American and European art and acquiring examples for themselves. His greatest Pittsburgh customer for paintings was his brother, who bought ten paintings. Before 1866 Thompson Bell, a banker, bought nine works. George Black, who owned an iron foundry, and the oilman William Frew each purchased one. More significantly, the artist George Hetzel bought three paintings from Wolff. In effect, Wolff was poised at an intersection of artistic activity in Pittsburgh, and his house was a place where artists and amateurs alike could absorb artistic influences from abroad—and from one another.

That Wolff's influence lasted long after his departure from Pittsburgh is evident from the catalogue of an important loan exhibition that took place in Pittsburgh in 1879. In the winter of the year when Strahan's first installments of *Art*

Treasures of America appeared, the leaders of Pittsburgh business and society, having organized themselves into many committees, staged a large public exhibition to raise money to establish a public library. The list of 105 "managers" of the exhibition included virtually every notable in the city, including Schmertz, Frew, and Charles Lockhart, Frew's partner. Held in the Library Hall on Penn Avenue, this was actually the eighth recorded art exhibition in Pittsburgh since 1859.[14] It lasted approximately six weeks, from late January through early March, and drew attendance in the thousands. One observer described it as "a perfect jam, or to put it more forcibly, a sort of marmalade of humanity."[15] Although paintings, sculpture, and prints formed an important part of the exhibition, it also contained textiles, ceramics, "bric-a-brac," books, manuscripts, music, jewelry, "household art," and "relics."

When the managers' call went out for objects to place on display, the public "responded to their appeals with such a profusion of articles of interest, virtu, and art, as to fill the halls to overflowing," according to the catalogue introduction.[16] Among the generous were seventy-nine Pittsburgh art amateurs and twenty-five professional local artists who lent a total of 241 paintings to the effort. Here, maybe, was a demonstration of collecting and cultivation that would have impressed Strahan, had he known of it. Although the preponderance of American art might have earned the Philadelphian's disdain—he was an avowed apologist for the modern art market of Paris—he could not have dismissed the impressive number of Pittsburgh collectors, amateurs, and artists who participated. Moreover, he could not have failed to perceive the influence of Christian Wolff behind some of the loans to the exhibition.

Western Pennsylvania artists such as Blythe, Hetzel, and Woodwell, whom Wolff had patronized, were well represented, but more conspicuous from our point of view were the four paintings lent by B. Wolff, Jr., the two by Thompson Bell, and the one by Mrs. George Black. A mixture of American, French, and German works, these had all been purchased from Christian Wolff in his Pittsburgh days. Other lenders included Wolff's partner George Duff and two other individuals, Henry Miner and John Harper, from whom he had purchased his first painting by Blythe and a work by A. B. Wall in 1858 and 1868, respectively. Frew was a lender, as were G. A. Shallenberger and John B. Jackson; these men, like Wolff, had been customers of Knoedler. John Moorhead, a later Knoedler client, lent, among other paintings, a view of the Bay of Naples by Oswald Achenbach, an artist particularly favored by Wolff. Strahan

would have been impressed that Toby Rosenthal was represented by two paintings: *Forbidden Longings,* lent by C. B. Shea, chairman of the Committee on Paintings, Engravings, and Etchings, who had recently purchased it for a reported $3,000,[17] and, of course, Schmertz's *The Celibate,* now chastely labeled *Monk.* (In his chatty column "What I Saw at the Loan Last Night," the reporter for the Pittsburgh *Telegraph* registered a preference for Schmertz's Rosenthal "on account of its simpler and more direct manner.")[18]

All in all, the Pittsburgh Library Loan Exhibition of 1879 constituted a massive demonstration of interest in art on the part of both the city's business and social elite and the general public. The exhibition was substantially the product of the circle of artists and collectors that once revolved around Christian Wolff, and the public's reaction—3,500 visitors were admitted during the evening of Valentine's Day alone, according to the reporter for the *Telegraph*[19]—boded well for art in Pittsburgh in the future.

The developments of the 1860s and 1870s—the rise of Christian Wolff as an art collector in Pittsburgh, his influence upon Pittsburghers with the means to become collectors, and the enthusiasm for the art exhibited in the city in 1879—are but prelude to a great vogue for art collecting that would captivate a new group of well-heeled Pittsburghers fifteen years later. The origins of this Gilded Age phenomenon, however, can certainly be found in the Wolff era. The generation of the 1890s inherited its taste for art collecting from Wolff's generation. Apart from inevitable shifts in taste, the main differences occurred in the levels of expenditure that art collectors could afford and in the sources of supply.

When a new generation hungry for impressive and expensive works of art began to look beyond Pittsburgh to major galleries in New York and abroad, the relationships developed by Wolff and his friends pointed the way. None was more important or more lasting than the bond that was to develop between those who were destined to become the outstanding art collectors of the era in Pittsburgh and M. Knoedler & Co., the art gallery that became their most important source for paintings.

Although Pittsburgh collectors patronized other galleries—Pittsburgh's own J. J. Gillespie, S. Boyd & Co., and Wunderly Brothers, or Gross and van Gigch of Chicago, Milwaukee, *and* Pittsburgh as well as more renowned firms in New York, London, and Paris—no other gallery fed the growing appetite of the burgeoning Pittsburgh fine art clientele to the degree that Knoedler, with

galleries in New York, Paris, and eventually Pittsburgh and London, succeeded in doing. Preserved in Knoedler's books of account in New York, which survive intact from 1863, is a continuous record of transactions with Pittsburgh clients before, during, and after the Gilded Age. Hundreds of entries leave little doubt as to the size and importance of the Pittsburgh art market. As the years advanced and the pace of art buying increased, the bold, handwritten records inscribed by Knoedler partners on page after page of blue-lined journal paper document the progress of that market, describing it as clearly as any textbook explanation and leaving for posterity a remarkable portrait of the most important cultural by-product of the great wealth formed in Pittsburgh during the Gilded Age. Scores of Pittsburgh clients announce their presence in these pages, but it is the acquisitions of the five most important collectors— Charles Lockhart, A. M. Byers, Henry Clay Frick, D. T. Watson, and Andrew Mellon—that reveal the true scope and texture of art collecting in Pittsburgh.

Fig. 53. Photographer unknown. Portrait of Roland Knoedler, c. 1925–30. Photo courtesy Knoedler & Company, New York.

We must return to the 1840s to begin this part of our story. In 1846 Michel Knoedler, a naturalized Frenchman from Bavaria, voyaged to America to open the New York branch of Goupil et Cie, a French firm of picture dealers and engravers. Eleven years later, in 1857, he purchased from its Paris parent the business he had established in New York. Seven years after that, in April 1864, John H. Shoenberger, heir to his father's ironworks in the "North Liberties" along the Allegheny River[20] and Knoedler's first recorded Pittsburgh client, purchased *Mamma's Cap* by Gesselschap and agreed to pay $525 in gold for another painting, which he later returned. In the 1860s and 1870s, five Pittsburgh clients—Shoenberger, Wolff, Shallenberger, Jackson, and G. B. Edwards—entered into fourteen transactions with Knoedler that came to a total value of $4,850. Wolff's purchases accounted for the majority of this volume and reflected tastes that would become standard in Pittsburgh (as in other cities): a mixture of Barbizon landscapes and anecdotal genre subjects rendered expertly by French, German, and Italian artists who exhibited regularly in the Paris Salon.

It was not until after 1885, however, that Pittsburghers started to patronize Knoedler's with any frequency. By that time the amounts Pittsburghers seemed willing to spend on art had escalated, and clients were graciously served by Roland Knoedler (fig. 53), the eldest of the founder's three sons. In 1878, at age twenty-two, Roland had become head of the firm upon his father's death. Until 1896, when they resigned their partnerships, Michel Knoedler's second and

would have been impressed that Toby Rosenthal was represented by two paintings: *Forbidden Longings*, lent by C. B. Shea, chairman of the Committee on Paintings, Engravings, and Etchings, who had recently purchased it for a reported $3,000,[17] and, of course, Schmertz's *The Celibate*, now chastely labeled *Monk*. (In his chatty column "What I Saw at the Loan Last Night," the reporter for the Pittsburgh *Telegraph* registered a preference for Schmertz's Rosenthal "on account of its simpler and more direct manner.")[18]

All in all, the Pittsburgh Library Loan Exhibition of 1879 constituted a massive demonstration of interest in art on the part of both the city's business and social elite and the general public. The exhibition was substantially the product of the circle of artists and collectors that once revolved around Christian Wolff, and the public's reaction—3,500 visitors were admitted during the evening of Valentine's Day alone, according to the reporter for the *Telegraph*[19]—boded well for art in Pittsburgh in the future.

The developments of the 1860s and 1870s—the rise of Christian Wolff as an art collector in Pittsburgh, his influence upon Pittsburghers with the means to become collectors, and the enthusiasm for the art exhibited in the city in 1879—are but prelude to a great vogue for art collecting that would captivate a new group of well-heeled Pittsburghers fifteen years later. The origins of this Gilded Age phenomenon, however, can certainly be found in the Wolff era. The generation of the 1890s inherited its taste for art collecting from Wolff's generation. Apart from inevitable shifts in taste, the main differences occurred in the levels of expenditure that art collectors could afford and in the sources of supply.

When a new generation hungry for impressive and expensive works of art began to look beyond Pittsburgh to major galleries in New York and abroad, the relationships developed by Wolff and his friends pointed the way. None was more important or more lasting than the bond that was to develop between those who were destined to become the outstanding art collectors of the era in Pittsburgh and M. Knoedler & Co., the art gallery that became their most important source for paintings.

Although Pittsburgh collectors patronized other galleries—Pittsburgh's own J. J. Gillespie, S. Boyd & Co., and Wunderly Brothers, or Gross and van Gigch of Chicago, Milwaukee, *and* Pittsburgh as well as more renowned firms in New York, London, and Paris—no other gallery fed the growing appetite of the burgeoning Pittsburgh fine art clientele to the degree that Knoedler, with

galleries in New York, Paris, and eventually Pittsburgh and London, succeeded in doing. Preserved in Knoedler's books of account in New York, which survive intact from 1863, is a continuous record of transactions with Pittsburgh clients before, during, and after the Gilded Age. Hundreds of entries leave little doubt as to the size and importance of the Pittsburgh art market. As the years advanced and the pace of art buying increased, the bold, handwritten records inscribed by Knoedler partners on page after page of blue-lined journal paper document the progress of that market, describing it as clearly as any textbook explanation and leaving for posterity a remarkable portrait of the most important cultural by-product of the great wealth formed in Pittsburgh during the Gilded Age. Scores of Pittsburgh clients announce their presence in these pages, but it is the acquisitions of the five most important collectors—Charles Lockhart, A. M. Byers, Henry Clay Frick, D. T. Watson, and Andrew Mellon—that reveal the true scope and texture of art collecting in Pittsburgh.

We must return to the 1840s to begin this part of our story. In 1846 Michel Knoedler, a naturalized Frenchman from Bavaria, voyaged to America to open the New York branch of Goupil et Cie, a French firm of picture dealers and engravers. Eleven years later, in 1857, he purchased from its Paris parent the business he had established in New York. Seven years after that, in April 1864, John H. Shoenberger, heir to his father's ironworks in the "North Liberties" along the Allegheny River[20] and Knoedler's first recorded Pittsburgh client, purchased *Mamma's Cap* by Gesselschap and agreed to pay $525 in gold for another painting, which he later returned. In the 1860s and 1870s, five Pittsburgh clients—Shoenberger, Wolff, Shallenberger, Jackson, and G. B. Edwards—entered into fourteen transactions with Knoedler that came to a total value of $4,850. Wolff's purchases accounted for the majority of this volume and reflected tastes that would become standard in Pittsburgh (as in other cities): a mixture of Barbizon landscapes and anecdotal genre subjects rendered expertly by French, German, and Italian artists who exhibited regularly in the Paris Salon.

It was not until after 1885, however, that Pittsburghers started to patronize Knoedler's with any frequency. By that time the amounts Pittsburghers seemed willing to spend on art had escalated, and clients were graciously served by Roland Knoedler (fig. 53), the eldest of the founder's three sons. In 1878, at age twenty-two, Roland had become head of the firm upon his father's death. Until 1896, when they resigned their partnerships, Michel Knoedler's second and

Fig. 53. Photographer unknown. Portrait of Roland Knoedler, c. 1925–30. Photo courtesy Knoedler & Company, New York.

third sons, Edmond and Charles, were also involved with the gallery. Charles, a handsome athlete famous for saving twenty-two lives at Coney Island, remained an active employee of the firm even after resigning his partnership. Michel Knoedler's brother John, another partner in the firm, dealt primarily in prints. His death in 1893 may have led to the admission to partnership of Charles Stewart Carstairs, an art expert from Philadelphia with strong social connections. This would have interesting consequences for art collections in Pittsburgh, as we shall see.

By all accounts a charming individual, Charles Carstairs was married to Esther Haseltine, daughter of Christian Wolff's old trading partner in art, Charles F. Haseltine. Before joining Knoedler, Carstairs worked for eight years in his father-in-law's galleries, where he could well have seen traces of transactions with Wolff. That Carstairs's own family, like Frick's, was in the whiskey distilling business would have done little to harm his chances of social and business success with Pittsburghers.[21]

When Carstairs joined the Knoedler firm, the partnership was remarkably youthful: Roland, at thirty-seven, was the eldest; Charles Knoedler was but thirty, and Carstairs himself was only twenty-eight. One can imagine them developing an easy rapport from the mid-1890s onward with younger Pittsburgh clients such as Frick and Mellon, who were building their fortunes early in life. In the 1880s, however, the Pittsburgh clientele was older, and it still accounted for only a tiny fraction of Knoedler's business. An oil pipeline owner and former Ohio River captain, J. J. Vandergrift, spent $20,000 for eight French, German, and American paintings in six months in 1883 and 1884.[22] Two of these were recent works by William-Adolphe Bouguereau, *Eventail Naturel* and *La Petite Vendangeuse,* which may have been the first Bouguereau paintings in Pittsburgh. *La Petite Vendangeuse,* a full-length portrait of a sultry, dark-haired little girl with a basket of freshly picked grapes at her bare feet, cost $5,000, which set a record among Pittsburghers at Knoedler's that held for eleven years.[23]

Andrew Carnegie first appears on the gallery's books in May 1888, when he purchased *Wallflowers* by "Lobedan of Berlin" for $250. No match for Vandergrift's acquisitions, this was an old-fashioned choice, reminiscent of the taste of Wolff and his times.[24] For all the impetus he gave art collectors, Carnegie never became a major Knoedler client himself. His friend John Caldwell, treasurer of Westinghouse Air Brake Company and later chairman of Carnegie

Institute's Fine Arts Committee, appeared somewhat more in tune with the times than did Carnegie when he acquired works by Jules Dupré, Etienne Berne-Bellecour, and Charles Jacque from Knoedler in the late 1880s. Even so, the Pittsburgh trade at Knoedler's remained financially insignificant in relation to the impact that leading New York collectors exerted upon the art market as a whole. Strahan reports that dry goods merchant A. T. Stewart spent $80,000 to purchase Jean-Louis-Ernest Meissonier's *1807, Friedland* (fig. 114) and transport it to New York.[25] In 1887, at the auction of the estate of Stewart's widow, Cornelius Vanderbilt acquired Stewart's best-known painting, *The Horse Fair* by Rosa Bonheur, for $53,000.[26]

Only in 1891, seven years after Vandergrift paid $5,000 for Bouguereau's little grape harvester, would another Pittsburgher spend an equivalent sum on a single painting at Knoedler's. In this instance, it was Mary Copley Thaw, the art-loving widow of Pittsburgh's greatest railroad millionaire and owner of Lyndhurst, the city's grandest new mansion. Mrs. Thaw paid $5,000 for a pastoral scene by Rosa Bonheur.[27] Also in 1891 Knoedler wholesaled nineteen paintings by Boldini, Mauve, Rico, Sanchez-Perrier, Stevens, and others to J. J. Gillespie for a total of $15,205, thereby inaugurating a long and mutually beneficial relationship. Apparently, this business relationship remained harmonious even after 1897, when M. Knoedler & Co. opened a Pittsburgh gallery at 432 Wood Street and operated it for ten years with Carstairs in charge.

The bushy-browed, unassuming oil millionaire Charles Lockhart, a taciturn Scottish immigrant in his early seventies who was identified with banking and steel as well as with Standard Oil, crossed Knoedler's threshold at Fifth Avenue and 22nd Street (fig. 54) for the first time in September 1891. There he spent $1,000 for a painting by the popular Belgian *animalier* Verboeckhoven, which is designated on Knoedler's books as "Goats, etc." (The actual title was *Sheep and Ram.)* Lockhart's art collection grew to include eighty works by the time of his death at eighty-seven in 1905,[28] but only 10 percent of his collection—eight paintings in all—came through Knoedler.[29] These acquisitions nevertheless trace a significant upward curve in quality and expense, and this ratio may obscure the extent to which the firm was instrumental in supplying works for Lockhart to buy from other galleries.

In 1894 Lockhart bought a large painting by William-Adolphe Bouguereau of a winged nude youth extracting a thorn from his toe. Finished in the winter of 1894, this transparently erotic work was acquired by Knoedler's Paris

third sons, Edmond and Charles, were also involved with the gallery. Charles, a handsome athlete famous for saving twenty-two lives at Coney Island, remained an active employee of the firm even after resigning his partnership. Michel Knoedler's brother John, another partner in the firm, dealt primarily in prints. His death in 1893 may have led to the admission to partnership of Charles Stewart Carstairs, an art expert from Philadelphia with strong social connections. This would have interesting consequences for art collections in Pittsburgh, as we shall see.

By all accounts a charming individual, Charles Carstairs was married to Esther Haseltine, daughter of Christian Wolff's old trading partner in art, Charles F. Haseltine. Before joining Knoedler, Carstairs worked for eight years in his father-in-law's galleries, where he could well have seen traces of transactions with Wolff. That Carstairs's own family, like Frick's, was in the whiskey distilling business would have done little to harm his chances of social and business success with Pittsburghers.[21]

When Carstairs joined the Knoedler firm, the partnership was remarkably youthful: Roland, at thirty-seven, was the eldest; Charles Knoedler was but thirty, and Carstairs himself was only twenty-eight. One can imagine them developing an easy rapport from the mid-1890s onward with younger Pittsburgh clients such as Frick and Mellon, who were building their fortunes early in life. In the 1880s, however, the Pittsburgh clientele was older, and it still accounted for only a tiny fraction of Knoedler's business. An oil pipeline owner and former Ohio River captain, J. J. Vandergrift, spent $20,000 for eight French, German, and American paintings in six months in 1883 and 1884.[22] Two of these were recent works by William-Adolphe Bouguereau, *Eventail Naturel* and *La Petite Vendangeuse,* which may have been the first Bouguereau paintings in Pittsburgh. *La Petite Vendangeuse,* a full-length portrait of a sultry, dark-haired little girl with a basket of freshly picked grapes at her bare feet, cost $5,000, which set a record among Pittsburghers at Knoedler's that held for eleven years.[23]

Andrew Carnegie first appears on the gallery's books in May 1888, when he purchased *Wallflowers* by "Lobedan of Berlin" for $250. No match for Vandergrift's acquisitions, this was an old-fashioned choice, reminiscent of the taste of Wolff and his times.[24] For all the impetus he gave art collectors, Carnegie never became a major Knoedler client himself. His friend John Caldwell, treasurer of Westinghouse Air Brake Company and later chairman of Carnegie

Institute's Fine Arts Committee, appeared somewhat more in tune with the times than did Carnegie when he acquired works by Jules Dupré, Etienne Berne-Bellecour, and Charles Jacque from Knoedler in the late 1880s. Even so, the Pittsburgh trade at Knoedler's remained financially insignificant in relation to the impact that leading New York collectors exerted upon the art market as a whole. Strahan reports that dry goods merchant A. T. Stewart spent $80,000 to purchase Jean-Louis-Ernest Meissonier's *1807, Friedland* (fig. 114) and transport it to New York.[25] In 1887, at the auction of the estate of Stewart's widow, Cornelius Vanderbilt acquired Stewart's best-known painting, *The Horse Fair* by Rosa Bonheur, for $53,000.[26]

Only in 1891, seven years after Vandergrift paid $5,000 for Bouguereau's little grape harvester, would another Pittsburgher spend an equivalent sum on a single painting at Knoedler's. In this instance, it was Mary Copley Thaw, the art-loving widow of Pittsburgh's greatest railroad millionaire and owner of Lyndhurst, the city's grandest new mansion. Mrs. Thaw paid $5,000 for a pastoral scene by Rosa Bonheur.[27] Also in 1891 Knoedler wholesaled nineteen paintings by Boldini, Mauve, Rico, Sanchez-Perrier, Stevens, and others to J. J. Gillespie for a total of $15,205, thereby inaugurating a long and mutually beneficial relationship. Apparently, this business relationship remained harmonious even after 1897, when M. Knoedler & Co. opened a Pittsburgh gallery at 432 Wood Street and operated it for ten years with Carstairs in charge.

The bushy-browed, unassuming oil millionaire Charles Lockhart, a taciturn Scottish immigrant in his early seventies who was identified with banking and steel as well as with Standard Oil, crossed Knoedler's threshold at Fifth Avenue and 22nd Street (fig. 54) for the first time in September 1891. There he spent $1,000 for a painting by the popular Belgian *animalier* Verboeckhoven, which is designated on Knoedler's books as "Goats, etc." (The actual title was *Sheep and Ram.)* Lockhart's art collection grew to include eighty works by the time of his death at eighty-seven in 1905,[28] but only 10 percent of his collection—eight paintings in all—came through Knoedler.[29] These acquisitions nevertheless trace a significant upward curve in quality and expense, and this ratio may obscure the extent to which the firm was instrumental in supplying works for Lockhart to buy from other galleries.

In 1894 Lockhart bought a large painting by William-Adolphe Bouguereau of a winged nude youth extracting a thorn from his toe. Finished in the winter of 1894, this transparently erotic work was acquired by Knoedler's Paris

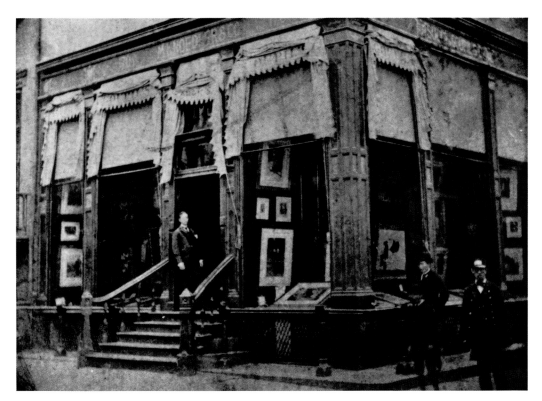

Fig. 54. Photographer unknown. Knoedler Gallery, 170 Fifth Avenue (corner of 22nd Street), New York City, c. 1890. Photo courtesy Knoedler & Company, New York.

gallery. Roland Knoedler noted on 11 April 1894 that Arthur Tooth, a close colleague in London, had requested a photograph of it, along with the paintings's dimensions.[30] By 31 May Knoedler had sold the work to Arthur Tooth & Sons for £720 ($3,600) under the title given it by the artist, *Amour piqué* (fig. 55). Tooth lent it to the 1894 annual exhibition at the Royal Academy in London before he sold it on 15 May to the Cooper Gallery, which in turn resold it to Lockhart for an unrecorded price, probably $5,000.[31] By the time the painting had crossed the threshold of Lockhart's strictly conservative household, all erotic suggestiveness had been removed from its title. When loaned to the opening exhibition of the Carnegie Art Galleries in 1895, the painting was catalogued as *Wounded Cupid,*[32] and on later inventories it bore the title *Love Feels the Thorn.*[33] It is worth speculating whether Lockhart's interest in Bouguereau was inspired by Captain Vandergrift's collection. The two men were closely associated in business and lived nearby one another.

Amour piqué was the first recorded Pittsburgh acquisition with an international exhibition history. Along with *The Little Turkey Herder,* which Knoedler sold to Harry Darlington of Irwin Avenue, Allegheny, at virtually the same time, this acquisition announced the Bouguereau epidemic that was to spread from household to household in Gilded Age Pittsburgh over the next eight years. Roland Knoedler had predicted the golden opportunity that lay ahead

Fig. 55. William-Adolphe Bouguereau. *Love Feels the Thorn* or *Wounded Cupid* *(Amour Piqué)*, 1894, oil on canvas, Reproduced from Lockhart photo album. Courtesy of Mr. James M. Edwards, Pittsburgh.

Fig. 56. Rosa Bonheur. *After a Storm in the Highlands*, n.d., oil on canvas, Reproduced from Lockhart photo album. Courtesy of Mr. James M. Edwards, Pittsburgh.

when he wrote to his Paris associate, Maurice Hamman, on 30 May 1894: "The Little Turkey Herder has been sold in Pittsburgh. You may be surprised, but we should be able to sell at least a half-dozen pretty pictures by this painter. . . . Every season we must have some beautiful examples."[34]

Lockhart's commitment to purchasing the work of important artists was set by May 1895. His next acquisition from Knoedler was Rosa Bonheur's *After a Storm in the Highlands* (fig. 56), for which he paid $11,000. Now he owned two large works by important contemporary French painters, and Knoedler had played a vital role in both transactions. At the same time he bought the painting by Bonheur, Lockhart also purchased *Turkish Children Fishing* by Diaz ($5,500) and *The Post of Danger* (cat. 19) by Alphonse De Neuville ($2,500), thereby spending a total of $19,000 at Knoedler's in one day.[35] Although Lockhart transacted business directly with Knoedler on only one more occasion— to commission portraits of himself and his wife by Théobald Chartran in April 1897 (cats. 10, 11)—Roland Knoedler and Charles Carstairs continued to monitor the collector's activities until the close of the century.[36]

The most important work of art in Lockhart's collection—and probably the most prestigious and most expensive painting acquired in Pittsburgh up to that time—was Meissonier's last great Napoleonic battle scene, *1806, Jena*. The precise acquisition history remains incomplete, but certain facts are known. When the first Carnegie Annual (now called International) opened on 1 November 1896, this painting was included as one of the relatively few works by a deceased master (Meissonier had died in January 1891) and was identified as having been lent by Arthur Tooth & Sons. Tooth had acquired it not long before from his art agent in France, Edmond Simon.

On 24 April 1896 Roland Knoedler wrote to Maurice Hamman while crossing the Atlantic on the *Campagna,* "Your disbelief concerning the success of the business with Gross doesn't surprise me. Colonel Gross spoke to me long ago about a Meissonier . . . yesterday Tooth told me that he had written to Simon for '1806.' My thought is that he seeks [a Meissonier] for Lockhart of Pittsburgh."[37] It can be deduced from this that Colonel August Gross of the Chicago firm Gross and van Gigch, whose Pittsburgh salesrooms were located in the Carnegie building, had long been searching for some way to satisfy Lockhart's desire for a major painting by Meissonier, an appropriately conservative painter whose prestige in the United States had been assured by Stewart's acquisition of *1807, Friedland* in 1876. Lockhart, it would seem, was

Cat. 19. Alphonse Marie De Neuville (1835–1885). *The Post of Danger*, 1876, oil on panel. Collection of Katherine L. Griswold, Pittsburgh [Ex. coll., Charles Lockhart].

open to the major outlay that an important Meissonier would necessitate. Having obtained *Amour piqué* through Tooth two years earlier, Lockhart would have known this dealer, and he may have been a frequent customer of Gross. In turn, Gross could easily have established that *1806*, the last great painting from Meissonier's easel, was in the hands of Tooth's agent Simon, because Simon had lent the work to the Meissonier exhibition at the Galerie Georges Petit in Paris in 1893. It may have been Gross who engineered Tooth's sending the painting to Pittsburgh, and if so, he would have received a substantial commission when it was sold to Lockhart. Whether the painting was promised to Lockhart before the annual exhibition or was sold to him after the opening is not known, nor is it important. What matters is that in a single stroke Lockhart had captured the crown jewel of his collection and elevated art collecting in Pittsburgh to a level that could compare with New York and other major cities. Roland Knoedler observed all of this from the sidelines and evidently learned important lessons about the potential of the Pittsburgh art market.

The Lockharts, with their conservative United Presbyterian background, were such a quiet couple that they probably exerted little overt influence on Pittsburgh society. Even if few collectors were ever invited to their mansion on Highland Avenue, which by the mid-1890s contained a skylit art gallery, many would have deduced the extent and character of their collection by counting their loans to the exhibition that opened the Carnegie Library's art galleries in November 1895. Lockhart was the largest lender to this exhibition, with twenty-five paintings in the catalogue credited to his ownership. These included all five works purchased at Knoedler's, plus paintings ascribed to Alma-Tadema, Corot, Courbet, Daubigny, Dupré, Flameng, Gérôme, Jacque, Knight, Meyer von Bremen, Munkácsy, Pasini, Schreyer, Troyon, and several lesser figures. Although it seems never to have been reported publicly, his acquisition of *1806, Jena* must have caused a stir.

The overt influence of Carnegie Institute's founder, Andrew Carnegie himself, can never be doubted. Even though he was not a major collector of art, Carnegie was a shrewd leader and philanthropist. He could not have been oblivious of one of the immediate benefits to result from the plan formally announced in June 1895 to open the library's art galleries with an exhibition that would showcase local collections. In anticipation of the opening, Pittsburgh blossomed as a major importer of fashionable European academic art in 1894 and 1895, and the exhibition itself formed a watershed in the history of art col-

lecting in the city. Over half of the 321 works loaned to the exhibition came from local collectors, and the majority of those were recent works by European artists.[38] Even the American artists represented, such as Toby Rosenthal,[39] Edwin Blashfield, and William Merritt Chase, bore the strong influence of their European origins or their European academic training. Moreover, with canvases by Bonheur (3), Bouguereau (6), Cabanel, Carolus-Duran, Benjamin Constant, Corot (8), Daubigny (4), Diaz (8), Gérôme (5), Henner (4), Jacque (5), Alma-Tadema (2), and Troyon (3), the exhibition presented the greatest array of major Paris Salon figures ever seen in Pittsburgh, and well over half these works were owned by local collectors.

One of the first to feel the tremors of excitement and to accelerate the pace of collecting was A. M. Byers, founding president of A. M. Byers & Co., "manufacturers of wrought iron pipe and boiler tubes, bar, and sheet iron." Although Byers did not enter into a transaction with Knoedler until June 1894, three years after Lockhart's initial visit to the gallery, his first purchase met Lockhart's standard in terms of prestige and price. This was *Brittany Washerwomen* by Jules Breton, which Byers acquired for $11,000 and later loaned to the first Carnegie Annual exhibition. Within a year Byers owned a respectable painting by Bouguereau, *Fardeau agréable (An Agreeable Burden)*. One year after that, in May 1896, he purchased a work that would signal a new direction for Pittsburgh collectors: the English school.

Byers had manifested exceptional powers of connoisseurship even before his first recorded visit to M. Knoedler & Co. In 1893 he acquired Eugène Delacroix's *Arab Horseman Giving a Signal* (cat. 20),[40] the only painting by the pre-eminent master of French Romanticism to enter a Pittsburgh collection. The route traveled by this painting to reach Byers is reminiscent of the course taken by Bouguereau's *Amour piqué*, in that it illustrates the interrelationships and remarkably rapid pace of art commerce in the late nineteenth century. After Knoedler's obtained this Delacroix from E. LeRoy & Co., Paris, in 1889, the painting languished unsold in the gallery's stock for four years, perhaps because Delacroix never enjoyed the popularity in nineteenth-century America that members of the Barbizon school did. When John Knoedler died in 1893, the firm was obliged to liquidate a large portion of the inventory in order to settle his estate. Accordingly, an exhibition was held in the galleries of the American Art Association in New York. This was followed by a well-publicized, four-day sale (11–14 April) at Chickering Hall, located at Fifth Avenue

Cat. 20. Eugène Delacroix (1798–1863). *Arab Horseman Giving a Signal*, 1851, oil on canvas. The Chrysler Museum of Art, Norfolk, Virginia; Gift of Walter P. Chrysler, Jr. [Ex. coll., Alexander M. Byers].

and 18th Street.[41] Delacroix's painting, included as number 353 among the 397 lots in the sale, attracted favorable notice. "The Knoedler collection also contains a spirited Delacroix, 'The Signal,' one of many red-cloaked Moorish cavaliers that the artist painted after his visit to Morocco," reported the (New York) *Critic* on 8 April. At least one Pittsburgher, Harry K. Thaw, son of Mary Thaw (and future assassin of Stanford White), attended the sale, and other Pittsburghers may well have known about it. Thaw bid successfully for paintings by Isabey, Vollon, and Corot.[42] A Detroit art dealer, William O'Leary, secured the Delacroix for $3,500, a modest price in relation to the $20,000 that

James J. Hill of St. Paul, Minnesota, had paid for Delacroix's *Fanatics of Tangier* in 1890.

If *Arab Horseman Giving a Signal* ever went to Detroit, which seems unlikely, it did not stay there long. By 30 April Knoedler had repurchased it from O'Leary for the same price paid. The next day Knoedler sold it to Cottier & Co., a distinguished firm of decorators, for $4,500.[43] Cottier & Co. had bid successfully on other lots at the Knoedler sale,[44] and in all likelihood the firm counted Byers, as well as other Pittsburghers, among its decorating clients.[45] (The firm also may have supplied framing services.)[46] A sure sign of the firm's presence in Pittsburgh was its loan of five paintings to the 1895 Carnegie exhibition. Exactly when Byers purchased *Arab Horseman Giving a Signal* from Cottier and how much he paid for it are not known, but the likelihood is that the transaction occurred shortly after 1 May 1893.

The full effect of the Knoedler sale on collectors in Pittsburgh is not known, but the event quite likely caused repercussions far beyond Byers's purchase of a painting by Delacroix. His painting by Breton, for example, was catalogued in the sale as *The Washerwomen: Souvenir of Douarnenez*. Acquired by Knoedler in August 1892 from Petit *aîné* in Paris, it was purchased by William Schaus for $8,200, the highest price achieved during the sale's third session.[47] Knoedler bought it back from Schaus in order to resell it to Byers at a 34 percent profit.

Two of the paintings that Lockhart purchased from Knoedler in May 1895 were also in the sale. These were Bonheur's *After a Storm in the Highlands* and Diaz's *Turkish Children Fishing*, which commanded $9,500 and $4,700, respectively. Schaus bought both of them. Knoedler repurchased the two canvases on 17 May 1895 at Schaus's cost, having arranged their resale to Lockhart one week previously for $11,000 and $5,500, and creating a profit of 16 percent. Schaus sold directly to Lockhart a third painting bought at the sale, *Une Sortie (The Departure of the Fishing Boats)* by Georges Haquette (cat. 2).

From the time Byers's mansion on Ridge Avenue was completed in 1898, Delacroix's *Signal* hung in the drawing room (fig. 57) beside an even more stunning acquisition, Jean-François Millet's *Young Girl Looking in a Mirror: Portrait of Antoinette Hébert*, which was purchased for a reported $30,000 in April 1898. With its soft, rococo palette and visual references to Velásquez, this masterpiece of French portraiture from 1844–45 was not the sort of work by Millet that was then being promoted with almost religious fervor in the United

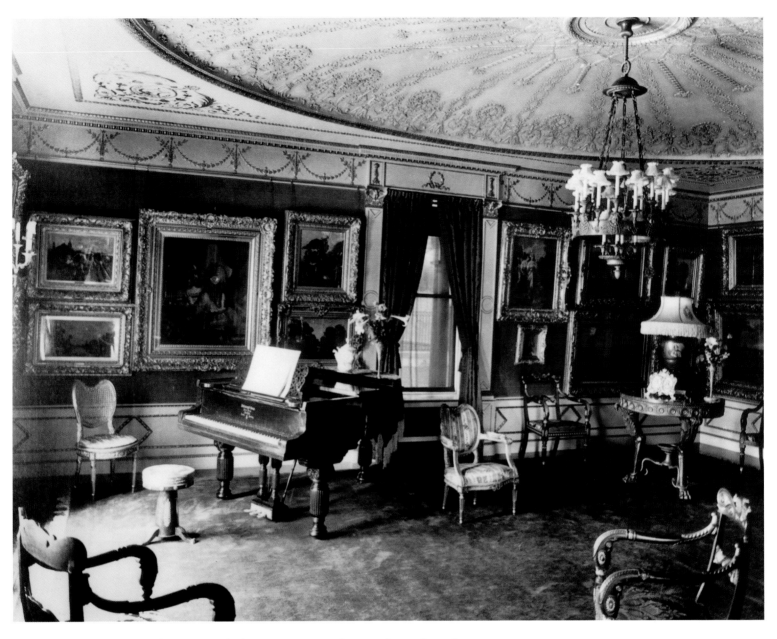

States.[48] What, precisely, persuaded Byers to spend more for it than for any previous acquisition is impossible to determine in the absence of documentation. Certainly, the combination of Millet's *Antoinette Hébert* and Delacroix's *Signal* with a third distinguished acquisition from Knoedler, Eugène Fromentin's *Arab Warriors Return from a Fantasia* (cat. 21),[49] lent an aura of inspired connoisseurship to Byers's white-and-gold drawing room that had hitherto eluded Pittsburgh.

Byers's first English acquisition was a landscape by John Constable, *Farm at Cheshire* (cat. 22), which he acquired from Knoedler in May 1896 for $8,500.[50] As far as can be determined from Knoedler records, this was the first foray by

Fig. 57. Photographer unknown. Drawing room of A. M. Byers' residence, 250 Ridge Avenue, n.d. Courtesy of Community College of Allegheny County, Pittsburgh.

The large painting above the piano is Jean-François Millet's *Young Girl Looking in a Mirror: Portrait of Antoinette Hébert;* the small vertical painting above the piano is Eugène Delacroix's *Arab Horseman Giving a Signal.*

Cat. 21. Eugène Fromentin (1820–1876). *Arab Warriors Return from a Fantasia*, 1861, oil on canvas. Carnegie Museum of Art, Pittsburgh; Gift of Mrs. J. Frederic Byers [Ex. coll., Alexander M. Byers].

a Pittsburgh collector into acquiring works by the English school of artists, and it heralded an extremely popular trend. Before long, a number of Pittsburgh collectors began hanging English paintings, especially portraits of aristocratic ladies and gentlemen, on their walls after paying the high prices these master-works commanded.

In the few years that were left to him, Byers assembled a collection from Knoedler that, by its variety and quality, would define the principal directions of collecting in Pittsburgh for the rest of the Gilded Age. Byers's enthusiasm for paintings seems to have been clearly evident to those who knew him. On 15

Cat. 22. John Constable (1776–1837) [school of]. *Farm at Cheshire*, n.d., oil on canvas. Collection of Laurada and Russell G. Byers, Chestnut Hill, Pennsylvania [Ex. coll., Alexander M. Byers].

Cat. 23. George Romney (1734–1802).
*Maria and Katherine, Daughters of
Edward, Lord Chancellor, Thurlow*, n.d.,
oil on canvas. Yale University Art
Gallery, New Haven, Connecticut; Gift
of Mrs. Alison G. Paine [Ex. coll.,
Alexander M. Byers].

August 1898 Frick wrote to Roland Knoedler in Paris, "I am just informed that A. M. Byers and family sail for Europe on the 'Kaiser Wilhelm der Grosse' tomorrow. I think they are going to Bremen first. You will probably be able to get the run of them. I am satisfied, if you can get hold of Mr. Byers in Paris, you will be able to sell him some pictures."[51]

From 1896 to 1900, the year he died, Byers bought nineteen paintings from Knoedler, not including three portraits by Chartran. At the same time he purchased Fromentin's *Arab Warriors*, for example, he bought a landscape by Gainsborough. This was followed the next year by the acquisition of George Romney's *Maria and Katherine* (cat. 23), as well as by one work each by Raeburn and Gainsborough, and—as if to demonstate his continued loyalty to nineteenth-century France—paintings by Lhermitte, Corot, and Meissonier (*L'Amateur de Tableaux*, from the Salon of 1859). Although Byers simultaneously purchased English and French works until his death, he added one major category of art to his collection: paintings by the old masters. In September 1898 Byers obtained *A Waterfall* by Jacob van Ruisdael, which Knoedler had obtained from Lawrie & Co., London, and sold to Byers on commission.[52] (Images of waterfalls were especially popular among Pittsburgh collectors. Henry Clay Frick purchased one by Jacob's uncle, Salomon van Ruysdael, in 1903 [cat. 24].) Six months later Byers acquired three more old master paintings via the same route: a putative Rembrandt entitled *Saskia with a Black Feather in her Hair* (thereby preceding Frick's first "Rembrandt" purchase by one year), Anthony van Dyck's *Holy Family*, and Nicholas Maes's *Woman Making Lace*.[53] These transactions were arranged by Charles Carstairs, who by this time was on very easy terms with Byers. "Roland has probably written to you that Mr. Byers has after all taken the LeRoy Rembrandt. It is hanging in his house. I returned from Pittsburgh this m'n'g, dined last night with the Byers family & had a good talk with Mr. B," Carstairs reported to Maurice Hamman, head of Knoedler's Paris office, on 10 December.[54]

The final six months of Byers's life brought Turner's *Wreckers—Coast of Northumberland* (exhibited at the Royal Academy in 1843) and Corot's *Danse des Nymphes* (shown at the Paris Salon of 1861) into his collection, as well as a painting by Daubigny and Gainsborough's portrait of the English actor David Garrick.

It is probable that had he lived beyond age seventy-four, Byers's reputation as a collector would have soared along with those of Frick and Mellon. A pat-

tern was established, a new, higher standard set—although the absence of works from the Byers collection in the first Carnegie loan exhibition is something of a mystery. Byers avoided the more lapidary excesses of the Paris Salons in favor of lyrical images by Corot, romantic scenes, and Barbizon landscapes that blended nicely with his paintings by the old masters, particularly the seventeenth-century Dutch and eighteenth-century British portraits that were gaining the upper hand at the end of the collector's life. The Knoedler gallery strove mightily to whet, and then fulfill, the growing appetites of its best Pittsburgh client. Dolefully, in October 1899, Charles Carstairs wrote to Arthur J.

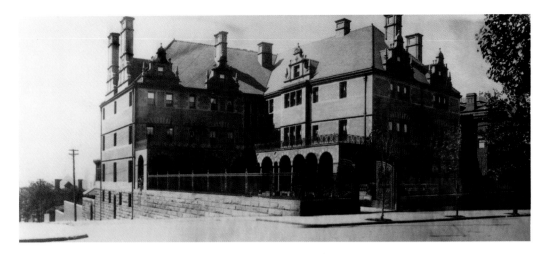

Fig. 58. Photographer unknown. The Byers residence, 250 Ridge Avenue, n.d. Courtesy of Community College of Allegheny County, Pittsburgh.

Also see figs. 40, 41, 57, 59.

Sulley at Lawrie & Co., "I had a very nice talk with Mr. Byers over the phone, and it seemed to me that he was rather in a buying humor, although he tells me that he is not very well. Unfortunately, we did not seem to have anything sufficiently big to interest him. He seems to want a Hobbema very much and a Cuyp. . . ."[55]

Even if Byers's buying spree of 1898 were prompted by the move to his expanded quarters on Ridge Avenue, where the Byers-Lyon double mansion (fig. 58) was completed by that September,[56] his enthusiasm for exceptional paintings propelled him far beyond the need to cover bare walls. So integral was Byers to Knoedler's relationship with the city of Pittsburgh that on 15 November 1899 Carstairs wrote to Sulley,

I am just back from Pittsburgh & am in hopes the Daubigny Solitude Gainsborough Garrick & Constable from Agnews are permanently placed in Mr. B's collection.

It would have been easier to have sold him something he has not got as he is well represented in all the above masters.

I trust you will be able to find some stunning things & make a flying trip here for I think the old man is full of cash. . . .

We are opening tomorrow and our place [in Pittsburgh] really looks stunning. We are exhibiting Byers' Gainsboro "Mrs. Kinloch," "The Wreckers" by Turner, the large upright Corot, and "Solitude" by Daubigny.

I think this ought to attract a great deal of attention & in my opinion will stimulate Mr. B's interest in his collection. He has bought nothing since the Turner until just now.[57]

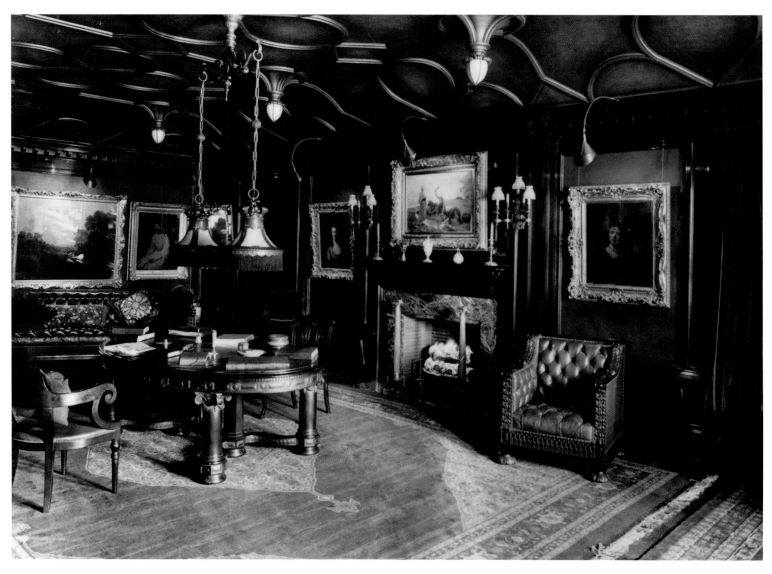

Fig. 59. Photographer unknown. Library of the Byers residence, 250 Ridge Avenue, n.d. Courtesy of Community College of Allegheny County, Pittsburgh.

On the fireplace wall hang (left to right) *Portrait of Isabella, Wife of David Kinloch* by Thomas Gainsborough, *Brittany Washerwomen: Souvenir of Douarnenez* by Jules Breton, and *Saskia with a Black Feather in her Hair*, attributed to Rembrandt.

Also see figs. 40, 41, 57, 58.

The end was near. On 27 March 1900 Roland Knoedler wrote to Sulley from New York, "I saw Mr. Byers at the hotel today. He is not looking at all well, and says he is feeling badly." Ten days later, on 7 April, he informed Carstairs, "I caught a glimpse of Mr. B. at the Holland on Thursday. The poor old gentleman is not looking well at all. . . ."[58]

The surviving album of the Byers house must have been made in the year of A. M. Byers's death. Most of the paintings entered in the Knoedler sale books and mentioned in letters are visible in its photographs. Judging from a similarity to pieces that Frick acquired from Cottier, the drawing room furniture would appear to have been supplied by that firm. The paintings hang together comfortably (fig. 59), united by a vision of quality shared by dealer and collector. Although it had been strictly private during Byers's lifetime, the Byers collection would long be a source of great pride in Pittsburgh. Loan exhibitions

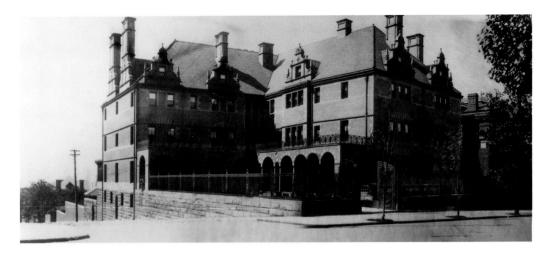

Fig. 58. Photographer unknown. The Byers residence, 250 Ridge Avenue, n.d. Courtesy of Community College of Allegheny County, Pittsburgh.

Also see figs. 40, 41, 57, 59.

Sulley at Lawrie & Co., "I had a very nice talk with Mr. Byers over the phone, and it seemed to me that he was rather in a buying humor, although he tells me that he is not very well. Unfortunately, we did not seem to have anything sufficiently big to interest him. He seems to want a Hobbema very much and a Cuyp. . . ."[55]

Even if Byers's buying spree of 1898 were prompted by the move to his expanded quarters on Ridge Avenue, where the Byers-Lyon double mansion (fig. 58) was completed by that September,[56] his enthusiasm for exceptional paintings propelled him far beyond the need to cover bare walls. So integral was Byers to Knoedler's relationship with the city of Pittsburgh that on 15 November 1899 Carstairs wrote to Sulley,

I am just back from Pittsburgh & am in hopes the Daubigny Solitude Gainsborough Garrick & Constable from Agnews are permanently placed in Mr. B's collection.

It would have been easier to have sold him something he has not got as he is well represented in all the above masters.

I trust you will be able to find some stunning things & make a flying trip here for I think the old man is full of cash. . . .

We are opening tomorrow and our place [in Pittsburgh] really looks stunning. We are exhibiting Byers' Gainsboro "Mrs. Kinloch," "The Wreckers" by Turner, the large upright Corot, and "Solitude" by Daubigny.

I think this ought to attract a great deal of attention & in my opinion will stimulate Mr. B's interest in his collection. He has bought nothing since the Turner until just now.[57]

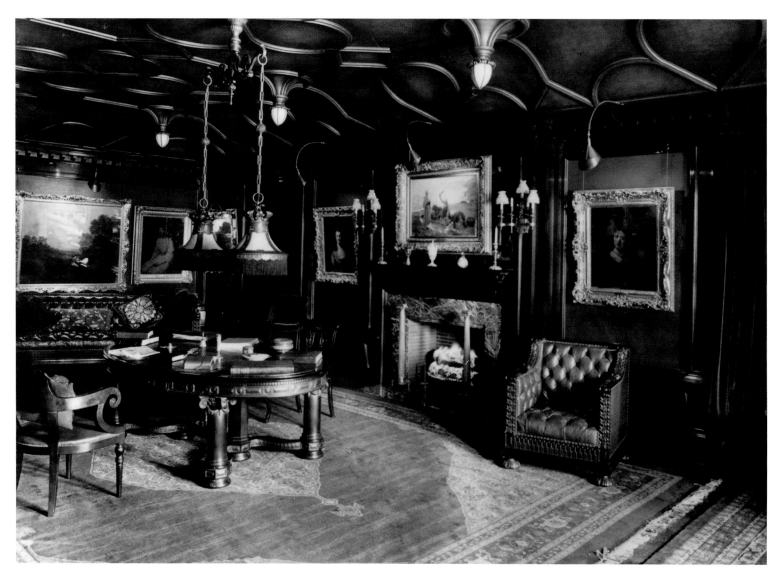

Fig. 59. Photographer unknown. Library of the Byers residence, 250 Ridge Avenue, n.d. Courtesy of Community College of Allegheny County, Pittsburgh.

On the fireplace wall hang (left to right) *Portrait of Isabella, Wife of David Kinloch* by Thomas Gainsborough, *Brittany Washerwomen: Souvenir of Douarnenez* by Jules Breton, and *Saskia with a Black Feather in her Hair*, attributed to Rembrandt.

Also see figs. 40, 41, 57, 58.

The end was near. On 27 March 1900 Roland Knoedler wrote to Sulley from New York, "I saw Mr. Byers at the hotel today. He is not looking at all well, and says he is feeling badly." Ten days later, on 7 April, he informed Carstairs, "I caught a glimpse of Mr. B. at the Holland on Thursday. The poor old gentleman is not looking well at all. . . ."[58]

The surviving album of the Byers house must have been made in the year of A. M. Byers's death. Most of the paintings entered in the Knoedler sale books and mentioned in letters are visible in its photographs. Judging from a similarity to pieces that Frick acquired from Cottier, the drawing room furniture would appear to have been supplied by that firm. The paintings hang together comfortably (fig. 59), united by a vision of quality shared by dealer and collector. Although it had been strictly private during Byers's lifetime, the Byers collection would long be a source of great pride in Pittsburgh. Loan exhibitions

at the Carnegie Art Galleries in 1902–1903, 1907, and 1925 included many paintings from the "A. M. Byers Estate," and in the winter of 1932 the Institute devoted an entire exhibition to "The Alexander M. Byers Collection of Paintings."[59] In all, fifty-five paintings were catalogued, supporting the claim of a visitor to Pittsburgh in 1925 that the Byers collection "is conceded to be by far the most important in Pittsburgh at the present time. It contains splendid examples of the English, French, Barbizon, Spanish, and early Dutch schools."[60]

Cat. 25. George Hetzel (1826–1899). *Woodland Stream*, 1880, oil on canvas. Frick Art & Historical Center, Pittsburgh.

If A. M. Byers, assisted by Roland Knoedler and Charles Carstairs, had by 1900 set a new standard for Pittsburgh, Henry Clay Frick, who was Byers's junior by twenty-two years, quickly grasped the significance of the Byers collection and applied its lessons to his own. When, at the age of thirty-one and still a bachelor (fig. 60), Frick made his first recorded art acquisitions in February and March 1881 (cats. 25, 26), it was said that he had been inspired by his

Cat. 26. Luis Jiménez y Aranda (1845–1903). *Au Louvre*, 1881, oil on canvas. Frick Art & Historical Center, Pittsburgh.

travels in Europe the previous summer.[61] As we have seen, he could as easily have been influenced by collections in Pittsburgh, and surely he was. Nonetheless, although he bought a "fruit piece" by George Hetzel and a few works by minor European artists later in the 1880s, he could not yet be considered a true art collector. Certainly his art holdings did not approach the value of the Byers collection, which was reported to be worth a minimum of $50,000 in 1890. Both Pittsburgh collections were then a far cry from that of James J. Hill, who had been collecting Barbizon paintings since 1883 and spent $66,500 in 1887 alone.[62]

"'Venant du Jardin' vient d'être vendu à Pittsburgh," Roland Knoedler wrote gleefully to Maurice Hamman, on 30 May 1894 after Carstairs sold Daniel Ridgway Knight's *Coming from the Garden* to Frick for $1,350.[63] This transaction occurred on Frick's first visit to the Knoedler gallery, still located at 170 Fifth Avenue in New York City but soon to move to number 355 at 34th Street (fig. 61). Indeed, Knoedler must have been relieved. On 30 March he had written to Hamman that the gallery had enough paintings by Knight in stock "pour le moment" (cats. 27, 28).[64] (Five years later, as he was consciously upgrading his collection, Frick must have had similar thoughts. He returned *Coming from the Garden* to Knoedler for credit against the purchase of *The Ferryboat* by Daubigny, which cost $12,000.[65] Knoedler resold *Coming from the Garden* to Judge James H. Reed of Pittsburgh on 20 November 1899.)

Evidently much pleased with his initial dealings with Knoedler, Frick became a major client of the firm in 1895 and remained so for the rest of his life. At the age of forty-five, when he was chairman and a 6-percent owner of the Carnegie Steel Company, a 23-percent owner of the H. C. Frick Coke Co., and a partner in other lucrative real estate and business ventures with his closest friend Andrew Mellon,[66] Frick resolved to collect art in earnest.[67] He bought an astounding eighteen paintings from Knoedler in 1895, expending $67,250. In addition, he purchased seven works of art from other dealers for a total of $9,313.24. This brought the grand total Frick spent on art in 1895 to $76,563.24, a sum equivalent to more than $1.5 million in today's currency.

Frick's acquisitions from Knoedler, though more numerous than those made by Byers, bore many similarities with them. The most prestigious was *The Last Gleanings* by Jules Breton (cat. 74), a more monumental and more expensive work than Byers's *Brittany Washerwomen*.[68] Byers's painting by Breton hung over the library fireplace; Frick's occupied the place of honor above the dining room mantel. Frick shared Byers's taste for genre scenes, such as those by Detaille and Domingo, for Charles-Emile Jacque's flocks of sheep, and for Bouguereau's maidens (although he may have bought the artist's *Espièglerie* primarily to please his adored daughter Helen).[69] A sudden, overwhelming enthusiasm for the Barbizon-inspired work of Jean-Charles Cazin, which prompted the purchase of six paintings from Knoedler in 1895, has no exact parallel in Byers's relationship with Knoedler, but Byers did own one work by Cazin. (Cazin's appeal to Americans soared following the artist's well-publicized visit to the United States in 1893.) Neither Frick's second painting by Ridgway Knight, which he bought in 1895, nor his Venetian view by Martin Rico y Ortega (cat. 29) would have been out of place in the Byers mansion on Ridge Avenue. A different precedent was already set for Frick's purchase in 1895 of two paintings by Gérôme: *Prayer in the Mosque of Quat Bey, Cairo* and *Sculpturae Vitam Insuflat Pictura*. Charles Lockhart owned two works by the French academician, which he had loaned to the 1895 exhibition at the Carnegie Art Galleries. Of all Frick's purchases made in 1895, only one, *Argenteuil* by Claude Monet, represented a significant departure from established taste in Pittsburgh.[70] By and large, the fundamentals of Frick's early collection, which were in place by the end of that year, suggested conformity over originality.

A degree of originality—or at least, audacity—was implicit in the number of purchases made by Frick. He was buying art at a pace unprecedented in

Cat. 27. Daniel Ridgway Knight (1839–1924). *Woman in Landscape*, n.d., oil on canvas. Collection of Katherine L. Griswold, Pittsburgh [Ex. coll., Charles Lockhart].

Pittsburgh and over the course of the next fifteen years obtained three times as many paintings from Knoedler as any other collector in Pittsburgh. In 1895 alone he purchased as many works from the dealer as Byers acquired in five years. This was not the reckless spending of a suddenly rich man—by 1895 Frick had been a millionaire for fifteen years—but rather a demonstration of resolve on the part of a successful industrialist who, in the prime of life, was stepping confidently onto the national scene and indulging a passion. Apart from golf, which he played enthusiastically later in life, collecting art was Frick's only hobby. Many years after Frick's death in 1919, an old colleague and adversary, Charles M. Schwab, waspishly described him to a journalist as "the most methodical thinking machine I have ever known. . . . He seemed to lavish on art all the passion that he might have bestowed on human beings."[71] More sympathetically, James H. Bridge, who served Frick as curator of his art collection, wrote in *Millionaires and Grub Street* (1931) that "the materialistic side of [Frick's] life . . . was qualified by his love of children and of art."[72]

Frick was in a prime position to monitor the planning and construction of the grand Carnegie Library and Art Galleries on behalf of Andrew Carnegie,

Cat. 28. Daniel Ridgway Knight (1839–1924). *Meditation*, n.d., oil on canvas. Collection of George D. Lockhart, Pittsburgh [Ex. coll., Charles Lockhart].

Cat. 29. Martin Rico y Ortega (1833–
1908). *Fishermen's Houses, Venice*, n.d.,
oil on canvas. Frick Art & Historical
Center, Pittsburgh.

who no longer lived in Pittsburgh. In his dual role as chairman of Carnegie Steel—the primary source of funds for the building—and as treasurer (until 1898) of the Library board, Frick occupied a pivotal position that put him in constant touch with Carnegie and allowed him to wield authority second only to that of the benefactor himself. This applied to a range of construction and management decisions, such as when Frick authorized an additional expenditure of $10,000 for heating and ventilating the new library. He also instructed his friend William Nimick Frew, president of the board, whom to hire as the library's chief financial officer. In at least one instance concerning Carnegie's control over the board, Frick informed Frew, "I have written Mr. Carnegie by this mail. Am satisfied that he will be pleased to know that you will accept compensation in connection with the Library, and will prefer that it should come directly from him."[75]

This personal involvement with the library, which even included influencing the invitation list for the opening, was bound to have sparked Frick's interest in collecting art. It undoubtedly focused his attention on a civic event of paramount importance, one that would command local, national, and international attention: the opening of the new library building and the loan exhibition. Here was an unprecedented opportunity for Pittsburghers to display their wealth and cultivation. Frick lent twelve paintings to the 1895 loan exhibition,

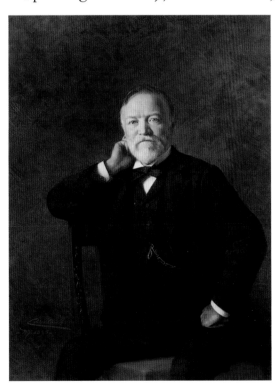

Cat. 30. Théobald Chartran (1849–1907). *Portrait of Andrew Carnegie*, 1895, oil on canvas. Carnegie Museum of Art, Pittsburgh; Gift of Henry Clay Frick, 1896.

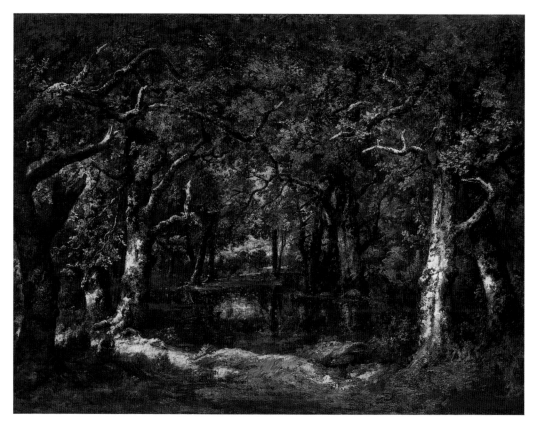

more than anyone except Charles Lockhart, John Caldwell, and Charles Donnelly. Nine of his paintings had been purchased in a four-month span, from that June to September. All twelve were insured at Frick's expense for their cost value of $56,600.[76]

Frick fretted over the loans and was displeased when John W. Beatty, the director of the art galleries, proved unclear about which paintings he intended to borrow.[77] He commiserated with John G. Butler, Jr., of Youngstown, Ohio, when Beatty omitted from the exhibition the work that Butler, a substantial collector, considered to be his best painting.[78] From all this it is plain that if anyone had been stimulated by Andrew Carnegie's overwhelming philanthropic gesture to form an instant art collection, it was Henry Clay Frick.

In honor of the library's dedication, Frick donated a portrait of Andrew Carnegie by Théobald Chartran (cat. 30). This gesture was guaranteed to earn the approval both of Carnegie and of Frick's colleagues on the Carnegie Library board. The next year Frick wrote to Beatty to offer "anything of mine you like for November" and thus became the leading private lender to the first Carnegie Annual exhibition (cat. 31).[79] The five paintings that he lent had been acquired since the 1895 exhibition, and Frick insured them, at cost, for $40,500.[80] Meanwhile, Roland Knoedler had been observing the compulsiveness with

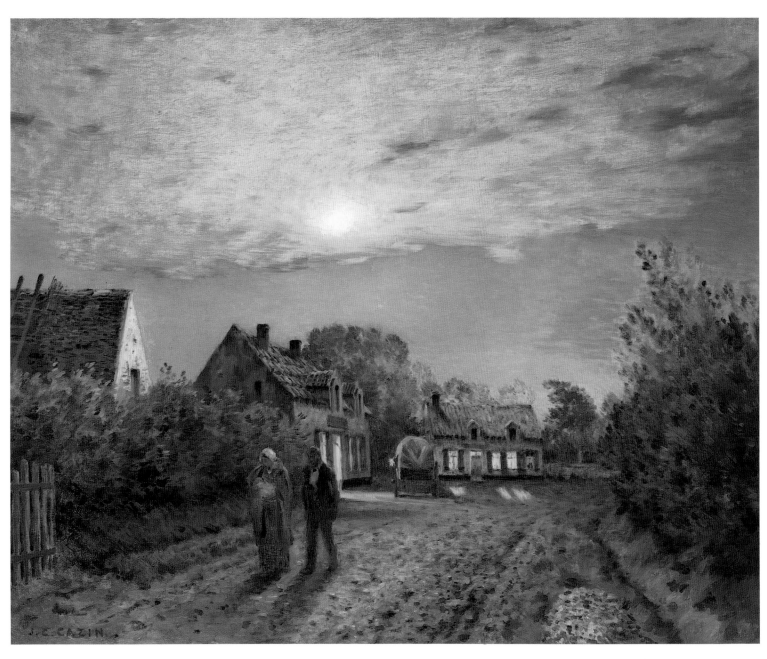

Cat. 32. Jean-Charles Cazin (1841–1901).
Sunday Evening in a Miners' Village,
c. 1892, oil on canvas. Frick Art &
Historical Center, Pittsburgh.

which Frick was buying paintings. Knoedler wrote to Hamman in February 1896 that he had notified Frick of the estate sale of William Schaus, who had recently died. Frick had replied, "Received a catalogue of the Schaus Estate Sale but am not in the market for any pictures at present." That did not prevent Frick, Knoedler commented, "from buying from Gross & van Gigh [*sic*] a head-and-shoulders by Henner that I had purchased at the King sale."[81]

Although the painting by Henner was not expensive, Frick drove a hard bargain for it, as he reported to Knoedler. Frick inquired from Pittsburgh on 25 February, "Is the Henner that Messrs. Gross & Van Gigh [*sic*] have here now, and purchased by you, I see, at the King sale for $1,500 the one that Mrs. Frick and I saw at you house in Paris last summer?" When Knoedler replied that it was, Frick wrote to him,

> I concluded to purchase that Henner from Messrs. Gross & van Gigh [*sic*]. Saw you had re-purchased it at the King sale for $1,500. I paid them $1,800 cash for it; price probably a little high, but thought it was about as good an example of Henner as I could secure. Said nothing to them about having telegraphed you, although they insisted all along you had been asking $2,500 for the picture, and they were satisfied Mr. King paid you that amount for it in Paris last summer.[82]

A subjective explanation of Frick's acquisitiveness may be found in his high tolerance for risk. Frick the art collector, like Frick the businessman, was inclined to take calculated risks to a degree greater than any of his art collecting peers in Pittsburgh. In 1895 that could mean buying six paintings by Cazin (cat. 32) or acquiring an Impressionist canvas by Monet. A parallel to the rapid growth of the Frick art collection can be found in the young man's drive to expand his coke company in the 1870s. The dramatic rate of growth was due entirely to Frick's combination of shrewdness and fortitude. He knew how and when to capitalize upon the demand for coke, just as he would later know how to seize opportunities in acquiring paintings.[83]

As in his business dealings, Frick's cupidity occasionally may have aroused resentment in the art world. As we have seen, in the summer of 1895 he traveled abroad with his family. Visits to artists' studios were *de rigueur* at the time, and Frick is known to have made at least two such visits during this European sojourn. In Paris the Fricks called at Bouguereau's studio (fig. 62) and came away with a large photographic reproduction of *Espièglerie* (fig. 63) that bore

the inscription, "à Miss Helen Clay Frick / souvenir de sa visite à mon atelier le 20 juillet 1895." While in London approximately one month later, Frick called at the studio of Sir Lawrence Alma-Tadema at 17 Grove End Road, St. John's Wood, but this time the interview apparently did not go well. On 28 August, Alma-Tadema, in writing to Roland Knoedler about a business matter, reported,

> I had last Monday the visit of a Mr. Frick who sent in the enclosed card with request on the back, which I do not comprehend. He told me he knew you. Perhaps when convenient you might let me know who Mr. Frick, who will not pay the 10 dollars, is.[84]

The misunderstanding could have arisen over an admission fee, which Frick might have considered an imposition. This unpleasantness, however, had no long-term effect on his desire to own a painting by Alma-Tadema. Frick clearly was stalling for the right painting when he wrote to Knoedler in February 1896, "Thanks for yours of the 8th. I think I will defer purchasing a Tadema painting until some time in the future, so do not hold the one you have for my inspection."[85] Sixteen months later, in late August 1897, Carstairs accompanied Frick on a second visit to Alma-Tadema's studio. This time all must have gone smoothly because by 30 August Arthur Tooth wrote to Frick that the artist was

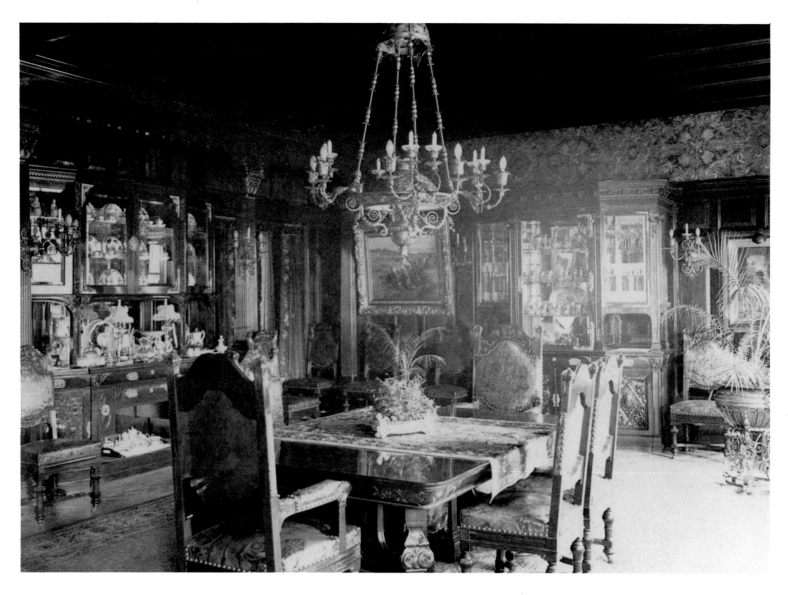

Fig. 64. Attributed to Lewis Stephany. Dining room at Clayton, c. 1900. Frick family archives, Pittsburgh.

Partially concealed by the potted palm at right is Alma-Tadema's *Watching and Waiting*. The painting on the left is Léon Lhermitte's *La Fenaison*.

Also see figs. 14, 65, 66, 68, 112.

delighted that Frick had purchased *Watching and Waiting*, a panel that Alma-Tadema had completed in June with reference to the story of Perseus and Andromeda. (Frick actually bought the work through Arthur Tooth & Sons, Alma-Tadema's principal dealer, for $8,000.) He hung it in the dining room at Clayton (fig. 64) and lent it to the 1897 Carnegie Annual.[86] "The Tadema is now hanging in my house," he wrote to Arthur Tooth in London on 9 September, "and looks very well indeed. I have this day remitted your New York house check in payment for it."[87]

This was the second painting by Alma-Tadema to enter a Pittsburgh collection; three others followed shortly after the turn of the century.[88] Frick may have contemplated purchasing a second Alma-Tadema from Knoedler in 1898, but if so, nothing came of it.[89] As with Gérôme, so with Alma-Tadema: nine-

teenth-century high academicism and exotic subject matter soon began to lose their charm for Frick. Gérôme's popularity in America had peaked around 1895,[90] the year Frick purchased his two works by the artist, and in late 1899 he exchanged both paintings for credit against the purchase of a surpassingly beautiful landscape by Constant Troyon, *Pâturage en Normandie*. Frick sold *Watching and Waiting* in 1906[91] to help pay for Aelbert Cuyp's *Sunrise on the Maas*.[92] Doubtless, this large, luminous canvas from around 1650 seemed far more in tune with the princely surroundings of the Vanderbilt house at 640 Fifth Avenue in New York, where Frick was living by that time, than a delicate, sentimental work by an artist who, at any rate, was starting to lose favor.[93]

In 1897, however, Frick was still primarily interested in contemporary artists, including some who were represented in the Carnegie Annual. He was unable to acquire two works that caught his fancy and would have lent a more painterly and American character to his collection. Frick revealed his frustration in a letter to Carnegie, who was then in Paris, a few days before the opening of the exhibition. "Have had a view of the pictures. . . . The one that has taken first prize is a picture I should like to own, and probably would have purchased but for your cable . . . would have purchased the one entered by Miss Cecilia Beau [*sic*], but it was not for sale."[94] The prize-winning painting was *Miss Kitty* by James J. Shannon, an American-born resident of London. Carnegie actually responded to Frick's letter, saying, "Don't hesitate to bring the picture for yourself as this will increase the sales of the Exhibition which is my great aim."[95] Either Carnegie's letter arrived too late or Frick thought better of upsetting the Carnegie art committee's plans. *Miss Kitty* was purchased for the "chronological collection" of the Carnegie Art Galleries and is preserved in the Carnegie Museum of Art today. The entry by Cecilia Beaux was a winsome, half-length portrait of a seated woman that presumably was returned to the sitter.

Frick's initial purchase of a British portrait, *Mary Finch Hatton* by George Romney, occured at Knoedler's in February 1898, only a month after Byers bought *his* painting by Romney, but Frick's acquisition was neither as grand nor as expensive as that made by Byers.[96] The stakes rose by the end of summer, however, when Frick bought for $24,000 a work entitled *Miss Puyeau, née Isabelle d'Almeida* that was attributed to Sir Joshua Reynolds (cat. 33).[97] Nonetheless, Frick's purchases in 1898 emphasized French, rather than British, painting. As in 1895, the year was an especially active one, with Frick acquir-

Cat. 33. Hugh Barron (1745–1791). *Portrait of a Lady (Perhaps Isabelle d'Almeida)*, n.d., oil on canvas. In the Collection of the Corcoran Gallery of Art, William A. Clark Collection [Ex. coll., Henry Clay Frick].

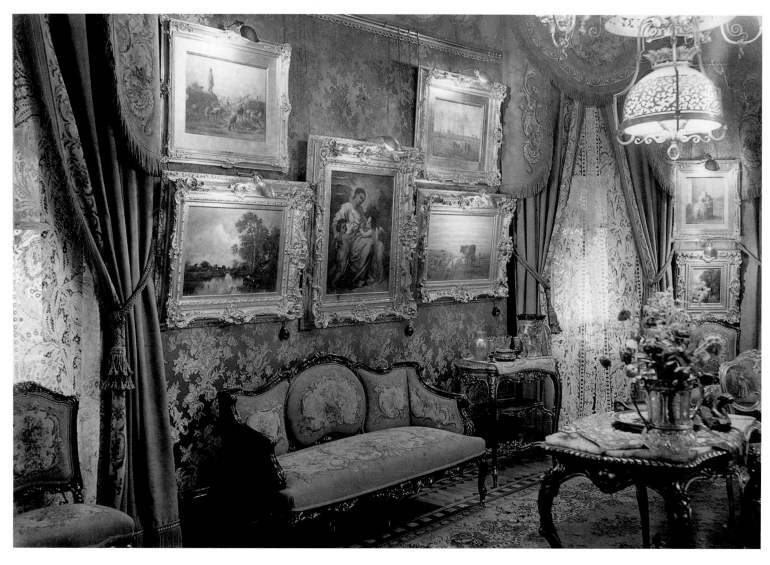

Fig. 65. Attributed to Lewis Stephany.
Reception room at Clayton, c. 1900.
Frick family archives, Pittsburgh.

Over the sofa, top row, are two pastels by
Jean-François Millet, *Shepherd Minding
his Flock* (left) and *La Fermière (The
Flight of Crows)* (right). Bottom row
(left to right) are Jules Dupré, *La Rivière*;
Narcisse Virgile Diaz de la Peña, *Love's
Caresses*; and Constant Troyon, *Pâturage
en Normandie*. At rear (top), Jean-
François Millet, *The Knitting Lesson* and
(bottom), Constant Troyon, *Road near
Woods*. All these works were acquired by
H. C. Frick, 1897–1899.

Also see figs. 14, 64, 66, 68, 112.

Cat. 34. Jean-François Millet (1814–
1875). *The Knitting Lesson*, c. 1858–60,
black chalk on paper. Frick Art & Histor-
ical Center, Pittsburgh.

ing twenty new paintings (fifteen of which came through Knoedler's) at a cost of $102,600.

The most distinguished additions to Frick's collection were the silvery *Ville d'Avray* by Corot,[98] two drawings by Millet, *The Knitting Lesson* (cat. 34 and fig. 65) and *Shepherd Minding his Flock*,[99] and *Christ and the Disciples at Emmaus* by P.-A.-J. Dagnan-Bouveret.[100] This painting was the most monumental and emotionally charged work that Frick had acquired to that time, and by donating it to Carnegie Institute in memory of his deceased daughter Martha, he underscored the very personal meaning that *Christ and the Disciples at Emmaus* held for him.

When the painting by Corot and the two drawings by Millet were displayed with Frick's first Millet drawing, *La Fermière* (cat. 35), which he had purchased from Knoedler in late 1897, the collection was infused with a new, poetic sensibility. Although this could have been the result of exposure to Byers's works by Corot and Millet, which would have been on view in his Ridge Avenue residence long enough for Frick to have seen them, the vogue for collecting paintings by Corot and Millet and the quality of the three acquisitions make it impossible to attribute Frick's motives entirely to a desire to emulate another

Fig. 66. Attributed to Lewis Stephany. Parlor at Clayton showing *Portrait of a Young Artist*, a painting purchased in 1899 as a Rembrandt. Frick family archives, Pittsburgh.

Also see figs. 14, 64, 65, 68, 112.

collector. In 1898 Frick was still committed to nineteenth-century French painting, his tastes were still very eclectic, and he was still buying works of art in amazing quantity.[101] Moreover, Roland Knoedler had all the proof he needed that Frick, like Byers, could be interested in British portraiture. Such painting was not, however, the most important element in Frick's collecting pattern in 1899. The pattern followed that of Byers—only, true to form, Frick acquired many more works than Byers did, and he reached out in more directions. Frick's only British portrait purchased in 1899 was *The Hon. Lucy Byng* by John Hoppner,[102] a likeness of a young lady in a white dress that resembled Romney's *Mary Finch Hatton*.

At the end of August, four months after Byers acquired *Saskia with a Black Feather in her Hair*, Frick made his first purchase of a work purportedly by Rembrandt, *Portrait of a Young Artist*,[103] which he bought from Tooth & Sons for $38,000. Since by this time virtually every inch of wall space at Clayton was covered, this prestigious addition to the collection was hung against one of the windows in the music room, over which the draperies were often closed to provide an appropriately opaque backdrop (fig. 66).

Even with works by Hoppner and Rembrandt, as well as *Elizabeth, Countess of Warwick* by Nattier, acquired from Lawrie & Co., paintings by the old masters were not Frick's main emphasis in 1899. Instead, that year he concentrated

on forming his Barbizon collection. Of the twenty-eight paintings that Frick purchased during the year,[104] ten were by Barbizon painters and another five were by Frits Thaulow, a Norwegian landscape painter who was living in France (cat. 36). (With a zeal surpassing even his enthusiasm for Cazin, Frick, having acquired his first work by Thaulow from the 1895 Carnegie loan exhibition, bought five more in 1899. Within five years he owned ten paintings by Thaulow, two of which he gave as presents to business associates and one he presented to President Theodore Roosevelt.)

Of the six paintings by Corot that Frick purchased in his lifetime, two entered his collection in 1899—*The Pond*[105] and *Crown of Flowers* (cat. 18)[106]— along with three more pastel drawings by Millet, three paintings by Daubigny, and two works by Troyon. Most of these were grouped on the rose-colored damask walls of the reception room at Clayton. Although within four years Frick parted with two of the Daubigny canvases, *The Ferryboat* and *Ducks*, and even more to our present regret, *Crown of Flowers*, by late 1899 he possessed a Barbizon collection unrivaled in the city. (Notwithstanding his own incipient affinity for Corot, he wrote to Roland Knoedler in January 1897 declining a painting by the master on behalf of the Carnegie Art Galleries. "Referring to

the Corot: I understand that a number of the Art Commissioners are quite enthusiastic over it. It certainly is a great picture. I am afraid that the Carnegie Art Commission is hardly rich enough yet to indulge in so fine a picture.")[107] Pittsburghers fortunate enough to call at both Clayton and Byers's home on Ridge Avenue in the autumn of 1899 might well have noted that the dynamic Frick had achieved parity with the ailing Byers in terms of art treasures and that both collectors had injected a new level of connoisseurship into the city as the century drew to a close.[108]

As Frick was drawing inspiration from Byers and was preparing to launch himself into the world of collecting old master paintings, two of his closest associates, David T. Watson and Andrew Mellon, were ominously entering into the art market. Watson was the attorney who, in combination with John G. Johnson of Philadelphia and Willis F. McCook of Pittsburgh, would represent Frick in his 1900 court battle against Carnegie.[109] Mellon, of course, was Frick's closest friend and business partner. Both men became Knoedler clients in the mid-1890s,[110] but Roland Knoedler had had his eye on Watson at least since 1894. He wrote to Maurice Hamman on 4 June of that year:

> Just a few words to alert you to the arrival in Paris, at the Grand Hotel, of Mr. and Mrs. D. T. Watson of Pittsburgh, who disembark from the "Paris" tomorrow. They will be passing through London and will spend the 14, 15, and 16 June in Paris. They want very much to see the Chauchard collection. Mr. Watson is an art-lover, a lawyer, and a friend of Johnson from Philadelphia. He could become a very important client of ours, albeit he has bought nothing from us yet. Do everything possible to gain entry for him to Mr. Chauchard's. . . . In any case see them. . . . Watson, it would seem, has bought pictures of the English School [including] a very beautiful Gainsborough landscape.[111]

What transpired during that sojourn in Paris is not recorded, but Watson made his first purchase from Knoedler—Corot's *Environs d'Etretat*—for $7,500 in May 1895. The following summer he purchased Jules Breton's 1896 Salon entry, *L'Aurore*.[112] A year later he paid $65,000 for Corot's *Le Bac*.[113] This price, if known to Frick, would have impressed him, for the highest price he had paid to that time was $14,000 for *The Last Gleanings* by Breton. Once *Le Bac* was hanging in his house at 261 Ridge Avenue, it was clear that Watson was a serious collector. By the time of Watson's death in 1916, his collection con-

tained seventy-four paintings, sixty-one of which were exhibited at a memorial exhibition held at Carnegie Institute (22 January–28 February 1917). Since he acquired only thirteen paintings from Knoedler between 1895 and 1909, Watson obviously relied heavily upon other sources. Nonetheless, his Knoedler transactions trace a by now familiar pattern. Moreover, all thirteen acquisitions remained in Watson's collection until the end of his life.

Having no apparent interest in minor (or major) artists who exhibited their works at the Salon,[114] Watson preferred to collect works by well-known Barbizon and realist painters. The trend he established by 1897 continued into the next year when he acquired *Going to Market* by Troyon and another landscape by Corot, *Le Soir*.[115] Still interested in Troyon two years later, he purchased *Pastoral Landscape* in August 1900. At the same time he bought *Enfants effrayés à la vue d'une chienne (The Frightened Children)*, a painting by Alexandre Decamps, an artist not represented elsewhere in Pittsburgh.[116] Similar to Byers's acquisition of a painting by Delacroix, this work fell slightly outside established conventions in Pittsburgh and enhanced the quality and originality of the collection.

Watson also shared Byers's affinity for paintings by John Constable, and in fact, he may have acquired a work by the British artist before his fellow collector did. The sales books of Arthur Tooth & Sons document the New York sale of a painting called *The Glebe Farm*. If this is the same *Glebe Farm* that appears in the 1917 catalogue of the Watson collection, Watson could have bought it anytime after 9 April 1895.[117] In any case Corot, not Constable, became Watson's favorite landscape painter. In the end he owned five paintings by Corot, four of which he had purchased from M. Knoedler & Co., and no other work by Constable beyond *The Glebe Farm*.

D. T. Watson's involvement with old master paintings began at least by November 1904, when he acquired *The Countess Lecari,* a portrait by Anthony van Dyck that came from Lawrie & Co. through Knoedler.[118] Judging from the fact that this was the only work illustrated in the 1917 catalogue, it must have been considered the most important painting in Watson's collection. Fourteen months later *The Beggar Boy* by Murillo entered the collection by way of Knoedler, which on this occasion functioned as an agent for Arthur Sulley, who had separated from Lawrie and opened his own gallery in London.[119] The final tally of works by Murillo in Watson's residence was three, the largest number of works by any painter active before 1800. While these and the portrait by van

Cat. 37. Henri-Joseph Harpignies (1819–1916). *Etang—Coucher du Soleil (Landscape)*, c. 1884, oil on canvas. The Art Museum, Princeton University; Gift of David H. McAlpin [Ex. coll., John G. Holmes].

Cat. 38. Henri-Joseph Harpignies (1819–1916). *Landscape of Trees and Lake*, 1906, oil on canvas. University Club, Pittsburgh.

Dyck were joined by two paintings by Gainsborough and two portraits by Reynolds, as well as Romney's *Lady Hamilton* (Frick bought Romney's *Lady Hamilton as "Nature"* from Knoedler in 1904), half of the Watson collection, as it was exhibited in 1917, consisted of nineteenth-century French art.

Andrew Mellon's first ventures into art collecting were less sure-footed than those of Watson. His initial dealings with Knoedler involved commissioning portraits of his parents, Judge and Mrs. Thomas Mellon, by Chartran (fig. 93, cat. 66), a fitting gesture for a forty-one-year-old bachelor still living at home. Later in 1896 he bought a modest landscape by Harpignies (cats. 37, 38)[120] and *Anthony Van Corlear, the Trumpeter of New Amsterdam* (cat. 39), a large historical genre painting by Frank D. Millet that includes the artist's portrait in the guise of a character from Washington Irving's *History of New York by Diedrich Knickerbocker*.[121] Adding to the painting's appeal was its distinguished exhibition history: it was shown at the Royal Academy in London (1889), the National Academy of Design in New York (1890), and the World's Columbian Exposition in Chicago (1893) before the artist loaned it to the 1895 Carnegie exhibition, where Mellon would have first encountered it. The acquisition met with Frick's resounding approval. He had purchased Millet's *How the Gossip Grew* from Knoedler in 1895 and lent it to the first Carnegie Annual. Millet, in turn, served on the London advisory committee to the Carnegie Annuals for several years beginning in 1897. Upon the presidential election of William McKinley in 1896, Frick supported Millet's rather unconventional bid for appointment as United States Minister to the Court of St. James's. Along with another American expatriate, John Singer Sargent, Millet resided partly in the Cotswold village of Broadway. Frick wrote to him there on 3 February 1897, after Millet had withdrawn his name from consideration.

> I feel satisfied we could have succeeded in having you appointed but, when you consider that it might be only for one term (owing to the changes that occur so often in this country), it is hardly worth the trouble. What I have done so far in the matter has been a great pleasure to me. . . . The picture of yours purchased by Mr. Mellon from Knoedlers is now in the Duquesne Club, over the mantelpiece, in the room in which I take lunch every day. Mr. Mellon loaned it temporarily to the Club. Eight of us lunch there regularly, and it is a pleasure to be able to see your cheerful countenance.[122]

Cat. 39. Frank D. Millet (1846–1912).
*Anthony Van Corlear, the Trumpeter of
New Amsterdam*, 1889, oil on canvas.
Duquesne Club, Pittsburgh; Presented by
Andrew W. Mellon [Ex. coll., Andrew W.
Mellon].

From this point until September 1902, Mellon purchased twenty-eight paintings from Knoedler, all of them safely within conventions observed by Lockhart, Byers, Frick, Watson, and other Pittsburgh art collectors. Not one of them may have been especially distinguished, although perhaps they were not as undistinguished as John Walker, a much younger Pittsburgher who one day would serve as director of the National Gallery of Art, would suggest.

Perhaps in an effort to mitigate the bleakness of [his] surroundings, the inventory of Knoedler's showed that in 1899 Andrew Mellon spent over $20,000 on pictures. He bought, however, paintings which can only be described as mediocre and which have all mercifully disappeared. For Troyon's *Cows in a Meadow,* the most expensive canvas that year, he paid $17,000; for Cazin's *Moonlight Effects* [actually, *Moonlight, Ecluse sur le Loing],* $3,000. . . . Many years later he asked Roland Knoedler: "When I first started buying pictures why didn't you offer me Gainsboroughs, Rembrandts, Frans Hals, et cetera?" To which the dealer replied: "Because you would not have bought them." One wonders whether this is quite true.[123]

Cat. 40. Henry Singleton (1766–1839). *Portrait of a Lady*, c. 1800, oil on canvas. Collection of Mr. and Mrs. Thomas M. Schmidt, Pittsburgh [Ex. coll., Andrew W. Mellon].

Walker's narrative typifies the view of his generation, which was effectively fifty years younger than Andrew Mellon, toward both turn-of-the-century Pittsburgh ("bleak") and the art collected in the city during the Gilded Age (which had "mercifully disappeared"). This view rules out the possibility that anything by Troyon, Cazin, Harpignies, Chelminski, or Ziem—all of whom were represented in Mellon's collection and in many others by 1900—could rise above mediocrity, and Walker ignores the fact that one purchase in 1899, a female portrait by Henry Singleton (cat. 40), a follower of Reynolds, provided an early indication that Mellon would follow the growing fashion for British portraiture. He did indeed do that in December 1900 by acquiring paintings by Raeburn and Reynolds.[124]

At this stage Andrew Mellon was simply falling into stride with his Pittsburgh peers, collecting what they collected, allowing his interests to develop in line with theirs, and accepting the advice of Charles Carstairs, his closest friend at M. Knoedler & Co. It is also worth noting that in 1898 he was falling in love—he would marry in 1900—and in his restrained, disciplined, taciturn way, he was broadening his life. Walker describes meeting Mellon thirty years later: "I found him, however, exceptionally silent, as I tried my best to convey

my admiration for his collection. He was inarticulate on the subject of art."[125]

Given Mellon's temperament and fortune, it seems likely that the act of collecting art was *his* way of expressing himself about art. In other words, the deed *was* the word. Acquisitions stemmed from the heart as well as the purse. In December 1898, for example, he purchased from Knoedler six modestly priced works by Robert W. van Boskerck, a landscape painter born in New Jersey. Mellon left instructions with the gallery to send one painting each to his father, his three surviving brothers, his nephew, and himself.[126] These paintings, which were obviously Christmas presents, speak eloquently of Mellon's generosity and loyalty to his family, of the role that art collecting had begun to play in his life, and of his conformity to prevailing Pittsburgh taste. (Knoedler had made van Boskerck extremely popular in Pittsburgh.) Mellon family legend has it that Andrew Mellon commissioned the artist to travel to Ireland and paint the Mellon homestead at Omagh and its surrounding sights. If this is true, the 1898 Christmas presents are the likely result.[127] Conversely, a letter from Carstairs to Hamman suggests that the van Boskerck paintings were purchased on the spot in Knoedler's Pittsburgh gallery. "Sold 6 Van Boskerck's to A. W. Mellon yesterday," Carstairs wrote from New York on 10 December. "Pittsburgh very slow - Am delighted to be at home."[128]

Mellon bought additional landscapes by van Boskerck in 1899 and 1900—in one case, Walker suggests, to make his new wife less homesick for England.[129] In 1900 he purchased seven paintings from Knoedler. Apart from portraits by Raeburn and Reynolds, the emphasis was decidedly on the Barbizon school, with one work by Daubigny, two by Harpignies, and one by Thaulow. (Frick had actually acquired the Thaulow painting in 1898 and returned it to Knoedler in October 1900 for credit against the purchase of a still life by Antoine Vollon.)[130] Mellon acquired eight more paintings in 1901, this time with the emphasis divided between the Barbizon and Hague schools. The most expensive work, at $18,000, was van Marke's *Cattle in the Valley of the Rille*. The second most expensive work was a Corot landscape that cost $12,000 but was returned within three years—at a profit to Mellon of $1,000!

All of this, in the eyes of John Walker, was a waste.

During six years, through 1905, Andrew Mellon spent on paintings over $400,000, a sum equal to several million dollars today, without buying a single picture which he ultimately considered worthy of the National Gallery of Art. Thus his education as a collector was expensive and wasteful. . . .[131]

Walker's arithmetic is correct, but his point of view is misleading to those who might not share his apparent antipathy toward Barbizon painting. In the years from 1902 to 1904 Mellon bought four Barbizon paintings at high prices, and at least one of those is in an important museum collection today. The four included Troyon's *Le Passage du Bac* at $70,000, Daubigny's *Printemps à Anvers* at $29,000, and two works by Corot, *Une Idylle, Ronde des Enfants* at $63,000 and *Le Lac de Garde (View of Lake Garda)* at $70,000 (cat. 41).[132] If the other

Cat. 41. Jean-Baptiste-Camille Corot (1796–1875). *View of Lake Garda*, c. 1865–70, oil on canvas. The Nelson-Atkins Museum of Art, Kansas City, Missouri; Gift of Mr. Clark Bunting in memory of his wife, Catherine Conover Bunting [Ex. coll., Andrew W. Mellon].

three paintings approached the quality of *Le Lac de Garde,* they would demonstrate that Mellon's education, while certainly expensive, had not been wasteful. On the contrary, he had developed an excellent eye for Barbizon paintings. His shortcoming, in Walker's terms, was merely that he had not yet delved seriously into the field of old master paintings.

Paul Mellon, Andrew's son, has written and spoken eloquently of the influence upon his father, from the period of their early European travels together until well into middle age, of his great friend Henry Clay Frick.[133] Although Frick, like Mellon, was spare with words, he was the more outgoing of the two men, and as the rapid growth of his collection from 1895 onward demonstrates, he was the more enthusiastic about paintings. He collected old masters sooner and, in characteristic fashion, at a faster pace than Mellon. While there is no reason to doubt that, as an art collector, Frick was Mellon's mentor, Walker's statement that from 1900 to 1905 Mellon spent over $400,000 on eminently forgettable paintings while Frick "had bought twenty-eight pictures all up to the standard of the Frick Gallery" is as misleading about Frick as it is unfair to Mellon.[134]

During these years, as before, Frick maintained a lively interest in nineteenth-century painting of the French and Hague schools. It was not until April 1901, after all, that he took delivery of his most *outré* French painting, Dagnan-Bouveret's *Consolatrix Afflictorum.* Moreover, most of the old master works that Walker cites did not enter Frick's collection until 1903 or afterward. Frick's most pronounced quality as a collector at this stage is eclecticism. He operated on two parallel tracks, acquiring nineteenth- and early twentieth-century painting on the one hand and old masters on the other. Thus, in a single year, or more precisely, in consecutive seasons of the same year, he purchased Dagan-Bouveret's *Consolatrix Afflictorum* and Jan Vermeer's *The Music Lesson*—and for comparable sums![135] Such extremes of taste are almost unthinkable in an informed collector today.

Mellon may not have been the leader of the two collectors at this point, but his acquisition of Corot's *Le Lac de Garde* shows that he was not without influence on his old friend. Mellon bought this painting on 8 September 1902. Five months later Frick bought a work by Corot from Knoedler with the same title and virtually identical dimensions for the same price—$70,000. The Frick painting is now exhibited at the Frick Collection with the title *The Boatman of Mortefontaine* (fig. 67).[136] Both paintings relate to Corot's famous *Souvenir of*

Mortefontaine, which was exhibited in the Paris Salon of 1864 and purchased by Napoleon III.

When the day arrived in 1905 that Mellon acquired a seventeenth-century Dutch painting, Aelbert Cuyp's *A Herdsman/Woman Tending Cattle*,[137] Frick, indeed, already owned paintings by Cuyp, Wouverman, Ruysdael, and Vermeer. He did not, however, possess a Gainsborough equal in stature to that artist's *Portrait of Mrs. John Taylor*, for which Mellon paid Knoedler $115,000 on 6 September 1906.[138] In a qualitative sense Mellon was pulling even with Frick. Even though his collection was much smaller than Frick's, he had begun to match his slightly older friend in the importance of his acquisitions. Moreover, while Frick had moved to New York, Mellon, now the city's richest resident, remained in Pittsburgh, where, no doubt, the rising stature of his collection did not go unnoticed.

It should not be inferred from this comparison of Mellon and Frick that they were rivals. On the contrary, evidence suggests that these lifelong friends supported and encouraged one another. They both loved paintings, and both took pleasure in the expanding opportunities for appreciating original works of art that their means afforded. At one point in 1898, Frick wrote to Roland Knoedler,

> Regarding the fine Daubigny: I should like much to see it, but I am afraid I will not be in New York for some time. I dislike to have you go to the trouble of sending it to me, for examination. It might be, however, if I did not purchase, Mr. Mellon would be attracted by it, and he could see it at my house.[139]

Three years later, Charles Carstairs took note of the similarity in Mellon's and Frick's taste when he wrote to Mellon about a small landscape by Diaz. "It is a most charming little landscape of the highest quality, I send it because I think you will be glad to own it. It is the same character of picture as the small Diaz belonging to Mr. Frick you admired so much."[140] Carstairs was referring to *La Plaine*, which Frick had acquired from Knoedler's in September 1901. Carstairs's argument succeeded: Mellon bought the Diaz landscape for $3,000 in February 1902.[141]

Helen Frick recalled that for years her father, D. T. Watson, and "the Mellon boys" enjoyed a weekly evening of cigars and poker in the breakfast room at Clayton (fig. 68).[142] It is inconceivable that the subject of paintings would not

Fig. 67. Jean-Baptiste-Camille Corot. *The Boatman of Mortefontaine*, c. 1865–70, oil on canvas. Copyright The Frick Collection, New York.

have cropped up from time to time during these congenial gatherings in which three of the card players were Pittsburgh's leading art collectors. Doubtless, many opportunities for discussing art also arose on the Atlantic crossings that the Fricks and Andrew Mellon made together at the turn of the century.[143]

John Walker points out that through Frick, Mellon met Carstairs, who "was far more influential in the formation of American collections than is generally known."[144] Also according to Walker, M. Knoedler & Co. supplied virtually every work that Mellon bought until the 1920s, when the insidious Joseph Duveen brought the monopoly to an end. It is doubtful, however, that Mellon's relationship with Duveen's firm ever evolved into the sort of easy familiarity that developed between Mellon and Carstairs, or approached the relationship that flourished, perhaps to an even greater degree, among Roland and Charles Knoedler and Frick.

Almost no one outside his family dared correspond with Andrew Mellon, a

man of stiff and hushed formality, on a first-name basis. Certainly, Frick never
did.[145] Uniquely, at least by 1906 Carstairs had begun to open his letters to Mel-
lon with "My dear Andy." The following letter from December 1906, wherein
again Carstairs invokes Frick's name to reassure Mellon, illustrates the depth
of their mutual understanding and regard:

> My dear Andy,
> I am writing Roland to send you a photograph of one of the most beau-
> tiful Romney's you ever laid your eyes on. A charming little girl. I
> thought of you the moment I bought it as a picture that would go straight
> to your heart. The dress is white, the sash and ribbons a pretty pink & the
> sky a lovely blue and the whole picture is full of light. It was painted just
> two years later than Mr. Frick's Lady Hamilton & is of Romney's finest
> period.[146]

Mellon purchased Romney's *Miss Willoughby* for $50,000 on 11 February 1907,
and today the painting hangs in the National Gallery of Art. Carstairs's letter
demonstrates that by the time it was written he had come to know Andrew Mel-
lon as few others ever would. The friendship it documents, as John Walker
rightly suggests, was one of the most productive in the history of American art
collecting.

Frick wrote the brothers Roland and Charles Knoedler on a wide variety of topics, not only on art but also on politics, referrals, children (Helen Frick, in particular), cigars, business (Frick's as well as Knoedler's), and money. The affable Charles Knoedler, to whom Frick referred as early as 1896 as "Charlie," seemed confident enough of his client's friendship to ask him on at least one occasion for investment ideas. Frick responded diplomatically: "If I see an opportunity to advise you where you can make a little money safely, I should be happy to do so, but at present I am not in that position."[147]

Relations between Frick and M. Knoedler & Co. had reached a point by September 1902 that Frick happily advanced nearly $100,000 to the firm (at 6 percent) to facilitate the acquisition of new inventory. The ninety-day note was renewed in December, then again in January 1903 for four months. The debt was paid in full in March.[148]

An advance to M. Knoedler & Co. was doubtless a sound business proposition. A loan to Charles Knoedler (fig. 69), when he was not even a partner in the firm, was something else. The extent of Frick's solicitude for "Charlie" became evident in the summer of 1899. While vacationing with the Fricks at

Fig. 69. Numa Blanc, photographer. Henry Clay Frick, John G. A. Leishman, and Charles Knoedler at Aix-les-Bains, July 1898. Frick family archives, Pittsburgh.

Aix-les-Bains—this in itself was a sign of an unusual level of friendship—Knoedler found himself short two thousand francs owing to losses at the gaming table. Frick readily loaned him the money, but Knoedler had difficulty repaying the amount. "Please excuse me if I do not return to you the $400 (2000 frs) you were so kind to loan me at Aix, at once, but you know I draw but $50 weekly," he wrote to Frick in October, "so [I] will have to save up, when I will send a little check for the above, please be lenient with me and I hate to ask you to wait but such is the case, unless I can call in some of my large loans to numerous friends of mine."[149]

Frick was understanding. "That little personal matter you refer to need not give you any trouble," he wrote the next day. "Any time convenient to you will answer for that."[150] Frick may have been flattered that Knoedler had mentioned that his brother Roland "had lunch with Mr. [Philander C.] Knox today. He wants another picture. I will see that he gets it. We will (you and I) pick it out for him."[151]

Charles Knoedler was obliged to go to Frick again the following spring, this time even more apologetically than before.

> Please pardon me a thousand times [Knoedler wrote on 26 April 1900] for the liberty I am taking in asking of you an exceptional favor in helping me out of a little trouble I have gotten into, you have been so good to me, in fact to our firm in general, that I feel prompted that you will be of assistance to me in this trying moment. I had a very good tip from a friend to buy Steel & Wire & it went the wrong way. I have never speculated and never intended to but for this opportunity, I did & now I am out considerably more than I have in bank, so I come to you dear Mr. Frick as my saviour to ask you to advance me $1200. . . . It is asking a great deal of you I know but I trust you will forgive me this time, as at Aix when you so kindly lent me two thousand francs, when I promised you faithfully not to venture at the game again & now here I am asking you to do me another favour. I am really ashamed of myself, but it cannot be helped, the deed has been done, encouraged by another as a sure thing. I give you my word that hereafter no gambling & speculating will ever enter my mind. . . . I promise to return to you your kind loan as soon as I possibly can. . . .
>
> P. S. Of course, I beg you not to speak of this to a living soul. I hope you can trust me![152]

This time Frick's reply, though avuncular, was less forgiving.

> I have always been greatly interested in your welfare, as you know, but I cannot see why I should advance you $1,200, - especially in view of the fact that you still owe me the 2,000 francs. . . .
>
> You must learn to keep your promises, my dear Charles, before you can expect your friends to extend you credit.
>
> Your best plan would be to go frankly to your brother Roland and explain your situation. I am quite sure he would gladly settle all these little affairs for you, and would much prefer it than to have you ask an outsider.
>
> You ask me not to say anything about this to anyone, and of course I shall be governed accordingly, - but I shall be in New York on Monday and I think it would be well, if you do not care to speak to Roland, to let me do so for you.
>
> I have great respect for your business ability if you would devote yourself to the business and would not object, of course, to your having a good time after business hours. You should, however, above all things avoid speculation and stick to your legitimate business.[153]

It is difficult to imagine Andrew Mellon engaging in a comparable correspondence with anyone outside his family. Knoedler's records, in any case, reflect very intermittent buying on Mellon's part between 1906 and 1911, which may owe to serious personal matters, such as the deaths of his parents in 1908 and 1909, and the disintegration of his marriage by 1909. (His divorce petition was filed in 1910 and the decree granted in 1912.) Other reasons for the temporary slowdown are difficult to surmise. The two most significant purchases he made during these years were George Romney's *Miss Willoughby* in 1907 and *Mortlake Terrace: Early Summer Morning* by J. M. W. Turner for $70,902 in 1908.[154] These paintings were shipped to Pittsburgh and hung in Mellon's relatively modest house at 5052 Forbes Avenue, a dwelling whose "silence and gloominess" made a lasting impression on his young son.[155] Today Turner's *Mortlake Terrace* (fig. 70) hangs with other British paintings in the library at the Frick Collection in New York City. As if to repay a debt to a fellow collector, Mellon sold this painting to Frick in 1909 and later acquired a companion piece, *Mortlake Terrace, the Seat of William Moffatt, Esq.: Summer's Evening*, which now hangs in the National Gallery of Art.[156]

Indeed, the National Gallery today holds four paintings that Mellon owned by 1912, when he still lived on Forbes Avenue. These are, in addition to *Miss Willoughby,* Sir Henry Raeburn's *Mrs. George Hill,* Thomas Gainsborough's *Mrs. John Taylor,* and Cuyp's *Herdsmen Tending Cattle.* It would be many years, of course—not until he was secretary of the United States Treasury—before Mellon actually formulated the idea of establishing a national museum of art modeled after the National Gallery in London's Trafalgar Square.[157]

Had Mellon's collection, as he formed it, eventually entered the Carnegie Institute, and had the Institute also fallen heir to the collections of Lockhart, Byers, Frick, and Watson, the Carnegie galleries certainly would have borne the indelible, if not exclusive, stamp of M. Knoedler & Co. Knoedler's stature in Pittsburgh is suggested by a single statistic: during the four years from 1898 to 1901, the firm's sales to four Pittsburgh collectors—Byers, Frick, Watson, and Mellon—accounted on average for 25 percent of the firm's gross revenues. In one of those years, 1899, the figure was as high as 30 percent. Considering all the cities in which Knoedler had clients, Pittsburgh's importance to the firm was certainly out of proportion to the city's size. It is also worth noting that Pittsburgh was the only U.S. city in which Knoedler maintained a branch in this period.[158]

The flood tide of Pittsburgh patronage of Knoedler, at least in terms of numbers of clients and purchases, began to ebb in 1906. M. Knoedler & Co. closed its Pittsburgh gallery in 1907, and Carstairs went to head the London branch. Even though Frick, Watson, and Mellon would remain important Knoedler clients for the rest of their lives, the heyday of collecting *in* Pittsburgh (as opposed to collecting *by* Pittsburghers) was drawing to a close. During the nearly half-century from 1864 to 1911, Knoedler transacted business with seventy-five Pittsburgh clients who purchased almost six hundred works of art. Although Lockhart, Byers, Frick, Watson, and Mellon may have accounted for nearly half this number, the other half, spread among seventy Pittsburghers, is still impressive. Almost three-quarters of the activity occurred over a dozen years at the height of the Gilded Age, from 1894 to 1905. A tally of acquisitions from M. Knoedler & Co. reveals that the gallery's Pittsburgh clientele as a whole was less venturesome than the five collectors discussed in depth here. The average collector displayed little inclination to stray from the tried-and-true in French or French-inspired painting, lacking either the commitment or the funds, or both, to venture into the field of old masters.

The popularity of Robert W. van Boskerck (fig. 71), who was represented by at least forty-eight paintings in the city, can be explained only by Knoedler's merchandising skill on the one hand, and the general Pittsburgh clientele's appetite for pleasant, relatively inexpensive wall decoration on the other. The fashion for portraits by Théobald Chartran—twenty-two of his works were in Pittsburgh—also may owe as much to Knoedler's merchandising as to anything else, except possibly, the artist's ingratiating personality. The only portraitist to approach Chartran in popularity in Pittsburgh during the Gilded Age was Raymundo de Madrazo (fig. 72), who supplied a dozen or more likenesses to Pittsburgh families. Works by John Singer Sargent, the ultimate Gilded Age portraitist, were nowhere in sight.[159] Even Cecilia Beaux, a frequent Carnegie Annual exhibitor whose work Frick had coveted in 1897, had few sitters in Pittsburgh. Chartran's precision and crisp brushwork endowed his Pittsburgh "men of affairs" with a clear-eyed assertiveness that must have bolstered their self-esteem. To be fair, his popularity with this oligarchy does it no disservice. It is, however, far more difficult to understand how such collectors could have overlooked the mediocre talent of van Boskerck.

After van Boskerck and Chartran, who represent rather specialized situations, the artist most favored by Knoedler's Pittsburgh clients was Corot. The

Fig. 70. J. M. W. Turner. *Mortlake Terrace: Early Summer Morning*, 1826, oil on canvas. Copyright The Frick Collection, New York.

Fig. 71. Robert W. van Boskerck. *Sussex Cottage*, c. 1899, oil on canvas. Frick Art & Historical Center, Pittsburgh.

first Pittsburghers to purchase a work by Corot from Knoedler were Mary Copley Thaw and her soon-to-be-infamous son Harry, who bought *Early Morning Pastoral* in 1893 for $7,100.[160] Other paintings by Corot that were acquired from Knoedler were in the residences of Lawrence Phipps, George and James Laughlin, and E. D. Speck, as well as in the Byers, Frick, Mellon, and Watson collections. Since most of the twenty-one works by Corot that Pittsburghers purchased from Knoedler, as well as those obtained elsewhere, have been lost, it is impossible to assess their quality or even their authenticity. In Pittsburgh society, as in the Chicago society of Henry Fuller's satirical novel *With the Procession*, owning a work by Corot was a status symbol. "We haven't got a Millet yet, but that morning thing over there is a Corot—at least, we think so," declared Fuller's Mrs. Bates of Chicago. "People of our position would naturally be expected to have a Corot."[161] Fortunately, at least some of the Corots in Pittsburgh, especially the views of Lake Garda that were owned by Andrew Mellon and Henry Clay Frick, as well as A. M. Byers's lyrical *Danse des Nymphes*, brought genuine distinction and status to the city.

Although the number of Corots purchased from Knoedler was more than double the ten works by William-Adolphe Bouguereau that the art dealer could

Fig. 72. Raymundo de Madrazo. *Portrait of Jane Eliza Kennedy*, 1904, oil on canvas. Collection of Eliza Smith Brown, by gift of Templeton Smith, Pittsburgh.

place in Pittsburgh collections, Bouguereau, rather than Corot, was Pittsburgh's favorite French painter by a wide margin. Pittsburghers acquired at least thirty paintings by this archetypal *pompier* artist. Even considering Bouguereau's enormous popularity in the United States, which may even have surpassed his reputation in his native France, Pittsburgh's love affair with this artist was phenomenal. Unlike Corot, whose works were concentrated in less than ten Pittsburgh collections, a painting by Bouguereau could be found in at least two dozen residences in the city. These included a few early works, such as the 1868 Salon painting *The Dance* (cat. 77), but more typically they were formulaic paintings from the years 1894 to 1901. Scenes of mischievous gamines, sultry peasant girls, dreamy maidens (cat. 42), or mothers caressing rosy-cheeked babies were all associated with this accomplished purveyor of academic perfection. A large, full-length, single-figure composition, such as Henry W. Oliver's *Rêverie* of 1894, cost $6,000 in January 1900. The following year Lawrence Phipps and Alexander Peacock each paid $9,000 for their double-figure compositions, *Idylle Enfantine* of 1900 (cat. 76) and *Mère et enfant* of 1901.[162] Although Frick disposed of his, and neither Watson nor Mellon had one, owning a painting by Bouguereau constituted one of the defining elements

of taste in Pittsburgh during the Gilded Age. If one were reconstructing a typical Pittsburgh collection, works by Bouguereau and Corot would have to be included.

Also essential to the typical Pittsburgh collection would be paintings by the following artists, who are listed here in descending order of popularity according to the number of paintings sold by Knoedler to Pittsburghers.

Cazin	19	Daubigny	10
Knight	17	Ziem	9
Mauve	15	Maris	9
Rico	15	Romney	9
Diaz	13	Troyon	8
Chelminski	13	Jules Dupré	8
Harpignies	12		

If we were to furnish a typical Pittsburgh mansion of circa 1903, we would hang portraits by Chartran symmetrically in the dining room or front hall and give pride of place to the paintings by Corot and Bouguereau in the reception room. Perhaps we would add a silvery work by Knight to this arrangement, which would complement the delicate, allegorical composition by Diaz. The Venetian scenes by Rico and Ziem might also be hung in the dining room, where they could be admired and compared during six-course dinners. The most important Barbizon works—those by Troyon, Daubigny, and Dupré— would be arrayed on a drawing room wall on axis with the entrance hall, so they would not escape the notice of arriving guests. Paintings by Cazin and Harpignies, and perhaps a watercolor by Mauve would also be hung in the drawing room, framed in deep, foliated, gilded mouldings. Chelminski's representation of a detachment of Napoleon's cavalry lost on a wintry plain would reinforce the masculine atmosphere of the billiard room or library,[163] along with a scene by Maris, which most likely depicts an exhausted peasant leaning into a horse-drawn plow. A landscape by van Boskerck would brighten a guest bedroom, as the walls of the master bedroom already have been covered with framed family photographs. This leaves the portrait by Romney, the only eighteenth-century work in the collection and the only one outside the French tradition. As probably our most recent and most expensive acquisition, it deserves a prestigious spot over the fireplace mantel in the reception room or

Cat. 42. William-Adolphe Bouguereau (1825–1905). *L'Iris (Woman with Iris)*, 1895, oil on canvas. The Art Museum, Princeton University, Gift of Mrs. William Hodge Burchfield in memory of her husband, William Hodge Burchfield, and her son, Thomas Howell Burchfield [Ex. coll., William Hodge Burchfield].

the sitting room, where it can be seen by Mr. and Mrs. Henry Clay Frick when they come to dinner!

This fictitious installation implies that the collection was assembled merely to furnish the house and impress guests. The harshest critics of the Gilded Age would resist any other conclusion. For our part, it would seem reasonable to allow for a certain degree of social ambition, or at least, social competitiveness, but we should look further for nobler motives on the part of many collectors. One such motive, the quest for "sweetness and light," as Andrew Carnegie put it, has been convincingly explored by Kenneth Neal in his study of the birth of the Carnegie Annual exhibitions.[164] While the members of Carnegie's Pittsburgh circle, which included all of the collectors discussed here, may not have subscribed fully to the great man's every pronouncement on the educational purpose of art exhibitions, the Carnegie philosophy reflected the prevailing view in late nineteenth-century America strongly enough to have been accepted throughout the upper reaches of the business and social communities.

However unpleasant industry's side effects may have been in Pittsburgh, its high profitability allowed successful businessmen to pursue art collecting, and M. Knoedler & Co. was their primary facilitator. The nearly six hundred works acquired from the New York firm gave evidence of a growing appreciation of the fine arts that went far beyond the demands of interior decoration and social advancement. Unwittingly or not, these collectors participated in a national search for cultural legitimacy, one in which rich Americans everywhere indulged through the acquisition of European art. The wonder is not that Pittsburghers collected art, or even why, but that they collected so much and that awareness of their collections was so ephemeral.

Art collections formed in Pittsburgh during the Gilded Age have been forgotten not because two of the city's major collectors, Frick and Mellon, left their collections in other cities, but because the great precedents of New York and Boston, where the collections of art museums were built jointly by a number of individuals, were not repeated in Pittsburgh. Andrew Carnegie had other ideas: he was the sole founder of his Pittsburgh institution, and though physically in the background, he was in charge of it. At one point, John Caldwell, chairman of the Fine Arts Committee, complained to John Beatty, "What can we do but approve the suggestion or action of AC and his friends?"[165]

It is intriguing to speculate what might have happened in Pittsburgh had there been no Andrew Carnegie. Would the circle of collectors around Chris-

tian Wolff or their descendants have banded together and founded an art museum? The enthusiasm surrounding the 1879 Library Loan exhibition suggests that eventually they might have. Even so, nothing had happened by 1890, and the way was open for Carnegie, the pre-eminent Pittsburgh industrialist and a man far richer than Lockhart, Byers, Frick, Mellon, or anyone else then living in Pittsburgh, to found a library and art gallery on his own terms.

Although Carnegie carefully established a local, Pittsburgh governing board of "men of affairs" who observed regular business procedures in handling his magnificent benefaction, in a practical sense these men, or some of them at least, were bound to feel constrained advancing their own independent notions. For example, Frew, the president, appears to have accepted compensation from Carnegie personally for his services to the Library.

Carnegie's specific wishes concerning the nature and scope of his institution prevailed for many years after its founding in 1895.[166] There can be no more concrete indication of Carnegie's order of priorities than the fact that in the original building, seven galleries were set aside for the Carnegie Annual exhibition, while only three were assigned to a permanent collection of art. This permanent collection, furthermore, was not intended to survey the history of art. Instead, it was conceived as a forward-looking "Chronological Collection," which would begin with two examples of the art of 1896 and grow organically, year by year, through the addition of two paintings purchased from each successive Carnegie Annual exhibition.[167] Even though Beatty grew increasingly opposed to this peculiarly Carnegiesque idea for both practical and philosophical reasons, it prevailed for some years. In 1907, as the Institute building was being enlarged, Carnegie wrote to his board of trustees, "The Art Department should not purchase Old Masters, but confine itself to the acquisition of such modern pictures as are thought likely to become Old Masters with time. The Gallery is for the masses of the people primarily, not for the educated few."[168]

When confronted with this philosophy, it is no wonder that Pittsburgh collectors, especially those who had begun to acquire old master paintings, did not earmark their art collections for Carnegie Institute, even when they had loaned their works to Carnegie exhibitions. Also, although Andrew Carnegie provided an initial purchase endowment, which he later augmented, this did not generate as much money for art acquisitions as either the exhibiting artists or Beatty would have liked. Nor did trustees or members of the Fine Arts Com-

mittee, despite their personal wealth, reach into their own pockets and contribute additional funds. Frick's statement in January 1897 that the Carnegie Art Commission could not afford to purchase a painting by Corot begs the question why neither he nor others of substantial means provided funds for acquisitions.[169] (The statement was made as Frick was on the point of spending $67,500 at Knoedler's for three Corots.) Again, the answer lies in Carnegie's founding mission, which focused on education. His view of education for the masses did not include instruction in the humanities as interpreted in original works of art handed down through the centuries. If other business leaders of Pittsburgh disagreed with Carnegie's philosophy, they kept their dissent off the record. The question of supplementing Carnegie's benefaction with a permanent, historically oriented art collection contributed by others seems never to have been discussed. Only many decades later would large donations be invited—and received—from other Pittsburgh philanthropists.

It is ironic that when Carnegie's philanthropy had done so much to encourage private art collecting in Pittsburgh, the same man's overwhelming presence and generosity inhibited the natural process by which, in virtually every other major American city, private collections were donated to museums for the public good. Such, apparently, was his power that in the entire art collecting community of Pittsburgh, no one ventured on an alternative course. Since the very galleries whose opening in 1895 provided such tremendous stimulus to personal collecting did not seek art collections on a permanent basis, the private art collections of Pittsburgh went their own, separate ways.

For almost fifty years after Charles Lockhart's death in 1905, the Lockhart collection, minus a few choice pieces that went to his children, remained virtually intact in the custody of Lockhart's daughter Martha and her husband Henry Lee Mason. Mason occupied the brooding mansion at 608 North Highland Avenue until he died in 1951. As the couple had no direct heirs, Mason bequeathed nine paintings to Carnegie Institute, leaving the rest of the collection to be divided among nieces and nephews. Of the nine paintings in the bequest, three remain in the permanent collection, and the others were deaccessioned.[170] More recently, Lockhart's painting by Daubigny, *My Houseboat on the Oise* (cat. 12), and his two North African subjects by Gérôme, *Night in the Desert* (cat. 47) and *The Lion and the Butterfly*, have been donated to the Carnegie Museum of Art by fourth- and fifth-generation Lockhart descendants. The rest of the collection either remains in family hands or has been sold.

The Byers collection was essentially intact, though under divided owner-ship, until after the A. M. Byers Memorial exhibition was held at Carnegie Institute in 1932. Much later, Fromentin's *Return from the Fantasia* entered Carnegie Institute as the gift of Byers's daughter-in-law. *Her* daughter-in-law gave Romney's *Maria and Katherine, Daughters of Edward, Lord Chancellor, Thurlow* to Yale University Art Gallery in memory of her husband in 1977. All the rest of the A. M. Byers collection has been dispersed, except for a small number of works that still belong to Byers's descendants.

Twenty-one paintings that Henry Clay Frick bought between 1896 and 1904 to hang in Clayton were included in the original deed of trust that established the Frick Collection, and they remain in New York City today. Many more are on display in Clayton and The Frick Art Museum.

Unique among Pittsburghers, D. T. Watson stipulated that upon his demise, his collection should be sold to establish a hospital. The D. T. Watson Home for Crippled Children (now D. T. Watson Rehabilitation Services) was built on Watson's farm property near Sewickley with the proceeds of a sale that took place in 1917. In February of that year, Watson's executor, John Freeman, offered the collection to Frick, but Frick declined.[171] R. B. Mellon bought a number of paintings at the Watson sale for his house at 6500 Fifth Avenue in Pittsburgh, and Mellon's two children, Sarah Mellon Scaife and Richard King Mellon, donated three of these works to Carnegie Institute in 1941: Jules Breton's *L'Aurore* (cat. 72) and Murillo's *Madonna and Child* and *The Beggar Boy*. The Breton is preserved at the Carnegie, but the Murillos have been deaccessioned.[172]

Andrew Mellon designated four of the forty-seven paintings he purchased from Knoedler's between 1896 and 1911 to the National Gallery of Art. Another of his major early acquisitions, Corot's *View of Lake Garda* (cat. 41), is in the Nelson-Atkins Museum of Art. The whereabouts of the rest of his early collection is unrecorded, with the exception of Chelminski's *Mounted Grenadier and Aide-de-Camp of Napoleon* and Singleton's *Portrait of a Lady*, both of which have been inherited by a collateral descendant.

While the pride of Pittsburgh may have suffered over the loss of the Frick and Mellon collections, all but the most chauvinistic Pittsburghers must recognize that the country and the world as a whole have been extremely well served by the benefactions of these two men. The service of the D. T. Watson Home is also quite beyond measure.

Figs. 73,74,75. Auction catalogue of paintings from the Peacock collection sold 10 January 1922. Notations are in Mrs. Irene Peacock's hand.

EVENING SALE

TUESDAY, JANUARY 10, 1922

IN THE GRAND BALLROOM OF

THE PLAZA HOTEL

FIFTH AVENUE, 58TH TO 59TH STREET

BEGINNING AT 8.30 O'CLOCK

ORDER OF SALE

1—MARTIN RICO
A Canal Scene in Venice

Height, 28½ inches; width, 18 inches

800

2—J. H. WEISSENBRUCH
Coast of Zeeland

Height, 13 inches; length, 19 inches

1300

3—JOSEPH MALLORD WILLIAM TURNER, R.A.
Glencoe (*Water Color*)

Height, 4 inches; length, 6 inches

500

handwritten: 122,875 00

40—FÉLIX FRANÇOIS ZIEM

Fête Day: Venice

Height, 27 inches; length, 44½ inches

handwritten: 6000 00

41—THOMAS FAED, R.A.

Homeless

Height, 46¼ inches; width, 34¼ inches

handwritten: · 3000 00

42—DANIEL RIDGWAY KNIGHT

French Fisher Girl

Height, 46¼ inches; width, 35¼ inches

handwritten: 1100 00

43—WILLIAM ADOLPHE BOUGUEREAU

The Mother

Height, 61 inches; width, 31¾ inches

handwritten: 3050 00

44—PETER GRAHAM, R.A.

A Spate in the Highlands

Height, 52½ inches; width, 39 inches

handwritten: 3300 00

handwritten: 1393

AMERICAN ART ASSOCIATION,

Managers.

THOMAS E. KIRBY,

Auctioneer.

With too few exceptions, however, the remaining jewels of art collecting in Pittsburgh during the Gilded Age have vanished without a trace. Each collection must have met with its own fate. Changes in taste, an enemy perhaps common to all, may have had the most devastating effect. The Gilded Age had begun to play itself out by the time Knoedler's sales to Pittsburgh showed a sharp decline. A new generation of collectors with a different viewpoint was maturing even as the world itself was approaching the upheaval of World War I. With some advantage of hindsight, Marjorie Phillips, wife of Duncan Phillips and his partner in the formation of The Phillips Collection in Washington, D.C., wrote of her husband's Pittsburgh upbringing (he was a grandson of James Laughlin, co-founder of the Jones and Laughlin Steel Company).

> The old mansion of his grandparents where Duncan was born and lived until his seventh year made a deep impression on him: He felt the dignity of the great, high-ceilinged rooms—especially the drawing room with its gilded, arched mirrors from floor to ceiling. The large paintings with huge shadow box frames did not appeal to him at all—they were of the dark school of Fontainebleau.[173]

It would not be long before others felt the same way about the paintings collected in the Gilded Age. A growing preference for the art of Georgian England as well as colonial and federal America on the one hand, and for Impressionism, Post-Impressionism, and other new styles on the other, posed a stiff challenge to the prevailing aesthetic at the turn of the century. Art-conscious members of the younger generation began to see the art of the nineteenth-century Salons in the same light as Frick's generation might have viewed paintings such as *Mamma's Cap* by Gesselschap, the first one imported into Pittsburgh from M. Knoedler & Co.: such works were hopelessly simple-minded and unworthy of serious attention. Monetary values of Barbizon and Salon painting plummeted. In 1922, when Alexander Peacock was forced to sell the fine collection he had assembled in the early 1900s, *The Mother* by Bouguereau, for which he had paid $9,000 twenty-one years earlier, was sold for only $3,050 (figs. 73–75).[174] Prices realized at the auctions of works deaccessioned by Carnegie Institute in the 1960s reflect yet a more disastrous devaluation, even allowing for doubtful attributions.

Recently the trend has reversed, and many artists prized during the Gilded Age have come back into fashion. Captain Vandergrift's painting by

Bouguereau, *La Petite Vendangeuse*, which never left Pittsburgh, was auctioned in 1994 at Sotheby's New York for $240,000.[175] Important works by Gérôme now command prices higher than a three-bedroom apartment in New York City, and Alma-Tadema has recovered even more dramatically since the 1960s, when television personality Allen Funt began collecting the artist's paintings because he had been told they were by "the worst painter of the nineteenth century."[176] The major international auction rooms schedule sales of nineteenth-century paintings, drawings, and sculpture in New York two or three times a year, while one auction house, Christie's, annually holds a sale of Barbizon, realist, and French landscape painting. The total realized from sixty lots offered for sale at Christie's on 22 May 1996 was $6,402,340, which included $3,412,500 for Millet's *La Cardeuse*, a painting that passed through M. Knoedler & Co. during the Gilded Age.[177]

In reality, the inspiration for this entire investigation owes a great debt of gratitude to the roller-coaster fortunes of the art collected in Pittsburgh during the Gilded Age. Had these great collections survived intact in the city—a fantasy that can be entertained only because of its very unfeasibility—our story would be redundant. Had the reputations of so many artists greatly esteemed before World War I not perished soon afterwards, only to be revived dramatically in our own time, our story would lack immediacy and credibility. As it is, we can now see the achievements of these art collectors in a clear light, understanding what Pittsburgh gained, what it gave to the world, and sadly, what has been lost.

Notes to this essay appear on pages 366–74.

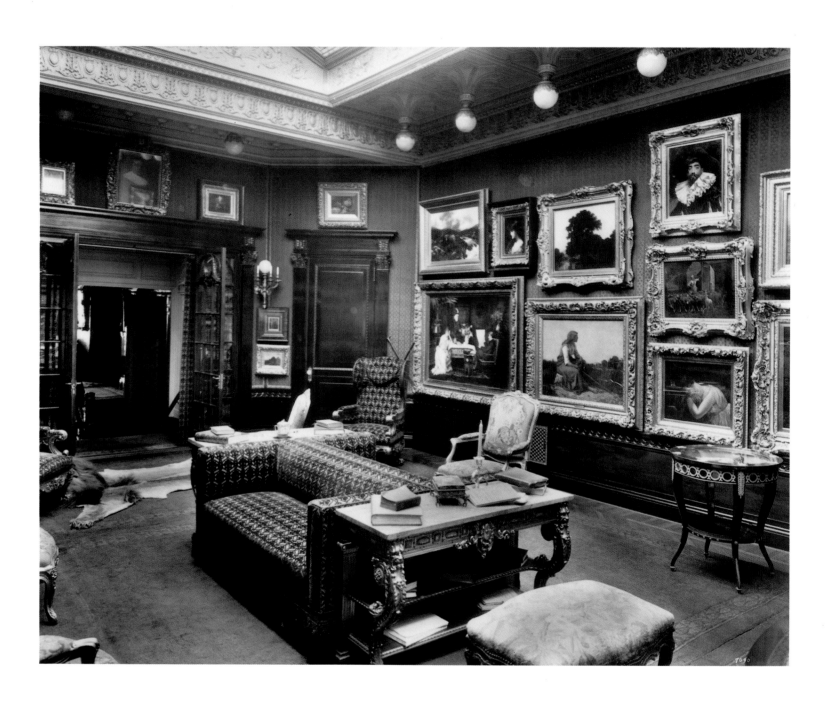

From Paris to Pittsburgh

Visual Culture and American Taste, 1880–1910

Gabriel P. Weisberg

IN THE DECADES AFTER the Civil War, American capitalism established a distinct civilization, one unconnected to native traditions in the United States. At its core members of this "new" civilization fervently endeavored to acquire cultural refinement and thereby create a look of gentility that passionately embraced a Eurocentric attitude.[1] With the arrival of imported elegance, many Americans tried to convey the impression that they had achieved a status equal to the European gentry.[2] The "cult of the new" spread to all major American cities as the sponsors of this new aesthetic acquired and exhibited works of art. They fostered a somewhat regal attitude, as if they had achieved aristocratic distinction, and they were eager to monitor taste, set patterns of social contact, and exercise control.[3] Leading families in New York, Philadelphia, and Pittsburgh satisfied their desire for status by becoming patrons of the arts. It actually mattered little which arts received their support: prestigious families became active in the theater, built lavish opera houses, and established museums. This desire to become cultured led many Americans to Europe and its centuries-old traditions, for they believed that only in Europe could they find the heritage that they so lacked in the United States.[4]

Thus, in the period from 1880 to 1915, as the number of wealthy families increased, Americans flocked to Europe to obtain culture. Trips to Italy became commonplace, and England and Scotland remained popular spots on their version of the Grand Tour. During the late 1880s Americans regularly toured Europe throughout the summer and into the fall, visiting sites, shopping, and making contacts with European bankers to continue their financial activities while abroad. Many Americans, thinking they should become more knowledgeable about the visual arts, attended the annual spring exhibitions in Paris. They obtained works from reputable dealers, such as Goupil et Cie and its successor, the firm of Boussod, Valadon et Cie in Paris, or M. Knoedler & Co., with its offices in Paris and New York.[5] In so doing, they believed they could

Fig. 76. Photographer unknown. Interior of the Charles Lockhart painting gallery showing *The Turkey Tender* by Jules Breton (right), c. 1899, Lockhart photo album. Collection of Mr. James M. Edwards, Pittsburgh.

Also see figs. 42–44.

raise American standards of appreciation by purchasing either works with an established provenance or pieces that represented the latest in contemporary European art.

Interestingly, those in Pittsburgh who became aware of contemporary European art did so with the assistance of advisors and with the foreknowledge that they had to travel overseas to locate an active art market. Like Americans elsewhere, they entered into a curious relationship with English and French collectors in an effort to form substantial art collections that testified to their status and refined sensibilities. Such acquisitions required adequate space for display, which led to the formation of several public and private art galleries.[6]

The establishment of private art collections in Pittsburgh therefore reflects tendencies in several American cities. Many individuals showcased collections in their homes. H. K. Porter and Charles Lockhart, for example, constructed art galleries in which family portraits and objects acquired in New York and Europe were displayed without any cohesive aesthetic plan (fig. 76).[7] Works were exhibited based on available space, with paintings hung two, three, and four high, as they were shown in fashionable exhibitions in New York, London, and Paris. Other collectors, such as Henry Clay Frick and A. M. Byers, positioned objects throughout their homes, giving the impression that they actually lived surrounded by art.[8] Paintings were arranged according to personal preference or symbolic association.[9] Whatever the reason for accumulating art objects, collections proliferated among the wealthy families of Pittsburgh. They acquired works by all types of painters, some of whom are now almost completely forgotten.

The Formation of Collections

The creation of art collections in the United States was not endemic to any one region or decade.[10] As elsewhere in the country, patrons in Pittsburgh fostered an artistic preference that largely resulted from their relationships with art dealers here and abroad.[11] These dealers obviously endorsed contemporary artists, especially those who had already launched successful careers. It would have been highly unusual for their nascent American clients to take a chance on unknown or radical artists.[12] Except for a few with personal ties to the Impressionists, collectors in Pittsburgh acquired works that reflected the prevailing art market and were likely to increase in value.[13] A uniformity of vision and pattern of collecting developed among art patrons across the country, whether

they lived in Philadelphia or Baltimore, acquired works in Chicago, or formed art collections in Pittsburgh.[14]

By the middle of the nineteenth century, collectors in Boston were known for their appreciation of Barbizon artists.[15] Collectors throughout the country soon followed suit,[16] and works by Camille Corot (cat. 41), Théodore Rousseau, and Jules Dupré were in high demand. Other aesthetes in Boston acquired paintings by Jean-François Millet (fig. 77),[17] which led those interested in Millet, such as Henry Clay Frick, to assess their purchases against works in collections in Boston and elsewhere on the East Coast.[18]

A decided change occurred in the last decades of the nineteenth century, when American collectors, spurred on by their European counterparts, turned their attention to realist paintings and anecdotal genre scenes.[19] Works by painters favored in the Parisian Salons soon appeared in the collections of industrialists John Jacob Astor and William H. Vanderbilt.[20] By the 1880s articles in the *New York Times* commented on how Americans were casting aside their penchant for British painting and English portraiture in the vein of Thomas Lawrence and Joshua Reynolds to follow the fashion for French art.[21]

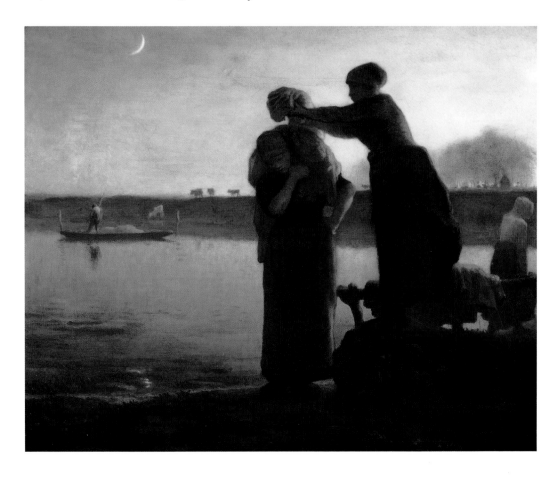

Fig. 77. Jean-François Millet. *Washerwomen*, n.d., oil on canvas. Bequest of Mrs. Martin Brimmer, Courtesy, Museum of Fine Arts, Boston.

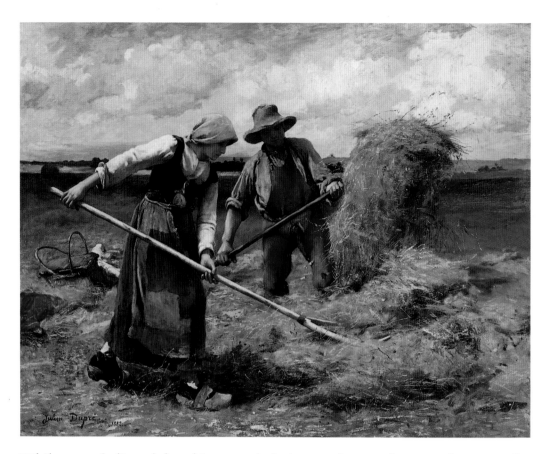

Cat. 43. Julien Dupré (1851–1910).
The Wheatfield, 1882, oil on canvas.
Allegheny Cemetery, Pittsburgh; Given
in memory of William C. Moreland.

While some believed that this overwhelming preference for French art was far
too obsessive, many collectors on the East Coast, including Astor and Vander-
bilt, acquired works by Jean-Léon Gérôme, Jean-Louis-Ernest Meissonier,
Edouard Detaille, William-Adolphe Bouguereau, Julien Dupré (cat. 43), Fer-
dinand Roybet (fig. 78), Jean-Jacques Henner, Constant Troyon, Rosa Bon-
heur, Alexandre Cabanel, Millet, and eventually Jules-Adolphe Breton. These
painters had established reputations in France, their works were actively pro-
moted by dealers, and their canvases and careers received increasing attention
in American and international art journals.[22]

The fame of East Coast collections, including those formed by John G.
Johnson in Philadelphia and the department store magnate John Wanamaker,
spread by word of mouth and through articles published in lavishly illustrated
catalogues.[23] Collectors in Pittsburgh quickly became sophisticated and secure
in their artistic tastes, and the focus of their collections gradually shifted to the
contemporary art that was being promoted by the leading art dealers in New
York and Europe.[24]

The formation of American painting collections during the last decades of
the nineteenth century was also sparked by several interconnected issues. Cer-

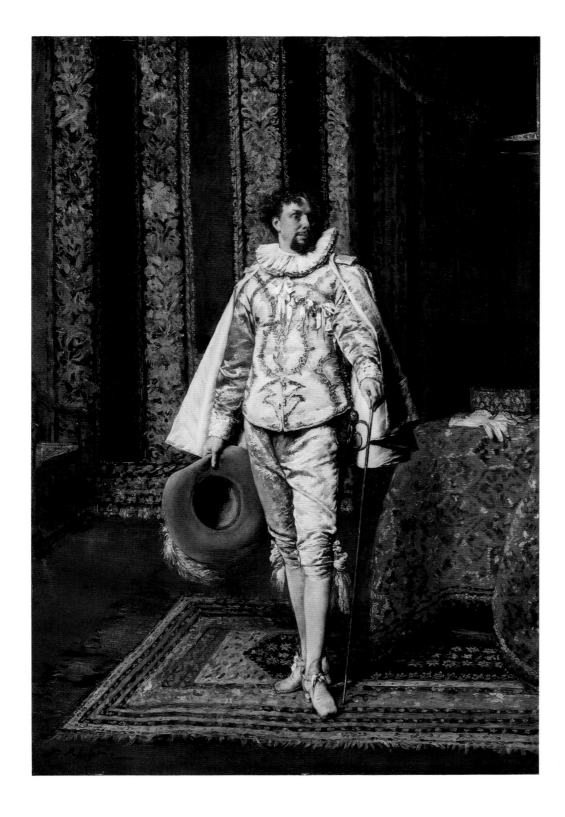

Fig. 78. Ferdinand Roybet (1840–1920). *A Cavalier*, n.d., oil on canvas. Carnegie Museum of Art, Pittsburgh; Gift of Joy Manufacturing Co.

Fig. 79. Daniel Ridgway Knight. *Woman in a Garden Cutting Roses*, n.d., oil on canvas. Cliché Musée Goupil, Bordeaux, France.

Fig. 80. Pascal-Adolphe-Jean Dagnan-Bouveret. *The Accident* (first version), 1880, oil on canvas. Cliché Musée Goupil, Bordeaux, France.

tain art galleries, especially Goupil et Cie in France, realized that they could better promote artists by using illustrations and the power of the press to attract a larger public audience. To achieve this aim, Goupil et Cie expanded its operations and teamed up with American publishing firms to promote works through engraved or photomechanically reproduced illustrations.[25] Featured artists, including Jean-Léon Gérôme, Daniel Ridgway Knight (fig. 79), and even Pascal-Adolphe-Jean Dagnan-Bouveret (fig. 80), owed a large part of their popularity to the reproductions of their works that Goupil sold.[26] This effective and lucrative means—artists received a percentage of the sales—made it easier for painters to find new patrons, and reproductions helped collectors recognize familiar styles and subject matter.[27]

Despite this apparent homogenization of taste, collectors firmly believed that they were acquiring and exhibiting the best works of art their money could buy. Since these industrialists often thought in financial terms, they considered their paintings an investment that would increase in value through exhibition and public demand. Admittedly, some objects were secured with a greater sense of competition and were displayed to arouse comment and envy.[28] Never before had such an interest been expressed in securing objects for homes and new museums. As a result, an extensive art trade grew in America. Art dealers who

promoted certain artists through an international network of contacts became crucial figures in aiding would-be collectors to develop their own artistic preferences.

The Pittsburgh Situation

Collectors in Pittsburgh—Charles Lockhart, H. K. Porter, Andrew Carnegie, and eventually Henry Clay Frick, among many others—entered the international arena of collecting paintings after they had become millionaires.[29] Since they were in continuous contact with one another, their collecting habits exhibited similar characteristics as they forged their common interest in culture. Each of these traits is worth examining in some detail, since together they provide a way to understand why works by certain painters were collected in Pittsburgh.

These gentlemen and others in Pittsburgh became increasingly aware of the art world through travel to New York, Philadelphia, Boston, and Chicago, and even further afield to England and France. Local newspapers from the late 1880s and throughout the 1890s frequently describe trips made by leading Pittsburgh residents.[30] Articles offer details of the hotels they stayed in and the length of time they spent abroad in the pursuit of culture.[31] Frick, for example, frequently traveled with friends and family members to England (fig. 81) and France (fig. 82), and on one occasion rented a schooner to sail along the coastlines. On other occasions he visited Germany or Switzerland (fig. 83), where he traveled in the company of artists or the art dealer Roland Knoedler.[32] These trips were recorded in letters, diaries, and newspapers, and were frequently photographed. References to the travels of Pittsburgh visitors (especially those who had become major collectors of French art) occasionally appeared in French newspapers or in the international edition of the *New York Herald*.[33] Gossip columns covered their activities and noted the ways these visitors lived and dressed, which fueled the growing public curiosity about Americans. Through such press coverage Pittsburgh collectors became known to numerous art dealers, to artists eager to make their acquaintance, and to others who were willing to place their private collections at the Americans' disposal.

During these excursions into the art world, Pittsburgh collectors forged close ties with both dealers and artists. Records of the Knoedler gallery in New York, for example, are filled with references to sales to Pittsburghers, especially to Henry Clay Frick.[34] During the 1890s European painters regularly toured American cities, starting in New York and heading westward towards the *mil-*

Fig. 81. Passenger list from R.M.S. *Campania*, New York to Liverpool, 14 July 1894. Frick family archives, Pittsburgh.

Fig. 82. Numa Blanc, photographer. Childs Frick, Charles Knoedler, and Gifford Bakewell at Aix-les-Bains, July 1898. Frick family archives, Pittsburgh.

Fig. 83. Postcard with view of the villa belonging to Théobald Chartran on the Island of Salagnon, Lake Léman, near Clarens, Switzerland (memento of a luncheon attended by Mr. and Mrs. Henry Clay Frick, 1904), 13 August, 1904. Frick family archives, Pittsburgh.

Fig. 84. Photographer unknown. Mihály Munkácsy, Paris Studio, n.d. Getty Research Institute, Resource Collections, Santa Monica, California.

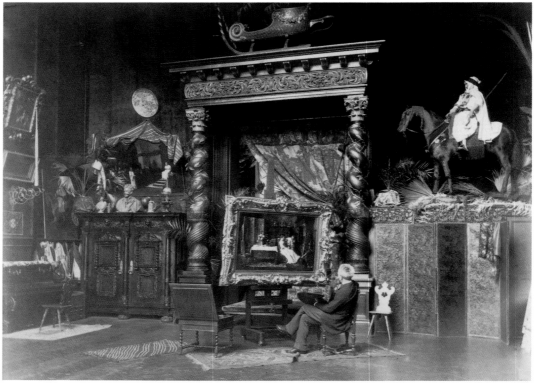

liardaires in Pittsburgh who were eager to spend money on art. Frits Thaulow, Jean-François Raffaëlli, and others journeyed to the Steel City.[35] There they established personal contact with collectors, which led to special commissions and an increase in sales.

In turn, when they went abroad, collectors from Pittsburgh and elsewhere not only attended painting exhibitions, but they also visited artists in their studios (figs. 84, 85). The well-established practice of using the studio as a showplace enabled the artist to become his own promoter and dealer, and some from Pittsburgh took this opportunity to make the acquaintance of current Salon favorites.[36] French painters were only too delighted to welcome visitors into their studios, and several contributed to publications that promoted their studios as pleasant places to discuss art.[37]

During these visits or through the yearly Paris Salons, travelers from Pittsburgh became familiar with portraits by Théobald Chartran, an artist who was eager to gain a broad international following. Throughout the 1890s he maintained a lucrative relationship with the Knoedler gallery in New York, where his popular portraits were frequently exhibited.[38] Thus, sitters in Pittsburgh who contracted Chartran to paint their portrait often agreed to have their likeness shown in New York before it was shipped to Pennsylvania. Such exposure served Chartran well by establishing his career and cementing ties with American collectors.[39]

Together, these contacts and associations led to the formation of elaborate collections that created a cosmopolitan atmosphere in Pittsburgh, and the city gradually became recognized as a center for the visual arts.[40] This advance became quite apparent when Andrew Carnegie helped inaugurate the Carnegie Library exhibition and the Carnegie International exhibitions in 1896. As a prelude to the foundation of a major public art museum, the Carnegie International exhibitions further secured Pittsburgh's position as an international artistic center. These yearly exhibitions, filled with works by artists who enjoyed proven careers in France, England, and the United States, were modeled after the more progressive Salons in Paris, such as those of the Société Nationale des Beaux-Arts. In this way the desired image of cosmopolitan elegance, wealth, and gentility was brought to Pittsburgh.[41] In addition to cultivating a high level of culture, American collectors wanted to rival their counterparts in England and France, yet they felt a need to express their own artistic preferences. As elsewhere in America and Europe, collectors in Pittsburgh endeavored to surround themselves with an air of sophistication, and they used their art collections to this end. Starting close to home, they acquired works by regional artists, and then looked to Europe in an effort to obtain works by the best-known foreign artists of their time.

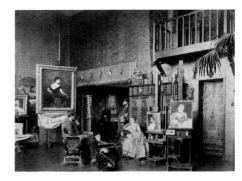

Fig. 85. Photographer unknown. Gustave Courtois, Paris Studio, 1890s. Private collection.

Early Tastes in Pittsburgh

At the turn of the century the area of Pennsylvania around Pittsburgh was home to several regional painters of considerable talent who were well acquainted with work by other American and international artists. These painters, such as George Hetzel and John W. Beatty (fig. 86), whose own landscapes recorded sites in the Allegheny valley (cat. 44), forged strong alliances with others in the area who depicted the rural scene and were interested in contemporary art.[42] Their enthusiasm encouraged budding collectors to learn about local painters and to purchase their works. They discussed the international art community and ways to improve the image of Pittsburgh as an area interested in high art and a willing sponsor of collections. The involvement of local painters was critical to the formation of an artistic culture in Pittsburgh during the mid-1890s. Since they intimately understood the art world, they regularly served as mentors to Pittsburgh collectors.

Prior to the formation of the Carnegie museum, the Pittsburgh Art Society, of which Beatty served as secretary, was actively involved in finding appropriate paintings for exhibition.[43] Beatty, along with William Nimick Frew, a member of an established Pittsburgh family, traveled to the East Coast in mid-1895 to find contemporary works suitable for display and acquisition. Beatty included works by the Dutch painters Anton Mauve (cat. 45) and Jacob Maris (cat. 46) in his exhibition, reflecting not only his personal taste in painting but also his awareness that realist works and genre scenes were more likely to find a receptive audience.[44] Extremely sensitive to American painters who were gaining national and international reputations, Beatty also sought out artists beyond the Allegheny community and brought their work to Pittsburgh for possible acquisition. Such activities, compounded by the formation of public and private collections, attracted dealers (and other collectors) to the city during 1895 and later.

Soon recognized as a central figure in bringing art to the public, Beatty repeatedly received positive comments in the Pittsburgh newspapers. His ability to work with the local papers created a supportive atmosphere for the arts, and his efforts motivated collectors to do more for their community than amass art objects. This was especially true with Andrew Carnegie, who wanted to make culture publicly available by erecting art institutions that would emulate those in Europe.

Outstanding in Pittsburgh's establishment of an art environment was the

Cat. 44. John W. Beatty (1851–1924).
Harvest Scene, n.d., oil on canvas.
Frick Art & Historical Center,
Pittsburgh.

Fig. 86. Photographer unknown.
George Hetzel (front) with John
W. Beatty (directly behind him) and
Walter Miller, n.d. Collection of the
Westmoreland County Museum of Art,
Greensburg, Pennsylvania.

Cat. 45. Anton Mauve (1838–1888). *The Shepherd*, n.d., watercolor. Frick Art & Historical Center, Pittsburgh.

Cat. 46. Jacobus Hendrikus Maris (1837–1899). *Man Ploughing*, n.d., oil on canvas. Frick Art & Historical Center, Pittsburgh.

construction of the Carnegie Library, which included a spacious art gallery for the public exhibition of paintings (fig. 87).[45] The library's opening in November 1895 was covered by the *New York Times,* which published a detailed article on the artwork shown there.[46] Among the preponderance of French painting that was then in vogue were six canvases by William Bouguereau, several by Jules

Fig. 87. View of the Main Gallery during the 1895 loan exhibition. Carnegie Library of Pittsburgh. This room now houses part of the Music and Art Department of the Carnegie Library of Pittsburgh.

Breton, and nine by Jean-Charles Cazin, a painter of considerable interest in the United States following a large exhibition of his work in New York.[47] Jean-Léon Gérôme was represented by *Two Majesties* and *Night in the Desert* (cat. 47), although one critic judged his depiction of Tanagra figurines just "what a painting should not be."[48] The article also mentioned Frits Thaulow, a young

Cat. 47. Jean-Léon Gérôme (1824–1904).
Night in the Desert, 1884, oil on canvas.
Carnegie Museum of Art, Pittsburgh;
Gift of the Thomas H. Nimick, Jr.
Family in memory of Florence Lockhart
Nimick [Ex. coll., Charles Lockhart].

landscapist from Norway, and Dagnan-Bouveret, a major painter in France, whose *Orange Girl* (fig. 88) was considered not up to his "usual high standard."[49] While many other works were shown in the library gallery, including several paintings by American artists, the *New York Times* review primarily emphasized Carnegie's tremendous achievement in fostering knowledge, education, and the arts in Pittsburgh. Importantly, numerous paintings in this inaugural exhibition came from local collections, including those of Frick and Porter, which indicates local collectors were willing to follow Carnegie's lead.[50] This exhibition also served as a benchmark against which other exhibitions in Pittsburgh were assessed. In bringing to Pittsburgh works from collections on the East Coast, such as those of Samuel P. Avery and John G. Johnson (he lent works by Bastien-Lepage and Alexandre Decamps), it became apparent that similar collections could be developed in Pittsburgh.[51] Indeed, when he was in Philadelphia to discuss business matters with Johnson, Frick often had time to study Johnson's personal collection and to develop his own preferences in art.[52]

Beatty's actions, which were crucial in bringing collectors together, were not lost on Carnegie (and by implication, on Frick), who was actively engaged

Fig. 88. Pascal-Adolphe-Jean Dagnan-Bouveret. *The Orange Girl (Jeune fille dans les Jardins d'Orangers)*, c. 1891, oil on canvas. Location unknown.

in discussions that would lead to the formation of a permanent art gallery or museum.[53] With his excellent reputation, community contacts, and extensive national and international ties, Beatty was the perfect candidate to serve as director of the new Carnegie Art Museum.[54] He was also crucial to successfully negotiating loans for the first Carnegie International exhibition held in 1896.[55] The Carnegie exhibition, which showed international paintings in a newly formed local museum, did much to nurture artistic taste among prominent citizens in Pittsburgh.[56] It also shifted attention away from traditional paths, such as collecting landscapes by Barbizon painters or acquiring small anecdotal genre scenes, and focused appreciation on contemporary works by artists active on an international level.

Even though Pittsburgh had entered the international cultural arena by the middle of the 1890s, some local collectors, including Frick, did not discard their allegiances to regional art. Paintings by Beatty and Hetzel entered local collections and were often hung alongside canvases by international realists and landscapists. Frick purchased *Harvest Scene* directly from Beatty in 1895 (cat. 44), at a time when the artist had become a major local celebrity.[57] Frick's acqui-

Cat. 48. Théodore Rousseau (1812–1867). *Dessous de Bois*, n.d., oil on canvas. Frick Art & Historical Center, Pittsburgh.

sition of this painting signifies his continued interest in local art just as he was turning his attention to France.[58]

Models from Europe: The Barbizon Aesthetic

As an outgrowth of forming collections and holding international exhibitions of art, Charles Lockhart and others became aware of the Barbizon school of painters.[59] Numerous articles and books discussed and recorded nineteenth-

century painting, and through them certain painters, such as Camille Corot, attained a special status in the United States. In fact, so many of his canvases were sold here that questions of legitimacy and attribution were eventually raised. Lockhart helped establish this interest in Pittsburgh early on, with his collection including paintings by Jules Dupré, Théodore Rousseau (cat. 48), Constant Troyon, Charles Daubigny, Narcisse Diaz, and Millet.[60] Andrew Mellon and other collectors acquired works by these same painters, as well as paintings attributed to John Constable, who contributed to the early vision of outdoor painting. The A. M. Byers family also acquired Barbizon paintings, with the nucleus of its collection being works by Diaz, Daubigny, and Dupré.[61] Henry Clay Frick followed suit, with his first recorded acquisition of a Barbizon painting occurring in 1895, when he bought *Minding the Flock* by Charles Jacque, a painter who was enjoying tremendous popularity in the United States (cat. 49).[62] Frick preferred works by Rousseau, Corot, and Millet, and to this day certain pieces remain in the Frick Collection in Pittsburgh and in New York.[63] Drawings and pastels by Millet, which began entering the Frick collection by 1898, confirmed the artist's reputation as a principal representative of the Barbizon school. Frick's appreciation for Corot was aided by the collector's

Cat. 49. Charles Jacque (1813–1894). *Safe in the Fold*, n.d., oil on canvas. Private Collection, Pittsburgh [Ex. coll., Charles Lockhart].

close relationship with the Knoedler gallery in New York, where he acquired *Ville d'Avray* in 1898 and *The Pond* the following year. These paintings demonstrated Frick's predilection for exceptional works, such as Corot's *Crown of Flowers* (cat. 18), by artists who were in great demand in the United States.[64] By 1906, when Frick purchased *The Lake (The Boatman of Mortefontaine)* (fig. 67), works by Corot dominated Frick's obvious appreciation for romantic landscape painting. Frick's acquisition of Barbizon paintings began, however, when he still lived in Pittsburgh, so these interests were most likely reinforced by what he saw in other collections.[65]

Appreciation for first-generation Barbizon painters had been growing in the United States since the mid-1870s, when these artists were seen as innovators whose works broke with traditional representations of nature. Interest in this group was generated by dealers and collectors on the East Coast, as well as by periodicals and books that delineated the evolution of the "modern" tradition.[66] Since preference for these painters dominated American art during the last two decades of the nineteenth century, Pittsburgh collectors were neither unique nor in advance of others in their interest in Barbizon art.[67] Prized collections routinely had a strong Barbizon component, with landscapes by Rousseau, figural studies by Millet, scenes by Daubigny, and dreamy "spiritual" landscapes by Corot.[68]

Collectors in Pittsburgh soon realized that to be considered as having impeccable artistic taste also required possessing paintings by the contemporary "old masters" of the Barbizon school. Acquiring major canvases by these artists, however, proved increasingly difficult. The Barbizon paintings that entered Pittsburgh collections during the Gilded Age were often small in scale and rarely exceptional in the choice of site or handling of the pigment. Some had remained on the market after dealers had sold larger pieces to collectors in Boston or New York, which makes it difficult to claim that collections in Pittsburgh consistently ranked at the highest aesthetic level. The Pittsburgh collectors, bar none, reserved their strongest preferences for those Barbizon artists whose works were readily available, and Frick made some noteworthy selections of works by Millet and Corot. A similar regard for Barbizon painters influenced Andrew Mellon in his purchases of Corot's loftier compositions (cat. 41).

Even though Barbizon paintings were found in numerous Pittsburgh collections, such art was not the only way through which collectors in the region

hoped to stand out.[69] As they looked beyond the Barbizon circle, these men were obviously counseled in their choices by Beatty at the Carnegie. They quickly became aware that outstanding collections could be formed with other types of art, such as easily understood scenes of everyday life.

The Taste for Genre Imagery

Alongside collecting Barbizon paintings was the fascination for all kinds of genre imagery.[70] American interest in genre painting coincided with a strong resurgence in this form of art in England and France during the latter part of the nineteenth century.[71] As the number of painters who dedicated themselves to genre imagery grew, genre painting itself took on many new inflections. No longer limited to small studies of daily life, as it had been since the seventeenth century, humanizing historical scenes and genre themes associated with the Orient became immensely popular and were painted on huge canvases destined for large public spaces.[72] An excellent case in point is John Wanamaker's 1887

Fig. 89. Mihály Munkácsy. *Christ Before Pilate*, 1881, oil on canvas. Location unknown.

Fig. 90. Luis Jiménez y Aranda. *Lady at the Paris Exhibition*, 1889, oil on canvas. Algur H. Meadows Collection, Meadows Museum, Southern Methodist University, Dallas, Texas.

acquisition of *Christ Before Pilate* (fig. 89), an oversize religious genre painting by the Hungarian artist Mihály Munkácsy.[73] The selection of this work ignited press coverage across the country, with the *New York Times* noting that the genre scene had garnered the highest price paid for a "modern painting." *Christ Before Pilate* became an instant "star" painting and confirmed that Wanamaker was eager to build an outstanding collection of contemporary art. His son eventually hung this work in the rotunda of Wanamaker's central department store in Philadelphia.[74] Wanamaker the private collector was also a recognized art entrepreneur who promoted genre painting by selling works in his stores in Pennsylvania and elsewhere.[75]

The craze for genre painting escalated to such a degree that by the close of the nineteenth century that category of art subsumed most others as thousands of genre compositions were created. Many beginning collectors with little art training or experience in evaluating works of art found genre scenes easily understandable. Genre painting also found strong support among art dealers in the United States who believed they could market these works with little difficulty. Collectors in New York, including John Jacob Astor, eagerly acquired genre scenes as a crucial component of their contemporary art collections. Naturally, these genre images attracted the attention of collectors in Pittsburgh, including Charles Lockhart and Henry Clay Frick.[76]

Frick's first recorded purchase of a genre painting was *Au Louvre* (cat. 26), a work by Luis Jiménez y Aranda dated 1881 and acquired that same year from the New York dealer William Schaus.[77] Late in the nineteenth century Schaus's gallery emerged as a primary source for contemporary painting.[78] Frick's limited dealings with Schaus indicate that the collector knew how and where to acquire interesting works from recognized dealers on the East Coast. During the 1880s, Jiménez enjoyed a solid following, yet ironically his work is almost totally forgotten today.[79] His paintings recorded current activities, such as visitors attending the Paris Exposition Universelle of 1889 (fig. 90), and his works reflected the nostalgia that viewers might have felt when they remembered their trip to Paris.[80]

Au Louvre shows a time-honored tradition of foreign visitors to France touring the museum's galleries. While the theme of visiting art galleries was explored by Edgar Degas in his image of Mary Cassatt walking through the Louvre, Jiménez's painting places primary importance on a larger narrative. In attempting to capture a personal experience, the story being depicted, rather

than the arrangement of the composition, becomes the primary reason to appreciate this genre scene. Indeed, Frick might well have been attracted to the theme of visiting museums as part of his own cultural activity.

Expectation (cat. 50), another interior scene in Frick's collection, was most likely purchased from the Schaus gallery as well. Madeleine-Jeanne Lemaire was already well respected in the 1880s,[81] and her ability to create fashionable portraits elevated her to a position of considerable distinction among the French aristocracy and in exhibitions of the Société Nationale des Beaux-Arts. While the date Frick acquired this watercolor is not known, the work's presence in his collection verifies his early awareness that such scenes of elegance and reserve by contemporary painters would help create a cultured, international atmosphere.[82]

Cat. 50. Madeleine-Jeanne Lemaire (1845–1928). *Expectation*, n.d., water-color. Frick Art & Historical Center, Pittsburgh.

Cat. 51. Jean-Louis-Ernest Meissonier (1815–1891). *Hussar*, c. 1880, oil on panel. Collection of Mrs. Henry Chalfant, Sewickley, Pennsylvania.

Cat. 52. Jan V. Chelminski (1851–1925).
Mounted Grenadier and Aide-de-Camp of
Napoleon (Asking Information, Episode,
Campaign of 1812, Poland), c. 1897,
oil on canvas. Collection of Mr. and Mrs.
Thomas M. Schmidt, Pittsburgh [Ex.
coll., Andrew W. Mellon].

Cat. 53. Jean-Baptiste Madou (1796–
1877). *The Disagreement*, 1860, oil on
panel. Collection of Mr. and Mrs. James
M. Edwards, Pittsburgh [Ex. coll.,
Charles Lockhart].

Interest in readable narratives was also found in paintings purchased by Charles Lockhart. In the 1880s and 1890s images by Georges Haquette appealed to a broad audience.[83] His *Une Sortie* (cat. 2) was typical of the large-scale, dramatic compositions of men battling the sea or working on the docks that brought the artist international attention. Such images were often reproduced in the leading Parisian periodicals, including *Le Monde Illustré* (1891), during the early 1890s and added to his popular acclaim in France.[84] As one of a number of painters exploring similar themes at this time (including the American painter and watercolorist Winslow Homer), Haquette was hardly unique in the type of imagery he created, but he nevertheless enjoyed some popularity in Pittsburgh. One of his paintings, *Steering Lesson* (from the J. M. Schoonmaker collection), was shown in the 1895 Carnegie Library exhibition,[85] and perhaps this is where Lockhart gained an awareness of the artist's work.

At the same time these works were acquired, other examples of anecdotal genre paintings entered collections in Pittsburgh. Some compositions reflected an international preference for contemporary military scenes, such as those found in paintings by Meissonier (cat. 51) or Detaille. Others documented unusual military encounters, such as images by Chelminski (cat. 52), a popular painter in France who became a close acquaintance of Henry Clay Frick.[86] Certain paintings continued a seventeenth-century interest in depicting commonplace people gathered in taverns and cabarets. In numerous scenes figures dressed in historical garb heatedly discussed matters (cat. 53), enjoyed drinks outside an inn (cat. 54), or waited for a team of fresh horses to be hitched to a coach. A flirtatious atmosphere could be created by showing a serving girl exchanging glances with a cavalier (cat. 55) or by depicting a haughty master who has returned from the hunt being offered a drink by an attractive servant in the hallway of his mansion (cat. 56). Such genre scenes, with their depictions of sometimes humorous moments, are best represented by the jolly toper of José Domingo (cat. 57).[87] Other artists (cat. 58) employed the habit of smoking as a vehicle for focusing on the mundane, albeit with figures in seventeenth-century dress. No matter the theme selected, the intimate scale of these paintings reveals a lingering sense of conservatism. Genre painting that was considered appropriate for genteel sitting rooms still underscored a sense of privilege and class. Few genre scenes in Pittsburgh depicted workers or rustic field laborers.[88]

Collectors in Pittsburgh and beyond eagerly acquired works by highly

Cat. 54. Walter Dendy Sadler (1854–
1923). *The Wayside Inn*, n.d., oil on can-
vas. Collection of Mr. and Mrs. William
Penn Snyder III, Sewickley, Pennsylvania
[Ex. coll., W. P. Snyder].

Cat. 55. Adolphe Alexander Lesrel (1839–1890). *The Stirrup Cup*, n.d., oil on canvas. Collection of Mr. and Mrs. James M. Edwards, Pittsburgh [Ex. coll., Charles Lockhart].

Cat. 56. Adrien Harmand (19th century). *The Whipper Inn*, 1888, oil on canvas. Collection of Mr. and Mrs. James M. Edwards, Pittsburgh [Ex. coll., Charles Lockhart].

Cat. 57. José Domingo y Muñoz (1843–1894). *The Cabaret*, 1881, oil on panel. University Club, Pittsburgh.

Cat. 58. Anonymous 19th century, possibly Dutch. *Smoker*, c. 1880–90, oil on panel. Collection of Mrs. Henry Chalfant, Sewickley, Pennsylvania.

Cat. 59. Mihály Munkácsy (1844–1909).
The Two Families, 1880, oil on panel.
Pittsburgh Athletic Association [Ex. coll.,
William H. Vanderbilt].

regarded artists, such as Munkácsy's *Two Families* of 1880 (cat. 59). Charles Lockhart, for all of his interest in major international painters, also purchased canvases by artists who were little known in the 1890s.[89] With his penchant for German paintings, he obtained one work by the unknown artist Arthur Heyer (cat. 60) that relates to the general nineteenth-century fascination with accurately recording historical scenes. The depiction of a German Renaissance castle, the walls of which are decorated with paintings, appealed to Lockhart as a representation of the way collections had been exhibited in earlier times. A similar transcription of reality appears in his selection of a painting by Léon Brunin (cat. 61), in which a scholarly alchemist symbolizes the value of educational activity.[90]

A few paintings concentrated on rural themes, with scenes set within stables to focus on a romantic depiction of horses (cat. 62) or moved out of doors to show cattle in the fields of a sweeping Scottish landscape (cat. 63). Whether numerous types of these paintings were collected in Pittsburgh remains to be ascertained, yet they do reflect a strain of genre scenes that were popular during the late nineteenth century. Here again, paintings in Pittsburgh collections reflected general tendencies in the international art world.

The works of Sir Lawrence Alma-Tadema occupied a special place in their own right. By the 1890s, when his works entered Pittsburgh collections, he had risen in prominence in international art circles through his images of a reconstructed history based upon Greek and Roman life.[91] His paintings conveyed an atmosphere of relaxed languor and unrequited love that meshed with the rococo revival of the nineteenth century.[92] In *Watching and Waiting* (cat. 64), which Frick acquired in 1897 after it was exhibited at the annual Carnegie International (it was later exchanged with Knoedler for other works), the soft coloring and sensuous mood create an atmosphere of playful restraint.[93] As one of several works by Alma-Tadema to enter Pittsburgh collections, this painting confirmed the strong interest in his work in the United States. American collectors appreciated his view of the classical past, and periodicals at the time reproduced his paintings that appeared in the Carnegie International. Alma-Tadema's works represent yet another way in which international tastes in genre painting influenced regional preferences in collecting.

The vast number of anecdotal paintings that were purchased by collectors included works by other international artists, including Daniel Ridgway Knight, who was represented in several collections in Pittsburgh. By the 1880s

Cat. 60. Arthur Heyer (1872–1931). *Interior Scene: German Renaissance Schloss*, n.d., oil on canvas. Private Collection, Pittsburgh [Ex. coll., Charles Lockhart].

Cat. 61. Léon Brunin (1861–1949). *The Alchemist*, n.d., oil on canvas. Private Collection, Pittsburgh [Ex. coll., Charles Lockhart].

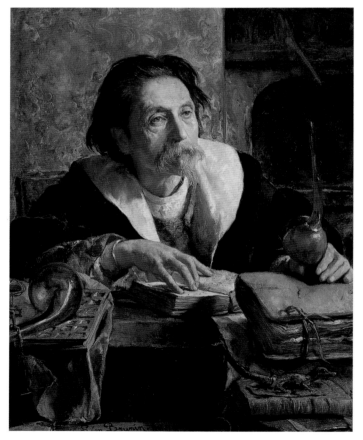

Cat. 62. Eugene Joseph Verboeckhoven (1798–1881). *Stable Interior with Two Horses and Chickens*, n.d., oil on canvas. Collection of Mr. and Mrs. Roy G. Dorrance, Pittsburgh [Ex. coll., Park-Kelly].

Cat. 63. Louis Bosworth Hurt (1856–1929). *Highland Cattle*, 1899, oil on canvas. Pittsburgh Athletic Association.

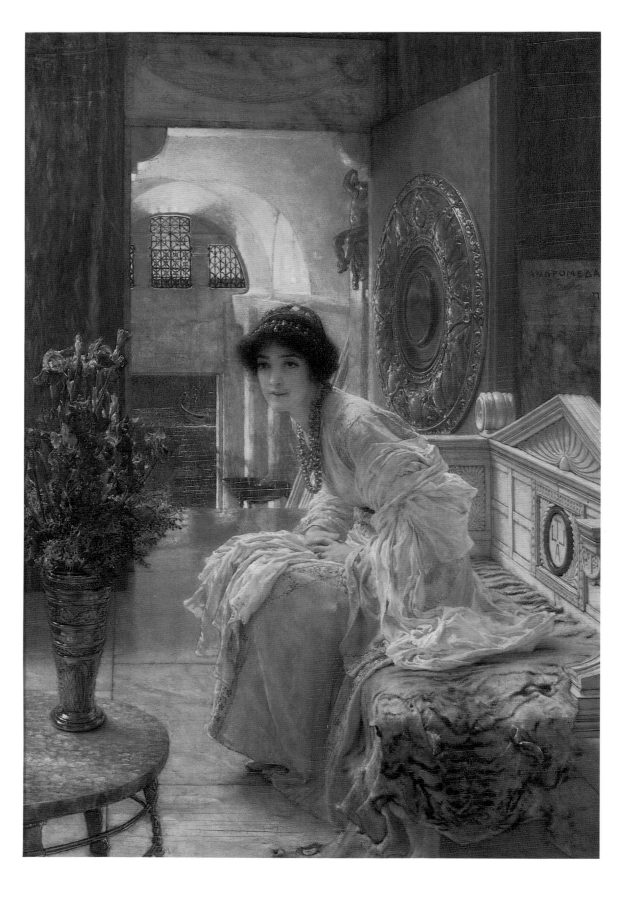

Cat. 64. Sir Lawrence Alma-
Tadema (1836–1912).
Watching and Waiting, 1897,
opus CCCXLIV, oil on panel.
Dorothy A. Smith Bequest,
Museum of Art, Fort Lau-
derdale [Ex. coll., Henry Clay
Frick].

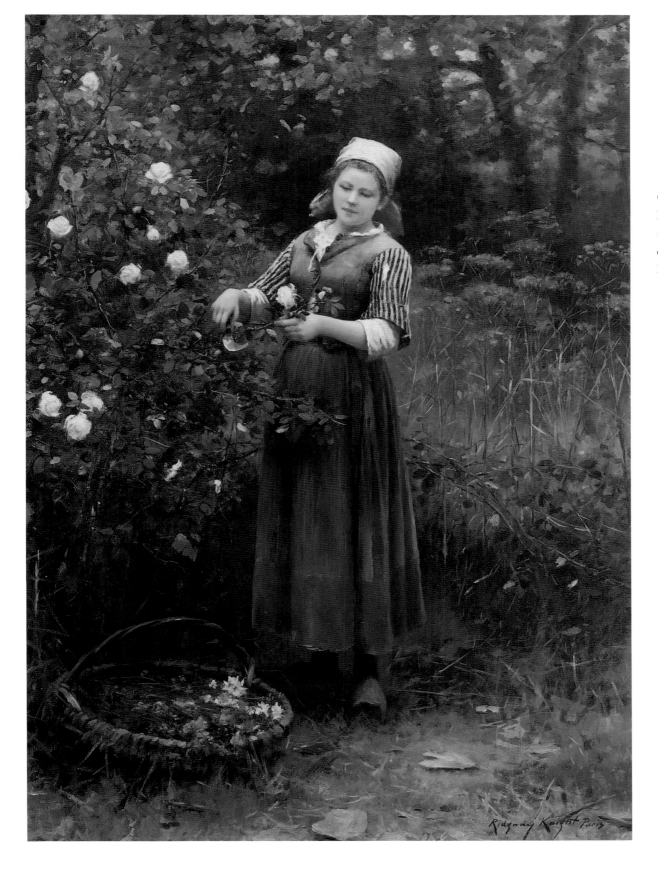

Cat. 65. Daniel Ridgway Knight (1839–1924). *Cutting Roses*, n.d., oil on canvas. University Club, Pittsburgh.

Knight was enjoying a strong career in France and the United States. His works were often compared with those by Jules Breton, and articles about him were published in major international journals.[94] One of his paintings entered the Pittsburgh Athletic Association, an organization that in the twentieth century came to play a significant role in the cultural life of Pittsburgh. As the Duquesne Club, the University Club, and others evolved, members contributed paintings to establish a collection for the organization.[95] In this way Knight's *Cutting Roses* (cat. 65) entered a public collection. This typical representation of a peasant girl in nature reflects the artist's penchant for depicting melancholy young women posed in a lush natural environment. Such scenes obviously appealed to Charles Lockhart, who acquired *Meditation* and *Woman in a Landscape*.[96] Knight occupied a central position among those painters who specialized in "safe" peasant imagery, infusing his scenes with an innocence and charm that was well received at the close of the century. His numerous paintings were often extremely similar in the arrangement of the composition, and his scenes became a metaphor for finding a balance between commonplace activity and contentment. With his works appearing in exhibitions throughout the United States and France, Knight became a favorite among collectors in Pittsburgh. His sentimental works were well painted and were widely known through exhibitions and reproductions, and his achievements set a high standard for other leading genre painters.

By the mid-1890s, however, considerable interest was generated in finding painters who explored more modern tendencies, such as using quick, expressive brushwork and handling pigment with panache. This was especially important to those in Pittsburgh who wanted their portraits painted. For this reason Théobald Chartran, among other portraitists, became a key figure in counseling Pittsburgh collectors and in directing the shift to the more cosmopolitan painters of the decade.

The New Portrait of Gentility

Among the artists who established close connections with American collectors was Théobald Chartran, a painter of historical and religious imagery who had a large following in France.[97] In the beginning, Chartran revealed a penchant for religious imagery that made traditional themes understandable for the public. An early work, *The Vision of St. Francis of Assisi* (fig. 91), established him as a significant painter of religious genre.[98] He found stalwart companions in

Fig. 91. Théobald Chartran. *The Vision of St. Francis of Assissi*, 1884. Reproduced in *Le Monde Illustré*, 28 June 1884.

Fig. 92. Jean-Charles Cazin. *Hagar and Ishmael*, 1880, oil on canvas. Collection du Musée des Beaux-Arts de Tours.

Jean-Charles Cazin (fig. 92) and Henri Lerolle, artists who instilled the commonplace with deeper religious meaning and portrayed the Holy Family as everyday figures.[99] Chartran's paintings were often reproduced in contemporary French periodicals, such as *Le Monde Illustré*, and he became known as a proficient portraitist during the Third Republic. This reputation gained him access into aristocratic circles in France and, in turn, into upper social circles in England and the United States, where he was brought into association with M.

Knoedler & Co. This firm promoted his work in the United States by holding frequent exhibitions in their New York gallery during the 1890s. While it is unlikely that Chartran was the sole reason Knoedler played an influential role in the formation of Pittsburgh collections, it is known that by 1897, during a time of intense appreciation for the portraitist, the New York firm established a Pittsburgh gallery and branch office at 432 Wood Street (it lasted until 1907).[100] This location undoubtedly made it possible for paintings to move rapidly between Pittsburgh and New York, where many collectors had frequent dealings with the firm. As early as 1891, Lockhart, Byers, and D. T. Watson all began acquiring paintings from Knoedler's in New York.[101]

In March 1895, Chartran exhibited a portrait at Knoedler's that generated extended commentary in the *New York Times*. The reviewer noted that "M. Chartran is of the younger Frenchmen whose work has attracted much attention in Paris, where he has painted many people of prominence. . . ."[102] Through such notices Chartran quickly became recognized as a painter of importance, a portraitist who was capable of creating exceptional likenesses of political dignitaries, prestigious sitters, and noted socialites. Clearly, those at the Knoedler gallery believed that Chartran, if properly managed, would attract a wide following in America. The artist had traveled to the United States in conjunction with this exhibition in March, and by November he had painted enough portraits to hold his own exhibition at Knoedler's, calling it "American Family Portraits by Théobald Chartran."[103] This was followed in March 1896 by another exhibition of Chartran's work at Knoedler's, which was also reviewed in the *New York Times*.[104] These exhibitions catapulted Chartran to fame as the day's leading portrait painter.

In addition to noting that Chartran was actively looking for sitters, the *Times* article commented on several specific portraits in the exhibition, including one of the art dealer Roland Knoedler, whose likeness was "positively startling" in its accuracy. The review described the portrait of the world-famous actress Sarah Bernhardt, as well as portraits of two prestigious men from Pittsburgh, Andrew Carnegie (cat. 30) and Judge Thomas Mellon (fig. 93).[105] Mellon's likeness was a study "of a man of fine, strong intellectuality" in which the artist underscored aspects of his individual character.[106] Both works, along with Chartran's portrait of Mrs. Thomas Mellon, were originally commissioned by Henry Clay Frick, which suggests that Frick as much as Knoedler introduced the artist into the upper social circles of Pittsburgh. Letters now in the Frick

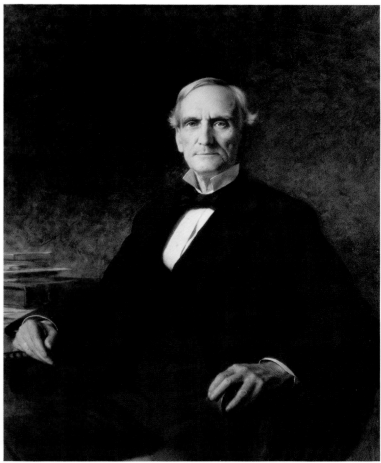

family archives further document this relationship and confirm Frick's involvement in the completion of these portraits.

My dear Mr. Knoedler:

Mr. Woodwell tells me that Mr. Chartran can have the use of his studio to paint Judge Mellon's portrait, and it will be entirely agreeable to the Judge to go there in the afternoons of such days as will be agreed upon. How soon will Mr. Chartran begin on this? I do not want this portrait rushed through as rapidly as Mr. Carnegie's. While I think Mr. Carnegie's portrait is a very good one, yet it might have been better if more time had been taken. Do you not think so yourself?

As to Mr. Phipps: as I stated to you, he will be in New York about the 5th of December, when he can arrange to sit for his. . . .[107]

Chartran's portrait of Andrew Carnegie, completed in New York in 1895, shows the industrialist alert and poised for activity. Its dark tones complement

Cat. 66. Théobald Chartran (1849–1907). *Portrait of Mrs. Thomas Mellon (Sarah Negley)*, 1896, oil on canvas. Carnegie Museum of Art, Pittsburgh; Gift of James R. Mellon, Andrew W. Mellon, Richard B. Mellon and the Children of the Late Thomas A. Mellon.

Fig. 93. Théobald Chartran (1849–1907). *Portrait of Judge Thomas Mellon*, 1896, oil on canvas. Carnegie Museum of Art, Pittsburgh.

the sitter's staid demeanor and focus all attention on the subtly illuminated face. The tradition of academic portraits by Léon Bonnat, then a reigning Salon favorite, must have influenced Chartran in the way space is limited behind the figure and colors are restrained in tone so as not to detract from Carnegie's intense gaze outward. Through Chartran the business partners Carnegie and Frick communicated their mutual interest in the visual arts. Existing letters confirm that Frick wrote to Carnegie concerning Chartran, and they corresponded about Carnegie's trip to France to meet Dagnan-Bouveret in his studio.

Among the canvases that Chartran completed in 1896 and either displayed at that time in New York or in a later exhibition (18–30 January 1897) at Knoedler's were portraits of Judge and Mrs. Mellon.[108] In his portrait Judge Thomas Mellon conveys a certain taciturn air and a powerful sense of austerity. The careful composition shows a learned figure surrounded by books that refer to his commitment to intellect and law. His portrait forms an unusual pendant to that of his wife Sarah Negley Mellon (cat. 66), for here Chartran

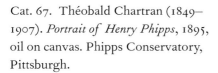

Cat. 67. Théobald Chartran (1849–1907). *Portrait of Henry Phipps*, 1895, oil on canvas. Phipps Conservatory, Pittsburgh.

demonstrated his abilities in depicting different temperaments and ages. The artist played upon the soft material of Mrs. Mellon's lavish dress to create a genteel atmosphere that may have suited her disposition and personality.

A fourth portrait by Chartran shows another socially prominent Pittsburgh resident, Henry Phipps, Jr. (cat. 67). Completed in 1895, it was exhibited at the Pittsburgh gallery of the art dealer Gillespie, along with Chartran's portrait of Henry Clay Frick, the instigator of these portrait commissions.[109] All these works, in addition to Chartran's portraits of Mrs. Rea, Mrs. A. M. Byers, Helen Frick, and Mrs. J. R. De Lamar, were among the series that Chartran completed to commemorate the leading figures of Pittsburgh. Since the painter maintained an accurate likeness and often conveyed a sense of fashion with even rather "reserved" and "unemotional" sitters, he was well regarded in the greater Pittsburgh community. The public display of these portraits guaranteed Chartran increased visibility and may well have brought him other commissions from Pittsburgh families. While he was engaged in completing these portraits, Chartran exhibited other types of paintings at the Carnegie museum, such as the religious scene *Les Matines à la Grande-Chartreuse* (cat. 68), which

Cat. 68. Théobald Chartran (1849–1907). *Les Matines à la Grande-Chartreuse*, 1896, oil on canvas. DePaul Institute, Pittsburgh; Gift of the artist to Carnegie Institute in 1899; donated to DePaul Institute in 1922.

he had shown in France in 1897. This work not only indicates his artistic diversity, but its exhibition also verifies that he was working to secure patrons in both the United States and France.[110]

To mark his international success Chartran was eager to have some of his better American portraits, such as that of Judge Mellon, shown in the Paris Salon of 1896. He turned to Frick for assistance in securing Mellon's portrait, although Frick thought the Mellon family would not favor its movement across the Atlantic.[111] For the next few years Chartran sought American sitters who would permit their portraits to travel to France, beginning with his study of President-elect William McKinley in late 1896. He continued to exhibit these new portraits at Knoedler's in New York, where, by January 1897, he showed the McKinley portrait as well as studies of Malcolm Graham of New York and the late A. M. Dodge.[112] To capitalize on his success with portrait painting in New York, Chartran traveled to Pittsburgh in early 1897. There he was both chaperoned and actively promoted by Henry Clay Frick, who was determined to find other potential sitters for the artist. In one instance Frick wrote to a leading executive of the Pennsylvania Railroad.

> My dear Mr. McCrea:
>
> Mr. Chartran is now in this city, having arrived here on the limited last night to paint the portraits of Mrs. B. F. Jones and Mrs. Buhl of Allegheny. He will be delighted to paint your portrait. His charge is $5,000.00 and he does not vary from that. I was much pleased with the exhibition of his portraits at Knoedler's Gallery. The President-Elect's is fine. The rooms are crowded all the time with visitors.[113]

Frick's personal involvement with Chartran must have brought the artist into contact with Charles Lockhart and his wife (cats. 10, 11), both of whom had their portraits painted by Chartran during his visit to Pittsburgh in 1897. Lockhart had already developed an important painting collection and was eager to sit for one of the most socially prominent French painters of the era. Charles Lockhart, wearing a dark suit and holding his glasses, appears in a moment of thoughtful awareness, as if he is about to acknowledge a visitor who has entered the room. Mrs. Lockhart, elegant in a soft satin dress with a delicate neckline, rests against soft pillows on a divan. Her femininity is underscored, although her expression and gaze seem a bit forced. Henry Clay Frick,

writing in May 1897 to Roland Knoedler, found the portrait of Mr. Lockhart to be quite fine, but in looking at Mrs. Lockhart he was disappointed: "Something wrong with the expression. . . . Probably a better acquaintance with it would improve it."[114]

Chartran's close relationship with Frick in Pittsburgh was later reciprocated when the Frick family traveled to Europe in the painter's company and visited his home near Montreux in Switzerland. The artist in turn used his American trips to great advantage in articles published by the Parisian press that chronicled his achievements and elaborated on his contacts with prominent Americans. In one, "Retour de New York, Chez M. Chartran," which appeared in *Gil Blas* on 25 May 1898, the writer discussed Chartran's observations of New York, with its tall buildings and modern setting, and quoted the artist's opinion that Pittsburgh was a model American industrial city.

Carnegie, the King of steel, and Frick the great builder whom I have also portrayed, have established their factories each of which employs several thousand workers. To try to make you understand, with the help of an example, the character of the representatives of this strong race, I will cite an event which took place during a recent and terrible strike in the "coal city"—this is the name Americans give to Pittsburgh because of the alarming use of this combustible made there.

Mr. Frick's workers had refused to work, following events I do not have to examine here. The latter who, because of this alone, was losing huge amounts of money every day resolved to make them come back to work. In order to do that, he didn't hesitate to go, one night, to a very large tavern which was the meeting place of his men to summon them back to work telling them that he would accede to a few of their demands.

Most of them agreed. However, a few feeling at home in their own surroundings, insulted and threatened the manufacturer. He answered coldly, but he was soon forced to use more energetic arguments than words against his opponents who fired their revolvers several times.

However, even though he was hurt, Mr. Frick resisted his adversaries and, gun in hand, made them promise to return to work; which was a done deal.

It is this man who, by the way, just purchased the Pélerins d'Emmaus.[115]

By highlighting his trip to Pittsburgh and his friendship with both Carnegie and Frick, Chartran cleverly revealed the circles in which he circulated. He emphasized Frick's strong personality and his avid interest in collecting French contemporary art, as indicated by his decision to acquire Dagnan-Bouveret's painting *Christ and the Disciples at Emmaus*. Such coverage both enhanced Chartran's reputation in France and established Frick (and to a lesser degree, Carnegie) as astute collectors of French painting. In short, the article proved to be a marvelous piece of propaganda.

In January 1898, close to the end of Chartran's stay in Pittsburgh, the *Pittsburgh Leader* took offense at the foreign artist's presence in the city. Chartran found himself caught in a nationalistic debate that downplayed his qualities as a portraitist in an effort to emphasize the need to employ American artists. The pointed attack stressed how foreigners who remain "but a few months in the country . . . never become familiar with the personality, tastes or home life of American women, hence portray them in the same manner they would a French woman. . . ."[116] The vitriolic article accused Chartran and others of coming to the United States to garner "a harvest of dollars" and leaving a "trail of sugary, superficial portraits."[117] Aiming at Chartran's international standing, local prestige, and high prices, the article claimed that the laudatory French press, much like the *New York Times,* never considered that the artist occupied "a place in the second rank of great artists."[118] The criticism claimed that Chartran had not found "a trace of the subject's character. [His portraits] are, in fact, what in studio talk are known as 'pot boilers.'"[119] This heated denunciation was, quite understandably, hurtful to Chartran, yet Frick steadfastly upheld his colleague, writing to Roland Knoedler that "Mr. Chartran should ignore all such trash. That is my judgment, at least."[120]

Chartran's intense friendship with the American *milliardaires* continued throughout the late 1890s. Another exhibition of his portraits that opened at the Knoedler gallery in early 1900 was reviewed in the *New York Times.*[121] This time Chartran exhibited a major group portrait: *The Signing of the Protocol of Peace Between the United States and Spain on August 12, 1898* (figs. 94, 95). The *Times* reported that this painting was executed in "Washington by the order of Mr. H. C. Frick of Pittsburg, who is now its owner."[122] The large work shows the French ambassador to the United States, M. Cambon, seated at a desk and signing the protocol of peace. To the left is the president of the United States, William McKinley. The *Times* article complimented Frick for having acquired

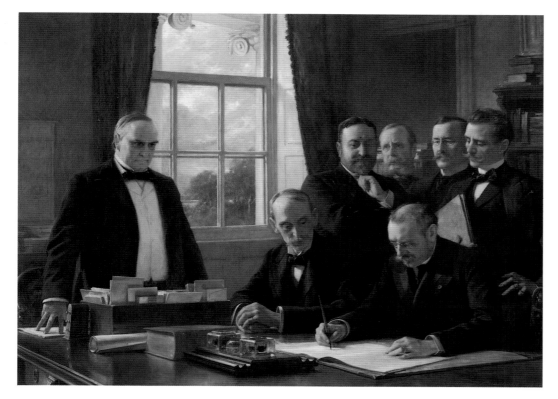

Fig. 94. Théobald Chartran. *The Signing of the Protocol of Peace Between the United States and Spain on August 12, 1898*, 1899, oil on canvas. The White House, Gift of Henry Clay Frick, 1902.

Fig. 95. Théobald Chartran. Study for *The Signing of the Protocol of Peace Between the United States and Spain on August 12, 1898*, 1899, graphic on paper. Musée des Beaux-Arts et d'Archéologie, Besançon, France.

such a satisfactory representation of a "notable historical event."[123] This type of laudatory coverage reinforced Chartran's reputation as a painter able to depict contemporary scenes of historical significance.[124] Frick was quite generous to Chartran in paying for this work: $20,000.[125] Always the skillful businessman, Frick used the painting to solidify his ties with political powers in the United States. He allowed his recent acquisition to be displayed at the Pan-American Exposition in December 1901, a site where the United States wanted to be seen supporting national and international artists.[126] Two years later Frick came into close contact with President Theodore Roosevelt when the art collector donated the painting to the federal government.[127]

As Frick's contact with the president increased, partly through his sponsorship of Chartran, the artist's association with American sitters grew through his acquaintance with Frick and Knoedler.[128] Another exhibition of Chartran's portraits in March 1902 at Knoedler's New York galleries added further to his reputation.[129] This time Chartran displayed portraits of Admiral George Dewey, a hero of the Spanish-American War in Cuba, as well as likenesses of several young socialites, including the aesthete James Hazen Hyde (cat. 69), who by 1899 had become a vice president in the Equitable Life Assurance Company and a devoted advocate of French culture.[130] By 1902 Hyde was also linked

to Frick through business ties—he was elected to the board of directors of the Mellon National Bank—and a mutual admiration for the work of Chartran.[131] Beyond Hyde's astute knowledge of finance and his keen taste in art, Frick was initially taken with the young man for another reason—he was able to put into practice Frick's admiration for French art and culture. The two men met frequently through business concerns, including Frick's serving on a special commission to investigate Hyde's questionable dealings with the Equitable Life Assurance Society in 1905.[132] Prior to this Frick tried to find a solution to the scandal at Equitable that was rocking New York City. He wrote to President Roosevelt late in 1904 and recommended that Hyde be appointed Minister to France. "Mr. Hyde, it seems to me, is eminently qualified for this position. In education and training he is peculiarly adapted to fill this responsible place and because of his knowledge of the country would perhaps be better than any other man you could consider."[133] This letter of endorsement not only shows Frick's admiration of Hyde's awareness of French culture, but it also indicates his involvement in issues at the White House.

It was important for Chartran to paint Hyde's portrait for several reasons. Hyde represented a younger generation that was inheriting (or was about to inherit) immense fortunes which were frequently used to promote and support cultural exchange. He himself was the founder and first president of the Alliance Française for the United States and Canada, an organization that still today encourages closer American associations with French culture.[134] By 1905 Hyde had spent considerable time in France, attending conferences, giving lectures, and making personal appearances to build upon his passion for modern French literature and culture.[135] His extensive collections of books and works of art dominated his apartment in Paris and bolstered Hyde's reputation as an aesthete of uncommon intellect. Some of these objects and his large library were eventually donated to the Union Centrale des Arts Décoratifs in 1941, when Hyde decided to return permanently to the United States.[136]

Throughout his career James Hazen Hyde associated with artists, and Chartran painted his portrait when Hyde was still a young man of twenty-six. Chartran depicted his sitter as a suave, fashionable intellectual. Posed before a book shelf with one hand on his hip, Hyde holds a small book, a reference to his literary interests, in his other hand. Hyde's portrait was later drawn by Emile Friant (fig. 96), another prominent painter during the 1890s whose work was collected by Frick.[137] Hyde obviously moved in desirable artistic circles, and

Fig. 96. Emile Friant. *Portrait of James Hazen Hyde*. Drawing reproduced in *Comoedia Illustré*, 20 April 1913.

Cat. 69. Théobald Chartran (1849–1907). *Portrait of James Hazen Hyde*, 1901, oil on canvas. The New-York Historical Society.

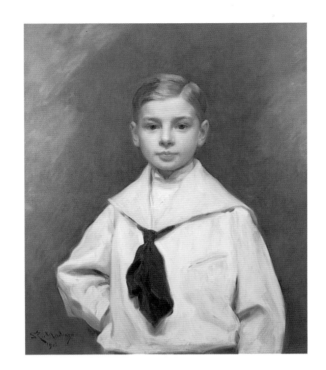

Cat. 70. Raymundo de Madrazo (1841–1920). *Portrait of Grant A. Peacock*, 1902, oil on canvas. Grant A. Peacock, Inc., New York.

through his efforts he singlehandedly validated the American passion for France.

Largely through the help of Frick and Knoedler, Chartran had gained access to many of the leading families and high-ranking politicians in the United States by the opening years of the twentieth century. Even though other European portraitists practiced in America, such as Raymundo de Madrazo, who painted portraits of the Peacock family in Pittsburgh (cat. 70),[138] it was Chartran who best matched the preferences and expectations of the genteel sitter by combining refined elegance with a certain panache for creating a lively impression. He became one of the most sought after and collected painters from France during the Gilded Age. Some, however, saw Chartran's popularity as a portraitist as a statement against American ability in portraiture. Indeed, American painters John White Alexander and Cecilia Beaux (cat. 71) were catching Frick's attention through their participation in the Carnegie Internationals. Despite the intense attention given his work, Chartran was not the only French painter who was in demand by American collectors in Pittsburgh and elsewhere.

The Pursuit of Jules Breton

The large number of canvases by Jules Breton that were collected in the United States testifies to Americans' extraordinary receptivity to this artist's work.[139]

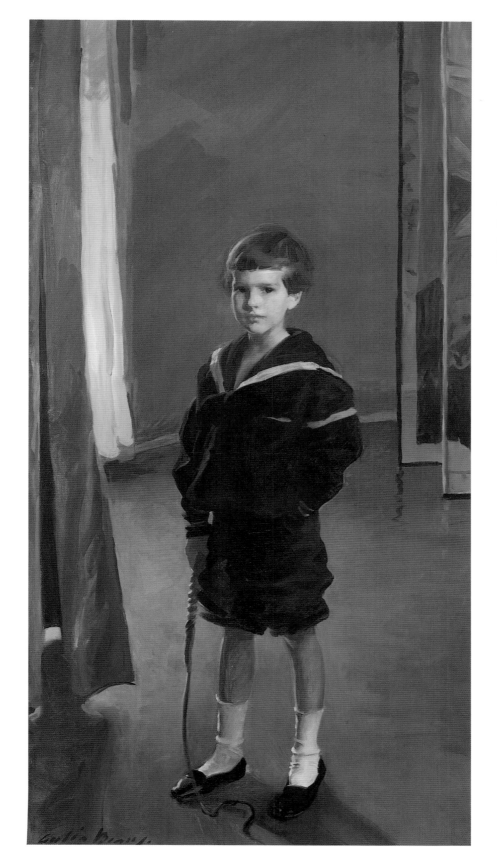

Cat. 71. Cecilia Beaux (1855–1942). *Portrait of James Murdock Clark, Jr.*, 1908, oil on canvas. Allegheny Cemetery, Pittsburgh; Gift of Mrs. E. Russell Peters.

No matter from which angle his career in America is examined—the number of times his work was mentioned in the popular press, his representation in private and public collections throughout the country, the high prices his paintings commanded, or the public exposure he received through exhibitions or

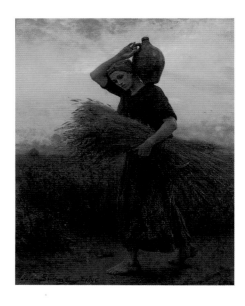

Cat. 72. Jules-Adolphe Breton (1827–1906). *Returning from Work (L'Aurore)*, 1896, oil on canvas. Carnegie Museum of Art, Pittsburgh; Presented by Sarah Mellon Scaife (Mrs. Alan M.) and Richard King Mellon in memory of their mother, Jennie King Mellon [Ex. coll., David T. Watson].

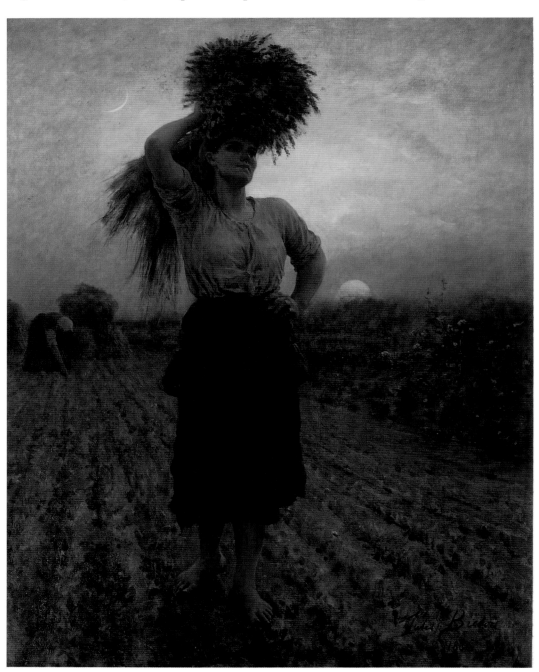

Cat. 73. Jules-Adolphe Breton (1827–1906). *Harvesters*, 1886, oil on canvas. Duquesne Club, Pittsburgh.

reproductions of his works—there is no denying that Breton was a phenome-non on this side of the Atlantic.[140] His novel, haunting, and even poetic imagery and his intelligible themes paralleled American interests in dedication to com-munity and the moral goodness of labor, beliefs that were being tested in the face of massive industrialization.

Somewhat ironically, those in Pittsburgh who were introducing advanced technology to the city and its industries were also avid collectors of works by Breton. The interest displayed by Charles Lockhart, Henry Clay Frick, A. M. Byers, and the businessman David Watson could well have been based on sen-timental memories of the rural labor that dominated a bygone era and sharply contrasted with the industrial mills and the new corporate establishment of the present day. Breton's moralistic treatment of menial laborers and his musings on agrarian traditions made his works as readily understandable to American viewers as compositions by Millet,[141] and his prodigious production made it possible for many Americans to own one of his paintings. In this regard, col-lectors in Pittsburgh proved to be no exception: two of his paintings of indi-vidual workers in the fields of northern France (cats. 72, 73) were sold by Knoedler to Pittsburghers. Of other works that were originally in Pittsburgh collections, one was early on deaccessioned by Frick, and another disappeared from view after originally belonging to Lockhart. *Washerwomen,* one of the two Bretons acquired by the Byers family, has since been lost, while the other reappeared at a Sotheby's sale in 1989.

The first painting by Breton in a Pittsburgh collection was *The Turkey Ten-der* (fig. 97), a representative example of the artist's earliest period that strongly alluded to classical and Renaissance influences.[142] Before it came to the United States, the painting was exhibited at the 1864 Paris Salon, entered the Cahusac collection in 1867, and was later sold at the Hôtel Drouot in 1887. Exactly when the painting became part of the Lockhart collection remains unknown (fig. 76). Its acquisition, however, suggests a great degree of independence on Lock-hart's part, since there was little consensus in Pittsburgh on which type of works by Breton should be collected.

Frick acquired a second painting by Breton after it was exhibited at the 1895 Paris Salon.[143] *The Last Gleanings* (cat. 74), which Frick may have first seen in France, was purchased by Knoedler, who promoted Breton's works interna-tionally, and then sold to Frick in September 1895.[144] This late work echoes Bre-ton's earlier compositions, such as his seminal *Recall of the Gleaners,* that had

Fig. 97. Jules-Adolphe Breton. *The Turkey Tender*, 1864, oil on canvas. Private Collection. Photo courtesy Sotheby's, New York [Ex. coll., Charles Lockhart].

established his reputation in 1857.[145] The atmospheric background and the group at the left that has just completed the day's labor are based on the artist's memories of his native village of Courrières. Even though Breton offered a traditional interpretation of an agrarian scene, one that had been presented to the public for over thirty years, the canvas was well received at the 1895 Salon, and the press reviews were quite favorable. While he was interested in the Carnegie International as an exhibition site (he showed works there in 1896, 1897, and 1898), Breton remained loyal to the official Salon in Paris and never joined younger painters at the Société Nationale des Beaux-Arts after its establishment in 1890.

Cat. 74. Jules-Adolphe Breton (1827–1906). *The Last Gleanings*, 1895, oil on canvas. The Henry E. Huntington Library and Art Gallery, San Marino, California [Ex. coll., Henry Clay Frick].

With these three paintings—*The Last Gleanings, The Turkey Tender,* and *Souvenir de Douarnenez*—and two other images of single figures (Carnegie museum collection and the Duquesne Club), Breton was apparently well represented in Pittsburgh and had become a favorite among collectors. Such interest partly stemmed from the high regard in which his art was held internationally, one of the basic guidelines for acquiring paintings in America at that time.

The Case for Jean-Léon Gérôme

Another painter whose works were appreciated and collected in the United States was Jean-Léon Gérôme, one of the most popular teachers in France among the American students who studied art abroad.[146] Gérôme's work, which largely consisted of realistic historical scenes, reconstructions of the ancient world, and depictions of the Near East, was widely disseminated as reproductions by Goupil and Company. As a powerful figure in the academic art world of France, Gérôme exerted considerable influence in selecting works for the official section of French art shown at the 1893 Columbian Exposition in Chicago. His support was also crucial in promoting the careers of French artists who emulated his detailed painting style and traditional subject matter.[147] Just as passionately, Gérôme clearly opposed the Impressionists and modernism. Nevertheless, collectors in America wanted to acquire his paintings, which were exhibited everywhere and were favored by the public.[148] Gérôme (along with Jules Breton and William-Adolphe Bouguereau) was heralded among nineteenth-century French painters in John Van Dyke's *Text-Book on the History of Painting* (1894). Van Dyke, a friend of Frick, noted that Gérôme was seen as "a man of great learning . . . he is no painter to be sneered at, and yet, not a painter to make the pulse beat faster or arouse the aesthetic emotions."[149] The author, himself a connoisseur and art collector, further qualified Gérôme's contribution by adding that "his work is impersonal, objective fact, showing a brilliant exterior but inwardly devoid of feeling."[150] Despite such biting comments, Lockhart, Carnegie, and Frick acquired works by Gérôme.[151]

A Night in the Desert was well received by critics when it was exhibited in 1884 first at the Paris Salon and then at the Royal Academy.[152] Later it was reproduced in a publication prepared by the art dealer Boussod, Valadon et Cie. Gérôme's technical prowess is evident in his rendering of the tiger and cubs who are sprawled before a desolate background. The scene's descriptive reality amidst the quiet desolation appealed to collectors' preference for paintings

that told stories. The work entered the Lockhart collection, where it would have been compared with Breton's *The Turkey Tender*.[153] *Lion Snapping at a Butterfly* (1889), the second work by Gérôme that Lockhart acquired, suggests the collector's continuing interest in the romantic depiction of animals.[154]

Two paintings by Gérôme also entered Frick's collection. Knoedler bought the first one, *Prayer in the Mosque of Quat Bey, Cairo*, from the artist in 1895 and then sold it to Frick that September.[155] Showing a man and his child inside a mosque, the painting actually focuses on spectacular light effects. The brilliant illumination streaming through stained glass windows proved Gérôme's technical proficiency and would have added to his growing appreciation in the United States. Although Frick did not hold onto this painting (by 1901 it was in the C. M. Hyde collection in New York), the fact that he collected works by Gérôme at all, much less one of his unusual orientalist themes that had just been exhibited at the Salon, reflects Frick's interest in expanding his artistic interests and broadening his collection of contemporary French art. When he displayed his recent acquisition at the Carnegie in November 1895, Frick stood out among those discerning men who were collecting works by Gérôme.[156]

The second Gérôme painting in Frick's collection, *Painting Breathes Life into Sculpture* of 1893, reflects the artist's own interest in tinted sculpture, a medium he had mastered by the 1890s.[157] The interplay of historical references, the amusing storytelling quality of the Tanagra figurines, and Gérôme's personal ties to the subject matter made this an unusual work in his oeuvre. The painting seems to have been in Frick's collection by the fall of 1899, but a few months later it was sold through M. Knoedler & Co. in New York.[158] It is uncertain why Frick would have been interested in this particular theme, although his appreciation of works by Alma-Tadema might have made it acceptable. At the same time, its depiction of decorating ceramics, a womanly artistic activity popular in the Midwest, might have been found nonetheless objectionable to genteel viewers in Pittsburgh, where most women largely remained in the background.

Gérôme's appeal in Pittsburgh was confined to only a few collectors. Andrew Carnegie is thought to have owned one, but it remains unidentified. Other Gérôme paintings entered Frick's collection for a brief time before they were resold through Knoedler. Two other works by Gérôme were included in the Carnegie Library exhibition in 1895. One, *The Marble Work* (cat. 75), was lent by J. G. Butler, Jr.,[159] while the other, *The Two Majesties*, came from the

Cat. 75. Jean-Léon Gérôme (1824–1904). *The Marble Work (L'Artiste Sculptant Tanagra)*, 1890, oil on canvas. Dahesh Museum, New York.

collection of J. M. Schoonmaker.[160] It is unusual that one of these paintings was an historical reconstruction and the other was orientalist in theme, given the literal nature of other genre scenes in Pittsburgh collections, yet Gérôme's works were becoming highly prized on the international art market. Any collection of significance required a painting by Gérôme. A similar situation existed with paintings by William-Adolphe Bouguereau, another artist who enjoyed a certain amount of success in Pittsburgh.

The Popularity of William-Adolphe Bouguereau

Works by the academic artist William-Adolphe Bouguereau were regularly illustrated in American periodicals during the 1890s.[161] A series of reproductions ran in the *Cosmopolitan* in 1895 and 1896, and other illustrations appeared in *Munsey's Magazine*.[162] These images revealed Bouguereau's penchant for feminine beauty and his interest in depicting awakening nymphs and erotic goddesses (fig. 98), figural types that would eventually be seen in the early cinema.[163] While Americans expressed little concern for his early paintings, deeming them too primitive, they were also troubled by his later risque compositions that challenged the American moral code. Those American collectors who could afford the high prices charged for Bouguereau's work tried to acquire his traditional representations of the classical past, canvases that dated from the 1870s and 1880s. Some interest in Bouguereau's current work from the 1890s was generated when Charles T. Yerkes acquired the controversial *Wasp's Nest* of 1892.[164] The artist's attempt to use antiquity in an unsettling and even emotional way was also evident in *L'Amour piqué (Love Feels the Thorn* or *Wounded Cupid)* of 1896 (fig. 55). Once again Bouguereau explored the theme of the love of the gods, but without his usual sense of reserve and distance. Since controversy surrounded Bouguereau's later imagery, the presence of his paintings in the collections of Lockhart, Frick, and Phipps, especially *Idylle Enfantine* (cat. 76), indicate that an attempt was made to build the artist's reputation in the Midwest. *Idylle Enfantine* was also shown in Paris at the Exposition Universelle of 1900, which granted it additional validity and further attests to the importance of acquiring works that had been exhibited in an international arena.

While few of the many Bouguereau paintings that were once in Pittsburgh have been located, including the two paintings owned by Lockhart or the individual canvases that belonged to Frick, Byers, Donnelly, and Laughlin, those that are known most likely conveyed the sense of repressed sexuality that is associated with his later classical themes.[165] Other works in Pittsburgh, such as *The Mother* in the Peacock collection, continued the religious and family themes on which the painter's career had been established earlier in the century.[166] Similarly, *The Harvest Girl,* originally in the Thaw collection, offered a sentimental image of the rural past, much like the work of Breton. *Espièglerie* by Bouguereau, which was purchased from Knoedler in June 1895, was among Frick's earliest purchases of French art, and it may have arrived in Pittsburgh through Knoedler's urging to generate interest in the artist's playful, classical

Fig. 98. William-Adolphe Bouguereau. *Return of Spring (Le Printemps),* 1886, oil on canvas. Joslyn Art Museum, Omaha, Nebraska, Gift of Francis T. B. Martin.

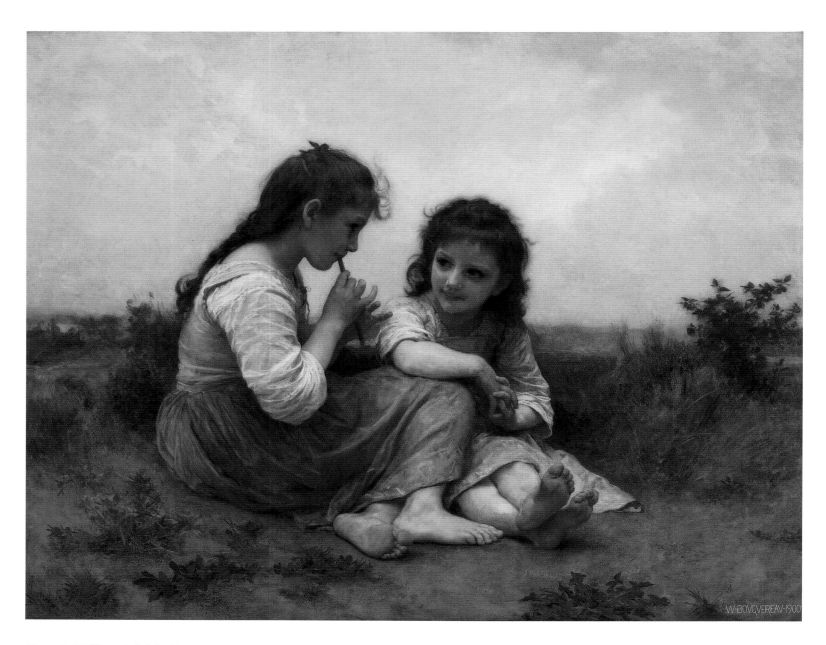

Cat. 76. William-Adolphe Bouguereau
(1825–1905). *Idylle Enfantine*, 1900, oil on
canvas. The Denver Art Museum; Gift of
the Lawrence C. Phipps Foundation [Ex.
coll., Lawrence C. Phipps].

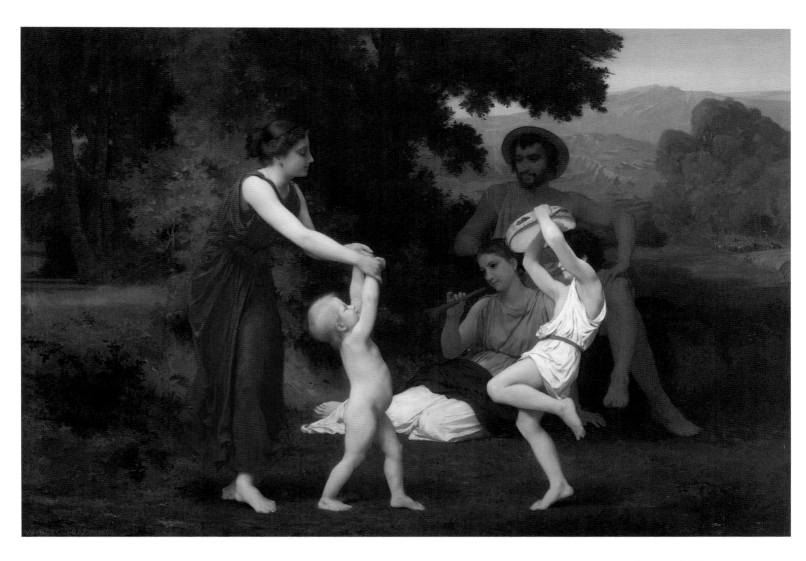

Cat. 77. William-Adolphe Bouguereau
(1825–1905). *The Dance*, 1868, oil on can-
vas. Pittsburgh Athletic Association.

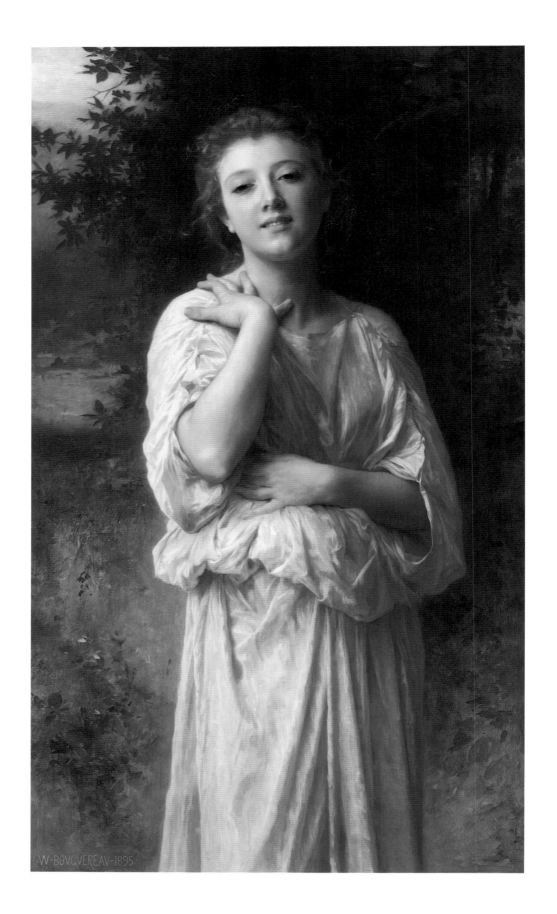

Cat. 78. William-Adolphe Bouguereau
(1825–1905). *Souvenir*, 1895, oil on can-
vas. Carnegie Museum of Art, Pitts-
burgh; Bequest of Henry Buhl, Jr.

themes.[167] One Bouguereau painting with a supposedly long connection to Pittsburgh is *The Dance* of 1868 (cat. 77).[168] Its bucolic theme and joyful depiction of the gods would have complemented the strong silhouettes and poses seen in Breton's *The Turkey Tender.*

Although Bouguereau was represented extensively in Pittsburgh collections (cat. 78), the fact that his works were collected at all was due in large part to the continuous prodding of Knoedler and to the idea that any contemporary art collection of note must include one of his paintings. Those works that were chosen, particularly his late compositions, often reflected market availability and did not represent his more restrained classical compositions. Admittedly, Bouguereau remains a difficult artist to assess, and his role in Pittsburgh collections eludes precise definition, especially since many of his later works are now lost. As paintings that were once in Pittsburgh are rediscovered and archival records are examined, a citywide pattern of collecting works by Bouguereau will emerge. Acquisitions will most likely parallel in style and selection purchases made by John G. Johnson in Philadelphia, among others.

A Shift: Ernest Meissonier and Jean-Charles Cazin

The approach to art and acquisition strategies of collectors in Pittsburgh changed radically due to developments in the French art world. The rupture between artists dedicated to academic practices and the more intuitive path selected by younger painters not only altered the way in which painters, decorative designers, and architects exhibited their works in the Salons but also led to the establishment of the Société Nationale des Beaux-Arts in 1890.[169] Ernest Meissonier, the group's first president, both endorsed the creation of history paintings and genre scenes, and actively sponsored the Société Nationale until his death in 1891.[170] With its new exhibition policies, interest in including decorative designers, and ability to hold a Salon with a refined atmosphere, the Nationale provided an air of gentility to the French art scene.[171] In addition to giving members the right to exhibit as few or as many works as they wished, the Nationale intended to create an "upper" house for art, an aristocratic environment in which to exhibit paintings. The Nationale's success during the 1890s helped artists sell their work through direct negotiations with collectors and brought many younger painters into the exhibition system, which made it an ideal avenue for acquiring contemporary art.

A major force behind the splintering of the French art world, Meissonier dif-

fered markedly in his position and work from Bouguereau, the spokesman for the more traditional public Salon.[172] With Meissonier serving as a spokesman for the Nationale, many other artists became members of the organization, including Jean-François Raffaëlli, who joined in 1891. Others were drawn to the more open structure and spacious, decorated interiors of the Nationale's Salons, which attracted American collectors eager to acquire works by leading artists.

A founding member and later vice president of the Nationale, Jean-Charles Cazin had established himself as a religious genre painter by the 1890s.[173] Interested in the decorative arts, an area in which both his wife and son worked, Cazin actively supported the integration of all the arts, a principal change in attitude that was orchestrated by the Nationale. He found a ready audience for his light-filled landscapes of the northern coast of France which he painted in a series (a notion then made popular by Claude Monet). Many of his landscapes were marketed abroad, with collectors in Pittsburgh securing a large number of his compositions.[174]

Well aware of the need to promote his work overseas, Cazin traveled to the United States in November 1893, where he was warmly welcomed in New York to host an exhibition of nearly 180 of his paintings at the American Art Galleries.[175] Reviews appeared in numerous American periodicals, including the *Critic* and the *Art Interchange*, which stated that Cazin was a painter of considerable individuality who expressed modernity and beauty through landscape.[176] His landscapes of the northern coast of France, veiled in a characteristic gray light, were easy to recognize, and reviewers expressed considerable support for his works in the United States, with one critic claiming "Americans love M. Cazin's art."[177]

Cazin's exhibition was also reviewed in the *New York Times* in an article that identified him as a "French tone painter."[178] The critic commented on how the exhibition combined works from the artist's own holdings with paintings housed in public and private collections, such as the Corcoran Gallery of Art in Washington, D.C., and the home of John G. Johnson in Philadelphia. He noted that Americans had become the "best buyers" of Cazin's landscapes, whose coloring in "low" tones made it seem the viewer's eyes were "stroked with soft feathers."[179] Such endorsement from America improved the painter's position in France, and he was soon comfortably compared with Monet, who was then emerging as the most appreciated landscapist in Europe.[180]

By January 1894 Cazin's work was enthusiastically described in the *Art*

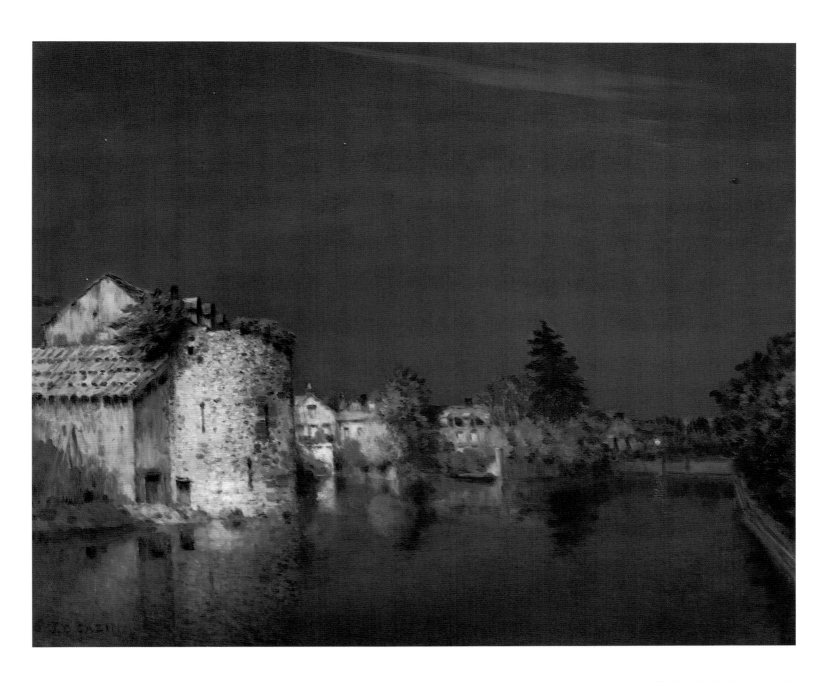

Cat. 79. Jean-Charles Cazin (1841–1901).
The Dipper, n.d., oil on canvas. Frick Art
& Historical Center, Pittsburgh.

Amateur, a periodical with a large circulation. This particular critic was impressed by Cazin's ability to capture "in each picture the aspect of the particular hour of day or night, and the season when it was painted."[181] Now linked with the evolution of modern landscape painting, Cazin was recognized for his handling of the "subtle effects of diffused light," which placed him in the artistic vanguard. Cazin's popularity as an artist soared, and his works soon came to the attention of Frick and others in Pittsburgh, who quickly added a number of his canvases to their private collections. Working carefully with Knoedler, Frick had added six canvases by Cazin to his collection by August 1895; a seventh, *The Dipper* (cat. 79), arrived in 1898.[182] Enthusiasm for the artist, spurred by national interest in his work and the presence of other paintings by Cazin in Pittsburgh (two in the Donnelly collection were shown at the Carnegie International in 1897), led Frick to establish direct contact with the painter as a sincere expression of his interest.

Judging from the detail in the letter that Frick wrote to Cazin on 23 September 1895, he had previously met the artist in New York or France.

My Dear Mr. Cazin:

Since I had the pleasure of visiting you, I have become the owner of another picture of yours, entitled, I believe, "Moonrise" . . . one almost as large as the first one purchased from Mr. Knoedler. This gives me now five of your works. They are now properly hung in my house, and are affording much pleasure to my family and friends who have seen them. I purchased this last picture through Mr. Knoedler's New York house.

The other picture that you so kindly loaned for exhibition in the new art gallery that is to be opened in November is also at my house, and I regret that I am not the owner of it, but there is some satisfaction in knowing that in case you should decide to sell it, I would have first opportunity of purchasing.

I stated to Mr. Knoedler (through whom, of course, I expect to purchase any pictures of yours that I may buy in the future, unless I should find one that has already passed out of your hands) that in event of your painting anything that showed the "Dipper" and the "North Star," I would like to have an opportunity at it, as well as any other pictures that are considered especially fine by yourself.

With kind regards to Mrs. Cazin and your son, I beg to remain. . . .[183]

Cazin willingly responded to these inquiries about paintings in his collection, as he regarded Frick a serious collector in search of specific information about dates and locations of works.[184] Frick's interest in acquiring other compositions, perhaps works that were not even under way, also opens the possibility that *The Dipper* was a commissioned painting. Familiarity with Cazin, and the need to bring appropriate jurors to Pittsburgh for the 1899 Carnegie International, led Frick to invite the artist to come to Pennsylvania and "stay with him."[185] Although Cazin did not serve as a juror or go to Pittsburgh at that time, he remained on the French advisory committee for the Carnegie International and helped to secure foreign loans for the 1899 exhibition.[186]

Frick's many paintings by Cazin were matched by those owned by A. M. Byers, Lockhart, and Donnelly. Each sought landscapes that reflected the different moods of nature, as in *The Approaching Storm* or *The Village by Moonlight*. Canvases held by Frick, such as *Sunday Evening in a Miner's Village* (cat. 32) or *The Pool—Grey Night* (cat. 80), were characteristic works by Cazin. The former, Cazin noted to Frick, had been completed in a small hamlet near Boulogne, while the latter commented on the setting's "loneliness" and the way the moon's rays created the gray "light."[187] These nocturnal views, with their romantic ambience reminiscent of works by Ralph Albert Blakelock, were both mesmerizing and spectacular. It became apparent with *The Dipper* that Cazin could ably handle the theatrical effects and dramatic qualities of natural phenomenon. Since so many of his works entered public and private collections, it became evident that dealers, including Knoedler in New York, and the artist himself, had successfully marketed his paintings throughout the country.[188] In this way Cazin emerged at the forefront of landscape painting, elevating it to an honorable category of artistic creativity and drawing American collectors away from narrative storytelling and sentimental scenes as appropriate subjects for acquisition.

Cat. 80. Jean-Charles Cazin (1841–1901). *The Pool—Grey Night*, 1886, oil on canvas. Frick Art & Historical Center, Pittsburgh.

The Presence of Frits Thaulow

When the Norwegian artist Frits Thaulow came to Pittsburgh in 1898 to serve as a juror for the Carnegie International, he was building on a relationship with Pittsburgh collectors that had begun earlier in the decade.[189] Although his paintings were not as intensely acquired as those by Cazin, several of his landscapes were owned by Donnelly, Mellon, and later Peacock, as well as by Thaulow's close acquaintance Henry Clay Frick.[190] All told, ten works by Thaulow entered

Cat. 81. Frits Thaulow (1847–1906). *Village Night Scene*, 1895, oil on canvas. Frick Art & Historical Center, Pittsburgh.

the Frick collection between 1895 and 1899, making his paintings an essential part of this contemporary art collection.[191] Such admiration for his work grew when Thaulow received a second-class prize at the Carnegie International of 1897.[192]

Thaulow developed an international reputation that spread from Norway to England and, by the mid-1890s, to New York, where his works were handled by L. Christ Delmonico from his gallery of "Modern Paintings" at 166 Fifth Avenue.[193] The first painting purchased by Frick, *Village Night Scene* (cat. 81), also called *Norwegian Village,* was obtained from Delmonico in 1895 at the same time Frick was buying from him an early Monet landscape (1873).[194] The wagon with horses was reminiscent of Scandinavian scenes that Thaulow had been showing in European exhibitions, yet the sketchy lines and quick application of paint was new to American collectors who were accustomed to the high

degree of finish associated with most Salon paintings. Why were so many people in the United States interested in Thaulow's work? The answer is not difficult to find.

In a letter written to Frick in October 1895, Delmonico mentions that he was preparing to promote to private collectors and museum officials the work of a painter who was "a big name in Paris, [but] not yet in America."[195] By November 1897, just as interest in Thaulow's landscapes was growing in Paris, enthusiasm was building in New York. Upon seeing an exhibition of Thaulow's recent work at Delmonico's gallery, the critic for the *New York Times* concluded that the artist was emerging as the "only art novelty of the last half decade."[196] This exhibition featured works by Thaulow that were for sale as well as his paintings already in American collections, including those of John G. Johnson, P. A. B. Widener, George A. Draper, and possibly Henry Clay Frick.[197] In asking for the loan of the painting, Delmonico mentioned that Frick was "among the first buyers at a time when Thaulow was not known in America."[198] Frick, however, mysteriously refused to lend *Village Night Scene,* claiming "circumstances are such that we could not spare the picture."[199] (Most likely he objected to exhibiting his painting with works for sale.) Despite the absence of this important piece, the *New York Times* critic believed that Thaulow had "caught the atmosphere and feeling of the various lands and climates to perfection."[200] He drew a parallel with landscapes by Cazin, noting that Thaulow's works were often "tonal studies" that captured nature's moods and served as interpretations "of the rippling stream and of the solitariness of winter and the snow."

By October 1898, after Thaulow had come to Pittsburgh, Frick's championship of the painter accelerated. He acknowledged in a letter to Roland Knoedler that at a "delightful dinner party" Thaulow had "enjoyed himself thoroughly." This led to the painter visiting Homestead the following day, where he was "busily engaged [in] taking pictures and making sketches."[201] As a result of this stay, Frick acquired a series of Thaulow's works, including *Nuit à Falaise, les amoureux* and *The Hoar Frost* (fig. 99), which reflected the artist's ability to record subtle climatic conditions, such as early morning frost covering fields.[202] Frick purchased additional works in 1898, with some staying in his collection a short time and others remaining much longer. As Thaulow became interested in recording how the urban landscape had been changed through industrialization and the construction of numerous factories, Frick encouraged him to make preparatory studies for a series of topographic views around Pitts-

Fig. 99. Frits Thaulow. *The Hoar Frost*, n.d., oil on canvas. Location unknown. Photo courtesy Christie's, New York.

burgh. One of these appeared in the Sunday issue of the *Pittsburgh Post* on 9 April 1899.[203]

These later landscapes, including *The Smoky City* (cat. 82), explored riverways and industries cloaked in clouds of pollution.[204] Critics in France applauded this change in the artist's approach, and these paintings were eagerly acquired in Pittsburgh. Frick presented one version of *The Smoky City* to President Theodore Roosevelt, who eventually kept it for himself. One image in pastel, *Steel Mills Along the Monongahela River* (cat. 83), suggests that Thaulow used the sketches he made in Pittsburgh to complete this expansive view. Similar to the way James McNeill Whistler depicted the waterways of London, Thaulow looked down on the river from a high bank. He returned to the dictates of the academic tradition by producing numerous studies on location, and then making oil sketches in the privacy of his studio. Later he worked carefully in pastel, adding the innovations with color that are so evident here.[205] Whether the scene would be developed into a large-scale oil painting was determined later.

The years 1898 and 1899 marked a high point in the appreciation of Thaulow's diverse work in Pittsburgh and elsewhere.[206] By 1903 Thaulow was being celebrated in the American press, with a major article appearing in *Brush and Pencil*. Here, the critic reiterated that Thaulow had mastered certain types

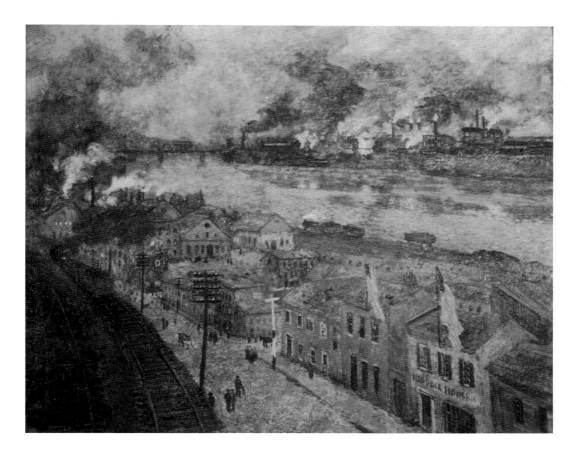

Cat. 82. Frits Thaulow (1847–1906).
The Smoky City, 1895, oil on canvas.
Sagamore Hill National Historic Site,
National Park Service, Oyster Bay,
New York.

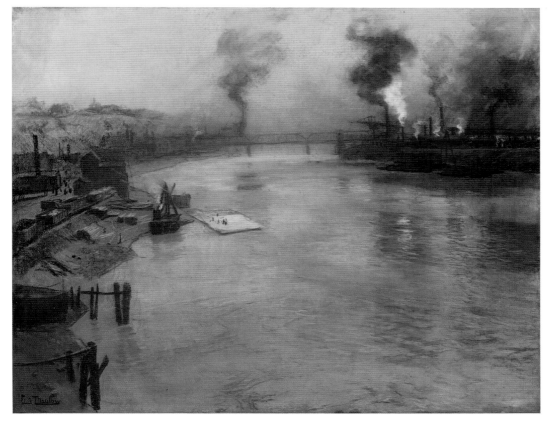

Cat. 83. Frits Thaulow (1847–1906).
Steel Mills Along the Monongahela River,
1898, pastel. Duquesne Club, Pittsburgh;
Presented by Arthur E. Braun.

of painting as he "expressed the most delicate and lovely things" with water, snow, and night scenes.[207] Collectors in Pittsburgh, as elsewhere, appreciated such works and had greatly advanced in their support of landscape scenes. John W. Beatty, who had urged Pittsburghers to consider acquiring contemporary painting, was especially intrigued by these developments in landscape painting and what it meant for regional artists. Naturally, collectors looked for other painters who depicted the countryside in a similar fashion.

The Role of Jean-François Raffaëlli

Works by Jean-François Raffaëlli were familiar to American viewers, especially after an extensive exhibition held at the American Art Galleries in April 1895 presented the multifaceted artist as a painter, illustrator, sculptor, and printmaker. In Pittsburgh, however, Raffaëlli's works were found only in the collections of Byers and Frick, who owned an atypical portrait study of a young girl and a number of etchings (cats. 84, 85).[208] Such meager representation of an artist who played a major role in the Paris art scene and enjoyed a strong international following may be because Pittsburgh collectors disliked his poignant naturalist images and in general may have been unaware of his later urban landscapes and fashionable portraits.

In the *New York Times* review of the American Art Galleries exhibition, the critic focused on Raffaëlli's ability to center attention on "the life about him," concentrating on the "ugly" and ignoring "the beautiful, the graceful and the decorative."[209] The writer discussed differences between Raffaëlli and other artists, and concluded that his realistic work "was gifted far above his fellows." The *Art Amateur* expressed concern that Raffaëlli was an Impressionist (he had participated in their exhibitions) who succeeded in finding themes amidst the "hustle and bustle" of city life.[210] Reproduced with the article was "Well, Here Goes" *(Blacksmith's Drinking)*, which showed two blacksmiths at a rural inn getting ready to gulp down their drinks, as well as one of Raffaëlli's urban types, a cobbler, that was part of the naturalist group with which he had achieved fame in the 1880s. The magazine also reported on a lecture that the artist had delivered at the New York exhibition, where he commented on his work, on political intrigues and rivalries in the Paris art world, and on his penchant for printmaking, particularly etching in aquatint and color. Raffaëlli's ability to charm audiences and to talk candidly about his work proved valuable, for he was later asked to serve as a juror for the Carnegie International of 1899.

Cat. 84. Jean-François Raffaëlli (1850–1924). *Terrain vague*, 1894, etching, aquatint printed in color; no. 25 in an edition of 30. Frick Art & Historical Center, Pittsburgh.

Cat. 85. Jean-François Raffaëlli (1850–1924). *Sur le banc*, 1894, etching, aquatint printed in color; no. 25 in an edition of 30. Frick Art & Historical Center, Pittsburgh.

Cat. 86. Jean-François Raffaëlli (1850–1924). *La Toilette*, c. 1898, oil on canvas. Frick Art & Historical Center, Pittsburgh.

Articles about Raffaëlli had earlier appeared in American periodicals. The June 1884 issue of the *Art Amateur* described a recent Raffaëlli exhibition in Paris, where his depictions of lower-class people were deemed "interesting and clever."[211] This kind of subject matter coincided with many American artists' interest in expanding their own visual vocabularies and instantly made Raffaëlli a hero. A decade later he was praised for his numerous contributions to the visual arts.

Considering this, as well as his participation in the Carnegie Internationals as an acclaimed artist and a valued juror, it is unusual that more works by Raffaëlli were not collected in Pittsburgh. Frick purchased his works from Arthur

Tooth & Sons, with galleries in New York and Paris, understanding that some of them had been shipped from Paris.[212] *La Toilette* (cat. 86), with its delicate color and sketchy paint application, demonstrated Raffaëlli's interest in Impressionism. The etchings *Terrain vague* (cat. 84) and *Sur le banc* (cat. 85), both completed in 1894, had been well received in Europe. As small black-and-white scenes of the urban poor on the outskirts of Paris, these prints would have lacked the visual impact of a work in color, yet this in itself might have made them acceptable to collectors who shied away from the artist's more compelling scenes.

In France, Raffaëlli was considered one of the country's leading artists. Photographs of his home, studio, and dining room filled with his sculpture and prints complemented an article about him published in the prestigious *Revue Encyclopédique* (1894).[213] With such international recognition Raffaëlli visited Pittsburgh for a month in the fall of 1899. Fluent in English and continually in the public eye, he proved so agreeable that he wrote an article for the *Pittsburgh Dispatch* in which he praised the Carnegie International.[214] He was completely

Cat. 87. Jean-François Raffaëlli (1850–1924). *Schenley Park, Pittsburgh*, 1899, oil on canvas. Collection of Adam Stolpen, Connecticut.

taken with America, and much like Thaulow, made landscape studies of suitable locations in Pittsburgh.[215] Among these works was *Schenley Park, Pittsburgh* (cat. 87), which he completed in the city during the late fall of 1899. Surrounded by fall foliage, the Carnegie Institute, then the city's emblem of culture, appears in the distance. Raffaëlli sought out the gritty urban environment that he believed symbolized Pittsburgh, but not everyone agreed with his choice of subject matter. He was even lampooned by a local cartoonist for being interested in the city's less attractive sites.[216] Despite this, Raffaëlli generally left a good impression with his Pittsburgh hosts, which makes it all the more unusual that his works were not widely collected.

Emile Friant: Frick's Personal Interest

Emile Friant stands out as an artist whose work was perhaps better known in France than it was in the United States. By the mid-1890s he had become a major representative of the Société Nationale and had received awards from the French government, including the distinction of having *All Saints' Day* (fig. 100) being sent to the Luxembourg Museum.[217] Unlike Cazin or Thaulow, Friant's images were linked to the area surrounding the city of Nancy,[218] and he expressed little interest in traveling to the United States to promote his art. Instead, he was content to have his works collected by a small group of friends, including the famous Parisian actors, the Coquelin brothers (Coquelin Aîné and Coquelin Cadet).[219] These private collectors appreciated the artist's connection to northern Renaissance masters and his fondness for filling his small-scale paintings with microscopic detail. Of all the collectors in Pittsburgh, however, only Frick acquired his work. Through his participation in acquiring noteworthy paintings for exhibition at the Carnegie Internationals, Frick collaborated with Knoedler in securing works that had received acclaim in Paris. This process allowed Frick to be among the first collectors to purchase paintings with a notable international provenance, which Friant's works could certainly claim.

That Frick was interested in Friant's work is not surprising. The French artist was highly regarded as a sensitive portraitist, a painter of small-scale genre scenes filled with naturalist details, and an artist who could work on a mammoth scale. This ability to handle various formats was nicely summarized in a short article in *Scribner's Magazine* that discussed Friant's painting *Cast Shadows*.[220] In it Philip Gilbert Hamerton, a well-known English art critic,

Fig. 100. Emile Friant. *All Saints' Day* (*La Toussaint*), 1888, oil on canvas. Musée des Beaux-Arts, Nancy, France.

Cat. 88. Emile Friant (1863–1932). *L'Entrée des Clowns*, 1881, oil on panel. Private Collection, France.

Cat. 89. Emile Friant (1863–1932).
Madame Coquelin Mère, 1888, oil on
panel. Private Collection, France.

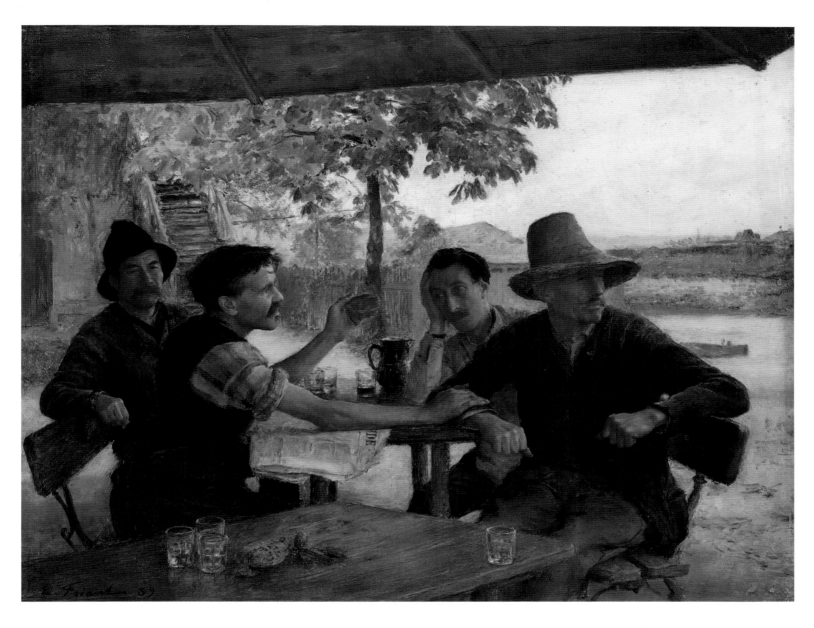

Cat. 90. Emile Friant (1863–1932). *La Discussion Politique*, 1889, oil on panel. Private Collection, France.

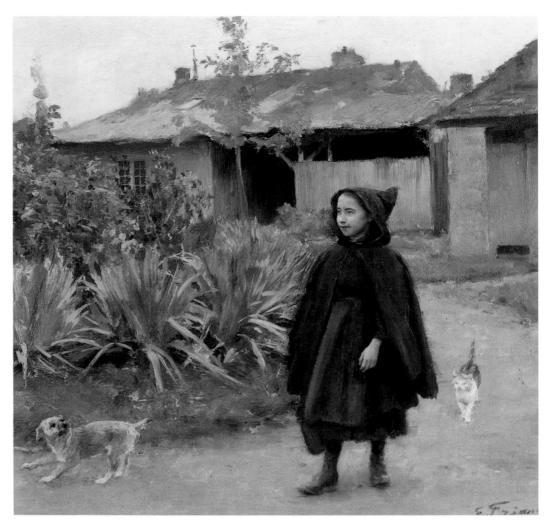

Cat. 91. Emile Friant (1863-1932). *The Garden Walk*, 1889, oil on panel. John G. Johnson Collection, Philadelphia Museum of Art.

introduced Friant to American readers by discussing *Cast Shadows,* a painting that had become popular when it was exhibited at the World's Columbian Exposition in Chicago the year before.[221] The article did not mention the artist's earlier paintings, such as *L'Entrée des Clowns* of 1881 (cat. 88), which approached anecdotal storytelling through popular entertainment, or his small-scale portraits of acquaintances, such as *Madame Coquelin Mère* (cat. 89), which confirmed his close association with the Coquelin family of actors. His interest in creating contemporary genre scenes and depicting types of local people and the nuances of group behavior is seen in *La Discussion Politique* (cat. 90), his observation of his colleagues arguing over matters near an inn. Despite these works' technical proficiency, they were not widely known images, and their small size suggests that they were not always intended for public viewing.

The Garden Walk of 1889 (cat. 91), one of Friant's small genre paintings, entered an American collection when John G. Johnson acquired it from M.

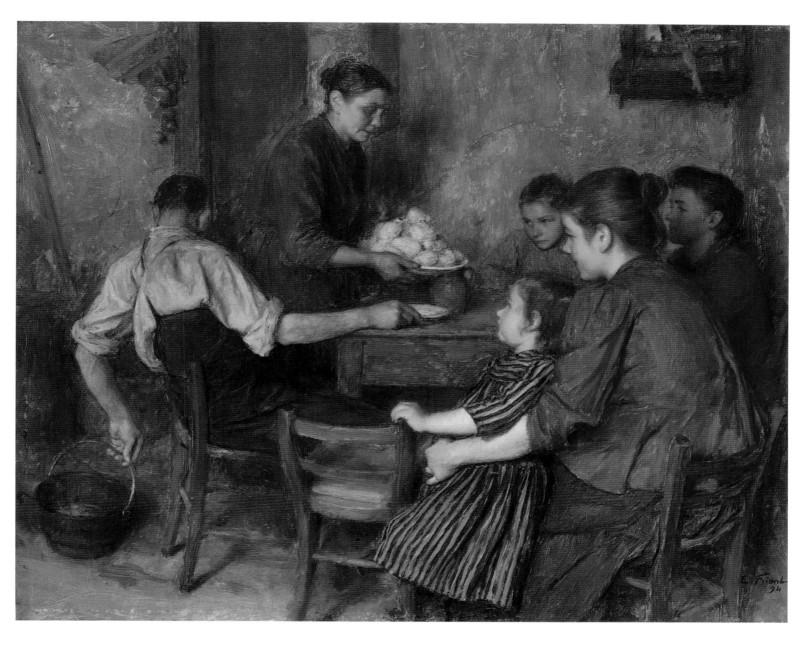

Cat. 92. Emile Friant (1863–1932). *Le Repas Frugal*, 1894, oil on panel. Private Collection, France.

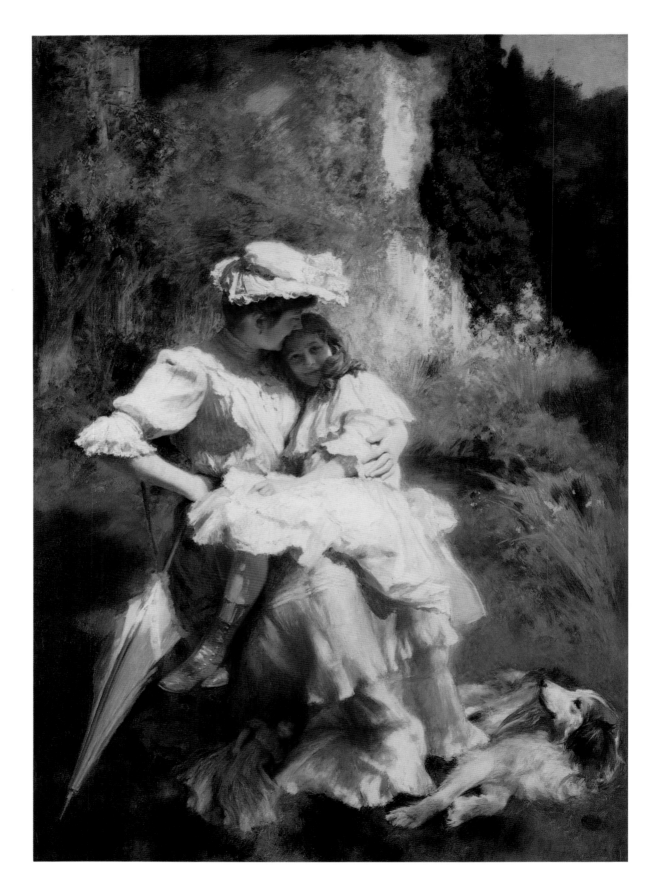

Cat. 93. Emile Friant (1863–1932). *Tendresse Maternelle*, 1906, oil on panel. Private Collection, France.

Knoedler & Co. in New York for $725 on 25 October 1890.[222] The painting's early date suggests that this was the first work by Friant to become part of a private collection in North America. Perhaps Johnson had become familiar with Friant's compositions at the Paris world's fair of 1889 or had generally followed the evolution of the artist's style throughout the 1880s when the American made trips to France. In this sentimental image, a child walking through gardens is accompanied by a cat and is eyed by a dog. Johnson might have been attracted to its theme of children's activities, a popular topic late in the nineteenth century, or he might have realized that it echoed Jules Bastien-Lepage's naturalist subject matter.[223] Johnson's acquisition of *The Garden Walk* undoubtedly gave Frick a chance to become familiar with Friant's work, which might have motivated the collector in Pittsburgh to purchase one of his paintings. Few other Americans became acquainted with Friant until his work was regularly included in the Carnegie Internationals.

During the mid-1890s, Friant often concentrated on commonplace themes based upon the lives of poor French families near Nancy. In *Le Repas Frugal* (cat. 92), family members share a simple meal in their cramped living quarters. A more congenial mood is conveyed in the later *Tendresse Maternelle* of 1906 (cat. 93), where the pleasant atmosphere reflects the tender relationship between mother and child. Through such drawings and paintings in which he explored moods, responses, and relationships among figures, Friant probed the character of children, almost as if he were responding to a growing contemporary interest in psychological studies of the young.

One painting that best records this tendency is *Chagrin d'Enfant* (cat. 96), which Frick purchased through Knoedler in 1899 after it had been shown in Paris at two major exhibitions that year.[224] In February 1899 it appeared in the annual exhibition of the Union artistique. A reviewer for the *Journal des Arts* noted the caring relationship evident between the girls and how the older one was "consoling" her tearful sister.[225] Similar comments were published when *Chagrin d'Enfant* was exhibited that April at the Salon of the Société Nationale des Beaux-Arts.[226] In closely examining the finished painting, however, the young girl seems more sad and angry than actually to be crying. Friant's ability to convey such subtle psychological states as melancholy is more apparent when the oil painting is compared with two preliminary drawings of the same theme. One is little more than a sketch of figure outlines (cat. 94). The other drawing, completed with considerable detail (cat. 95), depicts the child in the

Cat. 94. Emile Friant (1863–1932). Pre-
liminary study for *Chagrin d'Enfant*, n.d.,
charcoal on paper. Private Collection,
France.

Cat. 95. Emile Friant (1863–1932). Fin-
ished study for *Chagrin d'Enfant*, 1897,
charcoal on paper. Private Collection,
France.

Cat. 96. Emile Friant (1863–1932). *Chagrin d'Enfant*, 1897, oil on panel. Frick Art & Historical Center, Pittsburgh.

Cat. 97. Pascal-Adolphe-Jean Dagnan-Bouveret (1852–1929). *Self-Portrait*, 1876, oil on canvas. Musée Municipal Georges Garret, Vesoul, France.

Cat. 98. Pascal-Adolphe-Jean Dagnan-Bouveret (1852–1929). *Portrait of Jean-Léon Gérôme in the Uniform of the Académie Française*, 1902, oil on canvas. Musée Municipal Georges Garret, Vesoul, France.

midst of a tearful episode, her lips pursed to hold back her sobs. The child reportedly died shortly after serving as a model for Friant, and Frick might well have been attracted to this composition because it touched his personal sense of loss and reflected his own melancholy state of mind during the mid-1890s.[227]

Dagnan-Bouveret in Pittsburgh

Any consideration of paintings by Pascal-Adolphe-Jean Dagnan-Bouveret (cat. 97) in American collections, and specifically in Pittsburgh, must be framed against the growing international interest in this painter that stemmed from his achievements in Paris during the 1880s and in America during the 1890s. After the death of his friend Jules Bastien-Lepage in 1884, Dagnan-Bouveret emerged as the leading practitioner of naturalism in Salon exhibitions in Paris, and his achievements and awards influenced painters in England and Scandinavia to emulate his style.[228] His paintings ranged in subject matter from village traditions in Brittany to religious scenes with strong mystical overtones. Recognized as a portraitist, he received numerous commissions from wealthy sitters in France and elsewhere.[229] He produced portraits of those who circulated in fashionable and artistic circles, such as Gérôme (cat. 98). In keeping with a common practice of the time, he opened his large studio in Neuilly to social gatherings as a way to court potential sitters and collectors.[230] Dagnan's paintings were then widely circulated as illustrations in monthly periodicals and as reproductions through Goupil et Cie.[231] Such visibility, compounded by his participation in exhibitions sponsored by the Société Nationale des Beaux-Arts in the early 1890s, naturally added to his growing fame as an artist of high, international stature.

One painting that stirred considerable comment was the nationalistic theme of *The Conscripts* (fig. 101), which was unveiled at the 1891 Salon in Paris.[232] When it was exhibited at the World's Columbian Exposition in Chicago two years later, Dagnan received a medal as a member of the French section.[233] Although the painting was not included in the exhibition's official catalogue, it was repeatedly mentioned in American reviews, which suggests *The Conscripts* did travel to Chicago.[234] While this imposing canvas and its patriotic theme clearly demonstrated how naturalism could be used to support nationalistic causes, it also verified Dagnan's position as a primary painter of the French Republic. *The Conscripts*, however, was not the first, nor the only, painting by Dagnan-Bouveret to receive applause in the United States.

John G. Johnson's collection in Philadelphia contained three early pur-
chases of works by Dagnan (two paintings and a pastel).[235] Both paintings,
Gypsy Scene (fig. 102) and *Bernoise* (cat. 99), are indicative of the type of small
canvases that Dagnan completed early in his career. Members of the artist's
family served as primary models, with Dagnan himself posing as the traveling
gypsy in one work, and his wife Elizabeth Walter dressing in the native cos-
tume of Bern (fig. 103).

As Gérôme's best student and enduring friend, Dagnan-Bouveret had
attained considerable importance by the time of the 1889 Exposition Uni-
verselle, where he received a major award.[236] Collectors soon clamored to pur-
chase his works, making acquisitions for collections in New York, Baltimore
(fig. 104), and Pittsburgh.[237] By 1892 *Madonna and Child* had arrived in Pitts-
burgh, having once been owned by Thomas Shields Clarke, a painter and

Fig. 103. Photographer unknown. Eliza-
beth Walter in preparation for *Bernoise*.
Archives départementales, Vesoul,
France.

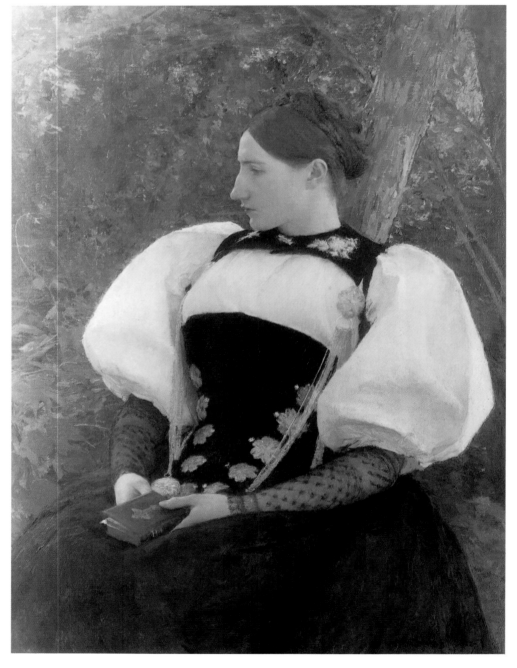

Cat. 99. Pascal-Adolphe-Jean Dagnan-
Bouveret (1852-1929). *Bernoise*, 1887, oil
on canvas. John G. Johnson Collection,
Philadelphia Museum of Art.

Fig. 104. Pascal-Adolphe-Jean Dagnan-Bouveret. *The Accident*, 1879, oil on canvas. The Walters Art Gallery, Baltimore.

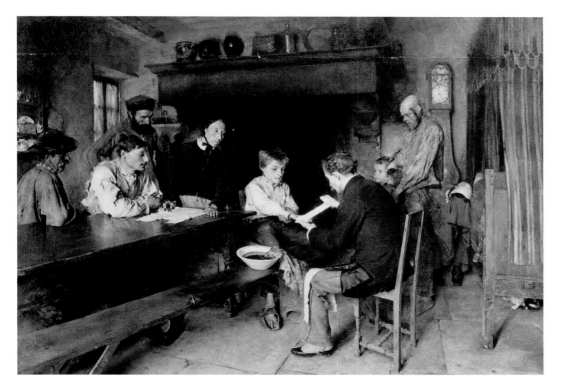

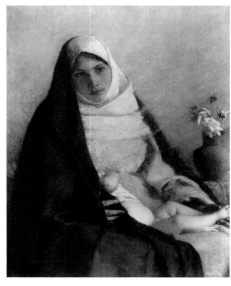

Fig. 105. Pascal-Adolphe-Jean Dagnan-Bouveret. *The Madonna of the Rose*, 1886, oil on canvas. The Metropolitan Museum of Art, Wolfe Fund, 1906. (06.1233.2), New York.

sculptor who had trained under Gérôme and Dagnan-Bouveret in Paris and was a friend of Frick.[238] This painting, now known as *The Madonna of the Rose* (fig. 105), was shown in the first Carnegie International in 1896 and purchased by the Metropolitan Museum of Art in New York in 1906.[239] When it was first publicly shown in Pittsburgh, *The Madonna of the Rose* did not go unnoticed by the local press. The critic for the *Pittsburgh Post* noted that its religious theme, underscored by the mysterious play of light, would "attract the greatest amount of attention," and the painting's size so dominated the wall on which it hung "that other pictures near it are unnoticed. . . ."[240]

By the mid-1890s paintings by Dagnan-Bouveret were in demand by an international clientele. One of his most admired works was *Concert in the Forest* of 1893 (fig. 106), which was shown at the Paris Salon and was widely repro-

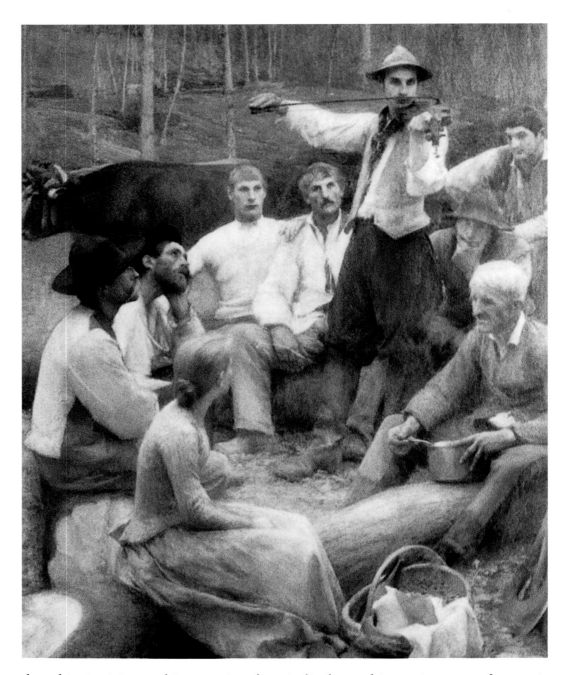

Fig. 106. Pascal-Adolphe-Jean Dagnan-Bouveret. *Concert in the Forest*, 1893, oil on canvas. Mairie de Neufchâteau, France.

duced in Parisian and international periodicals.[241] This rustic scene of a musician playing a violin to an informal gathering exudes a sense of poetry that is unusual in a genre composition. The muted tones, somewhat mystical setting, and graceful figures offer a symbolic meaning that was not evident in his earlier naturalist works. This painting extended Dagnan's reputation to England when it entered an English collection by 1896 and was shown at the Royal Academy in London in 1909. Americans could see it when it was displayed in San Francisco at the Pan American Pacific International Exhibition in 1915.[242]

Fig. 107. Pascal-Adolphe-Jean
Dagnan-Bouveret. *The Madonna
of the Trellis*, 1889, oil on canvas.
Location unknown.

Yet it was Dagnan-Bouveret's smaller paintings that first attracted notice in America. *Gypsy Scene* of 1883 represents an early stage in the artist's development and an unusual theme in his oeuvre. Here, a family of gypsies, accompanied by an emaciated white horse, have momentarily stopped in their wanderings of the countryside to cook a meal. Records show that Johnson purchased it from the Haseltine gallery in Philadelphia in September 1885 for $1,392.[243]

Bernoise of 1887, another painting in the Johnson collection, attests to the painter's practice of using his wife, himself, and members of his family as models dressed in costumes and other guises. This painting also reveals that Dagnan, like many of the Salon naturalists, employed a thoroughly modern approach to his portraits by using photographs as aids in completing his compositions. (Elizabeth Walter appears in the same dress and pose in both the photograph and the finished painting.) An earlier portrait of Elizabeth, completed in 1878 (cat. 100), demonstrates Dagnan's skilled use of vibrant color, brilliant

Cat. 100. Pascal-Adolphe-Jean Dagnan-Bouveret (1852–1929). *Portrait of Mademoiselle Walter with Parasol*, 1878, oil on panel. Musée Municipal Georges Garret, Vesoul, France.

Fig. 108. Pascal-Adolphe-Jean Dagnan-Bouveret. *Madonna and Child*, 1885, oil on canvas. Bayerische Staatsgemälde-sammlungen, Munich.

outdoor light, sweeping visual effects, and off-center composition. Such paintings effectively prepared the way for American appreciation of Dagnan's talents well before the World's Columbian Exposition of 1893.

Bernoise, with its introspective mood and meticulous detail, introduced an important article on Dagnan-Bouveret in the May 1894 issue of *Century Magazine.*[244] (This periodical had already illustrated other works by Dagnan, including *The Madonna of the Trellis* [fig. 107] and T. S. Clarke's *Madonna and Child.)*[245] The article, written by William A. Coffin, a naturalist painter and American expatriot, provided a thorough examination of Dagnan's life and work. Almost all his major works were illustrated, including *The Pardon, The Conscripts,* and *Concert in the Forest,* and his dedication to "incessant" work and his artistic relationship to the early German painter Hans Holbein were noted. Coffin concluded that this "sincere" painter was assured a place in French contemporary art, and the presence of his paintings in American collections ensured the continuing appreciation of this artist in the United States. Two years later another article about Dagnan written by Coffin for *Century Magazine* was included in John Van Dyke's *Modern French Masters,* which also furthered awareness of the artist's work.[246] Coffin's statement that Dagnan-Bouveret was "more like an artist of the early Renaissance than a Parisian of today" would have been understood by Johnson and Frick, both of whom had intensely studied the old masters and were favorably disposed to contemporary painters whose works were associated with the past.[247]

By the mid-1890s two paintings by Dagnan-Bouveret were in the H. K. Porter collection in Pittsburgh.[248] Porter, a friend of Frick who produced "light" locomotives for the railroads, had developed an extensive collection of contemporary art that he exhibited in the art gallery constructed in his mansion.[249] Photographs of *The Orange Girl* (fig. 88), which is now lost, resemble *Bernoise* in the Johnson collection. The young woman's wistful mood as she pauses in her mundane activity of collecting oranges is emphasized by the sweeping landscape beyond the trees. This close-up study of a single figure in a deeply reflective attitude, however, is unusual for Dagnan.

A second work in the Porter collection was actually a rephrasing of the earlier *Madonna and Child* (fig. 108) that was exhibited at the 1885 Paris Salon.[250] At that time, the painting announced Dagnan-Bouveret's shift from naturalist scenes toward mystical religious imagery. Since this move proved both effective for the artist and popular with a large audience, the 1885 version of

Madonna and Child was acquired by the Munich Neue Pinakotech. Dagnan finished another version of the painting with minor changes, and that one was acquired by Clarke at an unknown date. When this second version was shown in Pittsburgh in 1896, it was praised by many viewers who, like collectors and supporters of the arts in France, were apparently eager for Dagnan to develop larger-scale religious compositions that would attract the faithful. With such encouragement it is easy to see why the artist continued his lucrative portrait painting but surrendered his involvement in naturalistic genre imagery in exchange for scenes of religious mysticism.

Exactly when Frick began to acquire works by Dagnan-Bouveret is not known, but given the level of appreciation for the artist's work in the United States, and specifically in Pittsburgh, it is not difficult to see why Frick became interested in his work. Also, when he attended the Salons of the Société Nationale in the mid-1890s, Frick (and others in Pittsburgh) would have met not only dealers who were eager to promote Dagnan's work but perhaps the artist himself. A case in point is the exchange of correspondence between Frick and Edmond Simon, an agent of Arthur Tooth & Sons, concerning the availability of Dagnan's painting *Christ and the Disciples at Emmaus* (cat. 101). Dagnan had almost completed this large composition in 1897 (fig. 109), but he insisted on delaying its exhibition until the Paris Salon of 1898.[251] Frick must have seen the work in progress in Dagnan's studio and solidified his agreement with the dealer and the painter to acquire it.[252] Frick also wanted Dagnan to paint portraits of his son Childs—he was to send the artist a photograph of the boy—and he was thinking of having a portrait done of his wife.[253] In late September Frick wrote directly to Dagnan-Bouveret and mentioned that he was going to "Paris next year, and [wished] the pleasure of calling on [him]."[254] That October he wrote again, asking that the artist allow Andrew Carnegie to visit his studio and see the large painting in progress because he was sure that the work would "eventually find a resting place in the institution which he has founded."[255]

After Carnegie reported his approval of the religious painting, Frick requested that a reduced version of the composition be prepared for his own private collection, and he enthusiastically praised the work to Roland Knoedler.[256] The *Century Magazine* expressed interest in the painting when R. U. Johnson, its associate editor, contacted Frick to say that he was "glad to see the announcement that you are the purchaser of the Dagnan-Bouveret 'Supper at

Cat. 101. Pascal-Adolphe-Jean Dagnan-Bouveret (1852–1929). *Christ and the Disciples at Emmaus*, 1896–97, oil on canvas. Carnegie Museum of Art, Pittsburgh; Presented in memory of Martha Howard Frick by Mr. and Mrs. H. C. Frick.

Emmaus' which I had the pleasure of seeing in the painter's studio. . . ."[257] Johnson, who shared Frick's interest in promoting Dagnan's work in this country, believed the painting was "a wonderful picture," and he congratulated Frick on acquiring it for the United States. Now a central figure in endorsing Dagnan, Frick may well have been sympathetic to the artist's religious paintings because they related to the ways he thought about his own family, and specifically his deceased daughter Martha.[258]

In the midst of this adulation for *Christ and the Disciples at Emmaus,* which still had not been publicly exhibited, was considerable discussion of *La Cène* of 1896. When it was first exhibited at the 1896 Salon, critics in England and France claimed that Dagnan had maintained "the traditional mystical character" of the Last Supper by emphasizing the distinctive expressions of the disciples, and he should be applauded for the "serious quality of the execution."[259] Critics were astonished that he had successfully attempted to interpret the Last Supper in a supposedly nonreligious era, although some were unhappy with the composition's lighting.[260] Others objected to comparisons of his work to earlier religious imagery, especially that of Leonardo da Vinci.[261] They considered the composition forced and lacking in dramatic impact, even though Dagnan might well have been influenced by the religious presentations of *tableau-vivants* that were then in vogue in churches and musical performances.[262] The controversy surrounding Dagnan's religious imagery reached England, where a pamphlet, written by the Dean of Canterbury and disseminated by Goupil and Company in 1897, provided learned commentary on Dagnan's construction of the scene.[263] Building upon the enthusiasm expressed by English critics, the writer noted that "on every ground, [Dagnan's painting must] be regarded as memorable . . . and will take its place among the great religious pictures of the world."[264] Detailed examination of the composition's intricate meaning and the moment depicted led the writer to observe that Christ's position represented "a sort of transfiguration, the source and centre of all the light."[265] The intense discussion of this work, its meaning, and its relationship to earlier religious paintings added to Dagnan's new reputation as a religious painter and attracted intense scrutiny of the interpretive accuracy of his creation.

Responding to this pamphlet and to the painting's exhibition at the Goupil gallery in London, J. C. Warburg wrote a letter to the editor of the London *Times* that was published on 30 December 1896.[266] Claiming that he had discussed the painting with the artist himself, as well as with other collectors of

Fig. 109. Photographer unknown. Dagnan-Bouveret in the process of painting *Christ and the Disciples at Emmaus.* Collection of Gabriel P. Weisberg.

Dagnan's work in France, Warburg wanted to provide the proper interpretation of certain figures, particularly that of St. Peter and Judas. It was, he indicated, "M. Dagnan's intention to characterize only two Apostles on either side of the central figure; the one on his right is (as correctly explained by Dean Farrar) St. John, the one on his left Judas. The recognition of the others it was the intention to leave to the individual spectator."[267] The intensity of the discourse that surrounded *La Cène* was unusual, but it nevertheless succeeded in attracting even more attention to Dagnan.

Frick may have realized that he, too, was at the center of an ongoing artistic controversy. In light of this situation, Frick and Arthur Tooth allowed *Christ and the Disciples at Emmaus* to be exhibited in London before it was actually shown at the Paris Salon in the spring of 1898. When it was put on display at the gallery of Arthur Tooth & Sons on 21 December 1897, the London *Times*

examined the significance of *Christ and the Disciples at Emmaus* in an article entitled "Dagnan-Bouveret's new picture."[268] Its writer acknowledged that Dagnan was following a middle course between traditional artists (such as Raphael and other respected names of the Italian Renaissance) and the modern religious genre painters, represented by Fritz von Uhde in Germany and James Tissot in France. Placing the donors at the right added both a personal and a controversial dimension to the composition because it became obvious that these figures were the artist with his wife and son. The London *Times* reported that Dagnan tried to explain this by saying that "these three [are] representatives of the modern world face to face with the Divine mystery. The woman and the child are kneeling; the man stands perplexed." He continued by noting that "man, after all these troubles, after all these doubts and all these

Cat. 103. Pascal-Adolphe-Jean Dagnan-Bouveret (1852–1929). *Study for Christ and the Disciples at Emmaus*, n.d., colored chalk on paper, pricked for transfer. Carnegie Museum of Art, Pittsburgh; Leisser Art Fund.

Cat. 104. Pascal-Adolphe-Jean Dagnan-Bouveret (1852–1929). *Study for Christ and the Disciples at Emmaus: Portrait of Jean Dagnan*, n.d., graphite and white chalk on gray paper. Musée Municipal Georges Garret, Vesoul, France.

Fig. 110. Photographer unknown. Preparatory photograph for *Christ and the Disciples at Emmaus* by Dagnan-Bouveret. Photograph provided by Gabriel P. Weisberg.

Fig. 111. Photographer unknown. Preparatory photograph for *Christ and the Disciples at Emmaus* by Dagnan-Bouveret. Photograph provided by Gabriel P. Weisberg.

denials, can no longer kneel as he once did. His brow is care worn, anxiety has desolated his heart. . . ."[269] This deeply personal interpretation was published to dispel any immediate attacks against Dagnan's work, and yet it helps to explain why Frick was so moved by the composition.[270]

After the exhibition closed in London, *Christ and the Disciples at Emmaus* was now a work of considerable international fame. Once its controversial reputation reached Pittsburgh, local newspapers began to publish articles on the painting and what Frick had paid for it.[271] One writer drew a parallel with Rosa Bonheur's famous *Horse Fair*, which was then regarded as a paradigm of what

Cat. 105. Pascal-Adolphe-Jean Dagnan-Bouveret (1852–1929). *Étude de Soir, sous la lampe (Madame Dagnan and Her Son Jean)*, 1890, charcoal on white paper. Musée Municipal Georges Garret, Vesoul, France.

should be paid for a contemporary work of art. The price of $100,000 that was supposedly paid for Dagnan-Bouveret's painting caused a tremendous furor by setting new standards in price.[272] Another article examined the controversy raging in London over Dagnan's inclusion of himself and his family in the composition. Its author asserted that the artist had set himself up as a skeptical theologian, one whose dress as a *boulevardier* was antagonistic and sacrilegious.[273] Subsequent articles generated considerable interest in defining exactly what was being depicted. The *Pittsburgh Post* reported that Frick was searching the Bible to provide an accurate interpretation to the presentation.[274] Animosity toward the painting spread to Chicago, where the *Tribune* lambasted Frick for buying a "freak." It railed that such religious skepticism was ill advised and claimed that Frick was insensitive to those who needed assistance in society.[275]

Cat. 106. Emile Boilvin (1845–1899) after Pascal-Adolphe-Jean Dagnan-Bouveret (1852–1929). *Christ and the Disciples at Emmaus*, c. 1899, etching (remarque proof). Frick Art & Historical Center, Pittsburgh.

Frick must have been delighted by an article that ran in the *Pittsburgh Post* in February 1898 that talked about him and the painting, concluding that "Pittsburgh seemed to be absorbing all the good things." It continued: "The world has been laboring under the delusion that art could not thrive amid smoke. Pittsburgh has always been famous for its factories, but that is no reason why it should not rejoice in its noble reputation as an art center."[276]

When *Christ and the Disciples at Emmaus* was unveiled at the Salon of the Société Nationale des Beaux-Arts in April 1898, daily newspapers in Paris devoted considerable attention to it. The eminent critic Louis de Fourcaud, writing in *Le Gaulois,* chose to negate attacks against the painting by proclaiming the figures at the right were "beautiful," perhaps more "saintly religious than the principal subject [the Christ]."[277] The critic for *La Liberté* responded even more pointedly: he placed the work within the context of both historic and contemporary religious painters and noted that Dagnan was both "an excellent painter and a fervent Christian."[278] He directed attention to the sympathetic way in which the artist had constructed a "poetic landscape" in which Jesus "was seated in front of a very humble table." Although he interpreted the supernatural effect of light emanating from Christ's body as an "emblematic device suggesting divinity," the critic thought Dagnan had created Christ as an "unmoving" and "cold" figure (cat. 102).[279] The critic writing for *L'Evénement* praised the composition's beauty and the facial expressions of those who witness the miracle, in addition to the divine quality achieved by the mystical play of light.[280] Little question now remained that *Christ and the Disciples at Emmaus* was being discussed in depth on both sides of the Atlantic.

Placing blame on the Spanish-American War, Frick was prevented from traveling abroad for this exhibition, yet he was eager that the painting be shown in New York before it was shipped to Pittsburgh.[281] Its arrival generated considerable anticipation and excitement in Pittsburgh since the painting was a principal painting of the Carnegie International. It was also the first work donated to the Carnegie Institute, given by Mr. and Mrs. Frick in memory of their daughter Martha.[282]

At the opening of the Carnegie International, the *Pittsburgh Post* commented that "the one great picture which dominates everything is 'The Christ' by Dagnan-Bouveret. Any exhibition would be great which held this masterpiece by the great master. . . ."[283] The painting, which demanded that the viewer stand "reverently" before it to experience its otherworldly effect, had evolved

slowly in accordance with Dagnan's academic background. Preliminary charcoal studies for each major figure (cat. 104) were meticulously transferred to the canvas. Nothing was left to chance. Each figure drawing (cat. 103) conveyed the intense religious spirituality that the artist hoped to achieve in the final image. Following his more modern practice with portraiture, Dagnan employed photographic sources for the models at the right (figs. 110, 111).[284] Including his own family in the composition was not unique, for he had frequently placed his wife and son in other works, including *Étude de Soir, sous la lampe* (cat. 105). Despite such close examination of his process, we can only imagine how Dagnan intended *Christ and the Disciples at Emmaus* to be seen. A completely darkened environment around the illuminated work itself would have intensified the ethereal mood that Dagnan strove to achieve.

With the painting's exhibition in Pittsburgh, both Carnegie and Frick had achieved their goal of making people aware of art, particularly paintings with a didactic message.[285] Frick's attention was soon taken in another direction when he learned that Dagnan-Bouveret was at work on another painting destined to make a lasting impression. Edmond Simon wrote to Frick, saying, "I am pleased to tell you that the next picture will be also a *chef-d'oeuvre*. It is now on the canvas, and I cannot explain my admiration. Really Dagnan is the greatest Master living, and feel certain that you will agree with me when you see the picture next year."[286] Frick may well have welcomed another opportunity to acquire a work by Dagnan, and the *Consolatrix Afflictorum* became his next major purchase from France.

At the time that his painting was on view in Pittsburgh, Dagnan entered into a contractual agreement with Arthur Tooth & Sons concerning the production and sale of engravings after *Christ and the Disciples at Emmaus* and the *Consolatrix Afflictorum*.[287] Each artist's proof brought Dagnan fifty francs; other variations, either unsigned copies or those with a special mark, brought a smaller royalty fee. Since all the prints would most likely be sold through worldwide distribution, as had been the case with *La Cène*, the artist stood to make a handsome profit on reproduction rights. Of course, Frick also acquired prints of *Christ and the Disciples at Emmaus* (cat. 106) and the *Consolatrix Afflictorum* (cat. 107), which were dutifully framed and hung in his home.

The painting of the *Consolatrix Afflictorum* (cat. 108) presented an unusual theme that was based in popular imagery and had been occasionally painted by other nineteenth-century artists. Dagnan may have turned to it through Frick's

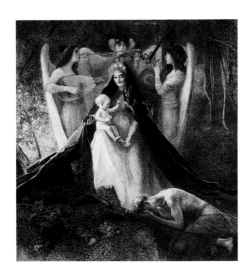

Cat. 107. Léopold Flameng (1831–1899) after Pascal-Adolphe-Jean Dagnan-Bouveret (1852–1929). *Consolatrix Afflictorum*, c. 1899–1903, etching (remarque proof). Frick Art & Historical Center, Pittsburgh.

Cat. 108. Pascal-Adolphe-Jean Dagnan-Bouveret (1852–1929). *Consolatrix Afflictorum*, 1899, oil on canvas. Frick Art & Historical Center, Pittsburgh.

influence, although it is uncertain whether the collector actually commissioned it. On Simon's advice, Frick reserved the painting in 1899, but he did not actually pay anything until April 1901, when he sent Arthur Tooth & Sons a check for $10,000, including the cost of the frame.[288] By that time, the painting had been shown in Paris at the Décennale exhibition held in conjunction with the Exposition Universelle of 1900.[289] There, Dagnan-Bouveret had been given the honor of having his own room as an exhibition space, where many of his best paintings in French collections could be studied and admired.[290]

Critics christened this room as the "sanctuary of Dagnan-Bouveret" since a number of his religiously inspired paintings (such as *La Cène*) were exhibited together. While some French critics found his religious imagery overdone or lacking in true "compassion," others drew positive parallels between it and the work of Jan van Eyck or the English Pre-Raphaelites.[291] Some who were unable to grasp the composition's different aspects deemed the painting "étrange."[292] Charles Holman Black, writing in the *English and American Gazette,* called this "a very beautiful" picture, a true "peinture sacrée."[293] A comparatively negative review of the works seen in Paris was written by Laredo Taft for the *Pittsburgh Post* in August 1900. In his troublesome review, Taft found success in Dagnan's "works . . . in a diminishing ratio."[294] He saved his most savage commentary for the *Consolatrix* that was "painted for Mr. Frick, . . . [and marked] a sad decline from the standard of *The Pardon* and *The Conscripts.* . . . Its chief fault, is its irrepressible green. To have the light filter down through forest verdure until it is saturated with its hue is an effective device, . . . but to add to this general tint the burden of that enormous cloak of vivid green is certainly overdoing the thing."[295] While Taft did comment favorably on Dagnan's general contributions to French painting, his lack of praise for paintings acquired by Frick was embarrassing to the collector who was trying to establish his own reputation as a connoisseur. While the *Consolatrix Afflictorum* achieved one goal by generating considerable attention, it clearly aligned Dagnan with the conservative arm of French art and ironically brought Frick's sponsorship of religious paintings under attack by some of the more "modern" critics. Lost in this particular line of discourse was Dagnan's conscious decision to paint in tones of green. Doing so certainly brought him in line with those "modern" artists who were using tones of mauve, blue, or green in their avant-garde works.

The *Consolatrix Afflictorum* can be examined from two directions: its impor-

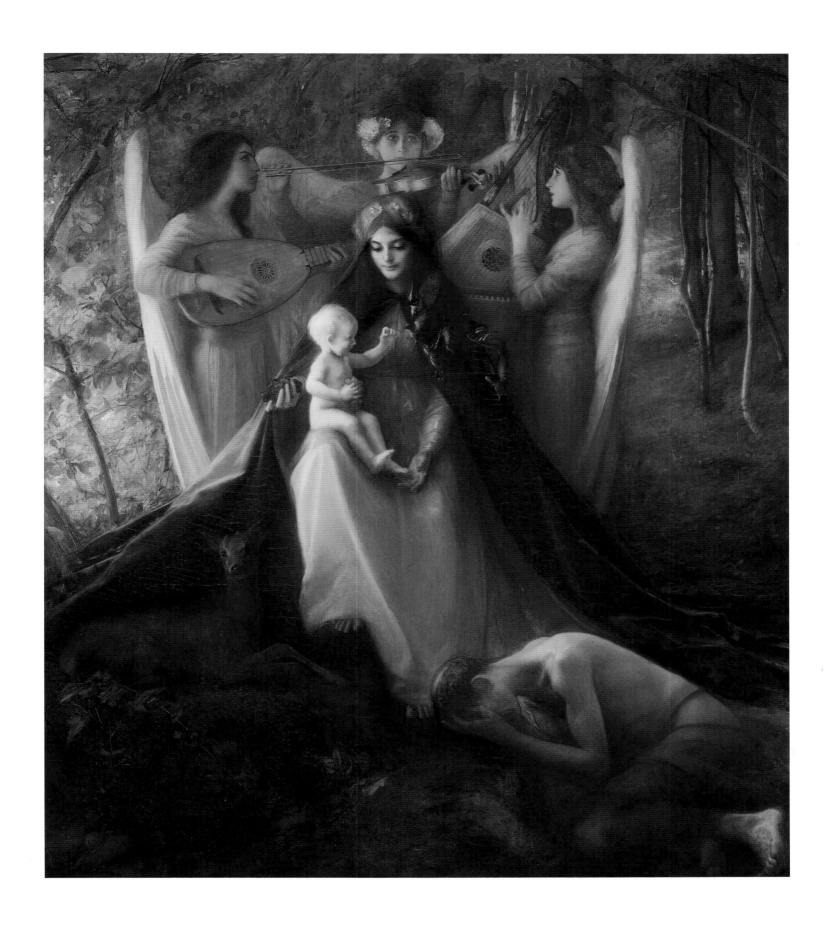

tance to Frick, and its significance to Dagnan-Bouveret and his French audience in 1900. The first avenue is somewhat easier to reconstruct, for the theme of this immense canvas meshed with the lingering melancholy felt by the Frick family. Seated in a glen, the Madonna and Child console a deeply distraught man who attempts to conceal his anguish by covering his face with his hands. The figure of the Madonna dominates the middle ground as she looks down on the Christ Child seated on her knee. Surrounding this group are three winged angels, each holding a musical instrument. The presence of animals and birds in the forest glade emphasizes nature's tranquility and reinforces the peaceful atmosphere. Even though Dagnan did not prepare a specific document to explain this work, as he had done with *Christ and the Disciples at Emmaus,* the scene's religious symbols would have been readily apparent to any viewer.

This Madonna of mercy, considerate of those in pain, holds a pomegranate in her hand to signify the unity of the Church and the earth's rejuvenation each spring.[296] The inclusion of this symbol suggests that through belief in the Madonna and Christ, and in their abilities to heal, there remains hope for immortality and resurrection. Elevating the scene to a spiritual realm are the musical angels who play hymns in praise of the Madonna who triumphs over baseness (as symbolized by the snail). This message of hope and salvation was largely directed toward Frick and his family. In returning to traditional imagery, Dagnan was helping to soothe their pain by creating an inspiring work of art that would ultimately hang in their home.[297]

Dagnan's extended interest in the painting involved the way in which it would be permanently displayed. In a letter to Edmond Simon in December 1900, the artist stated, "Now that my picture . . . is at the point of being shipped to Pittsburgh, I should like you to transmit to Mr. Frick some of my recommendations."[298] The artist had not been happy with the way the painting had been shown in 1900 because the "color of the hangings" did not harmonize with the composition. Perhaps he believed that negative comments from the press had been triggered by the work's improper display. Most concerned that the work be placed in a suitable light, he reminded the dealer that "people who see this picture now that it is back in my studio, do not recognize it; so much has the coloration changed in changing places." While Dagnan realized that he could not control where the painting was installed, he hoped that the room would be "about the dimensions of my studio, 8 or 9 yards by 11, the light coming from the side," and he even provided a drawing to clarify the proper placement. He

suggested that the walls of the room "be coloured like those of my studio;— olive green of a greyish tint, or reseda." (Such concern for subtle coloration and harmonious tints makes Dagnan sound like a very modern painter.) The artist's suggestions were followed when the *Consolatrix* entered Clayton and was installed in the dining room that had been modified to meet his specifications.

Dagnan's methodical preparation of this composition is evident from the drawings and oil sketches that exist for a number of figures, including one of the Christ Child (cat. 109). Another showing the head of the Madonna (cat. 110) is inscribed to the actress Julia Bartet, who might have served as a model. Since other works by Dagnan are dedicated to her, this suggests the artist enjoyed a close relationship with theatrical performers at the Comédie Française and elsewhere and lends credence to the notion that the initial conception for the *Consolatrix* could have been inspired by theatrical performances. Curiously, Dagnan-Bouveret may also have believed that Frick would be interested in retaining some of the preliminary studies for this painting or for *Christ and the Disciples at Emmaus* to decorate a hospital being constructed in Pittsburgh.[299]

To counter any remaining criticism of the *Consolatrix*, Frick allowed the *Pittsburgh Post* to report on the painting's arrival and installation at Clayton. Curiously, the writer believed the painting had not attracted attention from "painters and connoisseurs" the world over, yet he emphasized that "all are unanimous in the judgment that this is a great work of art."[300] Such comments are difficult to comprehend, especially since Laredo Taft had earlier reviewed Dagnan's work in the same newspaper. One point remained clear: the precise amount paid for the painting was not revealed. Frick had learned a valuable lesson from the stories that had circulated after his acquisition of *Christ and the Disciples at Emmaus,* and he did not want to repeat the same controversy. It is also unusual that Frick was able to generate this type of attention for a painting that was initially to be seen only in his home, which may have contributed to its mystery.[301] Indeed, Frick was repeatedly in the public eye concerning his financial dealings and his breakup with Carnegie, so it was "news" to report on anything associated with him.

In the late 1890s, Dagnan-Bouveret was actively completing another painting for Frick, *The Portrait of Childs Frick* (cat. 9). Although initial discussion about this work began in September 1897, with Frick "acceding" to the painter's requests, the final version was not ready until 1899. Wishing to create a fine portrait of a "boy who will be somebody one day," the artist requested a

Cat. 109. Pascal-Adolphe-Jean Dagnan-Bouveret (1852–1929). *Study for Consolatrix Afflictorum,* c, 1899, oil on panel. Frick Art & Historical Center, Pittsburgh.

Cat. 110. Pascal-Adolphe-Jean Dagnan-Bouveret (1852–1929). *Study for Consolatrix Afflictorum,* c, 1899, oil on paper laid down on cardboard. Musée Municipal Georges Garret, Vesoul, France.

photograph of Childs so he "could do a study of his face" before he came to Dagnan's studio for a formal sitting.[302] The finished painting, which apparently was never officially exhibited, was of interest to John W. Beatty, who hoped to include it in one of the Carnegie Internationals.[303] When the painting arrived in Pittsburgh, however, members of the Frick family did not like it. In a letter written to Edmond Simon early in January 1900, Frick wrote that "I regret to say the portrait of my son, by Dagnan, is not liked by any of our friends. It does not grow on acquaintance."[304] Such negative reaction confirms that the painting was not to be publicly exhibited. Instead it was kept within the family and has only recently been shown.

Given the general way official portraits were created in the 1890s by Dagnan, Chartran, and other artists, the painting of Childs Frick does conform to certain standards of the time. The young boy, dressed in modish clothes, holds both leather gloves and a stylish hat in front of him in a controlled and dignified way to match his demeanor. Much like Chartran's portrait of James Hazen Hyde (cat. 69), Dagnan portrays Childs as a youth of class and distinction entering the social world with considerable advantages. Problems in the composition arise in the artist's extensive reworking of Childs's face. The head, despite a good likeness and an intense gaze, seems a bit pronounced. It does not sit easily on the boy's neck and appears to float forward toward the viewer. The presence of plants to the left and flowers to the right were probably meant to soften the scene and to convey some of the delicacy of Childs's personality. In making Childs look like a young aesthete, which was very much in keeping with French portraits, Dagnan-Bouveret turned this American boy into a young Frenchman.

Frick's continuing advocacy of Dagnan-Bouveret has also to be placed within a wider context in 1901. As word of the artist's promotion to the Institut de France spread, and as collectors returned from the Exposition Universelle of 1900 in Paris, they recognized that this was an opportune moment to hold their own exhibition of Dagnan's paintings in North America. Accordingly, a small exhibition of eleven paintings was held at the Art Institute of Chicago in March 1901.[305] One major loan was Dagnan's *Christ and the Disciples at Emmaus,* which was listed as *The Disciples at Emmaus* in the exhibition's official catalogue. Other works came from collectors in Montreal, Hartford, Washington, D.C., Philadelphia, St. Louis, New York, and Chicago. Works that could not be obtained from France or elsewhere were reproduced as auto-

types, one of the first instances of photographs being used in a retrospective exhibition.[306] The exhibition received broad coverage in newspapers in Chicago, Pittsburgh, and throughout the nation. A number of the Chicago reviewers commented that once they were able to see the range of Dagnan's work presented together, it became apparent that he was not a prolific artist, and some came to the conclusion that he had almost done the impossible with his Christ at Emmaus.[307]

Others still attacked this religious composition as "far driven artificiality . . . full of cheap theatricals" that was saved only by "Dagnan himself, with his wife and child, placed in the obscurity to one side."[308] This critic, who apparently preferred realistic scenes, was more interested in Dagnan's studies from nature of the two horses in *The Watering Trough* of 1885. One point became clear from this exhibition: Dagnan-Bouveret's work generated discussion and often controversy. Those who supported his religious imagery were not attracted to his earlier, more naturalistic paintings. Yet only a few believed that Dagnan's moment was passing and that other directions in European art would one day overshadow his artistic achievements.

No documentation reveals what Frick thought of the exhibition at the Art Institute or whether he traveled to Chicago to see it. It is known that at this same time Harrison Morris, the director of the Pennsylvania Academy of the Fine Arts, contacted Frick to ask for the loan of the *Consolatrix* for an exhibition scheduled for early 1901. When this request failed, he asked for its loan for the following year. Morris wrote to Frick, "Might we hope that for the coming exhibition, opening January 21 and closing with February, you would care to entrust this master work to our care under such conditions of insurance and transportation as you may exact?"[309] Almost imploring Frick to lend this work from his house, Morris continued, "It is not for ourselves alone that we ask the favor, but for the whole Eastern public which loves pictures. Owners of the great pictures of the world have been said to be Trustees for the public. While not enforcing this intrusive axiom we still hope that you will feel its application and commit the picture to our carefullest custody."[310] Frick, not one to resist such enthusiasm, this time willingly agreed to send the *Consolatrix* to Philadelphia.[311] With this loan Frick not only allowed the public beyond Pittsburgh to examine the works he so greatly appreciated, but he also established the practice of publicly displaying art, a routine he would institute in New York with his collection of old masters.

Other Members of the Nationale:
Léon Lhermitte, Charles Cottet, and Gaston Latouche

Beyond Dagnan-Bouveret, other painters who exhibited their works with the Société Nationale des Beaux-Arts exerted some influence in Pittsburgh by being represented in the 1895 Carnegie Library exhibition, participating on the Carnegie International's foreign advisory committee, or having their works of art acquired by collectors in the city. Among these artists was Léon Lhermitte, a major pastelliste and draftsman known for his work in black and white, whose paintings of workers in the fields were readily compared with early compositions by Breton.[312] Lhermitte's paintings, while not extensively collected in Pittsburgh, were acquired by Henry Clay Frick, A. R. Peacock, and the Byers family, who purchased *The End of the Day*.[313]

The artist's works apparently did not generate the type of dynamic discussion in Pittsburgh that other contemporary French paintings did. This had not always been so, for Lhermitte was represented by two paintings in the 1895 Carnegie Library exhibition. The first, lent by the outstanding private collector Martin Ryerson of Chicago, showed the artist at his most typical.[314] *Harvesters* of 1888–89, a fairly large work with a panoramic view, romanticized the common farm labor of haymakers.[315] *The Grain Fields*, a second painting that focused on rural work, came from the G. W. Elkins collection in Philadelphia.[316] Both paintings set a high standard for Frick when he later decided to acquire a work by Lhermitte.

In October 1897 Frick purchased *La Fenaison* (fig. 112) from Knoedler's for $4,200. It had been exhibited at the Nationale earlier that year and fit Frick's desire to collect significant contemporary art with a French provenance.[317] Unfortunately, *La Fenaison* has since disappeared.[318] In its exploration of work themes, the painting echoed Lhermitte's earlier images, such as *The Noonday Rest* of 1890, which built upon Barbizon interest in workers taking a momentary respite from their toil in the fields.[319]

Lhermitte's role in Pittsburgh nevertheless remained limited, despite being a member of the prestigious Nationale and a major artistic figure in France. Even though he served on the advisory committees to the Carnegie Internationals of 1897 and 1898—he was never selected to be a juror—his exhibited works, such as *The Spinner*, did not attract a local collector.[320] Most likely those in Pittsburgh were not enticed by his interpretations of traditional labor, scenes that were acquired by collectors elsewhere in the United States.

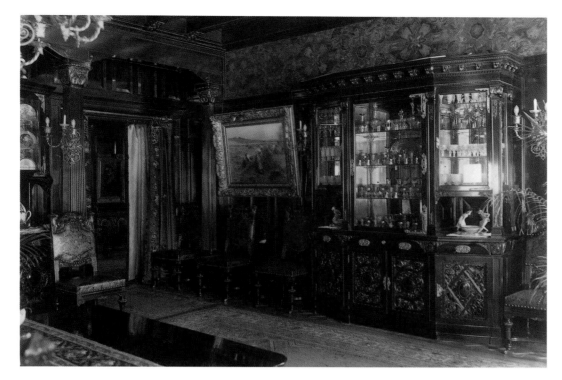

Fig. 112. Lewis Stephany. Photograph of Clayton showing *La Fenaison* by Léon Lhermitte, and through the doorway, *Chagrin d'Enfant* by Emile Friant, c. 1900. Frick family archives, Pittsburgh. Cabinet contains the Frick's set of crystal stemware, designed by Hawkes.

Also see figs. 14, 64–66, 68.

Much like Lhermitte, the work of Charles Cottet met with limited interest in Pittsburgh, with only the H. K. Porter family acquiring one of his paintings.[321] Cottet's subject matter focused on the Brittany region of northern France, with its rugged fisherfolk, dramatic seascapes, and traditional rituals of pardons. Despite being a member of the Nationale—his work was first exhibited there in 1893—and having had a small retrospective exhibition held at Siegfried Bing's Art Nouveau Gallery in Paris in 1896, the artist and his paintings seldom received mention in the press or were promoted by international art dealers.[322] The reason for this stemmed from the mood of his imagery: his somber themes, with their unsettling and often depressing sentiment, appealed to few. It was unusual that two of his works were in Pittsburgh collections. The Porter painting, *The Pardon in Brittany* of 1894, was first shown at the Nationale, an honor that added to its reputation among American collectors.[323] Its religious overtones and depiction of a pardon, however, probably required some explanation for viewers in the Midwest. The second Cottet painting owned by Porter was *The Three Generations* (cat. 111), which portrayed several members of a Brittany family. Although more viewers could relate to its depiction of familial bonds, its exotic setting and suggestion of mortality would have alienated many. The theme of *The Three Generations* was originally explored in an earlier version known as *Beaux-soir en Bretagne,* which had been in the

Cat. 111. Charles Cottet (1863–1924). *The Three Generations*, c. 1908–10, oil on canvas. Columbus Museum of Art, Ohio; Gift of Robert Lazarus, Sr. [Ex. coll., Henry Kirke Porter].

Bing collection.[324] Thus, the works by Cottet that Porter selected were unusual for the United States, yet they reflected a heightened awareness of the artist's role in the Parisian art world. Indeed, an article in *Brush and Pencil* in 1903 labeled Cottet as a dissenter, a painter with his own point of view.[325]

By the turn of the century Cottet had received several official awards, including gold medals at the world fairs held in Paris (1900) and Dresden (1901). He was continuously represented at the Carnegie Internationals, where he showed *By the Sea Brittany* (1898), *Night of Saint Jean—In the Sea Country* and *The Dead Child—Ile d'Oessant* in 1901, and *Fine Evening in a Small Breton*

Port and *Woman at Evening in Douarnenez, Brittany* in 1903.[326] Cottet's work was noted in Pittsburgh in the *Index* when the critic Raymond Gros praised his efforts by stating, "Cottet renders with surpassing skill the sovereign sadness of this country of his love, Brittany."[327] Nevertheless, the artist's limited focus on northern France and the primitive, rather coarse inference seen in his handling of figures demanded an acquired taste. Porter's *Pardon in Brittany* was the only work by Cottet to be displayed in the 1902 loan exhibition that was intended to showcase the outstanding acquisitions made by collectors in Pittsburgh.[328] Its inclusion reflects the willingness of the organizers to present tendencies that "would not be popular with the multitude."[329]

With the work of Gaston Latouche, Pittsburghers were introduced to a painter who began exhibiting at the Nationale in 1890.[330] The rich color and romantic themes of his scenes of gardens, flowers, women, and children soon attracted a public following.[331] Associated with the rococo revival at the end of the century, his work was often utilized as decorative panels in rooms, such as those he completed for the Mairie in Saint-Cloud.[332] After he received the Legion of Honor in 1900, Latouche became less reclusive, and his interest in sending works to the United States increased. He exhibited one work in the 1897 Carnegie International, but his efforts did not receive considerable notice until later, when he was represented by *Spanish Princesses* in 1899 and by *The Fountain* in 1901. His participation in the next six Internationals led to his award of a first-class medal for *The Bath* (cat. 112) in 1907.[333] This allegorical composition, with fluttering putti and a nude who has just disrobed on the riverbank, presented a type of painting that was not often seen or collected in Pittsburgh. Since the scene was based in fantasy or myth, Latouche's image could circumvent moral concerns about nudity, and the painting's positive reception in Paris when it was shown at the Nationale Salon of 1906 assured that it reflected the height of respectability. After the jury welcomed *The Bath*, with its suggestion of Parisian decorative styles of the 1890s, and after the painting was hung in the University Club, Latouche and his work were virtually guaranteed a warm reception in Pittsburgh. Even so, the artist does not seem to have ignited the passion or interest of others in the city. Other examples of his work are not found in public or private collections in Pittsburgh.

In a considerable effort to collect works that would eliminate the impression that Pittsburgh was an isolated, parochial enclave, collectors actively acquired and promoted works by artists from France, England, and elsewhere in Europe.

286

The paintings they collected balanced concerns about patriotism and the need to support American artists once the Internationals got under way in 1896. Even as a sense of internationalism dominated art in the Gilded Age, many collectors in Pittsburgh turned their attentions to the creative talents of painters in the United States.

The American Contingent in Pittsburgh: John White Alexander, Walter Gay, and Others

Crucial to transforming Pittsburgh into an American Paris, an implicit goal of the Carnegie Internationals was the realization that American art had to be promoted through exhibitions and purchases.[334] The public announcement of the 1896 Carnegie Library exhibition brought a flood of inquiries from dealers and artists who, in anticipating a new era in patronage, were interested in selling American art to collectors in Pittsburgh as well as to the new museum.[335] With Andrew Carnegie's financial support and Beatty's organizational skills and contacts with expatriate artists, the future looked promising.[336] The wish proved to be far removed from reality. Despite the extensive promotion of American works at the Internationals, the awarding of prizes to American painters, and an extremely active press campaign that led to numerous feature articles in *Brush and Pencil*, lucrative support for contemporary American art did not materialize.[337] Instead, Pittsburgh collectors adhered to their preference to collect French painting.[338] Few American paintings of the period entered private Pittsburgh collections, and those that did often were by artists who were active in Europe or enjoyed a substantial following outside Pittsburgh.

This attitude had not originally dominated Pittsburgh. The art exhibition that inaugurated the Carnegie Library in 1895 endeavored to present works by a broad range of active American painters.[339] In addition to John White Alexander, a native Pittsburgher, the exhibition included works by Winslow Homer, Frank Benson, William Merritt Chase, Thomas Shields Clarke, Bruce Crane, Joseph De Camp, Alexander Harrison, Childe Hassam, George Hitchcock, George Inness, Daniel Ridgway Knight, John La Farge, Walter McEwen, Gari Melchers, Robert Reid, Charles Platt, Edmund Tarbell, John Twachtman, and J. Alden Weir. Some painters, such as Harrison and Hitchcock, were frequently associated with Europe, while others, such as Hassam and Reid, were represented due to the urging of their dealers in New York. The range and quality of the American works was indeed impressive, especially when compared to

Cat. 112. Gaston Latouche (1854–1913). *The Bath*, c. 1907, oil on canvas. University Club, Pittsburgh [Ex. coll., William S. Stimmel].

the numerous French paintings on view. As a result, critics and collectors formulated theoretical guideposts in supporting and acquiring American art. They stressed, for example, internationalism as a way to lead America out of its artistic wilderness. This attitude sharply contrasted with those who advocated intense patriotism and an America-first approach. The fact that these two opposites were held in balance during the opening years of the Carnegie Internationals is astounding. It was clearly due to the skill and insight of John Beatty, among others, and the belief that neither tendency should dominate. Outside the museum and beyond the exhibitions, however, American painters simply did not attract the attention of the city's leading collectors for several reasons.

Foremost was the idea that supporting American art was the responsibility of Andrew Carnegie himself. He tried to excel in this arena, and it was generally believed that he would form collections for himself and the Institute he had constructed.[340] Since few wanted to compete with Carnegie, those who patronized the arts and maintained ties with him, such as Henry Clay Frick, largely shied away from American painters in order not to clash with the industrialist.[341] Others preferred to determine their own course, being intensely aware of collecting activities beyond Pittsburgh. The area of international art offered the greatest possibilities, and most collectors, including Frick, followed this route.

With the assistance of international dealers, Frick and others advocated contemporary European painting. Thus, few individuals in Pittsburgh dared support the American scene. Only one or two determined collectors were willing to oppose the local trends. Among the few who defied convention was H. K. Porter, whose collection contained several paintings by John White Alexander (cat. 1), a local artist who was on close terms with Beatty.[342] Alexander's participation in Pittsburgh art exhibitions proved crucial. He helped obtain loans from difficult American expatriots, and he personally sent a number of his best works to Pittsburgh. These paintings were warmly praised in the *Pittsburgh Post*, where Alexander was rightly recognized as a hometown boy who had made good. The critic of the 1896 exhibition commented that among Alexander's work was "'The Mirror,' 'Peonies,' 'Red and Black,' and 'The Yellow Girl,' the last one a remarkably bold and thoroughly artistic effort. It shows a young girl dressed in a yellow silk dress, leaning over the arm of a sofa and playing with a black kitten."[343] His "high style" compositions conveyed a mood of languor and elegance that was based upon a familiarity with the work of

contemporary French portrait painters who exhibited at the Nationale. Critics and cognoscenti recognized his ability to create images of ideal beauty as he transformed lovely women into symbols of refinement, leisure, and repose.[344]

One local painting with associations to those shown in 1896 is *Girl in Green with Peonies,* which Alexander exhibited in the Salon of the Société Nationale in 1897.[345] The decorative, almost two-dimensional arrangement of shapes suggests the tonal images of James McNeill Whistler that were extremely influential in the 1890s. Indicative of the many works that he exhibited in Pittsburgh and France at this time, *Girl in Green* places Alexander among the more progressive American artists whose paintings reflected these crosscurrents of influence. His peaceful yet mysterious depictions of repose, complemented by his delicate handling of pigments, came to symbolize longing to many of his genteel viewers.[346]

Alexander participated in the Carnegie Internationals throughout the 1890s, and he eventually served as a jury member in 1901.[347] By this time he had also received the French Legion of Honor and a gold medal from the Pan-American Exposition of 1901, at which both Beatty and Mrs. H. K. Porter served on the Honorary Committee.[348] Alexander's entries to the Pan-American Exposition in Buffalo had already earned him international honors: *Autumn* had been awarded a gold medal at the Exposition Universelle in 1900.[349] With such official recognition, works by Alexander would have been a prized addition to any reputable collection of local or international painting, yet few of his paintings were acquired in Pittsburgh. Instead, in 1905 he received the highly visible and extremely lucrative commission to complete wall murals for the Carnegie Institute.[350]

Porter avidly collected works by Walter Gay, another frequent contributor to the early Carnegie Internationals.[351] While living in Paris, the American cultivated his international connections and his awareness of artistic trends throughout Europe. His works were shown at the Nationale, and by 1905 he had been honored with an exhibition of his interior scenes at the Galerie Georges Petit in Paris.[352] Gay frequently contributed paintings to the Carnegie Internationals, as he did in 1901 when he lent *The Three Vases* (cat. 113) and *The Old Fireplace* (cat. 114).[353] Devoid of figures, these paintings nevertheless suggest the nearby presence of refined individuals. These eighteenth-century rococo interiors, replete with rich accessories such as Chinese vases and elaborate andirons, conveyed a domesticated yet elegant atmosphere and a love of

Cat. 113. Walter Gay (1856–1937). *The Three Vases*, n.d., oil on artist's board. Carnegie Museum of Art, Pittsburgh; Gift of Miss A. M. Hegeman from the Collection of her Mother, Mrs. Henry K. Porter [Ex. coll., Henry Kirke Porter].

Cat. 114. Walter Gay (1856–1937). *The Old Fireplace*, n.d., oil on canvas. Carnegie Museum of Art, Pittsburgh; Gift of Miss A. M. Hegeman from the Collection of her Mother, Mrs. Henry K. Porter [Ex. coll., Henry Kirke Porter].

possessions. Since the Porters and many other collectors in the United States were eager to create and then document similar cosmopolitan surroundings in their own homes, Gay's paintings found a ready audience.[354]

It was Cecilia Beaux, however, who emerged as the favorite at the Carnegie Internationals. Her work was applauded from her first honorable mention in 1896 to her receipt of a first-class medal for *Mother and Daughter* in 1899.[355] One of her paintings in Pittsburgh, the portrait of James Murdock Clark, Jr. (cat. 71), that is now hidden away at the Allegheny Cemetery, epitomizes the elegant portrait style that often brought her accolades similar to those given to John Singer Sargent.[356] This large canvas of a young child holding a riding crop verifies the artist's role as a painter of high society and leisure activities.

Yet like Alexander and Gay, Beaux attracted few Pittsburgh collectors, and her paintings seldom entered local collections, even though she was extremely talented and well connected to the upper-class society of Philadelphia.[357] Her elegant portraits of young women and children garnered her honors in Europe and brought Beaux to the attention of an international clientele. Her decorative portraits, with their suggestion of languor, however, won few converts in

Cat. 115. John F. Weir (1841–1926).
Roses, 1889, oil on canvas. National
Museum of American Art, Washington,
D.C.; Gift of Miss A. M. Hegeman [Ex.
coll., Henry Kirke Porter].

Pittsburgh artistic circles.[358] The local press varied in its reviews, especially in 1899 when *Mother and Daughter* received the highest award and was seen by some as an unrivaled "splendid portrait of two women."[359] Critics failed to grasp the importance of her representation at the Pan-American Exposition, where her paintings were hung in the same room as those by Childe Hassam and J. Alden Weir.[360] Why were so few of her paintings acquired at the turn of the century? Most likely it was because collectors in Pittsburgh were conservative men who could not fathom the talent and success of a female painter.[361] Even though she had received major awards and was well respected as an artist, most private collectors in Pittsburgh did not recognize her achievements, and in doing so chose not to accept the standards set by John Beatty or jurors to the Carnegie Internationals.

John Ferguson Weir, an artist not to be confused with his better-known brother J. Alden Weir, received an honorable mention at the Carnegie International in 1898 for his painting *Roses* (cat. 115).[362] The painting appealed to the conservative preference for still life painting in America and Europe, and was soon purchased by H. K. Porter.[363] Weir expertly applied pigments to create dif-

ferent effects of texture and light. The three-dimensional quality of the heavy impasto surface, which is most noticeable in the treatment of the background wall, was designed to reflect light. Similarly, the translucent vase seems to shimmer. A sense of passing time and with it, impending decay, is conveyed by the drooping flowers and falling petals. Such subject matter and delicate coloring resembles the work of Henri Fantin-Latour and other European artists, which would have increased the painting's appeal to American viewers. Hardly an innovative artist, Weir's traditional approach to nature meshed with aesthetic preferences in Pittsburgh.[364]

Paintings by William Merritt Chase fared well as a number of private collectors, including Porter, Beatty, Caldwell, and Watson, acquired several of his works over the years.[365] Since Chase had served as a jury member for the Columbian Exposition and had extensive international contacts, his presence

Cat. 116. William Merritt Chase (1849–1916). *Interior, Oak Manor*, 1899, oil on canvas. Richard M. Scaife, Pittsburgh [Ex. coll., Henry Kirke Porter].

as a juror for the Carnegie Internationals (1897–99) was applauded in the local press.[366] From the first International, at which Chase exhibited *Lady with a White Shawl,* it became apparent that he was well aware of the latest developments in portrait painting and that he had studied works exhibited at the Nationale. In 1891 Chase, well known for his rebellious streak, opened a summer school for painting at Shinnecock, Long Island. This brought him into contact with Mrs. H. K. Porter, a founding member of his art school.[367]

Chase participated in the 1896 Carnegie International, despite pressing personal debts that forced him to liquidate his renowned Tenth Street Studio in New York.[368] His inclusion reaffirmed his esteemed position as a major figure in American art. By the late 1890s Chase had emerged as a voice for change who sided with the younger American painters. His placement on the juries of the Internationals seems to indicate that Pittsburgh was remaining open to new attitudes in American art.

Of the numerous works Chase exhibited in Pittsburgh, four were included in the 1895 Carnegie Library exhibition.[369] Of these, *Port of Antwerp* was in the collection of John Caldwell, president of the Fine Arts Society, and another, *Sunshine and Shadow,* came from the Porter collection. The two other works shown also reflected Chase's commitment to outdoor painting. Like Caldwell and Mrs. Porter, John Beatty was greatly taken with Chase and added his *Portrait of Two Boys* to his own painting collection.

Chase's personal involvement with collectors in Pittsburgh, in particular the Porters, intensified when the artist arrived in the city in 1899 to serve as a juror. He visited the Porters' elegant home and completed *Interior, Oak Manor* (cat. 116), which he dedicated "To my friend Mrs. H. K. Porter, Wm. M Chase / 1899." In documenting the appearance of the Porters' front hall in South Oakland, Chase painted in a traditional manner that he had developed from studying European interior scenes by Théodule Ribot or Antoine Vollon.[370] *An Infanta* (cat. 3), a second painting by Chase that can be assigned to the Porter collection, clearly refers to the artist's long-standing admiration of Diego Velázquez and his handling of pigment.[371] In this homage to the seventeenth-century master, Chase dressed his daughter in a garment suggestive of Velásquez's original Infanta. (He also photographed her that way to have a pictorial aid on hand.) He even went so far in his admiration as to inscribe on the back of his painting: "My little daughter Helen Velasquez posing as an Infanta. Painted by me at Shinnecock Hills, 1899, Wm. M. Chase."

Cat. 117. Childe Hassam (1859–1935). *Nocturne, Big Ben*, n.d., oil on canvas. Collection of Alexandra and Sidney Sheldon, Beverly Hills, California [Ex. coll., William H. Black].

The Porters continued to support Chase by acquiring *The Big Brass Bowl* of 1898 and several other canvases that reflected the artist's dual interest in portraiture and outdoor studies. With the recognition of both the painter's work in Pittsburgh and his international acclaim, Chase was one of the few American artists of the period who received a warm welcome that was commensurate with his talents and respected position in the art world.

Such international prestige extended to Childe Hassam, a painter who consistently exhibited his works at the Nationale in the late 1890s and received a second-class medal at the International of 1898.[372] Although he ultimately exhibited ninety paintings in the Carnegie Internationals, Hassam was regu-

larly compared with European painters. He took the Impressionists as his models, and like them he was appreciated for his outdoor scenes of rural or urban landscapes. Honored internationally, Hassam received a bronze medal at the 1889 Exposition Universelle, and his work was shown in a large one-person exhibition at the Durand-Ruel gallery in Paris in September 1901.[373] Hassam's ties to Pittsburgh were also well established, since four of his paintings were shown at the Carnegie Library exhibition in 1895, including one that came from the collection of John Caldwell.

There can be little doubt that at the turn of the century Caldwell fully endorsed Hassam. In addition to owning *Paris in Winter*, which was exhibited in 1895, Caldwell acquired *Sortie—Paris* of 1871 and *Fifth Avenue in Winter*, two works that were exhibited locally in 1902.[374] In addition to Caldwell, William Black, a member of an old iron and steel family, seems to have been one of the few collectors in Pittsburgh to acquire Hassam's paintings. Exactly when Black purchased *Nocturne, Big Ben* (cat. 117) remains unknown, although it was listed in the index of the Pittsburgh Athletic Association. Hassam's sketchlike approach and tonal atmosphere owe much to the coloristic experiments of Whistler and the Impressionists. The inclusion of indistinct shapes to suggest figures moving across a street, and the highlights of brilliant color to

Cat. 118. Childe Hassam (1859–1935). *Le Jour du Grand Prix*, 1888, oil on canvas. From the Collection of the New Britain Museum of American Art, Connecticut; Grace Judd Landers Fund [Ex. coll., B. F. Jones, Jr.].

indicate the globes of burning street lamps, implies that Hassam had also studied the urban scenes of Camille Pissarro.

The presence in Pittsburgh of this work, as well as of *Le Jour du Grand Prix* (cat. 118), implies that certain collectors were aware of the Impressionist advances that had been adopted by American artists. An article in a 1901 issue of *Brush and Pencil* extols Hassam's independent point of view and his "matter of fact" Impressionism. This suggests that at least some collectors were moving along a more modern path than that of the French internationalists.[375]

The Pittsburgh Taste at the Turn of the Century

This overview of the types of paintings and specific works that were collected in Pittsburgh at the turn of the century generates certain impressions of the aesthetic preferences that dominated the city. Obviously, French and American paintings with an international outlook proved popular with the upper classes. Collectors sought out both French painters whose works represented academic traditions and American artists, either local figures or expatriots, who enjoyed extensive European ties. The artists were neither conservatives nor followers of more radical tendencies, such as the decorative abstractions created by the Nabis during the 1890s. Collectors in Pittsburgh nevertheless followed accepted standards of taste and acquisition as they turned from purchasing works by local landscape painters to Barbizon artists and French academics, and later, American Impressionists. Over time, this approach created a uniformity of vision and a sense of cosmopolitan elegance that was unique to the period.

Studied together, these grand collections of "safe" art often resulted from a desire to compete with others in one's social and economic class. Acquiring works of art was frequently pursued with considerable enthusiasm, even passion. It developed into a form of personal expression, conveying the status and prestige that made one a leader in the artistic community.[376]

The large amounts of money that were required to purchase objects of fine art motivated collectors to use their wealth in the most rational way and in accordance with the prevailing standards of taste. Without a history of collecting, those who acquired contemporary works also relied on their own personal preferences and the experience of others. They were assisted by the city's active art council and the exhibition system of the Carnegie Internationals, which broadened the range of artists and works that came to Pittsburgh. The more adventuresome with greater amounts of available capital placed them-

selves in the hands of dealers in the United States and abroad. Despite such efforts to form impressive, substantial collections, these works, once the latest examples of European and American art, did not stand the test of time.

Why have so many of these paintings and collections been forgotten? One overarching explanation is the spread of modernism since the late nineteenth century. Leaders of the avant-garde emphasized personal innovation in the drive toward abstraction. Art had to be on the cutting edge of creativity. These issues did not concern collectors in Pittsburgh. Even the Carnegie Internationals could never be considered showcases for new theories or abstract images.

With the possible exception of works by some regional American artists, almost all the paintings in Pittsburgh collections were by artists with established careers and international reputations. Few of them challenged tradition. As a result, their works projected refinement, cultivation, and a proper sense of "art appreciation," all desirable qualities for an industrialist turned art collector.

In their literal imagery, the works reflected the painstaking care of their creation, an awareness of past masters and traditions, and the application of current artistic theories toward landscapes and portraiture. By and large, collectors wanted "pleasing" paintings with which they could easily live. They sought out works that created an aura of stability, elegance, and proper breeding. And ideally, these acquisitions would increase in value over time. Instead, many of these collections were eventually dispersed or the paintings removed from public view. They no longer challenged viewers or met the revised standards for imaginative creativity.

Today, we must not judge these works or their collectors too harshly. For the most part, collectors in Pittsburgh learned as they evolved. Looking back, even the city's greatest collector, Henry Clay Frick, was simply preparing himself to develop his outstanding collection of old masters now housed in New York. The range of subject matter, color, and painting technique displayed in private rooms and public galleries created a sense of gentility that came to characterize the Gilded Age. As a result, these works reflected a pattern of acquisition and aesthetics that was decidedly of its time, and for that very reason these paintings deserve renewed attention. The tradition forged by collectors in Pittsburgh at the turn of the century has much to teach us as we continue to form new collections and support art museums into the twenty-first century.

Notes to this essay appear on pages 375–94.

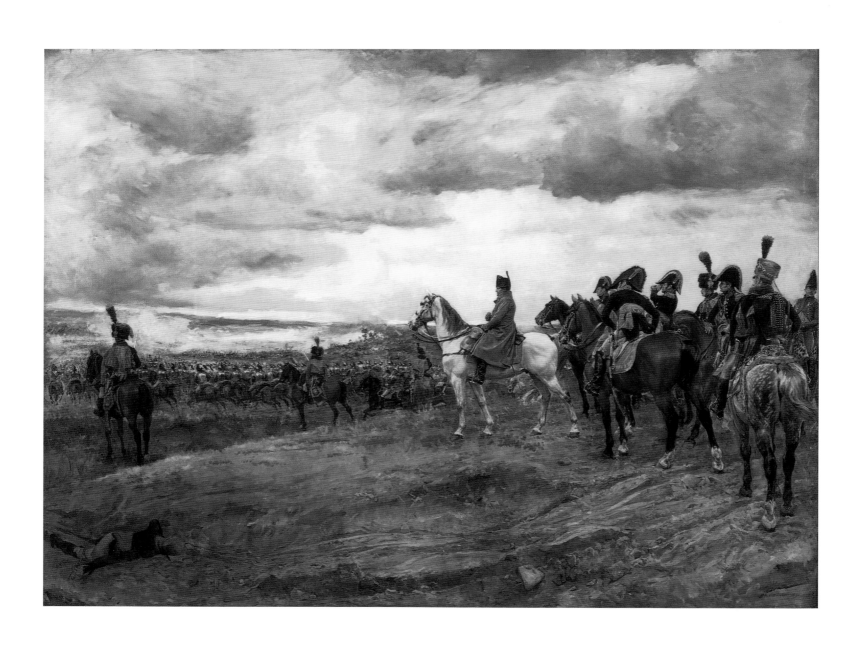

Meissonier's *1806, Jena*

Constance Cain Hungerford

PITTSBURGH IN THE GILDED AGE CAPTURED the last work that was exhibited by one of France's most illustrious painters in the nineteenth century, Jean-Louis-Ernest Meissonier. Long thought lost, *1806, Jena* (cat. 119) has never been on public view since it was acquired by Charles Lockhart shortly after the artist's death. It had remained in the possession of the Lockhart family, and in the 1970s and 1980s it hung in the corporate offices of Union National Bank in Pittsburgh. With the painting's "discovery" in the course of researching this exhibition, *1806, Jena* can now confidently be discussed when considering Meissonier's contributions to late nineteenth-century art.

Ambitiously scaled, *1806, Jena* (42³/₄ by 57¹/₄ in.) is one of five major canvases in which Meissonier presented Napoleon I and his armies at war, emblems of a transcendent patriotism that could still be evoked to unify the French nation eighty years later. Meissonier characteristically devoted his greatest efforts to depicting the officers who cluster supportively behind the emperor and the massed troops who ride to carry out his directives in the distance. Central to the realism with which he detailed these figures was the accurate depiction of movement, especially in the galloping cavalry, a concern that coincided with the early motion photography of Eadweard Muybridge. Meissonier was, in fact, a central figure in Muybridge's Paris debut. The painting *1806, Jena*, however, decisively refutes those who have maintained that Meissonier wholeheartedly accepted the photographer's revelations.

Completed in 1890, *1806, Jena* was last catalogued in 1893, when it was included among more than one thousand works in Meissonier's posthumous retrospective held at the Galerie Georges Petit in Paris. The lender of the painting was Edmond Simon, art agent in France for the London firm of Arthur Tooth & Sons, and through him the painting entered the collection of Pittsburgh oilman Charles Lockhart sometime later in the 1890s. Meissonier had evidently promised the painting to Simon even before its completion. A

Cat. 119. Jean-Louis-Ernest Meissonier (1815–1891). *1806, Jena*, 1890, oil on canvas. Private Collection, Pittsburgh [Ex. coll., Charles Lockhart].

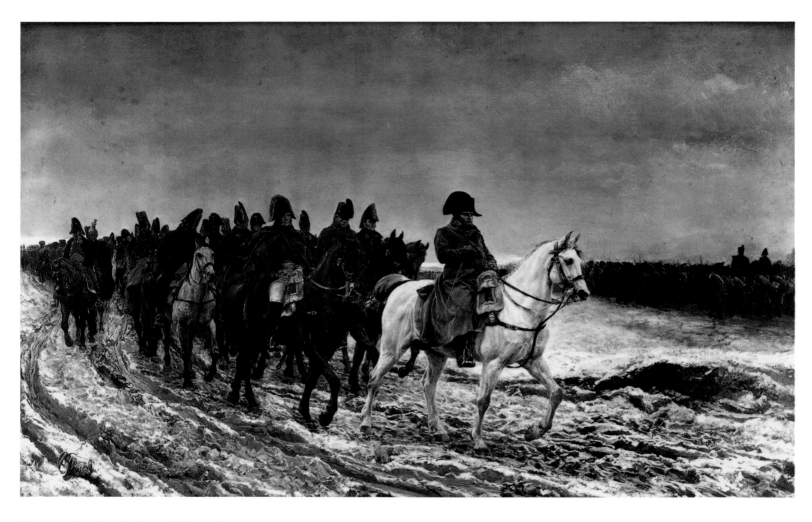

Fig. 113. Jean-Louis-Ernest Meissonier.
1814, The Campaign of France, 1864, oil
on canvas. Musée d'Orsay, Paris.

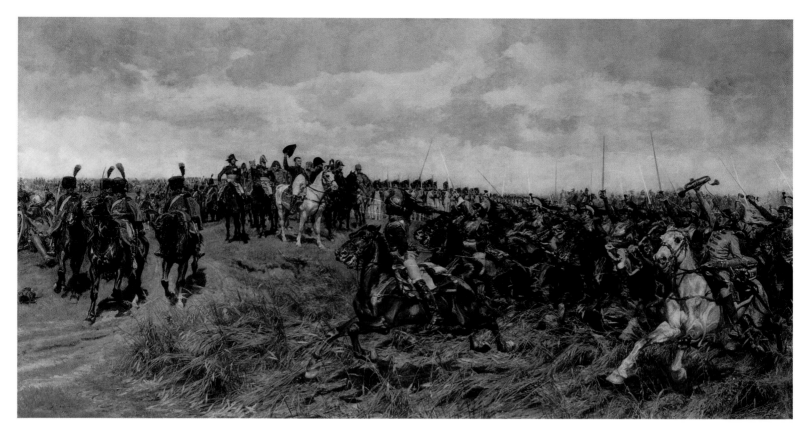

letter from Meissonier's wife Elisa in November 1889 mentions that the artist was deferring work on another project until "after he has finished for Simon the painting of Napoleon."[1]

His commitment to Simon, however, was more than matched by his own professional pride. When he began his final campaign on *1806, Jena* in 1887,[2] it was in anticipation of the 1889 Exposition Universelle. Meissonier's participation in this spectacle would have climaxed his career. At age seventy-four he presided over the international awards jury for the fine arts and subsequently became the first artist to receive the Grand-Croix, the highest rank in the Légion d'Honneur. He contributed a number of already famous works, such as *1814, The Campaign of France* (fig. 113), *The Emperor Napoleon III at the Battle of Solferino* (1864, Musée National du Château, Compiègne), *The Siege of Paris* (1870–84, Musée d'Orsay, Paris), and *1807, Friedland* (fig. 114), in the form of his own full-size watercolor copy of the oil painting from 1875. Of the more recent works that demonstrated his continuing vitality, *1806, Jena* would have stood out as being the most important one. Although it was listed in the Exposition catalogue as number 1009, the painting was not put on view during the exhibition, which ran from May to October, reportedly because it was

Fig. 114. Jean-Louis-Ernest Meissonier. *1807, Friedland*, 1875, oil on canvas. The Metropolitan Museum of Art, Gift of Henry Hilton, 1887 (87.20.1), New York.

Fig. 115. Jean-Louis-Ernest Meissonier. *The Emperor During the Battle*, 1880, watercolor. Reproduced from an illustrated copy of *Paris, Galerie Georges Petit, Exposition Meissonier* (1884), no. 108.

unfinished. Only an unusual circumstance prompted the artist to reconsider it and possibly work on it further. In December 1889 Meissonier led a schism within the principal artists' association, becoming the first president of the break-away Société Nationale des Beaux-Arts.[3] To grace its inaugural Salon in May 1890, he presented *1806, Jena*, still with many freely sketched passages in the background. He died the following January.

Meissonier first set forth the elements of *1806, Jena* in two works dating from 1880. The first was presumably an unlocated watercolor, signed and dated 1880, that was generally titled *The Emperor During the Battle* (fig. 115). Given to Alexandre Dumas's daughter Colette on the occasion of her marriage on 2 June 1880, the work was loaned by Madame Dumas-Lippmann to the 1884 *Exposition Meissonier*, which fêted the fiftieth anniversary of the artist's first Salon exhibition. By 1893, when her father loaned the painting to the Meissonier retrospective, it was titled *1806*.[4]

Simpler in its composition and less detailed than the final version, the watercolor (9 7/16 by 15 3/4 in.) features Napoleon in the center foreground, accompanied by three distinct officers. Also suggested are a fourth officer in silhouette and, on the right edge, the head of a fifth officer's horse. Two mounted members of the *Garde Impériale* are identifiable to the left of center, but the rest of what the catalogue described as a regiment of cuirassiers in line on a battlefield over which cannon smoke drifts is only hinted at smudgily, at least in the nineteenth-century reproduction.

Also dated to 1880 is an oil on panel (21 5/8 by 27 1/2 in.) that was kept in Meis-

Fig. 116. Jean-Louis-Ernest Meissonier. *1806*, 1880, oil on panel. Reproduced from G. Larroumet, *Meissonier* (Paris, 1895).

sonier's studio until his death, when it was identified as a sketch for *1806* (fig. 116).[5] Napoleon is now set somewhat farther back and, though he is still in strict profile to the left, his gray greatcoat is closed and covers the white breeches and vest that are discernible in the watercolor. There he seems pudgy and slumping, but here he appears more erect, and his right hand clasps a pocket telescope. His general staff has expanded to five distinct officers, who, like Napoleon, are characterized by more nuanced activities, such as looking through a spyglass, leaning forward to see better, or approaching the group, as the figure on the far right seems to do. The guardsmen, now grown to three figures, wear more precisely detailed uniforms. Most importantly, the nearest line in the mass of cuirassiers has been individuated, especially as to the posing of the horses.

Two undated sculptures by Meissonier that resemble these nearer cuirassiers were probably done at this time. One, surviving as a bronze cast of a lost original in wax and until now mistakenly associated with *1807, Friedland*,[6] is *Galloping Cuirassier* (20⅞ in. high; fig. 117). This study was used several times for the duplicated cuirassiers that form the group visible between the two guardsmen on the left in the panel. Meissonier referred to this model to arrange the body of the cavalryman and the legs of his horse. He then considered the motif

Fig. 117. Jean-Louis-Ernest Meissonier. *Galloping Cuirassier*, n.d., bronze. Musée des Beaux-Arts, Bordeaux.

from less conventional angles, as here, where he shows the figure from the rear, riding away. A second sculpture, recorded in a nineteenth-century photograph,[7] positioned the cuirassier in the center, twisting as he looks back at Napoleon.

Such sculptures evidence Meissonier's major involvement in *1806, Jena,* as well as in his study of moving horses. Until 1855 Meissonier had been known primarily as a painter of small but marvelously detailed genre scenes, but around 1856 he began to include horses in his paintings, such as *Inn in the Saint-Germain Forest* (fig. 118).[8] Even though these imaginary scenes were removed in time to the seventeenth and eighteenth centuries, Meissonier emphasized the true-to-life aspects of his representations by adding authentic costumes and vivid lighting effects to suggest an actual sunny day. With his horses he not only paid careful attention to bone structure, musculature, veins, and well-groomed coats, but he also placed in the foreground such ignoble touches as views of horse rumps and even a pile of droppings.

From such easily observed, stationary mounts, Meissonier mastered depictions of horses pacing forward, most memorably those in his first important

Fig. 118. Jean-Louis-Ernest Meissonier. *Inn in the Saint-Germain Forest*, 1860, oil on panel. Musée d'Orsay, Paris.

Napoleonic subject, *1814, The Campaign of France* (fig. 113).[9] Modeling one of his earliest sculptures, he posed Napoleon's horse with what specialists commended as "diagonal weight distribution"—the weight rests on the left rear foot and the right forefoot.[10] Critics in 1864, accustomed to Renaissance equestrian monuments such as Verrochio's *Colleoni Monument* (1483–88, Venice), reacted with disfavor, complaining that "the gait of Napoleon's horse is not naturally elegant . . . the animal is off-balance and threatens to fall."[11] Others, however, admired the accuracy of the depiction. As one reviewer noted, Napoleon's horse "really marches; the right leg is rendered with a science, an unbelievable truth."[12]

The adherence to truth and to satisfying the strictures of science became a critical part of Meissonier's identity as an artist. Despite being elected to the Académie des Beaux-Arts in 1861, the painter was in many respects an outsider amid colleagues who had been schooled in the classical tradition. Essentially self-taught, Meissonier's primary formative experience had been designing small-scale, wood-engraved book illustrations in the 1830s and 1840s. Scrupulous historical accuracy characterized his genre costumes and period accessories, and virtuoso exactitude in rendering tiny details became the hallmark of his art. While this brought him unequaled popular and financial success, exigent realism was also vital to Meissonier's self-esteem because it served as an alternative standard to idealizing classicism. Those who recognized the truth-

ful rather than the traditional appearance of his moving horses thus reinforced Meissonier's sense of artistic authority.

Writers and researchers in the later nineteenth century did indeed seize on Meissonier's studies of equine movement and set forth the principles underlying the unconventional renderings that they lauded. Foremost among French scientists was Etienne-Jules Marey, who began his research in the late 1850s analyzing gaits by measuring length, rapidity, and pressure as feet stepped and muscles contracted and relaxed. Although he later employed the camera in his research, Marey recorded his findings in graphs in his 1873 *La Machine Animale*. To illustrate what a horse actually looked like at key stages in its gait, he used drawings by Emile Duhousset, a lieutenant-colonel in the army and a drawing instructor at the Ecole des Beaux-Arts, who did his best to approximate the positions of the horse's limbs in accordance with Marey's charts. Duhousset published his own volume, *Le Cheval* (The Horse), in 1874, applying Marey's research to art by pointing out the inaccuracies of famous representations of horses from the past. He concluded by praising Meissonier for his willingness to put aside artistic experience and become a pupil again by tirelessly studying movement. Recommending *The Campaign of France* to artists "who want to be rigorously true," he diagrammed one of its horses to demonstrate the correct distribution of its weight.

Five years later, in January 1879, Duhousset marshaled new and irrefutable evidence of Meissonier's accuracy: Eadweard Muybridge's photographs of horses pacing. Duhousset introduced the images in the popular weekly *L'Illustration* as rebutting criticism of *The Campaign of France*, exulting, "Today it is no longer permissible to doubt the truth."[13] Meissonier learned of Muybridge's work immediately. He must have seen press reports by Duhousset, as well as those in *La Nature*, whose publication in December 1878 prompted an exchange of letters between Marey and Muybridge in its issue of February 1879. More importantly, Meissonier saw actual photographs in the fall of 1879 when former California governor Leland Stanford, who had sponsored Muybridge's work at his ranch in Palo Alto from 1872 to 1879, used the photographs to entice the artist into painting his portrait. In 1881 Stanford presented Meissonier with a copy of *Attitudes of Animals in Motion*, which was painted into the portrait that was finished later that year.[14]

Meissonier publicly embraced Muybridge as the validator of his own discoveries, and he later recalled Stanford as a "collaborator." When Muybridge

arrived in Paris in 1881 (reportedly at the artist's urging via Stanford), Meissonier hosted a reception for the art world in late November to complement the one Marey had earlier given for the scientific community. He also translated for "his protégé" when Muybridge appeared at the Cercle de l'Union Artistique, a select art club, in December.[15] In effect seeking to harness Muybridge's reputation to his own, Meissonier immediately proposed that he himself should "edit and publish a book on the attitudes of animals in motion" that would integrate Muybridge's photographs with Marey's research. Meissonier would control the results, and Muybridge was to assign to him the European and American copyrights not only for completed work but also for work to be done in the following year under the artist's auspices.[16]

Nothing came of this project, although Meissonier strung out the promise of collaboration for several years. With Meissonier's knowledge and even encouragement, Muybridge regularly included a lantern slide of *1814, The Campaign of France* in his presentations, contrasting its exceptional accuracy with the flawed renderings of moving animals by painters such as Rosa Bonheur.[17] Meissonier agreed to write an essay for Muybridge's planned publication of photographs, but he later defaulted, after causing Muybridge to delay a fund-raising effort late in 1882 in the hope of being able to announce the painter's participation. In March 1883 Muybridge again wrote to beg for the text. The University of Pennsylvania assumed sponsorship of Muybridge's work that August. In January 1887, when the photographer began raising money to publish the completed series, Meissonier was listed among the subscribers. Even as late as April 1890, when Muybridge toured Europe to publicize his *Human and Animal Locomotion,* he wrote to Meissonier soliciting his reaction and wondering whether he might wish to arrange another reception in Paris.[18]

Unfortunately, Muybridge's photographs not only confirmed Meissonier's veracity regarding the horse's walk, but they also pointed up errors with faster gaits, such as the trot and the gallop. In an article published in February 1881, Stanford described how he challenged Meissonier in his studio to follow up a quick drawing of a horse trotting with a sequel showing the stride in its next stage. The artist rubbed out several attempts before admitting himself confounded.[19] A second article, published that July and gleefully titled "How Governor Stanford Converted Meissonier. The Great Horse Painter Finds that He Has Been in Error as to the Horse all His Life," details how Meissonier com-

Fig. 119. Jean-Louis-Ernest Meissonier. Line drawing reproducing Muybridge's *Galloping Horse*, fig. 8 from Emile Duhousset, *L'Illustration*, 25 January 1879.

pared his wax models against Stanford's gift album of photographs, only to capitulate. Stanford reported, "It was almost pitiful to see the old man sorrowfully relinquish his convictions of so many years, and the tears filled his eyes as he exclaimed that he was too old to unlearn and begin anew."[20]

Images of the even faster gallop (fig. 119) showed mistakes in *1807, Friedland* (fig. 114). Meissonier's *pièce-de-résistance*, the painting had been finished in 1875 after fifteen years of extraordinary effort that included adapting a track and cart used by a mason to haul construction materials around a site so the artist could have himself pulled beside a running horse. He had noticeably improved on the hobby-horse look of the galloping animals in his own preliminary sketch (Musée des Beaux-Arts, Lyons), but Muybridge's photographs revealed that, while for the central cuirassier's horse the painter had accurately captured the appearance of the forefeet curled under and the back feet splayed outward, he had synchronized two different moments. Meissonier allegedly regretted, "If I could only repaint Friedland." When he undertook a watercolor copy in 1887, it would later be argued that one motivation was to redeem his reputation by making corrections.[21]

Partisans of Muybridge's importance have maintained that Meissonier became an instant convert of Muybridge. In advocating the utility of photography, Marey would claim that after 1881, "for all the paintings in which horses appear, Meissonier based his studies on chronophotographic documents."[22] Modern scholars have echoed Marey, asserting that Meissonier "had humbly taken from [Muybridge] the revelation of his cameras, always seeking to build from this knowledge a more prefect and accurate art" and "in all of his later paintings of horses, he applied the new knowledge provided by the analytical photographs."[23] Although Meissonier may have been persuaded of the camera's veracity, his work through the 1880s, climaxing with *1806, Jena*, indicates that he did not become a disciple of Muybridge, but instead balked at applying his lessons when they went beyond what he had achieved on his own. Indeed, the album of Muybridge photographs that Stanford gave to Meissonier is still in such pristine condition that the artist scarcely seems to have looked at it in his studio.

Perhaps he modeled the undated, correctly arranged *Horse Trotting* (15 3/4 in. high; fig. 120) from one of the images published in 1878–79, but he only experimented privately with using it in paintings.[24] Meanwhile, public debate increasingly revolved around whether photographic effects were appropriate for art

at all. In February 1882 the *Gazette des Beaux-Arts* published an article that condemned applying Muybridge's revelations to art because the camera saw stages of movement that the eye could not, and therefore, in terms of the human experience, it gave a false impression of movement.[25] From November 1883 to May 1884 Duhousset countered in the same journal with a four-part series on "The Horse in Art," in which he directly linked Meissonier and Muybridge. He asserted Muybridge's importance, illustrated a detail from *The Campaign of France*, and expressed his confidence that Meissonier would pursue the reconciliation of science and art.[26]

Throughout the 1880s, however, Meissonier painted horses only in positions that he could claim for his own account. In *The Poissy Inn* (Musée d'Orsay, Paris), shown in 1889, the horse is stationary, while other paintings feature horses walking. Meissonier reprised earlier paintings, for example, producing in 1883 an oil version (unlocated) of the 1874 watercolor *The Guide* (Yale University Art Gallery, New Haven). Duhousset praised this work for the way it incorporated the even more subtle observation of "lateral weight distribution," that is, all the weight of the horse on the left rests on its left front and rear feet. Meissonier continued work on *The Voyager,* in which a horse struggles against a fierce wind. After modeling a sculpture in 1878 (Musée d'Orsay, Paris), he completed a drawing, signed and dated 31 December 1879, and a painting that was shown in February 1880. In 1886 he painted a new version with the horse

Fig. 120. Jean-Louis-Ernest Meissonier. *Horse Trotting,* c. 1882 (?), bronze. Musée des Beaux-Arts, Bordeaux.

and rider shown in profile rather than head-on, and exhibited it in 1887 and 1889.[27]

In painting the watercolor of *1807, Friedland*, Meissonier made only minor adjustments, for example, to the right forefoot of the trumpeter's horse. (An analysis by Duhousset, diplomatically presented after Meissonier's death, isolated prominent mistakes in the painting that went unchanged in the watercolor.)[28] Perhaps modifications would have required too many consequent revisions to the composition, but perhaps Meissonier simply could not relinquish his autonomy to Muybridge. His first reaction to the photographs that challenged his observations had been an insistence that the camera "saw falsely," and a biographer later quoted him as defensively rejecting instantaneous photography. "For the artist, there is only one category of movements, those which his eye can seize. He no more has the right to put on a canvas what is only visible with a lens than to paint there what a microscope would reveal to him."[29]

The final version of *1806, Jena* is even more telling. In 1880, in defiance of Muybridge's already published work, Meissonier modeled his own sculpture of a galloping cuirassier, though perhaps in self-doubt he assigned the painted figures based on the sculpture to the middle ground and showed them severely foreshortened. He suspended work on the project after the watercolor and the panel that he kept. When he resurrected *1806, Jena* on a large scale in 1887–89, he continued to base the cuirassiers on his sculpture.[30]

He focused his attention instead on the stationary horses in the general staff and on detailing the vivid attire and gear of human figures, such as the officers with their sashes, the gold-bedecked bicorn hats worn into battle, and the red-and-gold saddle blankets. On the right he added a guardsman to the right of the three leftmost officers, and another officer included on the far right is emphasized by the pale blue jacket he wears over a red vest and the leopard skin that covers his pommel. Also of interest is the nearest officer, whose bright red shako is trimmed in glittering gold and whose dappled gray horse bears a saddle incorporating a leopard skin, complete with exotic head. Leading the eye across the left portion of the composition are three guardsmen wearing the distinctive and colorful uniforms of *chasseurs à cheval*, with fur-edged scarlet pelisses over green jackets and fur caps topped with red-tipped plumes. Farther back in the composition light accents the gleaming steel back plates of the cuirassiers as well as their shiny helmets with black horsehair manes. In the

foreground Meissonier prominently placed the corpse of a Bavarian ally, for which he did a sketch in 1889,[31] a rare and grim reminder of the price Napoleon's courageous troops will pay on the battlefield.

As suggested by the approximate nature of the titles given to the painting from 1880 onward, including *1806, Jena*, Meissonier does not illustrate a specific incident nor endorse particular policies. Instead, he constructs a more general cult around Napoleon, his interest simply being the leader's sustained record of military successes against the European allies. These achievements resonated particularly in the aftermath of France's humiliating defeat and occupation by Prussia in 1870. At Jena, it could be remembered, the French had been victorious over the same enemy; with renewed dedication to shared ideals, such triumph might be repeated in the future. Meissonier's images of Napoleon and his legendary troops, shown at universal expositions in 1878 and 1889, were part of an effort to restore national pride and honor during the Third Republic. Thus, in *1806, Jena* the mastermind emperor becomes an austere icon posed rigidly upright in the near center, and his strict profile is blocked in soberly in white, black, and gray, like a medallion relief.

Equally important, however, are the anonymous Frenchmen who serve Napoleon, and through him, their shared nation. One final detail is telling: to the left of center, between the center guardsman's body and his horse's head, is visible a large red, white, and blue flag. The *tricolore* was adopted in 1789, and except during the Bourbon restoration, it was maintained by all subsequent regimes, whether republic, monarchy (Louis-Philippe), or empire (Napoleons I and III). Featuring the *tricolore* in this painting, destined for the 1889 Exposition Universelle, which commemorated the centenary of the French Revolution, constitutes Meissonier's reminder that the glory we celebrate is not that of any individual, but of France.

Notes to this essay appear on pages 395–97.

The Rage for Collecting

Beyond Pittsburgh in the Gilded Age

Ruth Krueger Meyer and Madeleine Fidell Beaufort

PATTERNS OF COLLECTING AND ART PATRONAGE were firmly established in the American Midwest by the mid-nineteenth century. Well before the opulent decade of the 1890s, serious art collectors had emerged in Cincinnati, St. Louis, Chicago, Cleveland, Detroit, and the Twin Cities of Minneapolis and St. Paul. Today, the names and careers of these early collectors are still known in their respective communities. In many cases their memories have remained undimmed because their art collections are still on view in local museums. Some of these collectors, much like Henry Clay Frick in Pittsburgh, endowed institutions that continue to bear their names. Unfortunately, it is far more typical that those art collections that were assembled in the Midwest during the Gilded Age were dispersed upon the deaths of their owners. On occasion patient research has led to the reconstruction of a collection's former contents and has confirmed what riches were lost over the years to the Great Depression, the taxman, improvident children, or fickle spouses. So who were the cultural leaders of these nascent metropolises, and what kind of art did they collect? For answers we must turn to the pre-Civil War period when Americans in the midst of the formative stages of our republic looked reverently toward European models.

On the American frontier, lyceums and athenaeums were established as social centers for the pursuit of knowledge and cultural refinement.[1] Not surprisingly, the birth of true art collecting coincided with the growth of art markets to serve collectors. Without the impetus of strenuous marketing, the art scene in the Midwest would have developed more slowly. Clearly, promoting and selling art was just one more commercial enterprise among the many frontier businesses that were taking hold from 1820 into the 1860s.

One process through which prospective buyers could acquire art was a lottery system. Begun by the American Art Union in New York in the early 1840s, the system proved so popular that art unions were established in Cincinnati,

Fig. 121. Jules Emile Saintin. *Relief for the Sufferers of Chicago (Charity)*, 1872, oil on panel. Courtesy of Chicago Historical Society.

Philadelphia, Boston, and Newark. The principle was similar in all these associations. Lottery tickets for the annual drawing were sold on a nationwide basis. Purchasing a ticket entitled members not only to an opportunity to win an original work of art but also to an engraving made after one of the paintings in the collection. For people inexperienced with the fine arts, the system had strong appeal. Since a painting could cost no more than the price of a ticket, the winner could not be accused of spending money unwisely or of choosing a poor picture.

Another way collectors became familiar with art was through traveling exhibitions of individual paintings by European or American artists, such as Thomas Cole and Frederic Edwin Church. The frequently dramatic nature of the works themselves, with their grand scenes of the American West or the tropics of South America, often lent the air of a carnival to these cultural events.

Despite its horrors, the Civil War period was one of economic growth in the Midwest. Fortunes were made by supplying goods to the armies, just as David Sinton did in Cincinnati. In Chicago, Samuel Nickerson's small distilling business grew to meet the demand for alcohol that was used in manufacturing gunpowder. After the war Nickerson built one of the first residences to include an art gallery.

Indeed, the art market was thriving amidst the conflict of the Civil War. The number of auctions at which art objects were exclusively sold rose significantly, and throughout the nation art collectors associated themselves and their collections with charitable causes.[2] One such cause was the U.S. Sanitary Commission, which was approved by President Abraham Lincoln in June 1861. To fund the commission, which was implemented to coordinate the efforts of a vast number of local relief societies, the railroad director John Taylor Johnston and the banker August Belmont opened their private New York collections to the public and charged a small admission fee. Pittsburgh collector John H. Shoenberger did the same in 1863.

The Metropolitan Fair, held in New York in 1864, received national coverage in *Harper's Weekly* and drew crowds of visitors who were eager to pay admission for a good cause and to see paintings of "immense" value, reportedly in excess of $400,000 for the entire group.[3] To add greater respectability to the fair, engravings and photographs of eminent men were also exhibited. Some Sanitary Fairs, such as Chicago's Great North-Western Fair of 1865,

organized sales of works that had been donated by artists and collectors. By the end of the war, American artists had attained an acceptable level of prosperity and social esteem, as patriotic patrons placed orders for their landscapes and history scenes. Benevolent organizations served artists' professional needs, art clubs and societies organized their leisure time, and dealers marketed their paintings.

The arts thrived in the mercantile atmosphere of the reconstruction period that followed the Civil War. New money spawned new collectors, and artists migrated from city to city to show and sell their work. Word of artistic activities in Midwestern cities began to spread. A kind of "literary" art journalism developed, from the catalogues that complemented various art fairs to the journals that recorded the proceedings of artist groups, such as the Western Art Union of Cincinnati (1855) and the Sketch Club (1860). In addition, large, folio-size volumes documented international exhibitions and brought collectors in the Midwest into contact with the larger art world. The Philadelphia Centennial exhibition of 1876, for example, was documented in an illustrated catalogue that became an essential reference work for the next generation of connoisseurs. Such publications were of particular interest to those art lovers who would become leading collectors in the second half of the nineteenth century.

Most collectors in the Midwest developed a private art library and cultivated a literary background. One writer who surely took note of this was the Philadelphia journalist Edward Strahan. Born Earl Shinn, Strahan adopted his pseudonym to avoid embarrassing his Quaker family when he took up his first career as an artist. In the company of Thomas Eakins, Strahan visited the 1867 Exposition Universelle and studied with Jean-Lèon Gérôme at the Ecole des Beaux-Arts. After he returned to Philadelphia, Strahan worked as a journalist for *Harper's Weekly* and *The Nation*. As Earl Shinn he is cited as the author of the three-volume publication *The Masterpieces of the Centennial International Exhibition*, which documented the exposition held in Philadelphia in 1876. He returned to Paris in 1878 to gather material for his next publication, *Chefs d'oeuvres d'art of the International Exhibition*, which was published in Philadelphia under his pseudonym Strahan.

These transatlantic excursions brought Strahan into contact with the modern art market of Paris, for which he became an apologist, if not an entrepreneur, in his next significant undertaking as editor of *The Art Treasures of*

America. Originally released as a series of fascicles on individual collectors and specific regions, *Art Treasures* was published in Philadelphia as three volumes (1879–82). Together, these volumes form a highly selective compendium of art patronage in the United States at a crucial moment in the history of American art collecting. Lavish in his praise of modern French art, Strahan congratulates those collectors who assembled works by an array of the leading French painters. He is less complimentary about acquisitions of old master paintings, for he swears to have little knowledge of this field and warns that few others do either. Clearly his own studio experience in Paris and his continuing friendship with expatriate artists such as Frederick A. Bridgman afforded Strahan contacts with French artists that he intended to preserve.

The first and second volumes of Strahan's *Art Treasures of America* are devoted to the East Coast cities of New York, Boston, Philadelphia, and Baltimore, centers that could claim long associations with collecting art. Collectors in these cities became the stewards of newly founded American museums, and they established the aesthetic standards that others would emulate. Strahan openly favors his native Philadelphia. He has nothing whatsoever to say about Pittsburgh and its collectors.

As Strahan shifted to the Midwest, his focus becomes somewhat less distinct. Perhaps in his capacity as editor he did not visit every collection, relying instead on reports from fellow art journalists and dealers around the region. Nevertheless, volume two remains a valuable reference on collectors throughout the Midwest, and it offers a tantalizing look into the splendid homes and impressive picture galleries that have long since been destroyed. Strahan describes several collections in Louisville and devotes one fascicle each to St. Louis and Cincinnati. In another he presents under the heading Inland Art the cities of Chicago, Green Bay, Milwaukee, and Cleveland.

Cincinnati

By the time of Strahan's visit, Cincinnati had outgrown its ephemeral reputation as the Athens of the West to become not only a cultural outpost but also a major industrial and commercial center. Cincinnati prospered during the Civil War, and fine new homes with art collections dotted the hills around its central riverfront area. Downtown, Nicholas Longworth's mansion, Belmont, was a dormant treasure, abandoned by its heirs and converted to a rooming house. The landscape murals painted in the entrance foyer before the war by African

American artist Robert Scott Duncanson were hidden under wallpaper. In 1870 David Sinton purchased the house and restored its reputation as the residence of an eminent Cincinnatian, yet his daughter and her art-loving husband, Charles Phelps Taft, could not persuade Sinton, a conservative Irishman, to revive the local art scene. That would have to wait until after Sinton's death in 1900.

Strahan's survey of Cincinnati collectors was dominated by Henry Probasco. The formation of Probasco's collection has merited description in numerous histories of Cincinnati, and its later sale at various public auctions was well documented in the art journals of the late 1880s.[4] Probasco typifies a certain breed of Midwest collector who approached the arts both as a merchant and as a Maecenas. He was hugely successful both in the hardware business, as a partner in his brother-in-law's firm Tyler Davidson and Company, and in the field of commercial real estate during Cincinnati's boom years before the Civil War. He traveled to Europe in 1856, well before most other Americans did so, and there he admired the rural lifestyle that came with financial security. Back in Ohio he built Oakwood (1860–65), a suburban mansion that set standards of quality in construction which many others would attempt to rival. Following Tyler Davidson's death, Probasco sold the firm and in 1866 made another year-long tour of European capitals, studying museums of science and art, and collecting works of art. While in Munich in October, he visited the Royal Bronze Foundry and was shown designs for a fountain. This experience evidently made him recall earlier discussions with his civic-minded brother-in-law, who had wanted to erect a public fountain in Cincinnati that would be more beautiful than any other in the United States. The result was the Tyler Davidson Fountain, which was presented to the people of Cincinnati on 6 October 1871.

Strahan's first stop in Cincinnati was Probasco's residence, and in his text he praises the construction of Oakwood as extensively as its contents.[5] According to Strahan, Probasco's modern French paintings included thirty-seven works by artists familiar from the world of the Salons—Gérôme, Couture, and Bellangé—and from the Barbizon group of landscape painters, such as Millet, Rousseau, and Diaz. The collector purchased several of his Barbizon landscapes directly from the Durand-Ruel gallery in Paris.[6]

A more extensive list of Probasco's paintings can be found in the newspaper articles that describe the collection's sale in April 1887.[7] He also disposed of his library in a similar manner, leaving us to wonder at his unwillingness to con-

tribute some of these treasures to the Cincinnati Art Museum, which had opened its doors in 1886. Initially the museum's holdings of original works of art were slim, with casts of famous sculptures being far more prominent than original paintings. One explanation for Probasco's reluctance to donate his collection to the city involved local experts who had sneered at its quality. Probasco sold off the collection rather than suffer disdain by offering it to the city.[8]

St. Louis

Like Cincinnati, St. Louis's early history of cultural development was halted at the time of the Civil War, but it had been largely reinstated and reinvigorated by the time Strahan arrived to study its notable private collections. Similarities between Cincinnati and St. Louis form patterns that were repeated in other cities throughout the Midwest.

In both locations, local art communities attained a professional status and great cultural institutions were formed in the 1870s and 1880s. Before the war, art schools and academies were usually independent undertakings run by itinerant artists who tried to support themselves through commissions and by teaching classes. If their efforts failed, they simply moved on. Artists with exceptional talent might attract the attention of one or more patrons, who might fund a trip to New York, Washington, or even Europe. Nicholas Longworth in Cincinnati was the agent behind many a good artist's departure. After the war, the increasingly competitive and crowded field of the arts led to the formation of commercial alliances. Artists banded together to form "schools of design," "academies of fine arts," and other scholarly sounding institutions for the dual purposes of instruction (generating income) and display (providing public exposure).

One obstacle to chronicling the development of these schools and academies was the swift alteration and interchangeability of their names. This suggests that the artists were not businessmen, and their failure rate was high until the community's real business leaders took the time and interest to become involved themselves. This began to happen in 1870, when both cities instituted trade fairs: the Cincinnati Industrial Exposition, and the Agricultural and Mechanical Association Fair of St. Louis. Both fairs featured galleries devoted to the fine arts, where works by local artists and painters of national and international reputation, lent by private collectors and dealers, were on display.

These exhibitions were usually documented in catalogues and souvenir pub-

lications that continued to circulate long after the fairs ended.[9] Mention in these pages would enhance the reputation of an artist, collector, or dealer. Participation in these exhibitions, however, forced local talents into competition with artists of national and international acclaim. Artists therefore found it desirable to band together into organizations and clubs, frequently using the name "academy" to preserve their positions in the local art scene.

In Cincinnati, Alfred Goshorn is remembered for his efforts to integrate the ambitions of local artists into the aspirations of the business and social communities for whom the prestige of national and foreign involvement in expositions was of crucial importance. In 1872 Goshorn served as a manager of the exposition held in Cincinnati and enlarged the space available to display art. As a curator the next year, he demonstrated an adventurous spirit by introducing works painted by Mary Cassatt in Spain. He won the support of a powerful committee of women who eventually used the success of these annual art exhibitions as a way to launch a crusade for the founding of the Cincinnati Art Museum Association in 1881. Goshorn naturally became the association's first director and led the building campaign through to the opening of the new museum in 1886. A year later the most enduring and successful of Cincinnati's many "academies" joined with the art museum to form the Cincinnati Art Academy, which still survives to this day.

In St. Louis the future City Art Museum also benefited from the managerial and curatorial skills of a well-qualified individual who emerged from the local artistic community. Halsey Cooley Ives trained as an artist after the Civil War and spent a year in Europe before 1878, when he joined others to found a professional school, the St. Louis Academy of Fine Arts. This school then merged with the older St. Louis Museum and became an art department within Washington University. With the creation of galleries, the museum opened to the public in 1881, with Ives as its director. His administrative talents attracted the attention of the organizers of the World's Columbian Exposition in Chicago, who called on him in 1892 to plan the fair's art exhibition. Ives assumed similar responsibilities for the Louisiana Purchase Exposition held in St. Louis in 1904. The City Art Museum, founded in 1906, is still housed in the permanent art exhibition building on the former fairgrounds.

These consistent efforts to "professionalize" the production, display, and sale of art in the Midwest had profound repercussions on members of the business communities, who were called upon to support the arts. Close commercial

ties among these businessmen resulted not only from their common pursuits in trade and industry but also from their shared origins as immigrants to the United States. Many came from Dusseldorf and Munich, two cities whose art academies offered foreign training to numerous American artists.

Although it is not given much prominence in the second volume of Strahan's *Art Treasures of America,* the collection of Charles Parsons is important because it can still be studied in St. Louis today.[10] According to his bequest, Parsons's paintings were given to Washington University and now form the nucleus of its art collection. As a banker and financier, Parsons traveled the Midwest extensively before the war, seeking investment opportunities. He served in the Union army and afterwards settled in St. Louis, where he eventually became president of the State Bank. Later Parsons was presiding chairman of the World Congress of Bankers at the Columbian Exposition in 1893.

In writing the history of the Parsons collection, Graham Beal referred to a large holding of correspondence in the Missouri Historical Society, which presents Parsons as a thoughtful, intelligent collector with wide interests broadened through his travels.[11] A decade after he made a Grand Tour of Europe with his bride Martha in 1857, they visited Poland, Russia, and the Near East and met on that trip the famed archaeologist Heinrich Schliemann. In 1876 Parsons made another journey around the world, this time discovering new collecting interests in Japan. After a final global adventure with his nephew and heir in 1894, Parsons wrote *Notes of a Trip Around the World,* a small book in which he described his impressions of Europe as well as Japan, China, India, Egypt, and the Holy Land.

Strahan's concluding opinion of collections in St. Louis seems especially appropriate to Parsons. "To look at these necessary family adornments and educators, domiciled twelve or thirteen hundred miles from the seaboard, one is impelled to the thought that art belongs to no nation, but is universal in its teachings and command of admiration."[12] Much like Probasco and his collection in Cincinnati, Parsons had acquired anecdotal paintings by many of the same artists, such as Charles Baugniet's *The Visit of Consolation* (fig. 122) and Jules Breton's *Wine Shop—Monday* (1858).

Parsons's collection also included two excellent landscapes by the American artist Frederic Edwin Church—*Mount Desert Island, Maine* (1865) and *Sierra Nevada de Santa Marta* (1883)—and three by Sanford R. Gifford—*Mountain and Lake Scene* (1867), *Venetian Sails* (1873), and *Rheinstein* (1872–74). The

Fig. 122. Charles Baugniet. *The Visit of Consolation*, 1867, oil on board. Washington University Gallery of Art, St. Louis, Gift of Charles Parsons, 1905.

collector's scholarly interest and conservative nature are proven by his willingness to follow Church's advice and avoid acquiring works by the Impressionists, whose paintings were entering the American art market by the mid-1880s.

Strahan was much more lavish in his praise of Samuel A. Coale, whose collection has since been dispersed. He said it not only gave "an idea of the spread of refinement and culture in the heart of the continent, but shows how much a single example will do in influencing the civilization of a whole community."[13] Coale, he continued, was regarded as a pioneer collector in St. Louis. Ultimately, Coale proved to be more of a dealer, and the example of his acquisitions may have had dubious value. In addition, Strahan had only praise for the precautions taken by H. L. Dousman with the display of his collection. "Mr. H. L. Dousman has built a very beautiful picture gallery in connection with his residence where every picture, however large is seen under glass; the canvases are thus protected from the floating impurities of an atmosphere which is sometimes too much enamoured with the sooty bosom of a fire of bituminous coal."[14]

Chicago

The cultural history of Chicago is easily demarcated by activities before and after its Great Fire of 1871. The city's devastation was so widely known that the French dealer Adolphe Goupil used the event to introduce works by European artists to American collectors by selling paintings donated by artists from Dusseldorf and Paris for the benefit of victims of the fire. Expressing ideas then circulating in Paris, American artist Elizabeth Gardner wrote to art collector Jonas Gilman Clark that Goupil "thought that as America has done so much to encourage art, the artists here ought to do something for Chicago. It is estimated that the collection will bring about $40,000 in New York which I consider an exaggeration unless the purchasers are very generous on account of the good cause."[15] Jules Emile Saintin, a French artist who had lived in New York during the 1850s and early 1860s, created *Relief for the Sufferers of Chicago (Charity)* (fig. 121) especially for the auction. Against the charred remains of the Chicago skyline, a woman dressed in mourning clothes puts a coin into a collection box. To lend credibility to this fund-raising effort, Goupil wisely established an American committee and chose Edwin Dennison Morgan, governor of the state of New York and an avid art collector, to act as its chairman. As a result of this venture, French artists and their paintings figured significantly in Chicago collections formed over the next three decades.[16]

Grateful though they may have been for this transatlantic sympathy, Chicagoans had no difficulty in staging their own recovery or in finding inspiration closer at hand. The first Interstate Industrial Exposition, held in 1873, took place in a grand new hall built of iron and glass. Connected to it was a special gallery for the display of art, which became an integral part of these annual expositions. Ambitious Chicagoans set out to improve upon the successes of the expositions held in Cincinnati and St. Louis. The organizers made their objectives clear.

> The management of this organization has never sought to make the annual Expositions mere sensational or amusement shows—quite enough of such elements are sure to be present without searching. They are intended, rather, for the substantial education of those who study them in all that relates to mechanical and fine arts, to natural history and to all other departments of human activity which may properly find a place in such exhibitions.[17]

In his study of Chicago's Interstate Industrial Expositions, Stefan Germer concluded that these fairs had two conflicting purposes—"they had to be both art market and art museum"—and they were subject to two sources of organizing talent: "a first generation of entrepreneurial pioneers and a younger group of businessmen who had come to Chicago in the 1850s and 1860s."[18] These younger men soon exercised their far greater means and their will to support the cultural activities that evolved from these early trade fairs.

In the 1870s the production and acquisition of art in Chicago was every bit as dynamic as it was in Cincinnati and St. Louis. Although some artists had left the burned-out city on the shores of Lake Michigan after the Great Fire, many returned to engage in the same struggle for status and patronage that occupied all artists in the Midwest. The Chicago art fairs were soon dominated by organizers who intended to transform them into international events that would rival the Paris Salons. The city's leading art patrons, such as Potter Palmer and his wife Berthe Honoré Palmer, played active roles in organizing these exhibitions, and the impressive talents of Sara Hallowell were first recognized when she served as secretary to the Interstate Exposition. She is credited with introducing Impressionism to Chicago at the last art fair of 1890, and she later served as an organizer of the Art Loan Collection at the World's Columbian Exposition of 1893.

This major international event marked the end of Chicago's period of recovery and the beginning of its rise to preeminence in the Midwest. Never again has Cincinnati had the financial resources to play a decisive role in the international arena, and while St. Louis staged a powerful challenge with its Louisiana Purchase Exposition in 1904, Chicago dominated the American heartland in both the arts and commerce.

One symbol of the city's prosperity was the Art Institute of Chicago. Like so many other great American museums, the Art Institute traces its origins to a private school, the Chicago Academy of Fine Arts. Even though the Great Fire destroyed its buildings and sculpture casts, the academy reinstated its exhibition program of works by local artists. These efforts were soon eclipsed by the much more exciting presentations of art in the galleries of the Interstate Expositions. By 1882 new supporters helped to transform the academy into the Art Institute of Chicago. Rapid growth and expansion of the teaching programs required a new building, which was completed in 1887, but it too was outgrown by the time planning had begun for the World's Columbian Exposi-

tion. This time the trustees, envisioning the full integration and future expansion of the school and the museum, negotiated with the city of Chicago for the Art Institute to occupy a building and the surrounding area destined for the World's Congresses during the Columbian Exposition.

After the fair, the Art Institute's presence contributed to stabilizing the Chicago art scene as the museum resumed its schedule of exhibitions and concentrated on building its permanent collection. The Art Institute's school flourished in the 1890s, thanks to the publicity generated by the World's Columbian Exposition. Its permanent teaching staff grew, and after 1896 its visiting professors included Frank Duveneck and William Merritt Chase, who traveled to Chicago in 1897.

In the Gilded Age, Chicago's lively art scene was animated by some of the country's more flamboyant collectors and scholarly connoisseurs. From collectors who purchased a few canvases to brighten their parlors to those who added picture galleries to their mansions, Chicago was home to several art patrons and buyers whose civic contributions are still evident. Although Strahan's cursory survey of collections at the beginning of the 1880s gives little indication of the spectacular development that was to come, it is a starting point for introducing business partners Levi Z. Leiter and Henry Field. Strahan mentioned that Leiter, one of the founders of the Art Institute of Chicago, owned an important painting by Cabanel that represented Phaedra, the queen of Theseus, who had a mad passion for the boy Hippolytus and was forced to endure the torments of Venus.

Along with his older brother Marshall, Henry Field opened a dry goods store that marked the genesis of the world-famous Marshall Field's department store.[19] At the time of his death, Henry Field was accorded a memorial tribute by the members of the Chicago Literary Club, who praised him for the fame of his art collection as well as for his gifts of art to the club.[20] Field, much like the St. Louis collector Parsons, enjoyed collecting contemporary paintings because he could correspond with living artists.[21] In the Jules Breton archives is a letter written by Field at 293 Ontario Street in Chicago on 5 April 1887, in which he invites Breton to come to London as his guest and stay for a week or two at the Buckingham Palace Hotel. Field said, "We will promise you as quiet & restful a time as you may wish & we will together make some excursions into the lovely Country surrounding London." Field inquires about the artist's health and adds, "We feel such real admiration & love for your work that you

at least, are not a stranger to us." In his closing Field attached a wish: "To the anticipated pleasure of the summer may we not add the expectation of a visit from you."[22]

One of Breton's most popular paintings, *The Song of the Lark*, is now in the Art Institute of Chicago and came from Field's collection. The Art Institute also has a three-quarter length posthumous portrait of Field painted by Léon Bonnat (fig. 123). It exemplifies this French artist's Spanish training and shows his forceful realism. Bonnat, one of the most fashionable portrait painters of the time, met Field when he painted the Chicagoan's young daughters in 1887. Bonnat produced portraits of other American collectors, such as John Taylor Johnston, William T. Walters, and Catherine Lorrillard Wolfe.

Fig. 123. Léon Bonnat. *Henry Field*, 1896, oil on canvas. Henry Field Memorial Collection [1898.6], photograph © 1996, The Art Institute of Chicago. All Rights Reserved.

In its early days the Art Institute of Chicago also benefited from the generosity of Albert A. Munger, whose collection of paintings from the Barbizon school and by modern French artists was exhibited in the museum's galleries in May 1890. Following Munger's death, the collection was bequeathed to the Art Institute, where from a list of fifty-eight paintings eleven remained in 1956. Proceeds from the sales of his works have been used to expand the A. A. Munger collection. To paintings originally in the collection, such as Bonheur's *Cattle at Rest on a Hillside in the Alps*, Meissonier's *The Vidette*, and Vibert's *Trial of Pierrot*, have been added purchases of Poussin's *St. John on the Island of Patmos*, Gericault's *After Death*, and Manet's *The Philosopher*.

If Leiter and Field represent the older generation of Chicago merchant/collectors, then Samuel M. Nickerson stands as a transitional figure of the 1880s, preceding the collectors of the 1890s who would lead the Chicago art world into the twentieth century. Nickerson turned his Civil War profits from his distillery into investments in Chicago's flourishing banking industry. When the Great Fire damaged the First National Bank building, Nickerson supervised its reconstruction. At the same time he built an elegant residence for himself that had been designed by Edward Burling in the Italian Renaissance Revival style. Today the building appropriately serves as the headquarters of R. H. Love Galleries, Inc.

No doubt Nickerson's house was under construction when Strahan visited Chicago, but he did not see the art gallery, the single largest room in the house, with its domed Tiffany-style leaded glass ceiling. Contemporary photographs show the gallery with the paintings hung frame to frame in the preferred Salon style. Strahan remarked upon only a few works, but publications of the Art

Institute, which later received the collection, give a far better idea of its range.[23] By the time he was done, Nickerson had acquired several French paintings, from Delacroix to Cazin, along with works by other artists who had been trained in Paris, such as the Spanish painter Leon Escosura and the American Frederick Bridgman.[24] His taste in art was similar to that of Charles Parsons, for Nickerson bought paintings by Church and George Inness but abjured works by the Impressionists.[25]

Nickerson was one of the founding trustees of the Art Institute of Chicago. His colleague, Martin A. Ryerson, was elected to the museum's board in 1890. As a teenager, Ryerson lived in Europe for seven years and later studied at Harvard. He practiced law briefly before he assumed leadership of his family's company. In addition to his service to the museum, Ryerson acted as president of the board of trustees of the University of Chicago from 1892 to 1924. His scholarly skills and international tastes in art enabled him to make significant acquisitions of old master paintings both for his own collection and for the Art Institute.[26] In 1892 Ryerson toured India and began a collection of Asian art that soon expanded to include China and Japan. His greatest coup occurred with Charles Hutchinson in 1901, when the pair arranged for the purchase of fifteen outstanding Flemish and Dutch paintings from the collection of Prince Demidoff in Florence.[27] Ryerson's own collection of paintings began with works from the early Italian Renaissance and included contemporary art from France and the United States. He gave the Art Institute works by Giovanni de Paolo, Ghirlandaio, and Lucas van Leyden, as well as oriental textiles, rare illustrated Chinese and Japanese books, classical antiquities, and an extensive collection of drawings.

Field, Nickerson, and Ryerson typified the solid Chicago citizens who labored to ensure the steady growth of the Art Institute, yet other personalities enlivened the art scene, especially during the early 1890s. Charles Tyson Yerkes, for example, was a native of Philadelphia who had received an excellent education at the Quaker School and the prestigious Central High School, where artist Thomas Eakins and collector Albert Barnes were later students. After he moved to Chicago, Yerkes became involved in railway corporations and eventually took this interest to an international level. He joined the cartel that financed, organized, and managed the London underground railway system, and this success catapulted him out of Chicago and to New York.

While he was still in Illinois, Yerkes's art collecting activities were often dis-

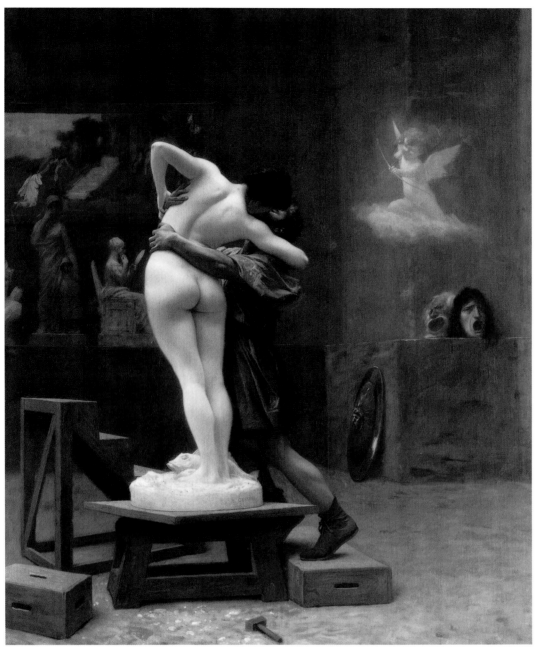

cussed in the press. His collection in his residence at Michigan Avenue and 32d Street overflowed two galleries and spilled into the adjacent corridors. He reportedly began collecting in 1883, and his acquisitions were frequently described in the *Collector*. In its issue of 1 April 1892, the *Collector* noted that the Yerkes collection had recently been given its first semipublic display before a select audience. Eighty-two paintings were then in the collection, with the old masters forming "a group by themselves," and a "handsome illustrated catalogue" had been produced. In an earlier issue, the *Collector* cautioned that

although Yerkes possessed a considerable number of old master paintings, some were of fine quality while the integrity of the condition of others perhaps would not bear the test of scrutiny.[28] In modern works Yerkes was said to show a catholic taste.[29] Paintings by Bellecour and Bouguereau were prominent in his collection, and he owned Gérôme's seductive *Pygmalion and Galatea* (fig. 124), a scene of a sculptor's studio in which an exquisite marble nude comes to life in the artist's arms as he kisses her. The figure of the artist is usually recognized as being Gérôme himself.

Although the majority of comments about Yerkes were positive, hints of problems surrounded him and his collection. When he commissioned a lifesize statue of General Philip Sheridan to be presented to Chicago's Union Park, complaints arose that he should have selected an American sculptor. It was also rumored that he had been cheated by his Belgian agent Jan van Beers. The same van Beers painted portraits of the collector and his wife (fig. 125).

Among Yerkes's more adventurous purchases were four works he acquired from Durand-Ruel in Paris. Two Dutch paintings—*Christ Chasing the Thieves*, attributed to Jan Steen, and *Portrait of an Old Man*, attributed to Rembrandt— were listed in the gallery's stock book in September 1890. The high purchase price of the Rembrandt (120,000F, or about $24,000) was particularly noteworthy. Yerkes was back at the gallery the following fall, buying two less expensive Impressionist works, *Seated Algerian* by Renoir for 5,000F ($1,000) and a landscape near Eragny by Pissarro for 2,000F ($400). Evidently Yerkes, who was fearless about entering the market for old masters, was quite willing to take a chance on the avant-garde.

With the publication of his catalogue and the opening of his private galleries on a limited basis, Yerkes seemed set to embark upon the next stage of his civic career in Chicago. By the spring of 1893, however, he was preparing to leave the city and establish himself in New York "in a vast and splendid mansion on Fifth Avenue," the goal of every "self-made" millionaire.[30] Yerkes's departure made way for the emergence of two of Chicago's most celebrated figures in the art world, Mr. and Mrs. Potter Palmer, whose names long have been synonymous with modern painting in the Midwest (fig. 126).

When Potter Palmer constructed an addition to his magnificent mansion on Lake Shore Drive—a new picture gallery measuring 38 by 72 feet—he was no doubt readying his home to receive the stream of international guests he expected would visit Chicago to attend the World's Columbian Exposition in

Fig. 125. Jan van Beers. *Charles Tyson Yerkes*, c. 1893, oil on panel. National Portrait Gallery, Smithsonian Institution, Gift of Mrs. Jay Besson Rudolphy, Washington, D.C.

1893.[31] Indeed, the strong French accent of Palmer's art purchases resulted from the many trips he and his wife had taken to Paris. Their visit to the 1889 Exposition Universelle made a lasting impression, inspiring not only their interest in art but also their commitment to organizing the Chicago fair four years later.

Their first purchases of Impressionist paintings dated from 1889, followed by the acquisition of six paintings by Monet, which they bought from Durand-Ruel in July 1891. The Palmers visited the galleries with Sara Hallowell, who had won their trust through her activities as secretary to the Interstate Expositions, and she continued to serve as the Palmers' agent in Paris. Intent upon building a well-rounded collection of modern French art, Palmer bought

Fig. 126. Photographer unknown. Potter Palmer House, period photograph of main gallery, looking south. Photograph © 1996 The Art Institute of Chicago, All Rights Reserved.

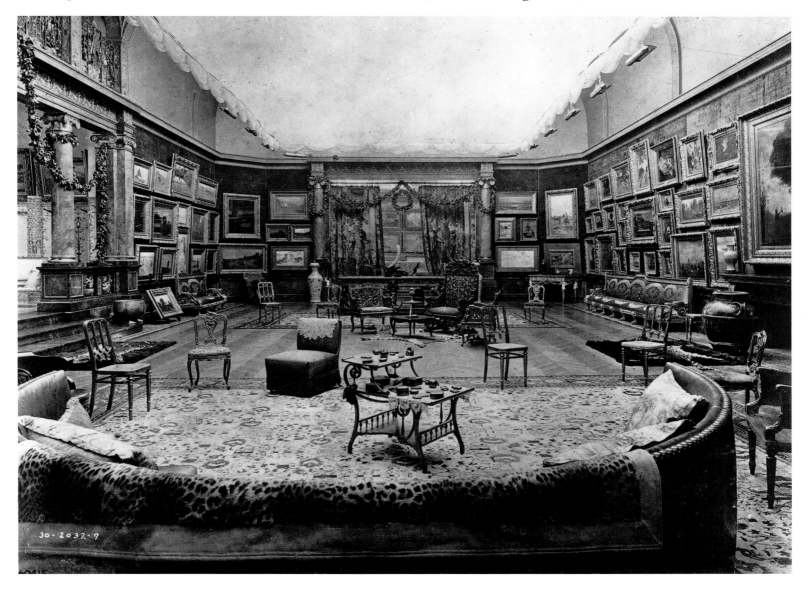

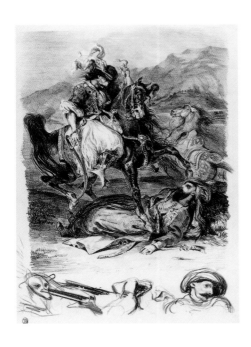

Fig. 127. Eugène Delacroix. *Battle Between the Giaour and the Pacha (Combat du giaour et du pacha)*, 1827, Delteil 55, lithograph. Mr. and Mrs. George B. Young Fund; Suzanne Searle Dixon Endowment, 1988.291, photograph © 1996, The Art Institute of Chicago, All Rights Reserved.

Delacroix's recognized masterpiece *Battle Between the Giaour and the Pacha* (fig. 127), which had been shown in the Salon of 1827. Based on verses by Lord Byron, the subject involves the tragic love of Le Giaour, a Venetian, and Leila, a slave girl who belonged in the harem of the rich Hassan. When Hassan discovered the young woman's infidelity, he tied her in a sack and threw her in the ocean. Le Giaour avenged Leila's awful death by ambushing Hassan. The triumph of the Delacroix purchase was reported in the *Collector,* along with the news that Palmer had acquired figure paintings by Camille Corot from the 1892 Cottier sale, including *Orpheus* at the price of $23,000.[32] This purchase ensured that the painting would remain in America and would not return to France, now that French collectors had at last awakened to Corot's merits.

The Palmers sometimes patronized American artists, many of whom they met on their travels abroad.[33] The real strength of Palmer's gallery was his outstanding collection of paintings by Charles Cazin, with more than twenty works by the French artist.[34] When the American Art Galleries in New York held a Cazin exhibition in December 1893, loans made by Palmer and Yerkes contributed significantly to the quality of the presentation.

Cleveland

Located on the shores of Lake Erie and linked by railways to Chicago, the Great Plains, and the West Coast, Cleveland flourished as a center for industries, steel foundries, and transportation. While Cleveland was not known for its astute patrons or for its initiatives in the art world, its citizens were hardly reluctant to imitate the activities of other cultural communities. On their tour around the country, history paintings by Benjamin West or Rembrandt Peale were viewed in Cleveland, as was the *Greek Slave* by sculptor Hiram Powers. One major event occurred in October 1878 when a group of philanthropic women held a benefit loan exhibition, bringing together paintings owned by prominent local citizens as well as works from the Knoedler gallery in New York, and charged a modest entrance fee with proceeds going to charity. Their early efforts eventually led to the founding of the Cleveland School of Art in 1882.

Jane Elizabeth Hurlbut, wife of Hinman B. Hurlbut and a vice president of the exhibition committee, loaned twenty-four paintings from the couple's collection, including works by the French artists Félix Ziem and Alexandre Cabanel, the Dutch painter Maurice Hendrick de Haas, and the Belgian artist

Eugene Verboeckhoven. Not surprisingly, Strahan devoted considerable space to the Hurlbut collection in his *Art Treasures of America,* remarking, "With these examples, the brilliant painters of the Paris exhibitions may be held in have a fair showing in the city of Cleveland. The modern emancipated group of Munich is also shown with effect. . . . Altogether the Hurlbut gallery is eclectic and cosmopolitan."[35] Judging by the list Strahan published, Hinman Hurlbut balanced his collection of works by popular European artists with a choice selection of paintings by Americans.

Hurlbut, a native of Vermont, took up art collecting while he was in Europe from 1865 to 1868.[36] He continued to build his collection with the intention that one day it would form the nucleus of a museum in Cleveland. This desire was expressed in Hurlbut's will, and he committed the bulk of his estate to realizing that vision. Jane Hurlbut outlived her husband, but after her death in 1910 it became apparent that the Hurlbut estate alone could not fund the ambitious project of establishing a museum. Other bequests were accepted before the Cleveland Museum of Art corporation, founded in 1899, was able to achieve its goal.[37] Before the museum opened in 1916, more than 120 paintings from the Hurlbut collection entered its holdings. The Hurlbuts' European paintings were sold, which directed greater attention to their American works, such as those by Martin Johnson Heade, Thomas Moran, Eastman Johnson, Gifford, and Church.

Most collectors in the Midwest evidently were more inclined to buy works by contemporary artists than by the old masters. As novices, they were probably wary of the well-publicized trafficking of fakes and feared being duped due to their ignorance. It seemed safer to invest in paintings by artists whose studios were open to visits and whose earlier works were known through Salon catalogues and photographs.[38]

One collector in Cleveland, Liberty Emery Holden, was willing to trust the advice of James Jackson Jarves, a well-respected American expert in art. For decades Jarves, a scholar of the Renaissance, had been encouraging museum curators on the East Coast to acquire early Italian paintings. In 1868, Jarves was forced to forfeit to Yale University his own art collection when he could not repay the money that the institution had loaned him to assemble it. Holden, a real estate agent and owner of the *Cleveland Plain Dealer,* bought fifty Italian paintings from Jarves's second collection in 1883.[39] Delia Holden was apparently an art lover, and she assisted Jarves by urging her husband to purchase the

collection. After a separate building on the family estate was designated as the Hollenden Gallery, Jarves wrote the foreword to the handbook that described the installation of the works. He frankly admitted that the paintings "were not presented as masterpieces, but as types of the greater men and their schools."[40] The Holden collection was further enlarged when it accepted the bequest from the estate of Minor K. Kellogg, an artist and a collector of Italian Renaissance paintings who had befriended the Holdens during their travels in Italy.[41] Eventually, the Holden collection found its way to the Cleveland Museum of Art, where, despite the deaccessioning of some works, the Holden name has been maintained through memorials and the purchase of other works.

Mention should also be made of a great collection that got away from Cleveland. Alfred A. Pope, a resident of Cleveland since 1861 who had made his fortune in the steel industry, had gathered a sizeable collection of French Impressionist paintings. He shared his early enthusiasm for Monet, Renoir, and Degas with his East Coast friends, the Whittemores and the Havemeyers, who were being guided in their purchases by the Philadelphia expatriot artist Mary Cassatt.[42] Today Pope's distinguished collection can be seen at the Hill Stead Museum in Farmington, Connecticut.

Others in Cleveland shared Pope's avant-garde tastes, including the collector Jeptha Homer Wade II, who was also attracted to the Impressionists. On the whole Wade's preference in art was conservative. There was no doubting, however, his commitment to the city of Cleveland. In 1892 Wade, the grandson of a founder of Western Union Telegraph Company, presented as a Christmas gift to the city the land on which to build an art museum.[43] Additionally, by the time of his death in 1926, Wade had given the museum 2,855 works of art and set up a purchase trust fund of $1.3 million.

Despite their somewhat tardy arrival on the national art scene, Cleveland's great collectors evened the score by 1894, when they held their second major loan exhibition. Although they could not begin to rival the display presented at the World's Columbian Exposition in Chicago the previous year, sponsors in Cleveland were delighted with the attendance figures and the proceeds donated to charities. The numbers of participants also grew to include collectors from Detroit and nearby Youngstown, where James G. Butler was beginning the collection that would evolve into the Butler Institute of American Art. An immensely popular history painting that was shown in the Cleveland loan exhibition was *The Last Hours of Mozart* by Mihály Munkácsy (fig. 128). The

Fig. 128. Mihály Munkácsy. *The Last Hours of Mozart*, c. 1868, oil on canvas. Photograph © 1996 Detroit Institute of Arts, Gift of Mrs. Henry D. Shelden, Mr. Russell A. Alger and Frederick M. Alger.

work entered the collection of the Detroit Art Institute in 1919 as a gift from the heirs of General Russell A. Alger.[44] There, the painting hung near Rembrandt Peale's *The Court of Death*, another large, dramatic composition that had been toured from town to town.

Detroit

Much like Cleveland and Cincinnati, the early development of Detroit's art community benefited from a series of loan exhibitions at the Fireman's Hall and the Young Men's Hall. One organized by the ladies of the First Presbyterian Church in 1862 featured European paintings and included a portrait of Martin Luther supposedly painted by Raphael. Not until 1883 could Detroit boast of sponsoring an international exhibition that attracted visitors from throughout the Midwest.

The Detroit Art Institute traces its origins to an art loan exhibition conceived by William H. Brearley and James E. Scripps, one a manager and the other the founder of the *Detroit Evening News*, the first of the Scripps newspapers.[45] Brearley was active in civic affairs, while Scripps had the time and financial resources to travel abroad in 1864 and 1881. They were well matched to organize and publicize the loan exhibition, and they could draw upon their national connections to ensure its success. When planners heard predictions of the financial disasters that awaited the exhibition's underwriters—based upon

rumors of the failure of the Cleveland loan exhibition—Brearley traveled to Cleveland and discovered just the opposite was true. While there, he engaged the support of the same ladies association, which agreed to organize a section of loans from Cleveland for the Detroit exhibition.

Although built upon earlier Midwestern models, the Detroit Art Loan Exhibition was, in fact, a more ambitious event. A temporary fireproof building, based on the design of the Art Annex at the Philadelphia Centennial, was constructed for the occasion. The catalogue ran to 175 pages in its first edition, and a supplement was published to cover late entries, which raised the total of exhibition items to 2,714 works on view. Typical of such loan exhibitions, paintings, sculptures, and the graphic arts were displayed along with an array of cultural artifacts, some of which were honestly presented as bric-a-brac.[46]

Gari Melchers and John Mix Stanley stood out among the Detroit artists whose paintings shared the spotlight with international figures. Works by Copley, Stuart, West, Peale, and other eighteenth-century Americans were presented next to landscapes by painters of the Hudson River school. *Fruit Piece* (1849) by Robert Scott Duncanson, an African American painter whose career had ended in Detroit, was loaned by Mrs. Hiram Walker, wife of the distiller. The most popular work was *Reading from the Story of Oenone* (fig. 129) by the

Fig. 129. Frank D. Millet. *Reading from the Story of Oenone*, 1883, oil on canvas. Photograph © 1994 The Detroit Institute of Arts, Detroit Museum of Art Purchase, Art Loan Fund and Popular Subscription Fund.

American illustrator Frank D. Millet. Created in the style of Alma-Tadema, Millet's painting offered a striking visual interpretation of a favorite story from Homer's *Iliad*. Oenone was the wife of Paris, who deserted her for Helen of Troy. This Victorian parlor picture was purchased by the exhibition's organizers with the intention of donating it to a future art museum in Detroit.

Flushed with their success, Brearley and Senator Thomas W. Palmer, a leader among the exhibition organizers, moved forward with their plan to found a permanent institution. Scripps and many others were committed as subscribers. Meetings of the incorporators began in 1884 and led to the Michigan state senate passing an act that was signed by Governor Russell A. Alger (owner of the Munkácsy painting). With Brearley leading the fund-raising drive, the building opened on 1 September 1888.

In the meantime, a second loan exhibition held in 1886 presented works that had already been donated to the planned art museum, including the Millet and

Fig. 130. William-Adolphe Bouguereau. *The Nut Gatherers*, 1882, oil on canvas. Photograph © 1984 The Detroit Institute of Arts, Gift of Mrs. William E. Scripps.

Fig. 131. Robert J. Wickenden. *James Edmund Scripps*, 1907, oil on canvas. Photograph © 1996 The Detroit Institute of Arts, Gift of the Estate of James E. Scripps.

an Italian painting of *The Mystic Marriage of Saint Catherine* that Pope Leo XIII had given at the time of the first art loan exhibition. Others offered their promises of future acquisitions. James Scripps, for example, lent *The Nut Gatherers* of 1882 (fig. 130), a recent painting by William-Adolphe Bouguereau, who was at the height of his popularity in the mid-1880s.

Following the opening of the museum building, Scripps, seen in a posthumous portrait by Robert J. Wickenden (fig. 131), donated in 1889 a collection of old master paintings that would form the core of the museum's holdings of European art.[47] At the time of his gift, Scripps catalogued the paintings and offered an introduction that placed his generous contribution in its proper context. "As a journalist it had been my lot, on frequent occasions to urge upon those who should have accumulated more than the average share of wealth, the duty and wisdom of employing, a part at least, of their surplus in public benefactions."[48] Newspaper magnates, or "journalists" such as Scripps, were well placed to survey cultural developments across the nation at the end of the nineteenth century. Scripps clearly demonstrates this as he continues:

> The pride I naturally felt in Detroit, from a thirty years residence in it, led me to anticipate for the city . . . some special fame in her undeveloped history. It was plain that she never could hope to win, like New York or Chicago, the prestige of a great commercial metropolis. Boston was already the literary center and Cincinnati was asserting her claims to first place as the musical. The country was just waking up to an appreciation of the fine arts, and as yet the place where their temple would be set up was an open problem. Why might not Detroit aspire to the honor, and become the Florence or the Munich of this continent?[49]

Having described his general intentions, Scripps enumerated six reasons why he had directed his attention to the field of old master paintings.

> 1. From having for some years been a collector of the etched and engraved work of the old masters, I possessed some slight acquaintance with the field.

> 2. It was a field which, in the prevailing rage for modern pictures, would not be likely to be taken up by any other beneficiaries [*sic*] of the Museum.

3. It was not difficult to see that it was the cities which possessed the choicest collections of the works of the great masters of the past that were the favored resorts of artists and art students. It was largely by the study of these old masters that great modern painters were developed; a collection of their works, therefore, seemed almost indispensable, if Detroit would become a center of art education.

4. No public gallery in this country had as yet made any considerable start in acquiring a collection of old masters. A field of preeminence was, therefore, open to the Detroit Museum in that direction, which in the line of modern pictures could only have been attained at the cost of a large fortune.

5. There appeared to me to be an element of permanent value in old masters, which modern pictures might not possess.[50]

6. Every year old pictures are becoming scarcer in the market, and every year that the beginning of our collection was postponed, made it more difficult of accomplishment.[51]

In all but his last item Scripps's views cannot be argued. He was mistaken, however, as to the future scarcity of old master paintings. In the 1890s and into the early twentieth century, art dealers sensed American collectors' growing receptivity to acquiring works by the old masters, and for a price, a great many glorious works became available.

Perhaps Scripps's caution arose from the fact that he had been building his old master collection on a budget. For two years it had been his sole occupation, and he had visited more than forty of the principal galleries in Europe, probed the art markets, and expended between $75,000 and $80,000 in purchases. As to his plan he said, "I have sought mainly for good examples of the works of masters of the second rank, and such as are comparatively plentiful in the market. Of this class are many of the Dutch masters of the 17th century, pictures by whom constitute nearly half this collection. But these I have happily been able to supplement by a few truly great works."[52]

Scripps made solid acquisitions in the field of Dutch and Flemish paintings. His purchase of *The Meeting of David and Abigail* by Peter Paul Rubens and

smaller works by Pieter de Hooch and Albert Cuyp established a standard for future collecting. In addition to his early contributions to the Detroit Art Institute, he built a second collection that featured paintings by modern French artists. Works from this collection later entered the museum as gifts from Scripps's heirs.

Milwaukee

Few accounts of American collectors and museum founders are as charming as that of Frederick Layton, an immigrant butcher with little education who became a cultural leader in Milwaukee.[53] As with so many others, the experience of foreign travel opened Layton's eyes and inspired him to collect art. When he went abroad to expand his meat-packing business, he was received in English homes with distinguished art collections. Dinner table conversations must certainly have turned to the latest gossip on the art market. It was London, rather than Paris, that influenced Layton's tastes, and he frequently acquired works from the gallery of Arthur Tooth & Sons in Haymarket between 1884 and 1910.

In June 1883, a year before he began collecting in earnest, Layton announced his gift of the Layton Gallery to the city of Milwaukee. He was obviously motivated by the efforts of prominent women in Milwaukee, who organized loan exhibitions and classes, and supported commercial galleries to spawn art appreciation in Wisconsin. Local businessmen soon shared in their enthusiasm, and an art department was included in the 1881 Milwaukee Industrial Exposition. Beyond such special occasions, exhibition space was limited, and it was not always possible to hold temporary exhibitions of works by local artists, many of whom had trained in Dusseldorf, Munich, Dresden, or Berlin. Layton's gift provided permanent exhibition space and set the foundation for the civic developments that resulted in the Milwaukee Art Center, where a nucleus of his collection remains.

The Layton Art Gallery was a little island of British taste in largely Germanic Milwaukee. In addition to his fondness for British art, Layton's collection was built on his trust in the increasing value of landscapes by the Barbizon school in France and the Hudson River school in the United States. He clearly wanted to avoid the perils of the old master market. Although Layton did not become an American citizen until the age of fifty-six, his adopted home welcomed the collection he built and the museum he guaranteed for the city. The

magazine *Brush and Pencil* reports, "The people of Milwaukee are reputed conservative and like the appellation; therefore this museum is fittingly conducted to please those for whom it exists."[54]

Minneapolis and St. Paul

Further to the west, in the Twin Cities of Minneapolis and St. Paul, two other collections greatly influenced the region's cultural scene. Today it is difficult to recognize the contribution made by the collection formed by Thomas Barlow Walker. His descendants decided to focus on modern art in creating the Walker Art Center in Minneapolis, and the original Walker collection has all but disappeared. Few people visiting its galleries today would associate them with Walker's admired collection of "highly prized paintings by such artists as Rousseau, Corot, Cazin, Hogarth, Sir Thomas Lawrence and others."[55]

The galleries attached to his lavish residence on Hennepin Avenue, now in downtown Minneapolis, were acclaimed for their illumination with skylights and rows of electric lamps and reflectors. Almost from their inception, Walker's galleries were opened to the public, a civic-minded gesture well in advance of its time for the Midwest. Evidently, Walker personally showed his collection to Clara White, the author of an 1899 article in *Brush and Pencil*, for her writings are enlivened with quotes from his correspondence with Jules Breton.[56] Today Walker's eclectic collection might be dismissed for its lack of focus or its domination by representational imagery by Breton or Bouguereau. Or he might be unkindly judged for having purchased too many false old masters. Nevertheless, Walker is remembered for allying his collecting with a spirit of civic beneficence.

Hill House, located on the east side of the Mississippi River in St. Paul, still stands as a memorial to its owner, James J. Hill. The art gallery where his collection of works of art by Corot and Delacroix once proclaimed his love of French painting now serves as a temporary exhibition space. A prominent benefactor, Hill donated paintings to the Minneapolis Institute of Arts, but the bulk of his collection was divided among his widow and children at the time of his death in 1916. In the business community he will always be remembered as "the empire builder," a railroad baron during the great years of the western and Canadian expansion of rail services.

In Hill's time a carefully monitored system of visiting cards limited access to his private gallery. Ledger books remain, detailing the names of those who

received tickets for admittance and by whom they were introduced. Hill, a cautious Canadian-Scot who kept track of every penny, retained these records, which now provide a wealth of information about his art collection and his personal fortune. In *Homecoming*, Sheila ffolliott refers to these numerous records about his collection.[57] From this documentation it appears that Hill's first significant purchase was made in 1881. Two years later he added an art gallery to his existing residence. Later in the decade Hill lent paintings to exhibitions in Chicago and Cincinnati, and presented his first gift of paintings to the Minneapolis Public Library. Hill House, built in 1891, was graced by a glass-roofed gallery with a pipe organ and a state-of-the-art system for changing installations of works from his growing collection.

Like other collectors in the Midwest, Hill began to acquire paintings without much formal education in art, expert advice, or travel in Europe. Later, on the recommendation of East Coast and Canadian business associates, he visited established dealers in New York, and he took his first trip to Europe in 1891. By following trends in the *Art Journal* and reading newspaper accounts of auctions, Hill might well have developed the skills of a connoisseur just as he had developed his successful career in business.

Before 1883 Hill limited his purchases of art to no more than $7,000, although he spent $5,250 to graze a pedigreed Scottish bull on his new farm. By 1886 he was willing to pay five-digit prices for paintings, spending $16,000 for a work by Gérôme and $20,000 for a painting by Alphonse De Neuville. Four years later, when he was elected president of the newly incorporated Great Northern Railway Company, journalists estimated his new worth at $9.6 million, and he entered another league in collecting art when he bought Delacroix's *Fanatics of Tangiers* for $25,000. His financial empire grew so large that in 1904 the United States Supreme Court ordered the dissolution of Northern Securities Company, a consolidation of Hill's railway interests.

Despite this setback, Hill continued to collect works of art. His records show an increase in expenditures to such an extent that in 1913 he spent $234,750 for thirteen paintings. Two years after the trial, Hill bought a house at 8 East 65th Street, just off Fifth Avenue and not far from the residence of Henry Clay Frick. In New York City, Hill and his wife Mary could pursue their shared interests in art by visiting galleries and exhibitions, buying art books, and commissioning portraits as gifts to their friends.

Considering the extent to which Hill documented the building and refining

of his collection—he frequently "traded up" to improve the quality of his holdings—it is surprising that he made no will, died intestate, and left no notes regarding the disposition of his art collection. Even though Hill's wife Mary and their children shared his artistic interests, no one wanted Hill House with its magnificent gallery after Mary's death in 1921. One local artist pleaded that it be turned into a public institution that would bear comparison with the Louvre and the Metropolitan Museum of Art, but instead the children gave the house to the Archdiocese of St. Paul and Minneapolis for use as a school for training nuns. In 1961, during this gentle custodianship, the house was proclaimed a National Historic Landmark, and in 1978 it was acquired by the Minnesota Historical Society.

Hill's collection evolved from an initial interest in academic, realist, and orientalist painters, such as Bonvin, Breton, Fortuny y Carbo, Fromentin, and Ribot, toward a clear preference for works by French painters who were active between 1830 and 1870 but were not necessarily successful in the Salons. He was attracted to the romantic style of Delacroix, who emphasized vivid colors, active brushwork, and striking interplays of light and shadow, as well as the landscapes of the Barbizon school. Hill's most celebrated work by Corot, *Silenus,* was an early painting that combined his love of classical mythology with traditional French landscape painting and nature.

No doubt dealers encouraged Hill to purchase works by the Impressionists. Monet and Renoir would have been appropriate since their paintings from the 1860s reflected the influence of Delacroix, Corot, and the realist Gustave Courbet, another artist who was well represented in Hill's collection. Hill bought only two paintings by Renoir—a small landscape scene of the Riviera and a copy the artist had made of Delacroix's *The Jewish Wedding.* Hill did show some interest in the Hague school of Dutch artists, which were vigorously promoted in the 1890s and early 1900s.

Cincinnati Revisited

Works by members of the Barbizon and Hague schools also played a role in the first collection assembled by Charles Phelps Taft and his wife Anna Sinton Taft in Cincinnati. As her father's only heir, Mrs. Taft became the richest woman in Ohio, with a fortune of $15 million. Among David Sinton's substantial real estate holdings was Belmont, the former home of Nicholas Longworth, where the Tafts had lived since their marriage in 1875 (fig. 132).

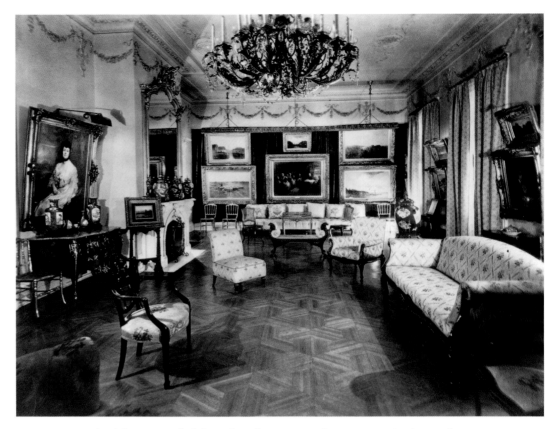

Fig. 132. Photographer unknown. North view, Music Room, Baum-Taft House, c. 1925. The Taft Museum, Cincinnati.

From a timid start of thirty landscape and genre paintings that were purchased in 1901 and 1902, Taft moved into the front ranks of American collectors within a decade. Isabella Stewart Gardner, the famous Boston collector and founder of her own museum, ironically lamented this fact in a letter written to Bernard Berenson on 11 August 1909. "We are rather amused by a newspaper account of the Great Collections in America. It eliminates Morgan's because so much of it is in Europe and goes on to say the 3 great ones are Frick's, Widener's and Charles Taft's. No hope for me."[58]

As a member of a prominent Ohio family involved in law and state politics, Taft concentrated upon his career as a newspaper publisher. Like Scripps, he was familiar with the international art market and strongly appreciated the social value of the arts in rapidly industrializing communities, such as Detroit and Cincinnati. He had studied and traveled in Europe during the late 1860s, earning a law degree in Heidelberg and examining modern European methods of manufacturing.

Taft revealed his art interests in a paper he presented in 1878 in connection with efforts to found a civic museum in Cincinnati. The lengthy title speaks for itself: "The South Kensington Museum. What It Is; How it Originated; What

It Has Done and Is Now Doing for England and the World; and the Adaptation of Such an Institution to the Needs and Possibilities of This City." Like so many others who were contemplating opening museums in the Midwest, Taft appreciated the operations of the London institution that became the Victoria and Albert Museum. Leaders in Cincinnati followed this London model perhaps too closely in the early years of the Art Museum Association's history of exhibitions, collecting, and educational programs. In 1902 Charles Taft privately complained to his younger half-brother William Howard Taft, future president of the United States, that the collection of the Cincinnati Art Museum was "a very inferior one." Now financially secure with his wife's fortune, Charles confided to William about his plans for displaying the collection. "Annie and I have about made up our minds that it would be just as well to invest money in pictures as to pile it up in bonds and real estate. At all events, we get a good deal of pleasure out of pictures."[59] Part of the pleasure came from sharing the collection with others. Taft, an art connoisseur and an active member of society, enjoyed belonging to business and artistic clubs, while Annie loved to hold musical entertainments for their friends. The paintings as well as their collection of Chinese porcelains and European decorative arts were displayed throughout their home in the charming confusion of the Victorian age.

For a while the Tafts considered building their own gallery, but ground was never broken. Instead, they decided to give the house, their collection, and a fund for its maintenance to the people of Cincinnati as part of a larger charitable trust that would benefit public education in the arts and culture. After their deaths the house was renovated and opened in 1932 as the Taft Museum. Its splendor was later replaced by a more sober treatment that respected the date of the building of Belmont, circa 1820, and imposed a more neoclassical decor.

The opening of the Taft Museum offers a fitting conclusion to this survey of art collecting in the Midwest during the Gilded Age. The Taft collection survived the extravagance of the Gilded Age and the museum weathered the Great Depression. Today, the Taft Museum exemplifies the application of wealth and consistent principles of individual taste at the turn of the century, yet no single model represents the Gilded Age collector. No individual typifies the variety of origins, educational backgrounds, business careers, and aesthetic preferences of these men and women. One thing they did share was the enthusiasm best expressed by Isabella Stewart Gardner, who had her motto emblazoned above the door to her museum: *C'est mon plaisir.*

Notes to this essay appear on pages 398–401.

Notes

INGHAM

1. Herbert Casson, *Romance of Steel* (New York, 1907), 274. Allegheny City, located across the Allegheny River from Pittsburgh, was annexed as part of the city in 1907 and became known as Northside Pittsburgh. Shadyside was also part of the city, but Sewickley Heights remained an independent suburb well to the west of the city.

2. Ibid.

3. Charles Dickens, *American Notes* (London, 1842).

4. Herbert Gutman, "The Reality of the 'Rags to Riches' Myth: The Case of the Paterson, New Jersey, Locomotive, Iron and Machinery Manufacturers, 1830–1880," in *Nineteenth Century American Cities: Essays in the New Urban History,* ed. Stephen Thernstrom and Richard Sennett (New Haven, 1969), 98–134.

5. Louis C. Hunter, "Financial Problems of the Early Pittsburgh Iron Manufacturers," *Journal of Economic and Business History* 2 (May 1930), 520–44. See also his "Factors in the Early Pittsburgh Iron Industry," in *Facts and Factors in Economic History: Articles by Former Students of Edwin Francis Gay* (Cambridge, 1932), 424–25. See also Glenn Porter and Harold Livesay, *Merchants and Manufacturers: Studies in the Changing Structure of 19th Century Marketing* (Baltimore, 1971).

6. For more detailed information on Pittsburgh's ante-bellum elite and its transformation and continuity in the postwar era see Joseph F. Rishel, *Founding Families of Pittsburgh: The Evolution of a Regional Elite, 1760–1910* (Pittsburgh, 1990), and John N. Ingham, *The Iron Barons: A Social Analysis of an American Urban Elite* (Westport, 1978), *Making Iron and Steel: Independent Mills in Pittsburgh, 1820–1920* (Columbus, Ohio, 1991), and "Rags to Riches Revisited: The Role of City Size and Related Factors in the Recruitment of Business Leaders," *Journal of American History* 63 (December 1976), 615–37.

7. See Ingham, *Making Iron and Steel,* for the most complete analysis of these firms and of the city's iron industry. To place them in a broader economic context see Peter Temin, *Iron and Steel in Nineteenth Century America: An Economic Inquiry* (Cambridge, Mass., 1964).

8. James Parton, "Pittsburg," *Atlantic Monthly* (1868), 31.

9. See Harrison Gilmer, "Birth of the American Crucible Steel Industry," *Western Pennsylvania Historical Magazine* 36 (1953), 17–36; Geoffrey Tweedale, *Sheffield Steel and America: A Century of Commercial and Technological Interdependence, 1830–1930* (Cambridge, England, 1987); and Ingham, *Making Iron and Steel.*

10. The literature on Carnegie and his steel ventures is enormous. For the most comprehensive treatment see Joseph Wall, *Andrew Carnegie* (New York, 1970), but also see Louis M. Hacker, *The World of Andrew Carnegie, 1865–1901* (Philadelphia, 1968), and Harold Livesay, *Andrew Carnegie and the Rise of Big Business* (Boston, 1975). Carnegie also wrote his own autobiography (Boston, 1920), but it should be used with great care, as should James H. Bridge, *The Inside History of the Carnegie Steel Company* (New York, 1903).

11. *New York Tribune,* 1 May 1892, 45, 50, and 51.

12. The *Tribune* listed a somewhat larger number of families than included in the above totals, but it lacked extensive information on sixty-three of them. The smaller number was used for the calculations above, but the following is the entire list of possible millionaires in Pittsburgh in 1892. In Allegheny City: Colonel James Andrews, Alexander M. Byers, Joseph S. Brown, Felix R. Brunot, John W. Chalfant, James A. Chambers, John Dunlap, Mrs. Herbert Dupuy, Mrs. Elizabeth Darlington, Harry Darlington, Jr., Rebecca Darlington, estate

Cat. 120. Pio Ricci (1850–1919). *Lady and Cavalier*, n.d., oil on canvas. Collection of Michael D. and Violanda R. LaBate, Ellwood City, Pennsylvania.

of William Eberhart, estate of David Gregg, A. Groetinger, A. Guckenheiner, Abraham Garrison, Mrs. J. Cosh Graham, Joseph Horne, Mrs. David Hostetter, D. Herbert Hostetter, Theodore Hostetter, Robert Hays, Thomas C. Jenkins, Benjamin F. Jones, J. Kaufman, William J. Kountze, Jacob Klee, James Laughlin, Jr., William Mullins, James McCutcheon, P. H. Miller, H. Sellers McKee, Mrs. Jacob N. McCullough, Mrs. William McKnight, John Porterfield, Henry Phipps, Jr., Mrs. James Park, Jr., David E. Park, Charles Park, William G. Park, James Park, A. E. W. Painter, Jacob Painter, Joshua Rhodes, William H. Singer, Andrew Smith, Mrs. David A. Stewart, Dr. Frank Wade, John Walker, Joseph Walton, and Samuel H. Walton. In Pittsburgh: Charles H. Anderson, Charles Arbuthnot, James M. Bailey, Thomas S. Bigelow, Charles H. Bradley, Alexander Bradley, Mrs. Breerton, estate of J. T. Brooks, Harry Brown, James W. Brown, Samuel Brown, William J. Burns, D. M. Clemson, Joseph Craig, Charles J. Clarke, Mrs. Thomas M. Carnegie, estate of William Carn, estate of James Callery, H. M. Curry, Lawrence Dilworth, Charles Donnelly, Mrs. O'Hara Denny, H. D. Denny, Miss Matilda Denny, Herbert Dupuy, James Eads, E. M. Ferguson, J. B. Finley, Mrs. William Frew, H. C. Frick, William Flinn, T. H. Given, E. Guckenhelmer, Mrs. Joseph M. Guskey, J. M. Guffey, Mrs. J. M. Guffey, E. N. Hukill, Samuel P. Harbison, Seward Hays, Henry J. Heinz, James J. Hemphill, John G. Holmes, Mrs. Thomas M. Howe, Dr. C. G. Hussey, Dallas C. Irish, Thomas G. Jenkins, E. H. Jennings, Morris Kaufman, R. H. King, H. A. Laughlin, George M. Laughlin, J. G. A. Leishman, Henry Lloyd, Charles Lockhart, F. T. F. Lovejoy, Chris L. Magee, Judge Thomas Mellon, Thomas A. Mellon, James R. Mellon, Andrew W. Mellon, R. B. Mellon, W. L. Mellon, Oliver McClintic, estate of Michael McCullough, James McKay, Henry McKnight, Mrs. Robert McKnight, William O'Neill, David Oliver, George T. Oliver, Henry W. Oliver, James B. Oliver, Mrs. D. C. Phillips, L. C. Phipps, Robert Pitcairn, Gilbert T. Rafferty, James H. Reed, D. P. Reighard, Mrs. Mary E. Schenley, Colonel J. M. Schoonmaker, Charles M. Schwab, Charles T. Schoen, John W. Scully, David Shaw, William H. Singer, Mrs. Mary Spring, Edward Thaw, Henry Thaw, estate of William Thaw, William R. Thompson, J. J. Vandergrift, John Walker, Mark W. Watson, George W. Westinghouse, H. H. Westinghouse, W. Dewees Wood, and Calvin Wells.

13. Ferdinand Lundberg, *America's 60 Families* (New York, 1937), 26.

14. Ibid., 29. Several of these families remained among the wealthiest in the United States well into the late twentieth century. A study of inherited wealth in 1957 indicated that members of the Mellon and Scaife families had the second, third, fourth, and fifth largest individual fortunes, worth between $1.6 and $2 billion. The Phipps/Guest family had the ninth largest fortune, at $200 to $400 million. See also Ferdinand Lundberg, *The Rich and the Super-Rich* (New York, 1968), 159. Massive fortunes, such as those of Carnegie and Frick, were either locked in philanthropic foundations or were hidden away by other means.

15. Stefan Lorant, *Pittsburgh: The Story of an American City* (Garden City, NY, 1964), 301.

16. Montgomery Schuyler, "The Building of Pittsburgh," *Architectural Record* 20 (September 1911), 203–82, and James D. Van Trump, "The Romanesque Revival in Pittsburgh," *Journal of the Society of Architectural Historians* 16 (1957), 22–29.

17. *Pittsburgh Press*, 28 July 1968, sec. 2, 1.

18. Lorant, *Pittsburgh*, 297. See Robert J. Jucha, "The Anatomy of a Streetcar Suburb: A Development History of Shadyside, 1812–1916," *Western Pennsylvania Historical Magazine* 62 (October 1979), 302–19, for the development of part of the East End. See also Joel A. Tarr, *Transportation Innovation and Changing Spatial Patterns in Pittsburgh, 1850–1934* (Chicago, 1978), and Annie Clark Miller, *Chronicles of Families, Homes and Estates of Pittsburgh and Its Environs* (Pittsburgh, 1921).

19. Casson, *Romance of Steel*, 275.

20. Nearly two-thirds of the city's inhabitants in 1890 were either immigrants themselves or the sons and daughters of immigrants.

21. Casson, *Romance of Steel*, 267.

22. Stewart Holbrook, *Age of the Moguls* (New York, 1953), 154.

23. Frances W. Gregory and Irene D. Neu, "The American Industrial Elite of the 1870s," and William Miller, "American Historians and the Business Elite," both in William Miller, ed., *Men in Business* (New York, 1962). Bureau of the Census, U.S. Department of Commerce, *Historical Statistics of the United States* (Washington, D.C., 1975).

24. Gregory and Neu, "Industrial Elite," 202, and Miller, "American Historians," 202. The figure on the American population is from Miller, ibid., 336.

25. Lorant, *Pittsburgh*, 168.

26. James Parton, "Pittsburg," *Atlantic Monthly* (January 1868), 17.

27. "Pittsburgh," *Harper's Weekly* (February 1871), 144–47.

28. "The City of Pittsburgh," *Harper's New Monthly Magazine* (December 1880), 57.

29. Willard Glazier, *Peculiarities of American Cities* (Philadelphia, 1883), 332.

30. Lorant, *Pittsburgh*, 177.

31. H. L. Mencken, *Prejudices* (New York, 1921), quoted in ibid., 328.

32. Parton, "Pittsburg," 31.

33. Ibid., 19.

34. Alexander K. McClure, speech given at the First Convention of the Scotch-Irish Society of America, *Proceedings* 1 (Pittsburgh, 1889), 184–85.

35. R. L. Duffus, "Is Pittsburgh Civilized?" *Harper's Monthly Magazine* 161 (October 1930), 537–45.

36. Some of the principal Core Upper Class families discussed here are Black, Chalfant, Childs, Dalzell, Dilworth, Howe, Jones, Laughlin, Lockhart, Lyon, Mellon, Metcalf, Miller, Moorhead, Nimick, Oliver, Painter, Park, Rea, Robinson, Singer, Smith, Walker, and Zug. Among the Non-Core Upper Class families are Byers, Carnegie, Curry, Dupuy, Fitzhugh, Frick, Gillespie, Graff, Kirkpatrick, Leech, Lloyd, McCutcheon, Phipps, Porter, Shinn, Shoenberger, Snyder, and Spang. Analysis of these families is developed in far greater detail in Ingham, *Iron Barons*.

37. See ibid., 107–17, for a more detailed breakdown on residence.

38. Ibid., 127–47.

39. These and other club listings are contained in a booklet held in the Frick family archives.

40. Henry Clay Frick to F. F. Nicola in a letter dated 25 October 1898 (Frick family archives).

41. Simon Goodenough, *The Greatest Good Fortune: Andrew Carnegie's Gift Today* (Edinburgh, 1985), 265.

42. George Harvey, *Henry Clay Frick: The Man* (New York, 1936), 269–70.

43. Frederick J. DePeyster, "Speech at the St. Nicholas Society Dinner," *New American Gazette* 7 (30 November 1891–7 January 1892), 2.

44. Casson, *Romance of Steel*, 195.

45. Lorant, *Pittsburgh*, 297. It is worth noting that the *Architectural Record*, arguably a more objective observer of the scene and certainly one with greater expertise in evaluating architecture, was far more generous in judging the homes of Pittsburgh's elite. It noted, "It is specially notable in considering the most expensive of the recent houses in Pittsburgh to observe how, although exteriorly and interiorly the design of it has been executed regardless of expense and the decoration is of great sumptuousness, successful pains are taken to avoid palatial pretentions . . ." *(Architectural Record* 30 [3 September 1911], 244).

46. Charles Beard, *The Rise of American Civilization* (New York, 1927), 392.

47. Casson, *Romance of Steel*, 200.

48. Lorant, *Pittsburgh*, 297.

49. Ibid., 297–98.

50. *New York Tribune*, 1 May 1892, 51.

51. Lorant, *Pittsburgh*, 301.

52. Ibid., 304.

53. S. J. Kleinberg, *The Shadow of the Mills: Working Class Families in Pittsburgh, 1870–1901* (Pittsburgh, 1989), 65.

54. F. Elisabeth Crowell, "Painter's Row: The Company House," in Paul U. Kellogg, ed., *The Pittsburgh District: The Civic Frontage* (New York, 1914), 131.

55. Kleinberg, *Shadow of the Mills*, 291. Louise Herron was a member of the Women's Christian Association and first vice president of the Temporary Home for Destitute Women. Mrs. Harmer Denny, another founder, was, according to her obituary, "identified with every Allegheny County benevolent enterprise" (Mary Darlington Scrapbook, Darlington Library, University of Pittsburgh). Mrs. Samuel McKee, wife of a lumber merchant, was a life member of the Women's Christian Association, a manager of the Temporary Home for Destitute Women, the Home for Aged Protestant Women, and Sheltering Arms.

56. Ronald J. Butera, "A Settlement House and the Urban Challenge: Kingsley House in Pittsburgh, Pennsylvania, 1893–1920," *Western Pennsylvania Historical Magazine* 66, no. 1 (1983), 25–47.

57. Julia Shelley Hodges, *George Hodges* (New York, 1926), 115–16.

58. H. D. W. English was head of the Pittsburgh Chamber of Commerce, head of the lay organization of Calvary Church, a member of Kingsley House, and a powerful force on the Civic Commission. (See his obituary in the Pittsburgh *Gazette-Times*, 29 March 1926.)

59. Paul Underwood Kellogg, ed., *The Pittsburgh Survey*, 6 vols. (New York, 1909–14). For some useful analyses of the survey and its relationship to the social, economic, and political scene in Pittsburgh see John F. McClymer, *"The Pittsburgh Survey,* 1907–1914: Forging an Ideology in the Steel District," *Pennsylvania History* 41 (April 1974), 169–88; Clarke A. Chambers, *Paul U. Kellogg and the Survey: Voices for Social Welfare and Social Justice* (Minneapolis, 1971); Charles Hill and Steven Cohen, "John A. Fitch and the *Pittsburgh Survey,*" *Western Pennsylvania Historical Magazine* 67 (January 1984), 17–32; Trisha Early, *"The Pittsburgh Survey,*" seminar paper, History Department, University of Pittsburgh, 1972; and Steven R. Cohen, "Reconciling Industrial Conflict and Democracy: *The Pittsburgh Survey* and the Growth of Social Research in the United States," Ph.D. diss., Columbia University, 1981.

60. Samuel A. Schreiner, Jr., *Henry Clay Frick: The Gospel of Greed* (New York, 1995), 278–79; Lundberg, *America's 60 Families*, 356–57; Lily Lee Nixon, "Henry Clay Frick and Pittsburgh's Children," *Western Pennsylvania Historical Magazine* 29 (1946), 65–72; and Marianne Maxwell, "Pittsburgh's Frick Park: A Unique Addition to the City's Park System," *Western Pennsylvania Historical Magazine* 68 (July 1985), 243–65. Frick's will stipulated that inheritance taxes had to be taken solely from the charities, which reduced their share substantially.

61. Peggie Phipps Boegner and Richard Gachal, *Halcyon Days: An American Family Through Three Generations* (Old Westbury, 1986), 20.

62. Lundberg, *America's 60 Families*, 357–58.

63. Francis G. Couvares, *The Remaking of Pittsburgh: Class and Culture in an Industrializing City, 1877–1919* (Albany, NY, 1984), 105.

64. Ibid., 93, 116–17.

65. Kathleen D. McCarthy, *Noblesse Oblige: Charity and Cultural Philanthropy in Chicago, 1849–1929* (Chicago, 1982), 117.

66. Wall, *Carnegie*, 822–23.

67. In fact, art and business matters were often liberally intermixed. Paintings were frequently used by Frick and others as a way of cementing business and other relationships. For example, in September 1899, Frick sent Charles Schwab a painting by Thaulow. Schwab expressed his deep gratitude to Frick for this gesture. This came at a time when the relationship between the two men was shaky at best. Similarly, on 11 July 1897, Henry Phipps, Jr., wrote to Frick from London and in a long letter discussed a painting he wished to purchase there, prior to getting on to discussing pressing business matters at Carnegie Steel. (See letter from Phipps to Frick in the Frick family archives.) Frick and Andrew Mellon also often mixed discussions of paintings with business, and Frick used one of his business and legal advisors, David T. Watson, to scout out paintings in Europe.

68. Quoted in Schreiner, *Frick*, 264.

69. Harvey, *Frick*, 334.

70. Annie Dillard, *An American Childhood* (New York, 1987), 210–13.

MCQUEEN

Note: Unless otherwise noted, the author based all the statistics in this essay on an appendix of Pittsburgh collections that she compiled. This appendix, which includes the names of collectors, the title, medium, dimensions, and exhibition history of the artworks, and reference sources, is available through the Frick family archives.

1. *Pittsburgh Post*, 31 March 1892, no page number.

2. After Mary's death, John remarried Alice Taylor and moved to New York. It is difficult to reconstruct the Shoenberger's art collection as it would have been known in Pittsburgh because of this move to another state. Information on their gallery and travels comes from Mary A. Stuhldreher's unpublished manuscript in the Pittsburgh History and Landmarks Foundation, mss. 6, box 1, folder 3 (Miscellaneous Material 1959–65). Other biographical information is taken from the Shoenberger biography file in the Pennsylvania room of the Carnegie Library. The terms of John Shoenberger's will led to the foundation of St. Margaret's Hospital in Pittsburgh.

3. I am grateful to David Wilkins, who generously shared his research on the Pittsburgh Art Association exhibitions. At the conference "David Gilmour Blythe's Pittsburgh: 1850–1865," Wilkins also presented an important paper on art in Pittsburgh in the mid-nineteenth century, in which he noted the Lambdin museum. See David Wilkins, "The Pittsburgh Art Community: 1850–1865," and the appendix "Preliminary Analysis of Three Pittsburgh Exhibitions," in *David Gilmour Blythe's Pittsburgh: 1850–1865* (Pittsburgh, 1981), 16–26, 60–61.

4. Biographical information on nineteenth-century artists in Pittsburgh and an analysis of the growing dynamic between local artists and industry are provided in David Wilkins et al., *Art in Nineteenth-Century Pittsburgh* (Pittsburgh, 1977).

5. William Thaw's role in the school is discussed at length in Britta Dwyer, "Nineteenth-Century Regional Women Artists: The Pittsburgh School of Design for Women, 1865–1904," Ph.D. diss., University of Pittsburgh, 1989, 200.

Cat. 121. Adolf Schreyer (1828–1899). *The Pass over the Hills*, n.d., oil on canvas. Collection of Mr. and Mrs. A. Charles Perego, Pittsburgh [Ex. coll., Willis F. McCook].

6. Ibid., and *Pittsburgh Post*, 7 April 1893, no page number.

7. Dwyer, "Regional Women Artists," 225.

8. The foundation of the Art Students' league was noted in the *Pittsburgh Post*, 27 December 1898, 23.

9. The Artists' Association of Pittsburgh was established on 10 February 1897 and opened its first annual art exhibition on 11 October in the art gallery of the Carnegie Library *(Pittsburgh Post*, 3 October 1897, 2). An estimated eight hundred people attended the opening reception *(Pittsburgh Post*, 12 October 1897, 2). Later reports noted the popularity of the exhibition *(Pittsburgh Post*, 14 October 1897, 2). In addition to showing their own works, the Art Society also organized a portrait exhibition at the Carnegie Institute in March 1900.

10. *Pittsburgh Post*, 31 March 1892, no page number. The exhibition was free and open to the public daily except Sunday *(Pittsburgh Post*, 5 February 1894, no page number).

11. *Pittsburgh Post*, 11 November 1900, 16.

12. While the names of few local artists appear in later inventories and records, it is not possible to know when collectors sold or disposed of these works. Since these inventories appear to list collections in their entirety and include works by unknown artists, it does not seem feasible that any works by local artists remaining in collections were not documented.

13. *Pittsburgh Post*, 12 March 1899, 17, and 28 January 1902, 2.

14. *Pittsburgh Post*, 6 March 1898, 18.

15. One example is an article that included written and illustrated views of the studios of Caldwell, Dalby, Dougherty, Hetzel, Johns, and Stevenson. See *Pittsburgh Post*, 30 January 1898, 15.

16. These artists were among those who are most frequently cited in the *Bulletin*, the *Index*, and the *Pittsburgh Post* during this period.

17. In Pittsburgh, Alexander was represented by eleven works in three collections, Hetzel by ten works in nine collections, Poole by five works in four collections, and Wall by twelve works in ten collections.

18. Works by Cassatt, Singer, and Stevenson were in the Frick, Laughlin, and Porter collections, respectively.

19. S. Boyd and Company was located at 436 Wood Street. The Wunderly Brothers sold prints from their studios at 329 or 337 Sixth Avenue, while "art goods" could be purchased at their location at 607–609 Smithfield Street. See *The Pittsburgh and Allegheny Blue Book: Shopping Guide* (Pittsburgh, 1903). Young's art store (unknown location) also exhibited art; see the *Pittsburgh Post* of 17 April 1898, 16. The Loughridge art gallery on Smithfield Street is mentioned only in 1901; see the *Bulletin* of 9 November 1891, no page number.

20. Dorothy Miller, "The Oldest Art Gallery," *Carnegie Magazine* 31 (May 1957), 159–61.

21. I am grateful to Mr. and Mrs. Evans for granting me access to the gallery's remaining records.

22. See the *Bulletin* of 18 November 1899, 12, and the *Pittsburgh Post* of 14 April 1901, 8. Views of the Wunderly Brothers' studio were published in the *Index* on 31 May 1902, 28.

23. The following excerpts from Pittsburgh publications suggest the excitement that new works of art created. "A landscape painted by Clarence Johns, which is in the window at Gillespie's . . ." *(Bulletin*, 5 March 1898, 12). "There is a late engraving of Victor Hugo that is attracting the notice of a good many admirers of the great French author to Wunderly's windows. . . . There is a new still life of Wooster's in Young's window. . . . Leisser has a new landscape in Boyd's window . . ." *(Pittsburgh Post*, 15 May 1898, 24). "Four soldier pieces in oils have attracted notice in Young's window. They are the work of a local artist, E. W. Ramdby" *(Pittsburgh Post*, 29 May 1898, 19). "A new Poole is a magnet of attraction in Boyd's window" *(Pittsburgh Post*, 6 November 1898), 26. "George Hetzel . . . brought a big canvas with him that is now on view in Boyd's window" *(Pittsburgh Post*, 11 December 1898, 28). "One of this year's salon pictures is now hanging in J. J. Gillespie's gallery, in Wood street. It is the work of J. Desvarreau Larpenteur . . ." *(Index*, 9 August 1902, 20). Chartran's portrait of Judge Thomas Mellon, which was commissioned by Frick and presented to the law library at the Pittsburgh Court House, was first exhibited in Gillespie's window (Frick family archives).

24. Special exhibitions at the Gillespie galleries were regularly advertised in local newspapers. Announcements of exhibitions held by Arthur Tooth between 1898 and 1904 appear in the *Bulletin* (15 October 1898, 19; 18 March 1899, 19; 9 November 1901, no page number; 15 March 1902, 14; 7 November 1903, 25; and 19 November 1904, 20) and in the *Pittsburgh Post* (4 November 1900, 19). "Mr. Scott, representing Arthur Tooth & Sons,

of New York and London, is showing a decidedly interesting collection at Gillespie's this week . . ."; see the *Index*, 3 November 1900, 18. S. Collins held exhibitions between 1890 and 1899; see the *Bulletin* (20 September 1890, 12; 14 December 1895, 19; 7 March 1896, 12; 23 October 1897, 12; 9 January 1898, 11; and 11 November 1899, 12). Two works were sold at a Collins exhibition held at Gillespie's in January 1895 (see also Lockhart collection), and twenty works were sold to local collectors that October *(Bulletin,* 12 October 1895, 12). Durand-Ruel exhibited paintings between 1895 and 1905; see the *Bulletin* of 11 January 1896, 12; 2 October 1897, 12; and 2 February 1901, 10; and the *Index* of 28 January 1895, 26; 25 January 1902, 21; and 28 January 1905, 26.

25. S. P. Avery exhibited works in 1895 *(Bulletin,* 30 November 1895). The Bleiman and Haseltine collections were exhibited in 1890 *(Bulletin,* 4 October 1890, 12, and 1 November 1890, 12). The Gross and Lane collection was exhibited in 1890 *(Bulletin,* 27 December 1890, 12). H. S. van Gigch exhibited works in 1896 *(Bulletin,* 14 November 1896, 12). Thomas McLeon of 7 Haymarket, London, showed paintings in 1900 and 1901 *(Pittsburgh Post,* 25 November 1900, 21, and *Bulletin,* 14 December 1901, 27). Henry Reinhardt exhibited works in 1901 *(Bulletin,* 30 March 1901, 13). Gillespie's hosted a collection from the Dowdeswell gallery of New York and London *(Index,* 8 February 1902, 20) and one from Scott and Fowles *(Index,* 11 February 1905, 26). The exhibition and auction of the Johnson collection from New York was directed by the Art Society at the gallery located at 506 Wood Street *(Pittsburgh Post,* 2 January 1898, 3).

26. C. H. Ault's collection from Cleveland was exhibited at Gillespie's in June 1899 *(Pittsburgh Post,* 4 June 1899, 16). For Frazier's travels see the *Pittsburgh Post* of 28 May 1899, 18.

27. See the *Pittsburgh Post* of 7 April 1901, 8; 26 May 1901, 8; and 2 June 1901, 8. Perhaps as a result of meeting with these Dutch artists, Gillespie's held a special exhibition of recent Dutch paintings in January 1903; see the *Pittsburgh Post* of 8 January 1903, 6.

28. The Gross and van Gigch gallery exhibited works in rooms 1217 and 1218 of the Carnegie building in 1896 and rented half of its ground floor in 1897; see the *Bulletin* of 28 February 1896, 12, and 25 September 1897, 12. The Durand-Ruel gallery held apartments in rooms 1208 and 1209 of the Carnegie building, where they exhibited works in 1896; see the *Bulletin* of 14 November 1896, 12, and 21 November 1896, 12. Edwin C. Holston also exhibited works, including sculpture and Barbizon paintings, for the Durand-Ruel gallery at the Hotel Henry in Parlor B in 1898. This marked the first time that this space was converted into a studio; see the *Bulletin* of 3 December 1898, 12, and the *Pittsburgh Post* of 27 November 1898, 23. In 1896 Julius Oehme of New York exhibited works at the private offices of Joseph Horne and Company; see *Pittsburgh Commercial Gazette,* 29 May 1896, no page number.

29. *Bulletin,* 7 January 1903, 12. Items to be auctioned from the Johnson collection were exhibited at the Wood Street Gallery, located at 506 Wood Street, in January 1898; see the *Pittsburgh Post,* 2 January 1898, 3.

30. *Bulletin,* 23 October 1897, 12.

31. Ibid. and *Bulletin,* 13 November 1897, 12. Their move was noted in the *Bulletin* of 2 November 1901, 12.

32. Examples of these advertisements include: S. Collins, "Importer of Fine Paintings" in New York *(Bulletin,* 8 November 1890, 20, and 7 March 1896, 12), and William Macbeth, "The Work of American Artists a Specialty" in New York *(Bulletin,* 6 January 1894, 10) and "Pictures in oil and watercolors by American and Foreign Artists, Early Dutch and Flemish Pictures" *(Bulletin,* 27 May 1899, 12). An article was devoted to the exhibition of Mauve's work at the Macbeth gallery, which was noted as "a place favorably known to Pittsburg[h]ers" *(Bulletin,* 27 January 1894, 10). Durand-Ruel advertised in the *Bulletin* (14 March 1896, 12), as did Gross and van Gigch *(Bulletin,* 8 February 1896, 12). Articles informing Pittsburgh readers of exhibitions in New York and elsewhere in the United States ran regularly in the *Bulletin,* the *Index,* and the *Pittsburgh Post.* See, for example, the Antonio de la Gandara exhibition at the Durand-Ruel gallery and Cecilia Beaux's exhibition at the American Art Galleries in New York *(Pittsburgh Post,* 2 January 1898, 4); the exhibition and sale of William H. Stewart's collection at the American Art Galleries in New York *(Pittsburgh Post,* 30 January 1898, 4); and an exhibition of American painters at the Durand-Ruel gallery in New York *(Pittsburgh Post,* 10 April 1898, 4).

33. S. P. Avery, Cottier and Company, and William Macbeth loaned works to an exhibition at the Carnegie museum in 1895. Boussod, Valadon et Cie, Durand-Ruel, M. Knoedler & Co., William Macbeth, and Arthur Tooth & Sons all loaned works to the Carnegie's 1896 exhibition. Durand-Ruel, Knoedler, and Tooth also attended this exhibition; see the *Pittsburgh Post* of 29 November 1896, 7. Cottier and Company, Durand-Ruel, and Knoedler loaned paintings to the 1902 exhibition at the Carnegie museum as well.

34. The following collectors are documented as having purchased works from Gillespie's: Armstrong, Baggaley, G. P. Black, W. Black, Byers, Card, Dalzell, Darlington, Donnelly, Frew, Frick, Kennedy, J. C. Laughlin, Lockhart, J. R. Mellon, Nicola, O'Neill, Porter, Schwab, and Watson. Undoubtedly, more than these collectors acquired paintings from this gallery.

35. *Bulletin*, 30 October 1897, 12.

36. *Pittsburgh Post*, 27 March 1898, 17.

37. *Bulletin*, 23 October 1897, 12, and 30 October 1897, 12.

38. *Pittsburgh Post*, 24 February 1901, 28.

39. I am grateful to Vicky Clark of the Carnegie Museum of Art for providing copies of the lists drawn from the Centennial Exhibition Project Report.

40. Chase's works were collected by Beatty, Caldwell, Stimmel, and Watson. The artist made his most important Pittsburgh contact with Annie and H. K. Porter. Paintings by Hassam were in the Black, Caldwell, and Stimmel collections. Homer's name appears only in Thomas Carnegie's collection.

41. East's works were in the Beatty, Peacock, and Stimmel collections, while paintings by Neuhuijs were in the Bosworth, Frick, and Laughlin collections. Raffaëlli's works are documented in the Byers and Frick collections. The artist made this comment during an impromptu speech to other jurors, but it was published in the local press; see the *Pittsburgh Post*, 13 October 1899, 2.

42. *Pittsburgh Post*, 1 November 1899, 2.

43. The work may not have been undertaken because the woman's parents did not approve of her posing as an artist's model. See the *Pittsburgh Post* of 26 October 1899, 2, and 27 October 1899, 5.

44. *Comedy* by Aman-Jean was illustrated in the *Index* (9 November 1911, 5), and his visit to the city in 1903 and praise of Andrew Carnegie's contribution to the advancement of art in Pittsburgh were described in the *Pittsburgh Post* (25 March 1903, 6). The latter article also noted that while Aman-Jean might accept a few commissions during his visit, he had actually come to Pittsburgh to rest after the numerous portrait commissions he had undertaken in New York.

45. Twenty of Thaulow's works can be traced to nine different collections: Black, Donnelly, Frick, Kennedy, Laughlin, A. W. Mellon, H. W. and E. A. Oliver, Peacock, and Porter.

46. Only one work by Turney was noted in the G. T. Oliver collection. Boznanska won a third-class medal at the Carnegie International in 1907 for *Portrait of a Woman*, one of her works in the Stimmel collection. A single painting by Gardner was in the Caldwell collection and three were in the Thaw collection. At least five works of art by Klumpke were in the Thaw collection. One painting by Lemaire is recorded in the Frick collection, and only one work by Vigée-Lebrun can be traced to the Watson collection.

47. Works by Bonheur were in the Baggaley, Byers, Finley, Frick, Lockhart, R. B. Mellon, Peacock, Thaw, and Watson collections. Through an introduction from Roland Knoedler, the Fricks visited Bonheur in her studio during their trip to France in 1895 (Frick family archives).

48. Chartran's annual portrait exhibitions, which were held at the galleries of M. Knoedler & Co. in New York, received much press coverage in Pittsburgh. See the *Index* of 31 January 1904, 9; 28 February 1903, 9; and 21 January 1905, 22; the *Bulletin* of 11 February 1899, 10, and 20 February 1904, 18. The large number of works shown at these exhibitions that were commissioned by Pittsburghers testifies to the city's importance as an art center. "One is again reminded of the prominence of Pittsburgh as an art center and of the international character of modern art in the exhibition of M. Theobald Chartran's latest paintings at Knoedler galleries" *(Art Amateur* [December 1900], 54). When Chartran visited Pittsburgh in January 1896, he retained a temporary studio in the Mohawk building; see *Pittsburgh Commercial Gazette*, 7 January 1896, no page number. Henry Clay Frick also commissioned portraits of Andrew Carnegie, Henry Phipps, and Thomas Mellon from Chartran.

49. *Index*, 28 June 1902, 1.

50. *Pittsburgh Post*, 13 July 1893, no page number.

51. *Bulletin*, 6 April 1901, 13, and *Pittsburgh Post*, 8 May 1898, 15. Spiestersbach supposedly had "some sculpture work awaiting him here," but there is no evidence of what these commissions were. See the *Pittsburgh Post*, 18 November 1900, 18.

52. The criticism was first published in the *Art Interchange,* a New York publication. It was then challenged by *International Studio* in London, and finally summarized in the *Pittsburgh Post* (27 March 1898, 17).

53. Those collections with engravings were Frick with thirteen, and Porter and Singer each with two. Those collections with etchings were Caldwell and Beatty each with one, Frick, Porter, and Singer each with two, and Nicolas with three.

54. Etchings by Barbizon artists were exhibited at Gillespie's in 1896 *(Bulletin,* 21 November 1896, 21). *Where Shakespeare Sleeps* by James Fagan was shown at Wunderly's in March 1898 *(Pittsburgh Post,* 6 March 1898, 18). An engraving of Victor Hugo was displayed in the window of Wunderly's in May 1898, as was a print by Copley of Lerolle's *By the River (Pittsburgh Post,* 15 May 1898, 24). Watercolors and etchings were exhibited in Gillespie's window in May 1898 *(Pittsburgh Post,* 8 May 1898, 15). Proof etchings by Jozef Israels were shown at Gillespie's in June 1899 *(Pittsburgh Post,* 25 June 1899, 20). Etchings by American and foreign artists were presented by Wunderly Brothers in 1903 *(Bulletin,* 31 January 1903, 33).

55. *Pittsburgh Post,* 6 March 1898, 18; 10 April 1898, 18; and 15 May 1898, 24.

56. *Bulletin,* 10 December 1904, 20.

57. The following collections included watercolors: With one watercolor each were Barr, Byers, Dupuy, C. Magee, W. Magee, and H. Moorhead. With two each were Black, Holmes, J. Moorhead, and Watson. Thaw owned three, and Kennedy possessed four. Leading this group were Porter with ten watercolors and Frick with twenty-three.

58. *Bulletin,* 24 April 1897, 12; *Pittsburgh Post,* 8 May 1898, 15, and 29 May 1898, 18.

59. *Pittsburgh Post,* 29 January 1898, 2.

60. *Pittsburgh Post,* 2 April 1899, 4.

61. *Pittsburgh Post,* 13 March 1898, 18.

62. *Pittsburgh Post,* 14 April 1901, 8, and 21 April 1901, 4.

63. *Catalogue of Curios Personally Collected by H. J. Heinz* (Pittsburgh, 1898). See also "The Heinz Collection," *Carnegie Magazine* 1, no. 4 (September 1927), 3–6. Further research in the Heinz archives would clarify the contents of the Heinz collection at this early date.

64. Frick owned fifteen drawings or pastels, Porter nine, Stimmel two, and Thaw one. One of Poole's pastels was exhibited at Gillespie's in May 1898 *(Pittsburgh Post,* 15 May 1898, 24, and 22 May 1898, 18). It is not clear if by this date the Dupuys had already acquired the drawing collection that they later donated to the Carnegie museum. See *Carnegie Magazine* 7, no. 8 (January 1934), 233–34.

65. Many Pittsburgh artists who specialized in miniatures belonged to the Duquesne Ceramic Club *(Bulletin,* 16 July 1904, 18).

66. In February 1893 Gerald Sinclair Hayward's collection of miniature paintings was exhibited in the Art Society's galleries *(Pittsburgh Post,* 5 February 1893, no page number). An exhibition of Mrs. Ames's miniatures was held at Boyd's in May 1898 *(Pittsburgh Post,* 22 May 1898, 18), and Mrs. Hildebrandt showed her miniatures at Gillespie's in late 1902 *(Bulletin,* 22 December 1902, 20).

67. *Pittsburgh Post,* 6 January 1901, 25.

68. *Pittsburgh Post,* 27 January 1901, 11.

69. In 1927 Herbert Dupuy said they had inherited many miniatures and had been collecting for "many years past," but it is not clear if they began as early as the 1890s. See *Carnegie Magazine* 1, no. 7 (December 1927), 5–23.

70. The following collections included sculpture: Frew and Frick with three each, Singer with two, and Schwab and Snyder with one each. The Porter collection held the greatest number at six.

71. *Pittsburgh Post,* 17 April 1898, 16.

72. *Pittsburgh Post,* 6 March 1898, 18. See also David Wilkins, *Paintings and Sculpture of the Duquesne Club* (Pittsburgh, 1986).

73. *Pittsburgh Post,* 10 June 1900, 22, and 12 August 1900, 28.

74. *Pittsburgh Post*, 25 January 1903, 1, 8 (4th part).

75. Letter from Annie May Hegeman to Edith Hall Dohan dated 1 May 1930 (administrative records, University Museum, Philadelphia, box 7, folder H). Information on these vases was kindly provided by Chrisso Boulis, assistant registrar, and Alessandro Pezzato, reference archivist, of the University Museum. See also E. H. Dohan, "Two Vases from the Hegeman Collection," *Museum Journal* 13, no. 1 (1932), 64–74.

76. Eaton owned three Byzantine and three Florentine mosaics, Schwab had one mosaic by Tarentoni, and Singer owned three mosaics. Schwab's contact with Tarentoni in Rome was noted in the *Pittsburgh Post* on 21 October 1900, 17.

77. Works purchased directly from artists were distributed in collections as follows: Baggaley, Heinz, Kennedy, Laughlin, J. R. Mellon, R. B. Mellon, H. W. Oliver, Rea, Scaife, Schenley, Stimmel, Watson, and Woodwell with one each; Alderdice, Beatty, Jones, Moorhead, and Schwab with two each, Lockhart with at least two; Thaw with four or more; Porter with at least five; Byers with six; and Frick with more than eighteen.

78. George Carspecken's *Portrait of Raymond Gros* was illustrated in the *Index* (6 December 1902, 7). Gros moved to Pittsburgh permanently around 1900. In 1903 the *Index* noted that "Mme. Raymond Gros and her two sons . . . are expected back home to-morrow after a four months' trip in France and Switzerland. Mme. Victor Gros, mother of M. Gros, comes to America with her daughter-in-law to make her home in Pittsburgh" *(Index,* 19 September 1903, 18).

79. Among Gros's articles in the *Index* are "The Flemish School" (16 November 1901, 12–13), "The Carnegie Art Exhibition" (7 November 1903, 8), "Tissot's Biblical Paintings" (8 April 1905, 6–9), and "John White Alexander" (17 June 1905, 20), as well as a series entitled "Art and Artists" (see 14 January 1905, 20; 21 January 1905, 22; 28 January 1905, 26; 4 February 1905, 18; 11 February 1905, 26; and continued beyond this date regularly). It is probable that many other articles published in the *Index* around this time were written by him but do not include his byline.

80. "The Trend of Modern Art" by R. W. Vonnoh and E. Aman-Jean appeared in the *Index* (Christmas 1903, 26).

81. *Pittsburgh Post*, 24 December 1899, 18.

82. This mission statement was noted in the club's publication *The Twentieth Century Club of Allegheny County 1894–97* (Pittsburgh, 1897), 9.

83. Lectures were held at the club at 408 Penn Avenue. (The club moved to 4201 Bigelow in 1911.) According to club financial records, $14,428.94 was spent on lectures from 1894 to 1904. See the *1894–1904 Scrapbook* in the files of the Twentieth Century Club. I am grateful to Mrs. Daniel, president of the Twentieth Century Club, and Diana Taylor, her assistant, for allowing me to consult the club's archives.

84. Ida Smith gave her criticism of the Carnegie art exhibition on 25 November 1903. Her earlier lecture on another International was noted in the *Bulletin* (30 November 1901, 23). Martin Leisser and Joseph Woodwell presented lectures in 1897, but the topics of their discussions were not specified.

85. Smith was responsible for organizing the club's art department *(Bulletin,* 11 February 1899, 10). Beatty lectured on the Carnegie International exhibitions in late 1897; this lecture was noted in the *Pittsburgh Post* (4 December 1897, 5). His presentation on 23 November 1898 was mentioned in the *Pittsburgh Post* the following day on page 4. He addressed the club again on 3 December 1902. Beatty also spoke on "Some Artists I Met in Holland" on 28 January 1899; mention of it appeared in the *Bulletin* that day on page 10. He gave the same lecture to the Art Club of Washington, Pennsylvania, the previous day. Sarah H. Killikelly presented an "Illustrated Lecture on the St. Louis Exposition" on 27 April 1904. Mrs. Semmes-Craig's lecture on "American Art and Artists," which was illustrated with stereopticon pictures, was advertised in the *Bulletin* (27 May 1899, 12), along with H. S. Stevenson's lecture on the "Barbizon School and Impressionism."

86. Two lectures on American art and artists were given by Mrs. Craig of New York on 10 and 12 June 1899 *(Pittsburgh Post,* 4 June 1899, 16). Mary H. Flint presented an "Illustrated Lecture on the Age of Praxiteles" and "Byzantine Art" on 2 and 3 December 1897. On 9 January 1901 a lecture illustrated with the stereopticon entitled "The Religious Idea in Early Italian Painting" was given by Mrs. Elizabeth M. Vermorcken, who also wrote on art for newspapers in Pittsburgh and New York *(Bulletin,* 5 January 1901, 10). A series of six lectures entitled "The Painting of the Renaissance in Italy Historically and Critically Considered" was presented by John C. Van Dyke. The lectures were offered on 1, 2, 8, 9, 22, and 23 March 1898 and cost three dollars.

87. Topics of lectures included "Modern Painters" by Eleanor B. Caldwell (6 June 1898 [?]); "Modern German Art" by Mrs. Leisser (1 February 1889); "John Ruskin" by John Graham Brooks from Cambridge, Massachusetts (19 November 1902); "How to See a Picture" by Dewing Woodward of New York (27 October 1897); and "A Few Hints on Mural Painting" by Walter Shirlaw, M.A. (26 April 1899 [?]). Two lectures that were noted as being illustrated by the stereopticon were John Quincy Adams's lectures on "Art and the Day's Work" (7 January 1903) and Mrs. Semmes-Craig's lecture. Many other lectures were noted as being "illustrated," probably with the stereopticon. Mrs. Semmes-Craig gave another lecture on American artists, which was held at the Hotel Schenley on 22 November 1899 (Bulletin, 14 October 1899, 10).

88. Charter members included Amy Dupuy, Emily Frew, Annie May Hegeman, Rachel Mellon, and Annie Decamp Porter. Early members included Ellen Alderdice (elected 1901 and 1907), Gertrude Armstrong (1911), Louise Dilworth (1898), Sue Jones (1899), Jennie Kennedy (1907), Nora Mellon (1900), Jennie Mellon (1895), Anne Moorhead (1899), Margaret Nicola (n.d.), Irene Peacock (1904), Rebecca Schoonmaker (n.d.), Hester Snyder (1894), Mary Snyder (1896), Frances Vandergrift (1896), and Margaret Watson (n.d.). Board members included Emily Frew (director 1884–94, 1898–1901; president 1897–98), Annie May Hegeman (director 1894–97), Rachel Mellon (treasurer, 1894–1903; director, 1909–11), and Margaret Nicola (director, 1900–1902). Membership information is taken from "Two Packs of Early Membership Record Cards (prior to incorporation)" that are now in the club's archives. There is no evidence that similar lectures were given at any of the local men's clubs.

89. Pittsburgh Post, 4 June 1899, 16.

90. Professor Sprague's four lectures were on the Forest of Fontainebleau, Millet, Corot, and Rousseau. This series was funded by the Art Society and were given in the Carnegie Music Hall on 10, 17, 23, and 30 November 1896. See the Bulletin (7 November 1896, 12) and advertisements in the Pittsburgh Commercial Gazette (24 November and 1 December 1896, no page numbers).

91. Raffaëlli's free lecture was given to the Art Society and other interested members of the Pittsburgh community on 31 October 1899. See the Bulletin (28 October 1899, 12) and the Pittsburgh Post (27 October 1899, 5, and 1 November 1899, 2).

92. Pittsburgh Post, 22 May 1898, 18.

93. Notice of Breasted's lectures ran in the Pittsburgh Post (15 November 1898, 2). Priggs's lectures covered "Painting Explanations and Definitions: How to Judge a Picture," "Mediaeval Painting and Modern Revivals of Mediaevalism: Pre-Raphaelites," "Classicism: The Rule of Reason," "Romanticism: The Emancipation of the Individual," "Development of Landscape Art," and "National Characteristics." Each lecture was illustrated with the stereopticon (Bulletin, 30 December 1899, 10).

94. Index, 25 May 1902, 15.

95. Reprinted in the Bulletin, 29 November 1890, 12.

96. Art Amateur, July 1892, 44–45.

97. In this category Byers owned 97 works of art, Frick had 242, Lockhart had 96, and both Porter and Watson had 90. The number of works in each collection is based on research of wills and inventories in the Allegheny County building, records from the Knoedler and Gillespie galleries, a catalogue from the archives of the Pittsburgh Athletic Association, relevant exhibition catalogues from the late nineteenth and early twentieth century, and articles published in the Index, Bulletin, Pittsburgh Post, and Pittsburgh Commercial Gazette.

98. Pittsburgh Post, 17 December 1903, 6. In a lecture held in the Twentieth Century Club, Michel also lectured on the cathedrals of Amiens and Chartres before the Alliance Française.

99. The Caldwell collection contained 45 works, plus etchings. Donnelly had 50 works, James Laughlin owned 64, Peacock had 62, Stimmel 67, and Thaw 52.

100. The number of artworks in each collection breaks down as follows: William Black 25, Bosworth 22, Andrew Carnegie 24, Darlington 26, Dupuy 37, Finley 27, Frew 25, Holmes 26, Andrew Mellon 32, J. R. Mellon 22, Moorhead 33, George Oliver 30, Henry. Oliver 27, Phipps 36, Schoonmaker 28, Schwab 34, Singer 25, and Wolff, Jr., 32.

101. The involvement of many prominent collectors in the early activities of the Carnegie museum is also noted in Kenneth Neal, A Wise Extravagance: The Founding of the Carnegie International Exhibitions 1895–1901 (Pittsburgh, 1996) and in his doctoral dissertation of the same title (University of Pittsburgh, 1993, 14-15).

102. George Black owned 10 works, Jones 16, Kennedy 15, George Laughlin 14, Nicola 17, O'Neill 12, and Vandergrift 17.

103. The group of small collections includes Alderdice with 8 works of art, Barr 3, Beatty 8, Boggs 2, Butler 6, Card 9, Thomas Carnegie 8, Clark 1, Childs 1, Donnell 3, Dravo 3, Gillespie 1, Grier 1, Hegeman 3, Jackson 8, Jefferson 3, Knox 1, H. Laughlin 1, H. McKee 1, R. B. Mellon 5, W. Mellon 1, H. Moorhead 2, D. B. Oliver 1, Park 2, Reed 8, Rook 1, Shea 1, G. Singer 1, H. K. Thaw 7, B. Thaw 7, Westinghouse 7, C. Wolff 8.

104. Before they can be properly evaluated, the collections of Armstrong, Bindley, Chalfant, Dilworth, Fitzhugh, Heinz, Kelly, John Kennedy, Thomas Mellon, Rea, Schwartz, and Snyder all require further research. Many members of this group traveled overseas, which would have enabled them to acquire international art. See, for example, "Mr. C. D. Armstrong arrived at Hotel Chatham in Paris," *Herald Tribune Review*, international edition, 13 December 1905, 4. (Most of the volumes of the *Herald Tribune Review* now stored at the Bibiothèque Nationale in Paris are now inaccessible due to deterioration. Only the year 1903 and the months of June through December 1905 could be consulted.) "Mr. H. J. Heinz with Miss Mary H., Miss Hettie D. Heinz . . . at the Hotel Russel, London after an extended tour of Spain," *Herald Tribune Review*, inter. ed., 8 May 1903, 4. "Mr. H. J. Heinz, Miss Henrietta Heinz and Miss Prager have just arrived in Paris from Vienna. They will sail on the Deutschland on the 30th inst," *Herald Tribune Review*, inter. ed., 23 September 1903, 4. "Mr. H. J. Heinz, of Pittsburgh, who has been passing some time in Germany, arrived at the Carlton Hotel, London, yesterday," *Herald Tribune Review*, inter. ed., 25 September 1903, 4. Charlotte Cohen, the historian at the Phipps Conservatory, does not believe Henry Phipps, Jr., had an art collection, but the possibility remains. He and his wife did travel extensively in Europe. "Among the latest arrivals at the Grand Hotel, Naples, are: . . . Mr. and Mrs. Henry Phipps, Pittsburgh," *Herald Tribune Review*, inter. ed., 19 November 1903, 4. "Mr. and Mrs. Henry Phipps have arrived at Claridge's Hotel, London, from Paris," *Herald Tribune Review*, inter. ed., 30 November 1903, 4.

105. A feature article on "The Nude in Art: What Masters in Painting and Sculpture have to say on the subject" ran in the *Pittsburgh Post* on 18 June 1893, no page number. Another on "Purity and the Nude in Art: Changes that have come about in ideas on the subject" appeared in the *Pittsburgh Post* on 14 April 1895, 13.

106. *Index*, 24 May 1902, 15, and the *Bulletin*, 30 December 1899, 10.

107. This figure represents 23 percent of the works they purchased.

108. Among those paintings returned to Knoedler's were Domingo's *Selling the Horse* (purchased January 1895) and Troyon's *Donkey and Cow* (returned in 1897) from the Byers collection; Diaz's *Turkish Children Fishing* (purchased in 1895) from the Lockhart collection; von Bremen's *Girl Reading/Distractions* (purchased January 1891) and Spring's *A Retired Mariner* (purchased October 1890) from the Thaw collection; and Daubigny's *Landscape* (purchased April 1873) from the C. H. Wolff collection.

109. Most exchanges were made on par with the purchase price of the work, although sometimes a slight loss was incurred. Domingo's *Chanson d'amour (The Charm of Music)* was acquired for $7,500 in 1895 and returned for $7,000 credit in 1899. Linnel's *Hampstead Heath, Evening* was purchased for $2,800 in 1897 and returned for $2,500 credit in 1909. In a few cases Frick gained a substantial amount through the exchange. For example, he purchased Alma-Tadema's *Waiting* for $8,000 in 1897 and returned it for $9,000 credit in 1906. He acquired Harpignies' *Lake at Briare* for $1,200 in 1896 and returned it for $6,000 credit in 1907. He bought Reynolds's *Portrait of Miss Puyeau* in 1898 for $24,000 and returned it in 1902 for $28,000 credit.

110. On 4 November 1899, Frick paid Knoedler's 100 shares of Pittsburgh Plate Glass for a work by Daubigny, probably *Le village de Gloson Bonnieres Seine et Oise* (Frick family archives).

111. Knoedler's acted as an intermediary in Frick's purchase of Alma-Tadema's *Waiting*, Murillo's *Portrait of Himself*, Nattier's *The Honorable Elizabeth Hamilton*, Romney's *Portrait of Madame de Genlis*, Swan's *Running Leopard*, and Thaulow's *Hoarfrost*. Knoedler's also accepted nine works returned by Frick for credit, even though the paintings were not originally acquired through the gallery.

112. Frick family archives.

113. Ibid.

114. Frick's business contacts included A. M. Byers, Andrew Carnegie, Charles Donnelly, William Nimick Frew, B. F. Jones, Jr., Andrew Mellon, George T. Oliver, Henry Kirke Porter, Charles Schwab, and David

Watson (Frick family archives). The Fricks had social engagements with the Byers, Carnegies, Chalfants, Dilworths, Frews, Gillespies, Laughlins, Phipps, Olivers (Henry), Porters, Reas, Thaws, Westinghouses, and Woodwells (Frick family archives). In writing to F. F. Nicola about who should be invited to a ball that was to be held in 1898, Frick proposed the following names: Schwabs, Schoonmakers, Peacocks, Phipps, Knoedlers, Carstairs, and Chartrans (Frick family archives).

115. In a letter to Roland Knoedler dated 16 September 1895, Frick said his friends Woodwell, Beatty, H. K. Porter, and Charles Donnelly had all been to see the paintings he had recently bought, but Watson had not had a chance to see them yet. John Beatty also came regularly to see the Frick collection and in particular new acquisitions. On other occasions Frick wrote of the pleasure his family and friends derived from seeing the works in his collection (Frick family archives).

116. Frick was a member of the Art Association of the Union League in Philadelphia and was asked to second A. R. Peacock's nomination to the club in 1897. He introduced Holmes to Roland Knoedler at a dinner in 1897 and to the Chartrans in 1899. He also sent Mr. and Mrs. Pitcairn to see the Knoedlers in Europe in 1902, hoping they would buy works for their home in Pittsburgh (Frick family archives).

117. Frick family archives.

118. Ibid.

119. They also loaned Daubigny's *View of Dieppe* from their New York collection (Frick family archives).

120. John La Farge made arrangements to visit in June 1903. Gros and Aman-Jean visited the Frick collection in 1902, at which time Gros said it was one of the best private collections he had ever seen. Through introductions from F. F. Nicola, George Reuling paid visits to the Frick collection as well as to other prominent collections in the city in 1900. Reuling later wanted to sell works to the Fricks. Charles Dowdeswell visited the Frick collection in February 1900 and Goujon visited late in 1904 (Frick family archives).

121. The Fricks traveled to Europe each year from 1895 to 1899, and again in 1901, 1904, and 1905. Frick also corresponded with the art expert John C. Van Dyke, who provided an introduction to the private patron Fuller, some of whose works Frick considered buying (Frick family archives).

122. See A. M. Byers supplemental inventory 24/583/551.

123. Biographical information on the couple is drawn from John Jordan's *Encyclopedia of Biography*, vol. 3 (New York, 1914), 779–81. One journalist noted in 1897 that the Byers collection "perhaps represents a greater outlay of money than any other private collection hereabouts" *(Bulletin,* 29 May 1897, 12). A. M. Byers' inventory of 1900 contained a total of $700,000 worth of paintings, a figure that represents 98.2 percent of the total amount listed for household goods.

124. *Bulletin,* 21 October 1899, 12.

125. *Bulletin,* 25 November 1899, 12. The article notes that New Yorkers had several opportunities to see the quality of Pittsburgh collections, but to date this is the only such exhibition for which documentation has been found.

126. This article in the *Bulletin* also quoted statements made in the New York *Commercial Advertiser* of 17 November 1899. A proposed auction of some works and the New York exhibition were noted again in the *Bulletin* on 2 December 1899, 12.

127. Bonheur's *Flock of Sheep,* noted in A. M. Byers's supplemental inventory, was probably purchased from Carstairs, who exhibited the Haseltine collection at Gillespie's in 1890. The sale of Bonheur's *The Flock* "to a prominent iron manufacturer" was noted in the *Bulletin* on 29 November 1890, 12.

128. Frick family archives.

129. The Byers collection was valued at a minimum of $50,000 in the *Bulletin* of 25 October 1890, 12. The collection's importance was cited in the *Index* of 24 May 1902, 15, and the *Bulletin* of 30 December 1899, 10. In 1925 many works from the Byers collection were included in the "Exhibition of Old Masters from Pittsburgh Collections," and in 1932 A. M. Byers's son loaned fifty-five works to the Carnegie museum for a special exhibition. Articles on the Byers collection ran in the *Carnegie Magazine* (December 1931, 204; January 1932, 227–32; and March 1932, 313).

130. The Millet acquisition was noted in the *Pittsburgh Post* of 27 November 1898, 23, while the Turner purchase was announced in the *Bulletin* on 25 November 1899, 12.

131. *Index*, 26 March 1904, 25–27.

132. See also Margaret Henderson Floyd, *Architecture After Richardson, Regionalism Before Modernism: Longfellow, Alden and Harlow in Boston and Pittsburgh* (Chicago, 1994), 273–77. The house cost $450,000 to build in 1898, according to the *Pittsburgh Sun-Telegraph*, 25 June 1941, no page number.

133. The house was left unoccupied in 1932 after their son E. M. Byers died *(Pittsburgh Sun-Telegraph*, 24 August 1939, no page number). The Eastern Star Temple Association purchased it from the wrecking company that had been contracted to tear down the house and converted it into their headquarters *(Pittsburgh Sun-Telegraph*, 25 June 1941, no page number). In 1968 the house was purchased by the County Commissioners from its owner Mrs. Rebecca Miller, and it became part of the Allegheny Community College campus *(Pittsburgh Press*, 29 March 1968, no page number.)

134. Both Jane and Charles Lockhart were born in Scotland and moved to the United States at the ages twenty-three and eighteen, respectively. They met and married in Pittsburgh. An exterior view of the Lockhart home was published in the *Bulletin* on 12 September 1903, 7. The Lockharts bought the house in 1871 and added on to it in 1874, 1887, and 1899 to accommodate their growing family. Ultimately it was a mansion on a ten-acre estate. The property passed to their daughter Martha Frew Lockhart and her husband Henry Lee Mason, Jr. The house was demolished in 1951 and was replaced by the Pittsburgh Theological Seminary.

135. James M. Edwards in particular gave generously of his time and provided copies of his family's documents. See also C. Lockhart will 81/411/223.

136. Descriptions of the art gallery were published when the house was demolished; see the *Pittsburgh Sun-Telegraph* and the *Pittsburgh Press* of 16 December 1951, no page numbers. Each article notes that the house was not intended as a showcase for society events but that the Lockharts lived a quiet life and were pillars of the United Presbyterian Church.

137. See the *Bulletin* of 25 October 1890, 12, where it was noted as being the most valuable collection in Pittsburgh and worth at least $125,000. Also see the *Bulletin* of 30 December 1899, 10, and the *Index* of 24 May 1902, 15.

138. See exhibition catalogues from 1891 and 1895 in which their works appear.

139. Their purchases were referred to vaguely, such as, "An important canvas passed into Mr. Lockhart's possession not long ago" *(Bulletin*, 14 March 1896, 12).

140. *Bulletin*, 16 February 1895, 11.

141. Meissonier's work was completed in 1890 but was probably purchased by Lockhart after 1891 since he is not listed as one of the American owners of the artist's works in the (New York) *Critic* (7 February 1891). Charles Lockhart may have been introduced to Meissonier's work through his business contacts with William H. Vanderbilt, who owned at least nine of the artist's paintings (ibid.). A complete list of Meissonier's American collectors, with the titles of works in their collection, was published in the supplement to the *Art Amateur* (March 1891, 6).

142. Ralph Baggaley owned one work by Portielje.

143. See the inventory of D. T. Watson, 61/1/1, dated 31 October 1916, and the will of M. H. W. Watson, 2023/1949. Also see *Exhibition of Paintings from the Collection of the Late David T. Watson* (Pittsburgh, 1917).

144. "Mr. and Mrs. D. T. Watson . . . went to Washington, D.C., early in the week and from there to New York. . . . To-day they sail for England, and after spending a week or so in London will start on an automobile tour through France and into Italy." *(Index*, April 1905 [Easter no. 5], 28). "He (both Watsons) had spent 26 consecutive summers in Europe" *(Gazette Times*, 26 February 1916, no page number). "For years he has taken an annual tour abroad, the great art collections having the chief attraction for him" *(Pittsburgh Dispatch*, February 1916, no page number).

145. See "Gift of Three Paintings," *Carnegie Magazine* (June 1941), 68. Watson also owned another painting by Murillo as early as 1897, which was noted as "one of the best Murillos in the United States" *(Bulletin*, 29 May 1897, 12).

146. See catalogues of exhibitions held in 1891, 1895, and 1902. The caption below a portrait of D. T. Watson that was reproduced in the *Index* reads, "Mr. Watson has a beautiful home . . . in which hangs one of the choic-

est private art collections in the United States" *(Index,* 25 April 1903, 7). The collection's high quality was also noted in the *Bulletin* of 30 December 1899, 10.

147. *Pittsburgh Post,* 5 December 1896, 1.

148. *Bulletin,* 29 May 1897, 12.

149. Frick family archives.

150. Frick family archives.

151. See A. D. Porter inventory 94/461/318, dated 15 May 1925, and A. M. Hegeman will 5248/1948.

152. The Porters were the fifth owners of Oak Manor, which was built by A. A. Hardy in 1842; see the *Pittsburgh Press,* 2 January 1931, no page number, and "Fine Oakland Mansion Offered Red Cross," *Pittsburgh Gazette Times,* 8 May 1917, no page number. See also James D. Van Trump, "Baronial Living in Oakland," *Pittsburgher* (May-October 1979), 23–24, and John W. Jordan, *Encyclopedia of Pennsylvania Biography,* vol. 4 (New York, 1915), 1139–40.

153. Porter was a one-term Republican member of congress. "Mr. and Mrs. Henry Kirk[e] Porter will return to 'Oak Manor,' their Pittsburgh home, about the middle of October and will probably remain in Pittsburgh until after the holidays" *(Index,* 3 October 1903, 17), and "Mr. and Mrs. H. K. Porter and Miss Heg[e]man, of this city and Washington, are in New York . . ." *(Index,* 27 May 1905, 25). The Porters offered the house to the Red Cross in 1917. In the 1920s they sold it to the University of Pittsburgh and it functioned as the Faculty Club. The house was demolished in 1931.

154. *Pittsburgh Gazette Times,* 8 May 1917, no page number, and *Pittsburgh Press,* 2 January 1931, no page number.

155. "An Art Collection: Some of the Rare Paintings and Rich Tapestries seen in H. K. Porter's Gallery," *Pittsburgh Post,* 28 May 1899, 17, and "Two Views of the only private art gallery in Pittsburgh," *Pittsburgh Post,* 28 May 1899, 25. The Porters' gallery was, in fact, not the only private art gallery, but judging from contemporary photographs, it certainly appears that it was the largest and best-designed gallery space. The quality of the Porter collection was also noted in the *Bulletin* on 30 December 1899, 10.

156. The Porters owned five works by Alexander; Mrs. Porter's daughter Annie May Hegeman owned at least three. None of these was purchased directly from the Internationals, but they were undoubtedly acquired and/or commissioned while Alexander was in Pittsburgh.

157. Chase's *Big Brass Bowl* was exhibited at the International in 1899 and purchased by the Porters.

158. Cottet exhibited one or two works every year from 1896 to 1910. Neither of the Cottets in the Porter collection was exhibited at the Internationals. Even though the artist was praised in the *Index,* his name does not appear in any other collection; see the *Index,* 7 November 1903, 8.

159. The Porters owned two works by Walter Gay—*The Old Fireplace* (cat. 114) and *The Three Vases* (cat. 113)—both of which they bought after the paintings were exhibited at the International in 1901.

160. John F. Weir's *Roses* received an Honorable Mention at the 1898 International and was purchased by the Porters.

161. For correspondence between John W. Beatty and H. K. Porter concerning the 1895 loan exhibition see Neal's doctoral dissertation, "A Wise Extravagance," 15, 20.

162. *Bulletin,* 27 May 1899, 12. The article notes Mrs. Porter's sponsorship of this art class "two or three years ago," which places it in 1896 or 1897. The Art Students' league visited Oak Manor again in May 1899 *(Pittsburgh Post,* 4 June 1899, 16).

163. *Bulletin,* 21 October 1899, 12. Chase also led monthly or bimonthly criticisms for the league during this period.

164. The Fricks were the only other Pittsburghers who lent paintings to this important exhibition. See *Catalogue of the Exhibition of Fine Arts, Pan-American Exposition, Buffalo, 1901,* (Buffalo, 1901), cats. 146, 164.

165. *Pittsburgh Post,* 13 October 1899, 3.

166. Frick family archives. Charles Dowdeswell had a letter of introduction to the Porters from James C. Parrish of New York.

167. A. D. Porter and Samuel L. Parrish provided the land for Chase's summer art school at Shinnecock, which was established by Mrs. Hoyt. The financial support was provided by Mrs. Astor, Mrs. Belmont, Mrs. Carnegie, Mrs. Vanderbilt, and Mrs. Whitney. See Ronald G. Pisano, *Summer Afternoons: Landscape Paintings of William Merritt Chase* (Boston, 1993), 13, and Pisano, *A Leading Spirit in American Art: William Merritt Chase 1849–1916* (Seattle, 1983), 121. The Porters maintained their connections with the school throughout their years in Pittsburgh, and Rhoda Holmes Nicholls, the instructor of watercolors at the school, visited them at Oak Manor in 1896 *(Bulletin,* 5 September 1896, 10). Annie Porter's involvement in the Shinnecock school was also noted in the *Pittsburgh Post* (9 April 1899, 28), and a watercolor view of Shinnecock, which was signed by students and her friends and hung in Oak Manor, received special mention. "Mr. and Mrs. Henry Kirke Porter . . . leave Monday of next week for their summer home at Shinnecock Hills, on Long Island, where they expect to spend the summer" *(Pittsburgh Post,* 13 June 1902, 16). It is not possible to connect Annie Decamp Porter with Joseph De Camp, who, along with Chase, was a member of the American artists group called The Ten. I am grateful to Anna J. Horton, head of the Art and Music Department of the Public Library of Cincinnati and Hamilton County, for tracing the family trees of both Decamps and confirming that Mrs. Porter and the artist had no familial ties.

168. I would like to thank Susan Dicker of the Newhouse Galleries in New York for helping to trace the current location of this work. Mrs. Porter's commission was noted by Katharine Metcalf Roof in *The Life and Art of William Merritt Chase* (New York, 1917), 185, and Keith L. Bryant, Jr., *William Merritt Chase: A Genteel Bohemian* (Columbia, Mo., 1991), 148–49.

169. I am grateful to Chase specialist Ronald Pisano for directing me to *Interior Scene* by Chase at the Pittsburgh Children's Hospital, which was indeed the work cited in Annie Porter's inventory. Especially insightful were Pisano's speculations in the Sotheby's sale catalogue of 24 May 1989, lot no. 132a.

170. *Pittsburgh Post,* 9 April 1899, 28.

171. *Pittsburgh Post,* 2–8 April 1899.

172. Among those Pittsburgh artists who attended classes at Shinnecock during the summer of 1899 were Miss Bakewell, Miss Witchead, and Mrs. Pears *(Pittsburgh Post,* 21 May 1899, 17).

173. *Bulletin,* 5 February, 1898, 11.

174. "Mrs. Porter . . . and Miss Hegeman of Pittsburgh, Pa, have arrived at the Langham Hotel [Paris]," *Herald Tribune Review,* inter. ed., 21 May 1903, 4. "Mr. & Mrs. H. Kirk[e] Porter have returned from Switzerland to Paris and are stopping at the Langham Hotel," *Herald Tribune Review,* inter. ed., 22 November 1903, 4.

175. *Pittsburgh Post,* 28 May 1899, 17.

176. Ibid.

177. Frick family archives.

178. These appointments were announced publicly in the *Bulletin* of 13 April 1901, 13.

179. Each donation was noted in the *Carnegie Magazine;* see June 1927, 12; September 1937, 119–21; November 1939, 181–84; and June 1942, 67–70. Held at the Parke-Bernet Galleries on 15 and 16 October 1942, the sale included furniture, objects, and paintings that Annie May Hegeman had inherited from her mother. I am grateful to George Gurney, curator at the National Museum of American Art, Smithsonian Institution, for providing a copy of this sale catalogue.

180. See M. C. Thaw will 208/404/521, dated 30 August 1924, and M. C. Thaw inventory 106/536/383, dated 12 July 1927.

181. *Pittsburgh Post,* 19 August 1889, no page number.

182. The Thaws went to the Paris Exposition in 1889, and William died in Paris *(Pittsburgh Post,* 19 August 1899, no page number). William Thaw built their first home on Fifth Avenue below Penn Ave in 1852; it was demolished in 1931. Mary Thaw moved to Lyndhurst in 1890 and donated their former residence to the Young Women's Christian Association *(Pittsburgh Press,* 3 May 1931, no page number). A later newspaper account described Lyndhurst as being a forty-two room mansion, but some of this space was probably constructed by Emile Winter, who purchased Lyndhurst and remodeled it in the 1920s. Lyndhurst was torn down in the mid-1940s *(Pittsburgh Sun Telegraph,* 10 December 1944, no page number, and 19 September 1946, no page number). An exterior view of Lyndhurst was published in the *Bulletin* on 12 June 1897, 12.

183. The quality of her collection was noted in the *Bulletin* of 30 December 1899, 10.

184. "The many Pittsburg friends of Miss Anna Klumpke, . . ." *Pittsburgh Bulletin*, 5 May 1897, no page number. Reports of Klumpke's travels and successes appeared in the *Pittsburgh Bulletin* between 4 September and 18 December 1897.

185. The exhibition was held at Gillespie's from 25 February to 6 March 1897; see the *Bulletin*, 20 February 1897, 12, and the exhibition catalogue. It then traveled to Cincinnati (Closson's Art Gallery, 15–20 March 1897) and San Francisco (Mark Hopkins Institute of Art, 22 July to 22 August 1897). Four works from Thaw's collection were exhibited in Pittsburgh and Cincinnati, and her portrait was shown in San Francisco. I am greatly indebted to Britta Dwyer for copies of these exhibition catalogues and for sharing her unpublished research on Klumpke.

186. Bonheur's *Highland Cattle* was first exhibited at the Carnegie museum in 1895. An article in the *Bulletin* noted that "Mrs. Thaw met the artist [Klumpke] during one of her trips abroad" *(Bulletin*, 4 June 1898, 10). According to the *Pittsburgh Commercial Gazette*, they first met in 1896, when Klumpke was "associated with Rosa Bonheur in a studio near Paris" *(Pittsburgh Commercial Gazette*, 25 February 1897, no page number).

187. *Bulletin*, 27 February 1897, 12, and a letter from Klumpke to Miss Gavan, formerly Mary Thaw's secretary, dated 13 January 1930. This letter notes that *Old Recollections: The Woman at the Well* was at that time in Miss Gavan's possession; it is now unlocated. Britta Dwyer discovered this letter in a private collection.

188. This work was "said to be a faithful likeness" *(Bulletin*, 13 February 1897, 11). Britta Dwyer located this portrait in the collection of Klumpke's descendants in Arizona.

189. Her will states that her ranch was located at 356 Magnolia Avenue, Riverside, California. She bequeathed it to her brother's widow Annie S. Copley. See will 208/404/521, dated 30 August 1924, 6.

190. John White Alexander's *Before the Mirror* was exhibited at the Carnegie International of 1896 under the title *Mirror. The Rose* was included in the 1902 exhibition. Her purchase of this work was noted in the *Index* of 25 January 1902, 21.

191. *Bulletin*, 27 June 1896, 12.

192. Although later appraisals are a problematic source for understanding the value of artworks, it is interesting to note that, according to Mary Thaw's inventory, Inness's *The Coming Shower* (1892) was appraised at $12,500. This is approximately twice the appraisal of the next most valuable work, Corot's *Early Morning-Pastoral*, at $6,500, and it is three times the appraisal of the third most valuable work, Shreyer's *The Pack Train: Winter*, at $4,500.

193. Rownlea was constructed by Longfellow, Alden and Harlow in 1901. The Peacocks sold the house in 1921, and it was demolished in 1924; see Floyd, *Architecture after Richardson*, 281–84. Before 1901 the Peacocks lived at Penn and Lexington Avenues in a home next to the Fricks. The ornamentation by Pasetti for their residence on North Highland Avenue was illustrated in the *Pittsburgh Post* on 19 January 1902, 2.

194. The Peacocks owned paintings by the English artists Alma-Tadema and East, the Dutch artists Mauve, Westerbeck, and Weissenbruch, and the American artists Inness and Poole.

195. They owned four scenes of the Scottish Highlands and/or cattle by Forbes and Graham.

196. Madrazo was brought to the United States for the first time in 1896 under the sponsorship of the dealer Julius Oehme of Boussod, Valadon et Cie of New York. Oehme managed Madrazo's portrait commissions. The artist's fees were $2,000 for a lifesize bust, $4,000 for a three-quarter bust, and $6,000 for a full-length portrait *(Art Amateur*, December 1896, 134). If these prices are accurate, the Peacocks must have paid around $12,000 for their full-length pendant portraits in 1902.

197. Born in Dunfermline, Scotland, A. R. Peacock immigrated to the United States in 1879 and worked in New York until some time in the 1880s when he was hired by Andrew Carnegie. Peacock was made a vice president of Carnegie Steel Company in 1897. See James D. Van Trump, "Peacock's Pride: Highland Park Once Boasted Turn-Of-The-Century Millionaire's Mansion," *Tribune Review*, 21 March 1982, 4–5. The article was republished as "Peacock's Pride: An East Liberty Millionaire Mansion of the Early 1900s," in *Life and Architecture in Pittsburgh* (Pittsburgh, 1983), 272–76.

198. The Peacocks were married in Brooklyn in 1887 and returned to New York permanently around 1920. See

Van Trump, "Peacock's Pride," *Tribune Review*, 4–5. They often traveled from Pittsburgh to New York, as was noted in the *Index:* "Mr. and Mrs. A. R. Peacock were in New York this week" (12 October 1901, 18) and "Among Pittsburghers in New York . . . were Mr. and Mrs. A. R. Peacock . . ." (23 November 1901, 20–21).

199. *Index,* 28 June 1902, 1–5. This article also lists other Americans who commissioned works from Madrazo, including Vanderbilt, Pierpont Morgan, and Post. Late 1902 marked the fifth winter that Madrazo spent in New York.

200. They purchased Daniel Ridgway Knight's *French Fisher Girl/Waiting* from Gillespie's.

201. In an article citing works exhibited at the Carnegie Institute, the critic noted, "F[a]ntin-Latour. The last almost unknown in America is nevertheless represented in Pittsburgh by two canvases in the gallery of Mr. Peacock; these are the only two examples of F[a]ntin-Latour in the United States of which I know" *(Index,* 18 March 1905, 26).

202. See *Illustrated Catalogue of Notable Paintings by Masters of the Barbizon, Modern French and Contemporaneous Schools: The Private Collection of Mr. Alexander R. Peacock of Pittsburgh* (New York, 1921).

203. A biographical sketch of Charles Donnelly, published in the *Index* (7 June 1902, 34), states that he "has a handsome residence on Fifth Avenue with an art gallery of rare pictures from the brushes of world artists." The quality of collection was noted in the *Bulletin* of 30 December 1899, 10.

204. See catalogues of Carnegie exhibitions held in 1891, 1895, 1908, and 1910. Donnelly also loaned works in 1897 *(Pittsburgh Commercial Gazette,* 20 February 1897, 10) and 1902 *(Index,* 28 June 1902, 12).

205. "Mr. Charles Donnelly, who owns one of the finest art collections in the city, said before leaving for a four months' tour of Europe recently, that he intended to resist any temptation to add to his collection while abroad this time" *(Bulletin,* 18 April 1896, 12).

206. "Mr. Charles Donnelly recently added a number of new pictures to his already fine collection, and has had all his pictures rehung. Last summer when the Donnellys were abroad they had the pleasure of meeting the French artist Jean Boldini, and admire the man quite as much as his art works" *(Bulletin,* 12 December 1896, 19). Boldini, who was actually an Italian artist named Giovanni, later traveled to the United States and perhaps visited Pittsburgh *(Bulletin,* 27 November 1897, 12). No works by Boldini can be documented in the Donnelly collection.

207. After the Paris Exposition, Caldwell was appointed an Officer of the French Legion of Honor *(Bulletin,* 5 January 1901, 10). See catalogues of Carnegie exhibitions held in 1895, 1902, 1903, and 1910. Caldwell also loaned works in 1901 *(Index,* 24 August 1901, 8–9) and again in 1902 *(Index,* 28 June 1902, 12).

208. The Caldwell collection of etchings was valued at a minimum of $25,000 *(Bulletin,* 25 October 1890, 12). The quality of the collection as a whole was noted in the *Bulletin* of 30 December 1899, 10.

209. Little information on the origins of the Laughlin collection is now available. James Laughlin and his wife Clara attended the Paris Exposition in 1900, and they probably made frequent trips within the United States, as is suggested by "Among Pittsburghers in New York . . . were Mrs. J. B. Laughlin" *(Index,* 23 November 1901, 20–21. See catalogues of Carnegie exhibitions held in 1903, and 1908. Laughlin also loaned works in 1901 *(Index,* 24 August 1901, 8, and *Pittsburgh Post,* 23 June 1901, 6) and in 1905 *(Index,* 24 June 1905, 26).

210. For loans from the Carnegie collection see the exhibition catalogues for 1879, 1895, and 1896. Carnegie also loaned works in 1897 *(Pittsburgh Commercial Gazette,* 20 February 1897, 10), 1899 *(Pittsburgh Post,* 26 March 1899, 17), 1901 *(Index,* 24 August 1901, 9), and 1902 *(Pittsburgh Post,* 2 February 1902, 4). For loans from the Moorhead collection see the exhibition catalogues for 1903 and 1908. Moorhead also loaned works 1901 *(Index,* 24 August 1901, 8, and *Pittsburgh Post,* 23 June 1901, 6) and 1902 *(Index,* 28 June 1902, 12). For loans from the O'Neill collection see exhibition catalogues for 1891, 1895, 1896, and 1902. For loans from the Schoonmaker collection see exhibition catalogues for 1891, 1895, and 1902. For loans from the Vandergrift collection see exhibition catalogues for 1895 and 1896. Vandergrift also loaned works in 1897 *(Pittsburgh Commercial Gazette,* 20 February 1897, 10).

211. Donnelly loaned von Bremen's *The Faggot Gatherer* in 1891, 1895, 1897, and 1902, and Jacque's *Sheep in Pasture* in 1891, 1895, 1897, and 1902. O'Neill loaned Cazin's *The Village Street* in 1891, 1895, 1896, and 1902. Caldwell loaned Chase's *Port of Antwerp* in 1895, 1901, 1902, and 1903. Carnegie loaned Simmon's *Heavy Sea* in 1895, 1896, 1897, and 1899.

212. Thirty-five works from the following collections were exhibited within a year of their acquisition: Buhl (Bouguereau's *Trust Her Not*, purchased in December 1895, exhibited in 1896); Caldwell (Hassam's *Fifth Avenue in Winter*, purchased in March 1901, exhibited in 1902; Mauve's *Over the Sand Dunes*, purchased in May 1890, exhibited in 1891; Weissenbruch's *A Gray Day, Holland/Canal in Holland*, purchased in March 1900, exhibited in 1901); Card (Deyroll's *The Gleaners*, purchased in April 1896, exhibited that same year); Frick (all exhibited in November 1895 were Bouguereau's *Mischievous/Espièglerie*, purchased in June 1895; Breton's *The Last Gleanings*, purchased in August/September 1895; Cazin's *Sunday Evening in a Miner's Village*, purchased in August/September 1895; Cazin's *The First Star, End of Day*, purchased in September 1895; Detaille's *A Calvary Division Reconnoitering*, purchased in September 1895; Domingo's *Chanson d'amour/The Charm of Music*, purchased in August 1895; Gérôme's *Prayer in the Mosque of Quat Bey, Cairo*, purchased in September 1895; Jacque's *Minding the Flock*, purchased in August/September 1895; Jacque's *Un pastorale/At Rest*, purchased in September 1895; Knight's *Coming Home from the Garden*, purchased in May 1894; Marcke's *Au marais/In the Marshes/Cattle in the Pool*, purchased in 1895; Thaulow's *Village Night Scene/Norwegian Village*, purchased in November 1895; and Vibert's *Eureka*, purchased in 1895; other loans included Swan's *Tigers Drinking/Lotus Pool*, purchased in October 1898 and exhibited later that year); Laughlin (Weiss's *Scene in France*, purchased and exhibited in 1905; Ziem's *Venice*, purchased in 1900, exhibited in 1901); Lockhart (Bonheur's *After a Storm in the Highlands*, purchased in May 1895 and exhibited that November; Flameng's *Promenade in the Tuileries*, purchased in February 1895 and exhibited that November; De Neuville's *The Post of Danger*, purchased and exhibited in 1895); O'Neill (Henner's *Head/Ideal Head of a Woman*, purchased in February 1890, exhibited in 1891; Rico's *Grand Canal, Vendramin Palace/Scene in Venice*, purchased in February 1890, exhibited in 1891; Wall's *Sheep/Landscape with Sheep*, purchased in September 1890, exhibited in 1891); Lawrence Phipps (Breton's *The Haymakers*, purchased in January 1902, exhibited later that year; Corot's *Matinée: Ville d'Avray*, purchased in January 1901, exhibited in 1902; Dupré's *The Fisherman*, purchased in January 1902, exhibited later that year; Harpignies' *Souvenir de Bony-sur-Loire*, purchased in January 1902, exhibited later that year; Ziem's *The Salute*, purchased in 1901, exhibited in 1902); Thaw (von Bremen's *Girl Reading/Distraction*, purchased in January 1890, exhibited later that year; Gardner's *David the Shepherd*, purchased in June 1896, exhibited later that year); and Westinghouse (Cazin's *The Roadway/A Country Road in Normandy*, purchased in December 1894, exhibited in 1895).

213. See *Catalogue of the Founder's Day Exhibition: The Private Collection of Mr. W. S. Stimmel* (Pittsburgh, 1918).

214. I am grateful to the University Club for granting me access to the club's archives. This made it possible for me to reconstruct the provenance of many paintings in the club's collection, most of which were previously undocumented. A work that Stimmel later acquired, Richard Jack's *String Quartet*, is now in the collection of the Pittsburgh Athletic Association. I would like to thank Phil Andrews and Stephen George of the PAA's art committee and Howard Kahler, general manager, for their assistance and for making the club's board minutes and *Artists' Index* available.

215. In 1897 Frick arranged for the Carnegies to meet Dagnan-Bouveret in France (Frick family archives).

216. The last line of this dialogue was mixed up by the printing press. The conversation was published in its entirety, with no source cited, in the *Pittsburgh Press* on 24 August 1902, 8 (3rd part).

217. The collection of Andrew Mellon's elder brother James Ross was of comparable size.

218. In 1896 they left the United States on 16 July and returned on 15 August. The next year they departed on 14 July and came back on 21 August. In 1898 they left on 22 June, with an unknown date of return (Frick family archives).

219. Frick family archives.

220. Ibid.

221. *Pittsburgh Post*, 21 October 1900, 17.

222. Frick family archives and *Pittsburgh Post*, 21 October 1901, no page number.

223. *Pittsburgh Post*, 30 May 1902, 1.

224. A description of the house before it was demolished in 1969 and of the woodwork that was saved from its interior can be found in James D. Van Trump, "Disseminated Mansion," in *Life and Architecture in Pittsburgh*

(Pittsburgh, 1983), 262–66. Oliver purchased this house in 1879 and significantly renovated the interior woodwork in 1891. See Van Trump's essay and the *Pittsburgh Press* of 28 July 1968 (sec. 2, 1) for photographs of the woodwork *in situ*.

225. "Senator H. W. Oliver and Mrs. George T. Oliver were also passengers on the Lucania. They were in Europe about two months, and they saw all there was to see in Paris, London, Berlin and elsewhere" *(Index,* 21 September 1901, 15). Henry Oliver's purchase of the Alma-Tadema was noted in the *Index* on 18 May 1901, 13. This article quotes another local daily paper but does not cite its source.

226. For loans from the Frew collection see catalogues of Carnegie exhibitions held in 1879, 1895, and 1903. Frew also loaned works in 1902 *(Index,* 28 June 1902, 12).

227. "Mr. William Frew is traveling on the continent with several members of the Yale class of 1903" *(Index,* 5 September 1903, 20), and "Mr. and Mrs. W. N. Frew are at the Holland, New York" *(Index,* 25 January 1902, 20).

228. Beechwood Hall is illustrated in Floyd, *Architecture After Richardson,* fig. 278.

229. The Moorheads' house was built in 1888–89 by Longfellow, Alden and Harlow (see Floyd, *Architecture After Richardson,* fig. 156) and was razed in 1976 *(Pittsburgh Press,* 12 December 1976, no page number). They purchased Henner's painting from Knoedler's in 1891, and they may have bought other works during their travels outside the city ("Among Pittsburghers in New York . . . were Mr. and Mrs. John Moorhead, Jr.," *Index,* 23 November 1901, 20–21).

230. The Schoonmakers built Vollenhouse, their home at 4940 Ellsworth Avenue, in 1887. Its interior decoration included a handcarved stairway and a mantel that had been shipped from Italy around 1887. The house was razed in 1950 *(Pittsburgh Press,* 30 August 1950, illus.). James Schoonmaker was on the art committee of the First Annual exhibition of Western Pennsylvania's Exposition Society in 1889; see David Wilkins, *The Pittsburgh Art Community* (Pittsburgh, 1981), 25.

231. The Singers' house, Edgehill Manor, is illustrated in Floyd, *Architecture After Richardson,* figs. 347, 348. The Singers may have acquired works during their travels abroad. They were in France in early 1903, as indicated by "Paris: At the Hotels: At the Hotel Regina: Mr. and Mrs. W. Henry Singer, Pittsburgh" *(Herald Tribune Review,* inter. ed., 21 March 1903, 4).

232. William Black purchased ten works from Gillespie's. On four occasions Gillespie's represented S. Collins, and on two it served Holston.

233. They acquired it from Tooth through Knoedler's in May 1901.

234. *Index,* 4 October 1902, 8–11.

235. "Among Pittsburghers in New York . . . were Mrs. Vandergrift" *(Index,* 23 November 1901, 20–21), and "Mr. and Mrs. Benjamin Thaw and children are on their way home from a summer spent abroad" *(Index,* 5 September 1903, 19).

236. *Index,* 24 May 1902, 15. See Floyd, *Architecture After Richardson,* figs. 168–70, for photographs of Highmont.

237. Jones did not move to Ridge Avenue until 1910. Paintings from his palatial home Fairacres were sold by Parke-Bernet Galleries, Inc., on 4 and 5 December 1941. His later collection focused on eighteenth-century English portraiture and sporting scenes.

238. The following offers a comparison of the values assigned artworks versus other items in inventories of household goods: J. Kennedy, 56.7 percent art, 28.4 percent rugs (inventory 107/269/182, 1932); J. R. Mellon, 22.8 percent art, 21 percent rugs, 52.6 percent furniture (inventory 114/439/296, 1934); E. Frew, 11.2 percent art, 41.5 percent jewelry, 21.2 percent furniture (audit 5134/1940); A. Porter, 23.4 percent art, 23.3 percent jewelry, 29.9 percent furniture (inventory 94/461/318, 1925); H. Singer, 8.2 percent art, 70.9 percent jewelry, 12.7 percent furniture (inventory 65/274/180, 1918); and M. Thaw, 73 percent art, 11.5 percent furniture, 8 percent rugs (inventory 106/536/383, 1929).

239. In their inventories of household goods, art represented 98.2 percent for A. M. Byers (inventory 24/583/551 and 20/174/159, 1900) and 96.4 percent for D. T. Watson (inventory 61/1/1, 1916).

240. These works were in the Byers collection.

241. Frick bought Hobbema's *View of a Woody Country* for $75,000 in February 1902, Lawrence's *Lady Julie Peel* for $90,000 in 1904, Rousseau's *The Village of Pecquigny* for $70,000 in December 1902, and Turner's *Antwerp: Van Goyen Going about to Choose a Subject* for $80,000 in March 1901. He paid $150,000 for three works in December 1905: van Dyck's *Portrait of Carnevaro*, El Greco's *Cardinal Guiroya*, and Raeburn's *Portrait of Mrs. Cruikshank*.

242. Pittsburghers who attended the exposition included: the Carnegies, the Dilworths, the Fitzhughs, T. A. Gillespie, Annie May Hegeman, Clara and James Laughlin, Andrew Mellon, James B. Oliver, the J. H. Parks, the Phipps, the Porters, the Scaifes, Elma and Benjamin Thaw, Mary Thaw and Henry Kendall Thaw, and the Watsons. Lists of Pittsburghers in Paris were published in the *Pittsburgh Post* (29 April 1900, 4; 27 May 1900, 4; 29 May 1900, 4; 3 June 1900, 4; 10 June 1900, 4; 17 June 1900, 4; and 24 June 1900, 4). The Watsons, Porters, Phipps, and Annie May Hegeman all traveled on the *St. Louis* and stayed in London before going to Paris; the Porters then took an automobile trip in Europe. The Dilworths and Parks sailed home together on the *Kaiser Frederick*. T. A. Gillespie sailed home with Andrew Mellon.

243. *Pittsburgh Post*, 24 June 1900, 4.

244. The Byers and Frews, Andrew Carnegie, Charles Donnelly, Henry Clay Frick, the Gillespies, Eugene O'Neill, Lawrence Phipps, Annie Porter, and Mary Thaw were listed as members of the Art Society in the *Pittsburgh and Allegheny Blue Book* (see the 1895, 1902, and 1903 editions. Carnegie and Frick were listed as life members in the 1902 edition.

245. These include John W. Beatty, Thomas Carnegie, William Nimick Frew, Henry Clay Frick, Andrew Mellon, H. K. Porter, David Watson, and J. R. Woodwell.

246. A list of the members from Pittsburgh was published in the *Pittsburgh Post* on 11 December 1898, 2. The incorporation and tenet of the club was noted on page 28. (See also Frick family archives.) Pittsburgh area members included Ralph Baggaley, Harry Darlington, Herbert Dupuy, Henry Clay Frick, Johanna Hailman, Annie May Hegeman, George Laughlin, Eugene O'Neill, Henry Kirke and Annie Decamp Porter, James H. Reed, C. B. Shea, Edward Thaw, Margaret and David Watson, and Joseph Woodwell.

247. A. W. Mellon, H. W. Oliver, G. M. Laughlin, and H. K. Porter, for example, were all invited to Frick's dinner for President Theodore Roosevelt in 1902 *(Pittsburgh Post*, 5 July 1902, 2). Mary Thaw received Annie Porter at Lyndhurst on the occasion of Prince del Drago's visit to Pittsburgh *(Pittsburgh Post*, 13 June 1902, 6). Adelaide Frick and Emily Frew were noted as being "intimate friends" *(Pittsburgh Post*, 4 June 1903, 6).

248. Frick family archives.

249. *Pittsburgh Post*, 12 May 1901, 8.

250. Frick returned Knight's *Coming from the Garden* in October 1899 and Reed bought it on 20 November. He returned Thaulow's *Spring Afternoon* on 20 October 1900 and Mellon bought it on 12 December. And he returned Harpignies' *Souvenir de Bony-sur-Loire* on 26 November 1901 and Phipps bought it on 21 January 1902.

251. This work was in the Vandergrift collection as late as 1897 and in the Schwab collection by 1900.

252. This population figure is taken from Wilkins et al., *Art in Nineteenth-Century Pittsburgh*, 45. Approximately 120 Pittsburghers (0.04 percent of the population) had art collections around 1900.

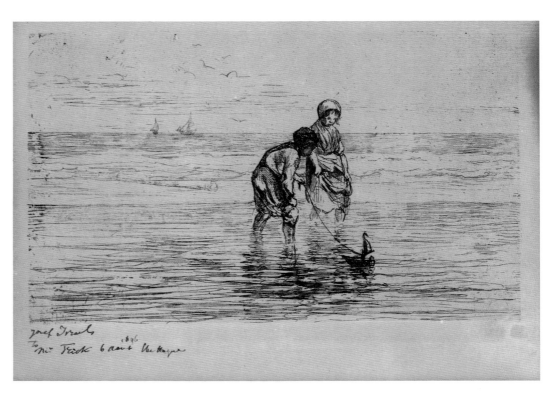

Cat. 122. Jozef Israels (1824–1911). *The First Sail*, n.d., etching. Frick Art & Historical Center, Pittsburgh.

McIntosh

1. Edward Strahan [Earl Shinn], ed., *The Art Treasures of America,* in twelve parts with a supplement (Philadelphia, 1879–82).

2. Ibid., 42–43.

3. Ibid., 43. Strahan even had Schmertz's first initial wrong: it was *W*, not *M*.

4. Christan H. Wolff, *Ledger of Art Possessions, 1857–85*. The original document is in the Music and Art Department, Carnegie Library of Pittsburgh. I am grateful to Kathryn P. Logan, head of the department, for making me aware of the existence of this crucial document and for holding it on reserve for me for several weeks.

5. The obituary of Christian Edward Wolff, a son or nephew (?) of Christian H. Wolff, states that the birthplace was Chambersburg. It also states that in Pittsburgh he entered the employ of W. E. Schmertz & Co., wholesale shoe manufacturers. See (Pittsburgh) *Bulletin* 65, no. 22 (15 March 1913).

6. Isaac Harris, *Harris' Pittsburgh Business Directory for the Year 1837* (Pittsburgh, 1837). Wolff's business is listed as "Whitmore & Wolff, Hardware merchants, cor. Liberty and St. Clair Sts."

7. See Walter C. Kidney, *Landmark Architecture: Pittsburgh and Allegheny County* (Pittsburgh, 1985), 24, 32.

8. See Pittsburgh city directories for 1839, 1841, 1844, 1847, 1861, 1865, and 1871–73.

9. Wolff Ledger, second page 1 (Pittsburgh, 1859); second page 4 (Philadelphia, 1872).

10. See n. 5.

11. See Dorothy Miller, *The Life and Work of David G. Blythe* (Pittsburgh, 1950), 50.

12. M. Knoedler & Co., Sale Book no. 2, 67, 125, 309–11.

13. *Catalogue of Modern Paintings by Celebrated Foreign and American Artists: Private Collection of the late Christian H. Wolff, Esq., April 2nd and 3d, 1888*. I am grateful to Professor William H. Gerdts for drawing my attention to this sale catalogue.

14. See Evangeline Beldecos et al., *Art in Nineteenth-Century Pittsburgh*, exh. cat. (Pittsburgh, 1977), 46.

15. This unsigned, undated article is laid down on paper in a scapbook preserved in the Carnegie Library of

Pittsburgh under the title "Library Ex. 1879." I am grateful to Kathryn P. Logan for making this document available to me.

16. Introduction, *Catalogue of the Pittsburgh Library Loan Exhibition* (Pittsburgh, 1879).

17. Carnegie Library scrapbook (see n. 15), and (Pittsburgh) *Telegraph*, 11 February 1879.

18. Ibid., 13 February 1879.

19. Ibid., 14 February 1879.

20. *Pittsburgh in the Year 1826* (Pittsburgh, 1826).

21. For biographical information on Carstairs see Sally Mills, "Of Art and the Haseltines: A Family Affair," in *Expressions of Place: The Art of William Stanley Haseltine* (San Francisco, 1992). Also see his obituary in *Art News* 24, no. 38 (14 July 1928), 10. I am grateful to Melissa De Medeiros for pointing out these sources.

22. For information about the origins of Vandergrift's considerable fortune see Ida M. Tarbell, *The History of the Standard Oil Company*, vol. 1 (New York, 1925), 16, 181.

23. M. Knoedler & Co., Stock Book no. 4, 10, 18. Knoedler acquired both works from Goupil in Paris in 1883, the year they were painted.

24. Numerous German painters were represented in Wolff's estate sale at the American Art Association, New York (2–3 April 1888). I am grateful to Professor William H. Gerdts for drawing my attention to this sale and for other information about Wolff.

25. Strahan, *Art Treasures*, vol. 1, 27.

26. *The Opulent Interiors of the Gilded Age: All 203 Photographs from "Artistic Houses,"* with new text by Arnold Lewis, James Turner, and Steven McQuillen (New York, 1987), 39.

27. This acquisition may have inspired Mrs. Thaw's patronage of Bonheur's American protégé, Anna Klumpke.

28. At his death, Lockhart was the oldest living oil operator. See Tarbell, *History of Standard Oil*, illus. opp. 53.

29. The Knoedler sale books offer the only surviving record of Lockhart's purchases. In the absence of more documentation, it is probable that he acquired most of his collection either from the stock of Pittsburgh galleries or that Knoedler's acted as his agent in arranging purchases from out-of-town or foreign dealers, such as Arthur Tooth & Sons of London.

30. Roland F. Knoedler to Maurice Hamman from on board *Fürst Bismark*, 11 April 1894. M. Knoedler & Co., Foreign Letter Books.

31. M. Knoedler & Co., Stock Book no. 4, 189; no. 179, Tooth Sale Books, Getty Research Institute for the History of Art and the Humanities, Resource Collections.

32. *Dedication Souvenir, Carnegie Library of Pittsburgh, Pa., Programme and Catalogue, Catalogue of Paintings Exhibited in the Carnegie Art Galleries, Pittsburgh, Pa., 1895*, no. 29, 66.

33. Undated inventory of Lockhart-Mason house, 608 North Highland Avenue, Pittsburgh (private collection).

34. Roland F. Knoedler to Maurice Hamman, 30 May 1894, from on board *Teutonic*. M. Knoedler & Co., Foreign Letter Books. (Author's translation from original French.)

35. It may have been around this time or earlier that Lockhart entered a New York silverware and jewelry establishment and wrote out a check in the amount of $50,000 for an elaborate silver service. (See clipping from unidentified newspaper, January or February 1905; private collection.) Knoedler had repurchased *After a Storm in the Highlands* and *Turkish Children Fishing* from the New York dealer William Schaus after Schaus had bought them at Knoedler's public sale at Chickering Hall, New York (11–14 April 1893) for $9,500 and $4,700, respectively.

36. Charles Carstairs to a London colleague, 8 March 1899: "The Lockharts have not been in this Winter. Mrs. L. has been very sick & Mr. L. don't [*sic*] go out much any more." (M. Knoedler & Co., Letter Books, 440.)

37. M. Knoedler & Co., Foreign Letter Books. (Author's translation from the original French.)

38. See *Dedication Souvenir, Carnegie Library of Pittsburgh*.

39. William Nimick Frew lent *The Woodcarver of Oberammergau* by Rosenthal (cat. 17) as no. 244.

40. The painting, which now belongs to the Chrysler Museum, originally bore the title *Cavalier arabe en vedette* and is listed as no. 1187 in Alfred Robaut, *L'Œuvre complet de Eugène Delacroix* (New York, 1969), 317.

41. See *Catalogue of Modern Paintings Belonging to M. Knoedler & Co., Successors to Goupil & Co., to be Sold by Absolute Auction to Settle the Estate of the late John Knoedler on the Evenings of Tuesday, Wednesday, Thursday, and Friday, April 11, 12, 13, and 14, etc.* (New York, 1893). This document and the newspaper coverage of the sale were brought to my attention by Melissa De Medeiros.

42. (New York) *Daily Tribune*, 13 April 1893, 7; 14 April, 2; 15 April, 7.

43. M. Knoedler & Co., Stock Book no. 4, 189; Sale Book no. 7, 70.

44. See n. 41.

45. Henry Clay Frick became a frequent client of the Cottier firm by the turn of the century. Documents surviving in the Frick family archives suggest that a division of the firm was called "Cottier Galleries." See Kahren Jones Hellerstedt et. al., *Clayton: The Pittsburgh Home of Henry Clay Frick—Art and Furnishings* (Pittsburgh, 1988).

46. See letter from Carmen Messmore, M. Knoedler & Co., to Messrs. Lawrie & Co., London, 28 September 1899. Knoedler Letter Books.

47. (New York) *Daily Tribune*, 13 April 1893, 2.

48. The author is grateful to Alexandra R. Murphy for her advice concerning this painting, which is now in the Murauichi Museum, Tokyo. Byers's acquisition of the work was reported in the *Pittsburgh Post*, 27 November 1898, 23.

49. The work is now in the Carnegie Museum of Art. The painting was exhibited in the Salon of 1861 and in the "Cent Chefs-d'œuvre" exhibition in Paris in 1892. Byers bought it from Knoedler in May 1897 for $12,000. See M. Knoedler & Co., Sale Book no. 7, 190.

50. It was acquired by Knoedler from Thos. Agnew & Sons in July 1895. According to the present owner, who is a Byers descendant, the painting has been demoted to the "school of Constable."

51. Henry Clay Frick papers, Frick family archives.

52. M. Knoedler & Co., Sale Book no. 7, 251. Knoedler's total commission for the Ruysdael and for Gainsborough's *Portrait of Isabella, Wife of David Kinloch*, which were both obtained from Lawrie & Co., was $7,000.

53. M. Knoedler & Co., Sale Book no. 7, 267. Knoedler's commission for all three works was $11,750.

54. M. Knoedler & Co., Letter Books.

55. Ibid.

56. Byers previously resided at 189 Western Avenue, Allegheny.

57. M. Knoedler & Co., Letter Books. (Italics are those of the author.)

58. Ibid.

59. The *Acknowledgment* in the catalogue reads, "The Trustees of the Carnegie Institute make grateful acknowledgment to Mrs. J. Denniston Lyon, Mr. Eben M. Byers, and Mr. J. Frederick Byers who have so generously made this exhibition possible." It is not clear whether these three surviving children of A. M. Byers are being thanked as trustees of a collection that has remained intact or as individual owners of the works in the catalogue. In view of what is known of the succession of individual works, the latter would appear to be the case.

60. Will J. Hyett, "Some Collections of Paintings in Pittsburgh," *Art and Archaeology* 14 (November-December 1922), 326.

61. On 12 February 1881 Frick purchased a landscape by George Hetzel from S. Boyd & Co. for $260 (cat. 25); on 24 March he bought Luis Jiménez y Aranda's *Une Révélation* (also called *In the Louvre;* cat. 26) from William Schaus in New York for $850. See Henry Clay Frick, Bill Book no. 1., folio 65.

62. On the value of the Byers collection see the Pittsburgh *Bulletin*, 25 October 1890, as cited in Alison McQueen's essay in this catalogue (n. 129?). A chronology of James J. Hill's purchases is contained in Jane H. Hancock, Sheila ffolliott, and Thomas O'Sullivan, *Homecoming: The Art Collection of James J. Hill* (St. Paul, 1991), 62–64.

63. M. Knoedler & Co., Letter Books; M. Knoedler & Co., Sale Book no. 7, 72.

64. Knoedler purchased *Venant du Jardin* from Petit aîné, Paris, on 21 May 1893 for 4,200 francs. See M. Knoedler & Co., Stock Book no. 4, 175.

65. It was also returned for credit on 28 February 1903. Information supplied by M. Knoedler on 26 September 1992.

66. Frick expressed his esteem for Mellon as a businessman in a letter to him on 11 May 1903: "Believe me, I take great pride in the several financial institutions with which we are connected, and especially the one that bears your name, and I am sure you would want to feel the business in that institution, in which you are looked on by the public as being the directing power, should be done in the most up-to-date business way" (Henry Clay Frick papers, Frick family archives).

67. Information about Frick's holdings was taken from George Harvey, *Henry Clay Frick, The Man* (New York, 1928), 185–86. For frequent correspondence between Frick and Andrew Mellon see the Henry Clay Frick papers in the Frick family archives. One enterprise in which Frick and Mellon were partners, along with Mellon's brother Richard Beatty Mellon, was A. Overholt & Company, the rye whiskey distillery begun by Frick's maternal grandfather in the late 1830s. On 8 February 1902 Frick wrote to R. B. Mellon, "I have to thank you for your favor of the 7th, enclosing dividend check, as therein stated. Also, statement of A. Overholt & Company's business for the six months ending February 1st. Congratulating you on the very satisfactory balance sheet, I am etc., etc." (Henry Clay Frick papers, Frick family archives). See also a letter from Henry Clay Frick to William P. Wakeman dated 5 July 1902 (Frick family archives).

68. The difference was $14,000 versus $11,000.

69. A framed photograph of the painting at Clayton is inscribed by the artist to Helen Clay Frick, and early photographs of Miss Frick's bedroom show that the original painting hung over her dressing table. It is now in a private collection in New Jersey.

70. It was purchased from L. Christ Delmonico, New York, on 12 November 1895 for $2,000. The price is comparable to what was paid for medium-size paintings by Cazin, and it is only one-seventh the price of Breton's *The Last Gleanings*.

71. Quoted in Kenneth Warren, *Triumphant Capitalism: Henry Clay Frick and the Industrial Transformation of America* (Pittsburgh, 1996), 374.

72. Ibid., 375.

73. Henry Clay Frick to W. N. Frew, Esq., 22 March 1894 (Henry Clay Frick papers, Frick family archives).

74. Henry Clay Frick to W. N. Frew, Esq., 26 March 1895 and 23 November 1895 (Henry Clay Frick papers, Frick family archives).

75. Henry Clay Frick to W. N. Frew, 28 February 1894 (Henry Clay Frick papers, Frick family archives).

76. Henry Clay Frick to George Ogden (an insurance agent), 7 October 1895 (Henry Clay Frick papers, Frick family archives).

77. Henry Clay Frick to John W. Beatty, 15 October 1895 (Henry Clay Frick papers, Frick family archives).

78. Henry Clay Frick to J. G. Butler, Jr., 10 October 1895 (Henry Clay Frick papers, Frick family archives).

79. Kenneth Neal, *A Wise Extravagance: The Founding of the Carnegie International Exhibitions, 1895–1901* (Pittsburgh, 1996), 40, 218.

80. Henry Clay Frick to John W. Beatty, 20 October 1896 (Henry Clay Frick papers, Frick family archives).

81. Roland Knoedler to Maurice Hamman from on board *Campagna*, 28 February 1896. M. Knoedler & Co., Letter Books. (Author's translation from the original French.)

82. This correspondence occurred between Henry Clay Frick and Roland F. Knoedler, 25–26 February 1896 (Henry Clay Frick papers, Frick family archives). Roland Knoedler himself was not to be spared Frick's bar-

gaining assertiveness. On 28 February 1896 Frick wrote to him, "Expect to leave for the South on the evening of the 4th of March. Before going, either want to buy that Jules Dupre or send it back. Think the price you ask me ($3,800) is too much. Do you not think so yourself? We like the picture very much, but am satisfied you want to make too much money on it. Suppose you give me your very lowest cash price for it. I should prefer to deal with you for anything I may buy in that line" (Henry Clay Frick papers, Frick family archives). Frick bought the painting in March for $3,500 but returned it for credit in 1899.

83. For a recently researched account of the growth of Frick's business in the 1870s see Warren, *Triumphant Capitalism*, 1–40.

84. Sir Lawrence Alma-Tadema to Roland Knoedler, 28 August 1895, M/s letter, Archival no. 840163, Getty Research Institute for the History of Art and the Humanities, Resource Collections.

85. Henry Clay Frick to Messrs. M. Knoedler & Co., 10 February 1896 (Henry Clay Frick papers, Frick family archives).

86. The visit of Carstairs and Frick to Alma-Tadema's studio is documented in a letter from Alma-Tadema to Carstairs, 18 August 1897, preserved in "Paintings Owned by Henry C. Frick, Bill Book No. 1," folio 48. Henry Clay Frick papers, Frick family archives.

The painting, *Watching and Waiting*, 1897, Opus CCCXLIV, was purchased by Arthur Tooth & Sons from the artist on 11 June 1897 for £1050 (Tooth stock no. 549). If Knoedler received a commission from the sale, evidence of it has not been discovered. Since relations between the Knoedler and Tooth galleries were extremely cordial, it is quite possible that Carstairs expected no direct compensation from Tooth for taking Frick to see Alma-Tadema and encouraging Frick to buy the painting.

According to Vern G. Swanson in *The Biography and Catalogue Raisonné of the Paintings of Sir Lawrence Alma-Tadema* (London, 1990), 82, no. 381, its theme is based upon a poem by Tennyson. Tooth wrote Frick on August 30, 1897, concerning the painting as follows:

> Dear Sir
> I have seen Mr. Tadema who is delighted that you are the owner of his picture "Watching," he thinks most highly of his picture, as I dare say he told you, he does not date his pictures. The figures under his pictures is [*sic*.] the number of his picture. The letters on the wall are Andromeda & Perseus which is the title [?] of the background & tale [?] written in center of the picture means "Fare thee well" which is a greeting to the departing boat. I hope that you and Mrs. Frick have had a pleasant journey.
>
> I remain
> Yours faithfully
> /s/ Arthur Tooth

"Paintings Owned by Henry C. Frick, Bill Book No. 1," folio 49. Henry Clay Frick papers, Frick family archives.

87. Henry Clay Frick to Arthur Tooth, 9 September 1897 (Henry Clay Frick papers, Frick family archives).

88. The first painting by Alma-Tadema in Pittsburgh was *Catullus at Lesbia's* (1865), which was purchased by Charles Lockhart at an unknown date. After Frick's purchase, the next one was *Hero* (1898), which George T. Oliver bought from Knoedler in March 1901 for $8,500 and presented to his eldest brother Henry W. Oliver, a close business associate of Frick's. (Roland Knoedler had admired the painting as early as March 1899 in Tooth's London gallery. See M. Knoedler & Co., Foreign Letter Books, 459.) In October 1902 George Oliver paid Knoedler $15,000 for *Caracalla: AD 211* (1902), which he retained for himself. A year or two later Alexander R. Peacock acquired *Welcome Footsteps* (1883) from Scott & Fowles for an unknown price. Alma-Tadema's paintings were obviously a status symbol among Pittsburgh collectors due to their high finish, rich, detailed allusions to Roman antiquity, often erotic subjects, and high prices.

89. Henry Clay Frick to Roland Knoedler, 11 February 1898: "Regarding the Alma-Tadema, what would you consider a fair net price for it?" (Henry Clay Frick papers, Frick family archives).

90. I am grateful to Professor Gerald M. Ackerman for pointing this out to me.

91. In 1910 Knoedler resold the painting to Scott & Fowles, who, in turn, sold it to William Flinn of Pittsburgh. The painting now belongs to the Fort Lauderdale Museum of Art.

92. See Bernice Davidson and Harry D. M. Grier, *Paintings in the Frick Collection*, vol. 1 (New York, 1968), 156 f.

93. See Jennifer Gordon Lovett and William R. Johnston, *Empires Restored, Elysium Revisited: The Art of Sir Lawrence Alma-Tadema* (Williamstown, Mass., 1991), 26.

94. Henry Clay Frick to Andrew Carnegie, 27 October 1897 (Henry Clay Frick papers, Frick family archives).

95. Andrew Carnegie to Henry Clay Frick, 10 November 1897 (Henry Clay Frick papers, Frick family archives).

96. The prices were $10,000 for Mary Finch Hatton, which was acquired by Knoedler from the family of the sitter, versus $20,000 for *Maria and Katherine, Daughters of Edward, Lord Chancellor, Thurlow*, which had been exhibited at the Royal Academy in 1867.

97. The purchase was not a success. Although for a time the portrait held pride of place above the mantelpiece in the music room at Clayton, Frick returned it to Knoedler on 20 March 1902. After passing through the possession of an art dealer in Washington, D.C., into the collection of Senator William A. Clark, the painting ended up in the Corcoran Gallery of Art, where it since has been ascribed to Reynolds's student Hugh Barron (cat. 33).

98. Ex. coll. Baron de Hauff. It was purchased for $25,000 and is now in the Frick Collection.

99. They were purchased for $4,250 and $6,000, respectively, and are now in the Frick Art & Historical Center. Both were exhibited at the Ecole des Beaux-Arts in 1887. Knoedler records state that *Shepherd Minding his Sheep* had been "bought from JFM through a mutual friend by Mrs. Cogniet about 40 years ago."

100. It was purchased from Arthur Tooth & Sons for $21,000 and is now in the Carnegie Museum of Art. This work and Frick's purchase of it are discussed in detail in Gabriel P. Weisberg's essay in this catalogue.

101. For example, the list of 1898 purchases includes four works by the Norwegian artist Frits Thaulow and two by Jan Chelminski, a Polish painter who specialized in dashing military genre scenes, particularly imaginary scenes from the Napoleonic wars.

102. It is now in the Frick Collection; see Davidson and Grier, *Paintings in the Frick Collection*, vol. 1, 73–74.

103. It is now in the Frick Collection; see ibid., 270–73. The authorship of the painting and identity of the sitter have been in question for many years.

104. Eighteen of the paintings came from Knoedler at a total cost of $139,125, a sum approaching $3 million in today's values.

105. It is now in the Frick Collection (99.1.26). See Bernice Davidson, *Paintings in the Frick Collection: An Illustrated Catalogue*, vol. 2, *Paintings—French, Italian, and Spanish* (New York, 1968), 66.

106. It is now in the Baltimore Museum of Art (1968.36). Frick returned it to Knoedler on 19 March 1903 for credit in the amount of the purchase price, that is, $12,500. It was sold to James J. Hill of St. Paul, Minnesota, on 11 January 1904. Hill owned it until 1913. It was eventually sold by Knoedler to Mrs. Abram Eisenberg of Baltimore in March 1945. (Knoedler records.)

107. Henry Clay Frick to Roland Knoedler, 4 January 1897 (Henry Clay Frick papers, Frick family archives).

108. This would have been even truer had Frick kept the Turner's *Falls of Clyde*, which he bought from Tooth on 1 June 1899 for $14,000. He returned the painting for credit within ten months.

109. McCook urgently cabled Johnson on 16 January 1900: "Would like to retain you for H. C. Frick in connection with his interest in Carnegie Steel Company. Can I submit papers in matter to you Saturday next? If not, name time convenient to you. Have been trying to get you on phone." This was the communication that famously succeeded in reaching Johnson ahead of word from Carnegie, who also sought Johnson's counsel (Henry Clay Frick papers, Frick family archives).

110. See Knoedler Letter Books.

111. Roland F. Knoedler to Maurice Hamman, 5 June 1894. (See M. Knoedler & Co., Foreign Letter Book, 22 April 1893 to 4 November 1895.)

112. M. Knoedler & Co., Sale Book no. 7, 106, 158.

113. Ibid, 196.

114. He owned no paintings by Bouguereau, for example, and only one work by Gérôme, *Majesty and Impudence*. No painting by that title is listed in Gerald M. Ackerman, *The Life and Work of Jean-Léon Gérôme* (New York, 1986). Perhaps it could have been either no. 363, *Lion tenant de saisir une guâpe importune* (1889), or no. 422, *Le Lion maudit* (1895), both of which Ackerman lists as being lost.

115. They were purchased in September 1898 for $18,500 each. (M. Knoedler & Co., Sale Book no. 7, 236.)

116. It appeared in the Salon of 1831. The painting cost $30,000.

117. See no. 450, Tooth Sale Books, Special Collections, The Getty Research Institute for the History of Art and the Humanities, Resource Collections. After 1893, when Tooth opened a New York branch, sales in America were simply designated "NY Sales." Since records of the New York gallery before 1907 have been lost, it is impossible to discover from the sale books exactly to whom paintings were sold in New York during this period.

118. The Knoedler commission was $3,000. (M. Knoedler & Co., Sale Book no. 8, 220.)

119. M. Knoedler & Co., Sale Book no. 8, 305. The price of the painting, which was entered into Knoedler's coded records as $rxxx, appears to have been $9,000. Knoedler's commission was £350. The painting is described in "Gift of Three Paintings: Presented to the Carnegie Institute by Sarah Mellon Scaife and Richard King Mellon in Memory of their Mother, Jennie King Mellon," *Carnegie Magazine* (June 1941), 68.

120. This was *Soleil Couchant sur l'Etang*, which he bought for $900. (M. Knoedler & Co., Sale Book no. 7, 159.)

121. Ibid., 171. The painting is now in the Duquesne Club, Pittsburgh, the gift of Andrew Mellon. For a commentary on the painting see David G. Wilkins, *Paintings and Sculpture of the Duquesne Club* (Pittsburgh, 1986), 84–85.

122. Henry Clay Frick to Frank D. Millet, 3 February 1897 (Henry Clay Frick papers, Frick family archives).

123. John Walker, *Self-Portrait with Donors* (Boston, 1974), 104.

124. The paintings were *Mrs. Hill, Wife of Principal Hill of Glasgow University* by Sir Henry Raeburn ($16,000) and *Robinetta* by Sir Joshua Reynolds ($25,000). (M. Knoedler & Co., Sale Book no. 8, 7.)

125. Walker, *Self-Portrait*, 106.

126. M. Knoedler & Co., Sale Book no. 7, 254.

127. Information derived from the author's conversation with Thomas M. Schmidt on 20 March 1996.

128. M. Knoedler & Co., Letter Books.

129. Walker, *Self-Portrait*, 104.

130. It was hung in the breakfast room at Clayton, where it is still installed.

131. Walker, *Self-Portrait*, 104.

132. M. Knoedler & Co., Sale Book no. 8, 194, 214, 190, 107. *Le Lac de Garde* (View of Lake Garda, 80–44) is now in the collection of the Nelson-Atkins Museum of Art.

133. Paul Mellon, *Reflections in a Silver Spoon: A Memoir,* (New York, 1992), 25–26.

134. Walker, *Self-Portrait*, 104.

135. He paid $22,000 for the Dagnan-Bouveret on 8 April 1901 and $26,000 for the Vermeer on 25 July 1901.

136. See Frick Collection, 03.1.24. Also see Davidson, *Paintings in the Frick Collection*, vol. 2, 62–65.

137. M. Knoedler & Co., Sale Book no. 8, 258. It is now in the National Gallery of Art.

138. Ibid., 353. It is now in the National Gallery of Art.

139. Henry Clay Frick to Roland Knoedler, 19 October 1898 (Henry Clay Frick papers, Frick family archives). Neither Frick nor Mellon purchased a painting by Daubigny in 1898. In August 1899, however, Frick bought three, and in December 1900 Mellon purchased *Bords de la Meuse* by Daubigny from Knoedler for $9,000.

140. Excerpt from a letter from Charles Carstairs to Andrew Mellon on 27 December 1901. (M. Knoedler & Co, Domestic Letters from 22 October 1901 through 2 January 1902, 444.) Walter Friedman generously drew my attention to this letter.

141. M. Knoedler & Co., Sale Book no. 8, 84.

142. Unpublished memoir by Helen C. Frick (Helen Clay Frick papers, Frick family archives).

143. Mellon's travels with the Fricks are discussed in Paul Mellon, *Reflections in a Silver Spoon*, 25 ff.

144. Walker, *Self-Portrait*, 103.

145. In all the Frick-Mellon correspondence preserved in the Frick family archives, Frick salutes his friend as "My dear Mr. Mellon." It must be considered, however, that all the letters concern business matters to one degree or another. Both business etiquette, which Frick observed meticulously, and the possible lack of privacy in the two men's offices may have necessitated a formal approach.

146. Quoted in Philip Kopper, *America's National Gallery of Art: A Gift to the Nation* (New York, 1991), 55. Walter Friedman kindly drew my attention to this letter.

147. Henry Clay Frick to Charles L. Knoedler, 6 May 1899 (Henry Clay Frick papers, Frick family archives).

148. Henry Clay Frick papers, Frick family archives, 12 September 1902 through 9 February 1903.

149. Charles L. Knoedler to Henry Clay Frick, 16 October 1899 (Henry Clay Frick papers, Frick family archives).

150. Henry Clay Frick to Charles L. Knoedler, 17 October 1899 (Henry Clay Frick papers, Frick family archives).

151. See n. 83. Frick's great friend and poker companion Philander C. Knox never became a great collector, but in May 1899 he purchased *Pont de Pierre* by Cazin (shown in the Salon of 1891) for $3,500. The painting chosen for him by Frick and Charles Knoedler appears to have been either *Club House, Castalia* or *Swimming Pool, Castalia* by Robert W. van Boskerck. Knox purchased these works from Knoedler in November 1899 for $500 each.

152. Charles L. Knoedler to Henry Clay Frick, 26 April 1900 (Henry Clay Frick papers, Frick family archives).

153. Henry Clay Frick to Charles L. Knoedler, 27 April 1900 (Henry Clay Frick papers, Frick family archives).

154. M. Knoedler & Co., Sale Book no. 8, 386; Sale Book no. 9, 63.

155. Mellon, *Reflections in a Silver Spoon*, 66.

156. For a discussion of the two paintings by Turner see Davidson and Grier, *Paintings in the Frick Collection*, vol. 1, 131–32. Provenance information was also supplied by the Getty Provenance Index.

157. For discussions of the inception of Mellon's idea for a national gallery see Walker, *Self-Portrait*, 108, and Mellon, *Reflections in a Silver Spoon*, 140. Also see remarks made by Paul Mellon on 5 May 1981 and 27 January 1983. These were kindly furnished by the Archives of the National Gallery of Art.

158. The firm operated branches in Chicago and Newport briefly in a later period.

159. The question has often been asked, Why did Frick never sit to Sargent? The answer is that he planned to do so in the summer of 1902, but his plans changed and he did not travel to England that summer. Inadvertently, he yielded his appointment for a sitting to Mr. and Mrs. Alexander, who were friends of W. F. McCook. See letter from Henry Clay Frick to Messrs. M. Knoedler & Co., 3 February 1902 (Henry Clay Frick papers, Frick family archives).

160. M. Knoedler & Co., Sale Book no. 7, 42. Also see Knoedler sale, New York, 11–14 April 1893.

161. Henry B. Fuller, *With the Procession* (Chicago, 1965), 56–57. Quoted in Teresa A. Carbone, *At Home with Art: Paintings in American Interiors, 1780–1920*, exh. cat. (Katonah, N.Y., 1995), 42.

162. M. Knoedler & Co., Sale Book no. 8, 35 and 54, respectively.

163. The Polish artist Jan Chelminski was married to Roland Knoedler's sister Léonie and lived in New York.

164. Neal, *Wise Extravagance*, 1–22. "The Founders and Their Philosophy," the first chapter of this refreshing examination of the early days of Carnegie Institute, contains a thorough analysis of the Institute's philosophical underpinnings.

165. Quoted in ibid., 22.

166. For a thorough analysis of Andrew Carnegie's attitude toward a permanent collection see Diana Strazdes,

American Painting and Sculpture to 1945 in the Carnegie Museum of Art (New York, 1992), pp. xi–xvii.

167. Both Neal and Strazdes describe the concept of the chronological collection in detail. See also an exchange of letters between Frick and Carnegie from 27 October to 10 November 1897 (Henry Clay Frick papers, Frick family archives).

168. Quoted in Strazdes, *American Painting and Sculpture*, xiv.

169. See n. 107.

170. The six works deaccessioned in the 1960s were: Corot's *Pastoral Scene* (small oil on panel), sold at auction in November 1960 for $105; Courbet's *Mountain Stream*, sold at auction in November 1960 for $200; Crome's *The Old Wood Farm*, sold at auction in November 1960 for $250; Rubens' *St. James*, sold at auction in 1966 for $1,600; Michel's *Approaching Storm*, sold at auction in 1966 for $930; and Schreyer's *Arab on Standing Horse*, sold at auction in 1966 for $3,300. (Registrar's Office, Carnegie Museum of Art.)

171. Henry Clay Frick papers, Frick family archives.

172. This information was supplied by Registrar's Office, Carnegie Museum of Art.

173. Marjorie Phillips, *Duncan Phillips and his Collection* (rev. ed., Washington and New York, 1982), 30. Phillips's mind was more open to the art favored by his grandparents' generation than might be expected. While at Yale and shortly afterward, he wrote in praise of both the lyrical landscapes of Corot and the academic realism of Ernest Meissonier, which he saw as charged with romantic emotion. It was evident in his essay on Meissonier that he was unaware of the existence in his native Pittsburgh of *1806, Jena*, the last painting from Meissonier's "Napoleonic Cycle." See the unpublished essay by David Scott, "The Evolution of a Critic: Changing Views in the Writings of Duncan Phillips," 1992, and Duncan Phillips, "A Word to the Freshmen," *Yale Literary Magazine* 73, no. 8 (May 1908). (Both articles are courtesy of Leigh Weisblat, librarian, The Phillips Collection, Washington, D.C.)

174. "Notable Paintings by the Barbizon and Other Modern Masters: The Private Collection of Mr. Alexander R. Peacock of Pittsburgh," American Art Association, Tuesday, 10 January 1922. (Catalogue with Mrs. Peacock's penciled notations courtesy of Grant A. Peacock, Jr.)

175. Sotheby's New York, Sale no. 6603, lot 46, *La petite vandangeuse* (1883). It was included in the Carnegie Loan exhibition of 1895.

176. "The Anatomy of an Art Sale: Profiting on the Worst Painter," *New York Times*, 16 November 1973, 43. The article chronicles the Allen Funt/Alma-Tadema sale of 9 November 1973, at which Funt offered thirty-five paintings by the artist for sale at Sotheby's Belgravia. The sale realized a total of $570,000.

177. Christie's Park Avenue, Barbizon VIII-8406, Wednesday, 22 May 1996.

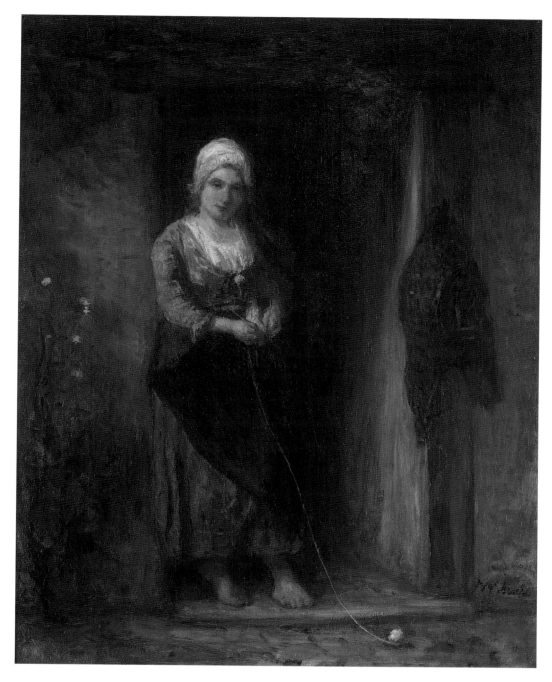

Cat. 123. Jozef Israels (1824–1911). *Madonna at the Door*, n.d., oil on panel. Collection of Mr. and Mrs. Edward J. McCague, Jr., Pittsburgh [Ex. coll., Willis F. McCook].

WEISBERG

1. On this topic see William Leach, *Land of Desire: Merchants, Power and the Rise of a New American Culture* (New York, 1994). An earlier examination is found in Russell Lynes, *The Tastemakers: The Shaping of American Popular Taste* (New York, 1980). On acquisition see Aline B. Saarinen, *The Proud Possessors: The Lives, Times and Tastes of Some Adventurous American Art Collectors* (New York, 1958). On the period see Sean Dennis Cashman, *America in the Gilded Age, from the Death of Lincoln to the Rise of Theodore Roosevelt* (New York, 1984).

2. The dissemination of refinement in America during an earlier era is discussed in Richard L. Bushman, *The Refinement of America: Persons, Houses, Cities* (New York, 1993).

3. Leach, *Land of Desire*, 5 ff. On the role of wealth in shaping these new social classes see Joyce Appleby, *Capitalism and the New Social Order* (New York, 1984). Also see Cashman, *Gilded Age*, 174–84.

4. For the creation of the "look" of wealth in the architecture and interior decorations of mansions built in Pittsburgh and Boston see Margaret Henderson Floyd, *Architecture after Richardson, Regionalism before Modernism: Longfellow, Alden and Harlow in Boston and Pittsburgh* (Chicago, 1994).

5. On Goupil's role in sponsoring art see Annick Bergeon, "Expositions en Province, Bordeaux, Ouverture du Musée Goupil, Conservatoire de l'Image Industrielle," *Nouvelles de l'Estampe*, no. 118–19 (October-November 1991), 42–45. The history of M. Knoedler & Co. is being prepared for publication. Drafts of preliminary text material prepared by Professor Sam Hunter as part of the Knoedler History Project were shared with the author. One chapter, under the rubric "Gallery Beginnings: New York at Mid-Century," provides insight into the firm's early operations. Access to this material was graciously provided by Melissa De Medeiros at Knoedler's in New York.

6. On the way the A. M. Byers family exhibited their collection in their Pittsburgh residence see Floyd, *Architecture after Richardson*, 274–80.

7. The exterior and interior of the Lockhart mansion, located at 608 Highland Avenue, was extensively documented in an album of photographs preserved by family descendants. These photographs not only record how the art gallery was arranged but also indicate how Lockhart tried to create a private gallery similar to ones constructed in England for the display of contemporary art. For further reference to this English development and photographs of the interiors see Kristi Holden, "George Clausen and Henry Hubert La Thangue: The Construction of English Rural Imagery, 1880–1900," Ph.D. diss., University of Minnesota, 1996.

8. For reference to the A. M. Byers house, including photographs of its interior hung with period works of art, see Floyd, *Architecture after Richardson*, 274–81.

9. Although Frick did not have a separate gallery space in his Pittsburgh residence, he may have contemplated adding an art gallery to Clayton. If so, he would have been in keeping with an English trend that had been adopted by Lockhart, Porter, and others in Pittsburgh. For further reference to Frick beyond his interest in the visual arts see George Harvey, *Henry Clay Frick, The Man* (New York and London, 1928). Also see Kenneth Warren, *Triumphant Capitalism: Henry Clay Frick and the Industrial Transformation of America* (Pittsburgh, 1996).

10. On this issue see W. G. Constable, *Art Collecting in the United States of America, An Outline of a History* (Toronto and New York, 1964). Also see René Brimo, *L'Evolution du goût aux Etats-Unis, d'après l'histoire des collections* (Paris, 1938), which presents a good overview of the types of objects collected. Also see the essays by John N. Ingham and by Ruth Krueger Meyer and Madeleine Fidell Beaufort in this publication.

11. Ibid., 48 ff.

12. One exception to this rule was the collection formed by the Havemeyers in New York largely through their close relationship with Mary Cassatt. For further reference see Frances Weitzenhoffer, *The Havemeyers: Impressionism Comes to America* (New York, 1988). For further reference see Alice Cooney Frelinghuysen et al., *Splendid Legacy: The Havemeyer Collection*, exh. cat. (New York, 1993).

13. Brimo, *L'Evolution du goût*, 45 ff.

14. The John G. Johnson collection in Philadelphia provides an excellent example of the type of collection that was often formed in the 1880s and 1890s. On Johnson see Barnie F. Winkelman, *John G. Johnson, Lawyer and Art Collector* (Philadelphia, 1942). The Walters Art Gallery in Baltimore provides evidence of a similar vision. See William R. Johnston, *The Nineteenth-Century Paintings in the Walters Art Gallery* (Baltimore, 1982). A comparable collection was formed in Cincinnati, where the Taft family amassed numerous Barbizon paintings by the turn of the century. For further reference see Ruth M. Myers, *The Taft Art Museum* (Cincinnati, 1995). It is worth noting that these three collections have not been the target of deaccessioning, and they thus furnish an accurate picture of the specific types of artwork that were once collected in America.

15. On Millet as the center of this appreciation see Susan Fleming, "The Boston Patrons of Jean-François Millet," in *Jean-François Millet*, exh. cat. (Boston, 1984), ix–xviii.

16. Constable *(Art Collecting*, 69 ff) discusses Henry Field's role in sponsoring Barbizon painting in Chicago.

17. Fleming, "Boston Patrons of Millet," ix–xviii.

18. Alessandra Murphy followed this direction in her work on the Millet pastels in the Frick collection in Pittsburgh. These pastels will be part of a future exhibition that concentrates on images by Millet.

19. Brimo, *L'Evolution du goût*, 48 ff. Susannah Gardiner comments upon recent renewed interest in genre painting in "Sentimental Reeducation," *Art and Auction* (November 1995), 126–31, 168. Also see Gabriel P. Weisberg, *Redefining Genre: French and American Painting, 1850–1900*, exh. cat. (Washington, D.C., 1995).

20. On the Vanderbilt collection see E. Strahan, *Mr. Vanderbilt's House and Collection Described by...*, 2 vols. (Boston and New York, 1883), and *Catalogue of the Collection of W. H. Vanderbilt, 640 5th Avenue* (New York, 1882). Also see Jerry E. Patterson, *The Vanderbilts and the Gilded Age: Architectural Aspirations, 1879–1901* (New York, 1989).

21. See "Americans' Purchase of French Instead of English Paintings Explained," *New York Times*, 26 February 1888. This reflected a shift toward objects that were popular and readily available on the art market.

22. In a special section dedicated to works in galleries, *The Art Amateur* devoted considerable attention to these Salon favorites. For Alma-Tadema see H. Zimmern, "Lawrence Alma-Tadema," *Art Amateur* 8 (April 1883), 102–104.

23. On Wanamaker's display of paintings in his stores see Leach, *Land of Desire*, 136–37. Many of the paintings that Wanamaker most highly valued were in his home, and he often took other businessmen or those interested in art there. Also see Winkelman, *Johnson*. A good number of Johnson's paintings have been used in the reinstallation of the permanent collection at the Philadelphia Museum of Art, although many works by nineteenth-century artists are still in storage.

24. By the end of the century Knoedler emerged as the primary dealer with extensive contacts in France. For reference to Knoedler's position see Brimo, *L'Evolution du goût*, 56–59, and Hunter's unpublished manuscript on Knoedler in New York.

25. The history of Goupil's involvement in the mass production and distribution of art can only be partially reconstructed due to the loss of many of the firm's documents and ledger books. Those works still in the Goupil Museum in Bordeaux indicate the painstaking care that was expended on such reproductions. Goupil often produced catalogues of available works for consumers. For reference see *Publications nouvelles de la Maison Goupil et Cie, Imprimeurs et éditeurs, Boussod, Valadon et Cie, Successeurs* (April 1890). Some reproductions were created as etchings after the original painting, which suggests that a special market existed for such works. Adolphe Goupil (1806–1893) opened his business in 1827. Four years later he became an associate of Rittner, an art dealer who also sold reproductions of artworks. The reproduction process became a specialty of the Goupil firm, which expanded its business to London, Berlin, New York (in 1846), and The Hague. After Rittner's death, Goupil became associated with Vibert in 1848. Following the deaths of Vibert in 1886 and Goupil in 1893, the reproduction of artwork became a specialty of Boussod, Valadon et Cie.

26. For reference to images by Ridgway Knight see *Rights and Reproductions Register*, Goupil et Cie, Bordeaux, 258. Many of the images were destined for *Le Figaro Salon*, where they were sold as reproductions of exhibited works. On Dagnan-Bouveret see ibid., 32. The first documented contact with Dagnan-Bouveret is dated 1878, although the full records of this association are missing.

27. Images by Ridgway Knight were used in *Le Figaro Salon* from 1896 to 1900, although notations in the Goupil files suggest these images were available for wide use. Reproductions of paintings as single prints were also used to popularize a work and its artist.

28. On related developments in the business world see Alan Trachtenberg, *The Incorporation of America: Culture and Society in the Gilded Age* (New York, 1982).

29. General reference to Pittsburgh collections is found in Will J. Hyett, "Some Collections of Paintings in Pittsburgh," *Art and Archaeology* 14, nos. 5–6 (November-December 1922), 323–29. A detailed list of collectors and the art they acquired was prepared by the Pittsburgh Athletic Association in the early twentieth century. For reference to Madrazo as a painter of Pittsburgh society see "The Art of Madrazo," *Pittsburgh Index*, 28 June 1902. This publication did much to focus the attention of collectors toward certain artists. On Frick's early collecting see *Henry Clay Frick: The Young Collector* (New York, 1988), with an essay and entries by Edgar Munhall.

30. Pittsburghers were greatly interested in cultural matters and the international art scene, and local newspapers carried numerous references to the comings and goings of painters to that city and elsewhere in the United States and Europe. Collectors in Pittsburgh maintained close ties with their counterparts in Boston, as is detailed in Floyd, *Architecture after Richardson*, 5–20.

31. During the late 1890s the *Pittsburgh Post* ran a popular article called "Happenings and Gossip in the Pittsburgh Art World." Considerable press coverage followed Frick's acquisition of *Christ at Emmaus* by Dagnan-Bouveret. In one column the *Pittsburgh Post* reported that "Pittsburgh's fine appreciation of art and rapid development along those lines is a matter of considerable comment on both sides of the Atlantic."

32. References to these trips are found in the Frick family archives. Although it begins in May 1893, much of this information was documented by Helen Clay Frick at a later date. For further reference see the collection of photographs of Henry Clay Frick in the Frick family archives.

Travel to Switzerland invariably brought Frick into contact with Théobald Chartran, who had built an Italian-style villa on an inlet of the Lake Geneva shoreline near the city of Montreux around 1901. This villa, which is still used today, had three guest rooms. This suggests that Chartran often entertained guests, many of whose portraits he probably painted. The Ile de Salagnon frequently appeared on postcards (see the Frick family archives), as it represented what an individual could build to please himself and to maintain his privacy. For further reference see René Koenig, *En séjour à Montreux à la Belle Epoque* (Geneva, 1991), 39, 41.

33. While a complete examination of the international edition of the *New York Herald* has proven difficult (the newspaper is in a state of decay in the Bibliothèque Nationale), issues from late 1905, for example, disclosed that a short entry on the death of Frick's mother appeared on 3 October and another article on 7 October detailed Frick's move to New York. The arrival of other Pittsburghers to Paris, such as C. D. Armstrong, was also noted.

34. For references see Knoedler's archives in New York. Discussions with Knoedler's archival staff confirms these relationships in the late nineteenth century.

35. On Raffaëlli's stay in Pittsburgh see "Center is Here, Says Raffaelli," *Pittsburgh Post*, 13 October 1899, 2. Raffaëlli made his comments in an impromptu speech to members of the international jury at the Pittsburgh Club. He emphasized that Pittsburgh was "destined to be famous as the art center of America."

36. See John Milner, *The Studios of Paris: The Capital of Art in the Late Nineteenth Century* (New Haven, 1988). For reference to the leading studios in Paris see H. Barbara Weinberg, *The Lure of Paris: Nineteenth Century American Painters and Their French Teachers* (New York, 1991).

37. French painters were eager to see articles on themselves in international journals. For reference see "Edouard Jean-Baptiste Detaille," in *Art Amateur* 1 (October 1879), 22–24. Other articles that emphasized the artist's studio appeared in the 1890s. See, for example, Raoul Sertat, "Revue Artistique," *Revue Encyclopédique* 4 (1894), 209–10, with photographs of Raffaëlli's atelier and house in Paris, where he put his canvases on display for prospective clients.

38. On Chartran see "Portraits by Chartran," *New York Times*, 18 March 1896, 4.

39. See "Art and Portraits," *New York Times*, 10 February 1898, 6.

40. On this cosmopolitan atmosphere and the creation of a viable visual culture see Francis G. Couvares, *The Remaking of Pittsburgh: Class and Culture in an Industrializing City, 1877–1919* (Albany, 1984), 96–119.

41. In ibid., 105, he discusses the creation of a "self-conscious leisure class" that was destined to reform culture in Pittsburgh.

42. Beatty was emerging as a key figure in late 1895. See "There are no Poor Pictures," *Pittsburgh Post*, 5 November 1895, 2. Beatty played a strong role in Pennsylvania's representation at the Chicago World's Fair of 1893. On Beatty see Kenneth Neal, "A Wise Extravagance: The Founding of the Carnegie International Exhibitions 1895–1901," Ph.d. diss., University of Pittsburgh, 1993, 15–19. Also see Louise Marie Fink, "An American Salon in Pittsburgh: The Carnegie International in the John W. Beatty Years, 1896–1921," in Vicky Clark, et al., *International Encounters: The Carnegie International and Contemporary Art, 1896–1996* (Pittsburgh, 1996), 48–65.

43. For reference see "Art for Pittsburgers," *Pittsburgh Post*, 26 June 1895, 2.

44. Ibid.

45. A series of articles appeared on the exhibition. See "There are no Poor Pictures," *Pittsburgh Post*, 5 November 1895, 2, and "Art and Anger Make Trouble," *Pittsburgh Post*, 7 November 1895, 2. Also see "The Art Show Ends To-Day," *Pittsburgh Post*, 4 December 1895, 5. The last article noted that "the success of the exhibit has surpassed the expectations of the friends of art who were instrumental in getting it up." Beatty was quoted as

saying 250,000 to 300,000 people saw the exhibition. The library, considered to be part of the Carnegie complex, united culture with civic purposes. On this aspect see Couvares, *Remaking of Pittsburgh*, 105–107.

46. See "Pittsburg's New Carnegie Library," *New York Times*, 6 November 1895, 2, and a detailed review of the works in "Pictures in Pittsburg," *New York Times*, 10 November 1895, 29.

47. For reference to specific works shown see *Dedication Souvenir, Carnegie Library of Pittsburgh, Pa., Programme and Catalogue*, November, 1895. Of the 321 works that were shown, many came from collections in Pittsburgh, including that of Frick. On the loan exhibition see Neal, "Wise Extravagance," 20–28.

48. *New York Times*, 10 November 1895, 29.

49. The Thaulow painting, *A Norwegian Village*, was number 270 in the catalogue, where it was listed as belonging to L. Christ Delmonico in New York. Dagnan-Bouveret, who had been well represented at the Chicago World's Fair of 1893 (although not listed in the official Fair catalogue), was represented in Pittsburgh by a work from the H. K. Porter collection. The writer for the *New York Times* (10 November 1895, 29) did not like the painting.

50. The names of all the Pittsburgh collectors are noted in the exhibition catalogue. Together they form an active group involved in collecting contemporary art. See Neal, "Wise Extravagance," 23.

51. Johnson's relationship with Carnegie and Frick was complicated since he served as Frick's primary counsel in the case against Carnegie. For further information see "Carnegie, Frick and John G. Johnson," *Temple Law Quarterly* 7, no. 4 (July 1933), 397–427.

52. In the detailed correspondence between Frick and Johnson, most of the discussion pertains to business matters or to the rupture with Carnegie. For the correspondence see Frick family archives.

53. See "To Stimulate Art Culture," *Pittsburgh Post*, 3 January 1896, 2, and "Will Elect an Art Director," *Pittsburgh Post*, 12 March 1896, 7.

54. Discussion of Beatty's candidacy appeared in "Will Hang the First Picture," *Pittsburgh Post*, 13 March 1896, 2.

55. Beatty emphasized how the first Carnegie International would be equal, if not superior, to the Paris Salon and exhibitions in London and New York. See "Rare Works of Fine Art," *Pittsburgh Post*, 3 October 1896, 3, and "Treasures in High Art," *Pittsburgh Post*, 3 November 1896, 2, where particular emphasis is given to works shown by Dagnan-Bouveret and Jean-Charles Cazin. Other articles commented upon the thousands of visitors who attended the exhibition. For further reference see *Catalogue, First Annual Exhibition, Carnegie Art Galleries, Pittsburgh*, 5 November 1896–1 January 1897 (Pittsburgh, 1896). The catalogue includes 307 works.

56. Considerable consternation was expressed among local artists, many of whom felt neglected. See "Pittsburg's Art Treasures," *Pittsburgh Post*, 29 November 1896, 7. For reference to the permanent exhibition see *Catalogue of the Second Loan Collection of Paintings and Permanent Collection of Statuary and Photographs, Carnegie Art Galleries* (Pittsburgh, 1896). Also see Neal, "Wise Extravagance," 32–34.

57. Contact between Frick and Beatty was extensive in 1895. See letter from Frick to Beatty dated 12 October 1895 about the purchase of the painting (Frick family archives). Also see letter from Frick to Beatty dated 15 October 1895 concerning Frick's loans to the Art Library exhibition (Frick family archives).

58. Curiously, strong interest in the international artists from France coincides with the establishment of artist committees in Paris and London to assist with the acquisition of major paintings for the Carnegie Internationals. See "Famous Artists are Named," *Pittsburgh Post*, 13 June 1897, 2. The Paris committee included Dagnan-Bouveret and Lhermitte.

59. Constable, *Art Collecting*, 69–82. A similar interest in Barbizon painters appears in the Taft collection in Cincinnati, Ohio. For discussion see "An Introduction to the Art Collection of Charles Phelps and Anna Sinton Taft," in *The Taft Museum, its History and Collections* (New York, 1995), 17–39. Many Barbizon paintings were in place by 1902.

60. Information provided by Melissa De Medeiros in a letter to the author dated 14 November 1995. She noted that Lockhart used Knoedler when he acquired a work of art by Rosa Bonheur. Lockhart began working with Knoedler in 1891.

61. Medeiros noted that A. M. Byers was "the biggest client" among the Pittsburgh collectors who worked with

Knoedler. Almost all the romantic and Barbizon paintings in his collection were acquired from Knoedler. See letter from Medeiros to author, 14 November 1995.

62. See Henry Clay Frick Papers, Series: Paintings—Works of Art, Paintings Purchased by Frick, 1881–1919 (Frick family archives). The work was acquired in August 1895 from M. Knoedler & Co. in New York. Also see Pierre-Olivier Fanica, *Charles Jacque, 1813–1894, Graveur original et peintre animalier* (Montigny-sur-Loing, 1995).

63. *Paintings from The Frick Collection*, introduction by Charles Ryskamp (New York, 1990), 130–33.

64. For reference see Henry Clay Frick Paintings Purchases, 1881–1919, (Frick family archives) for 1898 and 1899, respectively. Enthusiasm for works by Corot had spread throughout the United States by this time.

65. Paintings by Corot belonged to five other Pittsburgh collectors, including Peacock, Thaw, and Lockhart. See *Index, Pittsburgh Athletic Association* (Pittsburgh, n.d.).

66. Constable *(Art Collecting, 73)* noted that almost all collectors in the United States formed Barbizon collections in the "last thirty years of the nineteenth century," when Barbizon reigned as one type of avant-garde French art. Pittsburgh's ties with Boston, which were most noticeable with architects and architectural firms, would have helped maintain this interest in Barbizon painters. On Boston ties see Floyd, *Architecture after Richardson.*

67. On this issue see Peter Bermingham, "Barbizon Art in America: A Study of the Role of the Barbizon School in the Development of American Painting, 1850–1895," Ph.d. diss., University of Michigan, 1972, and Bermingham's catalogue *American Art in the Barbizon Mood* (Washington, D.C., 1975).

68. One reason for American fascination with Corot was his creation of a "spiritual landscape." See Laura L. Meixner, *French Realist Painting and the Critique of American Society, 1865–1900* (New York, 1995), 160–70.

69. Among the Barbizon painters Jules Dupré, Narcisse Diaz, and Charles Jacque were heavily represented. See *Index, Pittsburgh Athletic Association.*

70. Brimo, *L'Evolution du goût*, 48–61.

71. Weisberg, *Redefining Genre.*

72. Ibid.

73. "'Christ Before Pilate' Sold," *New York Times*, 10 February 1887, 1.

74. Leach, *Land of Desire*, 222.

75. Ibid., 136-137. Wanamaker may have held independent exhibitions in his stores to promote interest in certain types of art. Frick, who early on established contact with Wanamaker, could easily have visited the private collection of Wanamaker-Lindenhurst at different times.

76. Lockhart acquired from Knoedler works by the genre painters De Neuville, Verboerckhoven, and von Boskerck. See letter from Medeiros to the author dated 14 November 1995.

77. Henry Clay Frick Paintings Purchases, 1881–1919, 24 March 1881 (Frick family archives).

78. Brimo, *L'Evolution du goût*, 59. Schaus occupied a significant position among New York art dealers. *Art Interchange* (4 January 1890, 2) noted that he headed a delegation of art dealers that traveled to Washington, D.C., to protest against art associations. By April 1892 Schaus was about to retire *(Art Interchange* [April 1892], 104). Four years later *Art Interchange* (April 1896, 95) announced the sale of the Schaus collection after the dealer's death.

79. Frick seems to have been the only one to collect his work in Pittsburgh. *Index, Pittsburgh Athletic Association* (undated) lists no other works in Pittsburgh collections.

80. Beginning in 1879 Jiménez was represented in the annual Paris Salon by works based upon his Spanish background. These works often showed travelers from Spain strolling through museums or attending world expositions.

81. On Lemaire see Gabriel P. Weisberg, *Women of Fashion, French and American Images of Leisure, 1880–1920*, exh. cat. (Tokyo, 1994), 160, 179.

82. For reference to the provenance of the Lemaire work see "Index, Paintings Owned by Henry Clay Frick—Bill Book no. 1," Lemaire (William Schaus) (Frick family archives).

83. On Haquette see "Nécrologie," *L'Art et les Artistes, supplément* (August 1906), xxvii. A major sale of Haquette's work was held at the Hôtel Drouot in Paris on 11 December 1899. For reference see *Catalogue des Tableaux par G. Haquette* (Paris, 1899).

84. See "Beaux-Arts," *Le Monde Illustré* 69, no. 180 (14 November 1891), *(La Pêche au chalut,* Salon of 1891), for a reproduction of the type of painting favored by Parisians.

85. *Dedication Souvenir, Carnegie Library,* no. 125, 72.

86. Two paintings by Detaille—one was owned by Frick—were exhibited in the 1895 Carnegie Art Library exhibition. See *Dedication Souvenir, Carnegie Library,* 70. As a close acquaintance of the Frick family, Chelminski could have helped select works for the collection.

87. Two works by Domingo were originally in the Frick collection. One was a gift and the other was purchased in August 1895. See Henry Clay Frick, List of Purchases (Frick family archives). Frick's collection did not contain paintings by Meissonier, despite an interest in this painter in Pittsburgh.

88. To single out collectors in Pittsburgh for not being interested in depictions of the lower classes would be inappropriate, since this trend is evident in collections throughout the United States. On the type of anecdotal images that were in New York collections see Stranahan, *Collection of Vanderbilt.*

89. Lockhart obviously collected works by Munkácsy, whose painting *The Fête of the Landlady* was included in the Carnegie Art Library exhibition in 1895. For reference see *Dedication Souvenir, Carnegie Library,* 77. Munkácsy was clearly a prestigious artist at this time. A major article about him appeared in *Revue Illustrée* with a reproduction of his painting *The Two Familes.* See Boyer d'Agen, "Munkacsy," *Revue Illustrée* 22 (15 June 1896), 9–24. A second painting by Munkáscy, *The Peace Maker,* was also part of the Lockhart collection.

90. This painting is recorded as being part of the Lockhart estate. See *Index, Pittsburgh Athletic Association* (undated).

91. Alma-Tadema was represented by two works in the Carnegie Art Library exhibition of 1895. One, *Catulus Reciting His Ode to the Sparrow,* was in the Lockhart collection; the other, *A Reading from Homer,* was lent by Henry G. Marquand of New York. For reference see *Dedication Souvenir, Carnegie Library,* 80. At one time two of his works, *Welcome Footsteps* and *Catullus at Lesbias,* were also in the Peacock collection. See *Index, Pittsburgh Athletic Association* (undated), which does not mention when these works were originally acquired.

92. See "Lawrence Alma-Tadema," *Art Amateur* (April 1883), 102–104. The artist was extensively praised for his "historical and archeological exactitude."

93. See Henry Clay Frick Painting Purchases, 1881–1919, 9 September 1897 (Frick family archives). The work was secured by the American branch of the London firm of Arthur Tooth & Sons. Although Frick paid $8,000 for the painting, he returned it to Knoedler in January 1906. The painting most likely represented the second work by Alma-Tadema to enter a Pittsburgh collection. See letters from Arthur Tooth gallery, London, to the author dated 7 and 31 October 1994.

 Frick's relationship with Arthur Tooth may be further revealed in the firm's records preserved at the Getty Archives. This would contradict information provided to the author by this firm, which stated that gallery records were destroyed during World War II.

94. On Knight see *A Pastoral Legacy: Paintings and Drawings by the American Artists Ridgway Knight and Aston Knight,* exh. cat. (Ithaca, New York, 1989).

95. The Duquesne Club was organized in 1873 and incorporated in 1881. For reference to its collection see David G. Wilkins, *Paintings and Sculpture of the Duquesne Club* (Pittsburgh, 1986). Similar clubs throughout the United States exhibited their art collections on the walls of the club's city building. On Pittsburgh's social clubs see John N. Ingham, *The Iron Barons: A Social Analysis of an American Urban Elite, 1874–1965* (Westport, Conn., 1978), 117–27.

96. Knight was represented by three paintings in the 1895 Carnegie Art Library exhibition. *Meditation* was loaned by Lockhart, *Coming from the Garden* came from the Frick collection, and *Wash Day* was in the possession of J. M. Schoonmaker. See *Dedication Souvenir, Carnegie Library,* 75.

97. On Chartran see "Théobald Chartran," in vol. 2 of *Figures Contemporaines* (Paris, 1896–1908). A large collection of paintings and drawings by Chartran is housed in the Musée des Beaux-Arts et d'Archéologie, Besançon.

98. For reference see *Le Monde Illustré*, 28 June 1884, 408–409. This periodical was extensively distributed throughout the United States, and copies, even complete runs of the journal, were found in homes and libraries across the country.

99. On these artists and the category of religious genre scenes see Gabriel P. Weisberg, *Redefining Genre.*

100. Information provided by Melissa De Medeiros in a letter to the author dated 14 November 1995. The Pittsburgh gallery was located at 432 Wood Street. Knoedler's central archives in New York lacks additional information on this branch.

101. Letter from Medeiros to the author dated 14 November 1995. She mentioned that Lockhart began dealing with Knoedler in 1891 and Byers in 1894. Watson bought his first work from Knoedler in 1895.

102. "In the World of Art," *New York Times*, 10 March 1895, 13.

103. Information provided by Melissa De Medeiros in a letter to the author dated 10 February 1995. She noted that Knoedler did not have a catalogue of the Chartran exhibition that opened on 16 November 1895.

104. "Portraits by Chartran," *New York Times*, 18 March 1896, 4.

105. Ibid. Chartran's portrait of Sarah Bernhardt is now in a private collection in Minnesota.

106. Ibid.

107. Letter from Frick to Roland Knoedler, 11 November 1895 (Frick family archives).

108. See the catalogue for *Chartran Pictures now on Exhibition*, M. Knoedler & Co., New York, 18–30 January 1897. Included in this exhibition were two portraits of Mr. and Mrs. A. M. Byers. A simple typed list (with handwritten additions) serves as the catalogue and is housed in the library of M. Knoedler & Co., New York.

109. Letter from Frick to Knoedler, 17 December 1895 (Frick family archives); also see Frick's letter to Knoedler, dated 20 December 1895. Frick was eager to have these portraits presented to the Pittsburgh Bar Association or to the Phipps Conservatory, and he wanted their exhibition in New York to be limited in time.

110. See *Salon des Artistes Français* (Paris, 1897), no. 368, for the listing that mentions this painting was already owned by a collector in Pittsburgh.

111. Letter from Frick to Knoedler, 4 March 1896 (Frick family archives).

112. *Chartran Pictures now on Exhibition*, M. Knoedler & Co., 1897.

113. Letter from Frick to Mr. McCrea, 26 January 1897 (Frick family archives).

114. Letter from Frick to Knoedler, 5 May 1897 (Frick family archives). Period photographs show that the Lockhart pendant portraits were prominently placed in the Lockhart art gallery. Other Chartran portraits of Pittsburghers have not yet been located.

115. Henri Mace, "Retour de New-York, Chez M. Chartran," *Gil Blas*, 25 May 1898, 2.

116. W.T.M., "Art and Artists," *Pittsburgh Leader*, 9 January 1898, 15.

117. Ibid.

118. Ibid.

119. Ibid.

120. Letter from Frick to Knoedler, 15 January 1898 (Frick family archives).

121. "Chartran's Latest Pictures," New York Times, 6 January 1900, 6.

122. Ibid. The issue of Frick's commissioning the portrait has been challenged.

123. Ibid. The painting today hangs in the White House. It appeared in the background in several scenes of the movie *An American President* (1995). For further reference to the work see *Art in the White House, A Nation's Pride* (New York, 1992), 219–22.

124. Chartran was interested in painting this work because it allowed him to combine portraiture with a contemporary history scene. Ibid., 222.

125. A copy of the check to Chartran, dated 8 February 1901 and addressed to the artist at the Waldorf Astoria Hotel, New York, is in the Frick family archives.

126. For reference to this exhibition see *Pan-American Exposition, Catalogue of the Exhibition of Fine Arts* (Buffalo, 1901). Frick was a member of the Honorary Committee for this exhibition, along with John W. Beatty, William Nimick Frew, and Mrs. H. K. Porter.

127. See a copy of the letter from Frick to President Roosevelt dated 27 October 1903, and the president's response to Frick, dated 10 November 1903, now in the Frick family archives.

128. See *Art in the White House*, 221. Chartran painted a portrait of the president's wife Edith Carow Roosevelt (1902).

129. See *Portraits by T. Chartran*, exh. cat. (New York, 1902), which was held at M. Knoedler & Co. 17–29 March 1902. Thirteen paintings are listed in this brief document.

130. The Hyde portrait was exhibited as number 10 at the Knoedler gallery in 1902. For further reference see "Notes sur M. James Hyde," Archives, Bibliothèque du Musée des Arts Décoratifs, Paris. Also see "Musée des Arts Décoratifs, Beaux-Arts," *Bulletin des Musées*, no. 20 (1 December 1928), 314 on the Hyde donation.

131. Letter from James Hazen Hyde to Frick dated 13 July 1902 (Frick family archives).

132. For discussion of the situation within Equitable's management see Harvey, *Frick, The Man*, 278–81. Also see Walter Land, *The Good Years* (New York, 1960), 109–15, and R. Carlyle Buley, *The Equitable Life Assurance Society of the United States* (New York, 1967), 629–39, for further details on the scandals associated with Hyde and the perceptions developed by the "old guard" within the Equitable firm. The author acknowledges the role played by DeCourcy McIntosh in calling some of these references to his attention. The Hyde scandal long dominated New York newspapers and created a difficult situation for Hyde.

133. Letter from Frick to President Theodore Roosevelt dated 10 December 1904 (Frick family archives). Roosevelt offered Hyde the ambassadorship to Belgium, which he refused. See Harvey, *Frick, The Man*, 299.

134. See "Notes sur M. James Hyde." Hyde, who was two generations removed from Frick, was educated at Harvard and then at Princeton, where he received a Master's degree in 1903.

135. See James H. Hyde, "La Littérature française aux Etats Unis," text of a conference given in France on 17 December 1913 and published in *Lectures pour Tous* (n.p., n.d.), 1–8.

136. On Hyde's books see Inventaire, Donation James Hazen Hyde, Library of the Union Centrale des Arts Décoratifs, February 1941.

137. See Henry Roujon, "Un Ami: M. James Hazen Hyde," *Comoedia Illustré* (20 April 1919), 663, with a reproduction of Friant's portrait of Hyde. Roujon was both a member of the Académie Française and an important political figure in France. Also see "Obituary, James Hazen Hyde," *New York Times*, 2 August 1959. A huge archive on Hyde in The New-York Historical Society includes diaries, letters, and scrapbooks covering his years in France (1906–40). The author acknowledges the assistance of Albina De Meio of The New-York Historical Society.

138. On Madrazo see "Madrazo's Last Portraits," *New York Times*, 28 January 1900, 7. Also see "The Art of Madrazo," *Pittsburg Index* 7 (28 June 1902), 2–5.

139. Madeleine Fidell-Beaufort, "Jules Breton in America: Collecting in the 19th Century," in *Jules Breton and the French Rural Tradition*, exh. cat. (Omaha, 1982), 51–61.

140. Ibid.

141. Breton's role has been slighted in recent debates on the importance of Millet to American culture. On the excessive attention paid Millet see Laura L. Meixner, *French Realist Painting and the Critique of American Society, 1865–1900* (Cambridge, England, 1995).

142. Information on the significance, provenance and exhibition record of *The Turkey Tender* was supplied by Annette Bourrut-Lacouture, who is preparing a definitive study on Breton's position and work. It is not known when the painting entered the Lockhart collection.

After being out of view since the end of the nineteenth century, this painting has recently passed through public sale. For reference see *19th Century European Paintings, Drawings, and Sculpture*, Sotheby's New York, 24 October 1996, lot 25, where the work is noted as being the "property of a New York collector."

143. See *Exposition des Beaux-Arts, Catalogue Illustré de Peinture et Sculpture, Salon de 1895* (Paris, 1895), no. 294. The painting was reproduced as an engraving on page 15 of the Salon catalogue.

144. Information supplied by Melissa De Medeiros in a letter to the author dated 26 May 1994. She noted the painting arrived in New York from the Knoedler gallery in Paris in August 1895. The painting had been noted in the French press, with articles in *Le Débats* (24 May 1895) and *Nouvelle Revue Internationale* (7–15 May 1895). This information was kindly supplied to the author by Annette Bourrut-Lacouture.

145. For reference to the significance of this work and theme in Breton's imagery see Weisberg, *Realist Tradition*, 86–87.

146. On Gérôme see Gerald M. Ackerman, *The Life and Work of Jean-Léon Gérôme* (New York, 1986).

147. On the organization of the French section of the Columbian Exposition see Archives Nationales, Paris, F. 12, 4450. In conducting research on this topic the author examined references to the ways in which those at the Ecole des Beaux-Arts, where Gérôme was a powerful figure, selected paintings for exhibition. Gérôme was president of the painting section that chose works for the Columbian Exposition. See Archives Nationales, F12 4447, "Beaux-Arts, Comité," and the circular prepared by Léon Bourgeois titled "Exposition Universelle de Chicago."

148. Also see the section on Gérôme in Weisberg, *Redefining Genre*.

149. John C. Van Dyke, *A Text-Book of the History of Painting* (London and New York, 1913), 163. This book was regularly reprinted well into the twentieth century.

150. Ibid.

151. Van Dyke was in contact with Frick because of the author's interest in sponsoring painters whose works could be acquired by American collectors. See letters from Van Dyke to Frick (Frick family archives).

152. Ackerman, *Life and Work of Gérôme*, no. 330, where it is listed as lost.

153. This painting was shown at the 1895 Carnegie Art Library exhibition. See *Dedication Souvenir, Carnegie Library*, 72, no. 119.

154. See Ackerman, *Life and Work of Gérôme*, no. 363, where it is listed with a different title and as being lost. The painting was exhibited in 1895 in Pittsburgh. See *Dedication Souvenir, Carnegie Library*, 72, no. 120, where the work is listed as *Lion and Butterfly*.

155. See Ackerman, *Life and Work of Gérôme*, no. 420, where the work, listed as "whereabouts unknown," lacks a provenance that traces it to the Frick collection. His purchase in September 1895 made the work available for the Carnegie Library exhibition that November. Information from Knoedler documents that the painting came from its Paris gallery in August 1895. Frick returned the work to Knoedler in October 1899, which sold it two years later to C. M. Hyde of New York.

156. See *Dedication Souvenir, Carnegie Library*, 72, no. 117.

157. See Ackerman, *Life and Work of Gérôme*, no. 411, which does not include a reference to Frick. Records of the Frick family archives established that Frick bought this painting from an unknown gentleman named I. Collins. A version of this painting (lot no. 83) appeared in the nineteenth-century European paintings and sculpture sale held at Sotheby's in New York on 1 November 1995.

158. See letter from Medeiros to the author, 14 November 1995, which states that is was sold in November 1899 to H. Seligman of New York through M. Knoedler & Co.

159. The painting was similar in theme to a work that was in Frick's collection for a brief time. It was listed as *Gérôme Modeling Tanagra* in the 1895 Carnegie Library catalogue. See *Dedication Souvenir, Carnegie Library*, 72, no. 116, where it is listed as belonging to J. G. Butler, Jr., without a specific city listed. No painting with precisely this title is listed in Ackerman *(Life and Work of Gérôme)*, although the title of one work, *The Artist's Model* of 1895, suggests it might have been similar. See Ackerman, *Life and Work of Gérôme*, no. 419, which does not refer to J. G. Butler or provide a provenance earlier than the New York sale in 1909. Thus, it remains possible that this painting (now in the Haggin Museum, Stockton, California) was the one in Pittsburgh in 1895, a feasible completion date for this work. A version of this was sold in Sotheby's sale of nineteenth-century European paintings and sculpture, New York, 1 November 1995, lot no. 80. Ackerman included a variant of the Haggin painting as no. 419 B, but he implied that lost work was an oil sketch. This variant could possibly be the Gérôme canvas exhibited in Pittsburgh in 1895.

160. See *Dedication Souvenir, Carnegie Library*, 72, no. 118. The Schoonmaker collection contained works by

leading academic painters, including one by Meissonier and two by Bouguereau. See Ackerman, *Life and Work of Gérôme*, 322, for reference to the painting without mention of the Schoonmaker provenance.

161. Robert Isaacson, "Collecting Bouguereau in England and America," in *William Bouguereau, 1825–1905*, exh. cat. (Montreal, 1984), 104–13.

162. See *The Cosmopolitan, A Monthly Illustrated Magazine* 20 (December 1895), 225 for *The Awakening of Psyche,* and (February 1896), 452 for *The Butterfly.* Also see *Munsey's Magazine* 16, no. 6 (March 1897), for *A Rêverie.*

163. Isaacson, "Collecting Bouguereau," 113.

164. Ibid, 110–11. Also see *Catalogue of Paintings and Sculpture in the Collection of Charles T. Yerkes Esq.* (New York, 1904).

165. Six Bouguereau works were seen in the Carnegie Art Library exhibition in 1895. At least two represented erotic themes. For reference see *Dedication Souvenir, Carnegie Library,* 67, nos. 24–29. Two works came from the collection of J. J. Vandergrift.

166. See Martha L. Root, "Bouguereau and His Art," *Pittsburgh Index,* 24 May 1902, 11–12, which included several illustrations of works by Bouguereau in Pittsburgh collections.

167. See Henry Clay Frick Papers, Paintings—Works of Art, 1881–1919 (Frick family archives). It was purchased on 4 June 1895 from M. Knoedler & Co., New York, for $2,800.

168. The painting's lack of a provenance makes it difficult to determine exactly when it was first entered a Pittsburgh collection.

169. Changes were discussed in "The New Salon in Paris," 4. No history has been written on the activities of the Société Nationale. A large part of its membership records and documents on its activities may well have been lost. Information supplied to the author by Mr. F. Baboulet.

170. Ibid. The article noted that Meissonier, who was "far from a radical," had always been friendly to the more advanced "wing." In the article Bouguereau was presented as being far more traditional and conservative.

171. The aristocratic strains in the Nationale were immediately cited in "Is it an Upper Salon," *New York Times,* 17 February 1890, 4. From the start some saw this Salon as a secessionist group with self-promoting instincts rather than true democratic ideals.

172. "New Salon in Paris," *New York Times,* 2 February 1890, 4.

173. See Weisberg, *Redefining Genre.*

174. According to the *Index, Pittsburgh Atheletic Association* (undated), nine paintings by Cazin, excluding those owned by Frick, were in the collections of Peacock, Lockhart, Porter, Nicola, Finley, and Black. According to the 1895 Carnegie Library exhibition, works by Cazin were also in the Caldwell, O'Neill, and Westinghouse collections.

175. "The Cazin Exhibition," *Art Amateur,* January 1894, 43.

176. See "Jean Charles Cazin," *Art Interchange* 3, no. 6 (December 1893), 158, and "Photographing M. Cazin," *Art Interchange* 32, no. 1 (January 1894), 14. Also see "M. Cazin in this Country," *Critic,* no. 611 (4 November 1893), 288; J. L. G., "A Chat with M. Cazin," *Critic,* no. 614 (25 November 1893), 346; and "The Fine Arts, The Cazin Exhibition in New York," *Critic,* ibid., 349.

177. "Jean Charles Cazin," *Art Interchange* (December 1893), 158.

178. "A French Tone Painter," *New York Times,* 18 November 1893, 4.

179. Ibid.

180. The relationship with Monet was raised in the 1895 Carnegie Art Library exhibition in which three paintings by the Impressionist were shown. See *Dedication Souvenir, Carnegie Library,* 77, nos. 208–10.

181. "The Cazin Exhibition," *Art Amateur* (January 1894), 43.

182. See Henry Clay Frick Paintings Purchases, 1881–1919 (Frick family archives). The latter covers *The Dipper,* which was purchased on 31 March 1898.

183. Letter from Frick to Cazin dated 23 September 1895 (Frick family archives).

184. Letter from Cazin to Frick dated 9 October 1895 (Frick family archives), translated from French by someone at the Knoedler gallery, through which the original letter passed. Such correspondence suggests a strong link existed between the artist and the collector by October 1895.

185. Cable from Frick to Cazin dated 17 September 1898 (Frick family archives).

186. *The Fourth Annual Exhibition . . . Carnegie Institute*, 2 November 1899–1 January 1900 (Pittsburgh, 1899). In the listing of the Foreign Advisory Committees, Cazin is noted as being on the Paris committee with Thaulow, Dagnan-Bouveret, and Lhermitte, among others.

187. Letter of Cazin to Frick dated 9 October 1895 (Frick family archives).

188. Also see Aaron Sheon, "Nineteenth Century French Art in the Clark Collection," in *The William A. Clark Collection, The Corcoran Gallery of Art* (Washington, D.C., 1978), 117–27.

189. One Thaulow painting was shown in the 1895 Carnegie Art Library exhibition. See *Dedication Souvenir, Carnegie Library*, 80, no. 270.

190. Other paintings were listed as being in the Black, Porter, and Allison collections, without mention of when they were brought to Pittsburgh. See *Index, Pittsburgh Athletic Association* (undated).

191. For reference see Henry Clay Frick Paintings Purchases, 1881–1919, for 12 November 1895, for 2 October 1898, for 1 November 1898, for 29 December 1898, for 9 May 1899 for *The Smoky City* and for 26 June 1899 (Frick family archives).

192. "President Proclaimed the Winners," *Pittsburgh Post*, 4 November 1897, 2. President McKinley announced the winners at ceremonies held at Carnegie Music Hall. Thaulow received a second-class medal and a cash stipend of $1,000.

193. For reference to Delmonico see "The Week in the Art World, Saturday Review of Books and Art," *New York Times*, 20 November 1897, 15.

194. See letters from Frick to Delmonico dated 29 October and 11 November 1895 (Frick family archives). According to the correspondence, Frick paid $700 for the Thaulow painting *Norwegian Village*.

195. Letter from Delmonico to Frick dated 27 October 1895 (Frick family archives). He also notes that John Beatty had selected *Norwegian Village* for the 1895 Carnegie Art Library exhibition, which allowed Frick to see the painting before he actually bought it. For reference to the work see *Dedication Souvenir, Carnegie Library*, 80, no. 270, where it is listed as being lent by Delmonico, New York.

196. "The Week in the Art World, Saturday Review of Books and Art," *New York Times*, 20 November 1897, 15.

197. Ibid. See letter from Delmonico to Frick dated 30 October 1897, in which he asks for the loan of the "'Village-Night Scene' . . . which we had the pleasure of selling you 2 years ago" (Frick family archives).

198. Ibid.

199. Letter from Frick to Delmonico dated 1 November 1897 (Frick family archives).

200. "The Week in the Art World, Saturday Review of Books and Art," *New York Times*, 20 November 1897, 15.

201. Letter from Frick to Roland Knoedler dated 19 October 1898 (Frick family archives). Perhaps "taking pictures" refers to Thaulow using a camera to record sites for future landscapes.

202. *Hoar Frost*, from the Frick Collection, passed through sale at Christies, New York, on 12 October 1993, lot 99.

203. See "A Noted Artist Paints a Typical Pittsburg Scene," *Pittsburgh Post*, 9 April 1899, with a reproduction of the work.

204. This interest in depicting smoky effects placed Thaulow at the forefront of other artists who painted scenes of Pittsburgh. The tonal qualities created by smoke and haze were then being explored by landscape painters throughout the world. See Anna Mynott Docking, "Artist Chase Likes the Smoke Effect of Pittsburg," *Pittsburgh Post*, 9 April 1899, 28.

205. Wilkins, *Duquesne Club*, 52–53.

206. On Thaulow see *Frits Thaulow: un Norvégien Français*, exh. cat. (Paris, 1994).

207. See Edward H. Moore, "Fritz Thaulow, Norway's Master of Color," *Brush and Pencil* 13 (October 1903), 11.

208. On Raffaëlli's portraits see Weisberg, *Women of Fashion*, 164–65. The international press frequently commented on the range of Raffaëlli's work. See Frantz Jourdain, "Modern French Pastellists: J. F. Raffaëlli," *Studio* 32 (1904), 146–49, and Gabriel Mourey, "The Work of Jean François Raffaëlli," *International Studio* 14 (July 1901), 3–14. Since no work by Raffaëlli appears in the *Index, Pittsburgh Athletic Association* (undated), his work apparently was not widely collected in Pittsburgh.

209. "Work by J. F. Raffaelli," *New York Times*, 4 March 1895, 4.

210. "Exhibition of the Work of Rafaelli," *Art Amateur* 32, no. 5 (April 1895), 135–36. On Raffaëlli's ties with Impressionism see Joel Isaacson, *The Crisis of Impressionism, 1878–1882*, exh. cat. (Ann Arbor, 1979), 160–71.

211. "The Raffaelli Exhibition," *Art Amateur* 11 (June 1884), 12.

212. See Bill of Sale, Arthur Tooth & Sons, dated 28 September 1898 (Frick family archives).

213. See *Revue Encyclopédique* 4 (1894), 209–10.

214. See "Beautiful Gems of Art Described by a Master," *Pittsburg Dispatch*, 2 November 1899, 4.

215. Neal, "Wise Extravagance," 68–70.

216. Ibid., fig. 21. For further reference on Raffaëlli's ties with Pittsburgh see Getty Archive, 930076.

217. For reference to this painting see Gabriel P. Weisberg, *Beyond Impressionism: The Naturalist Instinct* (New York, 1992), 83–84. Also see Claude Petry, *Emile Friant (1863–1932). Regard sur l'homme et l'oeuvre*, exh. cat. (Nancy, 1988).

218. Ibid., 85.

219. On the Coquelin collection see *Catalogue des tableaux modernes . . . composant la Collection C. Coquelin, Galerie Georges Petit* (Paris, 1906). In this sale were twelve works by Friant (nos. 42–53). On Coquelin Cadet see Arsène Alexandre, "Cadet," *Revue Illustrée* 22 (15 July 1896), 67–74, which includes photographs of his collection and home.

220. See Philip Gilbert Hamerton, "Cast Shadows, painted by Emile Friant," *Scribner's Monthly* 16 (July–December 1894), 675–79.

221. See "France," *Catalogue, World's Columbian Exhibition* (Chicago, 1893), 207–34. It was one of two paintings that Friant exhibited in Chicago, which may have marked the first time his work was shown in the United States. French paintings in general received considerable attention in the *New York Times* (see "France Shows her Pictures," 6 May 1893, 8).

222. Information provided by Jennifer L. Vanim, Philadelphia Art Museum, in a letter to the author dated 5 December 1995.

223. Johnson was an early exponent of Bastien-Lepage's work in the United States, sending one of his canvases to Pittsburgh for the Carnegie Library exhibition in 1895. See *Dedication Souvenir, Carnegie Library*, 66, no. 7.

224. Letter from Melissa De Medeiros to Lisa Hubeny dated 1 June 1991, in which she notes that the painting came from the Paris branch of the Knoedler gallery in August 1899. Frick purchased it for $4,500.

225. Auguste Daligny, "L'Union Artistique, Exposition Annuelle," *Journal des Arts*, 8 February 1899, 1.

226. See *Catalogue, Société Nationale des Beaux-Arts, Exposition de 1899* (Paris, 1899), 80, no. 599, which indicated that the painting already belonged to M. Knoedler & Co. In a letter from Friant to Knoedler in Paris dated 16 June 1899, the artist revealed that Frick was making inquiries about his work. Thus, it is quite likely that Frick had seen Friant's work at the Paris Salon, had tried to contact the artist on his own, and may have first seen *Chagrin d'enfant* in Paris.

227. Frick's personal life was marked with tragedy when two of his children died in the early 1890s (Martha Howard Frick on 25 July 1891 and Henry Clay Frick, Jr., on 4 August 1892). These two children, and espe-

cially Martha, were deeply mourned by the family for several years, which makes the melancholic theme of *Chagrin d'enfant* potentially more personal.

228. For reference see Weisberg, *Beyond Impressionism*, 68–82.

229. To date, examination of Dagnan-Bouveret's portraits has been limited. Many remain in private family collections and others are lost. A substantial number of these works are reproduced as photographs in the Archives Départementales, Vesoul. For further reference see *P. A. J. Dagnan-Bouveret, Catalogue chronologique des oeuvres*, prepared by Marie Legrand, undated, private collection.

230. Milner, *Studios of Paris*, 190, fig. 238. Dagnan's large studio in Neuilly was specially built to reflect the painter's level of prosperity. For reference see Archives Départementales, Vesoul.

231. On Dagnan at Goupil see Scrapbook, Registre des photos, CD2, beginning with *The Accident* of 1880. Additional information is contained in Goupil Registre, Droits de Reproduction. Beginning with 1884, it includes the works *Hamlet*, *Halte des Bohémiens*, *La Vierge*, and *L'Enfant malade*, and continues through 1907.

232. For a comprehensive review see Paul Mantz, "Le Salon, Champs de Mars," *Feuilleton du Temps*, 21 June 1891.

233. Dagnan received a medal for participating in this exposition. He was listed as Hors Concours and a member of the Section française. This medal is now housed in the Archives Départementales, Vesoul.

234. No mention of Dagnan-Bouveret is made in the official catalogue of the French section. See "Fine Arts," *World's Columbian Exposition* (Chicago, 1893), 207–34. Since Dagnan was Hors Concours, his work may have been shown outside the official competition.

235. Letter from Jennifer L. Vanim, John G. Johnson Collection, Philadelphia Museum of Art, to the author dated 5 December 1995.

236. Dagnan received a Medal of Honor at the Exposition Universelle for *Brittany Pardon* (Gulbenkian Collection, Lisbon) and *Madonna of the Trellis*. For further reference see *Dagnan-Bouveret, Catalogue Chronologique*.

237. On the paintings in the Walters collection see Johnston, *Walters Art Gallery*, cat. nos. 142 and 143.

238. See Arthur Hoeber, "A Pittsburg Artist," *Pittsburgh Post*, 19 August 1900, 4. The article noted that Clarke had acquired other works while he was studying in Europe. Clarke, who moved to New York at an unknown date, was in contact with Frick (see letter dated 8 April 1901 [Frick family archives]).

239. *Catalogue, First Annual Exhibition*, Carnegie Art Galleries, 1896, cat. no. 73. *The Madonna of the Rose* had an asking price of $15,000 and was for sale in 1896, when it was shipped to Pittsburgh from the Manhattan Storage Warehouse in New York. See Pittsburgh International Exhibition (1896) Entry Blanks, Carnegie Museum of Art Archives, under Dagnan-Bouveret. Also see *French Paintings, A Catalogue of the Collection of The Metropolitan Museum of Art* (New York, 1966), 220.

240. "Treasures in High Art," *Pittsburgh Post*, 3 November 1896, 2. *A Brittany Peasant* was the second work by Dagnan-Bouveret exhibited at the International in 1896. In an undated letter to John Beatty (Carnegie Museum of Art Archives), Arthur Tooth & Sons fixed its sale price at $2,500, noting that this work was "the principal figure in his fine Pardon picture."

241. For one reference see "Dans la forêt—Les Salons—Description d'oeuvres," *Revue Encyclopédique* 3 (1893), 822–24 (with a reproduction of the painting).

242. This information was obtained during the summer of 1994 by carefully examining the stickers attached to the back of the canvas in the Mairie, Neufchâteau (Vosges). Also see Claude Phillips, "The Collection of George McCulloch, Esq.," *Art Journal* (January 1896), 65–68, where he says of the central figure that "in the midst stands erect the rustic Orpheus, holding his fiddle. . . ."

243. Letter from Vanim to the author dated 5 December 1995.

244. See the frontispiece of *Century Magazine* 48, no. 1 (May 1894).

245. William A. Coffin, "Dagnan-Bouveret," ibid., 3–15. For *Madonna (of the Trellis)* see *Century Magazine* 43, no. 2 (December 1891), 281.

246. See William A. Coffin. "P. A. J. Dagnan-Bouveret," in *Modern French Masters, a series of biographical and*

critical reviews by American artists, edited by John C. Van Dyke (New York, 1896), 239–48. Coffin noted that he had no personal friendship with Dagnan.

247. Ibid., 242.

248. See *Dedication Souvenir, Carnegie Library*, 69, no. 74. The second painting, *Head of a Woman*, was listed in *Index*, *Pittsburgh Athletic Association* (undated) as being part of the Porter collection.

249. On Porter see letters between Frick and Porter from September 1895 to June 1905 (Frick family archives). On his art gallery see "Two Views of the Only Private Art Gallery in Pittsburg," *Pittsburgh Post*, 28 May 1899, 25.

250. See "Pascal-Adolphe-Jean Dagnan-Bouveret, Mutter Gottes," in *Die Malerei auf der Munchener Jubiläums-Kunst-Ausstellung* (Munich, 1888), 177–79. This painting was also described in an article in *Harper's Bazaar* 19, no. 1 (2 January 1886), 13.

251. Letter from Frick to Simon dated 24 September 1897 (Frick family archives). Tooth had initially contracted with Dagnan-Bouveret to buy *Supper at Emmaus*. See contract between Dagnan-Bouveret and Arthur Tooth dated 11 January 1897, Archives Départementales, Vesoul.

252. This point is reiterated by Edgar Munhall in "An Early Acquisition by Henry Clay Frick: Dagnan-Bouveret's Christ and the Disciples at Emmaus," in *Reto Conzett*, 15 December 1986, 4, which is based upon statements culled from the *Pittsburgh Post*.

253. Letter of Frick to Simon dated 24 September 1897 (Frick family archives). Frick was unable to convince his wife to have her portrait painted by Dagnan. In a letter to Simon dated 12 March 1898 (Frick family archives), Frick confirmed that a portrait of Childs was absolutely certain.

254. Letter from Frick to Dagnan-Bouveret in Neuilly dated 24 September 1897 (Frick family archives).

255. Letter from Frick to Dagnan-Bouveret dated 21 October 1897 (Frick family archives). Frick apparently wanted Carnegie's prior approval of a painting he planned to give to his partner's new museum.

256. Letter from Frick to Simon dated 1 November 1897 (Frick family archives). Frick noted that the "reduction" was being prepared by a student of Dagnan-Bouveret. Its production suggests that Frick had been thinking of giving away the large original all along.

257. Letter from R. U. Johnson, associate editor, *Century Magazine*, to Frick dated 3 February 1898 (Frick family archives).

258. Munhall, "Early Acquisition," 4–5.

259. Auguste Daligny, "L'Exposition de la Société Nationale, Champs de Mars, Peinture, Salle IV," *Journal des Arts* (6 May 1896), 1.

260. "La Peinture aux Salons de 1896," *Revue des Deux Mondes* 135 (1896), 901–906. The writer carefully links Dagnan's work to paintings by Renaissance artists.

261. See Charles Fremine, "Le Salon du Champs de Mars," *Le XIXe Siècle*, 25 April 1896, which notes that "oeuvre sérieuse je le répète, mais grêle, comme efféminée, sans la force nécessaire pour atteindre à la grandeur." Also see "Le Salon de 1896," *L'Illustration*, 2 May 1896, 3.

262. G. Geffroy, "Le Salon du Champs de Mars—1896—Le Salon I," *Le Journal*, 24 April 1896, 5. This critic never supported Dagnan's work, as he found the artist anathema to the direction of modernism.

263. See "Descriptive Note by the Very Rev. the Dean of Canterbury on 'The Lord's Supper' painted by P. A. J. Dagnan-Bouveret," which was distributed by Goupil and Company, London, 1897.

264. Ibid., 8. The pamphlet reproduced a series of preparatory figure studies in charcoal.

265. Ibid., 20.

266. J. C. Warburg, "Letter to the Editor, Dagnan-Bouveret's 'Lord's Supper,'" (London) *Times*, 30 December 1896.

267. Ibid.

268. "Dagnan-Bouveret's New Picture," (London) *Times*, 21 December 1897.

269. Ibid.

270. For a slightly different use of English see "'Christ and the Disciples at Emmaus' by P. A. J. Dagnan-Bouveret," published by Arthur Tooth & Sons' Galleries, 5 and 6 Haymarket, S.W., London (undated), (Archives Départementales, Vesoul). The original French text, ostensibly written by Dagnan-Bouveret, is appended.

271. "100,000 for a Painting," *Pittsburgh Post*, 3 February 1898, 2.

272. Ibid.

273. Frank Marshall White, "Frick Painting Shows a Bold, Artistic Idea," *Pittsburgh Post*, 6 February 1898.

274. "More of Frick's French Painting," *Pittsburgh Post*, 8 February 1898, 3. At this time conflict between nationalistic interests and larger international ties was affecting the art trade and may well have been a factor in these attacks against Frick and his acquisition of French art.

275. As noted in Munhall, "Early Acquisition," 2, who cites an article in the *Chicago Tribune* that appeared on 6 February 1898.

276. "Happenings and Gossip in the Pittsburg Art World," *Pittsburgh Post* (February 1898).

277. Louis de Fourcaud, "Les Deux Salons de 1898, III La Société Nationale des Beaux-Arts," *Le Gaulois*, 30 April 1898, Supplément.

278. A. Pallier, "Les Salons de 1898—A propos de peinture religieuse—M. Dagnan-Bouveret—M. Roybet—Mm. Melchers, Duhem, Roger—Mlle. d'Anethen—Mm. Deschamps etc." *La Liberté*, 11 May 1898.

279. Ibid.

280. Léo Claretie, "Les Deux Salons XIII à la Société Nationale des Beaux-Arts," *L'Evénement*, 1 May 1898, 1.

281. Letter from Frick to Simon dated 4 June 1898 (Frick family archives). Frick also expressed his eagerness to pay the bill for this painting.

282. *Catalogue, The Third Annual Exhibition Held at the Carnegie Institute, November 3, 1898 til January 1, 1899* (Pittsburgh, 1898), cat. no. 85 and listed as "Presented to the Carnegie Institute by Mr. and Mrs. H. C. Frick, 1898."

283. "The Gallery is Open Today," *Pittsburgh Post*, 3 November 1898, 1.

284. For the first documentation of the photo sources for this painting see Gabriel P. Weisberg, "Tastemaking in Pittsburgh, The Carnegie International in Perspective, 1896–1905," *Carnegie Magazine* 56, no. 10 (July-August 1983), 20–22.

285. For the 1898 Carnegie International Exhibition, Dagnan-Bouveret was appointed to the Paris Advisory Committee. Neal ("Wise Extravagance," 83–84) notes that Dagnan was not an active participant in this group's meetings in Paris. Dagnan's connections to Frick and his overwhelming popularity in the United States and Pittsburgh were enough to warrent his inclusion in the Carnegie Internationals.

286. Letter from Simon to Frick dated 26 August 1898 (Frick family archives).

287. See Contracts between Dagnan-Bouveret and Arthur Tooth dated 11 January 1897 and between Dagnan-Bouveret and Edmond Simon (for Arthur Tooth & Sons, Paris) dated 8 July 1898 (Archives Départementales, Vesoul).

288. Letter from Frick to Arthur Tooth & Sons dated 9 April 1901 (Frick family archives). The payment was only the balance due; the total cost was $22,000, then a very large amount for a contemporary painting.

289. On the Décennale exhibition see *La Presse*, 2 May 1900. This presentation of works done between 1890 and 1900 was intended to demonstrate that French creativity was still at its peak.

290. See Marcel Fouquier, "Les Beaux-Arts à l'Exposition . . . L'Exposition décennale, Le Grand Palais / A travers les Salles Salle II—Le Sanctuaire de M. Dagnan-Bouveret," *Le Rappel*, 2 May 1900, 1. On Dagnan's election to the Academy see "A L'Académie des Beaux-Arts—L'Elu d'hier: Dagnan-Bouveret," *Le Siècle*, 29 October 1900, 4. Dagnan also had recently been elected to the Institut de France.

291. Fouquier, "Les Beaux-Arts," 1.

292. Gaston Stiegler, "Au Grand Palais, Exposition décennale," *L'Echo de Paris*, 2 May 1900, 2.

293. Charles Holman Black, "Art at the Exhibition, France," *English and American Gazette of Paris*, 20 October 1900.

294. Loredo Taft, "Art of the Frenchman, Dagnan-Bouveret's Great Painting 'The Last Supper' is one of the masterpieces of the Salon," *Pittsburgh Post*, 5 August 1900, 26.

295. Ibid.

296. George Ferguson, *Signs and Symbols in Christian Art* (New York, 1966), 37.

297. On the relevancy of these religious themes for Frick see Munhall, "Early Acquisition," 2–11.

298. Translation of a letter from Dagnan-Bouveret to Simon dated 5 December 1900 (Frick family archives). Other quotes by Dagnan concerning the painting's installation are taken from this letter.

299. This concept is contained in a fragment of a letter from Dagnan-Bouveret to his wife dated April 1898 (Fond Dagnan-Bouveret, Archives Départementales, Vesoul). The letter states, "Sur l'achat par Mr. Frick d'un tableau (dont le sentiment répondait si intimement à ses rêves) de Dagnan—avec réservation de toutes les études préparatoires—devant orner la pièce principale d'un hôpital qu'il a construit après la mort de sa fillette, et sur la demande que lui a faite Engel-Gros de venir s'installer au château de Ripaille pour peindre ses deux petites filles."

300. Letter from Simon to Frick dated 14 September 1897 (Frick family archives).

301. "Fine Painting for Pittsburg," *Pittsburgh Post*, 17 January 1901.

302. Ibid. The painting was to be "set up in the dining room of his handsome residence. . . ."

303. Letter from Roland Knoedler to Frick dated 9 October 1899 (Frick family archives). Knoedler wrote that Beatty "was anxious to have Dagnan's Portrait of Childs for their exhibition. . . ."

304. Letter from Frick to Simon dated 9 January 1900 (Frick family archives).

305. See The Art Institute of Chicago, *Catalogue of the Works of P. A. Dagnan-Bouveret, A Loan Exhibition*, 1–24 March 1901 (Chicago, 1901), unpaginated.

306. Ibid.

307. For some of the reviews see the *Chicago Post*, 2 March 1901; *Chicago Times-Herald*, 3 March 1901 (with a reproduction of Dagnan's *Pardon in Brittany*); (Chicago) *Inter-Ocean*, 3 March 1901; and the *New York Commercial Advertiser*, 22 March 1901.

308. *Inter-Ocean*, 3 March 1901.

309. Letter from Harrison Morris to Frick dated 24 September 1901 (Frick family archives).

310. Ibid.

311. The painting was briefly mentioned in one review of the exhibition. See "Academy Exhibition is Better than Ever," *Philadelphia Public Ledger*, 20 January 1902, 7.

312. On Lhermitte see Monique Le Pelley Fonteny, *Léon Augustin Lhermitte, Catalogue Raisonné* (Paris, 1991).

313. See *Index, Pittsburgh Athletic Association* (undated).

314. *Dedication Souvenir, Carnegie Library*, 75, no. 187.

315. See Le Pelley Fonteny, *Lhermitte*, cat. no. 48. This painting was most likely shown in Pittsburgh, although no reference is made to the 1895 exhibition in the detailed provenance and exhibition history that is provided in the catalogue raisonné.

316. *Dedication Souvenir, Carnegie Library*, 75, no. 188. This painting has not been identified in the Le Pelley Fonteny catalogue raisonné of Lhermitte.

317. See Henry Clay Frick Paintings Purchases, 1881–1919 (Frick family archives). The current location of this painting is unknown, but it was never officially deaccessioned from the Frick collection. This suggests that Lhermitte was not of great interest to Frick.

318. On this painting see Le Pelley Fonteny, *Lhermitte*, cat. no. 165. The catalogue raisonné does not list its current location or its purchase by Frick, although it was shown at the Nationale in 1897 and acquired by Knoedler.

319. See Le Pelley Fonteny, *Lhermitte*, cat. no. 52.

320. *Catalogue, The Third Annual Exhibition Held at the Carnegie Institute* (1898), cat. no. 115.

321. *Index, Pittsburgh Athletic Association* (undated).

322. For reference to the Bing exhibition see E. Durand-Greville, "L'Exposition de Ch. Cottet," *L'Artiste* 66 (1896), 336–38, and G. M., "Studio-Talk," *Studio* 9 (1896), 291. It is doubtful that dealers with international connections held a large stock of Cottet paintings for sale. Cottet was, however, well represented in the Bing collection of paintings some of which were sold at public auction in 1900. For reference see *Collection Bing, Catalogue de Tableaux Modernes* (Paris, 1900).

323. See *Catalogue Société Nationale des Beaux-Arts* (Paris, 1894), 50, cat. no. 288. It is not certain when or through which dealer *Pardon in Brittany* entered the Porter collection.

324. The existence of an earlier version raises the issue of when *The Three Generations* was actually painted and why Cottet repeated themes so similar in style and attitude. See *Collection Bing*, fig. 31.

325. Arthur Anderson Jaynes, "The Art of Charles Cottet," *Brush and Pencil* 11 (October 1902–March 1903), 210–22.

326. See *Catalogue of the Eighth Annual Exhibition at the Carnegie Institute* (Pittsburgh, 1903), cat. nos. 172 and 173.

327. Raymond Gros, "The Carnegie Art Exhibition," *Pittsburgh Index*, 7 November 1903, 10.

328. "Art Exhibit's Collection is Now Complete," *Pittsburgh Post*, 17 October 1902, 2.

329. Jaynes, "Cottet," 212.

330. Gabriel Mourey, "The Work of Gaston Latouche," *Studio* 16 (March 1899), 84.

331. *Gaston Latouche, Exhibition of Paintings*, Bury Street Gallery, 17 October–2 November 1979 (London, 1979).

332. Mourey, "Latouche," 87.

333. *Catalogue, The Fourth Annual Exhibition Held at the Carnegie Institute* (1899), cat. no. 14, and *Catalogue, The Sixth Annual International Exhibition at the Carnegie Institute* (1901), cat. no. 134. Information on Latouche's receipt of the 1907 award was provided by the University Club, Pittsburgh.

334. On these attitudes see Neal, "Wise Extravagance," 30–32.

335. Ibid.

336. Ibid. Neal gives the impression that Beatty was "a stranger" to European art circles. This is misleading since Beatty was well acquainted with key European artists and their work.

337. *Brush and Pencil* published articles on American works at the Exposition Universelle ("American Art at Paris," vol. 6, April 1900) as well as numerous reports on "The Pittsburg Art Exhibition" (vol. 7, December 1900). Such articles reinforced the idea that Pittsburgh was actively engaged in sponsoring new American art. Neal ("Wise Extravagance," 28) notes that the "most elaborate" treatment of the Internationals appeared in *Brush and Pencil*, although he contends that the Internationals exemplified a "moderate school of American taste," without clarifying exactly what this signified at the turn of the century. On the purchasing of works from the Internationals see Neal ("Wise Extravagance," 94–99), where he comments that "an artist's chances of making a sale were remote."

338. Carnegie was interested in supporting American and some British painters (ibid., 95). This tendency was documented in the *Catalogue of the Second Loan Collection of Paintings and Permanent Collection of Statuary and Photographs, Carnegie Art Galleries* (Pittsburgh, 1896), which mentioned such works in the Carnegie collection, including paintings by E. A. Hornel (cat. nos. 26 and 31), Edwin Abbey (cat. no. 51), and Bruce Crane (cat. no. 78).

339. See *Dedication Souvenir, Carnegie Library* (1895).

340. On Carnegie's taste and collecting habits see Neal, "Wise Extravagance," 96–98. Neal stresses that Carnegie "made a point of buying the work of local artists."

341. Carnegie made it amply clear that he believed French art was in "no need of encouragement" (ibid., 96), and others pursued a collecting policy that did not clash with Carnegie's preferences.

342. Ibid., 32–33. On paintings by Alexander in Pittsburgh collections see *Index, Pittsburgh Athletic Association* (undated). His paintings and watercolors were also in the collections of Edward Jay Allen and Mrs. William Thaw. Beatty commissioned him to paint a portrait of Miss Helen M. Beatty.

343. "Treasures in High Art," *Pittsburgh Post*, 5 November 1896, 2.

344. See Julie Anne Springer, "Art and the Feminine Muse: Women in Interiors by John White Alexander," *Woman's Art Journal* 6, no. 2 (Fall 1985/Winter 1986), 1–8.

345. Information housed in the archives of the University Club, Pittsburgh. Alexander was elected a full member of the Société Nationale des Beaux-Arts in 1894 (Springer, "Feminine Muse," 3).

346. Springer, "Feminine Muse," 3–4. Women were seen as the exclusive vehicles for such subjective realities.

347. See "Jury of Award," *The Catalogue of the Sixth Annual International Exhibition at the Carnegie Institute*, 7 November 1901–1 January 1902 (Pittsburgh, 1901). Significantly, Alexander was also listed as participating on the Paris Advisory Committee to the International.

348. See "Honorary Committee," *Pan-American Exposition*, v. Also listed on this committee from Pittsburgh were Henry Clay Frick and William Nimick Frew. Charles L. Freer of Detroit served as a committee member as well.

349. Ibid., 6. Alexander's works were exhibited in Gallery C along with major paintings by James McNeill Whistler and Robert Henri.

350. Sandra Leff, "Master of Sensuous Line," *American Heritage* 36, no. 6 (October-November 1985), 83. She notes that his commission to paint the murals was $175,000.

351. For reference see *Index, Pittsburgh Athletic Association* (undated).

352. For reference see Gary A. Reynolds, "The Spirit of Empty Rooms: Walter Gay's Paintings of Interiors," *The Magazine Antiques* 137, no. 3 (March 1990), 676–82.

353. See *The Catalogue of the Sixth Annual International Exhibition at the Carnegie Institute*, 7 November 1901–1 January 1902, cat. nos. 93 and 94.

354. Reynolds carefully notes that Gay had extensive connections with the wealthy. He eventually painted scenes of the Fragonard and Boucher rooms in the Frick collection, New York. His patrons included Mrs. Vincent Astor, Robert W. Bliss, and Mrs. George S. Amory ("Spirit of Empty Rooms," 680).

355. Neal, "Wise Extravagance," 168.

356. Burns, "Untiring Worker," 38–45. How this painting came to be donated to the Mausoleum at Allegheny Cemetery still needs to be ascertained.

357. On her Philadelphia ties see Tara L. Tappert, "Cecilia Beaux: A Career as a Portraitist," *Women's Studies* 14, no. 4 (1988), 395.

358. To date, Beaux's European associations have been poorly examined. Sarah Burns, in an otherwise exemplary study of Beaux and Sargent, skimmed over her academic ties and training in Paris. See Sarah Burns, "The 'Earnest, Untiring Worker' and the Magician of the Brush: Gender Politics in the Criticism of Cecilia Beaux," *Oxford Art Journal* 15, no. 1 (1992), 36–37.

359. Ida A. Smith, "Art Show is Ready," *Pittsburgh Post*, 2 November 1899, 2.

360. *Pan-American Exposition*, 24–30. For a recent discussion of Beaux see Tara Leigh Tappert, *Cecilia Beaux and the Art of Portraiture*, exh. cat. (Washington and London, 1995).

361. Tappert *(Beaux, 391)* comments that at that time all "women were treated as a distinctive group by virtue of their gender." Due to praise for her work, Beaux may well have placed herself above others. Many male patrons would have found it difficult to accept her attitude.

362. Neal, "Wise Extravagance," 168. See "Prize Winning Artists," *Pittsburgh Post*, 4 November 1898, 2. A drawing of the painting also appeared in the newspaper. The review stated that the prize winners were "all quite famous on both sides of the Atlantic," which struck an international note.

363. *Index, Pittsburgh Athletic Association* (undated), where the painting is listed as *White Roses in a Bowl*.

364. John Ferguson Weir is briefly considered within the context of his brother's development. See Doreen Bolger Burke, *J. Alden Weir, An American Impressionist* (Newark, 1983), 34–35. The papers of John Ferguson Weir are found at Yale University, Sterling Memorial Library.

365. *Index, Pittsburgh Athletic Association* (undated).

366. Neal, "Wise Extravagance," 170–71. On the importance of the jury selection in 1897 see "Artists of Great Fame," *Pittsburgh Post*, 30 September 1897, 2. Chase served on the jury with Cecilia Beaux, Frank Benson, Winslow Homer, Frank Duveneck, and John La Farge. One local writer observed that "the election of this body has made Pittsburg the cynosure of the eyes of the artistic world." The writer also commented that Chase's work had "been viewed with delight in the art centers of the world."

367. Neal, "Wise Extravagance," 68. Also see Nicolai Cikovsky, Jr., *William Merritt Chase: Summers at Shinnecock, 1891–1902*, exh. cat. (Washington, D.C., 1987), 17.

368. Nicolai Cikovsky, Jr., "William Merritt Chase's Tenth Street Studio," *Archives of American Art Journal* 16, no. 2 (1976), 2–14. Also see *Catalogue, First Annual Exhibition, Carnegie Art Galleries*, 1896, cat. no. 47.

369. *Dedication Souvenir, Carnegie Library*, nos. 45–49.

370. Ulrich W. Hiesinger, *Impressionism in America: The Ten American Painters* (Munich, 1991), 235. Chase at one point owned twenty works by Antoine Vollon, a painter whose work was moderately collected in Pittsburgh.

371. Chase continually admired both Velásquez and Frans Hals. See ibid., 234. Also see Cikovsky, *Shinnecock*, 52-56, who notes that "Velásquez was not Chase's private enthusiasm . . . but one he shared with many of his contemporaries (like his friends Whistler and Thomas Eakins)."

372. See Gail Stavitsky, "Childe Hassam and the Carnegie Institute: A Correspondence," *Archives of American Art Journal* 22, no. 3 (1982), 2–7.

373. Hiesinger, *Impressionism in America*, 240.

374. Stavitsky ("Hassam," 3) notes that *Fifth Avenue in Winter* was purchased from the 1899 International for the Carnegie museum. This contradicts the impression that this painting was in the collection of John Caldwell before the turn of the century.

375. Frederick W. Morton, "Childe Hassam, Impressionist," *Brush and Pencil* 8 (April 1901), 141–50. For further discussion of the varied phases of Hassam's career see Ulrich W. Hiesinger, *Childe Hassam, American Impressionist* (Munich and New York, 1994).

376. For insight, albeit without any discussion of Pittsburgh high society, see Russell Lynes, *The Tastemakers: The Shaping of American Popular Taste* (New York, 1980), 136–37. Lynes comments that "social competition was acute among the rich, and standing was determined . . . by the richness of its homes, collection of paintings and tapestries. . . ."

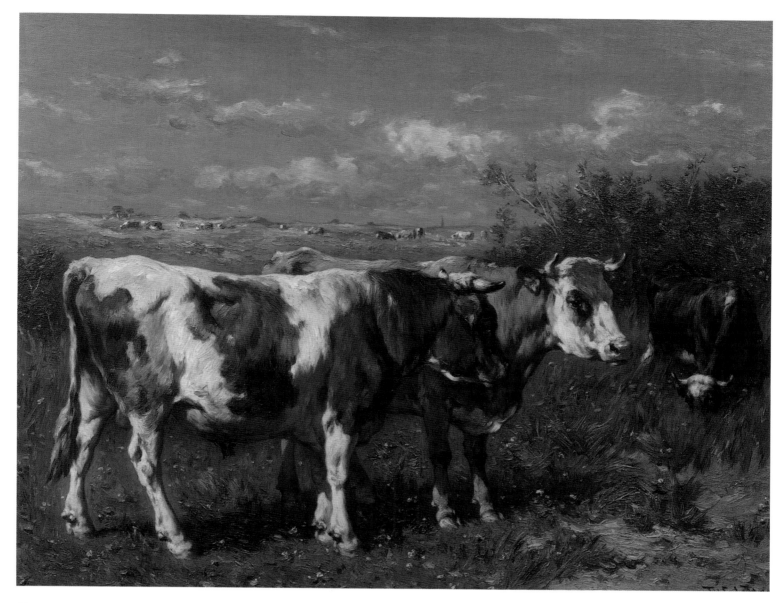

HUNGERFORD

1. Letter from Elisa Meissonier to Alphonse Moutte, 2 November 1889, Meissonier family archives.

2. Sketches for individual motifs, either undated or assigned to 1887–89, were auctioned in Meissonier's studio sale; see *Catalogue des tableaux, études peintes et dessins par E. Meissonier,* 13–20 May 1893, Hôtel Drouot, Paris. They include horses (nos. 207, 251, and 296), guides and grenadiers (nos. 297 and 759), and officers (nos. 201, 758, and 760).

3. See press reports on Meissonier's working actively on *1806, Jena,* for example, in *L'Evénement,* 19 March 1890. On the schism see Constance Cain Hungerford, "Meissonier and the Founding of the Société Nationale des Beaux-Arts," *Art Journal* 48, no. 1 (Spring 1989), 71–77.

4. See *Exposition Meissonier,* 24 May–24 July 1884, Galerie Georges Petit, Paris, no. 108 (measuring 24 by 40 cm.), and *Exposition Meissonier,* March 1893, Galerie Georges Petit, Paris, no. 922 (25 by 40 cm.).

In an uncatalogued album of photographs that Meissonier's widow gave to the Louvre's Département des Arts Graphiques, the 1884 work is annotated as "donnée à Mme Lippmann-Dumas / Colette à son mariage."

Born out of wedlock to the Princess Naryschkine on 20 November 1860, Marie-Alexandrine-Henriette, nicknamed Colette, was legitimized when Dumas married her mother four years later. Her father may have

Cat. 124. Johannes Hubertus Leonardus de Haas (1832–1908). *Landscape with Cattle,* n.d., oil on panel. Collection of Mr. and Mrs. Charles G. Pauli, Jr., Pittsburgh [Ex. coll., Park-Kelly].

loaned the work in 1893 because his daughter's marriage to Maurice Lippmann ended in divorce the previous year. See André Maurois, *The Titans: A Three-Generation Biography of the Dumas* (New York, 1957), 331, 341, 478 n. 2.

5. See *Exposition Meissonier*, 1893, no. 167; illustrated in the sale version of the catalogue *(Catalogue des tableaux*, 1893). Gustave Larroumet calls it a sketch *(Meissonier* [Paris, 1895], 15).

6. For a photograph of the wax sculpture see Antoinette Le Normand-Romain, "Meissonier Sculpteur," in *Ernest Meissonier Rétrospective*, exh. cat. (Lyons, 1993), 241, fig. 8. Although assumed to be for *1807, Friedland*, the figure resembles none of its cuirassiers, who lunge and twist rather than ride stiffly upright and straight ahead.

7. See ibid., 245, fig. 19. The photograph was taken from an album given to the Louvre by Meissonier's widow, who mistakenly inscribed the image as a model in red wax for *1807, Friedland*.

8. According to Lieutenant-Colonel Emile Duhousset (in *Le Cheval. Etudes des allures* [Paris, 1874], pl. 8 and comment), the first genre work to feature horses was *Cavalcade* of 1856. The work, now unlocated, is catalogued as *The Chariot* and reproduced in Valery C. O. Gréard, *Meissonier, His Life and His Art* (New York, 1897), 367, col. 2, no. 5, reproduced on p. 232. In the Paris version *(Jean-Louis-Ernest Meissonier, ses souvenirs, ses entretiens* [Paris, 1897], see 394–1–5, reproduced on p. 213.

9. The same pose was used in a number of subsequent works, including *Marshal Saxe and his Troops* (1866, Private Collection), *Antibes, Promenade on Horseback* (1868, Musée d'Orsay, Paris), and *A General and his Aide-de-Camp* (1869, The Metropolitan Museum of Art, New York).

10. Lieutenant-Colonel Emile Duhousset, *Le Cheval dans la nature et dans l'art* (Paris, 1902), 147. For the wax sculpture of Napoleon on his horse (Private Collection) see *Meissonier Rétrospective* (1993), 246–47, no. 146.

11. Olivier Merson, "Salon de 1864," *L'Opinion nationale*, 14 July 1864. See also Léon Lagrange, "Le Salon de 1864," *Gazette des beaux-arts* 16 (1864), 520.

12. Louis Auvray, *Exposition des Beaux-Arts. Salon de 1864* (Paris, 1864), 26.

13. Emile Duhousset, "Variétés: Reproduction instantanée des allures du cheval, au moyen de l'électricité appliquée à la photographie," *L'Illustration* 73 (25 January 1879), 58. Reproductions were in the form of silhouettes and outline drawings.

14. See Françoise Forster-Hahn, "Marey, Muybridge and Meissonier: The Study of Movement in Science and Art," in *Eadweard Muybridge. The Stanford Years, 1872–1882* (Palo Alto, 1972), 91–92. She also argues that Meissonier first saw the photographs at Marey's. See also Gréard, *Meissonier*, New York version, 77–78, 210–22, and Paris version, 72–73, 294–95.
 Meissonier's album is now in the Houghton Library at Harvard University.

15. See Gréard, *Meissonier*, New York version, 77–78, and Paris version, 72–73, as well as Robert Haas, *Muybridge. Man in Motion* (Berkeley, 1976), 128. The account in *Le Temps* (29 November 1881) referred to Muybridge as Meissonier's protégé and complimented the "elite" Meissonier for his unself-aggrandizing generosity in signaling the merit of another.

16. See Muybridge's report in a letter to Frank Shay, 23 December 1881, quoted in Haas, *Muybridge*, 138.

17. Muybridge reported using *1814, The Campaign of France* in a letter to Meissonier dated 12 December 1882 (Paris, Bibliothèque des Musées Nationaux, Ms. 424(2)M., f.225). Accounts of a lecture in London also mention that contemporary artists who rendered animal poses inaccurately were cited *(Illustrated London News*, 18 March 1882, 267). Muybridge's *Animals in Motion: An Electro-photographic Investigation of Consecutive Phases of Animal Progressive Movements*, first published in 1899, describes a painting by Bonheur, probably *Labourage Nivernais*, that had been faulted by Duhousset in 1874 (see Muybridge, 5th ed. [London, 1925], 23, and Duhousset, *Le Cheval)*. See also Haas, *Muybridge*, 133, on the transcript of one lecture published by the *Journal of the Society of Arts* (23 June 1882). Anita Ventura Mozley (in "Introduction to the Dover Edition," *Muybridge's Complete Human and Animal Locomotion*, vol. 1 [New York, 1979], xxxiii) reports that in the article in *La Nature* (5 October 1878) in which he first responded to Muybridge's photographs, Marey also used examples from art history and that Meissonier then encouraged Muybridge to make such comparisons.

18. See letters of 12 December 1882, 6 March 1883, and 21 April 1890 from Muybridge to Meissonier (Paris,

Bibliothèque des Musées Nationaux, Ms. 424(2)M., ff.225–230). On the planned joint publication see also Muybridge's correspondence to Shay on 23 December 1881, as quoted in Forster-Hahn, "Marey, Muybridge and Meissonier," 124, and Marta Braun, *Picturing Time: The Work of Etienne-Jules Marey (1830–1904)* (Chicago, 1992), 54–55, 229–31.

19. See "Leland Stanford's Gift to Art and Science" (attributed to Muybridge), (San Francisco) *Examiner*, 6 February 1881, reprinted in Forster-Hahn, "Marey, Muybridge and Meissonier," 119–23.

20. (Sacramento) *Daily Record-Union*, 23 July 1881 (dated from Paris, 26 June), quoted in Forster-Hahn, "Marey, Muybridge and Meissonier," 92.

21. See Mozley, *Muybridge's Complete Locomotion*, xxxiii, and a letter by Charles M. Kurtz, published in the (New York) *Evening Post*, 26 March 1887, reprinted in Forster-Hahn, "Marey, Muybridge and Meissonier," 127–28.

22. Braun, *Picturing Time*, 53–54; quoted from Etienne-Jules Marey, *La Chronophotographie* (Paris, 1899), 24.

23. Haas, *Muybridge*, 168, and Forster-Hahn, "Marey, Muybridge and Meissonier," 98–99.

24. The sculpture served as an aid in painting *General Championnet on the Seashore* (Musée des Beaux-Arts, Lyons), a problematic work that was kept in Meissonier's studio and then exhibited and sold only after his death. Though dated to 1882 in the studio sale *(Catalogue des tableaux*, 1893, no. 178), it bears only the estate monogram, not a signature, and is manifestly unfinished. Smudging and repainting indicate that the position of the feet of the trotting horse most dissatisfied the artist. See also *Meissonier Rétrospective*, 216–17, no. 125.

25. Georges Guéroult, "Formes, couleurs et mouvements," *Gazette des Beaux-Arts*, ser. 2, vol. 25 (February 1882), 178–79.

26. Emile Duhousset, "Le Cheval dans l'art," *Gazette des Beaux-Arts*, ser. 2, vol. 28 (1 November 1883), 407–23; vol. 29 (1 January 1884), 46–54; (1 March 1884), 242–56; (1 May 1884), 437–50, especially 446–50.

27. Duhousset's comment was published in 1902 in *Le Cheval dans la nature*, 147–48.

The drawing of *The Voyager*, dated 31 December 1879, is in the Musée du Louvre in the Département des Arts Graphiques, R.F. 2404. Several other drawings from the same sculpture are reproduced in Antoinette Le Normand-Romain's thorough discussion of the piece, *"Le Voyageur* de Meissonier," *La Revue du Louvre* (April 1985), 129–35. The first painting, *Voyager on Horseback* (unlocated), was exhibited in February 1880 at the Cercle de l'Union Artistique. An 1878 variant, *The Gust of Wind*, was auctioned in the Meissonier sale in 1893 (no. 157). The 1886 painting, illustrated by Le Normand-Romain (fig. 8), was shown in 1887 at the Cercle de l'Union Artistique and in 1889 at the Exposition Universelle. Gréard *(Meissonier*, New York version, 378–1–2; Paris version, 415–2–3) lists another painting with the same title, dated 1890 and unfinished.

28. See Emile Duhousset, "Les Cires de Meissonier," *Magasin pittoresque* 61 (15 June 1893), 196.

29. Braun, *Picturing Time*, 53, and Gustave Larroumet, "L'Exposition de Meissonier," *Nouvelles Etudes* (Paris, 1893), 214.

30. Only in *The Morning of Castiglione* (Musée d'Art et d'Archéologie, Moulins), a work left unfinished on his easel at his death, would Meissonier accept Muybridge's gallop. Begun in 1884, *Castiglione* was to be an ambitious work, destined for a eight-foot wide surface the equivalent of *Friedland*. Many of the horses are again sketched in Meissonier's way, with accurately bent forefeet paired with back feet splayed outward. The considerable degree of smudging and repainting suggests, however, that Meissonier was concentrating on these feet. Moreover, in December of 1890 he made another sculpture of General Duroc and his horse (wax and bronze versions are in the Musée des Beaux-Arts, Lyons). This time, although the rider's seat in his saddle is wrong—he should be raised forward—Meissonier incorporated the most disturbing revelation of Muybridge's photographs: at the moment when a galloping horse's feet are most off the ground, they are bunched under its body, the antithesis of the conventional "flying" position. He faithfully included this in the composition at a greatly foreshortened angle, placing the horse two figures to the right of Napoleon. On the Duroc sculpture see *Meissonier Rétrospective* (1993), nos. 162 and 163.

31. The 1889 sketch, located in a private collection, is reproduced in ibid., no. 112; for two others see Meissonier sale *(Catalogue des tableaux*, 1893), nos. 216 and 762.

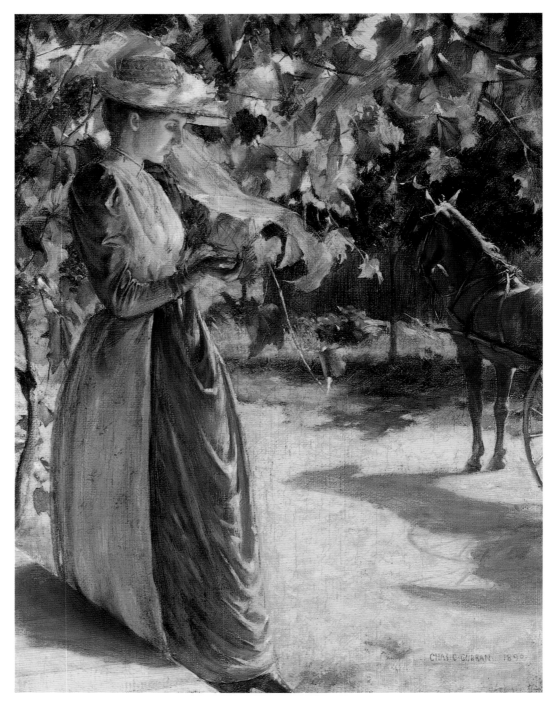

Cat. 125. Charles C. Curran (1861–1942). *Woman Standing by Horse and Carriage*, 1890, oil on canvas. Frick Art & Historical Center, Pittsburgh.

MEYER AND BEAUFORT

1. See William H. Gerdts, *Art Across America: Two Centuries of Regional Painting, 1710–1920*, 3 vols. (New York, 1990), for extensive information about these early institutions.

2. A historical background for collecting in the Midwest with information about its patriotic flavor is found in chapter 15 of Lillian B. Miller, *Patrons and Patriotism: The Encouragement of the Fine Arts in the United States, 1790–1860* (Chicago, 1966).

3. *Harper's Weekly*, 16 April 1864.

4. *The History of Cincinnati and Hamilton County, Ohio* (Cincinnati, 1894), 498, which is typical of local historical information.

5. Edward Strahan [Earl Shinn], ed., *The Art Treasures of America*, vol. 3 (Philadelphia, 1882), 69.

6. Probasco purchased at least nine major paintings by Rousseau, Millet, Rosa Bonheur, and Jules Dupré at the Durand-Ruel gallery in Paris between May and December 1867.

7. Montezuma [Montague Marks] repeatedly alluded that Probasco sold his collection directly to the American Art Galleries, making it incorrect to call this the Probasco sale *(Art Amateur* 1, no. 6 [April 1887], 124). In June 1887, Marks mentioned that Mr. Durand-Ruel was going to sue the American Art Association for his claim of profits on this sale, which he had affected on its behalf *(Art Amateur* 22, no. 2 [20 January 1890], 30–31).

Millet's *Peasants Bringing Home a Calf Born in the Fields* was sold to Samuel P. Avery for $18,500, and William Schaus purchased Theodore Rousseau's *Summer Landscape* for $21,000. Probasco paid 7,000F (about $1,400) for the Millet in 1867.

8. Montezuma, "My Notebook," *Art Amateur* (May 1887), 124, mentions that Probasco intended to give his collection to Cincinnati, but people took it for granted and spoke slightingly of the collection.

9. "Art Notes," *American Register* 16, no. 858 (13 September 1884), 5, said that the catalogue of the Cincinnati exhibition would have fifty illustrations and next year's publication would contain no advertising.

10. Strahan, *Art Treasures*, vol. 2, 58.

11. Graham Beal, *Charles Parsons' Collection of Paintings* (St. Louis, 1977).

12. Strahan, *Art Treasures*, vol. 2, 58.

13. Ibid., vol. 3, 54–55.

14. Ibid., 56.

15. Letter from Elizabeth Gardner to Jonas Gilman Clark dated 14 March 1872, University Archives, Clark University, Worcester, Massachusetts.

16. Committee members included American artists and art collectors, the Reverend Henry Ward Beecher, and Goupil's former associate Michel Knoedler, who had established his own gallery in New York in 1857. A similar committee in France included a number of established French artists. As chairman of the French committee, Ernest Meissonier was theoretically assisted by a prestigious list of Salon favorites: the director of the Ecole des Beaux-Arts, Guillaume, Baudry, Bouguereau, Boulanger, Brion, Cabanel, Dubufe, Fromentin, Garnier, Gérôme, Jalabert, Pils, Puvis de Chavannes, and Vibert. These charitable auctions became more frequent in France at the time of the Franco-Prussian War (1870–71) and presented an alternative to exhibiting at the juried French Salon.

17. Stefan Germer, "Pictures at an Exhibition," *Chicago History* (Spring 1987), 8.

18. Ibid.

19. Evidently Marshall Field's own significant collection was unknown to Strahan, or its contents lay outside his interests.

20. Chicago Literary Club, "In Memoriam, Henry Field," n.d., information provided by the Chicago Historical Society.

21. Lilian M. C. Randall, *The Diary of George A. Lucas: An American Art Agent in Paris, 1857–1909*, 2 vols. (Princeton, 1979). Lucas provides information about Field, who retired in 1883 at the age of forty-two. He lived in Paris for extended periods from 1880 to 1882, and was assisted by George A. Lucas in purchasing paintings and etchings. See entries for 2 October and 7 December 1887, and 3, 4, and 12 January 1888. *Collector* 4, no. 16 (1 July 1893), 247, provides a list of the forty-one works in the Henry Field collection.

22. We thank Madame Annette Bourrut-Lacouture for bringing this letter to our attention.

23. Strahan, *Art Treasures*, vol. 3, 66.

24. Both of these artists were trained or influenced by Gérôme.

25. Arthur Hewitt, *Brush and Pencil* 7, no. 1 (October 1900), 63, felt that paintings in the collection were less important than the objects. Nickerson purchased much of his porcelain at Mary Jane Morgan's highly publicized sale in 1886.

26. By the end of the 1880s references were consistently made to the issue of collecting paintings by the old masters. See, for example, "Art Notes," *Art Review* 1 (January 1887), 10; "The Reopening of the Metropolitan

Museum," *Harper's Weekly* (29 December 1888); and William Howe Downes, "Old Masters in New York," *Atlantic* (July 1889), 37–43.

27. The Wallace Collection, *Anatole Demidoff, Prince of San Donato (1812–1870)* (London, 1994), contains an appendix with details of the Demidoff family art sales.

28. *Collector* 3, no. 7 (1 February 1892), 98. Alfred Trumble was the editor and proprietor of the *Collector* in New York. In 1889 Trumble inaugurated his newsletter for art and book collectors out of his concern that Americans, disadvantaged in their dealings on the international art market, needed up-to-date information. Intending the semimonthly publication to be "a current record of art, bibliography and antiquarianism," Trumble published lists of prominent collector's holdings, auction results, and reports of the activities of famous or popular artists.

29. *Collector* 3, no. 11 (1 April 1892), 171.

30. Jacob Landy, "The Domestic Architecture of the 'Robber Barons,'" *Marsyas* 5 (1950), 63–85.

31. Before coming to Chicago, Potter Palmer, a six-foot-tall Quaker, began his career in Albany County, New York, as a grocer's clerk. On his arrival in Chicago he sold dry goods before he made his fortune in real estate.

32. *Collector* 3, no. 16 (15 June 1892), 252.

33. The *American Register* reported on 28 November 1885 that David Neal would be in Chicago to paint a frieze for Mrs. Potter Palmer's library in her new home. Gari Melchers worked in Chicago during the winter of 1889–90 in a room set aside for him by the Palmers. Melchers was credited with having painted a portrait of Potter Palmer in 1889. See Diane Lesko, ed., *Gari Melchers, A Retrospective Exhibition* (St. Petersburg, Florida, 1990), 63. *An Aztec Artist* by George de Forest Bush was in the Palmer collection, as was a study of the central figure playing castanets in *The Spanish Quatour* by W. T. Dannat.

34. *Collector* 4, no. 15 (1 June 1893), 231, also suggests that Palmer was one of the first in the United States to buy a work by Cazin. Henry Field's collection actually included four Cazin paintings by that time.

35. Strahan, *Art Treasures,* vol. 3, 68, provides a list of the Hurlbut paintings.

36. *American Register* 15, no. 824 (19 January 1884) announced that David Neal of Munich was returning to the United States to paint portraits of the Hurlbut family of Cleveland. It also announced that Hurlbut had just purchased Neal's *Cromwell Visiting Milton.*

37. Walter C. Leedy, Jr., *Cleveland Builds an Art Museum: Patronage, Politics, and Architecture, 1884–1916* (Cleveland, 1991), and Evan H. Turner, *Object Lessons: Cleveland Creates an Art Museum* (Cleveland, 1991).

38. Photographs were made of many paintings exhibited at the Paris Salons. Goupil and later Boussod, Valladon et Cie. in Paris compiled volumes of photographs of paintings by the artists they represented.

39. Nancy Coe, "The History of the Collecting of European Paintings and Drawings in the City of Cleveland," master's thesis, Oberlin College, 1955; see chapter 3.

40. *Handbook for Visitors to the Hollenden Gallery of Old Masters: Exhibited at the Boston Foreign Art Exhibition in 1883–4, Collected by James Jackson Jarves and Purchased by L. E. Holden of Cleveland, Ohio* (1884). Before he worked in real estate and journalism, Holden held a post as professor of rhetoric and English at Kalamazoo College (1853–59) and received a master's degree from the University of Michigan in 1858. He served as superintendent of schools in Tiffin, Ohio, in 1861 and 1862, at which time he was admitted to the Ohio bar.

41. Minor Kellogg trained in Cincinnati from 1841 to 1845 and worked in Italy from 1854 to 1858.

42. Frances Weizenhofer, *The Havemeyers: Impressionism Comes to America* (New York, 1986), 263, n. 1, mentions that Pope lent a painting by Monet to an exhibition of works by the artist at the Union League Club in New York in February 1891.

43. Coe, "History of Collecting," chapter 4, xxiii.

44. Alger was a general during the Civil War, governor of Michigan in the 1880s, U.S. Secretary of War from 1897 to 1899, and a U.S. senator from 1902 to 1907. Although he already owned the Munkácsy painting, Alger allowed the dealer Charles Sedelmeyer to arrange for it to tour the country. An etching of the painting by Armand Mathey as well as a brochure describing the artist and discussing Mozart's career and the "favorable opinions of the press" were available for purchase on the tour.

45. William H. Peck, *The Detroit Institute of Arts, A Brief History* (Detroit, 1991).

46. These objects sometimes included souvenirs, such as a leaf found on Virgil's tomb or items found at archaeological excavations.

47. Robert Wickenden, a naturalized American artist, studied with Carroll Beckwith and William Merritt Chase before he went to Paris in 1883 and attended the Ecole des Beaux-Arts. He painted portraits of notable Canadians and produced a portrait of Edward VII, king of England, in 1911 for the government of Nova Scotia.

48. James E. Scrippes, ed., *Catalogue of the Scripps Collection of Old Masters* (Detroit, 1889), i.

49. Ibid.

50. Ibid., v. Here Scripps quotes from a letter he received from Charles B. Curtis of New York, who had published a book cataloguing works by Velásquez and Murillo. Curtis endorses Scripps's views and says, "At present the fashion sets toward the style of Diaz and Bouguereau. How long this may last we cannot tell. . . . But Murillo and Claude have lasted two centuries with increasing fame."

51. Ibid.

52. Ibid., vi.

53. Lillian B. Miller, "The Milwaukee Art Museum's Founding Father Frederick Layton (1827–1919) and His Collection," in *Milwaukee, Wisconsin, Milwaukee Art Museum 1888–1988, A Centennial Exhibition* (Milwaukee, 1988).

54. *Brush and Pencil*, no. 3 (October 1898).

55. A description of the house and collection is provided by Clara M. White, "A Western Art Collection," *Brush and Pencil*, no. 4 (July 1899). "Opening from this room is still another, called the bronze room, where Mr. Walker has a large collection of rare and costly bronze vases, and a case of curious and valuable articles of Chinese workmanship—crystal snuff-bottles, and small intricate carvings in ivory. Here too are hung a few precious old paintings, among them an 'Old Crome,' and a portrait of an old lady by Ferdinand Bol." Walker also collected portraits from the Napoleonic era. More recently, Martin Friedman discusses Walker's taste in the introduction to *Catalogue of the Walker Art Center* (Minneapolis and New York, 1990).

56. White, "Western Art Collection." Walker also described his purchase of a painting by Virginie Demont-Breton, the artist's daughter, which he discovered hanging in the Salon of 1889.

57. Jane H. Hancock, Sheila ffolliott, and Thomas O'Sullivan, *Homecoming: The Art Collection of James J. Hill* (St. Paul, 1991).

58. Rollin Van N. Hadley, ed., *The Letters of Bernard Berenson and Isabella Stewart Gardner* (Boston, 1987), 452.

59. See William Howard Taft papers, series 1, 11 February 1903, Library of Congress, Washington, D.C.

Cat. 126. Jean Georges Vibert (1840–1902). *Scramble for the Lunch*, n.d., oil on canvas. Collection of Katherine L. Griswold, Pittsburgh [Ex. coll., Charles Lockhart].

List of Exhibited Works

John White Alexander (1856–1915)
Girl in Green with Peonies
1896
Oil on canvas
48 x 36 1/2 inches
University Club, Pittsburgh
(Cat. 1)

Sir Lawrence Alma–Tadema (1836–1912)
Watching and Waiting
1897
Opus CCCXLIV
Oil on panel
26 x 17 3/4 inches
Dorothy A. Smith Bequest, Museum of Art,
Fort Lauderdale
[Ex. coll., Henry Clay Frick]
(Cat. 64)

Sir Lawrence Alma–Tadema (1836–1912)
Hero
1898
Opus CCCLII
Oil on panel
15 1/4 x 9 3/4 inches
Private collection, courtesy Guggenheim-
Asher Associates, New York
[Ex. coll., Henry W. Oliver, Jr.]
(Cat. 16)

Anonymous 19th century, possibly Dutch
Smoker
c. 1880–1890
Oil on panel
12 x 9 1/2 inches
Collection of Mrs. Henry Chalfant,
Sewickley, Pennsylvania
(Cat. 58)

Hugh Barron (1745–1791)
*Portrait of a Lady (Perhaps Isabelle
d'Almeida)*
n.d.
Oil on canvas
50 x 40 inches
In the Collection of the Corcoran Gallery of
Art, William A. Clark Collection
[Ex. coll., Henry Clay Frick]
(Cat. 33)

John W. Beatty (1851–1924)
Harvest Scene
n.d.
Oil on canvas
19 1/2 x 29 inches
Frick Art & Historical Center, Pittsburgh
(Cat. 44)

Cecilia Beaux (1855–1942)
Portrait of James Murdock Clark, Jr.
1908
Oil on canvas
62 x 32 3/8 inches
Allegheny Cemetery, Pittsburgh
Gift of Mrs. E. Russell Peters
(Cat. 71)

Emile Boilvin (1845–1899)
after Pascal-Adolphe-Jean Dagnan-Bouveret
(1852–1929)
Christ and the Disciples at Emmaus
c. 1899
Etching (remarque proof)
22 1/4 x 29 7/16 inches
Frick Art & Historical Center, Pittsburgh
(Cat. 106)

William-Adolphe Bouguereau (1825–1905)
The Dance
1868
Oil on canvas
45 x 64 inches
Pittsburgh Athletic Association
(Cat. 77)

William-Adolphe Bouguereau (1825–1905)
Souvenir
1895
Oil on canvas
45 x 26 inches
Carnegie Museum of Art, Pittsburgh;
Bequest of Henry Buhl, Jr.
(Cat. 78)

William-Adolphe Bouguereau (1825–1905)
L'Iris (Woman with Iris)
1895
Oil on canvas
18 1/8 x 15 inches
The Art Museum, Princeton University.
Gift of Mrs. William Hodge Burchfield in
memory of her husband, William Hodge
Burchfield, and her son, Thomas Howell
Burchfield.
[Ex. coll., William Hodge Burchfield]
(Cat. 42)

William-Adolphe Bouguereau (1825–1905)
Idylle Enfantine
1900
Oil on canvas
40 x 51 1/2 inches
The Denver Art Museum
Gift of the Lawrence C. Phipps Foundation
[Ex. coll., Lawrence C. Phipps]
(Cat. 76)

Jules-Adolphe Breton (1827–1906)
Harvesters
1886
Oil on canvas
40 x 31 inches
Duquesne Club, Pittsburgh
(Cat. 73)

Jules-Adolphe Breton (1827–1906)
The Last Gleanings
1895
Oil on canvas
36 1/2 x 55 inches
The Henry E. Huntington Library and Art
Gallery, San Marino, California
[Ex. coll. Henry Clay Frick]
(Cat. 74)

Jules-Adolphe Breton (1827–1906)
Returning from Work, (L'Aurore)
1896
Oil on canvas
36 x 28 1/2 inches
Carnegie Museum of Art, Pittsburgh; Pre-
sented by Sarah Mellon Scaife (Mrs. Alan M.)
and Richard King Mellon in memory of their
mother, Jennie King Mellon
[Ex. coll., David T. Watson]
(Cat. 72)

Léon Brunin (1861–1949)
The Alchemist
n.d.
Oil on canvas
21 3/4 x 17 3/4 inches
Private collection, Pittsburgh
[Ex. coll., Charles Lockhart]
(Cat. 61)

Jean-Charles Cazin (1841–1901)
The Dipper
n.d.
Oil on canvas
23 5/8 x 28 3/4 inches
Frick Art & Historical Center, Pittsburgh
(Cat. 79)

Jean-Charles Cazin (1841–1901)
The Pool — Grey Night
1886
Oil on canvas
21 1/4 x 17 3/4 inches
Frick Art & Historical Center, Pittsburgh
(Cat. 80)

Jean-Charles Cazin (1841–1901)
Sunday Evening in a Miners' Village
c. 1892
Oil on canvas
46 x 32 inches
Frick Art & Historical Center, Pittsburgh
(Cat. 32)

Edvard Charlemont (1848–1906)
Venetian Pageboy
n.d.
Oil on canvas
9 x 5 inches
Collection of Katherine L. Griswold, Pitts-
burgh
[Ex. coll., Charles Lockhart]
(Cat. 127)

Théobald Chartran (1849–1907)
Portrait of Andrew Carnegie
1895
Oil on canvas
46 1/2 x 35 inches
Carnegie Museum of Art, Pittsburgh;
Gift of Henry Clay Frick, 1896
(Cat. 30)

Théobald Chartran (1849–1907)
Portrait of Henry Phipps
1895
Oil on canvas
42 1/4 x 34 1/4 inches
Phipps Conservatory, Pittsburgh
(Cat. 67)

Théobald Chartran (1849–1907)
*Portrait of Mrs. Thomas Mellon (Sarah
Negley)*
1896
Oil on canvas
46 x 36 inches
Carnegie Museum of Art, Pittsburgh; Gift of
James R. Mellon, Andrew W. Mellon,
Richard B. Mellon and the Children of the
late Thomas A. Mellon
(Cat. 66)

Théobald Chartran (1849–1907)
Les Matines à la Grande-Chartreuse
1896
Oil on canvas
68 x 84 inches
DePaul Institute, Pittsburgh
Gift of the artist to Carnegie Institute in
1899; donated to DePaul Institute in 1922
(Cat. 68)

Théobald Chartran (1849–1907)
Portrait of Charles Lockhart
1897
Oil on canvas
45 1/4 x 34 1/4 inches
Collection of Mr. and Mrs. James M.
Edwards, Pittsburgh
[Ex. coll., Charles Lockhart]
(Cat. 11)

Théobald Chartran (1849–1907)
Portrait of Mrs. Charles Lockhart
1897
Oil on canvas
45 1/4 x 34 1/4 inches
Collection of Mr. and Mrs. James M.
Edwards, Pittsburgh
[Ex. coll., Charles Lockhart]
(Cat. 10)

Théobald Chartran (1849–1907)
Portrait of James Hazen Hyde
1901
Oil on canvas
51 1/2 x 34 3/4 inches
The New-York Historical Society
(Cat. 69)

William Merritt Chase (1849–1916)
Interior, Oak Manor
1899
Oil on canvas
26 1/2 x 26 1/2 inches
Richard M. Scaife, Pittsburgh
[Ex. coll., Henry Kirke Porter]
(Cat. 116)

William Merritt Chase (1849–1916)
An Infanta, a Souvenir of Velasquez (Helen Velasquez Chase)
1899
Oil on canvas
30 1/4 x 24 1/8 inches
Collection of Joel R. Strote and Elisa Ballestas, Westlake Village, California
[Ex. coll., Henry Kirke Porter]
(Cat. 3)

Jan V. Chelminski (1851–1925)
Mounted Grenadier and Aide-de-Camp of Napoleon
(*Asking Information, Episode, Campaign of 1812, Poland*)
c. 1897
Oil on canvas
18 x 26 1/2 inches
Collection of Mr. and Mrs. Thomas M. Schmidt, Pittsburgh
[Ex. coll., Andrew W. Mellon]
(Cat. 52)

John Constable (1776–1837) [school of]
Farm at Cheshire
n.d.
Oil on canvas
22 3/4 x 34 inches
Collection of Laurada and Russell G. Byers, Chestnut Hill, Pennsylvania
[Ex. coll., Alexander M. Byers]
(Cat. 22)

Robert Cooper (b. 1821 active 1850–1874)
On the Truro near Dalwhini, Perthshire
1870
Watercolor
23 x 35 1/2 inches
Collection of Dr. and Mrs. Robert Lipinski, Pittsburgh
[Ex. coll., Park-Kelly]
(Cat. 129)

Jean-Baptiste-Camille Corot (1796–1875)
Crown of Flowers
c. 1865–1870
Oil on canvas
25 1/2 x 17 inches
The Baltimore Museum of Art: The Helen and Abram Eisenberg Collection
[Ex. coll., Henry Clay Frick]
(Cat. 18)

Jean-Baptiste-Camille Corot (1796–1875)
View of Lake Garda
c. 1865–1870
Oil on canvas
24 x 36 3/8 inches
The Nelson-Atkins Museum of Art, Kansas City, Missouri
Gift of Mr. Clark Bunting in memory of his wife, Catherine Conover Bunting
[Ex. coll., Andrew W. Mellon]
(Cat. 41)

Charles Cottet (1863–1924)
The Three Generations
c. 1908–1910
Oil on canvas
22 x 27 1/2 inches
Columbus Museum of Art, Ohio; Gift of Robert Lazarus, Sr.
[Ex. coll., Henry Kirke Porter]
(Cat. 111)

Charles C. Curran (1861–1942)
Woman Standing by Horse and Carriage
1890
Oil on canvas
11 1/2 x 8 3/4 inches
Frick Art & Historical Center, Pittsburgh
(Cat. 125)

Pascal-Adolphe-Jean Dagnan-Bouveret (1852–1929)
Head of Christ, Study for Christ and the Disciples at Emmaus
n.d.
Charcoal on paper
13 1/4 x 13 1/4 inches
Frick Art & Historical Center, Pittsburgh
(Cat. 102)

Pascal-Adolphe-Jean Dagnan-Bouveret (1852–1929)
Study for Christ and the Disciples at Emmaus
n.d.
Colored chalk on paper, pricked for transfer
14 1/2 x 13 3/4 inches
Carnegie Museum of Art, Pittsburgh
Leisser Art Fund
(Cat. 103)

Pascal-Adolphe-Jean Dagnan-Bouveret (1852–1929)
Study for Christ and the Disciples at Emmaus: Portrait of Jean Dagnan
n.d.
Graphite and white chalk on gray paper
9 1/2 x 6 3/4 inches
Musée Municipal Georges Garret, Vesoul, France
(Cat. 104)

Pascal-Adolphe-Jean Dagnan-Bouveret (1852–1929)
Self-Portrait
1876
Oil on canvas
10 x 8 1/4 inches
Musée Municipal Georges Garret, Vesoul, France
(Cat. 97)

Pascal-Adolphe-Jean Dagnan-Bouveret (1852–1929)
Portrait of Mademoiselle Walter with Parasol
1878
Oil on panel
6 x 5 inches
Musée Municipal Georges Garret, Vesoul, France
(Cat. 100)

Pascal-Adolphe-Jean Dagnan-Bouveret (1852–1929)
Bernoise
1887
Oil on canvas
21 7/8 x 16 1/2 inches
John G. Johnson Collection
Philadelphia Museum of Art
(Cat. 99)

Pascal-Adolphe-Jean Dagnan-Bouveret
(1852–1929)
Étude de Soir, sous la lampe (Madame Dagnan and her Son Jean)
1890
Charcoal on white paper
32 3/4 x 20 1/4 inches
Musée Municipal Georges Garret, Vesoul, France
(Cat. 105)

Pascal-Adolphe-Jean Dagnan-Bouveret
(1852–1929)
Christ and the Disciples at Emmaus
1896–1897
Oil on canvas
78 x 110 1/2 inches
Carnegie Museum of Art, Pittsburgh;
Presented in memory of Martha Howard Frick by Mr. and Mrs. H. C. Frick
(Cat. 101)

Pascal-Adolphe-Jean Dagnan-Bouveret
(1852–1929)
Portrait of Childs Frick
c. 1899
Oil on canvas
56 1/4 x 42 1/2 inches
Frick Art & Historical Center, Pittsburgh
Gift of Dr. and Mrs. Henry Clay Frick, II
(Cat. 9)

Pascal-Adolphe-Jean Dagnan-Bouveret
(1852–1929)
Consolatrix Afflictorum
1899
Oil on canvas
88 x 77 inches
Frick Art & Historical Center, Pittsburgh
(Cat. 108)

Pascal-Adolphe-Jean Dagnan-Bouveret
(1852–1929)
Study for Consolatrix Afflictorum
c. 1899
Oil on panel
17 5/8 x 12 5/8 inches
Frick Art & Historical Center, Pittsburgh
(Cat. 109)

Pascal-Adolphe-Jean Dagnan-Bouveret
(1852–1929)
Study for Consolatrix Afflictorum
c. 1899
Oil on paper laid down on cardboard
17 1/2 x 13 3/4 inches
Musée Municipal Georges Garret, Vesoul, France
(Cat. 110)

Pascal-Adolphe-Jean Dagnan-Bouveret
(1852–1929)
Portrait of Jean-Léon Gérôme in the Uniform of the Académie Française
1902
Oil on canvas
19 1/2 x 16 inches
Musée Municipal Georges Garret, Vesoul, France
(Cat. 98)

Charles-François Daubigny (1817–1878)
My Houseboat on the Oise
n.d.
Oil on canvas
9 3/8 x 15 inches
Carnegie Museum of Art, Pittsburgh
Gift of Mary McCune Edwards
[Ex. coll., Charles Lockhart]
(Cat. 12)

Ferdinand Victor Eugène Delacroix
(1798–1863)
Arab Horseman Giving a Signal
1851
Oil on canvas
22 x 18 1/4 inches
The Chrysler Museum of Art, Norfolk, Virginia
Gift of Walter P. Chrysler, Jr.
[Ex. coll., Alexander M. Byers]
(Cat. 20)

Alphonse Marie De Neuville (1835–1885)
The Post of Danger
1876
Oil on panel
14 x 9 inches
Collection of Katherine L. Griswold, Pittsburgh
[Ex. coll., Charles Lockhart]
(Cat. 19)

Alphonse Marie De Neuville (1835–1885)
French Grenadier
1876
Oil on panel
12 5/8 x 9 1/4 inches
Collection of Katherine L. Griswold, Pittsburgh
[Ex. coll., Charles Lockhart]
(Cat. 13)

Narcisse Virgile Diaz de la Peña (1807–1876)
A Pond of Vipers
1858
Oil on canvas
22 x 30 inches
Frick Art & Historical Center, Pittsburgh
(Cat. 31)

José Domingo y Muñoz (1843–1894)
The Cabaret
1881
Oil on panel
25 1/2 x 18 inches
University Club, Pittsburgh
(Cat. 57)

Julien Dupré (1851–1910)
The Wheatfield
1882
Oil on canvas
25 x 31 1/2 inches
Allegheny Cemetery, Pittsburgh
Given in memory of William C. Moreland
(Cat. 43)

Léopold Flameng (1831–1899)
after Pascal-Adolphe-Jean Dagnan-Bouveret
(1852–1929)
Consolatrix Afflictorum
c. 1899–1903
Etching (remarque proof)
25 5/16 x 20 1/8 inches
Frick Art & Historical Center, Pittsburgh
(Cat. 107)

Emile Friant (1863–1932)
Preliminary study for Chagrin d'Enfant
n.d.
Charcoal on paper
17 3/4 x 11 3/4 inches
Private Collection, France
(Cat. 94)

Emile Friant (1863–1932)
Finished study for Chagrin d'Enfant
1897
Charcoal on paper
25 1/4 x 33 inches
Private Collection, France
(Cat. 95)

Emile Friant (1863–1932)
Chagrin d'Enfant
1897
Oil on panel
27 3/4 x 17 5/8 inches
Frick Art & Historical Center, Pittsburgh
(Cat. 96)

Emile Friant (1863–1932)
L'Entrée des Clowns
1881
Oil on panel
10 1/2 x 16 inches
Private Collection, France
(Cat. 88)

Emile Friant (1863–1932)
Madame Coquelin Mère
1888
Oil on panel
16 1/2 x 11 3/4 inches
Private Collection, France
(Cat. 89)

Emile Friant (1863–1932)
La Discussion Politique
1889
Oil on panel
10 1/2 x 13 1/2 inches
Private Collection, France
(Cat. 90)

Emile Friant (1863–1932)
The Garden Walk
1889
Oil on panel
8 5/16 x 8 1/8 inches
John G. Johnson Collection
Philadelphia Museum of Art
(Cat. 91)

Emile Friant (1863–1932)
Le Repas Frugal
1894
Oil on panel
11 3/4 x 14 3/4 inches
Private Collection, France
(Cat. 92)

Emile Friant (1863–1932)
Tendresse Maternelle
1906
Oil on panel
24 1/4 x 17 1/2 inches
Private Collection, France
(Cat. 93)

Eugène Fromentin (1820–1876)
Arab Warriors Return from a Fantasia
1861
Oil on canvas
47 x 38 inches
Carnegie Museum of Art, Pittsburgh;
Gift of Mrs. J. Frederic Byers
[Ex. coll., Alexander M. Byers]
(Cat. 21)

Walter Gay (1856–1937)
The Old Fireplace
n.d.
Oil on canvas
21 3/4 x 18 1/4 inches
Carnegie Museum of Art, Pittsburgh;
Gift of Miss A. M. Hegeman from the Collection of her Mother, Mrs. Henry K. Porter
[Ex. coll., Henry Kirke Porter]
(Cat. 114)

Walter Gay (1856–1937)
The Three Vases
n.d.
Oil on artist's board
21 3/4 x 18 1/4 inches
Carnegie Museum of Art , Pittsburgh;
Gift of Miss A. M. Hegeman from the Collection of her Mother, Mrs. Henry K. Porter
[Ex. coll., Henry Kirke Porter]
(Cat. 113)

Jean-Léon Gérôme (1824–1904)
Night in the Desert
1884
Oil on canvas
21 1/2 x 38 1/2 inches
Carnegie Museum of Art, Pittsburgh;
Gift of the Thomas H. Nimick, Jr. Family
in memory of Florence Lockhart Nimick
[Ex. coll., Charles Lockhart]
(Cat. 47)

Jean-Léon Gérôme (1824–1904)
The Marble Work (L'Artiste Sculptant Tanagra)
1890
Oil on canvas
19 7/8 x 15 9/16 inches
Dahesh Museum, New York
(Cat. 75)

Frederick Goodall (1822–1904)
Rosa Bonheur at Work near Wexham
1856
Oil on panel
15 3/4 x 20 inches
Collection of Morton C. Bradley, Jr., Arlington, Massachusetts
[Ex. coll., H. J. Heinz]
(Cat. 6)

Johannes Hubertus Leonardus de Haas
(1832–1908)
Landscape with Cattle
n.d.
Oil on panel
21 x 27 inches
Collection of Mr.and Mrs. Charles G. Pauli,
Jr., Pittsburgh
[Ex. coll., Park-Kelly]
(Cat. 124)

Georges-Jean-Marie Haquette (1854–1906)
Une Sortie
n.d.
Oil on canvas
36 1/2 x 55 inches
The McCune Foundation, Pittsburgh
[Ex. coll., Charles Lockhart]
(Cat. 2)

Adrien Harmand (19th c.)
The Whipper Inn
1888
Oil on canvas
19 x 24 1/2 inches
Collection of Mr. and Mrs. James M.
Edwards, Pittsburgh
[Ex. coll., Charles Lockhart]
(Cat. 56)

Henri-Joseph Harpignies (1819–1916)
Etang - Coucher du Soleil (Landscape)
c. 1884
Oil on canvas
31 3/4 x 20 1/4 inches
The Art Museum, Princeton University
Gift of David H. McAlpin
[Ex. coll., John G. Holmes]
(Cat. 37)

Henri-Joseph Harpignies (1819–1916)
Landscape of Trees and Lake
1906
Oil on canvas
26 x 32 inches
University Club, Pittsburgh
(Cat. 38)

Childe Hassam (1859–1935)
Nocturne, Big Ben
n.d.
Oil on canvas
11 x 14 inches
Collection of Alexandra and Sidney Shel-
don, Beverly Hills, California
[Ex. coll., William H. Black]
(Cat. 117)

Childe Hassam (1859–1935)
Le Jour du Grand Prix
1888
Oil on canvas
37 1/4 x 49 1/4 inches
From the Collection of the New Britain
Museum of American Art, Connecticut
Grace Judd Landers Fund
[Ex. coll., B. F. Jones, Jr.]
(Cat. 118)

J. J. Henner (1829–1905)
Meditation
n.d.
Oil on canvas
23 1/4 x 15 inches
Allegheny Cemetery, Pittsburgh
Given in memory of William C. Moreland
(Cat. 8)

George Hetzel (1826–1899)
Woodland Stream
1880
Oil on canvas
45 x 30 inches
Frick Art & Historical Center, Pittsburgh
(Cat. 25)

Arthur Heyer (1872–1931)
Interior Scene: German Renaissance Schloss
n.d.
Oil on canvas
22 x 28 inches
Private Collection, Pittsburgh
[Ex. coll., Charles Lockhart]
(Cat. 60)

Louis Bosworth Hurt (1856–1929)
Highland Cattle
1899
Oil on canvas
35 1/2 x 53 1/4 inches
Pittsburgh Athletic Association
(Cat. 63)

Jozef Israels (1824–1911)
Kitchen Interior with Two Figures
n.d.
Oil on panel
27 x 25 1/4 inches
Collection of Mr. and Mrs. Charles G. Pauli,
Jr., Pittsburgh
(Cat. 5)

Jozef Israels (1824–1911)
Madonna at the Door
n.d.
Oil on panel
22 3/4 x 17 1/4 inches
Collection of Mr. and Mrs. Edward J.
McCague, Jr., Pittsburgh
[Ex. coll., Willis F. McCook]
(Cat. 123)

Jozef Israels (1824–1911)
The First Sail
n.d.
Etching
11 x 12 1/2 inches
Frick Art & Historical Center, Pittsburgh
(Cat. 122)

Charles Jacque (1813–1894)
Safe in the Fold
n.d.
Oil on canvas
19 1/4 x 25 1/4 inches
Private Collection, Pittsburgh
[Ex. coll., Charles Lockhart]
(Cat. 49)

Luis Jiménez y Aranda (1845–1903)
Au Louvre
1881
Oil on canvas
23 x 16 1/2 inches
Frick Art & Historical Center, Pittsburgh
(Cat. 26)

Jacobus Simon Hendrik Kever (1854–1922)
Children Peeling Apples
(Interior View, Family)
n.d.
Watercolor
16 1/2 x 21 1/2 inches
University Club, Pittsburgh
[Ex. coll., James B. Laughlin]
(Cat. 7)

Anna Klumpke (1856–1942)
Portrait of Mary Copley Thaw
1897
Oil on canvas
44 x 31 inches
Collection of Harold and Catherine Mueller,
Sedona, Arizona
[Ex. coll., Mrs. William Thaw]
(Cat. 15)

Daniel Ridgway Knight (1839–1924)
Cutting Roses
n.d.
Oil on canvas
46 x 32 inches
University Club, Pittsburgh
(Cat. 65)

Daniel Ridgway Knight (1839–1924)
Woman in Landscape
n.d.
Oil on canvas
30 x 24 inches
Collection of Katherine L. Griswold, Pittsburgh
[Ex. coll., Charles Lockhart]
(Cat. 27)

Daniel Ridgway Knight (1839–1924)
Meditation
n.d.
Oil on canvas
28 1/2 x 23 1/2 inches
Collection of George D. Lockhart, Pittsburgh
[Ex. coll., Charles Lockhart]
(Cat. 28)

Gaston Latouche (1854–1913)
The Bath
c. 1907
Oil on canvas
79 x 66 inches
University Club, Pittsburgh
[Ex. coll., William S. Stimmel]
(Cat. 112)

Madeleine-Jeanne Lemaire (1845–1928)
Expectation
n.d.
Watercolor
16 x 10 inches
Frick Art & Historical Center, Pittsburgh
(Cat. 50)

Adolphe Alexander Lesrel (1839–1890)
The Stirrup Cup
n.d.
Oil on canvas
19 x 23 1/4 inches
Collection of Mr. and Mrs. James M. Edwards, Pittsburgh
[Ex. coll., Charles Lockhart]
(Cat. 55)

Jean-Baptiste Madou (1796–1877)
The Disagreement
1860
Oil on panel
12 x 13 1/2 inches
Collection of Mr. and Mrs. James M. Edwards, Pittsburgh
[Ex. coll., Charles Lockhart]
(Cat. 53)

Raymundo de Madrazo (1841–1920)
Portrait of Grant A. Peacock
1902
Oil on canvas
29 1/2 x 24 1/2 inches
Grant A. Peacock, Inc., New York
(Cat. 70)

Jacobus Hendrikus Maris (1837–1899)
Man Ploughing
n.d.
Oil on canvas
18 1/2 x 44 1/2 inches
Frick Art & Historical Center, Pittsburgh
(Cat. 46)

Anton Mauve (1838–1888)
The Shepherd
n.d.
Watercolor
17 3/4 x 10 3/4 inches
Frick Art & Historical Center, Pittsburgh
(Cat. 45)

Jean-Louis-Ernest Meissonier (1815–1891)
Hussar
c. 1880
Oil on panel
8 1/2 x 6 inches
Collection of Mrs. Henry Chalfant, Sewickley, Pennsylvania
(Cat. 51)

Jean-Louis-Ernest Meissonier (1815–1891)
1806, Jena
1890
Oil on canvas
42 3/4 x 57 1/4 inches
Private Collection, Pittsburgh
[Ex. coll., Charles Lockhart]
(Cat. 119)

Frank D. Millet (1846–1912)
Anthony Van Corlear, the Trumpeter of New Amsterdam
1889
Oil on canvas
42 x 66 inches
Duquesne Club, Pittsburgh
Presented by Andrew W. Mellon
[Ex. coll., Andrew W. Mellon]
(Cat. 39)

Jean-François Millet (1814–1875)
The Knitting Lesson
c. 1858–1860
Black chalk on paper
13 1/2 x 10 7/8 inches
Frick Art & Historical Center, Pittsburgh
(Cat. 34)

Jean-François Millet (1814–1875)
La Fermière (The Flight of Crows)
c. 1868–1870
Pastel on paper
14 1/2 x 18 3/4 inches
Frick Art & Historical Center, Pittsburgh
(Cat. 35)

Mihály Munkácsy (1844–1909)
The Two Families
1880
Oil on panel
42 1/2 x 59 inches
Pittsburgh Athletic Association
[Ex. coll., William H. Vanderbilt]
(Cat. 59)

Gerard Portielje (1856–1929)
The Relay
1885
Oil on canvas
23 x 30 inches
Collection of Mr. and Mrs. James M. Edwards, Pittsburgh
[Ex. coll., Charles Lockhart]
(Cat. 14)

Jean-François Raffaëlli (1850–1924)
Terrain vague
1894
Etching, aquatint printed in color; no. 25 in an
edition of 30
15 1/2 x 16 1/4 inches
Frick Art & Historical Center, Pittsburgh
(Cat. 84)

Jean-François Raffaëlli (1850–1924)
Sur le banc
1894
Etching, aquatint printed in color; no. 25 in an
edition of 30
14 x 15 inches
Frick Art & Historical Center, Pittsburgh
(Cat. 85)

Jean-François Raffaëlli (1850–1924)
La Toilette
c. 1898
Oil on canvas
21 1/4 x 13 3/4 inches
Frick Art & Historical Center, Pittsburgh
(Cat. 86)

Jean-François Raffaëlli (1850–1924)
Schenley Park, Pittsburgh
1899
Oil on canvas
26 x 32 inches
Collection of Adam Stolpen, Connecticut
(Cat. 87)

Pio Ricci (1850–1919)
Lady and Cavalier
n.d.
Oil on canvas
25 1/2 x 21 inches
Collection of Michael D. and Violanda R.
LaBate, Ellwood City, Pennsylvania
(Cat. 120)

Martin Rico y Ortega (1833–1908)
Fishermen's Houses, Venice
n.d.
Oil on canvas
17 x 28 inches
Frick Art & Historical Center, Pittsburgh
(Cat. 29)

George Romney (1734–1802)
*Maria and Katherine, Daughters of Edward,
Lord Chancellor, Thurlow*
n.d.
Oil on canvas
60 1/8 x 47 7/8 inches
Yale University Art Gallery, New Haven,
Connecticut
Gift of Mrs. Alison G. Paine
[Ex. coll., Alexander M. Byers]
(Cat. 23)

Toby Edward Rosenthal (active 1848–1917)
Woodcarver of Oberammergau
n.d.
Oil on canvas
35 x 27 inches
Private Collection, Pittsburgh
[Ex. coll., William N. Frew]
(Cat. 17)

Théodore Rousseau (1812–1867)
Dessous de Bois
n.d.
Oil on canvas
20 7/8 x 16 inches
Frick Art & Historical Center, Pittsburgh
(Cat. 48)

Salomon van Ruysdael (c.1600–1670)
A Waterfall
n.d.
Oil on canvas
39 1/2 x 33 1/2 inches
Private Collection
[Ex. coll., Henry Clay Frick]
(Cat. 24)

Walter Dendy Sadler (1854–1923)
The Wayside Inn
n.d.
Oil on canvas
33 x 47 inches
Collection of Mr. and Mrs. William Penn
Snyder, III, Sewickley, Pennsylvania
[Ex. coll., W. P. Snyder]
(Cat. 54)

Adolf Schreyer (1828–1899)
The Pass over the Hills
n.d.
Oil on canvas
29 1/2 x 55 1/4 inches
Collection of Mr. and Mrs. A. Charles
Perego, Pittsburgh
[Ex. coll., Willis F. McCook]
(Cat. 121)

Henry Singleton (1766–1839)
Portrait of a Lady
c. 1800
Oil on canvas
20 1/2 x 16 1/2 inches
Collection of Mr. and Mrs. Thomas M.
Schmidt, Pittsburgh
[Ex. coll., Andrew W. Mellon]
(Cat. 40)

Frits Thaulow (1847–1906)
Village Night Scene
1895
Oil on canvas
25 1/2 x 36 inches
Frick Art & Historical Center, Pittsburgh
(Cat. 81)

Frits Thaulow (1847–1906)
View Along the Monongahela River
1895
Oil on canvas
15 5/8 x 19 1/2 inches
Collection of Mr. and Mrs. Henry L.
Hillman, Pittsburgh
(Cat. 36)

Frits Thaulow (1847–1906)
The Smoky City
1895
Oil on canvas
43 x 50 inches
Sagamore Hill National Historic Site,
National Park Service, Oyster Bay, New
York
(Cat. 82)

Frits Thaulow (1847–1906)
Steel Mills Along the Monongahela River
1898
Pastel
25 1/2 x 32 inches
Duquesne Club, Pittsburgh
Presented by Arthur E. Braun
(Cat. 83)

Constant Troyon (1810–1865)
Milking Time
n.d.
Oil on canvas
36 x 40 inches
The McCune Foundation, Pittsburgh
[Ex. coll., Charles Lockhart]
(Cat. 128)

Eugene Joseph Verboeckhoven (1798–1881)
Stable Interior with Two Horses and Chickens
n.d.
Oil on canvas
20 3/4 x 27 3/4 inches
Collection of Mr. and Mrs. Roy G. Dorrance,
Pittsburgh
[Ex. coll., Park-Kelly]
(Cat. 62)

Jean Georges Vibert (1840–1902)
Scramble for the Lunch
n.d.
Oil on canvas
26 x 20 inches
Collection of Katherine L. Griswold, Pittsburgh
[Ex. coll., Charles Lockhart]
(Cat. 126)

A. Bryan Wall (1825–1896)
Landscape
n.d.
Oil on canvas
19 1/2 x 29 1/2 inches
Frick Art & Historical Center, Pittsburgh
(Cat. 4)

John F. Weir (1841–1926)
Roses
1889
Oil on canvas
20 x 30 1/8 inches
National Museum of American Art, Washington, D. C.
Gift of Miss A. M. Hegeman
[Ex. coll., Henry Kirke Porter]
(Cat. 115)

Cornelis Westerbeek (1844–1903)
Sheep with Shepherd
1899
Oil on canvas
23 x 38 1/2 inches
Collection of Mr. and Mrs. Roy G. Dorrance,
Pittsburgh
[Ex. coll., Park-Kelly]
(Cat. 130)

Cat. 127. Edvard Charlemont (1848–1906). *Venetian Pageboy*, n.d., oil on canvas. Collection of Katherine L. Griswold, Pittsburgh [Ex. coll., Charles Lockhart].

Selected Bibliography

Ackerman, Gerald M. *The Life and Work of Jean-Léon Gérôme*. New York, 1986.

Amaya, Mario, and Eric M. Zafran. *Treasures from the Chrysler Museum at Norfolk and Walter P. Chrysler, Jr.* Norfolk, 1977.

Appleby, Joyce. *Capitalism and the New Social Order*. New York, 1984.

Baetjer, Katharine. *European Paintings from the Metropolitan Museum of Art by Artists Born In or Before 1865. A Summary Catalogue*. 3 vols. New York, 1980.

Beal, Graham. *Charles Parsons' Collection of Paintings*. St. Louis, 1977.

Beldecos, Evangeline, et al. *Art in Nineteenth-Century Pittsburgh*. Exh. cat. Pittsburgh, 1977.

Beaufort, Madeleine Fidell. "Jules Breton in America: Collecting in the 19th Century." In *Jules Breton and the French Rural Tradition*. Exh. cat. Omaha, 1982.

Bergeon, Annick. "Expositions en Province, Bordeaux, Ouverture du Musée Goupil, Conservatoire de l'Image Industrielle." *Nouvelles de l'Estampe*, no. 118–19 (October-November 1991): 42–45.

Bermingham, Peter. *American Art in the Barbizon Mood*. Washington, D.C., 1975.

Boltanski, Christian. *Archive of the Carnegie International, 1896–1991*. Pittsburgh and New York, 1991.

Bridge, James H. *The Inside History of the Carnegie Steel Company*. New York, 1903.

Brimo, René. *L'Evolution du goût aux Etats-Unis, d'après l'histoire des collections*. Paris, 1938.

Burns, Sarah. *Inventing the Modern Artist: Art and Culture in Gilded Age America*. New Haven, 1996.

Bryant, Keith L., Jr. *William Merritt Chase: A Genteel Bohemian*. Columbia, Mo., 1991.

Bushman, Richard L. *The Refinement of America: Persons, Houses, Cities*. New York, 1993.

Butera, Ronald J. "A Settlement House and the Urban Challenge: Kingsley House in Pittsburgh, Pennsylvania, 1893–1920." *Western Pennsylvania Historical Magazine* 66, no. 1 (1983): 25–47.

Carbone, Teresa A. *At Home with Art: Paintings in American Interiors, 1780–1920*. Katonah, N.Y., 1995.

Carnegie Museum of Art. *David Gilmour Blythe's Pittsburgh: 1850–1865*. Pittsburgh, 1981.

Casson, Herbert. *Romance of Steel*. New York, 1907.

Cashman, Sean Dennis. *America in the Gilded Age, from the Death of Lincoln to the Rise of Theodore Roosevelt*. New York, 1984.

Chambers, Clarke A. *Paul U. Kellogg and the Survey: Voices for Social Welfare and Social Justice*. Minneapolis, 1971.

Clark, Vicky, et al. *International Encounters: The Carnegie International and Contemporary Art, 1896–1996*. Pittsburgh, 1996.

Cikovsky, Nicolai, Jr. *William Merritt Chase: Summers at Shinnecock, 1891–1902*. Exh. cat. Washington, D.C., 1987.

Coffin, William A. "P. A. J. Dagnan-Bouveret." In *Modern French Masters, a series of biographical and critical reviews by American artists*. Edited by John C. Van Dyke. New York, 1896.

Constable, W. G. *Art Collecting in the United States of America, An Outline of a History*. Toronto and New York, 1964.

Couvares, Francis G. *The Remaking of Pittsburgh: Class and Culture in an Industrializing City, 1877–1919*. Albany, 1984.

Crowell, F. Elisabeth. "Painter's Row: The Company House." In Paul U. Kellogg, ed. *The Pittsburgh District: The Civic Frontage*. New York, 1914.

Davidson, Bernice. *Paintings in the Frick Collection*. Vol. 2, *Paintings—French, Italian and Spanish*. New York, 1968.

Davidson, Bernice, and Harry D. M. Grier. *Paintings in the Frick Collection.* Vol. 1. New York, 1968.

Duhousset, Emile. *Le Cheval dans la nature et dans l'art.* Paris, 1902.

Fanica, Pierre-Olivier. *Charles Jacque, 1813–1894, Graveur original et peintre animalier.* Montigny-sur-Loing, 1995.

Fleming, Susan. "The Boston Patrons of Jean-François Millet." In *Jean-François Millet.* Exh. cat. Boston, 1984.

Floyd, Margaret Henderson. *Architecture After Richardson, Regionalism Before Modernism: Longfellow, Alden and Harlow in Boston and Pittsburgh.* Chicago, 1994.

Forster-Hahn, Françoise. "Marey, Muybridge and Meissonier: The Study of Movement in Science and Art." In *Eadweard Muybridge. The Stanford Years, 1872–1882.* Palo Alto, 1972.

Frits Thaulow: un Norvégien Français. Exh. cat. Paris, 1994.

Gaston Latouche, Exhibition of Paintings. Exh. cat. London, 1979.

Gerdts, William H. *Art Across America: Two Centuries of Regional Painting, 1710–1920.* 3 vols. New York, 1990.

Gilmer, Harrison. "Birth of the American Crucible Steel Industry." *Western Pennsylvania Historical Magazine* 36 (1953): 17–36.

Goodenough, Simon. *The Greatest Good Fortune: Andrew Carnegie's Gift Today.* Edinburgh, 1985.

Gréard, Valery C. O. *Jean-Louis-Ernest Meissonier, ses souvenirs, ses entretiens.* Paris, 1897.

———. *Meissonier, His Life and His Art.* New York, 1897.

Gregory, Frances W., and Irene D. Neu. "The American Industrial Elite of the 1870s." In William Miller, ed. *Men in Business.* New York, 1962.

Gutman, Herbert. "The Reality of the 'Rags to Riches' Myth: The Case of the Paterson, New Jersey, Locomotive, Iron and Machinery Manufacturers, 1830–1880." *In Nineteenth Century American Cities: Essays in the New Urban History.* Edited by Stephen Thernstrom and Richard Sennett. New Haven, 1969.

Haas, Robert. *Muybridge. Man in Motion.* Berkeley, 1976.

Hacker, Louis M. *The World of Andrew Carnegie, 1865–1901.* Philadelphia, 1968.

Hancock, Jane H., Sheila ffolliott, and Thomas O'Sullivan. *Homecoming: The Art Collection of James J. Hill.* St. Paul, 1991.

Harrison, Jefferson C. *The Chrysler Museum: Handbook of the European and American Collections.* Norfolk, 1991.

Harvey, George. *Henry Clay Frick, The Man.* New York and London, 1928.

Hellerstedt, Kahren Jones, et al. *Clayton, The Pittsburgh Home of Henry Clay Frick: Art and Furniture.* Pittsburgh, 1988.

Hiesinger, Ulrich W. *Childe Hassam, American Impressionist.* Munich and New York, 1994.

Hill, Charles, and Steven Cohen. "John A. Fitch and the Pittsburgh Survey." *Western Pennsylvania Historical Magazine* 67 (January 1984): 17–32.

Holbrook, Stewart. *Age of the Moguls.* New York, 1953.

Hungerford, Constance Cain. "Meissonier and the Founding of the Société Nationale des Beaux-Arts." *Art Journal* 48, no. 1 (Spring 1989): 71–77.

Hunter, Louis C. "Factors in the Early Pittsburgh Iron Industry." In *Facts and Factors in Economic History: Articles by Former Students of Edwin Francis Gay.* Cambridge, 1932.

———. "Financial Problems of the Early Pittsburgh Iron Manufacturers." *Journal of Economic and Business History* 2 (May 1930): 520–44.

Ingham, John. *The Iron Barons: A Social Analysis of an American Urban Elite, 1874–1965.* Westport, Conn., 1978.

———. *Making Iron and Steel: Independent Mills in Pittsburgh, 1820–1920.* Columbus, Ohio, 1991.

———. "Rags to Riches Revisited: The Role of City Size and Related Factors in the Recruitment of Business Leaders." *Journal of American History* 63 (December 1976): 615–37.

"An Introduction to the Art Collection of Charles Phelps and Anna Sinton Taft." In *The Taft Museum, its History and Collections.* New York, 1995.

Isaacson, Robert. "Collecting Bouguereau in England and America." In *William Bouguereau, 1825–1905.* Exh. cat. Montreal, 1984.

Johnston, William R. *The Nineteenth-Century Paintings in the Walters Art Gallery.* Baltimore, 1982.

Jucha, Robert J. "The Anatomy of a Streetcar Suburb: A Devel-

opment History of Shadyside, 1812–1916." *Western Pennsylvania Historical Magazine* 62 (October 1979): 302–19.

Kellogg, Paul Underwood, ed. *The Pittsburgh Survey.* 6 vols. New York, 1909–14.

Kidney, Walter C. *Landmark Architecture: Pittsburgh and Allegheny County.* Pittsburgh, 1985.

Kleinberg, S. J. *The Shadow of the Mills: Working Class Families in Pittsburgh, 1870–1907.* Pittsburgh, 1989.

Kloss, William, et al. *Art in the White House: A Nation's Pride.* Washington, D.C., 1992.

Landmark Architecture: Pittsburgh and Allegheny County. Text by Walter C. Kidney. Pittsburgh, 1985.

Leach, William. *Land of Desire: Merchants, Power and the Rise of a New American Culture.* New York, 1994.

Leedy, Walter C., Jr. *Cleveland Builds an Art Museum: Patronage, Politics, and Architecture, 1884–1916.* Cleveland, 1991.

Le Normand-Romain, Antoinette. "Meissonier Sculpteur." In *Ernest Meissonier Rétrospective.* Exh. cat. Lyons, 1993.

Livesay, Harold. *Andrew Carnegie and the Rise of Big Business.* Boston, 1975.

Lorant, Stefan. *Pittsburgh: The Story of an American City.* Garden City, N.Y., 1964.

Lovett, Jennifer Gordon, and William R. Johnston. *Empires Restored, Elysium Revisited: The Art of Sir Lawrence Alma-Tadema.* Exh. cat. Williamstown, Mass., 1991.

Lundberg, Ferdinand. *America's 60 Families.* New York, 1937.

———. *The Rich and the Super-Rich.* New York, 1968.

Lynes, Russell. *The Tastemakers: The Shaping of American Popular Taste.* New York, 1980.

Maxwell, Marianne. "Pittsburgh's Frick Park: A Unique Addition to the City's Park System." *Western Pennsylvania Historical Magazine* 68 (July 1985): 243–65.

McClymer, John F. "The Pittsburgh Survey, 1907–1914: Forging an Ideology in the Steel District." *Pennsylvania History* 41 (April 1974): 169–88.

Meixner, Laura L. *French Realist Painting and the Critique of American Society, 1865–1900.* New York, 1995.

Mellon, Paul, with John Baskett. *Reflections in a Silver Spoon: A Memoir.* New York, 1992.

Meyer, Ruth K. *The Taft Art Museum.* Cincinnati, 1995.

Miller, Annie Clark. *Chronicles of Families, Homes and Estates of Pittsburgh and Its Environs.* Pittsburgh, 1921.

Miller, Lillian B. "The Milwaukee Art Museum's Founding Father Frederick Layton (1827–1919) and His Collection." In *Milwaukee, Wisconsin, Milwaukee Art Museum 1888–1988. A Centennial Exhibition.* Milwaukee, 1988.

———. *Patrons and Patriotism: The Encouragement of the Fine Arts in the United States, 1790–1860.* Chicago, 1966.

Miller, William. "American Historians and the Business Elite." In William Miller, ed. *Men in Business.* New York, 1962.

Milner, John. *The Studios of Paris: The Capital of Art in the Late Nineteenth Century.* New Haven, 1988.

Mozley, Anita Ventura. *Muybridge's Complete Human and Animal Locomotion.* Vol. 1. New York, 1979.

Munhall, Edgar. *Henry Clay Frick: The Young Collector.* New York, 1988.

Neal, Kenneth. *A Wise Extravagance: The Founding of the Carnegie International Exhibitions, 1895–1901.* Pittsburgh, 1996.

Nixon, Lily Lee. "Henry Clay Frick and Pittsburgh's Children." *Western Pennsylvania Historical Magazine* 29 (1946): 65–72.

The Opulent Interiors of the Gilded Age: All 203 Photographs from "Artistic Houses." With new text by Arnold Lewis, James Turner, and Steven McQuillen. New York, 1987.

Paintings from Europe and the Americas in the Philadelphia Museum of Art: A Concise Catalogue. Philadelphia, 1994.

Paintings from The Frick Collection. Introduction by Charles Ryskamp. New York, 1990.

A Pastoral Legacy: Paintings and Drawings by the American Artists Ridgway Knight and Aston Knight. Exh. cat. Ithaca, N.Y., 1989.

Patterson, Jerry E. *The Vanderbilts and the Gilded Age: Architectural Aspirations, 1879–1901.* New York, 1989.

Peck, William H. *The Detroit Institute of Arts, A Brief History.* Detroit, 1991.

Petry, Claude. *Emile Friant (1863–1932). Regard sur l'homme et l'oeuvre.* Exh. cat. Nancy, 1988.

Phillips, Marjorie. *Duncan Phillips with His Collection.* Rev. ed. Washington and New York, 1982.

Pisano, Ronald G. *A Leading Spirit in American Art: William Merritt Chase 1849–1916.* Seattle, 1983.

———. *Summer Afternoons: Landscape Paintings of William Merritt Chase*. Boston, 1993.

Porter, Glenn, and Harold Livesay. *Merchants and Manufacturers: Studies in the Changing Structure of 19th Century Marketing*. Baltimore, 1971.

Randall, Lilian M. C. *The Diary of George A. Lucas: An American Art Agent in Paris, 1857–1909*. 2 vols. Princeton, 1979.

Reynolds, Gary A. "The Spirit of Empty Rooms: Walter Gay's Paintings of Interiors." *The Magazine Antiques* 137, no. 3 (March 1990): 676–82.

Rishel, Joseph F. *Founding Families of Pittsburgh: The Evolution of a Regional Elite, 1760–1910*. Pittsburgh, 1990.

Roof, Katharine Metcalf. *The Life and Art of William Merritt Chase*. New York, 1917.

Saarinen, Aline B. *The Proud Possessors: The Lives, Times and Tastes of Some Adventurous American Art Collectors*. New York, 1958.

Schuyler, Montgomery. "The Building of Pittsburgh." *Architectural Record* 20 (September 1911): 203–82.

Schreiner, Samuel A., Jr. *Henry Clay Frick: The Gospel of Greed*. New York, 1995.

Sheon, Aaron. "Nineteenth Century French Art in the Clark Collection." In *The William A. Clark Collection, The Corcoran Gallery of Art*. Washington, D.C., 1978.

Springer, Julie Anne. "Art and the Feminine Muse: Woman in Interiors by John White Alexander." *Woman's Art Journal* 6, no. 2 (Fall 1985/Winter 1986): 1–8.

Stavitsky, Gail. "Childe Hassam and the Carnegie Institute: A Correspondence." *Archives of American Art Journal* 22, no. 3 (1982): 2–7.

Strahan, Edward [Earl Shinn], ed. *The Art Treasures of America*. 3 vols. Philadelphia, 1879–82.

Strazdes, Diana. *American Painting and Sculpture to 1945 in the Carnegie Museum of Art*. New York, 1992.

Swanson, Vern G. *The Biography and Catalogue Raisonné of Sir Lawrence Alma-Tadema*. London, 1990.

Tappert, Tara L. *Cecilia Beaux and the Art of Portraiture*. Exh. cat. Washington and London, 1995.

Tarr, Joel A. *Transportation Innovation and Changing Spatial Patterns in Pittsburgh, 1850–1934*. Chicago, 1978.

Temin, Peter. *Iron and Steel in Nineteenth Century America: An Economic Inquiry*. Cambridge, Mass., 1964.

Trachtenberg, Alan. *The Incorporation of America: Culture and Society in the Gilded Age*. New York, 1982.

Turner, Evan H. *Object Lessons: Cleveland Creates an Art Museum*. Cleveland, 1991.

Tweedale, Geoffrey. *Sheffield Steel and America: A Century of Commercial and Technological Interdependence, 1830–1930*. Cambridge, England, 1987.

Van Dyke, John C. *A Text-Book of the History of Painting*. London and New York, 1913.

Van Trump, James D. *Life and Architecture in Pittsburgh*. Pittsburgh, 1983.

———. "The Romanesque Revival in Pittsburgh." *Journal of the Society of Architectural Historians* 16 (1957): 22–29.

Walker, John. *Self-Portrait with Donors*. Boston, 1974.

Wall, Joseph. *Andrew Carnegie*. New York, 1970.

Ward, Roger, and Patricia J. Fidler, eds. *The Nelson-Atkins Museum of Art: A Handbook of the Collection*. Kansas City, Mo., 1993.

Warren, Kenneth. *Triumphant Capitalism: Henry Clay Frick and the Industrial Transformation of America*. Pittsburgh, 1996.

Weinberg, H. Barbara. *The Lure of Paris: Nineteenth Century American Painters and Their French Teachers*. New York, 1991.

Weisberg, Gabriel P. *Beyond Impressionism: The Naturalist Instinct*. New York, 1992.

———. *Redefining Genre: French and American Painting, 1850–1900*. Exh. cat. Washington, D.C., 1995.

———. "Tastemaking in Pittsburgh, The Carnegie International in Perspective, 1896–1905." *Carnegie Magazine* 56, no. 10 (July-August 1983): 20–22.

———. *Women of Fashion, French and American Images of Leisure, 1880–1920*. Exh. cat. Tokyo, 1994.

Wilkins, David, et al. *Art in Nineteenth-Century Pittsburgh*. Pittsburgh, 1977.

Wilkins, David G. *Paintings and Sculpture of the Duquesne Club*. Pittsburgh, 1986.

Winkelman, Barnie F. *John G. Johnson, Lawyer and Art Collector*. Philadelphia, 1942.

Chronological Listing of Relevant Exhibition Catalogues, 1860–1910

Catalogue of the Work of Art, Exhibition of Paintings and Statuary in aid of the Pittsburgh Fair Fund of the United States Sanitary Commission together with Paintings Contributed by the Artists of Pittsburgh and Others, paid Sale, paid Benefit of the Fair. Pittsburgh, 1864.

Catalogue of the Pittsburgh Library Loan Exhibition. Pittsburgh, 1879.

Art Department, Pittsburgh Exposition. Pittsburgh, 1891.

Dedication Souvenir, Carnegie Library of Pittsburgh, Pa., Programme and Catalogue, Catalogue of Paintings Exhibited in the Carnegie Art Galleries, Pittsburgh, Pa., 1895. Pittsburgh, 1895.

Catalogue of the Second Loan Collection of Paintings, and Permanent Collection of Statuary and Photographs. Pittsburgh, 1896.

Catalogue of a Loan Exhibition of Paintings at the Carnegie Institute. Pittsburgh, 1902.

The Carnegie Institute Catalogue of Paintings, Sculpture, and other objects in the Department of Fine Arts. Pittsburgh, 1903.

Catalogue of a summer loan exhibition of Paintings. Pittsburgh, 1908.

Catalogue of a summer loan exhibition. Pittsburgh, 1910.

Cat. 128. Constant Troyon (1810–1865).
Milking Time, n.d., oil on canvas. The
McCune Foundation, Pittsburgh [Ex.
coll., Charles Lockhart].

Index

Page numbers of illustrations are set in italics.

Cat. 129. Robert Cooper (b. 1821, active
1850–1874). *On the Truro near Dalwhini,
Perthshire*, 1870, watercolor. Collection of
Dr. and Mrs. Robert Lipinski, Pittsburgh
[Ex. coll., Park-Kelly].

Photo Credits

Allegheny Cemetery, Pittsburgh
The Art Institute of Chicago
The Art Museum, Princeton University,
 Princeton, New Jersey
Assemblée Nationale, Paris, France
The Baltimore Museum of Art
Bayerische Staatsgemäldesammlungen,
 Munich, Germany
Peter L. Bloomer
Carnegie Library of Pittsburgh
The Carnegie Museum of Art, Pittsburgh
Chicago Historical Society
Charles Choffet
Christie's, New York
The Chrysler Museum, Norfolk, Virginia
Columbus Museum of Art, Ohio
Collection of Mrs. Teresa Heinz, Pittsburgh
Community College of Allegheny County,
 Pennsylvania
The Corcoran Gallery of Art, Washington, D.C.
Dahesh Museum, New York
The Denver Art Museum
DePaul Institute, Pittsburgh
Detroit Institute of Arts
Duquesne Club, Pittsburgh
Frick Art & Historical Center
The Frick Collection, New York
Frick family archives, Pittsburgh
Getty Research Institute for the History of Art
 and the Humanities, Santa Monica
Goupil Archives, Bordeaux, France
Guggenheim-Asher Associates, New York
The Henry E. Huntington Library
 and Art Gallery, San Marino, California
International Museum of Photography
 at George Eastman House. Rochester

Joslyn Art Museum, Omaha, Nebraska
M. Knoedler & Company, New York
Erik Kvalsvik
Mairie de Neufchateau, France
The McCune Foundation, Pittsburgh
Meadows Museum, Dallas, Texas
The Metropolitan Museum of Art, New York
Musée des Beaux-Arts, Bordeaux, France
Musée des Beaux-Arts de Tours, France
Musée des Beaux-Arts, Nancy, France
Musée d'Orsay, Paris, France
Musée Goupil, Bordeaux, France
Musée Municipal Georges Garret, Vesoul, France
Museum of Art, Ft. Lauderdale, Florida
Museum of Fine Arts, Boston
National Museum of American Art,
 Washington, D.C.
National Portrait Gallery, Washington D.C.
The Nelson-Atkins Museum of Art,
 Kansas City, Missouri
Denis J. Nervig
New Britain Museum of American Art,
 Connecticut
The New-York Historical Society
Philadelphia Museum of Art
Phipps Conservatory, Pittsburgh
Pittsburgh Athletic Association
Adam Reich
Sagamore Hill National Historic Site,
 National Park Service, Oyster Bay, New York
Templeton Smith
Sotheby's, New York
Brad Stanton
Richard Stoner
The Taft Museum, Cincinnati
University Club, Pittsburgh

The Walters Art Gallery, Baltimore
Washington University Gallery of Art, St.
 Louis
Westmoreland Museum of Art,
 Greensburg, Pennsylvania
Rolland E. White
The White House
Yale University Art Gallery,
 New Haven, Connecticut

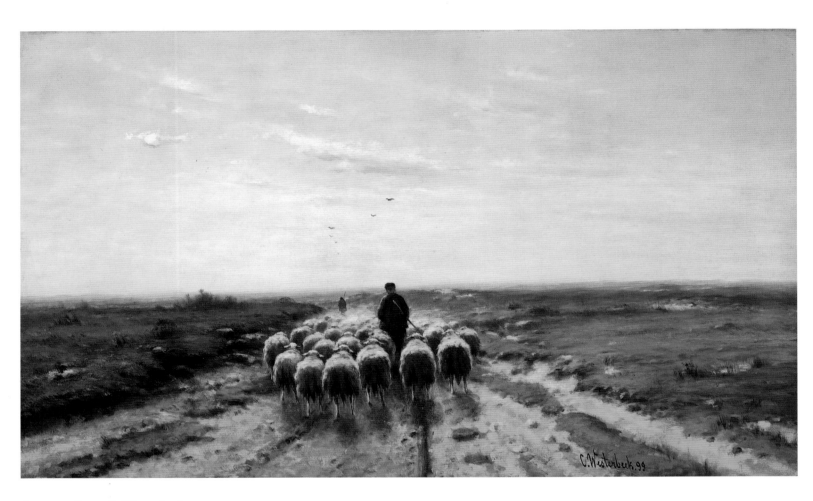

Cat. 130. Cornelis Westerbeek
(1844–1903). *Sheep with Shepherd*, 1899,
oil on canvas. Collection of Mr. and Mrs.
Roy G. Dorrance, Pittsburgh [Ex. coll.,
Park-Kelly].

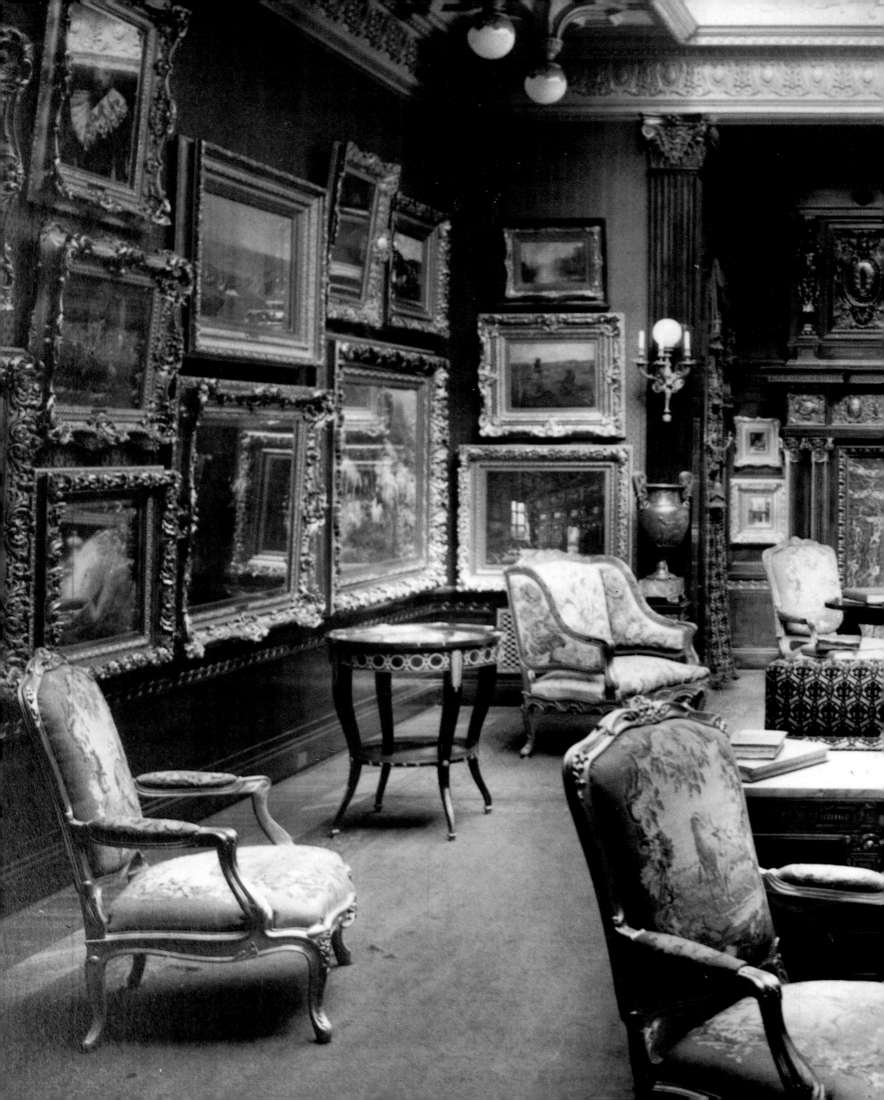